BALTINGLASS CHRONICLES
1851-2001

PAUL GORRY

The History Press

Cover Image: Main Street, Baltinglass, *c.*1910, from the Eason Collection. (Reproduced with the permission of the Board of the National Library of Ireland).

First published 2006 by Nonsuch Publishing
This paperback edition first published 2023

The History Press
97 St George's Place, Cheltenham,
Gloucestershire, GL50 3QB
www.thehistorypress.co.uk

© Paul Gorry, 2006, 2023

British Library Cataloguing in Publication Data.
A catalogue record for this book is available from the British Library.

ISBN 978 1 80399 478 9

Typesetting and origination by The History Press
Printed and bound in Great Britain by TJ Books Limited, Padstow, Cornwall.

MIX
Paper from
responsible sources
FSC® C013056
www.fsc.org

Trees for LƳfe

CONTENTS

This book is dedicated to my parents, Pat and Eileen Gorry, who shared in Baltinglass life for more than half a century. To Lizzie Bollard (1914-2004), a life-long resident and my first friend in life. To Mrs Eva Doyle, Frank Glynn, Tony Harbourne, Dr & Mrs Lyons, John McLoughlin of Main Street & Jimmy Nolan of the Wood, who nurtured my early interest in local history and to Colette Johnston (1928-2005), who encouraged my early attempts at writing.

ABOUT THE AUTHOR

Paul Gorry has had a life long interest in local and family history. He was born in Baltinglass in 1959 and grew up in the town, attending St Pius X National School and Baltinglass Post Primary School (now Scoil Chonglais). He has been engaged professionally in genealogical research since 1979. He was joint-author of *Tracing Irish Ancestors* (Glasgow: HarperCollins, 1997) with Máire Mac Conghail. He also wrote *Baltinglass Golf Club 1928-2003*. He was a founder member of the West Wicklow Historical Society in 1980, of the Association of Professional Genealogists in Ireland in 1986, and of the Irish Genealogical Congress in 1989. In 1999 he was elected a Fellow of the Society of Genealogists (London) and in 2005 a Fellow of the Irish Genealogical Research Society.

INTRODUCTION

When I was about ten or eleven, and already addicted to history, Canon Chavasse published his *The Story of Baltinglass*. To my mind he had written all there was to know about the town's history. It was only when I got older and learned more about Baltinglass's past that I realised that no one book could ever encapsulate all there was to know about Baltinglass in the past. In the 1980s various contributors to the *Journal of the West Wicklow Historical Society* added to the body of published material on the town, yet I never seriously thought of writing a book bringing together what I knew on the subject.

This book grew out of a relatively small idea. It was going to be one of those 'millennium' projects that were being germinated a few years ago. Originally I was going to compile a street directory of Baltinglass as of 1 January 2001. It was to be a record, a sort of 'snap shot', of the town on the first day of the twenty-first century (the true beginning of the new millennium; not the premature one expensively celebrated all over the world twelve months earlier). While toying with the idea and deciding how to go about it, I decided that, using the 1901 Census and the Valuation Office revision books, it would be possible to do a similar reconstruction of Baltinglass a century earlier. Then Noel Farrell suggested that I use the Electoral Lists and the revision books to reconstruct 1951. As Griffith's *Primary Valuation* was published for the area in 1854 and the earlier Valuation Office house books were also available, I decided to add 1851 to the project.

It occurred to me that the four street directories alone would be of limited interest. Then in 2000, when the Kosovars were to leave Rathcoran House and I thought that maybe they would all be gone from Baltinglass before 1 January 2001, I thought of how much change occurred between each of the directories and how many recent events would one day be remote history to younger generations. It was this line of thinking that made me 'fill in' the years between the four directories and the small project developed into chronicles of 150 years of the town's history.

The geographical area to be covered in the directories was chosen arbitrarily, based on my perception of what constituted Baltinglass town in terms of ribbon development by 2001, but covering whole townlands. It could be argued that Carrigeen has as much right as other areas to be regarded as part of the sprawling Baltinglass of 2001, but I made a conscious decision not to go beyond the Wicklow border. Including Carrigeen would have added greatly to the workload.

When committing the directories to paper I became aware that it would be difficult, if not impossible, to indicate exact locations by recording houses outside the town itself by townland. For that reason, where practicable, houses were listed by road, with the relevant townlands also indicated. I took a certain amount of licence when naming these roads, and I am sure that some people will take exception to my decisions. For instance, in the case of the road leading from Tuckmill Cross to the gates of Kilranelagh House, I called it the Kilranelagh Road, while other people may refer to it differently. On the other hand, where there are old names, such as Colemans' Road, which may not be familiar to everyone today, I used these.

The official spellings of townland names are often at variance with the spellings used locally (e.g. Clogh and Clough) so I kept with the official spelling, while noting the local spellings in brackets. There is considerable confusion locally about the boundaries of townlands in the immediate area of the town. In particular, Bawnoge (locally Bawnoges) has stretched in the popular imagination as far north as the top of Belan Street and is now wandering out the Rathmoon Road. Within the town itself there seems to be uncertainty as to where streets begin and end. In relation to the division between Main Street and Weavers' Square I take the precedent established by Griffith's *Valuation* as the only logical one to follow. As for the imaginary lines I drew between Chapel Hill and the Sruhaun Road and between Edward Street and the Carlow Road, I make no apologies for my arbitrary decisions. Griffith's *Valuation* has the town boundary at about the site of the present Bramble Court, so Chapel Hill never went beyond that point. On the other hand, Griffith's *Valuation* listed the last few houses in Edward Street separately under Bawnoge townland. I placed them under Edward Street because that is the logical place for them.

Reference will be found in the text to the Turtle Ms. and the Kinsella Ms. The former was written in 1940 by Joseph Turtle and it contained a wealth of information on the town during and before his residence in Baltinglass. I was given access to it by his great-grandson in the 1980s and took brief notes. Sadly the original disappeared shortly afterwards. The Kinsella Ms. was compiled by Rev. Edward Kinsella while he was a curate in Baltinglass (1936-1942). It is a mixture of material from printed sources and oral tradition. It includes a number of letters from Tom Doran, who was then an old man and who was highly regarded as a custodian of oral tradition. I am indebted to Joseph Turtle, Father Kinsella and Tom Doran, none of whom I ever met, for preserving some of the information I used in this book.

ACKNOWLEDGEMENTS

I am indebted to many people for help in compiling this book, whether for providing advice, information or practical assistance. I am particularly grateful to Shauna and Liz Bradley, Billy Doody, Paddy and Josephine Dunne, P.J. Hanlon, Sister Josepha O'Donnell and Kathleen Wall for providing substantial information. Cyril McIntyre (Bus Éireann public relations office) gave me valuable information from his personal collection on bus routes. The late Tommy Doyle of the Lough supplied information long before this book was even contemplated. Noel Farrell put great work into the 1851 and 1901 maps of Baltinglass. Majella (Harbourne) Murphy did a huge amount of work on the survey for the 2001 street directory, and I really appreciate the co-operation of all who responded to that survey.

The various institutions and businesses I visited or contacted while compiling the book were very accommodating. In particular I wish to thank Carmel Flahavan and the staff of the Local Studies section of Carlow County Library. My thanks are also due to the staffs of the Garda Museum, Kinsella Estates (for information on the commencement of Allen Dale estate), the National Archives (in particular Brian Donnelly, Aideen Ireland and Gregory O'Connor), the National Library of Ireland (in particular Fran Carroll and Sandra McDermott), the Representative Church Body Library (in particular Susan Hood), the Valuation Office and Wicklow Superintendent Registrar's Office, as well as to Liz Gibbons of Wampfler, Paul Kavanagh of J.J. Kavanagh & Sons, Sister Baptist Meaney, Presentation Convent, Lucan, Sister Mary O'Riordan, Brigidine Convent, Dartmouth Road, Dublin, Sister Mary Rowsome, St. John of God Community, Sister Rosario Walsh, Presentation Convent, George's Hill, Dublin, and Teresa Kenny and Catherine Walsh of Baltinglass Library.

The following individuals helped me in various ways: Christy Alcock, Dermot Allen, Anne Aspill, the late Davey Bradley, Kathleen (Mackey) Byrne, Margaret (Mrs. Stephen) Byrne, Pat Byrne (Scoil Chonglais), Culm Carty, Owen Cooney, Cora Crampton, Madge Crampton, the late Maureen Darcy, Marcus de Burca (GAA historian), Piers Dennis, Brigid Dooley (Chapel Hill), Mary (Powell) Doyle, the late Seamie Doyle (Irongrange), Tommy Doyle (Main Street), Mihail Evans, John Farrar, the late John Farrell (Yellowford), Steven ffeary-Smyrl, Vera Finlay, Phyllis Flanagan, Kathleen (Hanrahan) Gahan, Sister Rose Gargan, Nigel Gillis, the late Frank Glynn, Nan Glynn, Mary Gorry, Pat Gorry, the Groves family, Dave Hallahan, Kathleen Hanlon, Tom Hannafin, Tess Healy, Ceddy Hendy, Frank

Hunt, Basil Jach, the late Colette Johnston, P.J. Kavanagh, Dan Kehoe (Weavers' Square), Frances Kenny, Johnny Kenny (Clough), Bill Lawlor (Bawnoges Road), the late Eileen Lynch, Maria McCormack, Anne, Emer and Freddie McDaid, Donal McDonnell, Father P.J. McDonnell, John McGrath (former Baltinglass N.S. teacher), Pat (Harbourne) McGrath, Maureen (Nolan) Molloy, Fergal Morrin, Jimmy Murray, Nicky Mustafa, Pam (Flood) Nolan, Kevin O'Brien, my colleague Eileen O'Byrne, Nuala O'Connell, Michael O'Keeffe, Peter O'Kelly and Rhona O'Kelly Loughman, Breeda O'Neill, Orla O'Sullivan, Ann Patterson, Fran Quaid, Joe Rattigan, Nuala Rogers, Father Padraig Shelley, Cora Shortt, June Snell, Dorothy Stephenson, the late Willie Sutton, the Timmins family, Mary Wade, and my friends in the West Wicklow Historical Society.

BALTINGLASS IN 1851

Less than fifty years before the starting point of these chronicles, Michael Dwyer was still roaming the Wicklow mountains. The events of the 1798 and 1803 rebellions were still in living memory. People in their sixties in 1851 would have been children during that turbulent period. Middle-aged adults would have remembered Napoleon's defeat at Waterloo, Catholic emancipation and the Tithe War. Even teenage children would have remembered the night of the Big Wind and Daniel O'Connell's Monster Meetings, one of which was held at Baltinglass just eight years before, in August 1843. However, in 1851, life throughout Ireland was overshadowed by the effects of the Famine which had begun in 1845. The country was just beginning to recover from its darkest hour in recent history.

The most prominent Baltinglass citizen at the time was in fact an eccentric semi-recluse. He lived alone on the outskirts of the town making plans to build a hot air balloon. He was the forty-two year old Benjamin O'Neale Stratford, sixth (and, as it transpired, last) Earl of Aldborough, whose family had owned the town and much of the surrounding area for generations, but whose fortunes were on the decline.

Local government in 1851 was very much local. On a county level the Grand Jury, an appointed committee drawn from the gentry, had the responsibility of building and maintaining such facilities as roads, bridges, courthouses and gaols. Their revenue was generated by the collection of a county cess. Relief of the poor was the responsibility of the Guardians of Baltinglass Poor Law Union, a body partly elected by the ratepayers within the union. Their revenue was generated by the collection of the poor rates. Administration of justice on the most basic level was handled locally by magistrates (or Justices of the Peace) sitting fortnightly in Petty Sessions and four times a year in Quarter Sessions. As there was a Resident Magistrate in Baltinglass in 1851, he would have taken on himself many of the functions of the local magistrates. More serious crimes were handled at the twice yearly Assizes, presided over by a judge on circuit.

In 1851 Baltinglass had a courthouse, a gaol (or bridewell), a constabulary station, a small hospital (or infirmary) and, as the centre of a poor law union, a workhouse. At the time Wicklow was unique in having two county infirmaries, and that in Baltinglass was one of them. There were Roman Catholic, Church of Ireland and Wesleyan Methodist places of worship, with the new Roman Catholic church under construction. There were three schools, Stratford Lodge School, attended by Protestant boys and girls, with a section for infants,

Baltinglass National School, attended by Catholic boys and girls, and a school in the Workhouse for children of inmates.

Public transport was provided by the Royal Mail coach, travelling between Dublin and Kilkenny, and a caravan connecting Dublin with Tullow. The following passage gives some idea of what it was like to travel by the mail coach. It was written by a lady from a privileged background recalling visits she made to Belan as a girl, possibly in the late 1830s. Her journey would have taken her through Naas and Kilcullen, but the departure to Baltinglass would have been similar:

> A lovely summer morning was chosen for our start, my father took my beautiful sister and myself into Dublin to the coach office, in the yard of which stood the bright red mail-coach; its coachman of many capes; its guard, his horn strapped round his shoulder lying on his breast; its four prancing horses led from their stables by cheery, though ragged, ostlers; the passengers squabbling for the best seats, and mounting to the top by a ladder; our guesses as to which of them were coming inside, or if we were to have the luxury of having it all to ourselves; my father tipping the coachman and guard, and begging them to look after us ... The guard lifting us in and banging the door; the coachman mounting his box and gathering up his reins; the guard standing up behind, horn in hand; the horses shaking their heads free from the ostlers; our last wave of the hand to father; a loud crack from the coachman's whip; a shrill blast from the guard's horn; and off we started at a tremendous pace through the gateway and streets till we came to the open country.[1]

Writing of Rathvilly in the 1860s, Edward O'Toole describes an insular atmosphere, having little contact with the outside world. Mail was brought by the postman each day from Baltinglass, along with the only daily newspaper, the *Freeman's Journal*. As this Dublin paper arrived in Baltinglass on the mail coach in the afternoon, it was a day old by the time it reached Rathvilly. When Edward O'Toole made his first visit to Dublin, in 1875, he went to Baltinglass to take the long car operated by Anthony O'Neill of North Strand, Dublin. The long car was the Bianconi invention that had two rows of open air seats, arranged back to back with the passengers facing sideways. The four horses drawing the car were changed three times on the six hour journey between Baltinglass and Dublin. It appears that at that time no coach, as described in the extract above, operated on the route as, according to O'Toole, the long car was later succeeded by a mail coach.[2]

Markets were held on Fridays, and fairs were held on 2 February, 17 March, 12 May, 1 July, 12 September and 8 December. As the names imply, these were held in Market Square and the Fair Green. It is unclear whether the savings bank was still in operation by 1851, but it is certain that there was one as little as five years earlier. There was not much industry in the town, with the two bleach greens having closed in recent years. One had been near the river in Lathaleere (close to what is now the Fourth Avenue of Parkmore). The other had been north of the Ballytore Road (now covered by Quinns' Super Store and yard), with an entrance

off the Dublin Road opposite the horse pond. There were, however, two mills, that in Mill Street operated by Robert H. Anderson and that at Tuckmill, owned and operated by Robert F. Saunders.

The only significant physical change to Baltinglass in the decade before 1851 was the building of two new roads. One was what was termed the 'Ballytore Road' in Griffith's *Primary Valuation* and the other became known locally as 'Colemans' Road'. The Ballytore Road linked the existing road to Ballytore, the 'Tinoran Road' with Mill Street, coming out at the side of the Methodist Church. Up to then people travelling towards Ballytore went up Cuckoo Lane (or Belan Street) and down what is now called the Brook Lane. Presumably the reason for the construction of this new link road was to avoid the steep hill on Cuckoo Lane. The street created by this initiative gave Baltinglass less of the appearance of an elaborate crossroads and within eight years there were six small houses lining it. However, it was to be short lived, as just over forty years after its construction it was to be dissected with the coming of the railway. Colemans' Road, so called as it crossed the Coleman family's farm in Rampere, was built about the same time. It linked the Dublin Road with Rampere Cross, in the process converting the latter into the 'Five Crossroads'. The obvious reason for its construction was the avoidance of the very steep incline on what is termed in this publication the 'Raheen Hill Road'.

At the beginning of 1851 a topic of conversation in Baltinglass must have been the minor controversy raised late the previous year by Rev. Daniel Lalor, the Parish Priest, when he accused the Board of Guardians of Baltinglass Union of encouraging proselytism. In a letter to the Under Secretary at Dublin Castle, dated 2 October 1850,[3] Father Lalor claimed that twenty-six inmates of the workhouse had become Protestant as a result of visits made to the institution by the Misses Saunders of Fortgranite. Ellen and Charlotte Saunders were daughters of Morley Saunders of Saundersgrove and they were evidently fervent Christians. By 1851 they were above middle age, and living at Fortgranite, the home of their brother-in-law, Thomas Stratford Dennis. Their brother, Robert F. Saunders, was then chairman of the Board of Guardians, while Mr. Dennis was deputy vice-chairman. At the time the Dennis family maintained a school on the estate where children received 'a strictly religious education'.[4] From the opening of Baltinglass Workhouse in 1841, the Misses Saunders made weekly visits to read the Bible and give religious instruction to Protestant inmates.

Father Lalor's letter alleged that they did not confine their instruction to Protestants and that they had lured many away from Catholicism. He also alleged that in more recent times they had been permitted to visit Baltinglass Bridewell for similar purposes. He further stated that workhouse inmates had been allowed to go on excursions to Fortgranite and he referred disparagingly to the ladies' 'Proselytizing school'. As a result of the allegations, Charles Crawford, inspector for the Poor Law Commission, carried out an enquiry, interviewing many inmates and staff members. His lengthy report, dated 9 December 1850,[5] indicated that conflicting statements had been presented. While he did not find definite evidence

for the accusations levelled at the Misses Saunders and some guardians and staff members, it appeared that Rev. Samuel Potter of Stratford, the Church of Ireland chaplain, had very much exceeded his authority in baptising at least one child against its Catholic grandmother's expressed wishes.

In February 1851 Baltinglass had something new to talk about with the attempted murder of John Jones of Newtownsaunders. Jones was a resident of the area for years, and a prominent member of the Wesleyan Methodist community. In 1833 he was one of two trustees to whom Lord Aldborough granted the lease of the ground in Mill Street on which the Methodists built their chapel.[6] He was a land agent to various small landlords in the Baltiboys area[7] and by 1851 he was an elderly man. As a matter of purely irrelevant interest, his wife was Mary Disney, a great-great-grandaunt of Walt Disney, the man who transformed his surname into a byword for family entertainment. On Saturday 8 February, Jones was returning home from Donard in his gig. At 4.30pm, while he was passing through Deerpark, a man hiding behind a wall shot at him. Six months prior to this incident Jones had been warned by his land bailiff, James Byrne of Granabeg, that there was a conspiracy to kill him. Byrne again warned him that very day, but at the time he was not aware of the identity of the attacker. Whether Jones was injured in any way, he certainly survived. Within days one Andrew Davis was arrested. He was convicted a few weeks later at the Spring Assizes in Wicklow town and sentenced to ten years transportation.[8] By January 1853 John and Mary Jones had left Newtownsaunders, where Sheppard Jones remained, and gone to live in Weavers' Square, Baltinglass, in the house now owned by O'Sheas.

Later in 1851 two of Father Lalor's curates were whipping up a political storm over legislation before Parliament. At mass on Sunday 11 May 1851, Rev. Edward Foley in Baltinglass, and Rev. John Nolan in Stratford and Grangecon, encouraged the congregation to sign a petition to the House of Commons against the proposed legislation. Father Nolan supposedly called O'Connell's 1843 Monster Meeting and presided over it. In later life, as Parish Priest of Killeigh and subsequently Kildare, he played an active role in politics as a champion of tenant farmers[9]. A detailed account of Father Foley's sermon survives because Constable Michael Sheehy was attending mass and he reported it to his Head Constable, John Barton.[10] Father Foley reportedly said that the proposal was 'a disgrace to any Government in the world, that for three hundred years there was a Penal-law against the Roman Catholics and that now the Government of England was bringing in another Penal Bill to Exterminate the Roman Catholics altogether, that it was not enough to starve them to Death, but to put them out of the way altogether'. He then advised the congregation to sign the petition that was in the chapel yard, saying 'every Roman Catholic in Town & Country that can write should sign it, & those who cannot write should put their mark in order to show how much they abhor in their hearts the injustice they are about doing us'.

Father Foley's words were stirring indeed, but they were also grossly misleading. The legislation before Parliament was far from an attempt to exterminate

Roman Catholics. In fact, it had no bearing on the daily lives of the laity. It was the Ecclesiastical Titles Bill and it aimed to prohibit the assumption by Roman Catholic bishops anywhere within the United Kingdom of the titles of their sees. There is little likelihood of Father Foley's misunderstanding the extent of the proposal, as it was discussed at length in the *Freeman's Journal* as much as three months before. The Ecclesiastical Titles Act became law on 1 August 1851, and it merits the importance of a mere footnote in the history of Ireland in the nineteenth century. The priests' promotion of the petition, and the heated words used in doing so, give some indication of the political activity of the Roman Catholic clergy in Baltinglass in the 1850s. It is interesting to speculate on the bearing this may have had on the level of Land League activity in the area some thirty years later.

AFTERMATH OF THE FAMINE

Little if any folklore of the Famine exists in the area and it is tempting to think that perhaps its effects were minimal in Baltinglass, but statistics and contemporary accounts show that this was not the case. Sufficient material exists for an in-depth study of conditions in the district at the time. However, the scope of the present work does not allow for any such study. A cursory examination of the more accessible records is sufficient to reveal evidence of the severe effects of the catastrophe in the Baltinglass area.

Under the Poor Relief Act of 1838, provision was made for establishing workhouses throughout Ireland, with each workhouse serving an area called a Poor Law Union. Those unable to sustain themselves independently could seek admission to the workhouse of the Union in which they lived but, to discourage the idle, inmates were expected to work for their keep. On 29 May 1840 the contract for construction of Baltinglass Workhouse was made. It was to contain accommodation for 500 paupers. The first admission of paupers was on 28 October 1841.[11] It must be remembered that the Workhouse served Baltinglass Poor Law Union (which extended as far north as Hollywood, as far south as Rathdangan, and took in parts of Counties Carlow and Kildare), so only a percentage of those in the Workhouse would have been from the immediate area of the town.

In June 1841 the population of the area being considered in this book (Baltinglass town and the surrounding townlands) was 4,588. That was approximately 12% of the total population of Baltinglass Poor Law Union (38,305). By March 1851 the population of the same area (excluding the Workhouse buildings) was 3,259. At the time there were 1,028 people in Baltinglass Workhouse and its fever hospital. Even allowing for as many as 20% of these people being from the immediate vicinity of the town, there was a drop of almost a quarter of the population of the relevant area between 1841 and 1851.[12] However, the fall in population is not an indication of the number of people who died as a direct result of famine. Diseases that attacked the weakened people in the wake of repeated failure of potato crops accounted for many deaths, while others vanished through emigration. The fact

that in 1851 Baltinglass Workhouse was accommodating more than twice the 500 it was originally designed to hold is evidence in itself of distress in the area. This is further highlighted when it is considered that ten years later there were only 264 residents in the workhouse buildings.

The original Ordnance Survey town plan of Baltinglass,[13] dating from the 1830s, shows a row of buildings extending along the north side of the Rathmoon Road from its junction with the Brook Lane. It also shows buildings along that part of Chapel Hill which now forms the entire eastern boundary wall of the graveyard. By 1851 none of these buildings existed. In 1851 several houses in the town were unoccupied or in ruins. Many of the poorer families were living in what the surveyors for Griffith's *Primary Valuation* described as dilapidated houses.

The Famine had its origins in the arrival of potato blight in September 1845. A Relief Commission was appointed in November with the aim of encouraging the establishment of local committees throughout the country. A relief committee was set up in Baltinglass. In March 1846 public works schemes were introduced all over Ireland to provide a source of income for the poor, with the government paying half of the costs. At a meeting of the vestry of Baltinglass Parish on 22 June 1846, it was unanimously agreed to draw out from the savings bank of Baltinglass a sum of £4-5-12, with any interest accruing, and 'apply it to the fund for the relief of the poor who are employed in public works'.[14] Those present were Rev. Dr. William Grogan (the Rector), James Murphy, John Johnson (medical officer of Baltinglass Workhouse), Robert Parke, Benjamin Haynes and George Moorhouse. The sum of money was not large even by the economy of the day, but the decision is evidence that distress was being experienced in the area by that time. The money also appears to represent the only disposable funds the Church of Ireland parish had at hand.[15] The building of the new Roman Catholic Church in Baltinglass began about this time and it would have provided work for many labourers during the worst period of the Famine.

In the autumn of 1846 the potato crop was completely lost. Official correspondence over the winter between December 1846 and February 1847[16] indicates that Baltinglass, no less than other parts of Wicklow, was in crisis. On 16 December 1846 the superintendent engineer for County Wicklow, James Boyle, referred to Baltinglass as '... a nucleus for misery and without a resident landlord or agent, and where there are 280 labourers having relief tickets ...' The then Lord Aldborough was the profligate Mason Gerard Stratford, who was living in Italy. His career is outlined below. On 17 January 1847 Boyle wrote that Baltinglass had an inadequate amount of meal for the 700 relief labourers who relied on the town for their food supply. In a comment on the general state of the areas of the county he had visited, he added that in the previous fortnight the number of hucksters (or provision dealers) had decreased through lack of credit, and that 'as competition diminishes, prices of course rise'.

Daniel McCloy, assistant engineer, in a report to Boyle on the situation in the Baltinglass-Kiltegan-Rathdangan region, dated 20 February 1847, wrote: 'The labourers and small farmers are in a most awful condition in this district generally,

having neither food nor clothes; and many of the middle-class farmers are very badly off, and will have to sell their cows to buy seed and food. The greater part of this district is on the verge of starvation, and not able by any means to till the land'. On 25 February, Boyle himself made some frank comments on the relief labourers based in Baltinglass: 'I cannot but regard the condition of some parts of the county, especially that of the town of Baltinglass, as extremely critical. There are in it, and within a circle of half a mile around it, 500 men who are employed on Relief Works ... They are, generally speaking, a most inflammable community, chiefly consisting of the rejected from other districts and counties, bound by no ties of connexion or character, living on a property where there is neither a resident landlord nor agent. In summer they earn some money by cutting turf, and during the hurry of the harvest; during the remainder of the year, they idle, steal or beg. I cannot contrive two months work for them; with great difficulty can I make out employment for even a week; yet these men fancy they must and will be fed. Nothing could be more dangerous than to leave them to go about unemployed'.

At the time there was a proposal to set up a food distribution centre in Kiltegan, to which the local gentry intended to contribute. This may have been one of the soup kitchens which were opened around the country in that month. Boyle added: 'I am quite convinced that to establish the proposed private depot of food at Kiltegan (four miles distant) without affording suitable protection, would be but to tempt a foray from the rabble of Baltinglass from one side, and from the wild and starving people of Moyne and Imale on the other'. In February 1847 the famine was at its worst. It is, therefore, very surprising that, though army recruiting parties had been stationed in Baltinglass for many months, Boyle noted that 'scarcely a man has been induced to enlist'.

With starvation came disease. Dropsy, dysentery, scurvy and typhus attacked the malnourished population. A temporary fever hospital operated in Baltinglass from March 1847 to July 1849, during which time 127 patients died within it, all from fever.[17] It would appear that in September 1847 typhus was rampant in the Baltinglass region, as there are reports of three prominent men dying of malignant fever that autumn. One was Rev. John O'Brien, a Roman Catholic curate newly arrived in Baltinglass.[18] John Johnson, one of the vestrymen who had voted the donation to the relief fund the previous summer, died on 19 September. As well as being medical officer of Baltinglass Workhouse, he was a surgeon and apothecary long resident in the town, with a premise in Main Street.[19] The third man whose death can be attributed to typhus was Rev. John Marchbanks, Church of Ireland minister in Stratford. He died on 21 September. Folklore has it that he gave away his own food to the needy, and his memory is still alive in Stratford.[20] The three men were under the age of fifty. Their occupations brought them in close contact with the ill and starving masses. The names of the vast majority of those unfortunate people who succumbed to typhus during that outbreak are lost to posterity.

Of the people lost to Ireland during the Famine, the lucky ones were those who managed to emigrate. A ship was the one beacon of hope for people with the

means to leave. Others were sent overseas. Again, one can only guess at how many Baltinglass inhabitants left Ireland and settled in Great Britain, North America or Australia during those terrible years. One group of whom something is known are fifteen girls from the general area of Baltinglass who were among a party of 'orphans' sent to New South Wales in 1849. They were aged between fourteen and twenty, and in most cases both their parents were dead. The girls were Mary A. Dempsey, Mary Dowling, Bridget Doyle, Sarah Fegan, Eliza Icombe, Margaret Keys, Elizabeth Nolan and Judith Nolan from Baltinglass, Mary Duff from Hollywood,[21] Ann and Ellen Hanbidge from Stratford, Mary Lalor from Rathvilly, Ann Moran from Kiltegan, Celia Moran from 'Kiltort', and Eliza Wilden from Coolamadra. Eliza Icombe was one of the inmates of the workhouse mentioned in the evidence in Crawford's report on the enquiry on proselytising. These fifteen girls arrived in Sydney on 3 July 1849 on the ship *Lady Peel*.[22]

The option of assisting inmates of the workhouse to leave the country was enticing to the beleaguered Guardians of Baltinglass Union. Early in 1850 they applied to the Poor Law Commissioners for permission to send over 300 people to Canada. Having visited the workhouse, the Commissioners' inspector disapproved of 120 candidates on the grounds that they did not have a fair prospect of being able to provide for themselves or their dependants in Canada. Those rejected were widows with large families and no means of support, or unaccompanied young women.[23]

In 1851 the workhouse still had over a thousand inmates, but the Famine appears to have been by then a thing of the past. This is evident from the complaint about proselytism made in October 1850 by Father Lalor. Had hunger or disease been a factor at that time, the temporal, as well as spiritual, needs of those living in the workhouse would have featured in the correspondence.

DECLINING FORTUNES OF THE STRATFORDS

By the mid-nineteenth century the Stratford family had owned Baltinglass town and most of its environs for over 140 years and had held the earldom of Aldborough for half that time. 1851 was quite an eventful year in their history, one that signalled the beginning of a legal dispute about the title and the end of the family's influence in the Baltinglass area. 1851 also produced a minor scandal for the Stratfords, with the arrest of three young men in Italy.

The Stratford family's fortune had been somewhat weakened fifty years before, on the death of Edward, second Earl of Aldborough. He had quarrelled for years with members of the family. He died in 1801 and was succeeded by his brother John. While John inherited the earldom and all entailed properties, Edward willed all possessions at his personal disposal to his nephew, John Wingfield. What remained of the family estates eventually came into the hands of Edward and John's nephew, Mason Gerard, fifth Earl of Aldborough. On 4 October 1849 Mason Gerard died at the age of sixty-five at the Italian seaport of Leghorn, leaving an indelible blot on

the annals of the family. His chief characteristics were those of a spendthrift and bigamist. The legacies of his profligate life were two sets of offspring competing for legitimacy and the burdening of the family's property with enormous debts.

Jane Austen would not have been comfortable writing about this man. He was an archetypal regency cad. At the age of twenty, Mason Gerard Stratford met Cornelia Jane Tandy in Waterford. They eloped and went to Kirkcudbright in Scotland, where they married in a Gretna Green-type ceremony in the King's Arms tavern in August 1804. They had two sons and two daughters over the next six years and evidently money was in short supply. As an officer in the Wicklow Militia, Mason Gerard was stationed from 1808 at Drogheda, and there he and Cornelia got to know Thomas Newcomen and his wife. In 1810 Cornelia was staying in her father's house 'partly from economical considerations' and Mason Gerard took the opportunity to abscond with Mrs. Newcomen. They travelled to London and on to the Isle of Man. In 1812 they returned to London, where they lived as Major and Mrs. Stratford with their 'several children'. Mason Gerard was committed to debtor's prison in 1818 and he remained there for the next eight years. In the meantime, Cornelia and her children were supported by her father. In 1823 Mason Gerard's father, Benjamin O'Neale Stratford, succeeded to the earldom and Mason Gerard received the courtesy title Lord Amiens. Mrs. Newcomen, who evidently remained with him in debtor's prison, took to calling herself Lady Amiens.[24]

At this point the new earl began providing for Cornelia's maintenance. Apparently Mason Gerard was by then disputing the validity of his marriage to her. This, of course, brought into question their children's legitimacy and the future succession of the earldom. In 1826, apparently with her father-in-law's support, Cornelia sued for divorce. The Arches' Court of Canterbury upheld the validity of the marriage and eventually granted the divorce in December 1826.[25] In the meantime, Mason Gerard had been released from debtor's prison in September. Taking no part in the divorce proceedings and discarding Mrs. Newcomen, he left for Paris. On 23 September he went through a form of marriage at the British Embassy with Mary Arundell.[26] He was then forty-two and Mary was less than half his age.

Mason Gerard and Mary remained together until his death twenty-three years later and they had at least five children. At his father's death in July 1833, Mason Gerard became the fifth Earl of Aldborough, with the family estates at his disposal. In his later years, to supplement his income, he endorsed the efficacy of Professor Holloway's Pills. The Villa Messina, in which he lived in Leghorn, was apparently built by Holloway. Holloway's newspaper advertisements included a letter from the Earl, dated 21 February 1845, testifying to the wondrous cure of his liver and stomach complaints. Despite the cures, Mason Gerard died four and a half years later, and the advertisements continued to be published for some decades afterwards, causing much upset to his estranged son and heir, the then Earl, who had no financial enticement or wish to endorse the professor's pills.

To the last, Mason Gerard maintained that Mary Arundell was his lawful wife. In a sealed envelope attached to his will he left a message stating that before he

married Cornelia Tandy he had married one Mary Teresa Davenport, who was still alive at the time of the 1804 marriage.[27] In 1851, according to a report in *The Times*, the Aldborough estates were reckoned to be worth £9,000 a year, but the debts left by Mason Gerard were estimated to amount to £150,000. As a result, the Commissioners of Incumbered Estates were in the process of selling off these properties, including most houses in the town of Baltinglass. On Mason Gerard's death his only surviving child by Cornelia, Benjamin O'Neale Stratford, assumed the style of Earl of Aldborough, while in Italy, Mary Arundell's son Henry was also using the title. Henry and his younger brothers brought public attention to this irregularity when they were arrested for subversive activities against the Tuscan government in the summer of 1851.

BALTINGLASS 1851

ADMINISTRATION

Members of the Grand Jury of County Wicklow [as of Spring Assizes 1851] (resident within the Baltinglass area):
Robert F. Saunders, Saundersgrove
Board of Guardians for Baltinglass Poor Law Union:
Chairman- Robert F. Saunders, Saundersgrove;
Vice-Chairman- William J. Westby, High Park, Kiltegan;
Deputy Vice-Chairman- Thomas S. Dennis, Fortgranite
Resident Magistrate:
Captain Bartholomew Warburton
Justices of the Peace (resident within the Baltinglass area):
Benjamin, Earl of Aldborough, Stratford Lodge
Robert F. Saunders, Saundersgrove
Clerk to the Board of Guardians & Returning Officer:
Michael Cooke, Mill Street
Clerk of Petty Sessions Court:
Peter Douglas, Saundersville, Dublin Road, Tuckmill
Registrar of Marriages:
Henry W. Fisher, Main Street
Cess Collector for Talbotstown Upper Barony:
John H. Fenton, Stranahely, Donard

PUBLIC TRANSPORT
Coaches

to Dublin

Caravan	departing Baltinglass 8.30am	every day
Royal Mail (from Kilkenny)	departing Baltinglass 12.30pm	every day

from Dublin

Royal Mail to Kilkenny	departing Baltinglass 1.00pm	every day
Caravan to Tullow	departing Baltinglass 5.00pm	every day

STREET DIRECTORY

Ballytore Road ['County Road'][28][29] Baltinglass West townland
North Side
(Mill Street to Tinoran Road/Brook Lane)
1 see No. 22 Mill Street [James Jones]
2 Dowling, William, sen.
3 Dowling, William, jun.
South Side
(Brook Lane to Mill Street)
4 Wright, Mary
5 Flinter, Henry & Lennon, Thomas
6 Donoghoe, Edward
7 Johnston, William
8 see No. 23 Mill Street [Wesleyan Methodist Chapel]

Bawnoge ['Bawnoges'] townland, (see Carlow Road, Edward Street, Rathvilly Road
& Tullow Old Road)

Bawnoges Road, Baltinglass West &Bawnoge townlands (see Tullow Old Road)

Belan Street, ['Cuckoo Lane'][30][31][32] Baltinglass West townland
North Side
(Mill Street to Brook Lane)
1 see No. 32 Mill Street [Patrick Doyle]
2 Nolan, John
3 Cummins, Christopher
4 Coventry, Patrick
5 Byrne, Thomas
6 Crow, Michael
7 Kelly, William
8 Lucas, Thomas
9 Curran, John
10 Nolan, John
11 out office owned by Thomas Prendergast
12 Johnson, William
[here land held by William Johnson]
13 Jones, John
14 Yeates, Michael
[here space with no buildings]
South Side
(Tullow Old Road to Edward Street)
15 unoccupied
16 McEvoy, Edward
17 Neill, Edward
18 Dowling, Joseph
19 Smith, John
20 Lusk, Ralph, (partly in ruins)
21 Neill, John

22 Byrne, Charles, (dilapidated)
23 Lynch, Michael
24 Fleming, Thomas
25 unoccupied
26 Byrne, Michael
27 Lawlor, James
[here space with no buildings]
28 Byrne, William
29 Byrne, Christopher
[here laneway to 'Gallows Hill']
30 Doyle, Eliza
31 Doyle, Edward, house & forge
32 Patten, Judith
33 Prendergast, Ellen, (ruin)
34 Neill, James & Daly, Michael
35 Shea, Richard, (dilapidated)
36 unoccupied
37 Lyons, Stephen
38 Byrne, Garret
39 Prendergast, Thomas
40 Mooney, Daniel
41 Toole, Michael
42 Donegan, Thomas
43 Maguire, James
44 Hayden, Bridget
45 Gorman, Patrick, (dilapidated)
46 Clarke, Thomas
47 Byrne, Mary
48 Doyle, John
49 out office[33] owned by Patrick Doyle
50 unoccupied house, (dilapidated)
51 ruin or building ground
52 see No. 1 Edward Street [James Roche]

The Bridge, Baltinglass East &Baltinglass West townlands
South Side
(Edward Street to Main Street) [Baltinglass West townland]
1 see No. 37 Edward Street [George Dunckley]
[here River Slaney]
[Baltinglass East townland]
2 see No. 1 Main Street [Baltinglass Infirmary]
North Side
[Baltinglass East townland]
3 see No. 63 Main Street [George Darcy]
4 see No. 64 Main Street [Mary Mangan]
[here River Slaney]
[Baltinglass West townland]
5 see No. 1 Mill Street [Thomas Cooke]

Brook Lane, Baltinglass West townland, (between Belan Street/Rathmoon Road & Ballytore Road/Tinoran Road)
no houses here

Cabra Road, Rampere, Rampere townland (between the 'Five Crossroads' & Goldenfort)
no houses here
[road continues into Goldenfort townland]

Carlow Road, Bawnoge, Irongrange Lower & Irongrange Upper townlands
West Side
(Edward Street to Carrigeen) [Bawnoge townland]
no houses here
[here 'Clough Cross'; Tullow Old Road & Rathvilly Road intersect]
no houses here
[Irongrange Lower townland]
1 Murphy, Edward
2 Hoey, Michael, farmer
[Irongrange Upper townland]
no houses here
[road continues into Carrigeen, Co. Kildare at this point]
East Side
(Carrigeen to Edward Street)
[Irongrange Upper townland]
3 Irongrange House (entrance to), Lalor, James, farmer
[Irongrange Lower townland]
4 out offices owned by James Lalor
[here shared entrance to No. 3 of Irongrange Lower and Nos. 2 & 3 of Irongrange Upper townland]
[Bawnoge townland]
no houses here
[here 'Clough Cross'; Tullow Old Road & Rathvilly Road intersect]
5 Flinter, Henry, farmer

Cars' Lane, Baltinglass East townland (see Chapel Hill)

Carsrock townland[34]
2 Wynne, Catherine[35], farmer
3 herd's house owned by John Thorpe[36]

Chapel Hill, Baltinglass East townland
South Side
(Weavers' Square/the Fair Green to Sruhaun Road, including Cars' Lane)
1 Shaw, James, (dilapidated)
2 ruins
3 Crathorne, Thomas
4 Roche, John
[here space with no buildings]

5 Nolan, Denis
(Cars' Lane south side)
6 unoccupied, (dilapidated)
7 unoccupied, ruins[37]
8 Lynch, John
9 Ellard, Peter
10 ruins
11 unoccupied, (dilapidated)
[here space with no buildings]
12 National School (boys' & girls')
schoolmaster: Peter Byrne
schoolmistress: Bridget Tyrrell
(Cars' Lane north side)
13 Roman Catholic Chapel, (dilapidated) & graveyard
Parish Priest: Rev. Daniel Lalor, Parochial House, Kiltegan Road
Curates: Rev. John Boland (Workhouse chaplain), Rev. Edward Foley
Rev. John Nolan
14 Kirwan, James
15 Williams, Richard
(Cars' Lane to Sruhaun Road)
no houses here
North Side
(Sruhaun Road to the Fair Green, Main Street)
16 unoccupied, (dilapidated)
17 Harris, John[38]
18 Harris, Joseph
19 Rawson, Richard, attorney[39]
20 Byrne, Peter, house & forge
21 Flynn, William, house & workshop
22 Harris, William & others
23 Fox, John
24 Nowlan, Patrick
25 Deigan, Michael, huckstery
26 Brien, Nicholas, huckstery

Church Lane, Baltinglass East townland
East Side
(Main Street to the Abbey)
1 see No. 62 Main Street
[Robert H. Anderson]
[here side entrance to No. 61 Main Street]
2 Cashel, Mary(behind No. 3, in side entrance to No. 61 Main Street)
3 Out office[40] owned by William Murphy
4 Little, Bridget & Quinn, Eliza
5 Cooke, Samuel
6 Huntston, Robert
[here space with no buildings]
7 Rawson, Thomas

[here space with no buildings]

8 Baltinglass Castle[41],Hayden, Bridget,farm buildings

9 Baltinglass Abbey (in ruins), Church of Ireland Parish Church (within Abbey) & graveyard,

Rector: Rev. Dr. William Grogan, Slaney Park

Curate: Rev. Henry Scott, Church Lane

Church Wardens: Anthony Allen, Deerpark, & James Murphy, Main Street

West Side

(Abbey to Main Street)

[here space with no buildings]

10 Scott, Rev. Henry[42], Church of Ireland curate

11 see No. 63 Main Street [George Darcy]

Cloghcastle, ['Clough Castle'] townland (see also Rathvilly Road)

1 Lennon, Laurence

2 Kinsella, Philip

4 Earle, William

5 herd's house owned by William Jones

Clogh, ['Clough'] Lower townland (see also Rathvilly Road)

1 herd's house owned by George Douglas

2 herd's house owned by Thomas Neill

5a Fennell, James, farmer

7a Kehoe, James, farmer

7b Kehoe, Patrick

7c Kelly, Michael

Clogh, ['Clough'] Upper townland (see Rathvilly Road)

Colemans' Road, Raheen &Rampere townlands

West Side

(Dublin Road to the 'Five Crossroads'),

[Raheen townland]

No houses here

[Rampere townland]

1 Coogan, James, farmer

East Side

('Five Crossroads' to Dublin Road), [Rampere townland]

2 McGrath, Andrew

[here joins Cabra Road]

3 Coleman, Mary, farmer

4 Kelly, Thomas

5 Lyon, William[43]

[Raheen townland]

6 Hunt, Nicholas[44]farmer

County Road, Baltinglass West townland, (see Ballytore Road)

Cuckoo Lane, Baltinglass West townland, (see Belan Street)

Cunninghamstown, Sruhaun townland, (see under Sruhaun)

Deerpark townland, (see also Kiltegan Road)
2 Kirwan, John
3 Doyle, Thomas
4a Doyle, Patrick
4b Brien, James
6 Workhouse graveyard
7 Pearson, Thomas
9 Redmond, Nicholas
11a herd's house owned by John Hendy
12 Brien, Charles

Dublin Old Road, Baltinglass East, Sruhaun &Tuckmill Upper townlands, (see Sruhaun Road)

Dublin Road, Baltinglass West, Stratfordlodge, Raheen, Tuckmill Upper, Tuckmill Lower, Saundersgrove & Saundersgrovehill townlands
West Side
(Mill Street to Ballinacrow Upper)
[Baltinglass West townland]
1 (entrance to) out offices[45] owned by the Earl of Aldborough
[Stratfordlodge townland]
2 Infant School[46], infant school mistress: Martha Dillon
3 Stratford Lodge Male & Female Schools, (under Church Education Society)
Schoolmaster: Joseph Grothier[47]
Schoolmistress: Elizabeth Robinson
[here entrance to Stratford Lodge – see under Stratfordlodge townland]
4 Gate lodge, Haliday, Isaac[48]
[here joins Raheen Hill Road]
5 Nue, Henry[49]
[Raheen townland]
no houses here
[here joins Colemans' Road]
6 Mannering, Michael[50],
[here Eldon Bridge; road crosses River Slaney]
[Tuckmill Upper townland]
7 Toole, Felix, carpenter[51]
[here 'Tuckmill Cross'; here joins Rathbran Road]
[Tuckmill Lower townland]
8 Moran, Christopher
[Saundersgrove townland]
[here entrance to Saundersgrove – see under Saundersgrove townland]
9 Kean, James[52]
[here joins road by Manger Bridge to Stratford]
[Saundersgrovehill townland]

[here the 'Hangman's Corner']

10 (entrance on road to Manger Bridge), Williams, John

[here joins second road to Manger Bridge]

no houses here

[road continues into Ballinacrow Upper at this point]

East Side

(Ballinacrow Upper to Mill Street)

[Saundersgrovehill townland]

11 Roche, Thomas

[here the 'Hangman's Corner']

12 Saundersville, Douglas, Peter, clerk of the Petty Sessions Court

[Tuckmill Lower townland]

13 untenanted corn mill, owned by Robert F. Saunders

14 Doyle, Laurence

[here 'Tuckmill Cross'; here joins Kilranelagh Road]

[Tuckmill Upper townland]

15 Dempsey, Matthew, farmer

16 Kelly, John, farmer

17 Dublin & Carlow Turnpike Trust (toll house)

[here joins Sruhaun Road]

no houses here

[here Eldon Bridge; road crosses River Slaney]

[Raheen townland]

18 Nue, William

19 Maher, Edward

20 Carpenter, Richard

[Stratfordlodge townland]

no houses here

[here 'Horse Pond']

Edward Street ['Pound Lane'], Baltinglass West & Bawnoge townlands

West Side

(Belan Street to Carlow Road)

[Baltinglass West townland]

1 Roche, James, leather & grocery shop

2 Darcy, Thomas

3 Ward, John

4 Long, Robert, huckstery

5 Flinter, Thomas, public house

6 Nolan, Ellen, public house

7 unoccupied[53]

8 Roe, Joseph

9 McLoughlin, John

10 Finn, Matthew

11 Abbott, Laurence

12 out office owned by Edward Mahon, (behind No. 11)

13 building ground held by Patrick Fennell

14 Abbey, John

15 Byrne, Garret, blacksmith (see No. 24 Edward Street)
16 Byrne, Peter
17 Fennell, Patrick
[Bawnoge townland]
18 Abbott, Edward[54]
19 ruins
20 O'Kane, Peter[55]
East Side
(Carlow Road to The Bridge)
[Bawnoge townland]
21 Donohoe, Thomas, farmer
22 Flinter, Martin
23 Ellis, John
[Baltinglass West townland]
24 Byrne, Garret, (dilapidated forge), (see No. 15 Edward Street)
25 Dunne, William
26 unoccupied ruins
27 Doyle, Sarah, (dilapidated)
28 Dunne, James
29 unoccupied
30 Kehoe, Martin
31 unoccupied
32 out offices & old tan yard[56], owned by James Roche
33 Doyle, Patrick
34 Leonard, George, keeper of the Courthouse, toy shop & the Pound[57]
35 Dunckley, Mary Anne (dilapidated)
36 Dunckley, Mary Anne (lodgers), (dilapidated)
37 Dunckley, George, grocery shop[58]

Fair Green, Baltinglass East townland (an alternative name for the area north of the
 'south-east' block in Main Street; see Main Street)

Glennacanon ['Glencannon'] townland, (see Tinoran Road)

The Green, (see Fair Green)

Green Lane, Newtownsaunders townland
North Side
(Kiltegan Road to River Slaney)
1 Bracken, Corneliusfarmer
2 see No. 8 Redwells Road [unoccupied]
[here Redwells Road intersects]
3 White, Patrick
4 Finn, Anne
[ends at Maidens Ford at River Slaney]
South Side
no houses here

Hartstown Road, Oldtown, Hartstown, Rampere, Tinoranhill North &Tinoranhill
 South townlands
North Side
('Tinoran Cross' to 'Five Crossroads')
[Oldtown townland]
1 Timmins, George[59]
2 Byrne, Peter
3 Keogh, John, farmer
4 Harte, Peter, farmer
[Hartstown townland]
5 (entrance to), Byrne, John
6 Moffatt, Patrick, farmer
7 Barry, Brian
[Rampere townland]
no houses here
South Side
('Five Crossroads' to 'Tinoran Cross')
[Rampere townland]
8 herd's house owned by Thomas Fearis
[here site of Rampere Church]
[Tinoranhill North townland]
9 Byrne, Anne
10 Hendy, William, farmer
11 Neill, George
[Tinoranhill South townland]
12 Byrne, Matthew

Hartstown townland
(see also Hartstown Road)
[shared entrance to Nos. 1aa, 1ba, 1bb, 2a, 3 & 4, and possibly 9 on the 'Bed Road'[60]]
1aa Leigh, Michael
1ba Dooley, John
1bb Kelly, James
2a Harte, John, farmer
3 Keogh, Anne
4 Harte, Bernard
9 Sleator, Christopher

Holdenstown Lower townland (see also Rathvilly Road)
1a house owned by Patrick Keogh, caretaker: Thomas Smith
1b Dempsey, Edward
1c Brien, Michael
3 Jones, Rebecca, farmer
4a Jones, John
4b Moore, Ellen
5 Brien, Patrick, farmer
7a Kelly, John
7b Gallagher, Hugh

7c Kelly, Michael
7d Gahan, James
9 Dempsey, Patrick
11a Corcoran, Christopher

Holdenstown Upper townland
1 Holdenstown Lodge, Jones, William, farmer
4 Jones, Edward
7 Kelly, Michael
8 Brennan, Murtagh, farmer
9 Deegan, Patrick
10 Deegan, Margaret
11 Carpenter, William, farmer
12a unoccupied house owned by William Carpenter
13 Carpenter, William, jun.
14 Carpenter, Joseph

Irongrange Lower townland (see also Carlow Road)
3a Kearney, Thomas, farmer

Irongrange Upper townland (see also Carlow Road)
2 herd's house owned by James Lalor
3 herd's house owned by John Nowlan
4 White, Bridget

Kilmurry townland (see also Kiltegan Road)
1a Farrar, Thomas
1b Lawler, James
2 gate lodge of Fortgranite estate owned by Thomas S. Dennis
4 Molloy, Michael
5 Lawler, Thomas
6 Neill, Charles
7 Lawler, Garrett

Kilmurry Lower townland (see also Kiltegan Road & Redwells Road)
6 Tutty, George, farmer
7a Jackson, Mary
7b Jackson, John
9 Coogan, John, farmer

Kilmurry Upper townland (see also Redwells Road)
1a Doyle, James, house & forge
2b Abbey, Bridget

Kilranelagh Road, Tuckmill, Tuckmill Lower & Tuckmill Upper townlands
North Side
('Tuckmill Cross' to 'Kyle Bridge')
[Tuckmill Lower townland]

1 see No. 15 Dublin Road [Laurence Doyle]
2 ('Doyles of the Lough'), Doyle, Bridget
3 Doyle, Mary
4 Brien, John
5 O'Neill, William[61]
[here lane leading to Haydens' in Ballinacrow Lower]
6 Moran, John
7i Moran, Matthew[62]
7ii Moran, John, junior
[road continues into Kill ['Kyle'] townland]
South Side
('Kyle Bridge' to 'Tuckmill Cross')
[Tuckmill Lower townland]
[here shared entrance to Nos. 8 & 9]
8 Fagan, Patrick
9 Moran, Mary
[here joins Tailor's Lane]
[Tuckmill Upper townland]
10 see No. 16 Dublin Road [Matthew Dempsey]

Kiltegan Road, Baltinglass East, Lathaleere, Newtownsaunders, Kilmurry Lower,
 Kilmurry, Woodfield & Deerpark townlands
West Side
(Weavers' Square to Fortgranite)
[Baltinglass East townland]
1 Parkmore House, De Renzy, Emily E.
[Lathaleere townland]
[here site of former bleach green & bleach mill]
2 Whitehall House[63],caretaker: Daniel Doran
['Whitehall Cross'; Redwells Road continues south; Kiltegan Road turns east]
[here lands of Allen Dale, site of the former race course]
[here Kiltegan Road turns south]
3 Allen Dale, Allen, Mary
4 Wynne, James
5 Chamley, Bridget
[Newtownsaunders townland]
6 Ryan, Thomas
[here joins Green Lane]
no houses here
[Woodfield townland]
7 Byrne, William
[Newtownsaunders townland]
no houses here
[Kilmurry Lower townland]
8 Tutty, William, farmer
9 Donegan, James
10 Donegan, Denis
[here joins road to Redwells]

[Kilmurry townland]

no houses here

[road continues into Fortgranite townland at this point]

East Side

(Englishtown to Weavers' Square)

[Kilmurry Lower townland]

11 Freeman, James, farmer

12 Freeman, George, farmer

[Woodfield townland]

[here joins road to Talbotstown]

13 Cullen, Bridget

14 Byrne, Alice, farmer

15 Whelan, Owen

16 Doyle, Patrick

17 Merner, John[64]

[here shared entrance to Nos. 18 & 19, and to Nos. 1, 2, 5 & 6 of Woodfield townland]

18 Byrne, John, farmer

19 Byrne, Timothy

[Newtownsaunders townland]

[here shared entrance to Nos. 20, 21 & 22, opposite Green Lane]

20 Finn, Thomas

21 Callaghan, Patrick[65]

22 Leigh, Michael

23 Baltinglass Poor Law Union Fever Hospital

[1851 Census stats.: males 8, females 4; total 12]

Medical officer: Henry W. Fisher, Main Street

24 Baltinglass Poor Law Union Workhouse

[1851 Census stats.: males 437, females 579; total 1,016]

Clerk to the Board of Guardians: Michael Cooke, Mill Street

Medical officer: Henry W. Fisher, Main Street

R.C. chaplain: Rev. John Boland

C. of I. chaplain: Rev. Samuel G. Potter, Stratford

master: Thomas Allen

matron: Ellen Wheatly

other identified employees:

Thomas Cardell, night watchman

Sally Nolan, cook

Thomas Thornton, porter

[Deerpark townland]

25 Lennon, Bridget

26 Lennon, John

27 Deerpark House[66] (entrance to) Allen, Anthony, farmer

28 Barrett, George

29 Crampton, William

30 Hendy, John[67], farmer

31 Ryan, John

32 Jones, William

[here lane leading to No. 33, and to Nos. 2, 3, 4a, 4b, 5, 6, 7, 8 & 9 of Deerpark and No. 3 of Carsrock townlands]

[Lathaleere townland]
33 herd's house owned by Richard Rawson [of Chapel Hill]
[here Kiltegan Road turns west]
no houses here
['Whitehall Cross'; Kiltegan Road turns north]
34 herd's house[68] owned by Robert Parke
[of Mill Street]
[Baltinglass East townland]
35 Barrett, Adolphus
36 Parochial House, Lalor, Rev. Daniel, Parish Priest

Knockanreagh Road, Baltinglass West, Glennacanon, Knockanreagh & Rathmoon
 townlands
West Side
(Tinoran Road to Rathmoon Road)
[Knockanreagh townland]
1 Lyons, Edward
2 Brien, Edward, farmer
[Rathmoon townland]
3 Hayden, Dora
4 Dallon, Nicholas

East Side
(Rathmoon Road to Tinoran Road)
[Baltinglass West townland]
5 herd's house owned by William Johnson[69] [of Belan Street]
[Knockanreagh townland]
6 Timmins, Bridget farmer
[Glennacanon townland]
no houses here

Knockanreagh townland (see Knockanreagh Road & Tinoran Road)

Lathaleere townland (see Kiltegan Road & Redwells Road)

Main Street, Baltinglass East townland
South Side
(The Bridge to Weavers' Square)
1 Baltinglass Infirmary[70] (County Wicklow Second Infirmary)
surgeon: Nicholas William Heath, Stratford Cottage, Stratford
2 Norton, Patrick
3 out office owned by George Darcy [of Main Street]
4 out office owned by John Walsh
5 Walsh, John
6 Heath, N. William[71] surgeon to Baltinglass Infirmary & medical superintendent of
 Stratford Fever Hospital
residence: Stratford Cottage, Stratford
7 Murphy, James[72] drapery, grocery & general business shop
8 Murphy, William, provisions & delft shop

9 Byrne, John, pawnbroker
10 Toole, Edward, leather & huckstery
11 Byrne, John, grocery & public house
12 Nolan, Thomas, huckstery
13 Neill, James, butcher
14 Lyons, John, (dilapidated)[73]
15 Ryan, James,
Kitson, Bridget (part of house)
16 Sheridan, James, huckstery
17 Lawler, Rose, rag store & delft shop
18 unoccupied (dilapidated)
19 unoccupied (dilapidated)
20 Pearson, Patrick (dilapidated)[74]
21 unoccupied
22 McNally, John, boot & shoe maker
23 Sharpe, William
24 Shaw, Christopher, carpenter
25 Fegan, James, huckstery
26 Shaw, Hannah
27 Hayden, Catherine, (dilapidated)[75]
South-East block
(south face)
28 Constabulary Force, officers' residence, Thompson, Thomas, Sub-Inspector
[here side of No. 29]
(west face; facing into Market Square)
29 Courthouse & District Bridewell
Petty Sessions clerk: Peter Douglas, Saundersville, Dublin Road, Tuckmill
Courthouse keeper: George Leonard, Edward Street
Bridewell keeper: Thomas Cope;
Matron: Margaret Cope
30 ruins (north of & adjoining the bridewell)
(north face; facing into the Fair Green)
[here side of No. 30]
28 (part of) Constabulary Force police barracksß
Sub-Inspector: Thomas Thompson
identified constables:
Head Constable: John Barton
Constable: Michael Sheehy
(east face; facing into Weavers' Square)
[here side of No. 28]
north-west block
(east face; facing into the Fair Green)
31 Mitchell, Patrick
(south face; facing into Market Square)
32 Shaw, Abraham
33 Clarke, James
34 Byrne, Loftus
35 ruins
36 Kavanagh, Michael, (dilapidated)

(west face; facing into Market Square)
37 Walsh, Michael, meal store & bakery
38 Clarke, Andrew, provisions & leather shop
(north face)
39 unoccupied
40 unoccupied
41 Lynch, Mary, (dilapidated)
42 McGrath, John, blacksmith (forge dilapidated)
North Side
(Chapel Hill to The Bridge)
[Nos. 43-46 facing the Fair Green]
43 unoccupied, (dilapidated)
44 Hayden, Michael, (dilapidated)
45 Fox, John
46 Griffin, Patrick, (dilapidated)
47 Horan, Anne[76]
48 out offices owned by John Byrne
49 Byrne, John
50 Hayden, Henry
51 iron store[77] owned by William Kelly
52 Kelly, William, grocery & public house & post office
53 Rawson, James, huckstery
54 Flinter, Christopher, huckstery
55 Mackey, Daniel, pawnbroker
56 Nicholson, Peter, public house
57 Byrne, Michael, provisions & huckstery
58 Smith, Abigail, private dwelling
59 Johnson, Anne, apothecary's shop
60 Fisher, Henry W., medical doctor, medical officer to Baltinglass Union, Workhouse & Fever Hospital, Kiltegan Road
61 Ennis, Michael, drapery shop
62 Anderson, Robert H., mill retail store, meal store, grocery & coal yard, residence: Mill Street
[here joins Church Lane]
63 Darcy, George, public house & caravan shop
64 Mangan, Mary, huckstery

Market Square (an alternative name for the areas south and west of the 'north-west' block in Main Street; see Main Street)

Mattymount townland[78], (see Rathbran Road)

Mill Street, Baltinglass West townland
East Side
(The Bridge to Dublin Road)
1 Cooke, Thomas, grocery & general business
[here right of way to the river[79]]
[Nos. 2-3 facing south]
2-3 Kitson, Edward, grocery & general business

4 Long, Alexander, (dilapidated)
5 Nue, William, public house
6 Parke, Robert, (dilapidated out office)
7 Wall, James
8 Hayden, Michael, huckstery
9 Lynch, Matthew
10 Sharpe, Robert[80]
11 Doran, John & Corcoran, Christopher
12 Corcoran, James
13 Anderson, Robert H., house, flour mill & corn mill[81]

West Side
(Dublin Road to Belan Street)
14 building ground
15 unoccupied
16 Parke, Catherine
17 Cooke, Michael, clerk to the Board of Guardians
18 McLoughlin, William
19 unoccupied[82]
20 Harbourne, Elizabeth
21 Campbell, Nicholas (behind No. 20)
22 Jones, James
[here Ballytore Road intersects]
23 Wesleyan Methodist Chapel
no resident minister
24 O'Brien, Thomas, butcher
25 Flinter, Henry, huckstery
26 Darcy, James
27 out offices owned by Robert H. Anderson (behind No. 26)
28 Butler, Benjamin[83]
29 Parke, Robert, drapery shop
30 Lynch, John, public house
31 Neill, Thomas, grocery shop & hotel
32 Doyle, Patrick, public house & bakery

Newtownsaunders townland (see Green Lane, Kiltegan Road & Redwells Road)

Oldtown townland (see also Hartstown Road)
1 Keogh, Michael, farmer
2 out office owned by Christopher Sleator
5 Bolger, John
6 Owens, Henry

Pound Lane, Baltinglass West & Bawnoge townlands (see Edward Street)

Raheen Hill Road, Stratfordlodge, Raheen & Rampere townlands
West Side
(Dublin Road to the 'Five Crossroads')
[Stratfordlodge townland]

1 vacant[84]

[Raheen townland]

2 Nowlan, Laurence

3 Nowlan, James

4 Brisk, John

5 Coleman, Patrick

6 Coleman, Thomas

7 Hendy, Francis[85], farmer

8 herd's house owned by Martha Neal (entrance to)

[Rampere townland]

9 Condell, James, farmer

East Side

('Five Crossroads' to Dublin Road)

[Rampere townland]

10 Connor, Edward

[Raheen townland]

11 Ryan, Ellen

12 Mahon, Hannah

13 Hunt, John

14 Eustace, Esther

15 Condell, Samuel, farmer

16 Coogan, Jeremiah[86]

[Stratfordlodge townland]

17 see No. 5 Dublin Road [Henry Nue]

Raheen townland (see also Colemans' Road, Dublin Road & Raheen Hill Road)

1 Neal, Benjamin

9 Dowdall, William[87]

Rampere townland (see also Cabra Road, Colemans' Road, Hartstown Road & Raheen
 Hill Road)

1 Flinter, Margaret[88], farmer

2 Fowler, Michael

Rathbran Road, Tuckmill, Tuckmill Upper, Mattymount & Tuckmill Lower
 townlands

South Side

('Tuckmill Cross' to Goldenfort)

[Tuckmill Upper townland]

1 see No. 8 Dublin Road [Felix Toole]

[here Tuckmill Bridge; road crosses River Slaney]

[Mattymount townland]

2 Clarke, John[89], farmer

[road continues into Goldenfort townland]

North Side

(Goldenfort to 'Tuckmill Cross')

[Mattymount townland]

no houses here

[here Tuckmill Bridge; road crosses River Slaney]
[Tuckmill Lower townland]
no houses here

Rathmoon Road, Baltinglass West & Rathmoon townlands
North Side
(Belan Street/Brook Lane to Carrigeen)
[Baltinglass West townland]
no houses here
[here joins Knockanreagh Road]
[Rathmoon townland]
1 herd's house owned by Edward Kenna
[road continues into Carrigeen, County Kildare at this point]
South Side
(Carrigeen to Tullow Old Road)
[Rathmoon townland]
2 Brien, Mary, farmer
3 Lennon, Michael
4 Doolan, Margaret
5 Rathmoon House, Brophy, James, farmer
[Baltinglass West townland]
no houses here

Rathmoon townland, (see Knockanreagh Road & Rathmoon Road)

Rathvilly Road,[90] Bawnoge, Clogh Upper, Holdenstown Lower, Cloghcastle & Clogh
 Lower townlands
West Side
('Clough Cross' to Rahill)
[Bawnoge townland]
1 Thorpe, John, farmer
[Clogh Upper townland]
2 Thornton, James, farmer
3 herd's house owned by Henry Kavanagh
4 Farrell, James, farmer
5 Coogan, Owen, farmer
6 Byrne, John
7 Brennan, Murtagh
8 Kehoe, Margaret
9 Molloy, Daniel, farmer
[Holdenstown Lower townland]
no houses here
[road continues into Rahill, Co.unty Carlow at this point]
East Side
(Rahill to 'Clough Cross')
[Holdenstown Lower townland]
10 Clarke, Christopher
[Cloghcastle townland]

[here joins road through Holdenstown]

11 (entrance to) Brien, Sylvester, farmer

12 Kane, Terence

13 Jones, William

14 Kelly, Edward

15 Farrell, John

16 Clarke, Sarah

17 Lennon, Bridget

18 Toole, Bridget

19 Kane, Michael

20 Kavanagh, Laurence

21 Kelly, Bridget

22 Kehoe, Mary, jun.

23 (entrance to) Kehoe, Mary, farmer

[Clogh Lower townland]

24 Hennessy, William

[here site of Rellickeen]

25 Kehoe, Patrick, farmer

[here shared entrance to No. 26 and No. 5a of Clogh Lower townland]

26 Kelly, Denis

27 Abbott, Martin

28 Hegarty, Martin

29 herd's house owned by Patrick Doyle

[Bawnoge townland]

30 Tobin, James

31 Molloy, James, (behind 30 [Tobin])

32 Nowlan, James

The Redwells, (see Kilmurry Lower, Kilmurry Upper & Redwells Road)

Redwells Road, Lathaleere, Newtownsaunders, Slaney Park, Kilmurry Upper & Kilmurry
 Lower townlands

West Side

(Kiltegan Road at 'Whitehall Cross' to Mountneill Bridge)

[Lathaleere townland]

[here lands of Whitehall House]

1 Thorpe, William

2 Thorpe, Thomas

3 Doyle, Patrick

4 Quinn, Thomas

5 Kavanagh, Sylvester

[Newtownsaunders townland]

6 Mahon, Thomas

7 see No. 3 Green Lane [Patrick White]

[here road intersects with Green Lane]

no houses here

[Slaney Park townland]

8 Slaney Park (entrance to) Grogan, Rev. William, Rector of Baltinglass Parish

9 unoccupied[91]
[here 'Redwells Cross'; here joins road through Holdenstown]
[Kilmurry Upper townland]
10 Thorpe, Eliza
[here Mountneill Bridge; road continues into Mountneill, Co. Carlow at this point]
East Side
(Mountneill Bridge to Kiltegan Road at 'Whitehall Cross')
[Kilmurry Upper townland]
[here shared entrance to Nos. 11 & 12]
11 Byrne, Edward, farmer
12 Nolan, John, farmer
13 Jones, Edward, farmer
[here 'Redwells Cross'; here joins road through Kilmurry]
[Kilmurry Lower townland]
14 Brennan, John
15 Coogan, Catherine farmer
[Slaney Park townland]
no houses here
[Newtownsaunders townland]
16 Newtownsaunders (entrance to), Jones, John, land agent
[here road intersects with Green Lane]
17 unoccupied
18 Neill, John
[Lathaleere townland]
no houses here

Saundersgrove townland, (see also Dublin Road)
1a Saundersgrove, Saunders, Robert F., landowner
1b Wilson, Eliza, (estate farmhouse)[92]

Saundersgrovehill townland, (see also Dublin Road)
5 Cullen, James

Slaney Park townland, (see Redwells Road)

Sruhaun ['Shrughaun' or Dublin Old] Road, Baltinglass East, Sruhaun & Tuckmill
 Upper townlands
West Side
(Chapel Hill to Dublin Road)
[Baltinglass East townland]
1 Pearson, Thomas
[Sruhaun townland]
2 Murphy, Patrick
[Tuckmill Upper townland]
no houses here
East Side
(Dublin Road to Chapel Hill)
[Tuckmill Upper townland]

3 Brien, James, farmer
[Sruhaun townland]
4 Kelly, Thomas
[here lane to No. 12a of Sruhaun townland]
5 Toole, James (entrance to)
[Baltinglass East]
no houses here

Sruhaun ['Shrughaun'] townland[93], (see also Sruhaun Road)
12a Toole, James
13 Byrne, Patrick
14a Mara, John
14b Cunningham, Thomas
14c Lyons, John
14d unoccupied house owned by the Earl of Aldborough
14e Malone, Edward
14f Cunningham, Henry
16 herd's house owned by Hannah Shaw [of Main Street]

Stratfordlodge townland, (see also Dublin Road & Raheen Hill Road)
1a herd's house owned by Thomas Condell
1b Fogarty, James
1c Lawler, John[94]
2a Stratford Lodge, Aldborough, Earl of
2aa Hendy, John[95]
2c unoccupied[96]

Tailor's Lane, Tuckmill, Tuckmill Lower & Tuckmill Upper townlands
East Side
(Kilranelagh Road to Coolinarrig)
[Tuckmill Lower townland]
1 Lee, Thomas
2 Lee, Patrick
3 Byrne, Thomas
4 Reddy, John
[road continues into Coolinarrig Lower townland]
West Side
(Coolinarrig to Kilranelagh Road)
[here Tuckmill Hill townland – outside of area being covered]
[Tuckmill Upper townland]
no houses houses

Tinoran Road, Baltinglass West, Glennacanon, Tinoranhill South & Knockanreagh
 townlands
North-East Side
(Ballytore Road/Brook Lane to 'Tinoran Cross')
[Baltinglass West townland]
1 out offices[97] owned by the Earl of Aldborough

[Glennacanon townland]
2 unoccupied house owned by Michael Brophy
3 Brophy, Michael, farmer
4 Doogan, Charles, farmer
5 Doogan, Mary
6 Byrne, Maurice, farmer
[Tinoranhill South townland]
7 Neill, Joseph, farmer
8 Neill, John, farmer
9 Byrne, Maurice
[here 'Tinoran Cross'; here joins Hartstown Road; road continues into Oldtown
 Lackareagh & Monatore townlands]
South-West Side
('Tinoran Cross' to Brook Lane)
[here Monatore townland – outside of area being covered]
[Tinoranhill South townland]
no houses here
[Knockanreagh townland]
10 herd's house owned by Robert H. Anderson [of Mill Street]
11 Connolly, John
[here joins Knockanreagh Road]
[Glennacanon townland]
no houses here
[Knockanreagh townland]
no houses here
[Baltinglass West townland]
no houses here

Tinoranhill North townland, (see Hartstown Road)

Tinoranhill South townland, (see also Hartstown Road & Tinoran Road)
7a Brennan, James[98]

Tuckmill Lower townland, (see Dublin Road, Kilranelagh Road, Rathbran Road &
 Tailor's Lane)

Tuckmill Upper townland, (see also Dublin Road, Rathbran Road, Sruhaun Road &
 Tailor's Lane)
11 Jones, John
13c unoccupied house owned by James Brien[99]

Tullow Old Road, Baltinglass West & Bawnoge townlands
East Side
(Belan Street to 'Clough Cross')
[Baltinglass West townland]
1 see No. 15 Belan Street [unoccupied]
2 Nolan, James
3 Higginson, Mary

4 Byrne, Bridget
5 Fitzgerald, Robert
6 Scully, Thomas
7 ruin or building ground
8 Groves, William (dilapidated mud wall cabin)
9 ruin or building ground
10 Byrne, Christopher (dilapidated)
11 Lennon, Michael
12 Lennon, Peter
13 unoccupied (dilapidated)
[Bawnoge townland]
no houses here
West Side
('Clough Cross' to Belan Street)
[Bawnoge townland]
14 herd's house owned by James Murphy
15 herd's house owned by Robert Anderson
[Baltinglass West townland]
16 herd's house owned by the Earl of Aldborough

Weavers' Square[100] , Baltinglass East townland
West Side
(Main Street to Kiltegan Road)
[here ground held by William Murphy]
1 Thornton, Jane
2 Mahon, Christopher
3 Flynn, John
4 Wilson, Anthony, public house
5 unoccupied, (dilapidated)
6 McNamara, John
7 Farrell, Laurence, public house
8 Magennis, Michael
9 Browne, Christopher
10 Robinson, Michael
11 Curran, Arthur
12 Strahan, William
East Side
(Kiltegan Road to the Fair Green/Chapel Hill)
13 Roman Catholic Chapel (under construction)
14 Gaffney, Michael
15 Neill, James
16 Magennis, Edward
17 Gaffney, James
18 Byrne, James
19 Kavanagh, John
20 Hennessy, Bridget
21 Mooney, James
22 Farrell, Mary

23 Warburton, Bartholomew[101]Resident Magistrate
24 Tyrrell, Patrick
25 Byrne, Peter
26 Carty, Michael
27 Dunckley, George, lodgers
28 Dunckley, George, lodgers
29 Brien, John, (behind No. 27)
30 Brien, Catherine
31 Cairnes, William
32 Conway, Peter
33 Kerry, Michael, (next to No. 28)
34 Byrne, John &Taaffe, Samuel
35 Toole, Bridget
36 Finn, Luke
37 Sinnott, Mary Anne
38 Farrell, Mary, (dilapidated)
39 see No. 1 Chapel Hill [James Shaw]

Woodfield townland, (see also Kiltegan Road)
1 Murphy, John
2 Whelan, John
3 Reilly, Mary, farmer
5 Neill, James
6 Donohoe, Anne
10aa Brennan, Laurence
11 Nicholson, John, junior
12 herd's house owned by John Nicholson
13 Burke, John
14 Jones, Edward

STRATFORD FAMILY ARRESTS IN LEGHORN
SATURDAY 7 JUNE 1851

The arrest in Italy of three sons of Mason Gerard Stratford, late Earl of Aldborough, on 7 June 1851 brought further notoriety to the Stratford family and forced the then Earl into making a public statement asserting his right to the title. The arrests came after the family villa in Leghorn (or Livorno) was searched in the presence of the British Consul and a printing press was found.

In 1848 unsuccessful rebellions had broken out in many European countries. The disturbances throughout the various Italian states had been linked to the movement for unification of Italy, of which Guiseppe Mazzini was one of the main leaders. Though the insurrections failed, the revolutionary spirit remained. Leghorn was then a prosperous Mediterranean port in the Grand Duchy of Tuscany. In 1849 the Grand Duke was restored to power and his government was bolstered by the presence of the armed forces of the Austrian Empire. The Stratford brothers had been living in Leghorn from at least 1845, when they were

teenagers. After their father's death in 1849 they remained with their mother in their villa, described by a *Times* correspondent as 'a solitary out of the way place, with poverty written, as it were, on the doors'.

When the house was raided many papers and 'treasonable publications' were confiscated along with the printing press, while Henry Stratford and his two younger brothers were taken into custody. It was reported that they were connected with Mazzini's group, but later one of the brothers was quoted as saying that they had no links with Mazzini and that their only aim was to encourage insurrection at Leghorn. As many of the papers found were in English, some delay was caused by translation into Italian, so the brothers were held for over ten weeks by the Austrian commander-in-chief, who declared Leghorn to be in a state of siege. However, on 22 August it was reported that they had been handed over to the local judicial authorities. There are no further accounts of the affair in *The Times* after this point, so the outcome of their trial is uncertain.[102] However, a decade later Tuscany was part of the new Kingdom of Italy.

What caused the then Earl of Aldborough, Benjamin O'Neale Stratford, considerable embarrassment was that the eldest of the three arrested brothers was referred to in newspaper accounts as Lord Aldborough. Indeed, in an article published in *The Times* on 4 July a correspondent from Florence stated:

> As the title claimed by these young men is disputed, I have only to say that I have seen a certificate of the marriage of the late Lord Aldborough with the English lady, their mother, and that to the hour of death his Lordship said she was his legal wife.

On 17 July 1851 the following letter to the Editor of *The Times* was published:

> Sir, – My attention having been called to paragraphs professing to be copied from *The Times* in a Dublin newspaper, and also in Galignani, relative to young men who are compromised in an affair with the Austrian Government at Leghorn, in which one of them is styled 'Lord Aldborough,' and some particulars stated with regard to my father, the late Earl, which contain just sufficient truth to lead the public (or any persons, at least, who are not fully acquainted with the facts) to suppose the question a doubtful one, I cannot avoid expressing my surprise that the editor of a journal should put forward a statement of this kind on the authority of a correspondent, which a reference to the *Peerage* would have set him right on.
>
> I consider I am not unreasonable in hoping (if the paragraphs are correctly copied) that you will make the necessary inquiries to satisfy yourself on this point, and that having done so you will correct the error.
>
> I am, Sir, your obedient servant,
> Aldborough.
> Stratford-lodge, Baltinglass, County Wicklow, July 14.

The question of the legality of the late Earl of Aldborough's 1826 marriage to Mary Arundell finally came to a head in June 1854, when Mary opposed Benjamin O'Neale Stratford's claim to the title on behalf of her son, Henry Stratford, the eldest of the brothers arrested in Leghorn. Mason Gerard Stratford's 1804 marriage to Cornelia Tandy was recognised as legal before Cornelia was granted a divorce in December 1826. As he had married Mary Arundell over two months before the divorce was granted, this second marriage was bigamous and illegal. Mary Arundell's claim was rejected by the House of Lords on 12 June 1854, on the recommendation of its Committee for Privileges.

Having lost her claim, Mary Arundell is said to have spent the rest of her life in Florence under the name of Mrs Gerard. However, the dispute made the columns of *The Times* again in the 1860s. In December 1864 the newspaper reported the death of a twenty-six year old son of the late Earl's relationship with Mary Arundell. He had drowned off the coast of North Africa in the Bay of Tunis on 31 November. The Earl's legal widow took exception to the young man being described as 'Hon. Byron Stratford, son of the late Mason Gerard, Earl of Aldborough, and Mary Arundell, his wife'. On 6 January 1865 a letter from the Dowager Countess's legal representative appeared in *The Times*, reasserting the legal status of her 1804 marriage to the late Earl and her son's right to the title, as confirmed in 1854 by the House of Lords.

SALE OF THE ALDBOROUGH ESTATES
WEDNESDAY 2 JULY 1851

A large part of Baltinglass town and its environs, owned by the Stratford family since 1707, changed hands at the Court of the Commissioners for Sale of Incumbered Estates in Ireland, 14 Henrietta Street, Dublin, on 2 July 1851.[103] It was possibly the single most important sale of property in the history of the town, effecting numerous houses and transferring title to a combination of occupiers and new landlords.

The town and several of the surrounding townlands had been purchased outright from James Carroll on 31 July 1707 by Edward Stratford. Edward's son, John, had become Earl of Aldborough in 1777. The colossal debts accumulated by John's grandson, Mason Gerard, the fifth Earl, who died in 1849, occasioned the sale. As well as the Baltinglass property, there were lands in Limerick and Tipperary in the auction. Some of the Aldborough estates had already been sold by the Incumbered Estates Court. In this sale it was intended that the residue would go. Lord Aldborough's residence, Stratford Lodge, was not in the sale, nor were various properties which had been the property of his aunt, Lady Elizabeth Stratford, who died in 1848. There were fifty-seven lots (fifty-three of them in the Baltinglass area) and, according to *The Times*, all but four were bought. These were withdrawn because of a legal technicality. Most of the remainder of the Aldborough estates was auctioned on 12 December 1854, with more than four lots for sale.[104]

The gross rental of the properties sold at the 1851 auction was estimated at £4,100 per year and they sold for £61,566, roughly fifteen years' rental. However, many of the properties bought by sitting tenants fetched up to twenty or even thirty years' rental and those which went for relatively low amounts were considered to have obtained their market value. *The Times* stated that the auction could be regarded as 'the most satisfactory of any that have taken place since the Court commenced its arduous duties'.[105]

Though the Stratford family's connection with Baltinglass was to continue for another twenty-four years, and their descendants were to retain property interests into the twentieth century, this large sale in 1851 heralded the beginning of the end.

STRATFORD LODGE DESTROYED BY FIRE
SUNDAY 28 FEBRUARY 1858

On the morning of Sunday 28 February 1858, flames were seen coming from the windows of Stratford Lodge, the home of the Earl of Aldborough overlooking the town. Within twelve hours the mansion was a ruin.

Lord Aldborough was alone in the house on the night before the fire, which started in the drawing room. According to a contemporary account by his cousin Ellen Saunders,[106] an old woman from Baltinglass called Betty Hunt was the first to raise the alarm. She and others spent over an hour trying to waken the Earl. He was roused only when the police broke his bedroom windows with stones. He escaped to safety but, with no water supply closer than the river, any effort to save the building was futile. Some furniture was saved but it was broken in the effort. When the roof fell in the house became a mass of flames. The fire burned late into the evening. The following account appeared in the *Leinster Express* on Saturday 6 March 1858:

DESTRUCTIVE FIRE AT STRATFORD LODGE, COUNTY WICKLOW. –

The inhabitants of the town of Baltinglass and its vicinity were thrown into excitement on Sunday last on hearing of a fire having occurred at Stratford Lodge, the beautiful residence of the Right Hon. Earl of Aldborough. At 6 o'clock on the morning of Sunday last, an alarming fire was discovered breaking out at the drawing room window. The alarm being given, the police and several of the workmen and nearest inhabitants were on the spot, but for want of an engine, all their efforts to check the progress of the destructive element were unavailing. Fanned by a strong easterly breeze, the flames raged with unabated fury, and by 6 o'clock p.m., the county Wicklow residence of the noble family of Stratford had become a total heap of ruin. Several articles of furniture, books, pictures, &c., &c., were saved, but nevertheless the destruction of property must be enormous. His lordship made his escape through the window of his bed room, fortunately without injury. The origin of the fire has not been yet ascertained.

One of the Earl's major passions was hot air ballooning. Some years before the fire, in pursuit of this interest, he had a large granite outhouse constructed, apparently west of the mansion. This balloon house supposedly had a doorway fifty feet wide and sixty feet high.[107] It would appear that it was built between 1843 and 1852[108] and most likely after he succeeded his father in 1849. The balloon house survived the fire, but Lord Aldborough's plans for the balloon were destroyed. He moved his surviving furniture into the balloon house and lived there while he remained in Ireland.

Stratford Lodge had been built in the eighteenth century, but the family's principal country residence was Belan House near Moone. Benjamin O'Neale Stratford, a younger son of the first Earl and a militia captain during the 1798 Rebellion, seems to have lived in Stratford Lodge on a permanent basis during his adult life. After succeeding to the earldom in 1823 he remained there. Benjamin's successor as 5th Earl was his disreputable son Mason Gerard, who lived abroad. Another Benjamin O'Neale Stratford, one of the young children abandoned by Mason Gerard in 1810, spent at least part of his early life with his namesake grandfather in Stratford Lodge. During at least part of Mason Gerard's time as Earl, Benjamin (then Viscount Amiens) lived at Stratford Lodge with his aunts. One of these aunts, Lady Elizabeth Stratford, was known for her charity and religious zeal. She maintained a shop for supplying goods at cost price to poor residents and endowed Stratford Lodge School and an infant school, all of which were built on the edge of the estate. Lady Elizabeth died in 1848. Her sister, Lady Sophia, later lived in Dublin and their nephew, the sixth Earl, remained in Stratford Lodge as a semi-recluse.

E.P. O'Kelly was an eleven year old boy at the time of the fire and the account he wrote many years later[109] differed somewhat from Ellen Saunders's. He said that the alarm was raised by the driver of the post-car from Athy to Baltinglass and that the same man had already roused the Earl by throwing stones at his window. According to Ellen Saunders, Lord Aldborough believed the fire was started maliciously, as he had not lit a fire in the drawing room for six weeks prior to the incident. He said he would stay in the balloon house until he had his salvaged possessions packed and then he would go to London and never return to Ireland. Evidently the destruction was caused by burglars. E.P. O'Kelly stated that a gold watch which the Earl remembered having left in the drawing room the night before the fire was recovered from a Dublin pawn shop some months later.

Lord Aldborough eventually moved to Alicante in Spain, where he died in 1875. His balloon house was dismantled and the granite was used in the construction of the tower of St Joseph's church. In the late 1920s, when the parkland of Stratford Lodge was adapted to the use of the golf club, the gradual destruction of the ruins of the mansion and its outhouses began. The last piece of the structure, an archway, was torn down in 1980.

DEATH OF JOHN THOMOND O'BRIEN
SATURDAY 1 JUNE 1861

It is not at all certain that the death of John Thomond O'Brien had any great impact on Baltinglass at the time. He died in Lisbon while returning to South America, where he had lived most of his life since the 1810s. Though he was an important man in the former Spanish colonies of South America, his fame did not have the same currency in Ireland.

Martin Bryan, or O'Brien, was a relatively prosperous merchant in Baltinglass in the last two decades of the eighteenth century, acquiring leases of a number of premises and lands. He died in the first decade of the nineteenth century, leaving an interest in his property to four children. One was John, who is said to have been born on 24 June 1786. After his father's death John got into financial difficulty which weakened the family's fortunes. Shortly afterwards he went to London and then sailed for South America intending to get started in business. Instead, he got involved in the movement for independence from Spain, becoming a founder of the Mounted Grenadiers under General San Martin, whose exploits forged the way for the establishment of many of today's South American countries. John O'Brien (he added 'Thomond' as an adult) distinguished himself in the military sphere, playing a significant role in the independence process, and was rewarded in becoming an aide-de-camp to San Martin.[110]

Later O'Brien devoted much of his time to developing mining interests. In 1827, on one of many voyages back to Europe, he went about encouraging investment in South America and building trade links. In 1858 he made his last visit to Europe, during which he is said to have spent time in Baltinglass. He remained more than a year in England. When he eventually set sail for South America in 1861 he became unwell and had to stop off at Lisbon. There he died, at Casa calle Alecrim No. 71, on 1 June 1861. A measure of his importance in South America is that in 1935, the government of Argentina had his body exhumed and 'repatriated' to Buenos Aires. There he was given an elaborate reburial.[111] It is strange that his memory faded in his native town and by the late twentieth century there was virtually nothing known about his connection with Baltinglass. It was not until 2005 that his name was re-established in the town.

DEDICATION OF ST JOSEPH'S CHURCH
SUNDAY 21 APRIL 1872

Though the building of the Roman Catholic Church in Baltinglass was begun in the 1840s and it was opened for worship in the 1850s, the ceremony of dedication did not take place till 1872. On Sunday 21 April 1872 the Bishop of Kildare and Leighlin, Right Rev. James Walshe, came to Baltinglass to dedicate the church to St. Joseph.[112] The building Bishop Walshe visited had no tower, no bell and no

gallery as these were added later. Indeed construction work on the church was to continue intermittently throughout the nineteenth century.

At the time of the dissolution of Baltinglass Abbey in the 1530s, its church was serving as the parish church. After the Reformation it continued to be used as the Church of Ireland parish church until the 1880s. Where the Roman Catholic community worshipped prior to the late eighteenth century, or whether they had a chapel in the town itself in the interim, is not known. It is just possible that there was one somewhere on the lands acquired in the mid-nineteenth century by the Roman Catholic parish, as the 1844 lease of part of these lands described them as part of the 'Chappelfield, Monkfield & part of the Old Deer Park of Baltinglass'.[113] Certainly by 1799 there was a Catholic chapel in the town. At the time the term 'parish church' was applied to the Church of Ireland place of worship, as it was recognised as the established or state church. Catholic places of worship were referred to as chapels, while places of worship for dissenting Protestants were chapels or meetinghouses. On 9 December 1799 Richard Rawson of Baltinglass granted a lease to Rev. William Dooley, Parish Priest of Baltinglass, in trust for his parishioners, of 'the new chapel or house of worship situate in the Town of Baltinglass together with the yard thereto belonging'.[114] How long this 'new' chapel had been in existence is unclear, but by 1802 it was well established, as another deed referred to property 'on the Chapel Hill of Baltinglass'.[115]

One of the least oppressive of the eighteenth century Penal Laws was that prohibiting Roman Catholic chapels from having steeples or bells. As with many of the other Penal Laws, there were ways of getting around this particular one. By erecting a belfry adjacent to, but not adjoining, the chapel no law was broken. In Baltinglass a bell tower was built some yards away from the chapel in the north-eastern extremity of the chapel yard. Following the 1829 enactment of Catholic emancipation, a plaque was placed on this tower by the then Parish Priest, Rev. John Shea, commemorating the event. Apparently about the same time Father Shea had several feet added to the tower's height.[116] Long after the church on Chapel Hill had been abandoned and had fallen into decay, the bell in this tower continued in use, until a bell was placed in the tower of the new church in the 1890s. Today the tower stands alone in the centre of the extended graveyard.

By the 1840s the church on Chapel Hill was in a bad state of repair, and was possibly too small for the congregation. In March 1841 it was described as having three galleries, the ground floor was 'very bad and uneven' and a large part of one of the side walls was leaning outwards.[117] In the autumn of 1853 it was recorded that: 'A great portion of this building fell since old valuation'.[118] The man chiefly responsible for the initiative of building a new church would appear to have been Rev. Daniel Lalor, who replaced Father Shea as Parish Priest in 1831. Certainly it was during the first thirty years of Father Lalor's long pastorate that the parish acquired a very extensive property, including all houses on the south side of Chapel Hill, some on the east side of Weavers' Square, and all the land extending south from Chapel Hill almost as far as Lathaleere. According to the Kinsella

Manuscript, before Father Lalor began this acquisition the only parish property was 'the C.C. house and strip of land between avenue and road', i.e., the northern half of the present day Parochial House and the piece of land between it and the Kiltegan Road. This would seem to equate to the piece of land leased by Father Lalor from James and Margaret Murphy of Newry near Carnew on 8 July 1844.[119]

The site for the new church was leased on 4 June 1846 by James Kehoe of Clogh to three trustees, Dr Francis Haly, Bishop of Kildare and Leighlin, Francis Nolan of Carrigeen and James Lalor of Irongrange.[120] The lease was for 999 years at an annual rent of £8. The site, which contained one acre and thirty perches, statute measure, was described as a piece of land in Baltinglass with a front of sixty-four feet on the street.

The architect was John Bourke, who was responsible for many fine churches of the period.[121] The stone for the building was quarried at Carsrock and near the moat in Rathvilly parish. The construction begun while the Famine devastated the country, and it continued into the early 1850s, so it would have been a source of employment for labourers during that bleak period, providing them with a means of supporting their families. Supervision of the project was in the hands of Rev. John Nolan, a curate in Baltinglass since 1835. He engaged a contractor from Newtownbarry (now Bunclody) named Browne, who built the first thirteen feet. However, Father Nolan was not satisfied with the work and he dismissed Browne and completed the project by direct labour. Most of the scaffolding was lent by William Wentworth Fitzwilliam Hume of Humewood. However, when Hume asked Father Lalor for support in his bid for election to Parliament in 1852, the Parish Priest refused, accusing him of evictions.[122] [123] Felix Toole, a carpenter living at Tuckmill Cross, is said to have roofed the church.[124]

The new building was opened for worship sometime about 1854. Father Lalor added the porches towards the end of his term as Parish Priest. He died on 24 January 1871, a few weeks short of forty years after coming to Baltinglass, and he was buried in the new church, a side altar being erected to commemorate him. He was succeeded by Very Rev. Dr. Denis Kane. Just over a year later the dedication took place. The only entry in Dr Kane's diary under 1872 simply reads:

St Josephs opened
Sermon by F. Fox[125]

The architect J.S. Butler is credited with designing the main altar.[126] According to the Annals of Baltinglass Convent, the altar was erected in 1873 and was carved by a local carpenter named Evans. This craftsman was Francis Evans (1838-1889), a native of Portrushen, near Kiltegan, who moved to Baltinglass sometime between 1868 and 1870.

Dr Denis Kane is remembered in Baltinglass chiefly as the man who brought the Presentation Sisters to the town, though his predecessor had instigated that move. On the wider stage, Dr Kane was known for his academic career. He was educated

in Carlow College and Maynooth. After his ordination in 1848 he spent almost a decade on the staff of Carlow College. His fame as a preacher drew the attention of John Henry (later Cardinal) Newman, Rector of the Catholic University of Ireland, which opened in November 1854. Newman invited Kane to lecture at the University Church. Kane also conducted retreats in religious houses throughout Ireland before taking up parochial work in 1857. In 1866, with Bishop Walshe, he travelled to Rome, where he received his Doctorate of Divinity. His tenure as Parish Priest in Baltinglass lasted only twelve years. Dr Kane died after a short illness on 2 July 1883, and he too was buried in the church. The parishioners formed a committee to raise funds for the erection of a memorial. Cardinal Newman contributed £5 towards it. In February 1884 this memorial, a side altar dedicated to St. Philip Neri, was completed over the grave.[127]

Dr Kane's successor as Parish Priest was Rev. Arnold Wall. During Father Wall's time the steps in front of the church were added[128] and, according to the Annals of Baltinglass Convent, the tower and the organ gallery were added in 1887. The tower is said to have been built with the stone from Lord Aldborough's balloon house. The Convent Annals also state that the organ was built by a Mr. White, who played it when it was ceremoniously launched in May 1891. Father Wall died in 1893 and the following year his memorial window, depicting the Crucifixion, was erected behind the main altar.[129] His successor, Rev. Thomas O'Neill, continued the work of completing the church. According to the Convent Annals, the tower was finished by 1895, when the bell and clock were installed. However, as the bell was defective it was replaced by a new one three years later. The bell in the old tower on Chapel Hill being thus made redundant, it was removed to the church in Stratford[130] and the tower was left as a silent witness to the continuing evolution of Baltinglass.

ARRIVAL OF THE PRESENTATION SISTERS
TUESDAY 18 MARCH 1873

The Presentation Sisters had an enormous influence on the life of Baltinglass for over a century, providing education for generations of girls and in latter years, through their involvement in Baltinglass Post Primary School, teenagers of both sexes. Their association with the town began quite modestly on 18 March 1873 with three of their number travelling from Carlow, accompanied by the Administrator of Carlow parish, Rev. Andrew Phelan, to be received in St Joseph's church, Baltinglass, by the clergy and parishioners. The three pioneers were Sister Magdalen Hussey, Sister Augustine Hussey and Sister Agnes Barrett. After prayers in the church, the three nuns went to their new home, on the corner of Weavers' Square and Chapel Hill. The convent was officially founded the following day, the feast of St Joseph. In the morning the nuns attended eight o'clock mass, at which the Parish Priest, Dr Kane, gave an impressive sermon on 'the great usefulness of the Institution about to be founded in Baltinglass'.[131] This was followed by

Benediction, and then Dr Kane brought the Blessed Sacrament to the chapel of the convent.[132] The three nuns represented the first religious order to have a presence in Baltinglass since the dissolution of the Abbey over 330 years earlier. The community they founded was to last for 117 years.

Though the Presentation Sisters came to live in Baltinglass in 1873 under the protection of Dr. Kane, the creation of this new community apparently had its origins in Father Lalor's attempts more than twenty years earlier to acquire parish property. According to the Kinsella Ms., once he had managed to rent the various properties which were to form the block of parish property, he decided to buy them out. For this purpose he required £2,000. He approached two of his most prosperous parishioners, Lalor of Irongrange and Nolan of Carrigeen, but they would not or could not assist. He then turned to the convent in Mountrath, of which community two of his sisters were members. The convent agreed to put forward the money on condition that a Presentation convent be erected on the site and endowed.

There may be some truth in this story but it is not strictly accurate. The convent in Mountrath was of the Brigidine order, so it would be strange for them to advance the money on condition that a Presentation convent be built. Father Lalor was a native of Ballyfin parish and his contemporary Margaret (Sister Brigid) Lalor, from the same parish, was in the Brigidine community in Mountrath. She entered in 1812, was professed in 1814 and died in 1871 aged 86, so she may well have been Father Lalor's sister.[133]

In any case, the parish property was purchased through the Incumbered Estates Court in two separate transactions, in 1851 and 1852.[134] The purchase was in the name of Ellen Lalor of Mountrath, who may have been another sister of Father Lalor, but she was not in the convent. In 1851 she paid £1,145 for three properties which together formed a block containing about seventy-three statute acres. This included all the south side of Chapel Hill and Cars' Lane. It extended eastwards into Carsrock townland and southwards along the Kiltegan Road as far as the site of the present Scoil Naomh Iósaf (formerly St. Pius X National School). It included the Parochial House and the church. By this one purchase Ellen Lalor became the outright owner of all the property in this block with the exception of several houses on the east side of Weavers' Square.[135] The purchase appears also to have included some of the houses on the lower part of the north side of Chapel Hill.[136] In 1852 Ellen Lalor paid £140 for just over thirteen acres in Sruhaun and another property in Weavers' Square.[137]

The property of which the Parochial House and the church were part (the 'Chappelfield, Monkfield & part of the Old Deer Park of Baltinglass') had a complicated history which it took Father Lalor another two transactions to rectify. In 1796 Lord Aldborough had granted a lease for lives, with allowance for perpetual renewal, to Bartholomew Bryan, and this was inherited by James and Margaret Murphy of Newry near Carnew. Evidently the Murphys sublet the property, or most of it, to the Kehoes of Clogh. By

deeds dated 1853 and 1857[138] Father Lalor secured the interests of the Murphys and the Kehoes, and somehow Ellen Lalor's purchases became vested in Father Lalor.

Finally, on 1 November 1862 Father Lalor made over all the property purchased under the name of Ellen Lalor to three trustees. They were Right Rev. James Walshe, Bishop of Kildare and Leighlin, Most Rev. Paul Cullen, Archbishop of Dublin (later Cardinal Cullen), and Rev. Patrick Celestine Nolan, Parish Priest of Rathvilly. According to the memorial at the Registry of Deeds, the trustees were to hold the property 'upon the charitable trusts and to and for the intents and purposes therein after declared'.[139] Unfortunately, no other evidence has been found in relation to what become known as the Lalor Trust, but it would appear that the erection of a convent was one of its purposes.

Father Lalor died in January 1871, just over two years before the convent was founded, so plans for the building of the nuns' first home in Baltinglass must have been made during his lifetime. This first convent, on the corner of Weavers' Square and Chapel Hill, was built on the site of what had been in 1851 a dilapidated house and adjoining ruins. Evidently there was a tower attached to the building, as a bell was placed in the convent tower on 29 September 1873. From the outset, the position of superioress was held by Mother Magdalen Hussey, who had been professed in 1855. She and Sister Augustine Hussey were sisters from Dublin, and in their early forties. The third foundress, Sister Agnes Barrett, from County Kilkenny, was in her late twenties, having been professed in 1870. On Sunday 30 March 1873, twelve days after the three nuns arrived in Baltinglass, Dr Kane blessed the convent primary schools on Chapel Hill, naming the senior school St Mary's and the junior St Joseph's. The following day classes commenced, with 101 children present. These included junior boys, but after some time Dr Kane decided to confine admission to girls only.

On 15 September, just six months after the convent opened, the first postulant entered. She was Catherine Heydon from Rathvilly parish, and she entered as a lay sister. Just over two weeks later, on 2 October, the first 'choir postulant', Julia Byrne from Athy, arrived. She was the first nun to be professed in Baltinglass when, as Sister de Sales, she took her vows on 8 May 1876. She was followed by Sister Joseph Comerford on 24 January 1877 and by Sister Catherine Heydon, the first postulant, on 12 August 1878. These three new sisters, along with the foundresses, formed the community of the first convent. Just over six years after the foundation, the sisters moved to their new convent, built on the high ground between Chapel Hill and the church.

DEATH OF LORD ALDBOROUGH
SUNDAY 19 DECEMBER 1875

The death of the last Earl of Aldborough was a sadly minor event as far as Baltinglass life was concerned. He had left the area many years before and the once

supreme influence his family had in the town's affairs was already consigned to history. Benjamin, Lord Aldborough died in Alicante on the Mediterranean coast of Spain on 19 December 1875, a sixty-seven year old recluse. He was the last legitimate descendant in the male line of his great-grandfather, John Stratford, the first Earl of Aldborough.

Even at the death of Benjamin, his long departed father's hedonistic existence continued to cast a shadow over the son's reputation. Those advertisements for Professor Holloway's Pills were still appearing in the newspapers all those years later, and no doubt causing annoyance to the son if such information reached him in his hideaway. Whether he knew it or not, the world at large seems to have credited him with his father's endorsement of the medicine; Mason Gerard spent the money and Benjamin's reputation paid the price. A brief newspaper obituary (which wrongly gave his date of death as 24 December) referred to him as 'an Irish nobleman whose name used constantly to appear in the newspapers as voucher for a patent medicine'. It went on to say that he 'had been living a very secluded life on the Cantabrian coast for some years and from his very eccentric habits and mode of life, attracted no small attention among the Spaniards', adding that he 'studiously avoided his own countrymen and resented any attempt at breaking in on his voluntary retirement.'[140]

The destruction by fire of his house in 1858, which he believed to have been malicious, cannot account for his anti-social behaviour. Long before he left Baltinglass he had a reputation for strangeness. While living at Stratford Lodge he kept only one servant and it is said that his meals were brought each day from Dublin on the Royal Mail coach. E.P. O'Kelly stated as fact that once when an old man named Billy Nolan, living on the edge of the estate, displeased him, the Earl had stonemasons block up all doors and windows in Billy's house, leaving him inside. He had to be rescued by his neighbours that night.[141] Whether Benjamin's abandonment in infancy, the legal doubt during his teens about the validity of his parents' clandestine marriage, and his father's deathbed attempt to deprive him of his inheritance had a bearing on his personality, there is no doubting that he was a misanthropic eccentric.

After the 1858 fire he stated that he would go to London and never return to Ireland. At that time his closest surviving relatives were his mother and his aunt, Lady Sophia Stratford, both of whom were living in Dublin. On the death of Lady Sophia in 1864, a cousin, Morley Dennis, commented: '… Benjamin alas! has proved himself devoid of natural affection, has never gone to see his aunt …'[142] Living abroad, he rarely wrote to his mother. In 1871, when Baltinglass Church of Ireland parish wished to build a new church, they communicated to him their request for a site. His unadorned refusal was communicated to them by his agent, Robert H. Anderson.[143]

Despite the last Lord Aldborough's undeniable lack of warmth, it would be unfair to simply portray him as an unfeeling eccentric. His knowledge of the construction of hot air balloons would appear to have been considerable. He is

said to have taken out five patents for improvements to the balloon.[144] Robert H. Anderson told E.P. O'Kelly that Lord Aldborough had intended to sail his balloon to England and then on to France, where he had purchased a small plot of ground by the Seine for landing the craft. He had expressed regret at not having it completed for the Crimean War, where he thought it might have been of use.[145] At the time of the fire the balloon was not finished and his plans went up in flames.

Benjamin O'Neale Stratford, sixth and last Earl of Aldborough, was survived by his mother, Cornelia Jane, Countess of Aldborough. Administration of his estate of £14,000 was granted to her on 1 March 1876. She died at Mulgrave Terrace, Kingstown (now Dun Laoghaire) on 5 August 1877, seventy-three years after she eloped with the good-for-nothing Mason Gerard Stratford. There being no surviving legitimate descendants of the fourth Earl, what remained of the Aldborough estates in Baltinglass reverted to the descendants of the third Earl, John Stratford. John had left three daughters, all of whom were deceased by the 1870s. Their representatives, Catherine Dora St John, Baron Tollemache and John Stratford Best, inherited the property, including the lands of Stratford Lodge, with the ruins of Lord Aldborough's home.

BLESSING OF THE NEW CONVENT[146]
WEDNESDAY 6 AUGUST 1879

Within a matter of weeks of the arrival of the Presentation Sisters in Baltinglass in 1873 an architect, a Mr Butler, was engaged to draw plans for a new convent. The site allotted for this building was part of the parish property acquired by Father Lalor, on high ground adjoining St Joseph's church and with access from Cars' Lane at the top of Chapel Hill. On the feast of St Joseph, 19 March 1876, the foundation stone was laid by Bishop Walshe. In May 1876 the masons' work began but the building was not completed till 1879. In August 1879 the Sisters' annual retreat was to take place and the Parish Priest, Dr Kane, suggested that it should be held in the new convent. The nuns selected their new cells and dusted them. While they washed out the cells, Mother Magdalen Hussey and some girls took down the beds in the old convent on the corner of Weavers' Square and Chapel Hill and carried them across the field to the new building. Mother Magdalen carried the statue of St Joseph and placed it in the hall. Then on 6 August Dr Kane blessed the new convent and dedicated it to St Joseph. Ten years later, on 31 May 1889, the stone statue of St Joseph was placed over the hall door.

By 1883 there were six nuns in the convent and by 1901 they had grown to a community of twelve. The Sisters continued to teach the girls of the area, though the junior boys' classes were discontinued at some point. The convent schools moved from Chapel Hill shortly after the nuns occupied their new home. On 25 August 1879 the schools opened in the new building with 180 pupils present. In 1896 classrooms were opened adjoining the convent and in July that year improvements in the convent were begun, with the two old schools being converted into

an oratory. On 30 July 1911 during a violent storm the convent was struck by lightening, with the conductor torn from the tower, gutters shattered and a down pipe twisted out of shape, but there were no injuries. The Convent Annals record that in November 1914 the Sisters saw an aeroplane for the first time, and this is likely the first plane ever seen in the Baltinglass area.

In 1923 the community was fifty years in existence and on 18 April there was a public celebration in St Joseph's church. By then the convent was one of the most identifiable Baltinglass landmarks. Standing side by side with the church it still contributes to one of the town's most picturesque views, on the approach along the Carlow Road. The Presentation Sisters were to remain in this building for over a century. Until the 1920s their movements within Baltinglass were confined to the convent grounds and the church. On 2 September 1925, with the Bishop's permission, they climbed Baltinglass Hill for the first time and visited the Pinnacle. This was the first of many such climbs. Though they were to remain an enclosed order till the late 1960s, they were very much part of the life of Baltinglass throughout their time in the town.

THE LAND WAR: FIRST LAND LEAGUE MEETING
SUNDAY 24 OCTOBER 1880

Thousands thronged Baltinglass for the town's first big gathering in support of the Land League on 24 October 1880. Many in the crowd wore green leaves or rosettes, while a few wore green sashes. It was a fine day and, under green banners, the Cryhelp and Hacketstown brass bands marched through the streets playing Irish tunes, with *O'Donnell Aboo, Tramp, Tramp* and *God Save Ireland* repeated several times. In front of the courthouse a platform was erected, and in front of it were banners proclaiming 'The Land for the People' and 'Erin-go-Bragh'. At about two o'clock the speakers took to the platform and E.P. O'Kelly of Main Street was put forward to chair the meeting. This, he said, was his first time to preside over a meeting.[147] It was, therefore, an important step on what was to be a long career in politics.

Following the bad winter of 1878-79 during which very wet weather, crop failures and falling agricultural prices threatened the livelihood of many small farmers, the Irish National Land League was formed in October 1879. Its aim was to bring about land reform and it took direct action against landlords it considered as treating tenants badly. In the autumn of 1880 the organisation famously targeted a Mayo landlord, Charles Boycott, isolating him and his family in an action that was to add the word 'boycott' to the dictionary. Boycott's situation was alleviated only when volunteer labourers from Monaghan went under military protection to harvest his crops. An emergency committee of the Orange Order was formed to counter the activities of the Land League and it financed 'Emergency men' to work for boycotted landlords.

By the end of 1880 local branches of the Land League were forming throughout the country and they were active in setting what they regarded as fair rents and

in resisting evictions. Over five hundred branches were established. There was a Baltinglass committee in place, with George O'Toole of Sruhaun as honorary secretary, by the time of the public meeting on 24 October, which was held under the auspices of the 'Irish National Land League for South Wicklow'. However, it would appear that the formation of a Baltinglass branch was one of the objectives of the meeting.[148]

Those on the platform included James McCoan, the new MP for Wicklow, and Thomas Sexton, MP for Sligo. The first resolution was proposed by Joseph Nolan of Carrigeen House, one of the most prosperous Roman Catholic farmers in the Baltinglass area. It was 'that the time has come when the final settlement of the Land Question can be no longer delayed, and, here present, we pledge ourselves to use every constitutional means to secure the satisfactory solution of this all-important question'. Nolan went on to caution against the use of violence, saying '… I will tell you what we will have and what we will not have. My county will never be disgraced by an outrage of any kind. We look for our rights peaceably, united, and with one voice and, tell me what will resist that? … You are good industrious men, and I say that the men who say "don't pay rent; but shoot your landlords," I say that they are the greatest enemies that you and I have. Are you not men of thought and men of mind, and have you not wives and brothers and sisters and children to stand by, and to stand by you? Then let us have peace and concord, and a feeling of religion'. His speech was cheered, but so was every speech, regardless of the pacifist or militant rhetoric. The motion was seconded by Edward Kehoe, Poor Law Guardian, and he was followed by James McCoan, both of them reiterating the need for restraint.[149]

McCoan spoke at length, drawing a distinction between good and bad landlords. He said that there seemed to be 'some wild notion abroad that the Land League intended to abolish the landlords, seize their property, and commit a huge national fraud – nothing of the kind', adding that he did not think 'a crusade of that kind would have any chance with honest conscientious Irishmen'. As a Protestant he called on Protestant farmers to join the movement.[150]

The second resolution was proposed by Dr O'Neill of Athy. It was 'that we deprecate those acts of violence recently committed, and disassociate ourselves entirely from them, and that we, who have always spoken openly, take grave exception to the conduct of those landlords who held a private interview with the Viceroy at the Castle of Dublin, and had not the manhood to speak openly their convictions'. Presumably the second part was added to guarantee that the first was accepted by the huge crowd. Surprisingly, in support of the motion, O'Neill began by stirring the gathering with fighting talk of Fiach macHugh O'Byrne and the Battle of Glenmalure. Sailing close to the wind as he did, his speech may have been designed to show the people that the Land League was not a body that turned its back on past struggles. Skilfully he reined in the enthusiasm with reference to O'Connell: 'but like the great Liberator, of immortal memory, we must confine our operations within the limits of the Constitution, and if there be any man here amongst you who says otherwise, I say to you, eliminate him as a wolf from the

fold – as a spy from the enemy's camp, and if there should be one here amongst you who should exceed these limits by one inch, regard him as an enemy to the cause, an enemy to his race, and an enemy to the country'.[151]

The resolution put forward by Thomas Sexton was to pledge to boycott anyone who took a farm from which the previous tenant had been evicted, and to establish a branch of the Land League 'in this neighbourhood'. He drew attention to a placard that had been posted in the town. It read:

> To the labourers of the County Wicklow. Fellow-labourers, assemble in your
> thousands at the Land League meeting to be held in Baltinglass on Sunday next, and
> assert your rights as the real tillers of the soil. Why should we allow the tyrannical
> farmers to have it all their own way? It appears that at all the meetings held not one
> word was said about the poor labouring man, who toils from morning till night for
> the small wages grudgingly given by the farmer, and which are not able to give us
> and our families sufficient food to keep body and soul together. Labourers, now is
> your time.
> Down with the Land Leaguers.
> Our good parish priest is against them. Let us follow him and we will do well. If the
> farmers are our masters they will work the marrow out of our bones, and we will be
> no better than slaves.
> We have more right to the land than what they have.
> The farmers expect us to come in our thousands to fight their battle, but it is only
> fair to know what they are going to do for us in return. Will they give us good
> wages, constant employment, and a comfortable house to dwell in? Will they give
> us an acre of land under £6 to plant our potatoes (what they only pay £2 or 30s.
> for themselves or nothing at all)? Is that not rack-renting the poor labourer with a
> vengeance? Don't trust the farmers. Fight your own battle, and let the farmer fight
> his. – Your Fellow-labourer. God save the labourers.

The placard highlighted the fact that the Parish Priest of Baltinglass, Rev. Dr Kane, was not a supporter of the Land League. In fact, at that point the Roman Catholic clergy were by and large very wary of the movement. Sexton was in no doubt as to the 'Fellow-labourer' being 'one who rode a hunter and drank champagne at his dinner'.[152] However, the author was not necessarily a landlord. There could have been another motive behind the placard. Not everyone was steadfastly behind the speakers' stance on non-violence. The Irish Republican Brotherhood, a secret society that advocated physical force, had a policy of infiltrating Irish cultural and political movements; the Land League was no exception. However, early in 1880 the IRB supreme council decided to stop supporting the League, and a circular was issued to members to oppose its meetings, as a result of which many League meetings were disrupted.[153]

As early as 1878 the IRB was organising in the general area. That year John Wyse Power visited Rathvilly in a bid to recruit key members. In May 1879 Edward

O'Toole was inducted and given the task of organising in the Rathvilly area. Sometime later he was instructed to meet a messenger at Lynch's (or the Harp) Hotel[154] in Mill Street, Baltinglass. The messenger was a young man named Joe Brady, who was later to be executed for his part in the Phoenix Park murders of May 1882. What he gave O'Toole and his companions were 'six British bull-dog revolvers, each wrapped up in a woollen stocking, and some boxes of cartridges'. In October 1879 an organiser visited the area to 'inspect and instruct the "circles" in Tullow, Rathvilly, Tynock and Baltinglass'. O'Toole had to accompany him to meet the various groups. They were to meet their final circle in a pub in Baltinglass at ten p.m., but they were unable to hire a car in Kiltegan and ended up walking to the town on what was a cold, wet night. They arrived two hours late, and an hour after the Baltinglass men had gone home. The publican, evidently a sympathiser, had arranged a room for the organiser in Doyle's Hotel, then the stop for the mail coach to Dublin. One Baltinglass resident who was in the IRB and active at that time was Joseph Flynn of Weavers' Square.[155]

The Baltinglass meeting in October 1880 was not disturbed by any untoward incidents. With a crowd estimated as about six thousand the town was 'extremely orderly throughout the day' and, while the many who had travelled great distances were served drink, 'there were few cases of drunkenness'. In the evening James McCoan joined the organisers and some of the more prosperous farmers for dinner at Doyle's (or the Imperial) Hotel. Before leaving the platform George O'Toole announced that he had an enrolment book at the hotel for those who wished to join the League. After the meeting concluded the bands continued to march through the streets and the crowds remained for the evening.[156]

During the public meeting Sexton joked about framing the 'Fellow-labourers' placard and a voice from the crowd shouted 'We will hang it in the Munster Bank below'. This response had to do with an incident in Baltinglass earlier that month. Patrick Doyle, a shopkeeper in the town, had a farm in Clogh. He had borrowed from the Munster Bank, using the land as security, but had fallen into debt and the bank had taken possession of the land. Early in October 1880 the bank manager, W. George Burton, spoke to an auctioneer about setting the farm. On Sunday 3 October Sub-Constable Carty saw a notice posted on Thomas Lucas's house on the bridge. It read: 'Let no man take honest Pat Doyle's land. If he do let him take care of a pill from Rory'. On the other side of the bridge, at Webb's corner, was a similar notice: 'Let no man bid for honest Pat Doyle's land. If he do he shall share the fate of Lord Leitrim. – So Rory says.' About a dozen such threatening notices were found about the town. Allegedly Pat Doyle bought one field at the sale and said 'Now boys, buy away; I don't want any more'. The land was not set.[157]

A second large meeting of the Land League was held in Baltinglass on Sunday 13 February 1881. On this occasion the wet weather resulted in a poor attendance, though it was still estimated that a thousand were present. The League members 'wore green rosettes, interwoven with orange ribbons, and all wore laurel leaves in their hats'. The meeting was chaired by Nicholas O'Brien of Chapel Hill, who

was a shopkeeper, bacon curer and livestock exporter. He was described as president of the Baltinglass branch, though it would appear that he was vice-president, while E.P. O'Kelly was president. Though there were no clergy present, letters of apology were received from Father Joseph Delaney, the Baltinglass curate, and Father Lynch of Donard. Jasper Tully of Boyle attended as a representative of the national organisation, and there were deputations from Castledermot, Rathvilly and Tullow.[158]

Michael Davitt had been arrested in Dublin ten days earlier and parliament had given the government exceptional powers of coercion to counter the tactics of the Land League. These were the subject of the first resolution of the meeting. In seconding the motion, George O'Toole said that the Irish were as true to the cause of their country as were their 'grandfathers in '98, when they put their heads into the pitchcap and halter in this town sooner than lay down their rights'. Despite the force of the rhetoric, it was emphasised that protest must remain within the law if the Land League was to achieve its aims. Indeed, when opening the meeting O'Brien commented that, as predicted, the League had not been disgraced by any outrages.[159]

The Baltinglass branch sent delegations to meetings at various locations in the area throughout 1881. Those whose names featured in delegations included Cornelius Bracken of Newtownsaunders, James Byrne, John Byrne, P.L.G., Matthew Byrne, Patrick Byrne, J. Geoghegan, Loughlin Haydon, D. Kehoe, Michael Kelly, John Lynch, Thomas Rickerby of Main Street, and Thomas Whelan of Raheen. Thomas White was listed as treasurer of the Baltinglass branch when he attended a meeting in October, while E.P. O'Kelly was president and George O'Toole was still secretary.[160]

In Baltinglass itself 1881 was an eventful and turbulent year, despite the Land Leaguers' best intentions. On Thursday 5 May there was an alleged riot in the town during which, according to *The Times*, 'many Protestant houses were wrecked and other serious outrages committed'. Speaking in the House of Commons, James McCoan, the Wicklow MP, said that he had 'received telegrams contradicting the report, and stating that it was a case of a few boys throwing some stones, the matter being grossly exaggerated'. Nonetheless, the Chief Secretary's office received police reports on damage to houses in Baltinglass, including that of George E. Cope in Main Street. During April and May the Chief Secretary's office received a number of communications regarding the disturbed state of Baltinglass. One from Dr. McDowell called for reinforcements. In mid-May the constabulary force in the town was increased from five to eight men.[161]

THE LAND WAR: SALE OF CONFISCATED CATTLE
WEDNESDAY 24 AUGUST 1881

During April 1881 the Land League flexed its muscles by forcing the authorities in Carlow to attempt auctioning cattle seized from tenants who refused to pay

'rackrent'. The second such auction involved ten cattle owned by Matthew Tobin of Rathmore. Land Leaguers from neighbouring areas descended on Carlow, with Baltinglass represented by Nicholas O'Brien, George O'Toole, M. Byrne, J. Geoghegan, Loughlin Haydon, D. Kehoe and Thomas Rickerby. The auction of a heifer was commenced by an Emergency man bidding £4. When the price was raised to £5-5-0 a Land Leaguer bid £5-6-0. The bid was accepted and, his protest having been made, Tobin indicated to the County Sheriff that he was now prepared to pay the rent and costs. A meeting followed at which a Roman Catholic curate pointedly warned car owners and others providing services that co-operation with 'fraudulent landlordism' would make them 'just as much enemies of the popular cause' as Emergency men. He also referred to the upcoming Carlow Hunt Club race meeting as 'the sport of the landlords', saying:

> I want you to "boycott" it. The Land Leaguer or the sympathiser with the Land League that attends the County Carlow Hunt Races is doing the work of the enemy[162]

As the 'Land War' progressed throughout 1881 the dispute grew more bitter. The attempted sale of confiscated land or livestock for arrears of rent caused angry scenes. One such sale took place in Baltinglass on 24 August. Cattle belonging to a man called Prendergast, who was a tenant of Rev. Mr. Mason and Mr. J.H. Mason of Clonmel, had been impounded in the yard of Baltinglass Courthouse. That afternoon the cattle were to be sold. At two o'clock Sub-Inspector Holland of Dunlavin arrived with about fifty policemen. They were followed by a huge crowd 'who indulged in the most violent groaning and cheering'. When the gate of the yard was opened there was a stampede, but the police only allowed in a small number. Land League members including E.P. O'Kelly, George O'Toole and Thomas Rickerby, did their best to calm the crowd.'[163]

When the sale began J.T. Heffernan, representing the Land League central executive, demanded to see the auctioneer's licence. His refusal, made with 'an impertinent answer', sparked a near riot. The correspondent for the *Kildare Observer* commented: 'The scene that followed would beggar description. Land Leaguers, police, Emergency men, sub-sheriff, magistrate, and sub inspector were all huddled and hustled together.' Eventually, at Heffernan's suggestion the Sub-Sheriff for County Wicklow, William Brownrigg, conducted the auction. A Mr. Smyth and Heffernan were the only two bidders, and Heffernan purchased the cattle for Prendergast. They were sold for considerably less than the judgment and costs allowed to the Masons. Afterwards the cattle were paraded through the town, allegedly followed by about two thousand people. Then a meeting was held at Market Square[164], with delegations from all the neighbouring League branches and three bands in attendance.[165]

THE LAND WAR: ARRIVAL OF RAWSON'S EMERGENCY MEN
TUESDAY 30 AUGUST 1881

The term 'Emergency man' came to be applied loosely to anyone prepared to work for a boycotted individual, and did not necessarily imply a connection with the emergency committee of the Orange Order. However, Richard Rawson was forced into getting real Emergency men in to save his crops at the end of August 1881.

Rawson was a solicitor and landowner from Baltinglass. He married late in life and by 1881 he was almost eighty but had a young family.[166] At the time he was being boycotted by the Land League, so the local men saving hay on his land in Sruhaun were subjected to mounting intimidation. A farmer who hired his mowing machine to Rawson had to make an apology which was printed and circulated in Baltinglass. It read:

> Baltinglass Land League. An apology. I, Anthony Dwyer of Ballinacrow, am exceedingly sorry for having earned boycotting. I have suffered considerably by it, and ask to be forgiven, and will be good in future. I have asked Mr. O'Toole to publish this placard. – Anthony Dwyer, Ballinacrow.[167]

On the day of the cattle sale, 24 August, a man called Lynch, who was allegedly drunk, went about 'exhorting the mob to attack the haymakers'. The police attempted to arrest him but he was lost in the crowd. It was stated that repeated requests for protection for these workers had been made to the constabulary but that they only acted when it was threatened to report the matter to Dublin Castle.[168]

The following week, on the evening of Tuesday 30 August, four Emergency men from Portadown arrived in Baltinglass to assist the crop saving on Rawson's land. They started work in Sruhaun the next day. A report 'from a correspondent' published in the *Daily Express* and taken up by *The Times*, claimed that the Emergency men were intimidated on their way back from work that first day. It was almost certainly written by Rev. John Usher, the Church of Ireland Rector of Baltinglass. It stated that they finished work at six o'clock but remained in the field for twenty minutes expecting the police to escort them back to Rawson's house in Mill Street.[169] An 'excited mob hooted at them' from the next field and this allegedly drew the attention of Mr Usher and his son. When they arrived on the scene they were subjected to 'a most insulting attack by Mr Kelly's workmen and the mob'. This Mr Kelly was E.P. O'Kelly who, after about ten minutes, 'in a sneering manner, said to the crowd, "For goodness sake, stop that shouting now"' and 'immediately the booing began again'. The Emergency men left the field and walked with the Ushers along a right-of-way towards Church Lane. On the way they met John Lynch, the owner of Lynch's Hotel in Mill Street or more likely his son. He stood with a hay fork at the gate of a field and said he would not allow them cross his land. While Mr Usher remained

arguing with him about the right-of-way, the Emergency men went on up Church Lane. As they were crossing the bridge stones were thrown at them, but 'bravely facing their opponents, they overawed the crowd by their determined aspect, and were not further molested'. As the Ushers crossed the bridge 'a determined rush was made to surround and hustle them'.[170]

On the Thursday morning Mr Usher sent a telegram to the Chief Secretary's office in Dublin Castle, stating: 'We want protection for the emergency men working here for Mr. Rawson they stand in great danger were attacked last night the police promised protection but did not give it I ask for an enquiry into their conduct'.[171] Constable McCabe was immediately asked for a report on the incident and his version, written later that day, was at variance with the published account. According to him, having been informed that the Emergency men would be returning to the town at six o'clock, he positioned two sub-constables on the west side of the bridge, while he and another sub-constable went to Chapel Hill, expecting them to come down the road from Sruhaun. However, the Emergency men crossed the fields and came up Church Lane. At the bridge they were met by about a dozen 'small children who cheered them'. This attracted the attention of Constable McCabe, who had 'a full view of them'. The Emergency men were met on the other side of the bridge by the two sub-constables and went on to Rawson's house and 'no violence whatever was offered to them beyond the cheering of the children'. McCabe added that on the night the Emergency men arrived he had six policemen on duty for their protection and that whenever assistance was required since then it was freely given. The sub-inspector's office subsequently stated that the Emergency men denied seeing any stones thrown and that the two sub-constables on duty on the bridge saw Mr Usher pass but did not see him interfered with, adding that 'at present the town is in a peaceable state'.[172]

Constable McCabe's account makes Mr Usher's story seem greatly exaggerated, but there is no reason to doubt that there was a hostile crowd attempting to intimidate the Emergency men in the field.

THE LAND WAR: SHOPKEEPERS IN COURT
FRIDAY 30 SEPTEMBER 1881

Baltinglass Courthouse was densely packed for the Petty Sessions on 30 September 1881. A number of the town's shopkeepers appeared on charges of having 'knowingly and unlawfully published a certain notice inciting or tending to incite an unlawful combination or confederacy'. They had displayed posters on their premises worded as follows:

A Patriotic Request – People of Wicklow, farmers, labourers, and artisans – Do not enter nor remain in any public house or store wherein you shall or may see Emergency men and such like suitably entertained – George O'Toole, Baltinglass.[173]

This notice was not just displayed by these shopkeepers, but distributed widely in the area.

In August 1881 the Prime Minister, William Gladstone, had succeeded in having the second Land Act passed, guaranteeing the 'Three Fs' – fair rent, fixity of tenure and freedom for the tenant to sell his interest. However, by then the Land League was intent on securing ownership for land occupiers and the agitation continued. At a meeting of the Baltinglass branch on Saturday 10 September it was agreed to display a placard the next morning with the above wording. A delegation called to various shopkeepers, demanding that they stop serving boycotted individuals. Baltinglass Fair took place on Monday 12 September, and cattle belonging to two local men, John Jackson of Kilmurry and Patrick Doyle of Edward Street, were boycotted because their sons acted as 'quasi-Emergency men'. As well as the 'Patriotic Request' notices being on display, two placards were carried around with the captions: 'Emergency cattle, who will buy them? God Save Ireland!' and 'The broken down Emergency men have made their appearance. Murder!'. The boycotted livestock belonging to one of the men remained unsold, while the other had his purchased late in the afternoon by a magistrate.[174]

On 19 September Melville Keay of Kiltegan received the 'Patriotic Request' notice through the post from Nicholas O'Brien of Chapel Hill, along with a covering letter. As well as being sub-postmaster in Kiltegan, Keay ran a bakery and shop. O'Brien's letter read as follows:

> Sir I being a Land Leaguer and an Irishman I am bound by the enclosed poster to not eat bread out of the same oven with emergency men therefore send me no more bread send me by post amount of Pass Book and I will send it to you –
> – yours &c:
> Nicholas O'Brien.[175]

A few days earlier the constabulary had seen the 'Patriotic Request' notice in Baltinglass shop windows. Presumably acting on advice from the Inspector General's office, they brought charges against at least eleven shopkeepers.[176]

At a meeting of the Land League in Dublin on 27 September, Charles Stewart Parnell displayed the notice which had appeared in Thomas Rickerby's window[177] in Baltinglass and said that the summons was 'an example of the intimidation resorted to by the Government, … which was calculated to bring the administration of the law in Ireland into contempt'. Parnell said that on his return to Avondale he would put the notice on his hall door, adding that 'he would like to see who would compel him to remove it'.[178]

At the Petty Sessions the Crown Solicitor claimed that the notice was 'inciting or tending to incite an unlawful combination or confederacy'. In the first case, that of Matthew Byrne,[179] the defence counsel argued that the notice could have been placed in Byrne's window without his knowledge by a servant or a passer-by. Counsel asserted that it was a lawful notice and that the only question was whether

it was 'inciting or tending to incite an unlawful combination or confederacy'. This he interpreted as tending to incite conspiracy, and a conspiracy involved people combining or acting together. The notice, on the other hand, 'appealed to individuals' not to patronise certain businesses. The notice 'contained a mere request and not a word of menace, threat or intimidation'.[180]

The magistrates retired to deliberate in their chamber. They were Edward A. Dennis of Eadstown Lodge (in the chair), Major Robert J. Pratt Saunders of Saundersgrove, James A. Wall, QC, of Knockrigg (County Court Judge), W.W. Fitzwilliam Hume Dick of Humewood, Abraham Coates of Parkmore House and another man erroneously reported as 'Mr. Nicholson'. On their return the chairman 'said that an important point of law had been raised, and without expressing any opinion one way or the other, thought the case ought to be sent for trial'. Byrne's case would, therefore, go to trial at the Wicklow Assizes. Coates then stated that he had dissented from that decision and said he felt the case should be dismissed. This provoked 'a tremendous outburst of cheering' from the gallery, 'again and again renewed'. Several times Dennis ordered the court to be cleared but it was so full that the police could do nothing.[181]

The next case was that of Matt Byrne's brother-in-law John Byrne,[182] who was a Poor Law Guardian. Two policemen stated that they had seen the notice in his window and had spoken to him about it, but had seen it there several times afterwards. Byrne commented 'Yes, and if you look at the window on your way back from court you will see it there still'. This predictably drew applause from the gallery. John Byrne was sent for trial, as was Denis Kehoe.[183] James Sheridan[184] of Main Street was also charged but the defence counsel argued that his case could not go forward for trial as the Crown had not shown any evidence that he 'even saw or heard of this placard, or that he was in the town of Baltinglass or the country when the placard appeared'. The magistrates dismissed this case and the Crown Solicitor then withdrew the charges against six other shopkeepers as the evidence against them was similarly unsound. They were Thomas Rickerby, M. Byrne,[185] Michael Maher,[186] and Messrs. Lennon, 'Hunter' and Flinter.[187] Anne O'Brien[188] was also charged. A policeman stated that he had spoken to her about the notice in her shop. However, a young man named Abbey came forward and swore that he had put the notice up and that Miss O'Brien knew nothing about it. Nevertheless, the magistrates returned her for trial.[189] The outcome of the Assizes has not been ascertained but it seems doubtful that the shopkeepers were found guilty.

THE LAND WAR: ARREST OF E.P. O'KELLY & GEORGE O'TOOLE
MONDAY 24 OCTOBER 1881

At three o'clock on the morning of 24 October 1881 the two leading officers of the Baltinglass Branch of the Land League, E.P. O'Kelly and George O'Toole,

were arrested under the Coercion Act.[190] Michael Davitt, Charles Stewart Parnell and the other main leaders of the movement had been imprisoned on 13 October. On 20 October the League had been proclaimed an unlawful association. All around the country the authorities were taking local activists into custody. O'Kelly and O'Toole were brought to prison in Dundalk.

Edward P. O'Kelly, who was known as E.P., was thirty-five years old and unmarried at the time of the arrests. He was an auctioneer and, in addition, he and his brother Michael ran the grocery and public house in Main Street established by their father. At some time, either before or after the height of the 'Land War', George O'Toole worked for Parnell at Avondale.[191] He was originally from Sruhaun. At the time he was thirty-six years old and unmarried.

It was exactly a year after the first big League meeting in Baltinglass that the men were imprisoned. During that year they had acted as president and secretary, respectively, of the branch. O'Kelly led most Baltinglass delegations to meetings in neighbouring towns and sometimes made speeches at them. On Sunday 9 October he chaired a public meeting in Kiltegan, to which there was a march from Baltinglass, with the speakers travelling in an omnibus.[192] The following week O'Kelly spoke at a League gathering in Dunlavin. Even before the Land League was proscribed the constabulary were considering arrests in the Baltinglass area. The Inspector General's office communicated to the Chief Secretary's office on 4 October regarding the proceedings of the Land League in Baltinglass, with recommendations for arrest. This was in follow up to communications in September concerning Land League action against W. George Burton and the boycotting of the Munster Bank. On 18 October the Inspector General's office wrote regarding the proposed arrest of O'Kelly.[193]

George O'Toole appears to have been more active that O'Kelly. A letter he wrote to the League headquarters a few days before his arrest gives some indication of his involvement:

Sir, – I beg to apply to executive for the consideration of the following claim. I have gone around the county of Wicklow on every urgent occasion that presented itself during the last six months, suggested all the various meetings, addressed them, attended all the sales in that and the neighbouring counties, managed the defence of the traversers at Wicklow Summer Assizes, attended frequently the Central League meetings for manifest purposes, and I am satisfied as a result that there is a perfect organization of the League in this country. I regret that my exertions may at any moment come to an end by arrest – a matter which gives little concern. I don't grudge my time, but I cannot afford to lose all my expenses, which I cannot estimate at less than £2 per week for about 20 weeks, which includes car hire, for which I will send you vouchers by next post. I also beg for the settlement of the lawyer's bill at the Wicklow Assizes furnished some time ago to Mr. Doriss, and acknowledged by him (number stated on the form). I can produce the guarantee letter of the office if it be required. Awaiting reply and settlement.

I am, Sir, respectfully yours,
George O'Toole.
To Mr. Harrison, Dublin office.[194]

O'Toole's name appeared in the reports of League meetings and court cases, and he addressed a League meeting in Dublin on 7 October.[195]

The loyalist community did not cower under the menace of Land League activity. A meeting was reportedly held at Knockanogue (sic), near Baltinglass on Friday 30 September for the purpose of forming an association of loyal inhabitants.[196] Presumably this was an exploratory meeting, as the first meeting of the West Wicklow Loyal Association took place at Humewood on Monday 3 October. This was chaired by W. W. Fitzwilliam Hume Dick, who had been MP for Wicklow from 1852 to 1880. Thirteen West Wicklow magistrates were present, as well as four Church of Ireland clergymen, including Rev. John Usher of Baltinglass. The others were gentlemen of the area. The attendance by no means represented all families of that class in the area, and there were no tenant farmers present. Captain Pennefather of Rathsallagh proposed and J. W. Mitchell of Ballinure seconded the following resolution, which was passed unanimously:

> That the attention of the Government be at once called to the insufficiency of the force of police, and to the total absence of any military, in the County of Wicklow, more especially in the town of Baltinglass and neighbourhood, which are now in such a seriously disturbed state.[197]

Commenting on this demand, on 11 October the County Inspector of the RIC stated that the county was indeed 'very much disturbed', 'particularly about Baltinglass, Coolkenno and the borders of Co. Carlow and Wexford'. The police force had been temporarily diminished because of the transfer of men to Cork and Kilkenny, and the deployment of forty-six men in Arklow due to disturbances there. He immediately transferred one policeman to Baltinglass and promised two more as soon as they could be released from Arklow. This would bring the Baltinglass force to six men above its fixed strength, which was five. Two days later the County Inspector stated that, as he could spare no more policemen, the allocation of a party of military would be advisable, and he suggested that they be accommodated in the Bridewell. On enquiry it was found that there was no suitable place in Baltinglass to accommodate a detachment. The Bridewell would only hold about forty men. A 'good house'[198] within 400 yards from the Bridewell would hold about sixty. However, the owner, Robert Anderson, said he would let it to an officer and family but not for the use of the military unless they took it permanently, as he would find it difficult to sell it afterwards. It was, therefore, decided not to send a military detachment to the town.[199]

What became of Richard Rawson's Emergency men is unclear as, on Tuesday 11 October, 'a large body of farmers from an adjoining part' accompanied by 'a large

party of police' came to save Rawson's crops. The exercise was at the suggestion of Rev. T.C. O'Connor, Rector of Donoughmore, 'as part of an organized movement to defeat the Land League in the district'. Later that month, following the intimidation of a tenant in the Glen of Imaal, a meeting of the Donard and Donoughmore Protection Society was held and a night patrol of farmers was set up. Then, on Wednesday 26 October, two days after the arrest of O'Kelly and O'Toole, a loyalist meeting was held in Kiltegan, with Hume Dick in the chair. There was reportedly a large attendance of tenant farmers, 'chiefly, but not exclusively Protestants'.[200]

On Tuesday 25 October, the day after the arrests, Katherine Rawson, daughter of the boycotted Richard Rawson, went into Webbs' in Mill Street[201] to buy sweets. While the shop assistant, Henry Thompson, was making up a parcel Mary Doherty[202] rushed into the shop. She grabbed the parcel, saying 'Are you going to give anything to that one? She'll never put a tooth in it. It's she and the likes of her got Mr. Kelly and the others into jail.' When Thompson pointed out to her that she was leaving herself open to prosecution, Mrs. Doherty threw the sweets on the counter and turned, with her hands on her hips, to face the other woman. She used threatening language and Miss Rawson thought she might be assaulted. She went to the police barracks and reported the incident. Mrs. Doherty was charged with intimidation.[203]

This minor incident was the beginning of a nightmare period for Herbert Webb, the proprietor of the shop. As a Quaker, Webb's beliefs would not allow him to refuse any customer even if he felt the Land League's cause was justified. A few days earlier he had received a visit from George O'Toole, warning him that he would be boycotted if he continued to serve certain customers, 'pointing out plainly to him that his large trade would probably be ruined by being lost to him'. According to O'Toole, Webb said that he was 'all through a sympathiser in the cause and struggles of the tenant farmers as far as to obtain good land laws, but that his religious feeling would not permit him to turn away his "customers and refuse them"'. O'Toole asked him to write a letter to this effect, which he did, and O'Toole showed it around. When O'Toole and O'Kelly were being arrested some people blamed it on Webb, but O'Toole said that the warrants were dated 'some days prior to the time of my interview with Mr. Webb'.[204]

Webb's business was boycotted. The police believed this was 'for not putting up his window shutters' on the day of the arrests. Six weeks into the boycott Webb himself stated: 'On several occasions I have refused to boycott any of my customers & am now suffering the consequences'. He added, 'Fortunately for me a good deal of my business is wholesale & greater part of my customers in the neighbouring towns have continued to deal with me. At present I believe I am loosing at the rate of £200 pr annum by being boycotted but am willing to suffer in a good cause if the government would keep a sufficient force in this town to preserve order & prevent any danger of the houses being sacked by the mob.'[205]

Those who supported the Land League were not entirely in concord. James McCoan, the MP for Wicklow, and George O'Toole probably represented the

two extremes of opinion within the movement. Writing from Dundalk Gaol on 2 November, O'Toole made this public attack on his colleague:

> I beg to inform my numerous sympathisers that Mr. M'Coan, M.P., has written to one of his constituents at Baltinglass justifying my arrest and imprisonment – 'O'Toole has long been qualifying for his present position.' This is cheering nearer home than Guildhall.[206]

During November O'Kelly asked for a transfer to Kilmainham. A few days later his brother Michael died following an accident. Despite the tragedy, O'Kelly was not released, but soon after he was transferred to Kilmainham, where he remained till February. O'Toole also sought a transfer to Kilmainham. Apparently he was refused, as he was still in Dundalk in March 1882 when a parliamentary question regarding his case was raised by William Corbet, another MP for Wicklow. O'Toole had then been in prison for nearly five months and had asked for parole in order to sow crops, he having 'no male relative or friend to manage his affairs'. The reply was that there was no objection to parole so long as he did not make his return home 'the occasion of any demonstration, and that he would strictly confine himself to his business'.[207]

In early December 1881 Baltinglass showed signs of being out of control. At about 10.30 on the night of Saturday 3 December Sub-Constables Chapman and Fitzgerald while patrolling the street came on Joseph Valentine who was drunk, with his coat off and shouting for someone to fight him. They sent for back up from the barracks and Valentine was overcome by a force of five policemen. Roused by Jude Valentine, the prisoner's mother, a crowd gathered and began shouting, encouraging the prisoner to become violent. The policemen brought him to the barracks, pursued by the crowd, and they were attacked a number of times. As they passed his house, Herbert Webb looked out on the scene and observed four constables dragging Valentine by the feet, with a fifth keeping a large crowd at bay with his drawn sword. As the police reached the safety of the barracks the crowd threw stones and bottles at them. A mob then gathered around Webb's house and threw stones at it for half an hour, breaking three large panes of glass. They remained another half hour, yelling and hooting, before dispersing. The incident may not have been related to the Land War, but the mob vented their anger on a boycotted premises.[208]

The Coercion Act had the effect of drawing recruits for the IRB and its ranks swelled.[209] In the early hours of Tuesday 6 December there was another arrest under the Coercion Act in Baltinglass. John Wyse Power, a journalist from Waterford, had been in the town for some days before his arrest. This was the man who had visited Rathvilly three years earlier in order to recruit key members for the IRB. Though it was stated that he was in Baltinglass on Land League business, it seems more likely that he was really working for the IRB. The blowing of a horn by the driver of the post car alerted the people to his arrest and a mob

gathered. Webb had another window broken, while the Munster Bank also had one smashed. Both Webb and the bank manager, Burton, wrote requesting that a resident magistrate be stationed at Baltinglass. Webb stated: 'The two serjeants we now have are good men but it is no light matter to disperse a mob at a time like the present as it is possible they may injure some one & may be tried for it.'[210] Ten months earlier Nicholas O'Brien had commented that the League had not been disgraced by any outrages. This could no longer be claimed, as intimidation and violence had most certainly taken the place of peaceful resistance in the town.

It must be remembered that it was not a straightforward case of greedy land-lords and righteous Land Leaguers. The moderate Leaguers said quite plainly at some of their public meetings that there were good landlords and that they were not looking to take away the landlords' rights. The League's aspirations should have been attractive to all tenant farmers, regardless of their religious background. However, the movement for land reform was intrinsically linked with national-ism, which was a cause of more than suspicion to most Protestants at that time. The illegal intimidation practised by some supporters of land reform must have been a cause of great anxiety to many Protestants and to those Catholics who did not subscribe to the views of the majority. More legitimate tactics such as boycott-ing employed by Land Leaguers were almost as intimidating. The only dissenting Catholics who were spared the ire of the majority were priests, such as Dr. Kane, the Baltinglass Parish Priest.

While the Land League had become a proscribed organisation, the Ladies' Land League, founded at the end of January 1881, still continued its activities. This was in essence a support group for the League, but it was historically significant as the first political movement in Ireland entirely run by women. The Baltinglass branch of the Ladies' Land League was formed in February or early March 1881.[211] At a meeting in July a resolution was proposed by Miss Lynch and seconded by Miss Rickerby thanking the ladies of Timolin for agreeing to join the Baltinglass branch. Placards relating to the Ladies' League were posted in the town in the autumn.[212]

Jennie O'Toole of Dublin, a native of Baltinglass, was on the executive of the national organisation by August 1881. She had been born in Main Street[213] in May 1858, two years before her family moved to the city. In November 1881 she came to the Baltinglass area reportedly to take charge of relief during a threatened eviction in Hacketstown. On 17 November she chaired a meeting of the Baltinglass branch at which they ejected one of their officers for a breach of their pledge 'to abstain from dealing with certain objectionable towns-people'. It would appear that the offender had been vice-president, as Mrs. Keogh of 'Tinoran' (actually Anne Keogh *neé* McDonnell of Oldtown) was then unanimously elected to that position. During the time O'Kelly, O'Toole and the other 'Suspects', as they became known, were in prison, the ladies col-lected books to send to them. They also collected money and co-ordinated relief work.[214]

John Wyse Power's visit to Baltinglass more or less coincided with that of Jennie O'Toole. A year and a half later, at the end of June 1883, Power became editor of the *Leinster Leader* and the following week he and Jennie O'Toole were married. Jennie Wyse Power was to spend a lifetime in Dublin political circles. In 1899 she started a restaurant in Henry Street, which became a well known meeting place for nationalists, and the 1916 proclamation was signed on the premises. She served in various public offices from 1902 and becoming a member of the Senate in 1922.[215]

On Friday 24 February 1882, after four months in detention, E.P. O'Kelly was released from Kilmainham. In anticipation of his arrival by coach via Dunlavin the following Monday evening, houses in Dunlavin, Grangecon, Stratford and Baltinglass were lit up, but he reached Baltinglass unobserved about three o'clock the next morning. Later that morning his supporters arrived to congratulate him. The *Leinster Leader* reported that 'The Cryhelp band played round the town, and the houses without an exception of those whose sympathy he shared were brilliantly lit up' adding, 'There was not a cabin on the wayside from Dunlavin to Baltinglass wherein an illumination was not displayed, as testimony to the lasting good feeling of the peasantry of the neighbourhood towards one who was willing to suffer, and who had suffered for their sake'.[216]

THE LAND WAR: INAUGURAL MEETING OF THE LABOUR LEAGUE
SUNDAY 28 MAY 1882

By May 1882 a certain amount had been achieved by the movement for land reform. Gladstone's second Land Act in August 1881 had secured the 'Three Fs' and early in 1882 the Kilmainham Treaty had been agreed between Parnell and Gladstone. The leaders of the Land League were released from prison and further land reform was promised. However, the murder by the Invincibles of the new chief secretary and his under secretary in the Phoenix Park on 6 May 1882 lead to another coercion act being passed in July. Nevertheless, the promised reforms came with the passing of the Arrears of Rent Act and the Labourers' Cottages and Allotments Act, both on 18 August.

Back in May, when these developments were merely anticipated, there was a move to mobilise the agricultural labourers who had supported the land movement. A number of meetings were held in late May and early June in the general area of south Leinster, organised by a new group called the Labour League, encouraging labourers to demand their share of the improvements from the farmers. On 28 May what was described in the press as 'the first public open air meeting, held under the auspices of the Labour League' took place in Baltinglass, though there was a gathering on the same day in Barntown in County Wexford.[217]

Large green placards had been posted around Baltinglass advertising the meeting for two p.m. on that Sunday, but it did not begin till after three o'clock, when a deputation arrived from Hollywood, accompanied by the ever present Cryhelp Brass Band. The meeting was chaired by the 'ex-suspect' George O'Toole.

No banners were carried, but laurel leaves were worn in the hats and caps of the chief number of those who took part in the demonstration, and the drag from which the speakers addressed the people was decorated with evergreens. ... though the proceedings were throughout of an extremely enthusiastic character, the attendance was not quite so large as might have been expected upon an occasion which witnessed the inaugural demonstration of a new departure in the history of the land struggle.[218]

O'Toole reminded those present of the public meeting held in Baltinglass in February 1881, when coercion was being introduced, and said that they were now in the shadow of 'another and more terrible threatened crash of coercion'. Referring to the proposed land reforms, he added that the government 'has given in intention one half acre of land and money to build a comfortable cottage out of every 25 acres of all Ireland to the labourer. And it is to obtain the effect of this intention of the Legislature this Labour League has now been called forth, to compel, by all manner of moral influences and pressure that can legitimately be applied, to the farmers of Ireland to give us a portion of the land on the conditions which we won it for them.'[219]

In proposing a resolution, Laurence McGrath stated that the farmers had done very little for the labourers and that Parnell had promised that if the farmers did not help the labour movement he would head it himself. He added that now that the Land League had succeeded in 'bringing down landlordism' the labourers were worse off than ever before. During his address George O'Toole suggested that Baltinglass might become as famous for this meeting as Irishtown had become for the meeting held there by the Land League.[220] The Baltinglass meeting took place some nine years before the Irish Labour League was formed and the first Irish Trade Union Congress did not take place till 1894.

While political conditions were changing in the early months of 1882, the Ladies' Land League were continuing their work. Anne Keogh chaired a meeting of the Ladies' Land League Baltinglass branch on 5 March at which it was reported that the central executive acknowledged receipt of £2-12-9 collected by the branch in boxes and £2 collected in America by Miss Jane Byrne and forwarded through the branch.[221] At a meeting of the branch on 7 May, again chaired by Mrs. Keogh, a resolution was passed congratulating Parnell, John Dillon and James J. O'Kelly on their release from Kilmainham the previous Tuesday.[222] On 6 May Davitt was released from Portland. The *Leinster Leader* of Saturday 13 May reported the following:

Demonstration at Baltinglass
On Friday[223] night a splendid demonstration came off in Baltinglass in honour of the release of Mr. Michael Davitt. The Cryhelp Brass Band came into town about nine o'clock, and was received by the townspeople with great cheering. The whole assembly formed into procession which was led by torch lights, while the music of the band was frequently drowned by hearty cheering for Parnell, Dillon, Davitt,

&c. The houses were tastefully illuminated. Two large bonfires blazed in the streets, whilst a third blazed on the hill over the town.

The accounts of the Ladies' League meeting and the Davitt rally make no reference to the people's reaction to the news of the Phoenix Park murders that same weekend. However, news of the killings would not have reached Baltinglass before Sunday 7 May. There is no doubt that the brutal murders had a major impact on public opinion. The Invincibles, who executed the crime, were a clandestine group within the IRB. The murders caused great damage to the secret society. In his memoirs Edward O'Toole of Rathvilly, who had by that time become head centre of the IRB for Co. Carlow, wrote:

> The supreme council of the I.R.B. issued a statement denying responsibility for the assassinations and repudiating the 'inner circle'. From that time my association with the I.R.B. ceased and the influence of the organisation itself seemed to have become very feeble if it did not die out altogether.[224]

A meeting in Baltinglass, chaired by Rev. John Usher and attended by the most prominent Protestant parishioners, passed a resolution condemning the murders. On the Tuesday the Baltinglass Poor Law Guardians also passed a resolution.[225]

The Baltinglass branch of the Labour League was still in operation two months after the initial meeting, as it held a gathering on Saturday 22 July. On Sunday 8 October 1884 George O'Toole spoke at the first Labour League meeting in County Carlow. It was held in Rathvilly, with one of its objectives being to establish a branch there. A large number of farmers were present and the common cause of the farmer and the labourer was highlighted. O'Toole spoke in support of the following motion:

> That we recognise that one of the principal causes of the wretched condition of the labourers has been the denial of a vote at elections, to enable him to compel attention to his grievances, and in order that he may have a vote in the representation of the country we demand that he be entrusted with the franchise.

He said that there was '…an inclination on the part of the labourers to discredit the generosity and the patriotism of the farmers'. He said that he spoke as a member of the executive of the Labour League, and added that in Baltinglass that season the farmers who had no mowing machines had not hired machines, but instead had engaged men to do the work, 'and no one was left idle at the corners of the streets'.[226]

George O'Toole disappeared from the local political scene during the 1880s. In 1883 he married Kate Lynch, the daughter of John Lynch of Lynch's Hotel. According to family sources, though he remained a staunch Parnellite after the split in the Irish Party over the Kitty O'Shea divorce case, he emigrated to the U.S.A. and

settled in New York.[227] He died there in the 1890s, in an accident, and his widow was forced to return to Ireland with their only surviving child. She kept a shop and boarding house in Mill Street, the house in which Richard Rawson's Emergency men had stayed back in 1881. In later years George O'Toole's daughter Kitty married E.P. O'Kelly's son Ned.

THE LAND WAR: MR. USHER FIRES SHOTS ON THE STREET
SATURDAY 26 AUGUST 1882

Rev. John Usher found himself before the magistrates at the Petty Sessions after discharging his revolver on the public street in Baltinglass. Already a controversial figure in the town, Mr. Usher clearly saw it as his duty to meet nationalist intimidation with vigour. Long before the quarrel on Baltinglass Bridge which led to his firing shots, he had experienced his share of altercations.

John Usher became Rector of Baltinglass in 1876 when Rev. William Norton retired. At the time there was no rectory in the town, so he moved into the house in Mill Street vacated by his predecessor. He had a tricycle for travelling about. The adult tricycle was then considered to give more dignity to people such as clergymen and doctors than a bicycle would afford. In October 1880, as the Land War hostilities were beginning in Baltinglass, he was returning home on his tricycle when he was waylaid near the corner of Lynch's Hotel. Four men obstructed his path while one of them tried to overturn the vehicle. Being near the constabulary barracks, he jumped off and shouted 'Police'. His attackers immediately ran down the right-of-way[228] to the river.[229]

The following year he and his son, John George Usher, involved themselves in the plight of Rawson's Emergency men, and he found himself in dispute with Constable McCabe, who contradicted his account of events. Then in August 1882 he wrote a lengthy letter to the *Daily Express* in which he gave his view of conditions in the Baltinglass area, saying 'we are in almost, if not altogether, as bad a condition as what we were last year, when mob law was the order of the day...'. He cited individual cases, pointing out that Patrick Doyle of Edward Street, John Jackson of Kilmurry, Richard Rawson and Herbert Webb were all still being boycotted. He further said that Doyle's family 'have to depend very much upon the kindly efforts of their Protestant neighbours to get them the common necessities of life. Thus, for instance, they would not be allowed to buy the potatoes and cabbages sold in the market, and some of the vendors of these articles of food had to go to the Dunlavin and Carlow markets for disobeying the orders of the Land League to refuse their goods to the Doyles. When Mr. Doyle goes to buy or sell his cattle at any of the neighbouring fairs, he is strictly and closely watched, and his Protestant neighbours or fast and intimate friends have to come to his rescue.' Doyle had been subjected to this treatment since at least September 1881. In February 1882 a notice was posted up in Baltinglass with an apology from a P. Kinsella for having transported goods for him.[230]

Usher also claimed that on the previous fair day, Friday 18 August, John Jackson junior of Kilmurry was crossing the bridge when 'a man, who deliberately walked up, and, without the slightest provocation, struck him a severe blow in the eye and another on the head, and was about continuing the attack, when Mr. Jackson had to draw his revolver in self-defence.' Jackson certainly was assaulted on the bridge, as his attacker, Denis Murphy, was given two week's hard labour in Naas Gaol. On the night of his release an effigy of Jackson was burned in the street and Murphy was escorted home by a crowd.[231]

Usher also referred to the intimidation of Peter Kehoe of Clogh, who was one of those who attended the first Baltinglass Land League meeting almost two years before. As well as being one of the area's more prosperous farmers, he was also a small-time landlord. Usher stated that Kehoe had had to evict a tenant for non-payment of rent. Then a leading Land Leaguer from the town, 'taking advantage of Mr Keogh's (sic) temporary absence from home, called upon Mrs Keogh, who became so frightened and alarmed by what this man said that, to use Mr Keogh's own words, "my wife, who has money in her own right, and over which I have no control, sooner than have me shot, paid £100 to satisfy the demands of the party."'[232]

Needless to remark, Usher himself was boycotted, and when he looked for a labourer to work for him, he stated 'some said, 'Do you want us to be shot?' while others said they would be simply ruined if they came to work for me' He recounted another incident concerning a Protestant from another town who took a lease of a house in Baltinglass in order to set up a bakery. On the day he came to finalise the deal, 'he was set upon by a mob, who pelted him with stones, used threatening language, and told him he had no business coming there; whereupon he became so frightened that he at once abandoned the idea of taking the house, and quitted the town as quickly as possible.' Usher said that there were individuals who carried unlicensed arms, and that while the police presence had been increased the extra men had since been transferred so that the force was 'now so small as to be almost useless for anything beyond the protection of their own barracks.' He further claimed that some time before this a petition had been sent from the loyalists of the area asking for an increase of the constabulary. The petition was returned and 'came into the hands of parties who had the names of all the memorialists published, and some of them abused in the streets for having signed it.'[233]

His description of those who collected about Webb's corner sets the scene for the drama involving him just a few days later:

As formerly, the roughs crowd the footpaths and corners, especially at the end of Mr Webb's establishment, which is the only thoroughfare from one side of the town to the other, and here, as a rule, the loyal people in the evenings have to walk into the centre of the street, no matter how dirty it may be, to the great delight of the rabble. Those who have the courage to try and pass through the blocked up pathway have mouthfuls of filthy tobacco smoke puffed deliberately into their faces, and have to quietly listen to some insulting remarks.'[234]

The facts of what happened on the night of Saturday 26 August 1882 are as follows. Mr. Usher had a revolver, which he claimed was necessary as he had been frequently attacked. That night he and his son walked over the bridge and up the town. On their return towards Mill Street they again crossed the bridge about ten-fifteen p.m. Just short of Webb's corner there were about six men on the footpath. Rev. John Usher had an altercation with a young man called Martin Flinter. Usher caught hold of him and pulled him down to Webb's corner, apparently intending to bring him to the constabulary barracks. Usher's son went to the barracks to alert the police. A man named Henry Fennell approached Usher, who struck Fennell with his umbrella. Flinter ran past Peter Ellard's[235] and down Edward Street. Usher followed him. Flinter went down a lane towards Byrne's old forge[236] and Usher pursued him. Sometime while running down Edward Street or when he was in the lane Usher fired a shot. In the lane he fired at least one more time. His son then arrived in the lane, followed by two sub-constables, Carty and Mason.[237]

Usher was charged with assaulting Flinter and Fennell and with discharging a revolver at Flinter, while Flinter and Fennell were charged with assaulting him. At the Petty Sessions Dr. Toomey, who represented Usher, requested that all witnesses except the police should leave the court while evidence was being given by others, and this was agreed. When being cross examined, Mr. Usher said he had pursued Flinter so as to make no mistake about his identity, adding, 'I did that, knowing that the mob in Baltinglass would swear anything, and would swear he was not there at all.' Counsel asked, 'Do you, a reverend gentleman, deliberately swear that the people of this town would perjure themselves?' Usher replied, 'I do believe that there are parties in Baltinglass who would not only perjure themselves, but are ready to commit murder. I have been threatened several times.'[238]

Predictably, there were varying accounts of the incident. The following is broadly what is to be gleaned from the evidence of Flinter, Fennell, Patrick Byrne, James Murphy, Patrick Murphy and Margaret Styles. Martin Flinter was on his way home and was on the bridge for about five minutes before the Ushers came. He was on the footpath with James Murphy. There were other men, including Patrick Byrne, about eight yards from them, nearer to Webb's corner. The Ushers had plenty of room to pass but Mr. Usher push up against Martin Flinter and Flinter push back. Usher said (according to Flinter), 'Is the footpath to be taken up by puppies like you?' or (according to Byrne), 'Is the path to be kept up by the like of you, and am I to be insulted in this manner?' Mr. Usher grabbed Flinter, saying 'Flinter I know you' and pulled him towards the constabulary barracks. Usher's son then went for the police. Henry Fennell approached and said 'What's this about?' Without further ado Usher struck him with his umbrella. According to Fennell, the blow left a wound on his lip which the doctor said 'placed his life in danger'. Martin Flinter ran. Usher followed and, according to Flinter, he took out his revolver at Ellards'. They ran down Edward Street, Flinter running past Patrick Murphy. Flinter was at Mrs. Byrne's when Usher shouted 'Now I have you' and

fired a shot at him. According to Margaret Styles, Flinter was 'fornenst' the lane at this point and, as Patrick Murphy put it, Flinter 'wheeled' down the lane.[239]

According to the evidence of Rev. Mr. Usher and his son, the following is what happened. As they crossed the bridge there was a group of men ahead of them on the footpath. The men separated slightly to let them pass. As he walked through them, someone spat at the father and then a hat was thrown at him. As Flinter was no longer wearing his hat the Ushers concluded that he had thrown it. The father went back and grabbed Flinter by the shoulder to get a look at his face. The clergyman said (according to himself) 'Flinter, you need not try to conceal yourself; I know you very well, and I won't leave you till the police come up. I'll teach you a lesson that you won't insult people in this way' or (according to his son) 'You might allow people to pass without insulting them. I know you, Martin Flinter'. The father brought Flinter towards Webb's corner. The crowd became hostile and Usher junior went down Mill Street to the police barracks for assistance. Someone shouted 'now is the time to pay him off'. A man rushed at the clergyman and he lifted his umbrella to protect himself but it hit the man on the mouth. Flinter and some others ran towards Edward Street and Usher followed. Flinter and another man turned down the lane and Usher pursued them. The two men separated. Usher realised he was isolated so he fired a shot in the air to let the police know where he was. Flinter threw a bottle at him and he fired another shot in the air. Just then his son arrived on the scene. Flinter and the other man ran away.[240]

Michael Wall also witnessed the altercation on the bridge. He stated that after Usher junior ran for the police several men made a rush at the clergyman who made a blow with his umbrella to keep them off and someone said 'now is the time to pay him off'. Wall was what was loosely termed an Emergency man. He later got into trouble with the police and left the area. On his return he and others signed an apology for their 'emergency' actions. Printed copies were posted up around the town and the neighbouring area. They read:

Notice. – We are sorry for all the blackguardism we have committed on the Roman Catholics of Baltinglass, under the direction of the Emergency Society. We have separated from them, and ask the people to take us back to their society.

The magistrates refused to commit Mr. Usher for trial on a charge of firing a revolver in the public street, but he was fined five shillings for assaulting Henry Fennell. Martin Flinter was also fined five shillings for assaulting Mr. Usher.[241]

A few weeks later Martin Flinter went to gaol for another incident. The boycotted Patrick Doyle was being persecuted by the Land Leaguers to the extent that when he tried to sell a heifer at the fair in Tullow, Johnny Prendergast followed him and prevented him from doing business. Prendergast was summoned for intimidation. Flinter went to Doyle's house before Prendergast's court case and

threatened him. He was caught in the act by the police and he received a month with hard labour in Naas Prison.[242]

Though Richard Rawson was about 80 years old while he was being boycotted, he was by no means too aged for a fight. Along with Rev. John Usher he was the Land Leaguers' fiercest opponent in Baltinglass. In 1881 he had Christopher Flinter and John Lynch junior (of the hotel) bound to the peace for twelve months for harassment, and in 1882 he had Edward Flinter bound to the peace for six months for assault, on both occasions conducting his own case. During a Petty Sessions hearing in Baltinglass Courthouse in March 1883 Rawson interrupted the proceedings and 'said, amongst other things, "that he had made a slaughter upon some of the Land League, and would make it on others of them before long. The Land Leaguers might say their prayers now, as their master was angry"'. This has to be taken with some scepticism as the source is the heavily nationalist *Leinster Leader*. In June 1883 Rawson made a complaint about the conduct of Abraham Coates of Parkmore House, in his capacity as magistrate, and requested that the Resident Magistrate attend the next Baltinglass Petty Sessions when the relevant case would be resumed. Rawson claimed that Coates, who disagreed with the other magistrates on the case, was biased and that he frequented E.P. O'Kelly's public house. He claimed that when he challenged Coates's view he called him 'an impertinent old blackguard' and added that he would 'blacken his eye'. Richard Rawson died in Dublin on 26 February 1885.[243]

By the end of 1882 the bank manager, W. George Burton, was still being boycotted. On 29 December 1882 a boy working for him went to buy potatoes in the market. Having got the price from a farmer called John Corrigan and having agreed to buy, he went back to the bank to tell Burton. On his return a few minutes later he was told that the potatoes were sold. In the meantime Corrigan had been told by Matthew Byrne that Burton was boycotted and that if he sold him potatoes he too would be boycotted. Matt Byrne, the man charged with displaying the notice in his shop window back in September 1881, was jailed for two months for forcing Corrigan to refuse Burton's custom. During his detention a placard was posted in the town requesting that his custom be doubled while he was in gaol. On Sunday 1 April 1883 he returned home from Naas Prison, with the Cryhelp Brass Band meeting him in Dunlavin and a reported fifty car loads of well-wishers to accompany him to Baltinglass. By the time they reached Whitestown there were a hundred cars in the procession, with eleven banners being carried. On reaching Baltinglass they 'paraded the streets for two hours'. A few weeks earlier, on Christopher Flinter's release from Naas after serving six weeks for intimidating the Brereton family of Weavers' Square, there were bonfires and celebrations on the streets.[244]

While the bitterest period of the Land Wars was up to about 1883, agitation continued for a few years. As a successor to the Land League on 17 October 1882 the Irish National League was founded in Dublin. A branch was formed in Baltinglass and on 19 November E.P. O'Kelly chaired a public meeting in the town. By order of the magistrates the public houses were closed. Dr Kane died in July 1883 and

his successor as Parish Priest was Father Arnold Wall. By October he was involving himself in the local National League branch. He became its president, and his curates were also involved. The branch was in existence until at least December 1887.[245] It has been said that the dispute during the Land War irreparably damaged Baltinglass as a trading town.[246] The dispute must have left scars of resentment behind, just as the 1950-1951 post office affair did generations later.

MAJOR FLOOD HITS BALTINGLASS [247]
SATURDAY 17 FEBRUARY 1883

Baltinglass experienced very heavy rain and wind on the night of Friday 16 February 1883 and throughout of next day, resulting in the river rising about eight feet and flooding an extended area in the vicinity. Within the town, properties in Church Lane, Edward Street and Mill Street were the worst hit. At the time it was said that it was the most severe flooding of the town since 1821.

The sudden rise of the river stopped work in the mill, then operated by Peter P. Morrin, and in the course of the flood a large amount of flour was destroyed. The properties close to the bridge suffered much damage. The main ones were Herbert Webb's 'extensive stores'[248], John Clarke's[249] (where stock stored on the ground floor was ruined) and Michael Harte's public house[250]. St. Kevin's, then owned by Robert H. Anderson, and most of the houses in Church Lane were completely flooded.

Many of the streets and surrounding roads were impassable in places. Some sheep were lost in the flood, while cattle in fields in the area of the river had to be moved swiftly to higher ground. Several trees fell and were carried away in the waters. During Saturday the safety of the century-old bridge was in question for some time. Luckily it was undamaged and there was no loss of life.

CLOSURE OF THE BALTINGLASS BRIDEWELL
SATURDAY 30 JUNE 1883

Baltinglass had a Bridewell or gaol as early as 1798, when a number of the rebels were held in it. That gaol, as well as the then courthouse, was situated beside the bridge in Mill Street. The building remained there as a shop until the 1860s when it was replaced by the building currently occupying the site, Gillespies' (formerly Webbs'). In about 1810 the present courthouse was begun, and with it the new District Bridewell. It was to remain in that location until its closure in 1883.

As early as the late 1830s it was in a dilapidated state and a report suggested that it be discontinued. Instead, some effort went into repairing it. Despite that, the site was regarded as a bad one and it was suggested that a new prison might be built elsewhere. It had ten cells, three day rooms and three small yards. There was no occupation for the pauper prisoners, the thread-wheel being out of order, and there was an ongoing problem with the clogged sewers.[251]

According to Tom Doran, the first keeper of the gaol was 'Old Coddy Cope' and his son was keeper after him, while the last man in the position was called Fitzpatrick. Thomas Cope was the keeper according to *Slater's Directory of Ireland*, 1846. From 1880 prisoners for trial or convicted at Quarter Sessions at Baltinglass, or sentenced to more than seven days at Petty Sessions were sent to Naas Prison. In the year from 1 April 1882 to 31 March 1883 there were only three prisoners committed to Baltinglass Bridewell, one male and two female, all on remand. The then keeper, Timothy Fitzpatrick, was paid an annual salary of £45, with a fuel allowance of £12 for himself and the prisoners. At that time it was in very poor repair, with water leaking from a toilet in the Courthouse.[252]

The Prisons Board saw no point in retaining it as a gaol. It was offered to the RIC as a police barracks or a detention area but they regarded it as unsuitable. It was therefore surrendered to the Grand Jury. A warrant for its discontinuance was published in the *Dublin Gazette* stating that from 30 June 1883 all prisoners sentenced at Baltinglass Petty Sessions to terms not exceeding seven days would be sent to Carlow Prison.[253]

Having been a gaol for some seventy years, the building began a long period of varied usage, being a temporary school, a community hall, a makeshift shop, a private dance hall, a cinema, a grain store, a badminton hall, a heritage centre and, in the early twenty-first century, a library.

CRICKET AT ALLEN DALE
SATURDAY 5 JULY 1884

In the late Victorian period leisure activities such as participation sports developed throughout Ireland, as they did in other parts of the then United Kingdom. Athletics, cricket, golf, rugby and tennis all became popular during the 1880s, and within Ireland the Gaelic Athletic Association was founded in 1884. Baltinglass very much followed the trend. Before the revival of horse racing and the introduction of athletics in 1885, the town already had a cricket club and a rugby club, and Gaelic football was soon to follow.

The lands of Allen Dale House in Lathaleere had been used for horse racing back in the eighteenth century. In the 1880s they became the centre of sporting activities of various kinds, beginning with cricket. Allen Dale was originally owned by the Allen family but by the mid-nineteenth century it had passed to the Hendys. In the 1880s it was the property of Alice Hargrove, *née* Hendy, and she evidently gave permission to Baltinglass Cricket Club to use part of the land as its grounds. The area in which cricket was played would appear to be the large flat field later used for hockey. This is on the east side of the Redwells Road, its gate being opposite McKeevers' house.[254]

When exactly the cricket club came into existence has not been established, but it would appear that it was the first sports club in Baltinglass, and for a period cricket had a strong presence in the town. The earliest reference to Baltinglass

Cricket Club found in researching this book was to a match against Narraghmore played at Baltinglass on Saturday 5 July 1884, which was won by the visitors. The Baltinglass players were William Browner[255], P. Byrne, J. Dooley, M. Doyle, C. Flinter, J. Geoghegan, Nicholas Hanrahan[256], H. Heydon, W. Kehoe, W. Lusk and W. Prendergast. 'The home team entertained their County Kildare friends in a most hospitable manner, and altogether a most enjoyable day was spent. The umpires, Mr. E.P. O'Kelly and Mr. E. Kelly discharged their duties with satisfaction to all.'[257]

Baltinglass won a match against Ballylinan, played in Ballylinan in August 1884. The members of the Baltinglass team were W. Browner, P. Byrne, J. Dooley, M. Doyle, C. Flinter, N. Hanrahan, J. Harding, H. Heydon, W. Kehoe, T. Lalor and W. Lusk.[258] It would seem that the same people who promoted cricket in Baltinglass were responsible for the introduction of rugby and athletics, as many of the same names crop up in the published results of all three. Baltinglass Cricket Club may in fact have been envisaged as a general sports organisation. Certainly in May 1886 the rugby club was referred to as 'the Football section in connection with the [Cricket] club'.[259] In September 1885 the first athletics day held in Baltinglass took place at the cricket club's grounds. Those who competed in the section confined to members of the club were William Browner, James Byrne, M. Cooke, A.R. Dagg, J. Ralph Dagg, Nicholas Hanrahan, T. Lalor, W. Lusk and W. Prendergast.[260]

Allen Dale was the scene of a match between 'Baltinglass District' and Athy on Wednesday 16 September 1885. The home team members were George Burton[261], G.C. Crampton, J.H. Grogan, W.E. Grogan, P. Horan, W. Keys, J. Malone, H.W. Maltby, Peter P. Morrin[262], S. Riley, the captain, and John Shanahan[263].[264] The officers of Baltinglass Cricket Club selected for the 1886 season were M. Doyle as President, William Browner as Captain, Michael Cooke as Secretary, and Ralph Dagg as Treasurer, while the committee members were Messrs. Hurley, Byrne, McMahon, Hanrahan and Cooke. There were then thirty-six members in the club. The only reference found to a match that season was to one against the Royal Dublin Fusiliers stationed at Naas. It was played in Baltinglass on Saturday 19 June and the home team consisted of William Browner, M. Byrne, W. Charles, W. Curham, Ralph Dagg, P. Heydon, P.M. Kay, the captain, T. Lalor, W. Lusk, L. Miley and E.P. O'Kelly.[265]

During the summer of 1887 Baltinglass crickets were very active, and of the six matches reported in the local newspapers they won four. Their opponents were the Royal Dublin Fusiliers at Naas, Staplestown at home and away, Belan away, and the City of Dublin Workingmen's Club in Baltinglass and at the Phoenix Park. The arrival of the railway allowed for travelling back and forth between Dublin and Baltinglass. Just two years earlier Baltinglass would not have been able to play a Dublin team. William Browner was the Baltinglass captain during those 1887 encounters, and the 'Brass' Kenny was prominent as a bowler.[266]

Reports of matches in 1888 are less numerous but the club did have a number of encounters. A more thorough examination of the local newspapers after 1888

would possibly provide a clearer picture of the club's history. As early as August 1888 there was a Grangecon club, as in August that year there was a match between it and Mullaghmoy. There may have been some overlap of members between Baltinglass and Grangecon, as William Browner played for Grangecon in an 1895 match. The clubs merged for at least a short period but for the most part they were separate.[267]

Baltinglass played at least five matches against County Kildare 2nd XI between August 1897 and June 1899, all of them at Oldtown, Naas. The Baltinglass players on the last of these occasions were M. Byrne, P. Byrne, A. Gailey, T.B. Doyle, T. Slater, E.P. O'Kelly, – Lawler, M. Leonard, J. Cope, P. Doody and J. Kelly. A match against Celbridge was held at Baltinglass in July 1899. On this occasion the Baltinglass players were listed as P. Byrne (captain), W. Browner, J. Mallen, P.P. Morrin, J. Fitzgerald, M. Byrne, J.H. Kidd, S.S. Manning, P. Byrne, C. Farrell and W. Slater.[268]

Grangecon played two matches against County Kildare 2nd XI in 1902, but by July 1904 a club called Baltinglass & Grangecon was in existence. On 16 July it played County Kildare 2nd XI at Oldtown. The team members were A.H. McLeod (captain), E.P. O'Kelly, J. Mallen, J. Leigh, J. Lawler, P. Norton, P. Holohan, W. O'Kelly, P. Byrne, J. Smith and J. Morrin. On Sunday 4 September Baltinglass & Grangecon played 'Captain Corballe's' XI at Fort Granite. The following day the Captain's team took on Clonmore on the same ground. Baltinglass & Grangecon was still in existence in September 1906, when it played the 'annual fixture' against County Kildare 2nd XI. In August 1908 County Kildare 2nd XI played 'Baltinglass' at Oldtown. The Baltinglass line up was J. Butler, P. Scully, J. Leigh, E. Doyle, J. McCarthy, A. Doyle, M. Kelly, T. Cooke, T. Shanks and J. Collins.[269]

Baltinglass Cricket Club must have gone through a bad patch about this time. In the summer of 1910 it played two matches against County Kildare 2nd XI, both of them in Naas. In an account of the first of these the *Kildare Observer* correspondent wrote:

> ... Baltinglass a club that has been thoroughly resuscitated by the very keen exponent, Mr. A. H. McLeod. There seems no lack of 'young blood,' and they play plenty of matches, so there is every prospect for the future. Up in their country the difficulty is in getting a ground, then paying a big rent and heavy expenses for its upkeep.[270]

Certainly there was an injection of 'young blood', as some of the identifiable names on the Baltinglass teams of 1910 indicate – Stanley Dagg, Michael Kelly of Talbotstown, Frank and Willie Morrin, Ned O'Kelly and Willie Turtle, all of them then in their late teens or early twenties.

Baltinglass Cricket Club held its annual general meeting in the Town Hall in April 1911. The officers elected were Denis Kenna as president, Matt Byrne as vice-president, Ned O'Kelly as treasurer, Matthew Kennedy and Andy Doyle as

joint secretaries, and Alister Macleod as captain. The committee members were G. Byrne, P.C. Corcoran, Marks Dalton, Hugh Doyle, E.P. O'Kelly and Joseph Turtle.[271] In the same month and at the same venue a meeting was held in an attempt to revive Gaelic football in Baltinglass.[272] It is possible that the temporary success of that venture, followed by the Great War, sealed the fate of Baltinglass Cricket Club. Alister Macleod was manager of the National Bank in Main Street. Perhaps it was after he left Baltinglass that the club went into decline.

There was a brief attempt at reviving cricket in Baltinglass in 1923. A club was formed in early June and at least one match was played. Kilcullen were the opponents, and the match was in Baltinglass, but the visitors won by twenty-two runs on the first innings. The Baltinglass players were P. O'Kelly, C. Byrne, Eddie Morrin, Cyril Corcoran, H. Doyle, Frank Wilson, G. Shade, T. Lalor, J. Carr, W. Kearney and J. McDaniel.[273] The Grangecon club survived until the advent of the Second World War. What is noticeable about cricket in Baltinglass is that it was not confined to people of any particular religious, political or social background. What is more remarkable is that it flourished during at least the latter years of the divisive Land Wars. It was a sport open to all, and evidently a fairly popular one. The fact that it survived for at least a quarter of a century is testimony to this. Its durability is further highlighted when it is considered that this was also the first quarter century of the existence of the GAA. Indeed, cricket may well have been responsible for the early weakness of Gaelic football in Baltinglass.

CONSECRATION OF ST MARY'S CHURCH
THURSDAY 14 AUGUST 1884

The building of a new church was the culmination of decades of aspiration on the part of Baltinglass Church of Ireland parish. The poor condition of the old building had long been a source of concern for parishioners and this new beginning was born out of necessity. Happy as was the occasion of its completion, there was a regrettable side to it as it brought to an end over seven hundred years of worship in the Abbey.

The church built by the Cistercian monks in the twelfth century was serving as the parish church as early as the 1530s, when the Abbey was dissolved. Shortly afterwards the Reformation saw the division of Christianity in Ireland into two denominations, both claiming their succession from St Patrick. In areas under English administration such as Baltinglass the reformed or Anglican church, the Church of Ireland, was recognised as the official religion. For that reason the church in Baltinglass Abbey continued in use as the Church of Ireland parish church. At some point a wall was erected across the nave of the original church in order to make a more compact place of worship. This may have been before the dissolution of the Abbey, when the number of monks had dwindled, or soon after the Reformation.[274] It would appear that only the eastern portion of the nave of the original cruciform building was used as the parish church.[275] In a 1792 print

from *Grosse's Antiquities of Ireland* the tower erected in the fifteenth century by the Cistercians is clearly visible, as is a window of later vintage in the west wall, but there is no roof extending over the transepts.

In 1810 the old church was in bad repair and an architect's opinion was sought. In February 1811 all those attending a vestry meeting, with the exception of the Rector, Rev. William Grogan, voted for a new church in preference to repairing the old one. Later that year the ceiling was examined to determine whether it would be necessary to take down the tower. In March 1812 it was agreed to repair the existing church instead of erecting a new structure. The work was carried out by Thomas Jackson, a local builder. In the process the fifteenth century tower was demolished and a porch tower was erected adjoining the west wall.[276] This new tower, with four pinnacles, remains today as a distinctive feature in the ruins of the Abbey church.

In 1828 Rev. Dr. Grogan received a petition from a number of parishioners calling for the erection of a new church 'for the better accommodation of the increasing parishioners'. Reacting to this, the parish vestry agreed that a new church should be built as soon as a sufficient loan could be obtained from the Board of First Fruits for the purpose. However, by 1830 the position had altered, with the vestry agreeing to the erection of two new galleries in the existing church, one at the expense of Lord Aldborough and one to be paid for by the parish. It would appear that this was done by May 1831.[277]

In December 1843 the state of the church was described thus: 'The walls of this church now very old but the wood work of galleries and pews is comparatively new and all in excellent state of repairs ...'[278] According to the Bishop's Visitation Book for 1851 it was 'in tolerable repair inside and out. Painting still much required. The whitewashing has been done from private sources and is a great improvement ...'[279] By the 1870s the need for a new church was again exercising the minds of parishioners. The Ecclesiastical Commissioners agreed to give a grant for the building provided that a site could be obtained. A request was made to Lord Aldborough, then living abroad, for a site adjoining Stratford Lodge School (on the Dublin Road). Whether or not Lord Aldborough responded, the plan was rejected because many parishioners expressed dissatisfaction with moving so far away from the old church.[280]

In January 1871 the vestry delegated Robert F. Saunders, William Grogan and Edward A. Dennis to approach Lord Aldborough to ask for a site between the existing church and the Castle,[281] and adjoining the Stratford Tomb. Presumably the proposed site was in the field directly south of the Stratford Tomb. In any case, Lord Aldborough's flat refusal was communicated by his agent, Robert H. Anderson. In April 1871 two vestrymen, Michael Cooke and James Thornton, proposed that it did not 'meet the approval of the Parishioners' to replace the existing church, that a new roof and an extension to the gallery would meet their requirements, and that application be made to the Ecclesiastical Commissioners for funding for these repairs. An amendment to this was carried by one vote. It proposed that if a site could be obtained

the Commissioners' offer to build a new church should be accepted and the old church should be kept as a mortuary chapel and a place for religious meetings. In any case, the Commissioners would not supply funding for the repair of the old church.[282]

In May 1872 the vestry sent a letter to Lord Aldborough asking him to reconsider. The letter stated that only two sites were then under consideration, one in and the other outside the town, and both 'open to considerable objections'. Under the circumstances they were again appealing to Lord Aldborough for the site adjacent to the Stratford Tomb. Evidently the request fell on deaf ears. By the late 1870s Lord Aldborough was dead and his property was in the hands of his heirs, Catherine Dora St John, Lord Tollemache and John Stratford Best. Eventually the situation was resolved by Major William Grogan of Slaney Park, son of the late rector, purchasing a site from them and presenting it to the parish. On 18 April 1882 he purchased three acres and thirty-eight perches of land adjoining the Abbey through the Land Judges' Court. It was bought in perpetuity subject to the tenancy of Thomas Cooke. On 8 May 1882 Grogan made over this property to Meade Caulfield Dennis of Fort Granite, Rev. John Usher and himself as trustees. On the same day the select vestry resolved to request the trustees to pay Mrs. Sarah Cooke compensation for her interest in the site. Finally, on 7 December 1883 the trustees made over the property to the Representative Church Body, with part as the site of the church and the remainder to be held in trust as a glebe for the minister.[283]

In April 1882 the select vestry placed advertisements in the *Irish Builder* and *The General Advertiser* inviting submission of plans and estimates from architects for a church to accommodate 300 people, with the cost not to exceed £1900. The closing date for receipt of plans was 8 May and about ten submissions were made. The select vestry chose the plans of a Mr Carroll, with a Mr Fuller in second place and Richard O'Brien Smyth third. They then set about finding a contractor to construct the building for £1900, but became aware that Carroll made alterations to his plans in an attempt to reduce building costs before the contractors saw them. In any case, the tenders received were too high. The circumstances delayed the building, so in March 1883 it was decided to replace Carroll as architect and Richard O'Brien Smyth was given the commission. A tender of £1820, received from Messrs. Thomas and John Pemberton for his building, was accepted. On Tuesday 5 June 1883 the foundation stone was laid by Elizabeth Grogan, wife of the man who had donated the land. On 11 June it was agreed that the height of the building should be increased by a foot at an extra cost of £30.[284]

At the same time as Pembertons were working on the church they were also building the rectory. As Rev. William Grogan, Rector from 1807 to 1854, lived in his own house, Slaney Park, there was no need for the parish to provide a residence during his long tenure. His successor, Rev. William Norton, occupied a house in Mill Street at least for some time prior to his retirement. His successor, Mr Usher, occupied that house after him. It was only when the new church was being built that the need for a permanent residence for the Rector of Baltinglass

was addressed. Sadly, it was decided to build the Rectory on part of Grogan's purchase that was occupied by what was called Baltinglass Castle. This was basically a tower house that had been the Abbot's residence. After the dissolution, when the Eustace family were granted the Abbey lands, they lived there. It was described in *Brewer's Beauties of Ireland*, published in 1825, as 'an irregular and not very extensive structure, evidently built at different periods. The outward doors are in a circular mode of architecture, whilst other parts are of various less ancient ages'. By the mid-nineteenth century the castle was being used as a cattle shed and hay loft.[285]

In an act of vandalism, credited to Rev. John Usher, the remains of the castle were demolished and the site was cleared for building. In the course of the destruction a cannon ball and the seal of a Papal Bull were discovered within the castle. The seal had the images of SS. Peter and Paul on one side and the name of the Pope, Alexander IV, on the other.[286] Therefore, it dated from the period 1254-1261. The Rectory was designed in 'domestic gothic' by Richard O'Brien Smyth and built by Pembertons at a cost of £998.[287] It is said that about the same time Pembertons also built the Munster Bank (later occupied by the National Bank and now the Bank of Ireland) in Main Street.[288]

By eleven thirty a.m. on 14 August 1884 the new St Mary's church was packed to capacity, with many not being able to gain admission. The Rector, Rev. John Usher, and the church wardens, George Burton and Ralph Dagg, received Right Rev. William Pakenham Walsh, Bishop of Ossory, at the church door. At the communion table William Grogan and Meade C. Dennis presented the Bishop with the deeds of conveyance, after which he performed the act of consecration. The morning service was read by Mr Usher and the Communion Service was read by the Bishop 'who afterwards gave an earnest and eloquent address'.[289]

A wall tablet commemorating the first Earl and Countess of Aldborough, John Stratford and his wife Martha O'Neale, was removed from the old church and placed in the south transept of the new building.[290] In March 1885 a general vestry voted unanimously to seek permission from the Representative Church Body to use the old church as a parochial hall.[291] As this never came about it is probable that the building was not considered suitable for repair. So the church of Baltinglass Abbey came to the end of its active career.

BALTINGLASS RUGBY CLUB'S FIRST MATCH
MONDAY 1 DECEMBER 1884

By the mid-1880s Baltinglass had developed a taste for team sports. The cricket club was in existence by July 1884 and later that year a rugby club was formed. On 1 December Baltinglass Football Club visited Carlow for its first competitive match.[292] This was against County Carlow Football Club and the match was reported by the *Carlow Sentinel* as 'being the first match played in Carlow under the new rugby rules and so excited considerable spectator interest – a very large number assembled to see the play which they appeared to thoroughly appreciate'.[293]

In preparation for this first venture, the fledgling Baltinglass Football Club held a practice match on Thursday 20 November on its own grounds. The team captains were [P?] Harding and E. Clarke and the match, 'which was played under the 'Rugby Rules' resulted in a win for Harding's team'.[294] The teams were:

Harding's – fullback, Whittle; halfbacks, Harding, Lusk; quarterbacks, Maher, M. Cooke; forwards, Prendergast, Lawlor, Byrne, Hurley, T.B. Doyle, Doody, Flinter, Shanrahan.

Clarke's – fullback, Hanrahan; halfbacks Geoghegan, M. Cooke; quarterbacks, Clarke, W. Cooke; forwards, Nolan, T. Cooke, Carroll, Elward, Byrne, Healy, Hayden, Doyle.

The team that represented the club against Carlow eleven days later was:

fullback, J.J. Hurley; halfbacks, H.J. Pennycook, W. Lusk; quarterbacks, E. Clarke, C. Maher; forwards, [M?] P. Harding, M. Flinter, J.J. Nolan, W. Prendergast, W. Browne, J.P. Pennycook, M. Cooke, J. Geoghegan, J. Casey, J. Carroll.

The match was curtailed by fading light. Though Baltinglass were defeated, their 'superior scrummaging' was reportedly remarked upon, but 'they were inferior to their opponents in not playing well together'. However, it was noted that the club 'dates only from this season'. A return match was played in Baltinglass on Friday 9 January 1885. Fielding a team two men short, County Carlow also won this encounter. Two Baltinglass club members, Yelverton and Browne, played for the visitors.[295]

On Thursday 5 February 1885 Baltinglass played a much more successful away match against Athy. The victorious team was: fullback, Hurley; halfbacks, Yelverton, Maher; quarterbacks, Cooke, Browne; forwards, Harding (the captain), Clarke, Dooley, Heydon, Lalor, Doyle, Casey, Healy, Elward, Geoghegan. The next reference found to the club was in November 1885. Baltinglass was the venue for another match against Athy, which the home side lost on Monday 16 November. The Baltinglass players were fullback, J.J. Hurley; halfbacks, C. Maher, W. Browner; quarterbacks, Michael Cooke, P. Byrne; forwards, C. Flinter, James Byrne, P. Heydon, T. Lalor, J. Carroll, T.B. Doyle, T. Maher, N. Hanrahan, Martin Cooke. The match was umpired by Ralph Dagg and M. Doyle.[296]

It would seem that Baltinglass Rugby Club developed as part of the cricket club. On Sunday 2 May 1886 'the Football section in connection with the [cricket] club' closed its season with an athletics competition, with prizes presented by James Byrne, Michael Cooke, Ralph Dagg, J.J. Hurley and E.P. O'Kelly. The results were as follows:

100 yards handicap (prizes presented by Byrne)
1, Hurley; 2, Dagg; 3, C Maher

220 yards handicap (prize presented by Hurley)

1, MacMahon; 2, M. Cooke; 3, Dagg

440 yards handicap (prize presented by Cooke)

1, C. Maher; 2, L Maher; 3, W. Lusk.

Half-mile handicap (prize presented by O'Kelly)

1, W. Browner; 2, C. Maher; 3, W. Lusk

Boys' Race (prize presented by Dagg)

1, P. Kehoe; 2, J. Leigh; 3, P. Crowe

Due to bad weather the 'drop and place kicking' event as adjourned.[297] No further reference to this club was found while compiling this book.

Rugby was quite strong in the general area in the mid-1880s. In January 1886 Naas Harriers and Football Club considered changing from 'the Association football to the more popular and more widely played game of Rugby'.[298] It is possible that rugby faded from Baltinglass as a result of a rule introduced into the GAA in September 1886 stating that 'persons playing Rugby or any other non-Gaelic rules cannot be admitted as members of any branch of the G.A.A.'.[299] While Gaelic games had not really taken root in Baltinglass by then, Gaelic football's subsequent development apparently deprived rugby of players.

In the 1920s an attempt was made to revive rugby. On Tuesday 6 January 1925 the new club made its debut with a friendly at home against Athy. The Baltinglass correspondent for the *Nationalist* wrote:

> After nearly forty years Rugby football has come again in Baltinglass. Formerly the little town had a fifteen that could hold its own with the best of them around, and included some of the finest athletes in the whole country. The arrival of the Gaelic code thirty-eight years ago was followed by the wane of Rugby ...
>
> The match ended in a scoreless draw, while the 'brothers Lalor, Deering, Morrin and the "Dr." were the pick of the homesters'.[300]

This new club continued up to 1927, when it appears to have gone out of existence. In January 1941 there was mention of a rugby match between Baltinglass and Arklow, with the former internationals Mark Deering and Pat Lalor (both from Dunlavin) representing Baltinglass.[301] However, this appears to have been a once off. In more recent decades Baltinglass rugby enthusiasts had to go to Carlow to find an outlet for their interest.

REVIVAL OF BALTINGLASS RACES
THURSDAY 19 MARCH 1885

In the eighteenth century horse racing had a home in Baltinglass. The Race Course, as it was referred to, was in Lathaleere. It was in use as early as 1755,[302] but it is not certain that the Baltinglass Races were run on a regular basis. Evidently

they were quite a happening in their heyday, as there was at least one week long meeting in 1791.[303] It is said that Lord Aldborough gave up racing after one of his horses was beaten by Captain King's.[304]

The Race Course was extensive, forming a circuit of the land of Allen Dale House. This consisted of much of the eastern portion of Lathaleere townland. It occupied the area between the Kiltegan Road on one side to the Redwells Road on the other. It stretched from the townland boundary with Newtownsaunders up to what is now the site of the Baltinglass Meats factory. In the field where hockey was played in the early twentieth century there was a tall lime tree standing about midway down the side adjoining the Redwells Road, several yards in from the road. This was the starting point for the Race Course. Two tall lime trees marked each of the four corners of the course, standing several yards in from the boundary ditch, and the horses ran outside them. None of these markers of the Race Course extremities are now standing. Their present day sites are the field adjoining O'Neills' in Newtownsaunders, the area behind Daltons' on the Kiltegan Road, the corner of the Kiltegan Old Road where Wampfler's football field was in 2001[305], and Milletts' house.[306]

For whatever reason, racing in Baltinglass appears to have died out before the mid-nineteenth century, and possibly much earlier. In 1885 an attempt at reviving the sport was made on the same course by a group of local enthusiasts when they staged the Baltinglass Steeplechases. The land was then the property of Alice Hargrove (*née* Hendy) and she gave permission to hold the race meeting. The organisers presented Mrs. Hargrove with an inscribed silver salver in appreciation.[307] The stewards were Robert J.P. Saunders of Saundersgrove, E.P. O'Kelly of Main Street, John Germaine of Graney House, Frederick McDowell, a doctor in Baltinglass, David Mahony of Grangecon House, Peter P. Morrin, the Baltinglass miller, George Burton, manager of the Munster Bank, Henry Kidd, a doctor in Tullow, Edward Grogan of Slaney Park, W. Malone, J. Nolan, and J. Hendy. The Treasurer was James Neill and the Hon. Secretaries were T.B. Doyle, P. Byrne and John Malone. The Judge and Clerk of the Course and Scales was Thomas Brindley, a professional race organiser from Dublin, and the Starter was J.D. Gibbs.[308]

The *Kildare Observer* reported on arrangements for 'the revival of this ancient gathering', stating that on Monday 16 February Thomas Brindley and the race committee laid out the track, which was 'a purely natural one', adding that 'the remodelling of the fences is all that could be desired'.[309] In the 7 March 1885 issue of the *Nationalist*, referring to the upcoming Baltinglass race meeting, 'Tatler' posed the question: 'Is it possible that Carlow with all its sporting traditions cannot emulate the enterprise of Athy, Baltinglass, Borris and Hacketstown?' The Hacketstown meeting, held in February, was termed 'illegal' in that it was not run under National Hunt rules.

So much for Tatler's bewilderment at Carlow's deficiency in relation to horse racing; just four years earlier the Carlow Hunt Club race meeting had been condemned at a Land League meeting as 'the sport of the landlords', with a call to

boycott it. Indeed, the Baltinglass committee received a barbed comment in the *Nationalist* on 14 March 1885 for holding the races on the same day as the hotly contested Poor Law election for Rathdangan division of Baltinglass Union. This was an unsporting battle between the conservative and nationalist candidates in the aftermath of the Land War. The Hacketstown correspondent wrote:

> Time was when Baltinglass would do no such thing, but no person need wonder at such being done, when one looks at the names of the "Patrons," as appearing on their programme.

Considering that E.P. O'Kelly was one of the stewards, the Hacketstown correspondent appears to have been somewhat paranoid. In any case, the races went ahead and the event was a success.

The weather was good, the attendance was 'large and orderly', and the arrangements were 'of a first-class character'. Though the course was considered fairly good, some of the fences were 'trappy' and as a result there were numerous falls.[310] The crowd the meeting attracted was mainly local. The *Irish Sportsman* commented that Baltinglass was not very accessible just then but that before the next racing season it would be connected to Dublin by rail, adding that then 'the Baltinglass folk may expect a very great increase of patronage from the metropolitan division'.

The one feature of the gathering that drew criticism was the frequency of objections, raised primarily as a result of races being won by horses that had taken part in the 'illegal' meetings that had been held in the area over the past couple of years. There were four steeplechases in the meeting – the Allendale Plate, the Ladies' Plate, the Baltinglass Plate and the Farmers' Race. The Allendale Plate was confined to horses owned by 'working farmers' in Counties Wicklow and Carlow or within a ten mile radius of Baltinglass. Though there were eleven horses entered, only eight ran. It was a two mile race and first past the post was Ringleader, owned and ridden by Francis Nolan of Carrigeen. Second by a length was P. Doyle's Eileen Alanna, ridden by L. Connor, and John Germaine's Green Hill was third. However, Doyle objected to Nolan's win as the horse had run at the illegal meeting at Hacketstown in February. The objection was sustained and Eileen Alanna was declared the winner.[311]

The Ladies' Plate was won by Fiddler, owned and ridden by P. Murphy, while three horses fell. The longest race of the day was the three mile Baltinglass Plate. Only six ran and Gipsy Glitters, owned by P.J. Williamson and ridden by a jockey named Lawless, won by a length. An objection was lodged, alleging that the winner had not gone the entire course, but this was overruled. Finally came the Farmers' Race. Though twenty-six horses were entered, according to The *Irish Sportsman* on 14 March, only five ran. E. Williams' Lightheart, ridden by Lawless, finished three lengths ahead. An objection was lodged on the grounds of the winner not having jumped all the fences and having taken part in an illegal race. Lightheart had indeed run at Hacketstown and won a race there, but the objection named Borris as the illegal meeting. The objection was sustained and P. Murphy's

Fiddler was declared the winner. However, it was discovered that Fiddler had carried the wrong weight, so the race was declared void.[312]

The second meeting of the revived Baltinglass Races did not take place until Thursday 14 October 1886. In advance of the fixture Thomas Brindley inspected the course and 'the "trappy" fence' was removed. In anticipation of attracting a larger crowd than in 1885, the committee were planning on enlarging the stand and the enclosures.[313] The large attendance drawn to the event was with the assistance of the new railway transport; 'the metropolitan contingent in particular availing themselves of the convenient special which left the Kingsbridge Terminus for the scene of action at 10.30am'.[314] Indeed, it would be expected that the train service should have been the making of Baltinglass as a racing venue, but for whatever reason the enthusiasm died. There was no Baltinglass meeting in 1887. Whether there were further events in later years has not been determined. However, the 1885 revival was characteristic of the passion for sport that evidently existed in Baltinglass in the 1880s. At the same time as the community was divided by political zeal it united in the enjoyment of sport.

OPENING OF BALTINGLASS RAILWAY STATION
TUESDAY 1 SEPTEMBER 1885

The arrival of the railway brought major change to Baltinglass. There was now an alternative to dependence on the mail coach and other horse-drawn modes of transport. There was also a direct link with Dunlavin and Naas, as well as Dublin, and the line was soon to be extended to Rathvilly and Tullow. Most importantly, as regards agriculture and business, the railway provided a means of mass transport for livestock and goods.

Baltinglass Station opened on 1 September 1885, with three services travelling the 24½ miles each way, to and from Sallins – morning, midday and evening. The day was not without its little drama. Before being attached to the train for the evening journey to Sallins, the engine was being moved to the turntable when it left the rails and damaged the track. The passengers already on the motionless train remained motionless for some considerable time while repairs were done. It was some six hours before they reached Kingsbridge (now Heuston) Station in Dublin that night.[315]

The railway was a lifeline for Baltinglass, but a rail link to Dublin might have happened a decade earlier had financial difficulties not hampered plans. As the name implies, the Dublin and Baltinglass Railway Company was established for the purpose of providing such a service. However, it seems that the venture was short lived, as the company was being wound up in 1871 before any construction work was commenced. One of those whose names appeared on the list of investors was William Wentworth Fitzwilliam Hume Dick, the local MP, who had recently finished constructing Humewood Castle. He appealed a decision to list him, stating that the conditions on which he applied for shares had not been fulfilled and that, therefore, he was not liable.[316]

Eventually it was the GS&WR Company that took the initiative. Its branch line from Sallins was begun early in 1883 under the supervision of the company's chief engineer, Kenneth Bayley, who also designed the stations. The contractor was Robert Worthington. On average 1,263 labourers worked on the construction each week, with the number increasing to 2,000 some weeks. They laid a double track as far as Naas and a single one thereafter, with passing loops at Dunlavin and Baltinglass. The line was opened from Sallins to Colbinstown on 22 June 1885. The intervening stations were Naas, Harristown and Dunlavin. On extension to Baltinglass ten weeks later, Grangecon was also added. The turntable at Baltinglass was near the 'Lord's Piers' and a Mr. Fleming was the first station master.[317]

In about April 1885, under a new contract for £50,000, Worthington began work on the extension of the line to Rathvilly and Tullow. The opening of the final stretch took place on 1 June 1886. Bringing the railway into Baltinglass involved the demolition of Stratford Lodge National School and its Infant School, which had stood on the Dublin Road, at the entrance to the town. Extending the line south to Tullow involved much more disruption. Two houses on the Ballytore Road and ten in Belan Street had to be demolished. In addition, the Ballytore Road was dissected, the eastern portion forming Station Road, the entrance to the railway station. The western portion being thus left as a dead-end, a new link road had to be constructed between it and Belan Street, running parallel to the train track. The ground directly south of the station was high, so it was necessary to make a cutting through the hillside from about the site of the Ballytore Road to Bawnoge townland, and put a bridge in place at Belan Street. The stretch of hillside directly south of Belan Street was traditionally called Gallows Hill. It was believed that the name originated with executions there in 1798, but the name was much older, featuring in records at the Registry of Deeds from the mid-eighteenth century. In any case, clearing the path for the railway involved excavation of part of Gallows Hill. In a talk given in 1907, E.P. O'Kelly related the following concerning 1798: 'To the west of the Slaney six young men were executed, at a place called Gallows Hill. And how true tradition is! I saw their skeletons exhumed, when the railway cutting was being made, some twenty-three years ago'.[318]

The railway was to be part of the life of Baltinglass for six decades. By the early twentieth century it had become an indispensable lifeline on which the town's economy depended. In 1885 Baltinglass moved from the era of the horse-drawn carriage to what was then the most modern form of transport. The instant transformation must have had a startling affect on the community.

FIRST BALTINGLASS ATHLETICS DAY
MONDAY 7 SEPTEMBER 1885

The week after the railway was opened Baltinglass hosted its first athletics day at the cricket club's grounds on the land of Allen Dale House in Lathaleere. It

was held under Irish Athletics Association rules, with P.B. Kirwan of *Sport* acting as judge and handicapper. The hon. secretaries were J. Ralph Dagg and W. McMahon, and the stewards were, according to the *Leinster Leader*, William Browner, 'F.J. Neade'[319] and 'T.J. Cooke'[320]. The event had a course of 220 yards to the lap and eight laps to the mile. During intervals in the programme the band of the Royal Dublin Fusiliers from Naas played 'a varied and exceedingly choice selection of music'.[321]

All items on the programme were handicap competitions. The first event was a one hundred yard handicap confined to locals. There were two preliminary heats, with four runners qualifying for the final heat. It was won by James J. Hurley in 10 4-5 seconds, by a yard from Harold Earl. Hurley, who was accountant at the National Bank in Main Street, was also the victor in the other local race, a 220 yards handicap which he won easily in 26 3-5 seconds. The other event confined to locals was a competition for throwing a cricket ball. This was for members of Baltinglass Cricket Club. The winner was T. Lawler and second was W. Lusk. In the open races, the Dowling brothers, J.H. from Naas and J.J. from Met Harriers, dominated the field. J.H. beat J.J. by half a yard to win the final heat of the 120 yards. He won the quarter mile by half a foot from W. Keating, while J.J. Dowling won the 220 yards by a yard and a half from George Hewitt.

In both bicycle races, the two mile and four mile, A. McCormack of Portarlington led by about three yards till half a lap from the finish. In each case he was overtaken by S.R. Stedman of Arklow, who won both events. The four mile turned into a contest between Stedman and McCormack after one of the other two participants was knocked down by a spectator crossing the track and the rider behind him was thrown off. Considering that the first recorded bicycle race in the world took place only seventeen years earlier, cycling must have been something of a novelty for the onlookers. Edward O'Toole recalls that the first bicycle seen in Rathvilly was in about 1872. It was a penny farthing owned by a visitor to Broughillstown, and when he came into Rathvilly he was followed about by 'a crowd of youngsters who were delighted with the novel sight'.[322]

The last competitive event of the day was the one mile tricycle race, which would be something of an oddity today, but was a recognised competition then. It was a bit of a damp squib in that C.J. Thompson's only serious challenger had his tricycle damaged prior to the race and only went a short distance before retiring. As for the other two opponents, the *Kildare Observer* wrote: 'the machines which the Messrs Dagg bestrode seemed to have been invented before the "Flood", and were never intended for speed'.

The day was rounded off with a mock donkey race in which the three stewards competed. 'Irish Molly' was ridden by William Browner, dressed as an old woman 'with a black eye, a mitred cap, and a broom to drive the donkey'. F.J. 'Neade' was dressed in what the *Leinster Leader* described in unintentionally crude terms as a 'nigger costume'. Cooke, the third steward, was dressed as a jockey. Finally, the prizes were presented by Catherine Hurley, wife of J.J. Hurley.

The Baltinglass Athletics did not appear in the fixture lists published in the *Irish Sportsman* in 1886 and 1887, so it would seem that the event did not become an annual feature. There was certainly at least one athletics day held in Baltinglass in the 1890s. In the 1920s and 1930s there were a number of similar events.

FIRST FOOTBALL MATCH FOR 'MAURICE DAVINS'
SUNDAY 4 DECEMBER 1887

The early years of the Gaelic Athletic Association were not particularly harmonious. Intrinsically linked as it was to nationalist politics, the GAA was almost destroyed in its infancy by a prolonged power struggle between two nationalist factions – those who pursued constitutional means and those who advocated physical force. The latter were aligned with the IRB, the secret society with a policy of infiltrating such organisations. Within the GAA Maurice Davin was the main leader of those opposed to the IRB. It seems fairly safe to hazard a guess as to which of the two factions was in control in Baltinglass, given that the Baltinglass club that existed from at least December 1886 was called the Maurice Davins.

The GAA was founded in November 1884. According to information given by Pat Furlong (once the teacher and later the Master of Baltinglass Workhouse) in the 1930s, the first GAA activity in west Wicklow was the formation of a football team in Woodfield by Denis Murphy in October 1885. Furlong said that Woodfield played their first match on 1 January 1886 and the survivors of that team living in 1935 were John Finn, Jim Fluskey, Anthony Ovington, Terry Reilly and Pat Furlong himself. As of 27 February 1886 only four GAA branches in County Wicklow had paid affiliation fees and none of these was in west Wicklow, though many unaffiliated clubs existed in the county. On 26 December 1886 T.P. Maher and Matt Byrne represented the Baltinglass 'Maurice Davins' club at the first county convention, held in Wicklow town.[323] At that time Matt Byrne was not yet seventeen years old.

On Sunday 4 December 1887 what was described at the time as the first football match 'under the Gaelic rules in this part of the county' was played at Baltinglass between the Maurice Davins and the William O'Briens of Rathdangan. Matt Byrne captained the Baltinglass side and the same Pat Furlong captained Rathdangan. The home side won 1-5 to 0-1. This is how the *Leinster Leader* described the match:

Shortly after two o'clock the ball was thrown in when the O'Brien's, who had the advantage of a strong wind, carried the leather into their opponents' territory and scored a point after ten minutes' play. Brennan kicked out splendidly, and a magnificent rush by the Davin's followed the ball being kicked dead barely outside the point post. From the kick out the ball was carried to half way, but Byrne (captain) returned it, when a fearful scrimmage followed under the goal post, Johnson finally carrying the ball through the point posts. Another point immediately followed for the Davin's, and just as half-time was called, P. Byrne very nearly scored again. The

second half was completely in favour of the Davin's, the ball scarcely ever coming out of the O'Brien's territory. A goal and three points were registered for the Davin's during the latter half. Byrne (captain), Johnson, Maher, Harte, Cooke, McMahon, O'Connor, and Irwan played well for the Davin's.

At the end the players 'cheered lustily' for T.D. Sullivan, William O'Brien and Maurice Davin.[324]

These two clubs met again on Sunday 15 January 1888, apparently at Baltinglass, when a match between their first twenty-one players was followed by one between their second twenty-one. The Maurice Davins won both. The Baltinglass players singled out for special mention were Matt Byrne (captain), R. Wall, J. Johnson, J. Burke, J. Kenny, J. Doheny, M. Cooke, J. Lynch and J. Kitt. The captain of the second Baltinglass team was Nicholas Hanrahan, and its goal scorer was 'little Dotie Kelly'.[325]

They met a third time, for a return match at Rathdangan on Sunday 29 January. The Baltinglass teams were again captained by Matt Byrne and Nicholas Hanrahan. The Maurice Davins won the first match 'by three kicked points to one kicked point and one forfeit' for Rathdangan, but the home side won the second match. Following this, the Maurice Davins ventured further afield the next Sunday when they took on Carlow on a field lent for the occasion to the Carlow club by Mr. Darcy of Tullow Street. This was referred to as 'the first contest which has taken place under the rules of the G.A.A.', presumably the first in Carlow. The home team won by one point to nil. Baltinglass were apparently unused to a full sized pitch and failed to scatter their players well enough.[326]

To raise funds for the club, a variety show was held at the Courthouse on Shrove Tuesday, 14 February 1888. There was a magic lantern exhibition, including views of the west of Ireland, but 'the picture of the night' was one called 'Rat-devouring Man'. Songs, dances and recitations followed. The singers, accompanied by Julia Shanahan on piano, included Ralph Dagg and E.P. O'Kelly, while Miss Clancy danced Irish jigs.[327]

The Maurice Davins' next outing was at home against Hacketstown on 18 March 1888. The Baltinglass teams named for that encounter were:

1st team, Matt Byrne (captain), J. McGuinness, J. Lynch, R. Wall, J. Hughes, senior, J. Johnson, P. Lennon, William Mahon, 'Brass', J. Donehy, T.P. Maher, L. Maher, J. Maher, J. Brown, D. Ring, S. Murphy, S. Roche, M. Cooke, W. Pender, J. Lalor and P. O'Connor.

2nd team, Nick Hanrahan (captain), P. Brown, J. Carroll, W. Johnson, R. Ryder, J. Donevan, M. Maley, J. McGuinness, junior, T. Doyle, J. Hughes, junior, J. Evans, P. Lynch, P. White, M. Dowling, J. Roche, J. Byrne, senior, J. Byrne, junior, Pat Byrne, senior, Pat Byrne, junior, Peter Byrne and 'The Doctor'.

Baltinglass won both matches easily.[328] 'Brass' was Johnny Kenny. Fifty years later, at the time of his death, it was recalled that his forward play was 'a revelation of opportunism and brainy work, while his tricks (legitimate) in beating his man always drew admiration and approbation'. He was a small man and was 'one of the best for his size that ever played the game'.[329]

When the return match against Carlow was played at Baltinglass on 15 April the visitors won by a point to nil. Remarkably, the referee was Ralph Dagg. On 6 May the Maurice Davins hosted the John Dillons, who travelled down from Naas on the morning train, accompanied by their brass band. However, the home club won both matches.[330]

The next game ended in a somewhat controversial manner. It was an away match against Hacketstown on 20 May. The *Leinster Leader* reported that after fifteen minutes of play Matt Byrne, the Baltinglass captain, withdrew his team, citing rough play. The score stood at one point each, but the referee awarded the match to Hacketstown. Matt Byrne took exception to this account and wrote a letter saying that the score was 2-0 to Baltinglass and that 'the treatment the Baltinglass men received was so rough, so unusual, and so unanticipated that to retire appeared preferable to remaining'. The reporter, Owen Doyle, submitted a letter from the referee which stated that 'after 15 minutes play the ball was taken to the Baltinglass ground, and immediately after, they left the field without referring to me, or without making any appeal; therefore I gave the match to Hacketstown'. It seems too much of a coincidence that the *Leinster Leader* report of a cricket match on 22 July 1888 involving Baltinglass should contain the following sentence: 'In the second innings the visitors not finding play likely to turn with them, some one called "Matty" withdrew his team without any seeming fault, and against the wishes of all, including some of his own men'. The same report, almost word for word, appeared in the *Nationalist* on the same date. It can only be guessed that Owen Doyle was taking revenge for young Matt Byrne's criticism.[331]

According to C.M. Byrne and P.J. Noonan, in April 1889 the Maurice Davins beat Barraderry Volunteers in the first championship game of the year, then beat Hollywood and reached the west Wicklow final, which they lost to the Ballyknockan '98s in a replay. Brophy also placed this in 1889, stating that the '98s were beaten in the county final by Annacurra by a single point. Writing in the Baltinglass notes in the *Nationalist* at the death in 1934 of Mick Whelan, one of the Maurice Davins, Matt Byrne indicated the date of this west Wicklow final as 1888. He stated that the replay was at Athgreany, and that the '98s lost the county championship to Annacurra. At the death in 1940 of a Ballyknockan player, he said that the '98s 'swept all before them in the championship clashes of the period' and that that west Wicklow final replay was 'one of the finest games ever played in the county', with 'thousands from every part of west Wicklow poured into the battleground'.[332]

GAA MEETING IN BALTINGLASS
SUNDAY 12 JANUARY 1890

The split in nationalist opinion following Charles Stewart Parnell's involvement in the O'Shea divorce case was mirrored in the GAA throughout the country. This left the organisation divided for years. However, before the divorce became a major political issue, there was a split in the GAA within County Wicklow which resulted in two rival organisations, one of which held a board meeting in Baltinglass on 12 January 1890.

It seems highly unlikely that the O'Shea scandal was the cause of the 1890 division in the Wicklow GAA. Katherine O'Shea's husband filed for divorce on 24 December 1889, naming Parnell as co-respondent. However, it was not until the following November that the case was heard and a verdict was given against Katherine O'Shea and Parnell. After that nationalists became divided on the issue of Parnell's political leadership. The meeting held in Baltinglass came less than three weeks after W.H. O'Shea filed for divorce, so it is very likely that there was another, possibly local, cause for the rift in the Wicklow GAA.

The Baltinglass gathering on 12 January 1890 was described as a meeting of the County Wicklow Gaelic Board. Those attending appear to have been loyal to the Central Council, which implies that their rivals did not recognise the national administration. The meeting was chaired by Patrick Byrne of Main Street, then a Poor Law Guardian. The others present were his next door neighbour, Thomas C. Cooke, who was described as treasurer, P. Doyle, who was secretary, D. Whelan of Knockananna, Joseph Doyle of Kyle, Jerome Murphy of Drummin and P. Byrne of Askinagap. The secretary was instructed to forward affiliation fees to the Central Executive and to contact the secretaries of clubs which had not sent in fees. T.M. O'Reilly of the Ballyknockan '98s and T.T. Grennan of Bray Emmets were co-opted to the board in their absence. The matter of nominating a representative to the Central Council was deferred to the next meeting, which was to be called by circular.[333]

That summer there were two simultaneous county championships, run by the rival county boards. The semi-finals of one Wicklow championship were advertised for 6 July 1890 at Clonskeagh in Dublin, with Annacurra playing Clara, and Wicklow playing Avondale. However, Thomas C. Cooke wrote to *Sport* commenting that these matches were unofficial and stating that the real championship final was yet to be arranged:

> I beg to correct a mistake which the County Dublin Committee make when they represent the county Wicklow board as having sent teams to play off the final ties in Dublin on Sunday last. Such is not the case, as those clubs that went to Dublin on Sunday are outside the pale of the Association – that is, they don't belong to the affiliated board of the county Wicklow, and whose final tie for the Wicklow

championships will be played off during the present month, to arrange which a meeting will be held at Rathdangan on Sunday next, the 13th inst.[334]

That meeting in Rathdangan on 13 July was chaired by Patrick Byrne. The others present were the secretary, P. Doyle, Thomas C. Cooke, Philip Doyle, Edward McDonnell, J.J. Malone, Tom Smyth and Dan Whelan. An objection made by Lemonstown over their defeat by Baltinglass was heard but not upheld. The Wicklow championship final was then fixed for Rathdangan on 27 July, with Askinagap Billy Byrnes playing Baltinglass. Apparently during the final a row broke out and the match was abandoned. Earlier in the 1890 championship, on 11 May in the Glen of Imaal, Baltinglass had beaten Dunlavin 2-13 to nil.[335] The disputed match with Lemonstown appears to have been a semi-final.

Whether the rival county boards continued into 1891 is unclear, but Baltinglass were beaten that year by Knockananna, 2-3 to nil. Matt Byrne, Pat Byrne and 'Brass' Kenny were three of the Baltinglass players on that occasion. The Baltinglass Maurice Davins club appears not to have been very active later in the 1890s, if indeed it continued to exist. In the meantime, the club in Stratford came into existence and its activities impinged on the area covered by this book. In March 1897 a football match was played at Saundersgrove between Stratford Bohemians and Inchaquire, with William Browner of Baltinglass as referee.[336]

By 1902 there was a club in Baltinglass called the Young McAllisters. The name implies that they were formed in or after 1898, when the Dwyer and McAllister Memorial Committee came into being, or that they were the Maurice Davins under a new title. The Young McAllisters took part in a tournament at Baltinglass on 9 February 1902 in aid of the Dwyer and McAllister Memorial. The organisers included Thomas C. Cooke, Denis Hanrahan, Nicholas Hanrahan and Joseph Kitson. The referee was Martin Gleeson (the Stratford schoolteacher), timekeeper was John Hourihane, and call steward was James Byrne. At some point after this tournament Gaelic football's popularity in Baltinglass waned and the club went out of existence. Certainly there was no mention of football being played in Baltinglass during 1904, while hurling was having a brief popularity.[337] It was not till 1911 that a new football club was formed.

NEW STRATFORD LODGE SCHOOL
MONDAY 25 MARCH 1895

Stratford Lodge School is the oldest school in Baltinglass. From its foundation in the 1820s to the early 1880s it had a permanent home in Stratfordlodge townland, on the edge of Lord Aldborough's estate. When the railway was being built the school was in its proposed path, so it was bought by the railway company and demolished. A replacement was to be built within a matter of a few years, but in the long run it was over a decade before the new school was opened in Church

Lane in 1895. In the meantime the Protestant children of Baltinglass were taught in the old Bridewell or gaol.

In the 1820s there were several teachers running what were termed schools in and around the town. Henry Stewart taught in the parish school, which operated under the Church of Ireland minister and had an average attendance of eighty pupils in 1824, of whom twenty-five were Roman Catholic and one was Presbyterian. This was separate entirely from Stratford Lodge School, which was built by, and operated under the patronage of, Lord Aldborough. It was in connection with the Society for Promoting the Education of the Poor in Ireland, better known as the Kildare Place Society. Christopher Thorp and Sarah Doyle were the teachers, and the average number of pupils in 1824 was 106, of whom 66 were Catholic and the vast majority were girls. Though children of mixed religions attended both these schools, they each followed the Protestant ethos in that the Bible was read as part of the educational programme.[338]

The other 'Protestant' schools in the town were those run by Thomas Cantwell and his wife (with an average of 30 pupils, including 14 Catholics and two Presbyterians), Henrietta Taylor (four female Church of Ireland pupils), Benjamin Haynes (ten Church of Ireland pupils) and that run by Mrs. Cope in the Gaol. There were five Catholic teachers in the town, each running a separate school. They were Daniel Dowling (with an average of 17 pupils), Michael Kerry (36 pupils), Elizabeth McDonald (ten Catholic pupils), John Nowlan (23 pupils) and John Ryan (20 pupils). In addition there were schools run by William Whelan, in Clogh (110 pupils), Thomas Heaverty, in the Catholic chapel in Rampere (50 pupils), John Mollay, in Tuckmill (45 pupils), and Peter Byrne, in Woodfield (76 pupils). With the exception of those taught by Elizabeth McDonald and John Mollay, all the 'Catholic' schools had at least some Church of Ireland children attending.[339]

What polarised education in terms of religious denomination was the objection in the mid-1820s of Roman Catholic bishops to the Bible being read in school 'without note or comment', as they believed that it should be interpreted by a priest. They also felt that the Kildare Place Society facilitated proselytism.[340] The controversy eventually led to the establishment in 1831 of the Board of National Education and the birth of the National School. One of the chief opponents of the Kildare Place Society was Bishop Doyle of Kildare and Leighlin, the famous J.K.L. He encouraged the establishment of new Catholic schools within his diocese. In 1830 a Catholic parish school was established in Baltinglass. From that time forward the Catholic children did not attend Stratford Lodge School. In 1833 the Catholic school was taken into connection with the National Board of Education, becoming Baltinglass National School.[341]

Stratford Lodge School eventually became the Church of Ireland parish school. Though the 4th Earl of Aldborough, Benjamin O'Neale Stratford, was its founder, it was his daughter Lady Elizabeth Stratford who was primarily associated with it. Apparently she herself gave religious instruction at least occasionally in the school.[342]

Certainly she did not teach general subjects, as there were teachers employed. The school was on what became the Dublin Road, on the edge of the estate of Stratford Lodge, where Lady Elizabeth lived. The school's site is now occupied by the cattle mart. It can be seen in the background of Bartholomew Colles Watkins' painting of Baltinglass Castle, which was executed in the mid-nineteenth century. The central portion of the building was the teachers' residence, and the boys' and girls' school-rooms were on either side.[343] Additionally, an infant school was run in a separate building. Originally this operated in a gate lodge about where the 'Lord's Piers' now stand. Sometime shortly after Lady Elizabeth's death in 1848 it moved to a building closer to the town, apparently the one seen to the left of the schoolhouse in Watkins' painting. This building had formerly housed the 'Poor Shop', where a committee of ladies met and distributed clothes to the poor.[344]

By her will Lady Elizabeth left her property to Charles Doyne of Newtown Park and Rev. Henry Scott, Church of Ireland curate in Baltinglass, as trustees. The bulk of her estate, property which was all or mostly in Baltinglass town, was to be held in trust for the use of her nephew, Benjamin O'Neale Stratford, then Lord Amiens, who succeeded his father as Earl of Aldborough the following year. He was to enjoy it for his lifetime and then it was to be held in trust for his children, if any. However, her trustees were to 'uphold forever the Stratford Lodge Schools as now established out of the issues and profits of my freehold estates'. In the event of her nephew dying without issue, as happened, she left her property to Rev. Henry Scott, subject to upholding the schools. Evidently Lady Elizabeth was a zealous Christian. Among the other legacies was £100 to the Protestant Orphan Society. In the event of her nephew dying before her she also intended to give sums to the Curates' Aid Fund Society, the Irish Society, the Deaf and Dumb Institution in Dublin, the Jews' Society and the Church Missionary Society for Africa and the East.[345]

After the death in December 1875 of the last Lord Aldborough, Rev. Henry Scott was solely responsible for maintaining Stratford Lodge School. By then he was living in Dublin. He died in March 1877 and by his will Lady Elizabeth's property and responsibility for the school devolved to Meade Caulfield Dennis of Fort Granite, Lady Elizabeth's first cousin twice removed.[346] Dennis maintained the school until 1 August 1879, when it became a National School under the Board of National Education and he continued as manager. At about this time the infant school was discontinued. Then under the Baltinglass Extension Act, 1881, the Great Southern and Western Railway Company bought the site of the school and later demolished it.[347] A new school had to be built, but as a temporary measure classes were transferred to the disused Bridewell (now Baltinglass Library), beside the Courthouse, which had been vacated in June 1883. Instruction started there on 2 April 1884 and approval of this 'temporary' transfer was granted by the Board of National Education on 29 August.[348] The teachers were housed in the old Constabulary buildings on the eastern portion of the Courthouse block (the sites now occupied by the Credit Union and Treasa's Beauty Salon). While once there

were three teachers – a master, a mistress and a mistress of the infant school – by then there was just a schoolmaster with an untrained work mistress. Apparently the master, Claud Sweeny, lived with his family in one of the houses, while the work mistress, Margaret Cooke, shared the other building with the retired school-mistress, Elizabeth Robinson.[349]

The demolition of the old school coincided with the building of the new Church of Ireland parish church. According to Chavasse, Richard O'Brien Smyth was engaged to design the new school. This is correct,[350] but Chavasse is in error in suggesting that he was subsequently asked to design the church and Rectory. His first commission was for the church. In any case, Meade Dennis paid £25 for plans for a new school in about 1885 and by 1888 he had the building material on his proposed site 'for a very long time'. However, by July 1889 there was no sign of any building commencing and a Board inspector condemned the current arrangement in the strongest terms, quoting a report dated 26 August 1886 which stated:

> School-room, an apartment in the old jail, surrounded by cells, black holes, and associations of the worst kind, degrading to pupils, teachers, and Inspectors, and in every way unfit for a permanent school-room.
>
> I would have never sanctioned the house but that I was led to believe that a proper school-house would be provided in a short time.

The site chosen by Dennis was the field of about half an acre between the Rectory and Church Lane. While the occupier, Robert H. Anderson, appears to have been willing to sell, there was a problem concerning the title.[351]

After Anderson died Dennis decided to try an alternative site. This was on his own land at the very top of Belan Street, more familiarly known as Cuckoo Lane in those days. As his property was considerably encumbered he proposed borrowing money to build a non-vested school and teacher's residence instead of using the money received from the railway company. A loan of £520 was sanctioned by the Commissioners of Public Works. However, Dennis became ill and the building was delayed, so no money was advanced. At this point a petition was drawn up by the Rector, Rev. John Usher, and signed by him and fifteen parishioners. They objected to the Commissioners advancing any money for the rebuilding of the school. They also objected to the distance children would have to travel if the school was sited in this new location. However, it would appear that their strongest objection was on moral grounds, because of the location itself. The problem was that the children would have to pass through Cuckoo Lane, which was 'the only place in the town inhabited by those of the unfortunate class'. In a memo to Mr. Usher in March 1892, J. Ralph Dagg commented on the additional corrupting influences of Cuckoo Lane:

> The ordinary conversation of Cuckoo Lane is of the most filthy description & to a simple question an obscene answer is the general reply & this passes for wit …
>
> Any site which would necessitate children going through any part of Cuckoo Lane

would be the road to contamination for the objectionable people congregate at Doyle's Corner [now Quinns' Corner] & I certainly would never allow a child of mine to go alone that way.

Rev. John Usher proposed an alternative site. This was part of a field in Church Lane held by John Cooke.[352]

Meade C. Dennis died in December 1891 and responsibility for the school was inherited by his son, Meade J.C. Dennis. He was a Lieutenant in the Royal Artillery and while he was serving in foreign parts his uncle, Col. Morley Dennis of Barraderry, took temporary charge. At about this time yet another site was suggested, 'close to the Railway Station-master's house'. It was owned by the Dennis family and it became available in November 1891.[353] This was formerly a bleach field attached to Parkes' bleach mill. Its site is now occupied by Quinns' Super Store and yard. In March 1892 an inspector visited Baltinglass and considered the four possible sites. The original one proposed by the late Meade C. Dennis had the problem about title deeds. His alternative in Cuckoo Lane was objected to on moral grounds. His son was now willing to donate the site near the Station House. However, as the children would still have to go up Cuckoo Lane as far as the County Road and thus possibly 'witness quarrelling & hear bad language', it was proposed that a footbridge be erected across the railway from Station Road to the County Road, on the site of the section of road taken away when the railway was being built. Finally there was Mr. Usher's suggested site in Cooke's field. While it was suitable, there was no proof that it could be obtained. On balance the inspector favoured the site beside the Station House. J.J.O. Ramsay of Dunlavin, who apparently was engaged as supervising architect, showed the inspector the plans which had been approved, and told him that the lowest tender received was £840.[354] So it would appear that all that was missing was a site, and all the while the children had their classes in the old gaol.

On 19 November 1892 Arnold A. Graves of the Commissioners of Charitable Donations and Bequests visited Baltinglass, met the people involved and visited the suggested sites. The original site in Church Lane was dismissed because of its limited space, allowing little room for a playground. Cooke's field, which adjoined it, was generally considered to be a more preferable site and it was said that Cooke was willing to part with an acre for £50. The only other location considered was the bleach field. Disregarding the earlier idea of a footbridge, this was looked at in the light of children approaching it by the lower half of Cuckoo Lane and the County Road. Evidently Graves thought that Cuckoo Lane started above the County Road and that the lower half was a separate road called Belan Street. In his report he said 'There is no doubt Cuckoo Lane has a bad name, and that fallen women do live at the other end of it, but not in Belan Street ...' He also wrote:

Cuckoo Lane is said to be a street frequented by Men and Women who loaf about, either looking for employment, or to use an expression used by one of the Parishioners, 'on the scoop'

It is the resort of tinkers and other questionable characters and some of the parents think that Protestant Children passing to and from School might be insulted by the inhabitants especially on fair days.

On the other hand John Neill [of Tinoran] says his children have passed through Cuckoo Lane going back and forward to School for 10 years and have never been insulted.

Graves pronounced decidedly in favour of Cooke's field.[355]

A draft schedule relating to the endowments belonging to Stratford Lodge School, in which the incorporation of a governing body was mentioned, was published on 18 March 1893. Final approval of the schedule was granted by the Lord Lieutenant on 31 December 1894. In September 1893 Col. Dennis wrote stating that legal difficulties stood in the way of purchasing Cooke's field and that he had written to the agent of the co-heirs of the Earl of Aldborough. Nonetheless, on 13 November 1894 Meade J.C. Dennis wrote stating that 'the new school buildings are complete & the contractor expects to hand over in the course of a week or 10 days'. There was a delay, but on 17 March 1895 he wrote that the work was complete.[356]

A Board of Education order struck off the existing non-vested National School (Roll No. 11888) as of 24 March 1895, cancelling all grants. The grants were transferred to the new non-vested National School (Roll No. 14835) as of 25 March, the date on which it came into operation. The earliest surviving roll book for the school commences on 6 January 1896.[357]

The building consisted of one large classroom with a small teacher's residence attached. Through the years the school doubled as a parish hall. In its early days there were meetings of Baltinglass Mutual Improvement Society and Baltinglass Literary and Debating Society. It was the venue for concerts and dances. Later it had its own badminton club. By the 1970s the beautiful, but draughty school was no longer considered suitable for the needs of the Church of Ireland parish, so it was decided to build a new one. It was constructed adjacent to the old building, which was to remain as a parish hall. The new school opened in April 1975, eighty years after Church Lane had become home to Stratford Lodge School.[358]

E.P. O'KELLY ELECTED M.P. FOR EAST WICKLOW
FRIDAY 26 APRIL 1895

In 1895 E.P. O'Kelly became the first Baltinglass person to win a parliamentary election since the abolition of the Irish Parliament and the accession of Ireland into the United Kingdom in 1801. However, Baltinglass was not part of his constituency. He won the East Wicklow by-election occasioned by the resignation of John Sweetman.

Only four weeks before this O'Kelly had achieved a political landmark in being voted chairman of Baltinglass Board of Guardians, a position which had up to

that point been occupied by members of the gentry. On Saturday 30 March 1895 the newly elected and ex-officio Baltinglass Guardians gathered to choose their officers. Those selected were O'Kelly as chairman, James Coleman of Griffinstown as vice-chairman, and Charles Wynne of Stratford as deputy vice-chairman. O'Kelly and Coleman were the first nationalists elected to those roles in the half century of Baltinglass Poor Law Union's existence.[359]

For most of the nineteenth century Wicklow was one constituency with two seats. One of those seats was held from 1852 to 1880 by William Wentworth Fitzwilliam Hume of Humewood (who changed his surname to Dick in 1864). He was the most 'local' MP during that period. In the 1880 general election both seats were won by Home Rulers, and for the 1885 general election the constituency was divided in two, with east and west each returning one member. The Irish Parliamentary Party, led by Charles Stewart Parnell, was the main political entity within Ireland by the late 1880s, and a significant minority in Westminster. When Parnell's relationship with Katherine O'Shea was made public through her husband's divorce action it was viewed throughout the United Kingdom as a major scandal. Despite this, Parnell refused to resign leadership and the party divided into two camps, the smaller one supporting Parnell. In October 1891 Parnell died and John Redmond became leader of the Parnellites.

The first general election after the split in the Irish Party was in July 1892. In West Wicklow there was a candidate from Baltinglass, or rather the area defined as Baltinglass in this book. He was Robert Joseph Pratt Saunders of Saundersgrove and he stood as a Liberal Unionist. However, Col. Saunders and John Howard Parnell, brother of the late Irish Party leader, were heavily defeated by the anti-Parnellite candidate, James O'Connor.[360] In East Wicklow, another anti-Parnellite, John Sweetman of Drumbarrow, County Meath, was elected. However, within three years Sweetman had a change of heart and his sympathies were now with the Parnellites. Under the circumstances he resigned his seat and sought the electorate's approval, contesting the by-election as an independent while supported by John Redmond.

In the wake of Sweetman's defection, at a meeting in Bray on 16 April 1895, the anti-Parnellites formally chose E.P. O'Kelly to contest the seat.[361] It was very much a test of loyalties and Sweetman was depending on his personal appeal to win over East Wicklow nationalists to Redmond's party. E.P. O'Kelly was a well known and respected figure in the west of the county. He had proven himself in the Land League days, emerging as an 'ex-suspect', having served four months in prison for the cause. His career mirrored the changing political climate in Ireland, as now he was a magistrate,[362] and he had just become the first nationalist to be elected chairman of Baltinglass Board of Guardians. His popularity in the west was unquestionable, but he was now contesting a parliamentary seat for East Wicklow.

The contest was close. About two hundred fishermen from Arklow, who would have been expected to vote for O'Kelly, were at sea at the time of the election, and this was seen as weakening his chances. Polling took place on Friday 26 April and

the following morning the votes were counted in Wicklow Courthouse. It took two hours for the 3,660 votes to be counted and all three candidates, O'Kelly, Sweetman and the unionist, Charles George Tottenham of Ballycurry near Ashford, were watching. John Redmond and some other MPs were also present. At one point Redmond expressed the opinion that Col. Tottenham would win, but when the final result came O'Kelly was sixty-two votes ahead of Sweetman and eighty-eight ahead of Tottenham.[363]

At one thirty p.m a special train brought the MPs, candidates and officials from Wicklow to Bray. O'Kelly, accompanied by his neighbour T.B. Doyle of Main Street, who assisted in his campaign, made his way to the city and got the five-thirty p.m. train to Baltinglass. At the various stations along the way he received congratulations. In Baltinglass a large crowd met the train and cheered the new MP. He addressed the gathering, referring to his party's aspirations of Home Rule, land and labour reform. The crowd accompanied him to his house in Main Street. That evening bonfires blazed on the hills surrounding Baltinglass and tar barrels burned in the streets.[364]

At this time E.P. O'Kelly was land agent for the portion of the Humewood estate which had been inherited from Mr Dick by William Hume, who lived mainly in Paris. Among the messages of congratulations O'Kelly received was an address from the ten ants of Humewood, a copy of which was published in the *Nationalist*:

Dear Sir – We, the tenants upon this estate of Mr W.H. Hume, desire to congratulate you on the victory you gained in East Wicklow, and we desire to refute the calumnies cast upon you by unscrupulous opponents, for we are heartily thankful it is our good fortune to have a sympathetic agent, and we hope you will long continue to be such, and to represent the Irish race in East Wicklow.
Signed on behalf of the tenants,
John Eardley, George Driver, John Wilson, William Alcock, Catherine Moody, Wm. Driver, William Quirke, Henry Moody, George Pollard, Catherine Lowe.

O'Kelly was reported as expressing his appreciation of this address, 'which was doubly dear to him as it was signed by tenants of different religious and political opinions'.[365]

E.P. O'Kelly's term as MP for East Wicklow was brief, as in July a general election was called and he did not contest the seat. The anti-Parnellite candidate in East Wicklow was Francis Arthur O'Keeffe, and he lost out to the Parnellite, William Corbet. In West Wicklow nominations were received in Baltinglass Courthouse on Wednesday 17 July 1895. James O'Connor, the outgoing member, was the only nominee and he was duly elected. His proposer was E.P. O'Kelly. The proposal was seconded by Father Henry Dunne, CC, Baltinglass, and the assenting electors were Matt Byrne (the politically active father as opposed to the sportsman son), T.B. Doyle, J.P., Ralph Dagg, William McLoughlin and Michael

S. Lalor of Baltinglass, Michael Kelly of Englishtown, Richard Kelly of Tuckmill, and William Kelly of Talbotstown. It was not until 1910 that O'Kelly returned to Westminster, this time representing West Wicklow, but his 1895 victory was more historic because it was a first.

SECOND OF THREE NEW SCHOOLS OPENED
MONDAY 27 APRIL 1896

Baltinglass saw the building of three new schools in the 1890s. The first was the long awaited replacement for Stratford Lodge School. The second was the Girls' National School, attached to the Convent. Finally came the Boys' National School on Chapel Hill. From 1879 the Presentation Sisters had run their school in rooms within the new convent. However, perhaps because of the growth of the community over the years, it was decided to build new classrooms attached to the north side of the convent. Work began in April 1895 with digging out of the foundations and the building was completed by early 1896. On the feast of the patronage of St Joseph, Sunday 26 April, the Parish Priest, Father O'Neill, blessed the new St Joseph's School. The following day it opened to 174 pupils.[366]

The first school in Baltinglass sponsored by the Roman Catholic Church was on the south side of Cars' Lane, opposite the then parish church. According to the Valuation Office House Book for Baltinglass town dated March 1841, it 'was built by subscription about fourteen yrs ago. The plot of ground on which it stands was purchased for £20'.[367] It was opened in 1830[368] and was attended by boys and girls. Its foundation was possibly due to the controversy over religious instruction in which a prominent role was played by the Bishop of Kildare and Leighlin, Dr James Doyle, better known to posterity as J.K.L. It was placed in connection with the Board of National Education on 14 February 1833. Originally it had two teachers – a master and a mistress – and it was classed by the Board as two separate National Schools, Baltinglass Male and Baltinglass Female, though they occupied the one building. In March 1857 the following recommendation was made in the Board of National Education's School Register:

> Walls should be raised and a proper School room for girls made over head. Entire ground floor to be left for Boys[369]

By 1873 there were assistant teachers as well as the master and mistress. In that year the mistress, Bridget Tyrrell, was replaced by the Presentation Sisters. She left on 31 March, the same day as the new Girls' School[370] opened beside the convent on Chapel Hill. This was recognised as the Girls' National School from 1 April 1873.[371]

The Boys' School remained in the original building for a number of years. As stated above, after the new convent was opened in 1879, the Girls' School was transferred to rooms within it. Sometime afterwards the Boys' School was moved down Chapel Hill to the building vacated by the girls. This was the building that

later became Fatima Hall. An entry in the Convent Annals dated 22 September 1904 states that the bishop 'gave permission to fit up as cookery school the old schools which were used by the Boys when the Srs. moved into their new convent'. How long the Boys' School remained there is uncertain. A note in the Board of National Education's School Register, dated May 1897, indicates that the manager, Father O'Neill, would build a new schoolhouse when grants were available.[372] In December 1898 Father O'Neill was given permission to dispose of a charitable bequest of £600 made to him as Parish Priest of Baltinglass. Among the uses he indicated for the sum was the contribution of one third of the expenses of the new Boys' National School.[373] It was erected on a vacant site on Chapel Hill, just above the old convent school. The girls continued to be taught in the 1896 school attached to the Convent until 1955, when a new school was opened adjacent to it. The boys were taught in the school on Chapel Hill till 1959, when St. Pius X National School opened on the Kiltegan Road, opposite Parkmore.

The old convent school on Chapel Hill was used for a time for Technical School classes before the permanent 'Tech' was built in Main Street in the 1930s. It was then used by the nuns for cookery and laundry classes for senior girls. In 1942 it became the home of their new secondary 'top' school, St Therese's. This was introduced by Mother Columba Russell to provide local girls with the opportunity to study for state examinations in Baltinglass. The old convent school consisted of what now constitutes the front of Fatima Hall, with just two class rooms. The upper room was where the entrance to Fatima Hall is now located. There were steps from it down into the lower one. The upper storey had been removed in both, so that the rooms had high ceilings, and only the upstairs windows on to Chapel Hill remained. There was no door on to the street. The school's entrance was at the back, so that the nuns could enter through the convent grounds. The pupils gained access through a gate opposite the graveyard and down a path behind the boys' school.[374]

By the 1890s, when Stratford Lodge, the Boys' and the Girls' Schools all got new purpose built premises, there were in fact four National Schools in Baltinglass. As well as those three there was Baltinglass Poor Law Union National School in the Workhouse. From the establishment of the Workhouse in the 1840s there was a need for teachers, since many children were born in the institution and spend their entire youth in it. In September 1874 the Workhouse school was taken into connection with the Board of National Education. There were two teachers – a master and a mistress. After the St. John of God nuns came to the Workhouse in 1900 the school was divided into male and female departments, with Sister Agatha Manning teaching the latter. At the time the boys were being taught by Daniel Aherne, who was also Master of the Workhouse and in 1901 it was noted that he had to be 'constantly out of the school room'.[375]

FIRST WOMAN ELECTED TO BOARD OF GUARDIANS
THURSDAY 6 APRIL 1899

According to the *Leinster Leader*, the 'memorable 6th of April opened hazy in Baltinglass, and afterwards turned to a regular downpour of rain. But notwithstanding the inclement weather, a most exhaustive poll was taken'.[376] Local elections were being held that day throughout the country. One reason for it being a memorable day was that it was the first time in Ireland that women were eligible to stand in an election of any kind. Though the level of representation extended only to the Rural District Councils and Boards of Guardians, bodies that were little more than community councils, it was a first step on the road to political determination for women. Within Baltinglass Poor Law Union there were thirty-one district electoral divisions, each with two seats. In only one of those divisions was there a woman candidate, and when Elizabeth Harbourne won her seat she was among a very small number of Irish women to achieve that distinction.

It was a memorable day too because elections to the new County Councils were also being held, though not in Baltinglass. There was no contest for the seat there because E.P. O'Kelly was unopposed. The Local Government Act of 1898 not only made provision for replacing each county's Grand Jury with an elected County Council, but it also established a system of Urban and Rural District Councils which were to superintend such things as the provision of labourers' cottages at a local level. The Poor Law Unions were retained, with their Board of Guardians, but they were given charge of dispensaries as well as their existing responsibility for poor relief. The Guardians had formerly been charged with building labourers' cottages. There was quite an odd relationship between Rural District Councils and Poor Law Unions. RDCs were confined by county boundaries, while PLUs could extend into a second or, as in the case of Baltinglass, a third county. So the area of Baltinglass PLU was covered by three new RDCs – Baltinglass No. 1 (within County Wicklow), Baltinglass No. 2 (within County Carlow) and the very small Baltinglass No. 3 (within County Kildare). However, the councillors of each of the three RDCs made up the Board of Guardians of Baltinglass PLU, so that those elected to the RDCs were simultaneously elected to the Board of Guardians.[377] The term of office was to be three years.

The local elections that day also marked an expansion of the franchise. Up to then only male ratepaying occupiers or owners were eligible to vote for the Board of Guardians, while householders (not just ratepayers) could vote in parliamentary elections. In the 1899 local elections householders, male or female, had the right to vote. Additionally, while women could not stand for the County Council, they were eligible, as stated above, to serve on the Rural District Council and the Board of Guardians.[378] It was not until 1918 that suffrage in parliamentary elections was extended to women.

The first hint that a woman might avail of the provisions of the Local Government Act in standing for election came a little over a month before polling.

On 26 February 1899 a public meeting chaired by the Parish Priest, Father O'Neill, was held in Baltinglass to discuss selection of candidates to stand as County and District Councillors for the area. At this meeting Michael Harbourne of the Bridge Hotel made a speech advocating pension rights for labourers, as apparently were being contemplated for English labourers. He began by saying 'The women and children have a right to have women to look after their interests. Women are perfectly qualified to go forward as councillors under this bill.' He went on to suggest that his wife wished to speak on behalf of the poor and ended by proposing her as a candidate.[379]

Five and a half weeks later Elizabeth Harbourne was contesting against four men for a seat in Baltinglass Electoral Division. Mrs. Harbourne (*née* Harte) was thirty-three years old, had five children and ran the family's small hotel. Baltinglass Electoral Division covered the town itself and its immediate vicinity, as well as Clogh, Deerpark, Holdenstown, Irongrange, Newtownsaunders, Raheen, Rampere and Rathmoon. Despite having a larger population than the other electoral divisions in the area, it had the same number of seats. The four other candidates contesting Baltinglass Electoral Division for the two places available were John Connolly of Knockanreagh, William Flinter of Main Street, Michael Gaffney of Newtownsaunders and William McLoughlin of Main Street. The *Leinster Leader* reported that 'over 220 out of 297 voters polled, and a feature of the election was the number of illiterates who voted'.[380] Lizzie Harbourne topped the poll with 125 votes, some 30 ahead of William Flinter, who took the second seat.

Mrs. Harbourne's husband sought election himself in Tuckmill Electoral Division, qualifying as a landholder in Goldenfort. Polling for Tuckmill and Stratford districts took place in Stratford school. Michael Harbourne evidently had a talent for the business, as 'Mr. Harbourne left all the other candidates behind in organisation. He had a brake and car chartered to bring in his supporters'.[381]

The inaugural meetings of Baltinglass Nos. 1, 2 and 3 District Councils and the first meeting of the new Board of Guardians of Baltinglass Union took place in the boardroom at the Workhouse on Saturday 15 April 1899.[382] That of Baltinglass No. 1 was the first, commencing at eleven thirty a.m., and there was a full attendance of councillors. The business of the meeting was to co-opt three members from among the magistrates who were ex-officios of the late Board of Guardians, to co-opt three members from among the ratepayers, and to elect a chairman. E.P. O'Kelly, John Ellis of Blackmoor, Dunlavin, and Peter Morrin, the miller, were selected from among the magistrates. However, when it came to the ratepayers there was some disagreement. William McLoughlin of Main Street, James Connell of Ballinabarney and James Byrne of Scurlogue were initially put forward, but there were counter proposals.[383]

One of these was made by John Neill of Tinoran. He said 'We have one lady councillor here and I think we should not leave her lonesome. I suggest that another lady be co-opted'. His suggestion was greeted by applause and continued laughter. He then handed in an amendment in favour of Alice Gardiner (formerly

Mrs. Hargrove) of Allen Dale House. In seconding the proposal, Philip Bollard of Coan gave two reasons for doing so: 'first because we should show ourselves men by selecting another lady for this board, and, secondly, because it would show a spirit of toleration that I hope will be always displayed at this board'. John Neill added 'I think you will all agree with me that it is hard to leave one lady by herself. They do not always like to talk with gentlemen, and they might like to chat with each other'. For whatever reason, his words drew more laughter from the councillors. Eventually the amendment was voted on and defeated by thirty-six votes to six. The four councillors who voted with Neill and Bollard were William George Leonard, representing Imael South, William O'Neill of Woodfield, James Wynne, representing Stratford, and Elizabeth Harbourne, but not her husband who had been advocating the election of women some weeks before. The three ratepayers originally nominated were duly co-opted.[384]

After the inaugural meeting, the next time Lizzie Harbourne attended the District Council was on 3 June, when by-laws regulating Baltinglass Market were being passed. Another item that was raised was a petition from residents for the Council to purchase a three and a half acre site referred to as Cooke's field, on Church Lane, as a recreation ground. The proposal was adopted, with the cost to fall on Baltinglass East and West townlands.[385] Perhaps the cost was found to be prohibitive as, of course, the recreation ground never materialised.

The meeting of the Board of Guardians followed that of the District Council, and a resolution submitted by Lizzie Harbourne was one of the items. It read:

> I propose that this council strongly and urgently recommend and insist on the Government to include Ireland in the old-age pension scheme now being pushed forward on behalf of the English and Scottish labourers – Ireland always being left in the background by the English Government when anything of any good is proposed for either labourer or anybody else. Let every public body insist on getting the labourers their rights, and save them from the callous and uncongenial surroundings of the workhouse.

Michael Harbourne had spoken along these lines back in February when he expressed his wife's interest in standing for election. As she had left the meeting before the resolution was raised, he moved the motion. It was seconded by James Wynne and adopted.[386] It was not until August 1908 that the Old Age Pensions Act was passed. The eligibility age was seventy and the pension was available to men and women throughout the United Kingdom.

Over the three years Lizzie Harbourne served on Baltinglass No. 1 RDC she was at only eight meetings. Her attendance was one of the lowest among the councillors.[387] She failed to attend the required number of meetings in the latter half of 1900 and was liable for disqualification. However, as explained by her husband, she and her eldest son had been ill and her son died on 21 December.[388] Lizzie Harbourne lost another child in May 1901 and another in July. She did not contest

the next election, in May 1902. There were only three candidates for Baltinglass District Electoral Division; William Flinter (outgoing), Michael Doyle of Mill Street, and Daniel J. Kehoe of Weavers' Square. Flinter did no canvassing and little interest was taken in the contest. Michael Doyle and Dan Kehoe took the seats. Michael Harbourne stood for re-election in Tuckmill DED but lost out.[389]

E.P. O'KELLY FIRST CHAIRMAN OF WICKLOW COUNTY COUNCIL
SATURDAY 22 APRIL 1899

Just four years after his first election to Parliament, E.P. O'Kelly reached another milestone in his political career in being chosen as the first chairman of Wicklow County Council. The *Nationalist* commented 'Wicklow is to be congratulated on its wisdom in putting at the head of affairs one of the most deservedly popular men in Ireland, Mr. E. P. O'Kelly, J.P.'. He was to hold the position of chairman for the first fifteen years of the council's existence.

Up to 1899 the responsibility for constructing and maintaining roads, bridges and public buildings in each county was that of a Grand Jury, a committee made up of men from the landed gentry. It was appointed rather than elected. The Local Government Act of 1898 replaced the Grand Jury with an elected County Council. For the purposes of electing the first county council, Wicklow was divided into nineteen County Electoral Divisions. Each of these was to return one councillor, with the exception of Bray, which was to return two. Therefore, there were to be twenty councillors elected. Added to this number were three Grand Jury nominees as well as the chairmen of each of the five Rural District Councils within the county. Of the nineteen CEDs, fourteen were contested.[390] In Baltinglass County Electoral Division E.P. O'Kelly was to run against Robert J.P. Saunders of Saundersgrove for a place on the Council, but Col. Saunders withdrew 'so as to save the division the expense of a contest' and O'Kelly was returned unopposed.[391]

The inaugural meeting of Wicklow County Council took place on Saturday 22 April 1899, commencing at eleven-thirty a.m. It was held at Wicklow Courthouse. The split in nationalism was still alive. O'Kelly and Denis J. Cogan of Laragh, a Parnellite, were nominated for the chair but O'Kelly was elected. He was to remain chairman of the Council up to his death in July 1914. The office would never again be occupied for such a long term. Later the practice of rotating it on a yearly basis came into effect. The next time a Baltinglass representative was to occupy the chair was 1975-1976, when Godfrey Timmins served the first of four separate yearly terms. His last term was 1996-1997. The only other chairman of the Council from Baltinglass was Thomas Cullen, who served in 1995-1996.

OPENING OF BALTINGLASS TOWN HALL
MONDAY 30 APRIL 1900

The concert held in the new Town Hall on 30 April 1900 served as a fundraiser as well as an inaugural event. The building was still not completed, but the evening was a resounding success.[392] It was the first of very many functions that were to be held in this community hall, which was built by local subscription. For over half a century the Town Hall was to be the focal point of social activity in Baltinglass.

For that first concert the committee applied to the Board of Guardians for the loan of eighty chairs[393] but presumably they got seats from other sources as well. The entertainment was to begin at eight o'clock, and by that time it was 'nigh impossible to secure even standing room in any part of the building'. Those organising the evening were E.P. O'Kelly, Ralph Dagg, William Flinter, George Leonard and John Alexander McDonald. The event was being held in the impressive ball alley and racket court. The *Leinster Leader* gives a good account of the venue:

> It is in fact one of the most remarkable features of the hall, and one of the triumphs of its energetic promoters. Spacious, lofty, well-lighted, excellently finished by the builder in all its details and covered in by a lofty roof, one half of which consists of stout glass, it combines in the most admirable manner facilities for a range of amusements generally classed as outdoor and for indoor recreations of all kinds. Upwards of 500 persons can be easily accommodated in it, and when as on Monday night, skill, resource, and decorative talent are brought into play to equip it with a suitable stage, and add various embellishments the spectacle suggests a hall specially provided for concert and dramatic purposes rather than a place mainly dedicated to purposes of sport and exercise.[394]

The other features of the Town Hall were to be a billiard room, recreation and reading rooms, and it was expected that alterations would be undertaken which would provide extra rooms for business or pastimes. Already the spacious and well lit billiard room was almost ready, and a first class table had been acquired for it. A company was being formed to administer the Town Hall and numerous applications for shares had been received.[395]

The concert included popular local amateur singers as well as artists from Dublin. Evidently their contributions went down well with the audience, as many of the songs were 'encored and "chorussed"'. Part One opened with the ubiquitous E.P. O'Kelly, who was a noted tenor, singing *The Bridge*. He followed it with *The Kerry Dance* and, for an encore, *A Bachelor*, which excited 'a perfect furore of enthusiastic applause'. Also appearing were the brothers William Frederick and Joseph Dunckley Cope.

It was an odd turn of events for the Cope brothers to be performing at the first concert in the new hall, as their father and his father before him had spent decades in charge of the building while it was the District Bridewell. Joseph Cope

was still in the family home in Main Street, while William was living in Dublin. He was a well-known singer and was 'now recognised as the foremost baritone in the country', according to the *Kildare Observer*.[396] His solo performance was one of the highlights of the inaugural concert. He sang *Holy City, The Skipper* and *Father O'Flynn*, but his choice of *The Soldiers of the Queen* drew the following comment from the *Leinster Leader* reporter:

> Notwithstanding the jingo and imperialistic associations of this song, the mixed audience received it with marked approval. The spheres of art and politics do not overlap each other so much in Baltinglass as in other places. Nevertheless songs identified with Imperialism or any other political-ism might with wisdom be avoided by those who contribute to future concerts.

It appears that the other singers, Miss Mary Carroll, Miss Ruby Ridings, Miss Figgis, Mr Fred Rohan and Mr J. Barrett McDonnell, along with the pianist who accompanied them, Miss Birrell, were from Dublin. Another local amateur, Mrs Mitchell of Ballynure, was on the programme but she did not appear because of a family bereavement.[397]

The far-sighted project of developing the site for the community began just a year and a half before the night of the concert. The following report appeared in the *Leinster Leader* on 12 November 1898:

> The Old Bridewell Baltinglass
>
> Meeting of the Inhabitants
>
> On last Friday[398] a meeting of several of the principal inhabitants of the town of Baltinglass was held in the courthouse for the purpose of buying up the old jail premises for the benefit of the town and county. Colonel R J P Saunders, D L, presided, and there was a representative attendance. Several substantial sums were guaranteed, amounting in the aggregate to a large total, and it is to be hoped that these commodious premises will be soon converted to some useful purpose. It has been urged that they would admirably suit for reading and recreation rooms, and it is quite possible that the idea will be carried out by the gentlemen who have secured them.

Those who bought the property were 'the gentry, clergy, shopkeepers, and farmers of the neighbourhood' and supposedly the cost of the purchase and building work was £600.[399]

After the Bridewell closed in 1883 the building was used for over a decade as a temporary home for Stratford Lodge School. It would appear that the exercise yard on the north side of the block was already being used for handball by the late 1880s, as a sketch map of the whole courthouse complex, drawn in 1889, indicates this as 'usually called Ball Alley'.[400]

The conversion of the site into the new Town Hall progressed quite swiftly after the initial meeting in November 1898. By April 1899 the old Bridewell had

been purchased and what was described as the 'Young Men's Institute' was about to be established. A committee chaired by E.P. O'Kelly, and including Ralph Dagg, M.J. Doyle, William Flinter and George Leonard, decided to advertise for tenders for 'the erection of a covered ballscourt, fitting up of billiard and reading rooms, and other improvements'. The plans were drawn up by J.J.O. Ramsay of Dunlavin, and tenders for the construction were to be submitted to E.P. O'Kelly, honorary secretary of the committee, by 20 May 1899, with the work to be completed by the following August. John Finn's tender of £500 was accepted.[401]

In March 1900 it was announced that the share capital would be £600, divided into 600 shares of £1 each. It was anticipated that shares in the Baltinglass Town Hall Company would sell quickly and it was reported that some people from outside the area 'who take a warm interest in the welfare of the town' had promised to invest in shares. The first statutory meeting was held at the Town Hall on 22 May 1900, almost a month after the official opening. Those present were E.P. O'Kelly (in the chair), Ralph Dagg, William Flinter and George Leonard. 400 shares had been sold by then and some 'handsome donations' had been received. It was expected that the contractor would complete the work within a fortnight, so that the ball court could be opened and the reading room could be started. It was intended to purchase a billiard table. Separate to the company set up to finance the venture, a Town Hall Club was being established. O'Kelly proposed that the annual membership fee be ten shillings for those residing within two miles of the town and that a separate membership of a billiard club should be a like amount, while commercial travellers and journalists should be admitted for five shillings.[402]

The second public event held in the new premises was a variety show in May 1900. Included was 'a display of the gramophone' and one of 'the cinematograph':

The opening scene was the entry of her Majesty the Queen through the city gates. The various pictures thrown on a twelve-foot square screen were very distinct, and much enjoyed, more especially as the vast majority of the spectators had never previously seen the cinematograph. Several humorous scenes were displayed. The one, however, that took best was one entitled *Sausage-making*. Numerous live animals were indiscriminately thrown into the machine. They included various breeds of dogs, cats, ducks (in their feathers), turkeys, an occasional rat, top boots, &c., all of which emerged beautifully fresh-coloured succulent sausages.[403]

Some six months after the opening night the *Leinster Leader* reporter commented:

As far as healthy amusement is concerned it has served to amply fill a long felt want and has admirably opened the way to social intercourse. If in other small towns in Ireland the example of the Baltinglass syndicate was imitated there would be less resort to public houses as centres of recreation.

By then several events had taken place in the Town Hall, but the first performances by a professional theatre company were held there on Monday 15 October and subsequent nights. The actors were Miss Lena Lewis' Company, and the *Leinster Leader* reporter was impressed:

> The repertoire was attractive, and Miss Lewis was supported by artistes of no mean ability. The hall was crowded to overflowing each evening, so much so, that a second week would have been entered on were it not for the fact that pre-arranged bookings elsewhere made it an impossibility.[404]

The billiard club was a popular source of recreation, though it would appear that its membership included only clergy, professional and business men, the annual fee being too much for 'workmen', and of course women did not belong to such clubs. Inter-clubs were played over the years against opponents from such places as Castledermot and Tullow. The billiard club flourished up to at least 1916, and the sport was still being pursued in 1919, while reference to a Baltinglass Billiard Club was found in 1929.[405]

The Town Hall Club was also very successful for quite some time, but it would appear that it had responsibility for the upkeep of the billiard table as well as running the ball court and the reading room for its members. At one of its meetings in 1904 it was suggested that a special fee should be set for the 'admission of the working class to the ball court and reading room', and later that year it was noted that the 'limited periodicals could be increased much to the appreciation of those whose recreation is confined more to that of literature'. By the 1910s there were considerable differences of opinion between the directors of the Town Hall Company and the committee of the Town Hall Club. At the club's half yearly business meeting on 3 January 1914 Marks Dalton, honorary secretary, reported that the company could not compel the club to repair the roof, nor could the club compel the company to do so. John T. Clarke suggested that if they did not get better terms from the company they should give up the premises and build their own hall. This suggestion seems to have been given serious thought at the meeting. The company agreed to make improvements, but in 1916 the club was again approaching the company about repairs. In December 1916 another agreement was reached, but the following month the members were still complaining about the condition of the building.[406]

In November 1917 Harry Reid was prosecuted for using the Town Hall 'for gaming purposes during the recent cinema productions there'. In November 1918 the Army was billeted there and a request from the soldiers to use the baths in the Workhouse was refused by the Board of Guardians as they had enough problems, 'the whole place being filled with influenza patients'. In November 1919 the Town Hall Company held an extraordinary general meeting to consider a resolution for voluntary liquidation. An amendment was proposed by Denis Kenna and seconded by J.H. Grogan, postponing the decision for a month to allow the shareholders

and the Town Hall Club to confer. At a subsequent meeting of the club Kenna pointed out that if they wanted to save the facility they would have to buy shares from those who wanted to sell, and a deputation was appointed to meet the shareholders. The outcome is unclear, but there was no immediate liquidation.[407]

In April 1920 the Town Hall was damaged when the Courthouse was completely destroyed by fire. Part of the building had to be thrown down to arrest the spread of the flames and the glass roof on the ball court was shattered by the heat. In October 1920, during the War of Independence, Webbs' general store was commandeered and the business was transferred to the Town Hall, Joseph Turtle paying the Town Hall Club £25 per annum for that part of the premises used. The business operated out of the premises until the summer of 1923. Eventually in December 1925 the Town Hall was sold by the liquidator to Andrew J. Doyle of Terenure, Dublin, formerly of Baltinglass. The premises continued to operate as a function hall, but under private ownership. It would appear that it remained in Andy Doyle's hands for some time, as his brother, Tommy Doyle of Main Street, was mentioned as manager of the hall in 1933.[408]

By the end of 1935 the name of Father Whitney of St. Patrick's College, Kiltegan, was associated with the Town Hall. On St Stephen's Night 1935 he presented a series of pictures there. It was used for dances, concerts and cinema presentations in the next few years. It was under the ownership or management of a number of people, including Walter Keogh of Carlow, who used it as an egg depot as well as its other functions. The LSF had use of it for training and for running functions during part of the Emergency.[409] Under the ownership of the Hughes family it again became a focus for dances, though it had competition through the years from the Golf Pavilion. In the mid-1950s it was sold to E. Morrin & Sons and became a grain store. In the 1980s it was leased to Baltinglass Badminton Club. In the 1990s it was sold by Morrins and converted into a heritage centre, and Baltinglass Library moved into its upper floor in 2000.

All sorts of organisations used the Town Hall during the half century it functioned as a place of entertainment and gatherings, under community and private management. Such long forgotten organisations as the Heather Club and the Quadrille Club, as well as the Town Tenants' Association, the Dwyer and McAllister Memorial Committee and the Gaelic League, met there in the early twentieth century, along with the Cricket Club, the GAA and Carrigeen Coursing Club. A number of amateur dramatic clubs formed and disbanded through the years, but they all graced the stage of the Town Hall. Touring companies paid occasional visits, and the time the boxer Jack Doyle and his film star wife Movita stopped off at the Town Hall was remembered for years. In 1914 the Irish Volunteers gathered there, as did the LSF during the Emergency, and the two opposing factions during the Battle of Baltinglass used the venue for their protest meetings. The Town Hall played an enormous part in the life of the town throughout the first half of the twentieth century.

ST JOHN OF GOD SISTERS COME TO THE WORKHOUSE
WEDNESDAY 7 NOVEMBER 1900

The Presentation Convent was so long a part of Baltinglass that there is little or no memory of the presence of another order of nuns in the town for part of the same period. The St John of God Sisters provided nursing care in the infirmary of Baltinglass Workhouse for the first two decades of the twentieth century. The idea of introducing nuns to the Workhouse was mooted more than a year before their arrival. The Board of Guardians appointed a committee to make the necessary arrangements in September 1899. The clerks of various Poor Law Unions in which nuns were working were asked their advice. It was noted that as well as being satisfactory workers, nuns would demand smaller salaries than lay nurses and would not require a pension.[410]

In February 1900 the Guardians received a letter of resignation from Maryanne Harmon, the work-mistress in the Workhouse school. This prompted them to replace her with a nun, so Miss Harmon was asked to remain until the nuns arrived.[411] Later that month the Board's engineer presented his plans for the nuns' apartments and subsequently the local contractor John Finn was given the contract for building them.[412]

While the building was under way, contact was made with the St John of God Convent in Wexford. By September it was known that Sister Alphonsus Cahill would be the new nurse, while Sisters Josepha Corboy and Celestine McDonald would be assistant nurses. They arrived two months later, accompanied by their Superior, Sister Clare Stafford, who remained with them for a few days. They were entertained by the Presentation Sisters in St. Joseph's Convent. On Wednesday 7 November they took up duty in the infirmary.[413] About a month later Sister Agatha Manning was appointed as teacher for the girls in the Workhouse school.[414] In February 1901 another nun, Sister Francis Burke, was sent from Wexford to take up the post of nurse in the Workhouse's fever hospital.[415]

The St John of God Sisters continued as nurses and teachers at Baltinglass Workhouse for almost twenty years. They were praised by Martin Gleeson, chairman of the Board of Guardians, for their 'devoted and untiring energies' during the 'flu epidemic in 1918. He said that 'the grateful feelings on the part of the general public will linger when this awful visitation will be but a memory'.[416] In September 1919 four St John of God Sisters, the head nurse in the fever hospital, the head nurse and assistant in the infirmary, and the teacher, resigned their positions at the Workhouse, due to 'changes in the Institution'. At the time Dr Kenna said that they 'could not have had more capable nurses'.[417]

The Annals of St Joseph's Convent mention under November 1919 that 'About this time' the Workhouse was closed and St John of God nuns returned to their mother house in Wexford. However, the Workhouse functioned as normal until May 1920, when it was commandeered by the military. It appears that the nuns, or some of them, were still there at the time, as two months later their order made a claim for the nuns' salaries and the value of their rations. The Guardians unanimously agreed to comply with the request.[418]

BALTINGLASS IN 1901

Fifty years is a long time in the evolution of a town, and between 1851 and 1901 there were many changes to life in Baltinglass. Perhaps the most noticeable one was the coming of the railway. Its opening in 1885 brought the town closer to Dublin. In doing so it facilitated dealers coming to the Baltinglass Fair and gave the town greater importance among farmers in the general area as a centre for collection, marketing and distribution. By 1901 the railway had been part of Baltinglass for a decade and a half and dependence on the mail coach as the sole source of public transport was a distant memory.

As chairman of Wicklow County Council and Baltinglass Board of Guardians, a renowned 'ex-suspect' and a one time MP, a driving force behind the Town Hall and the 1798 memorial committee, E.P. O'Kelly was unquestionably the leading citizen of Baltinglass in 1901. Two decades had transformed him from a young political agitator into the personification of the new nationalist establishment.

Perhaps the most fundamental change in Baltinglass between 1851 and 1901 was the shift in political control of local matters from the landlords to the national-ist majority, reflecting the transition that happened in most parts of Ireland. The strength of the Land League in the Baltinglass area fostered a strong political move-ment. From being a minority on the Baltinglass Board of Guardians in the early 1880s, the nationalists increased their influence to such an extent that by 1895 they were in a position to elect O'Kelly as chairman of the Board. The Local Government Act of 1898, in replacing the landlord-controlled Grand Jury with a mainly elected county council, further strengthened the nationalists. It also established the Rural District Councils, allowing for greater local control of housing and infrastructures than existed before or since. The Act extended the vote in local elections to proper-tied women and made them eligible to serve on RDCs and Boards of Guardians. Up to the 1899 local elections, the only examples rural Ireland had of democracy were the parliamentary elections and, on a local level, the appointment of the Boards of Guardians. The county councils and RDCs provided an extension of democracy.

The arrival of the railway brought about the only major changes to the shape of the town over the period. It necessitated the dissection of the Ballytore Road, with the lower part becoming Station Road (the entrance to the railway station) and the upper part being joined to Belan Street by a new link road. Otherwise the general appearance of the town remained the same on the map. However, several promi-nent structures appeared in the second half of the nineteenth century. St Joseph's

church, which was only partly built in 1851 was by 1901 the most dominant feature in the town, with its tower visible from many angles. On the approach to the town along the Carlow Road at Bawnoge, the church and the Presentation Convent beside it gave the place a more scenic look than it ever had before. The tower of St Joseph's could also be seen in the distance on the Dublin Road, and this approach to Baltinglass still had the familiar ruins of the Abbey Church. However, beside them now stood the new Church of Ireland place of worship, St Mary's. Across the river the Dublin Road entered the town beside the mill. With its mill wheel and stout castellated granite grain stores, it presented a picturesque approach to the town that almost certainly was unaltered since 1851. Standing above the town in the parkland on the side of Tinoran Hill were the ghostly ruins of Stratford Lodge, a physical reminder of the demise of the once all important owners of the town, the Earls of Aldborough.

Within the town the general pattern of two storey buildings had been dramatically altered with the addition of two particularly noticeable large premises. In Mill Street, beside the bridge, stood the relatively enormous business house built in the mid-1860s by the Chandlee family. By 1901 it was owned and run by Herbert Webb as one of the main shops in the town. Across the bridge in Main Street was the three-storey National Bank. This was built on the site of Dr. Heath's old house in the late 1870s as a new premise for the Munster Bank. After the Munster Bank failed in the mid-1880s, the building was acquired by the National Bank. Further up Main Street, on the north side, was another three storey building that served as E.P. O'Kelly's business premises. Other three storey houses in Main Street were Neills' on the south side and two adjoining houses on the north side. One was then unoccupied while Dr. McDonald lived in the other. His had been the National Bank's first home in Baltinglass before it moved across the street.

While Baltinglass did not grow between 1851 and 1901, there were some changes to the population distribution. In 1851 there were several poorer dwellings on the east side of Weavers' Square, some of them behind other houses in what would appear to have been little more than outhouses. By 1901 these dwellings were gone, but Tan Lane and Church Lane were then accommodating about seventeen poorer families in less than ideal conditions. Local authority housing was beginning to have an impact and the dwellings built were solid structures. They consisted of individual houses scattered about the area, with the exception of the four built together on the Bawnoges Road near the top of Belan Street.

As well as the Roman Catholic and Church of Ireland places of worship, the Methodist chapel was still there, and the Plymouth Brethren now had a small meetinghouse. Two religious orders had a presence in Baltinglass in 1901 where there had been none in 1851. The Presentation Sisters were now almost three decades in the town, while the St John of God Sisters had just arrived to minister in the Workhouse. Both were involved in education. The Workhouse school was an addition since 1851. The girls' school run by the Presentation Sisters had been part of Baltinglass National School in 1851. It was still in existence as the boys'

school, while Stratford Lodge School was also running, though in a new location. Institutions that vanished since 1851 were the Infirmary in Main Street, closed in 1868, and the Bridewell, closed in 1883. On the site of the latter was the new centre of social activity, the Town Hall.

The only real sources of employment were the mill and individual shops, while farms in the area provided work for agricultural labourers. There had been two banks in the town in the 1870s and early 1880s but by 1901 there was only the National Bank. Markets and fairs were an important part of the Baltinglass economy. Where there had been ten fairs a year there were now twelve, occurring on the third Tuesday of each month.

Baltinglass had a literary and debating society and a cricket club. Its new Town Hall incorporated a billiard club. The Dwyer and McAllister Memorial Committee were gathering money to build a 1798 memorial in Main Street. The town had, or was about to have, a new Gaelic football club called the Young McAllisters. Shortly afterwards the hurling and hockey clubs were in existence. In January 1900 the literary and debating society was organising its annual concert for the following month, and a matinee was to be held in aid of the widows and orphans of Irish soldiers who had died in the 'Transvaal War'.[419]

The Boer War was in progress in 1901 and it touched the lives of several Baltinglass families. Two young men from the town who served in the South African war were John Groves and John McCormack. Groves lived to a ripe old age, dying in the 1970s, while his friend McCormack never returned from the war. George Brereton of Weavers' Square also served in South Africa. At the time of the 1901 Census he was at home in Baltinglass and was described as a 'Natal volunteer'. Joseph Lindsay of Church Lane, but originally from Dunlavin, served in the Boer War from 1899 to 1902 with the Royal Irish Fusiliers.[420] Another Baltinglass man who was in the war was Jim Doyle of Mill Street who later drilled the Irish Volunteers.

By 1901 entertainment around Christmas and New Year for the inmates of Baltinglass Workhouse was well established as an annual event. It had been organised by Elizabeth Grogan of Slaney Park for years, and she was to continue running it for years to come. In 1901 it took place on 9 January. In the boys' school of the Workhouse, tobacco and snuff were distributed to the elderly, and toys to the children. Then in the girls' school there was a musical entertainment, with many of Mrs. Grogan's friends performing.[421]

In late 1900 there was a typhoid fever outbreak in the area and cases were taken to the Workhouse fever hospital. Kate Synnott (*née* Groves), a paid wards-maid, contracted the disease and died on 18 January 1901.[422] January 1901 also saw the death of Queen Victoria, who had been monarch since 1837. At St Mary's Church of Ireland the pulpit, reading desk and altar were draped in black. At the next meeting of Baltinglass Board of Guardians, a vote of sympathy to King Edward on the death of 'his august mother, Queen Victoria' was passed unanimously. Those present were all Roman Catholic and predominantly nationalist.[423]

BALTINGLASS 1901
ADMINISTRATION

County Councillors (resident within the Baltinglass area):
Edward P. O'Kelly, St. Kevin's (Chairman of Wicklow County Council)
Deputy Lieutenant for County Wicklow: Robert J.P. Saunders, Saundersgrove
Board of Guardians for Baltinglass Poor Law Union:
Chairman- Edward P. O'Kelly, St. Kevin's.
Vice-Chairman- William Flinter, Main Street;
Deputy Vice-Chairman- William Burgess, Tobinstown, Rathvilly
Baltinglass No. 1 Rural District Council:
Chairman- James H. Coleman, Griffinstown, Dunlavin;
Vice-Chairman- John Rochford, Dunlavin Division
Justices of the Peace (resident within the Baltinglass area):
Thomas B. Doyle, Main Street
William E. Grogan, Slaney Park
Peter P. Morrin, Mill Street
Edward P. O'Kelly, St. Kevin's
Robert J.P. Saunders, Saundersgrove
Clerk to the Board of Guardians & Returning Officer:
J. Ralph Dagg, Holdenstown Lodge
Clerk of Petty Sessions Court:
William J. Moore, Weavers' Square
Registrar of Births, Deaths & Marriages:
Thomas B. Doyle, Main Street
Coroner:
Thomas B. Doyle, Main Street

Rural District Councils

Councillors elected (for a 3 year term) in 1899 to Baltinglass Nos. 1, 2 & 3 Rural District
 Councils for each District Electoral Division, & Councillors co-opted in April 1899;
 all members of the three Rural District Councils were also members of the Board of
 Guardians for Baltinglass Poor Law Union.
[Divisions marked (*) at least partly cover the Baltinglass area dealt with in the Street
 Directories]

Baltinglass No. 1 (Co. Wicklow)
Chairman: James H. Coleman, Griffinstown
Vice-Chairman: John Rochford, Dunlavin Division
Ballinguile Division:
Laurence Byrne
Timothy Kelly
Baltinglass Division*:
William Flinter, Main Street
Elizabeth Mary Harbourne, Bridge Hotel
Donaghmore Division:
John J. McGrath
Thomas Toole

Donard Division:
Edward Lennon
Edward Synnott
Dunlavin Division:
James Cunningham
John Rochford
Eadestown Division:
Hugh Byrne
Daniel McDonnell, Coolinarrig
Hartstown Division*:
John Neill, Tinoran
Patrick Rourke
Hollywood Division:
James Dunne
Bartle McDonnell
Humewood Division:
Edward Cusack
John Farrell
Imael North Division:
Philip Bollard, Coan
Michael Kelly
Imael South Division:
Thomas Finlay
William George Leonard
Lugglass Division:
Peter Murphy, jun.
John Reilly
Rathdangan Division:
Christopher Toole
Edward Whelan
Rathsallagh Division:
Edward Butterfield
James Norton
Stratford Division:
Thomas Doyle
James Wynne
Talbotstown Division*:
William Byrne
William O'Neill, Woodfield
The Grange Division:
James Henry Coleman, Griffinstown
Matthew Murphy
Tober Division:
Edward McDonald
Thomas Metcalfe
Togher Division:
Patrick Fitzpatrick
James Mahon

Tuckmill Division*:
Michael Harbourne, Bridge Hotel, Baltinglass
Patrick Murphy
Co-opted Magistrates:
John Ellis, Jun., Blackmoor, Dunlavin
Peter P. Morrin, Mill House, Mill Street
E.P. O'Kelly, St. Kevin's, Church Lane
Co-opted Ratepayers:
James Byrne, Scurlogue
James Connell, Ballinabarney
William McLoughlin, Main Street[424]

Baltinglass No. 2 (Co. Carlow)
Chairman: William Burgess, Tobinstown
Vice-Chairman: Pierce Butler, Coolmanagh
Clonmore Division:
Edmond J. Ferris, Ballynakill
Maurice Roche, Ballyshane
Hacketstown Division
Patrick Cullen, Hacketstown
Nicholas O'Toole, Scotland
Haroldstown:
Pierce Butler, Coolmanagh
William Dempsey, Coolmanagh
Kineagh Division:
Patrick Finnegan, Raheendaw
James Molloy, Straboe
Rahill Division:
William Burgess, Tobinstown
Patrick Dowling, Broughillstown
Rathvilly Division:
John Donnelly, Broughillstown
Stephen Doyle, Knockevagh
Tiknock Division:
John Browne, Barnhill
Joseph Keane, Tiknock
Williamstown Division:
William Keely, Williamstown
William Salter, Ballybit
Co-opted Magistrates:
William E. Jones, Woodside, Hacketstown
William Murphy, Ballykillane, Hacketstown
Edward Wilson, Rathmore Park, Rathvilly
Co-opted Ratepayers:
James Browne, Knocklishen
John Hutton, Hacketstown
Michael Nolan

Baltinglass No. 3 (Co. Kildare)
Chairman: John Kelly, Ballitore
Ballitore Division:
Owen Connor
John Kelly, Ballitore
Carrigeen Division:
John Donohoe
John J. Heydon, Broadstown
Graney Division:
John Forbes
Patrick Kavanagh, Davidstown
Co-opted Magistrates:
Patrick P. Farnan, Bolton Castle
John Germaine, Graney
E.P. O'Kelly, St. Kevin's, Baltinglass
Co-opted Ratepayers:
Owen Cogan, Mullamast House, Ballitore
John Nolan, Glowens
P Whelan, Simonstown

Organisations
Baltinglass Cricket Club (may no longer have been in existence by 1901)
Baltinglass Literary and Debating Society (may no longer have been in existence by 1901)
Baltinglass Town Hall Billiard Club
Baltinglass Town Hall Committee
Dwyer and McAllister Memorial Committee
Young McAllister Gaelic Football Club (may not have been in existence as early as 1901)

PUBLIC TRANSPORT
TRAINS
2 or 3 trains daily stopping at Baltinglass to and fro between Tullow and Dublin
(Kingsbridge Station) via Sallins

STREET DIRECTORY
The following appeared in the 1901 Census in the town, within Baltinglass East townland,
but their exact location cannot be determined:
A) Coogan, Sarah, working woman
B) Doyle, Julia, charwoman

Ballytore Road, Baltinglass West townland (see County Road; Station Road)

Bawnoge ['Bawnoges'] townland, (see Bawnoges Road, Carlow Road, Edward Street
& Rathvilly Road)

Bawnoges Road, Baltinglass West & Bawnoge townlands
East Side
(Belan Street to 'Clough Cross')
[Baltinglass West townland]

1 see No. 4 Belan Street [ruins]

2 ruins

[Bawnoge townland]

no houses here

West Side

('Clough Cross' to Belan Street)

[Bawnoge townland]

3 Fleming, Patrick, agricultural labourer, Fleming, Bridget, his wife

4 Doyle, Thomas, gardener/ domestic servant, Doyle, Annie, his wife

[Baltinglass West townland]

5 Humphries, Mary, charwoman

6 Byrne, Michael, agricultural labourer, Byrne, Patrick, his son, agricultural labourer, Byrne, Margaret, his daughter

7 Lynch, John, agricultural labourer, Lynch, Mary, his sister, Lynch, John, his nephew, agricultural labourer

8 Cashin, John, agricultural labourer, Cashin, Mary, his wife

9 Lawlor, John, agricultural labourer, Lawlor, Rose, his wife, Lawlor, Bridget, his daughter, general domestic servant, Lawlor, Margaret, his daughter, general domestic servant

Belan Street ['Cuckoo Lane'], Baltinglass West townland

North Side

(Mill Street to Brook Lane)

1 see No. 29 Mill Street [Michael Doyle]

2 out offices owned by Michael Doyle

[here bridge over railway]

[here joins County Road]

[here street bounded by a field]

3 ruins

[here space with no houses]

South Side

(Bawnoges Road to Edward Street)

4 ruins

5 Doherty, James, Doherty, Michael, his brother

6-7 ruins

8 Kenny, Christopher, agricultural labourer, Kenny, Margaret, his wife

9 Lusk, Elizabeth, charwoman[425]

10a Doherty, Patrick, Carr, Patrick, lodger, agricultural labourer

10b Doyle, John, agricultural labourer, Doyle, Mary, his wife

11 ruins

12 Fleming, Thomas, agricultural labourer, Fleming, Kate, his wife, Fleming, Mary, his daughter, dressmaker in Main Street, Fleming, Annie, his daughter, dressmaker in Main Street

13 ruins

14 ruins

15 ruins

16 ruins

[here space with no houses]

17 ruins

18 Gorman, Patrick, agricultural labourer
[here laneway to 'Gallows Hill']
19 Nolan, Charles, agricultural labourer, Nolan, Elizabeth, his wife
20 Nolan, Mary, charwoman, Nolan, Edward, her son, agricultural labourer
21 Groves, James, agricultural labourer, Groves, Anne, his wife, Sutton, Katherine, his
 daughter, charwoman, Sutton, Laurence, his son-in-law, agricultural labourer
22 Cashen, Teresa, lodging house keeper, Leigh, Elizabeth, her daughter, charwoman,
 Fennell, John, lodger, agricultural labourer, Redmond, John, lodger, agricultural
 labourer
23 Groves, John, agricultural labourer, Groves, Elizabeth, his wife
24 Murphy, Joseph, agricultural labourer, Murphy, Anne, his wife, Foley, Margaret, lodger,
 Shea, Margaret, lodger
25 Connell, Ellen, charwoman, Connell, Patrick, her son, agricultural labourer, Connell,
 Katherine, her daughter-in-law, Kearney, William, lodger, agricultural labourer
26 English, Ellen, lodging house keeper, Dunne, Margaret, lodger, Ross, John, lodger,
 general labourer
[here bridge over railway]
27 Kenny, Margaret, charwoman, Kenny, James, her son, agricultural labourer
28 Deegan, Katherine, charwoman, Deegan, James, her son, agricultural labourer,
 Deegan, Elizabeth, her daughter
29 Doyle, James, agricultural labourer, Doyle, Anne, his wife, Doyle, Patrick, his son,
 agricultural labourer
30 Abbott, Laurence, agricultural labourer, Abbott, Anne, his wife
31 Murphy, James, shoemaker, Murphy, Mary, his wife, Murphy, John, his son, agricul-
 tural labourer, Murphy, Stephen, his son, miller, Hickey, Thomas, lodger, agricultural
 labourer, Ryan, John, lodger, agricultural labourer, Ryan, Katherine, lodger
32 Cummins, James, lodging house keeper, Cummins, Mary, his wife, Kane, James,
 lodger, agricultural labourer, Kavanagh, Michael, lodger, brush maker, Kavanagh,
 Mary, lodger, Keating, Michael, lodger, Keating, Mary, lodger, Mitchell, William,
 lodger, Mitchell, Susan, lodger, Pender, Daniel, lodger
33 Lynch, Patrick, agricultural labourer
34 Crowe, Peter[426], agricultural labourer, Crowe, Elizabeth, his wife

The Bridge, Baltinglass East & Baltinglass West townlands
South Side
(Edward Street to Main Street)
[Baltinglass West townland]
1 see No. 35 Edward Street [Joseph Hutton]
2 Clancy, Thomas, bootmaker, Clancy, Mary, his sister, dressmaker, Clancy, John[427], his
 brother, bootmaker, Clancy, Edward, his brother, servant
[here River Slaney]
[Baltinglass East townland]
3 see No. 1 Main Street [John Clarke]
North Side
[Baltinglass East townland]
4 see No. 61 Main Street [Michael Harbourne]
5 see No. 62 Main Street [Mary & Annie Fleming]
[here River Slaney]

[Baltinglass West townland]
6 see No. 1 Mill Street [J. Herbert Webb]

Brook Lane, Baltinglass West townland (between Belan Street / Rathmoon Road &
 Ballytore Road / Tinoran Road)
East Side
1 Byrne, Patrick, agricultural labourer, Byrne, Maria, his wife
West Side
no houses here

Cabra Road, Rampere, Rampere townland(between the 'Five Crossroads' &
 Goldenfort)
no houses here
[road continues into Goldenfort townland]

Carlow Road, Bawnoge, Irongrange Lower & Irongrange Upper townlands
West Side
(Edward Street to Carrigeen)
[Bawnoge townland]
no houses here
[here bridge over railway]
no houses here
[here 'Clough Cross'; Tullow Old Road & Rathvilly Road intersect]
no houses here
[Irongrange Lower townland]
1 Hunt, Thomas, farmer, Hunt, Mary, his wife
[Irongrange Upper townland]
no houses here
[road continues into Carrigeen, Co. Kildare at this point]
East Side
(Carrigeen to Edward Street)
[Irongrange Upper townland]
2 Irongrange House (entrance to), Lalor, Michael, farmer, Lalor, Maria, his wife, Lalor,
 Patrick, his brother, caretaker, Hunt, Christopher, employee, agricultural labourer,
 Donnelly, Kate, employee, general servant, Delaney, James, lodger, farm servant
[Irongrange Lower townland]
[here shared entrance to No. 3 of Irongrange Lower and No. 3 of Irongrange Upper
 townland]
[Bawnoge townland]
no houses here
[here 'Clough Cross'; Tullow Old Road & Rathvilly Road intersect]
3 out office owned by William Prendergast
[here bridge over railway]
no houses here

Cars' Lane, Baltinglass East townland, (see Chapel Hill)

Carsrock townland
2 Timmins, Michael[428], farmer, Timmins, Sarah, his wife

Chapel Hill, Baltinglass East townland
South Side
(Weavers' Square/ the Fair Green to Sruhaun Road, including Cars' Lane)
1 Brady, Joseph, tailor, Brady, Martha, his sister, housekeeper, Mellon, Patrick, boarder, tailor
2 Byrne, Elizabeth[429]
3 unoccupied house[430]
4 Boys' National School
principal: Patrick Heydon
other teachers: Matthew Byrne & James Carty
monitor: Garret Byrne
5 Harris, John, agricultural labourer, Harris, Mary, his wife, Harris, Kate his daughter, dressmaker
(Cars' Lane south side)
6 ruins
7 (entrance to)
a St Joseph's Presentation Convent
Comerford, Harriet (Mother Joseph), Superior of community, National School teacher, Barrett, Anastatia (Mother Agnes) nun, National School teacher, Byrne, Julia (Sister De Sales) nun, National School teacher, Carolan, Marcella (Sister Ignatius) nun, National School teacher, Casey, Anne (Sister Evangelist) nun, National School teacher, Ennis, Margaret (Sister Bernard) nun, National School teacher, Heydon, Catherine (Sister Catherine) nun, domestic duties, Hussey, Isabella (Mother Augustine) nun, National School teacher, McEniry, Mary (Sister Teresa) nun, National School teacher, O'Reilly, Josephine (Sister Aloysius) nun, National School teacher, Scurry, Catherine (Sister Clare) nun, National School teacher, Whelan, Mary (Sister Francis), nun, domestic duties
b St Joseph's Girls' National School
teachers: Mother Joseph Comerford, Mother Agnes Barrett, Sister De Sales Byrne, Sister Ignatius Carolan, Sister Evangelist Casey, Sister Bernard Ennis, Mother Augustine Hussey, Sister Teresa McEniry, Sister J. O'Reilly & Sister Clare Scurry
monitors: Mary Ellen Abbey, Mary Anne Harris & Jane Curham
8-11 ruins
[here space with no buildings]
(Cars' Lane north side)
12 Baltinglass Roman Catholic Graveyard
13-14 ruins
(Cars' Lane to Sruhaun Road)
no houses here
North Side
(Sruhaun Road to the Fair Green, Main Street)
[next five properties (15-19) a row of small houses running west off Chapel Hill]
15 Brien John, agricultural labourer, Brien, Mary, his wife
16 Conway, Catherine , widow of farm labourer
17 Doyle, James, labourer, Doyle, Bridget, his wife, Doyle, Martin, his son, labourer
18 Brien, Denis, general labourer, Brien, Kate, his wife, Brien, Margaret, his mother
19 Noon, John[431], dealer, Noon, Mary, his wife
20 Brennan, Daniel,[432] general labourer, Brennan, Anne, his wife
21 ruins

22 out office owned by John Jackson

23 Leigh, John, car owner, Leigh, Bridget, his wife

24 Byrne, Peter, car owner, Byrne, Bridget, Byrne, Timothy, car owner

25 Hennessy, William general labourer, Hennessy, Kate, his wife, Hennessy, Julia, his daughter, servant

26 Kendrick, Anne, charwoman, Curham, Emily, her daughter, laundress

27 Wilson, Peter[433], general labourer, Wilson, Mary, his wife, Coates, Margaret, lodger

28 Butler, Michael, car owner, Butler, Ellen, his wife, Baigel, Maurice, boarder, peddler

29 O'Brien, Mary, bacon merchant, O'Brien, Winifred, her daughter, O'Brien, Katherine, her daughter

Church Lane, Baltinglass East townland
East Side
(Main Street to the Abbey)

1 see No. 60 Main Street [Michael Lalor]

[here side entrance to No. 59 Main Street]

2 Wall, John, car owner, Wall, Mary, his wife, dressmaker

3a Kearney, Thomas, farm labourer, Kearney, Anne, his wife

3b Evans, Kate, seamstress, Hanrahan, Kate, her daughter

4 Crowe, Mary, general labourer, Crowe, Bridget, her step-daughter, general labourer

5 Byrne, Patrick, agricultural labourer, Byrne, Anne, his wife

6 Ellis, Eliza, McGeer, James, her son-in-law, agricultural labourer, McGeer, Eliza, her daughter

7 Lindsay, Eliza[434], agricultural labourer, Burke, Honora, Eliza's mother

8 Brien, Elizabeth, seamstress

9 Ryder, Nicholas, boot maker, Ryder, Anne, his wife

10 Whittle, Edward, baker

11 unoccupied

12 Doyle, Terence, carpenter, Doyle, Jane, his sister, general domestic servant

13 Devoy, James, agricultural labourer, Devoy, Ellen, his wife

14 Stratford Lodge National School

schoolmaster: Claud H. Sweeny

teacher: Margaret Cooke

14a Sweeny, Claud Henry, schoolmaster, Sweeny, Susan Grace, his wife, Sweeny, Amy, his daughter, music teacher

14b Cooke, Margaret, school teacher

[here space with no buildings]

15 The Rectory[435], Usher, Rev. John, Rector of Baltinglass, Usher, Mary, his wife, Usher, John George, his son, superannuated Civil Service 1st class clerk, Kennedy, Mary, employee, general domestic servant

16 St Mary's Church of Ireland

parish church

Rector: Rev. John Usher

17 Baltinglass Abbey (ruins of)

West Side
(Abbey to Main Street)

[here space with no buildings]

18 Deegan, Patrick, private income, Deegan, James, his son, post office employee

19 Hoey, William, carrier, Hoey, Catherine, his mother, Hoey, Julia, his sister, dress-
 maker, Hoey,.Mary, his sister, dressmaker
20a Plymouth Brethren Meetinghouse[436]
20b Baltinglass Dispensary[437], medical officer: F.J. Cruise, Main Street
20C St. Kevin's, O'Kelly, Edward Peter, merchant, auctioneer & public representative,
 O'Kelly, Judith, his wife
21 see No. 61 Main Street [Michael Harbourne]

Cloghcastle ['Clough Castle'] townland, (see also Rathvilly Road)
2 Kinsella, Philip, farmer, Kinsella, Dora, his wife, Kinsella, Richard, his father, retired
 farmer
5 herd's house owned by Mary Earle

Clogh ['Clough'] Lower townland, (see also Rathvilly Road)
5a Fennell, Peter, farmer, O'Meara, Ellen, his sister
7a Kehoe, Anne, farmer

Clogh ['Clough'] Upper townland, (see Rathvilly Road)

Colemans' Road, Raheen & Rampere townlands
West Side
(Dublin Road to the 'Five Crossroads')
[Raheen townland]
no houses here
[here bridge over railway]
no houses here
[Rampere townland]
no houses here
East Side
('Five Crossroads' to Dublin Road)
1 Keenan, Michael, farmer, Keenan, Kate, his wife
[here joins Cabra Road]
2 Coleman, Matthew, farmer, Coleman, Maria, his wife
3 Doyle, Richard, herd, domestic servant, Doyle, Margaret, his wife
[Raheen townland]
no houses here
[here bridge over railway]
no houses here

County Road[438], Baltinglass West townland
East Side
(Belan Street to Tinoran Road / Brook Lane)
[here road bounded by the railway cutting]
1 Station House (entrance to)[439], Cott, David, station master GS&W railway, Cott,
 Nicholas, his son, clerk, Cott, Gerald, his son, grocer's assistant, Marmion, Thomas,
 lodger, railway porter
[here County Road turns west]
North Side
no houses here

South Side
(Brook Lane to Belan Street)
2 Sharpe, George, millwright in Morrins'
Sharpe, Margaret, his wife
3 Doogan, Margaret[440]
4 Dunne, Henry, carter, domestic servant, Dunne, Anne, his wife, Kelly, Edward, boarder, labourer
5 Conway, Patrick, agricultural labourer, Conway, Mary, his wife
[here County Road turns south]
West Side
no houses here

Cuckoo Lane, Baltinglass West townland (see Belan Street)

Deerpark townland, (see also Kiltegan Road)
2 Moore, John, farmer, Moore, Anne, his wife, Moore, Patrick, his son, Moore, Julia, his daughter, Moore, Elizabeth, his daughter
3ADoyle, Thomas, farmer, Doyle, Maria, his wife
6 Workhouse graveyard

Dublin Old Road, Baltinglass East, Sruhaun & Tuckmill Upper townlands (see Sruhaun Road)

Dublin Road, Stratfordlodge, Raheen & Tuckmill Upper townlands
West Side
(Mill Street to Eldon Bridge)
[Stratfordlodge townland]
[here livestock loading bank for Railway Station]
[here 'The Lord's Piers'; right-of-way to properties in Stratfordlodge townland]
no houses here
[here joins Raheen Hill Road]
1 Slaney Lodge, Anderson, Emily, house property, Anderson, Rebecca, her sister, house property Henry (or Heney?) Mary, employee, general servant
[Raheen townland]
no houses here
[here joins Colemans' Road]
no houses here
[here Eldon Bridge; road crosses River Slaney]
[Tuckmill Upper townland]
2 Ward, Edward, carpenter, Ward, Elizabeth, his wife
[here 'Tuckmill Cross'; here joins Rathbran Road]
[Tuckmill Lower townland]
3 Phillips, James, oat meal miller, Phillips, Thomas, his son, mill clerk, Phillips, Julia, his daughter, unemployed cook
[Saundersgrove townland]
[here entrance to Saundersgrove estate – see under Saundersgrove townland]
4 Glover, William[441], land & stock steward, Glover, Mary, his wife
[Saundersgrovehill townland]
[here the 'Hangman's Corner']

5 (entrance on road to Manger Bridge), Williams, Thomas, farmer, Williams, Thomas, his
 son, agricultural labourer, Williams, Andrew, his son, Williams, Maria, his daughter
[here joins road by Manger Bridge to Stratford]
no houses here
[road continues into Ballinacrow Upper at this point]
East Side
(Ballinacrow Upper to Mill Street)
[Saundersgrovehill townland]
6 Brady, Henry, agricultural labourer, Brady, Ellen, his wife
[here the 'Hangman's Corner']
7 Saundersville, Douglas, Peter James, farmer, Douglas, Harriet Emily, his wife, Douglas,
 Samuel Marlborough, his uncle, Douglas, William Charles, his brother, farmer,
 Douglas, Thomas Winder, his brother, clerk, Murphy, James, employee, farm servant
[Tuckmill Lower townland]
8 Phillips, corn mill operated by James Phillips, (residence opposite)
9 Doyle ('Doyles of the Shop') Doyle, Mary, grocer & provision dealer, Doyle, James, her
 son, cattle dealer, Doyle, Kate B, her daughter, shop assistant
[here 'Tuckmill Cross'; here joins Kilranelagh Road]
[Tuckmill Upper townland]
10 Dempsey, Anthony, farmer, Hunt, Catherine, employee, general servant, Whittle,
 Martin, employee, farm servant
11 Kelly, Richard, farmer, Kelly, Mary, his wife
12 vacant[442]
[here joins Sruhaun Road]
no houses here
[here Eldon Bridge; road crosses River Slaney]
[Raheen townland]
13 Mahon, Thomas, agricultural labourer, Mahon, James, his brother, agricultural
 labourer
14 Conroy, Patrick, agricultural labourer, Conroy, Mary, his wife, Conroy, John, his son,
 agricultural labourer
15 Martin, Mary Anne
[Stratfordlodge townland]
no houses here
[here 'Horse Pond']

Edward Street ['Pound Lane'], Baltinglass West & Bawnoge townlands
West Side
(Belan Street to Carlow Road)
[Baltinglass West townland]
1 ruins
2 Darcy, Edward, nail maker
3 Greene, Patrick, tin worker, Greene, Mary, his wife, Greene, Patrick, his son, tin
 worker, Greene, William, his son, tin worker
4 Greene, John, tin worker, Greene, Kate, his wife
5 Bollard, grocers[443], Bollard, Mary, purveyor, Bollard, Thomas, her son, purveyor,
 Bollard, James, her son, shop assistant, Greaves, John, employee, labourer, domestic
 servant

6 ruins

7 Conlan, grocers & public house[444], Conlan, Mary, grocer & publican, O'Neill, Anne, her aunt, O'Neill, Margaret, her cousin

8 Hughes, butchers, Hughes, Patrick, cattle & pig dealer, Hughes, Mary, his wife

9 Pearson, William, tailor, Pearson, Kate, his wife

10 Doody, James, labourer, Doody, Bridget, his wife, housekeeper, Doody, Thomas, his son, labourer, Doody, Mary, his daughter, general servant

11 Byrne, Edward, blacksmith, Byrne, Anne, his wife, housekeeper, Flinter, Edward, his brother-in-law, pig dealer

12 Lawler, Michael, shoemaker, Lawler, Kate, his wife, housekeeper

13 Doyle, John, pig butcher, Doyle, Elizabeth, his wife, housekeeper, Healy, Ellen, his mother-in-law

14 Wall, Andrew[445], Wall, Mary, his wife, charwoman, Wall, John, his son, agricultural labourer, Wall, William, his son, agricultural labourer

15 Connors, Peter, agricultural labourer, Connors, Ellen, his wife

16 Fogarty, Patrick, agricultural labourer, Fogarty, Mary, his wife

17 Lawler, John, shoemaker, Lawler, Margaret, his wife, Lawler, Patrick, his son, labourer

18 Burke, John, carpenter, Burke, Elizabeth, his wife

[Bawnoge townland]

19 vacant

East Side

(Carlow Road to The Bridge)

[Bawnoge townland]

20 Donohoe, Anne, farmer, Donohoe, Thomas, her son

21 Conway, Sarah, charwoman, Groves, Margaret, lodger, charwoman

22 Conway, Thomas, general labourer, Conway, Honora, his wife, dressmaker

[Baltinglass West townland]

23 ruins

24 Doyle, Thomas[446]

25-26 ruins

27 Byrne, Margaret, housekeeper, Clancy, Jane, her daughter, dressmaker, Clancy, Michael, Jane's son, blacksmith, Clancy, Mary, Jane's daughter, dressmaker

28 vacant

29 Byrne, butchers, Byrne, Michael[447], Byrne, Bridget, his wife, shopkeeper, Lalor, Margaret, employee, general domestic servant

30 Bryan, William, RIC pensioner

31 out office owned by John Hendy

32 Hendy, butcher, Hendy, John, butcher, Hendy, Frances, his wife

33 Leonard, drapers, Leonard, Martha, draper

34 Byrne, Elizabeth

35 Hutton, public house[448], Hutton, Joseph, publican, Hutton, Bridget, his wife, Quinn, Mary, his sister-in-law, assistant in shop, Quinn, Margaret, his sister-in-law, assistant in shop

Fair Green, Baltinglass East townland (an alternative name for the area north of the 'south-east' block in Main Street; see Main Street)

Glennacanon ['Glencannon'] townland (see Tinoran Road)

The Green (see Fair Green)

Green Lane, Newtownsaunders townland
North Side
(Kiltegan Road to River Slaney)
1 Bracken, Bridget, farmer, Bracken, Bridget, her daughter, Bracken, James, her son
[here Redwells Road intersects]
2 Kearney, Patrick, general labourer, Kearney, Ellen, his wife, Neill, Eliza, his
 mother-in-law
[ends at Maidens Ford at River Slaney]
South Side
no houses here

Hartstown Road, Oldtown, Hartstown, Rampere, Tinoranhill North & Tinoranhill
 South townlands
North Side
('Tinoran Cross' to 'Five Crossroads')
[Oldtown townland]
1 Giffin, Michael, farmer, Giffin, Catherine, his wife, Giffin, Peter, his son, Byrne, Anne,
 his sister-in-law
2 Harte, Patrick, farmer, Harte, Margaret, his wife
[Hartstown townland]
3 (entrance to), Leigh, Thomas, shepherd
4 out office owned by Patrick Moffatt [of Tinoranhill North]
5 Barry, Thomas, farmer
[Rampere townland]
no houses
South Side
('Five Crossroads' to 'Tinoran Cross')
[Rampere townland]
6 Condell, William James farmer, Condell, Mary Anne, his wife
[here site of Rampere Church]
[Tinoranhill North townland]
7 Byrne, Peter, farmer, Byrne, Rosanna, his wife
8 Nolan, Thomas[449], general labourer, Nolan, Mary, his wife
9 Moffatt, Patrick, farmer
[Tinoranhill South townland]
no houses here

Hartstown townland (see also Hartstown Road)
[shared entrance to Nos. 2a, 3 & 4, and possibly 9 on the 'Bed Road'[450]]
2a Smyth, Bridget, farmer, Smyth, Mary, her daughter, Smyth, Julia, her daughter,
 Smyth, James, her son
3 Kehoe, Michael, farmer
4 Harte, Thomas, farmer
9 Slator, Christopher, farmer, Slator, John, his son

Holdenstown Lower townland (see also Rathvilly Road)
1a Black, Laurence, labourer, Black, Bridget, his wife

1b unoccupied house owned by Brien

3 Jones, Abraham, farmer, Carpenter, Charlotte, his daughter, Jones, Gilbert, his son

5 Brien, Anne, farmer, Brien, Sylvester, her son, Brien, Andrew, her son, Brien, Bridget, Sylvester's wife, shop assistant

7a ruins

7b Byrne, John, agricultural labourer, Byrne, Ettie, his wife, general domestic servant

9a unoccupied house

9b unoccupied house

9c Robinson, Harriot

12 Murphy, William[451], railway ganger, Murphy, Mary, his wife

Holdenstown Upper townland

1 Holdenstown Lodge, Dagg, John Ralph, farmer & clerk to the Board of Guardians, Dagg, Ellen, his wife, Abbey, Patrick employee, servant, Kearney, Mary, employee, servant

4 Jones, Henry, farmer, Jones, A. Maria, his wife

5 Ringwood, Mary, farmer, Ringwood, James, her son, agricultural labourer, Ringwood, Daniel, her son, agricultural labourer

7 Brennan, John, farmer, Brennan, Kate, his wife, Brennan, Alice, his aunt, Doody, Lizzie, employee, farm servant, Byrne, Michael, employee, domestic servant

8 unoccupied house owned by Alice Brennan

9 Deegan, Mary, farmer

12 Fennell, Dorcas, farmer

13 Plant, John, farmer, Plant, Ellen, his wife

14 Mitchell, Anne, retired farmer, Mitchell, John, her son, Mitchell, William, her son, Mitchell, Anne, her daughter

14a house under construction

Irongrange Lower townland (see also Carlow Road)

3 Kearney, Mary, farmer, Kearney, Walter, her son, Fowler [or Foley?], Mary employee, general servant

4 unoccupied house owned by Michael Lalor

Irongrange Upper townland
(see also Carlow Road)

3a Whelan, Edward, herd, domestic servant, Kervan, Bridget, his sister

Kilmurry townland (see also Kiltegan Road)

1 Lawler, James, farmer, Lawler, Margaret, his wife

2a gate lodge of Fortgranite estate, Jackson, Henry, land stewart, Jackson, Anne, his wife

2b Crampton, Thomas, coachman, Crampton, Margaret, his wife, Crampton, Annie, his daughter, Crampton, Margaret, his daughter, dressmaker

3 Neill, Peter, farmer

4 Clinch, John, farmer, Clinch, Mary, his wife, Clinch, Peter, his son, road contractor

5 Tutty, William, carpenter, Tutty, Rebecca, his wife, laundress, Tutty, William, his son, stable boy

Kilmurry Lower townland (see also Kiltegan Road & Redwells Road)

6 Tutty, Anne, farmer, Tutty, John, her son, Tutty, William, her son, Tutty, Jane, her daughter

7 Jackson, Joseph W, farmer, Jackson, Annie, his wife

9 Coogan, Peter, farmer, Coogan, Mary, his wife, Shiel, Sarah, his mother-in-law, retired farmer

Kilmurry Upper townland (see also Redwells Road)

1a Byrne, William, farmer, Byrne, Bridget, his wife

1b Doyle, James, blacksmith, Doyle, Margaret, his wife, Broughan, Thomas, employee, blacksmith

2b Gorman, Catherine , Abbey, James, her brother, herd, Cunningham, John, her grandson, gardener

Kilranelagh Road, Tuckmill, Tuckmill Lower & Tuckmill Upper townlands
North Side
('Tuckmill Cross' to 'Kyle Bridge')
[Tuckmill Lower townland]

1 see No. 9 Dublin Road ['Doyles of the Shop']

2 ('Doyles of the Lough') Doyle, Thomas, farmer, Byrne, Julia, his aunt, housekeeper

3 Doyle, Joseph, farmer, Doyle, Kate, his wife, Whyte, Matthew, employee, farm servant

4 Brien, Elizabeth, farmer, Brien, Michael, her nephew, farm worker

[here lane leading to Haydens' in Ballinacrow Lower]

5 Moran, John, farmer, Moran, Christopher, his son, Moran, Annie, his daughter, Brennan, Esther, his sister

6 Moran, Michael, farmer, Moran, Jane, his wife

[road continues into Kill ['Kyle'] townland]

South Side
('Kyle Bridge' to 'Tuckmill Cross')
[Tuckmill Lower townland]

7 Byrne, Bridget, farmer, Byrne, William, her son, Byrne, Bridget, her daughter, Byrne, Patrick, her son

8 Donnelly, Daniel, caretaker, domestic servant, Donnelly, Hannah, his wife

[here joins Tailor's Lane]
[Tuckmill Upper townland]

9 see No. 10 Dublin Road [Anthony Dempsey]

Kiltegan Road, Baltinglass East, Lathaleere, Newtownsaunders, Woodfield & Deerpark townlands
West Side
(Weavers' Square to Fortgranite)
[Baltinglass East townland]

1 Parkmore House, owned by Esther Anne Shaw, Main Street
[Lathaleere townland]
[here site of former bleach green & bleach mill]

2 (site of Whitehall House), McGeer, Denis, general labourer, McGeer, Catherine, his wife

['Whitehall Cross'; Redwells Road continues south; Kiltegan Road turns east]

[here lands of Allen Dale, site of the former race course]

[here Kiltegan Road turns south]

3 Allen Dale, Gardiner, Alice[452]

4 Breslin, Anne, general labourer

[Newtownsaunders townland]

5 Cullen, Matthew, general labourer

[here joins Green Lane]

no houses here

[Woodfield townland]

6 Gorman, Margaret, general labourer, Swain, Edward, her son-in-law, general labourer, Swain, Bridget her daughter, Gorman, Elizabeth, her daughter, general domestic servant

[Newtownsaunders townland]

[here entrance to Newtownsaunders – see under Redwells Road]

[Kilmurry Lower]

7 Doyle, Patrick, farmer, Doyle, Ellen, his wife, Scott, Joseph, employee, general domestic servant

8 out office owned by James Donegan

9 Donegan, James, farmer, Donegan, Mary, his wife, Donegan, Anne, his aunt

[here joins road to Redwells]

[Kilmurry townland]

no houses here

[road continues into Fortgranite townland]

East Side

(Englishtown to Weavers' Square)

[Kilmurry Lower townland]

10 Freeman, James, farmer, Freeman, Deborah, his wife

11 unoccupied house owned by James Freeman

[Woodfield townland]

[here joins road to Talbotstown]

12 Cullen, Patrick, farmer, McGeer, Mary, employee, housekeeper

13 McDonnell, Denis, farmer, McDonnell, Catherine his wife, Byrne, James, boarder ?, Doyle, James, boarder ?

14 Byrne, Eliza, farmer, Foley, Bridget, employee, general domestic servant

15 White, Patrick, general labourer, White, Julia, his wife

[here shared entrance to No. 16, and to Nos. 1, 5 & 6 of Woodfield townland]

16 Byrne, James, farmer, Byrne, Julia, his wife

[Newtownsaunders townland]

17 (entrance to, opposite Green Lane), Finn, Anne, farmer, Finn, John, her son, farmer, Finn, Anne, her daughter, Finn, Michael, her son, farmer

18 McGeer, James, general labourer

19 Baltinglass Poor Law Union Fever Hospital

[1901 Census stats. included under Workhouse]

medical officer: J.A. McDonald, Main Street

resident staff included under Workhouse

20 Baltinglass Poor Law Union Workhouse

[1901 Census stats: males 93, females 72; total 165]

clerk to the Board: J. Ralph Dagg, Holdenstown Lodge

medical officer: J.A. McDonald, Main Street
master: Daniel Aherne
matron: Charlotte A. Salter
boys' school teacher: Daniel Aherne
girls' school teacher: Sister Agatha Manning
resident staff (including Fever Hospital)
Aherne, Daniel, workhouse master & teacher
Elward, Eliza, hospital nurse
Donegan, William
Byrne, Maurice
Salter, Charlotte A, workhouse matron
Wilson, Peter, wardsman
Lawler, Maria, night nurse
Brennan, Mary, nurse
St. John of God Sisters:
Lacey, Sister Joseph Corboy, Sister Josepha, assistant nurse
Manning, Sister Agatha, teacher McDonald, Sister Celestine, nurse
Cahill, Sister Alphonsus, nurse
[Deerpark townland]
21 McLoughlin, Michael, farmer, Bowes, Felix, lodger, tailor
22 (entrance to) out office owned by Charles Fenton
23 Nolan, Michael, herd, Nolan, Michael, his son, agricultural labourer, Whelan, Catherine, his daughter, domestic servant, Nolan, John, his grandson, agricultural labourer
24 Staunton, William, general labourer, Staunton, Bridget, his wife, dressmaker, Malone, Bridget his daughter, dressmaker, Malone, Thomas, Bridget's husband, domestic servant
25 Connor, Edward, labourer, Connor, Ann, his wife, Connor, Mary, his daughter, domestic servant
26 Deerpark House (entrance to), Hendy, Thomas, farmer, Hendy, Elizabeth, his wife
27 Conway, Peter, labourer, Conway, Anne, his wife, Conway, Anne, his daughter, domestic servant
28 Davis, Anna & John[453]
[here lane leading to No. 29, and to Nos. 2 & 3A of Deerpark and No. 3 of Carsrock townlands]
[Lathaleere townland]
29 Doran, Mary, Doran, Thomas, her son, general labourer
[here Kiltegan Road turns west]
no houses here
['Whitehall Cross'; Kiltegan Road turns north]
no houses here
[Baltinglass East townland]
30 Byrne, Peter, farrier, Byrne, Elizabeth, his wife
31 Lennon, Owen, labourer, Lennon, Margaret, his wife
32a Parochial House, O'Neill, V. Rev. Thomas, Parish Priest, Swan, Ellen, employee, domestic servant, Butler, Thomas, employee, domestic servant
32b Parochial House [Curates' residence], Dunne, Rev. John, Roman Catholic curate, Breen, Rev. John, Roman Catholic curate, D(eering?), Mary, employee, general domestic servant

Knockanreagh Road, Baltinglass West, Glennacanon, Knockanreagh & Rathmoon
 townlands
West Side
(Tinoran Road to Rathmoon Road)
[Knockanreagh townland]
1 Piggott, John, agricultural labourer, Piggott, Ellen, his wife
2 Brien, Michael, farmer, Brien, John, his brother , farmer, Brien, Anne, his sister,
 housekeeper
[Rathmoon townland]
no houses here
East Side
(Rathmoon Road to Tinoran Road)
[Baltinglass West townland]
no houses here
[Knockanreagh townland]
3 Connolly, John, farmer, Connolly, Margaret, his wife
[Glennacanon townland]
no houses here

Knockanreagh townland (see Knockanreagh Road & Tinoran Road)

Lathaleere townland (see Kiltegan Road & Redwells Road)

Main Street, Baltinglass East townland
South Side
(The Bridge to Weavers' Square)
1 Clarke, drapers & bootmakers, Clarke, John, master bootmaker & shopkeeper, Clarke,
 Margaret, his wife, Clarke, Margaret, his daughter
2 Byrne, Mary, nursetender
3 Donegan, James, general labourer, Donegan, Jane, his wife, Donegan, Patrick, his son,
 general labourer, Death, Thomas, lodger, pensioner
4 Bergen, Maria, dressmaker
5 Schoales, bicycle shop, proprietor: Alfred Schoales, not resident on premises
6 National Bank, Manning, Aris Sherwood, bank manager, Corcoran, Patrick, bank por-
 ter, Hoare, Mary, employee, domestic servant
7 Douglas, drapers, milliners & auctioneers[454], Douglas, Samuel Marlborough, shop-
 keeper & farmer, Douglas, William Frederick, his son, auctioneer, Douglas, Mary W.,
 his daughter-in-law, shopkeeper
8 Clarke ('Geoghegan Clarkes') boot shop[455], Clarke, John T. shopkeeper, Clarke, Mary,
 his wife
9 M.J. Doyle ('Commercial Hotel') public house & hardware shop, Doyle, Michael J.,
 hardware & spirit merchant, Doyle, Mary, his wife, Byrne, Esther, employee, servant
10 Neill, butcher shop[456], Neill, Anne, farmer, Neill, Mary, her daughter, Neill, James,
 her son, Neill, Francis, her son
11 Byrne ('Dublin Byrnes') public house, Byrne, James, publican, Byrne, Ellen, his wife
12 Cope, drapers[457] ,Cope, Catherine, draper, Cope, Joseph, her son, shop assistant,
 Moody, Frances, boarder, shop assistant
13 ruins

14 Harris, shop, Harris, John, dealer, Harris, Anne, his wife

15 Cooke, shop. Cooke, Thomas C. shopkeeper & contractor, Cooke, Annie, his wife, shopkeeper, Kevin, Mary Anne, boarder, shop assistant

16 P Byrne, shop[458], Byrne, Patrick, farmer, Byrne, John, his brother, labourer, Murphy, Patrick, boarder, farmer

17 Lawler, public house & grocers, Lawler, Mary, grocer & publican, Byrne, Dorothy, boarder, shop assistant

18 Carmody, shop, Carmody, Mary, shopkeeper

19 Byrne, grocers, Byrne, Matthew, merchant, Byrne, Mary, his wife, Byrne, Matthew, his son, teacher, Baltinglass NS, Byrne, Patrick, his son, clerk, Cahill, Annie, employee, servant.

20 Kehoe, grocers, Kehoe, Denis, shopkeeper, Kehoe, Ann, his wife, Kehoe, William, his son, shop assistant, Kehoe, Bridget his daughter, housekeeper, Kehoe, Patrick, his son, baker, Fluskey, Mary, servant, general domestic servant

21 Crowe, Patrick, van man in Webbs', Crowe, Nannie, his daughter, Crowe, Bridget, his daughter, draper

22 Byrne, Esther, Byrne, Thomas, lodger, mason, Jones, Peter, lodger, baker, Piggott, William, lodger, baker

23 Shaw, Elizabeth, income from house property, Shaw, Esther Anne, her sister, income from house property, Barry, Lawrence C., boarder, bank clerk, National Bank & Insurance agent

24 O'Shea, drapers[459], O'Shea, Mary, shopkeeper

25 Cruise, Francis John, physician & surgeon, medical officer to Baltinglass Dispensary, McCann, Maria, employee, cook & domestic servant

South-East block
(south face)
26 Lyttleton, Bridget[460]
[here side of No. 27]
(west face; facing into Market Square)
27 Courthouse, Petty Sessions clerk: William J. Moore, Weavers' Square
28 Baltinglass Town Hall
(north face; facing into the Fair Green)
[here side of No. 28]
29 Hourihane, John principal, Bigstone NS, Hourihane, Sarah, his wife
(east face; facing into Weavers' Square)
[here sides of Nos. 26 &29]
North-West block
(east face; facing into the Fair Green)
[here sides of Nos. 30 &38]
(south face; facing into Market Square)
30 Lalor, Thomas, labourer, Lalor, Julia, his wife, dressmaker, Ellis, Mary, boarder, servant
31 Rourke, James, railway labourer, Rourke, Anne, his wife, Barker, Kate, lodger
32 Hearns, Catherine, Kelly, Michael, her nephew, butcher
33 Bayle, Thomas[461], saddler, Bayle, Elizabeth, his wife
(west face; facing into Market Square)
34 Crampton, dressmakers[462], Crampton, Delia, dressmaker, Hagerty, Mary K., lodger, dressmaker

35 McLoughlin, pork butchers, McLoughlin, William[463], McLoughlin, Andrew, his son pork butcher, McLoughlin, Mary, Andrew's wife, McLoughlin, John, William's son, pork butcher

(north face)

36 house owned by Andrew McLoughlin

37 Pearson, John[464], cooper, Pearson, Julia, his sister

38 store owned by Andrew McLoughlin

39 Coventry, William general labourer, Coventry, Nora, his wife

North Side

(Chapel Hill to The Bridge)

[Nos. 40-45 facing the Fair Green]

40 ruins

41 ruins

42 Clancy, William, general labourer, Clancy, Anne, his wife, Clancy, Elizabeth, his daughter, Ryan, Thomas, boarder, labourer, Butler, Joseph, boarder, labourer, McDonagh, Matthew, boarder, tinsmith, McDonagh, Maryanne, Matthew's wife, Mooney, Daniel, boarder, labourer, Mooney, Andrew, boarder, labourer

43 Cheney, Kate, lodging house keeper, Gaskin, Mary, her daughter, lodging house assistant, Farrell, William, boarder, dealer, Fox, John, boarder, labourer, Fox, Rosanna, John's wife

44 Abbey, Edward, general labourer, Kearns, Elizabeth, his daughter

45 'The Steps' a (ground floor)[465] Curran, William, bootmaker, b (upper floor), Doody, Myles, builder & carpenter, Doody, Mary, his sister, Doody, Rose, his sister, dress-maker, Kelly, William, boarder, carpenter

46 Kinsella, John, agricultural labourer, Kinsella, Mary, his wife

47 Carty, John[466], RIC pensioner, Carty, Mary, his wife, Carty, James, his son, teacher, Baltinglass NS

48 unoccupied house owned by Edward P. O'Kelly

49 O'Kelly, public house, grocers & auctioneers, proprietor: Edward P. O'Kelly, (residence: St. Kevin's, Church Lane)

50 Doyle ('Leinster House'), drapers & newsagents, Doyle, Thomas B., draper & coroner registrar of births, deaths & marriages, Doyle, Catherine P., his wife, draper, Kelly, Teresa M., his step-daughter, milliner, Whittle, Anne M., shop assistant, milliner

51 O'Neill, public house[467], O'Neill, Edward, publican, O'Neill, Dora A., his wife, Walshe, Michael W., boarder, sewing machine agent

52 Flinter, public house & grocers, Flinter, William, grocer, publican & farmer, Kitson, Joseph, shop assistant, grocer's assistant

53 Doyle, shop[468], Doyle, Edward, butcher, Doyle, Annie, his wife, Norton, James, assistant, butcher, Doody, Mary, apprentice, milliner, Ellis, Mary, employee, general domestic servant

54 vacant house owned by Edward Doyle

55 Byrne, shop, Byrne, Eliza, provision dealer, Byrne, William, her son, provision dealer

56 Kavanagh, drapers, Kavanagh, Michael, draper, Kavanagh, Mary Anne, his wife

57 unoccupied house owned by Michael J. Doyle [of Main Street]

58 McDonald, John Alexander, medical doctor, medical officer to Baltinglass Union Workhouse & Fever Hospital, Kiltegan Road, McDonald, Elizabeth M. his wife, Mangan, Eliza, employee, servant

59 T. Doyle, ('Finnegan-Doyles') public house & grocers[469], Doyle, Thomas, grocer & publican, Doyle, Jane, his wife, Kehoe, John, employee, servant, Bennet, Mary, employee, general domestic servant

60 M.S. Lalor, chemist shop, Lalor, Michael S., pharmaceutical chemist, Lalor, Madeline, his wife, Kinsella, Mary, employee, general domestic servant

[here joins Church Lane]

61 Bridge Hotel, proprietor: Michael Harbourne, Harbourne, Michael, hotel proprietor & farmer, Harbourne, Elizabeth M. ,his wife, hotel manageress, O'Brien, Elizabeth, employee, domestic servant

62 Fleming, dressmakers, Fleming, Mary & Annie, dressmakers, (residence: Belan Street)

Market Square (an alternative name for the areas south and west of the 'north-west' block in Main Street; see Main Street)

Mattymount townland(see Rathbran Road)

Mill Street, Baltinglass West townland
East Side
(The Bridge to Dublin Road)

1 Herbert Webb, grocers & ironmongers, Webb, J. Herbert, shopkeeper, Webb, Arabella, his wife, Waring, Alfred Wm., boarder, accountant, English, Sarah, employee, cook, domestic servant

[here right of way to the river]

[Nos. 2-3 facing south]

2-3 Lynch ('Lynches' Harp Hotel' or 'The Hollow'), public house & bakery[470], Lynch, James, publican & baker, Lynch, Maria, his wife, Lynch, Rose, his sister, shop assistant, Kehoe, Annie, employee, domestic servant, Cahill, George, employee, general labourer

4 Phelan, William, carpenter, Phelan, Rose, his wife

5 Morgan, Mary, Morgan, John, her son, bootmaker, Morgan, Joseph, her son, bootmaker, Morgan, Honor, her daughter

6 out office owned by William Phelan

7 Byrne, Mary, nurse

8 Jackson, public house[471], Jackson, Thomas, publican, Jackson, Mary, his wife, Jackson, Thomas, his son, blacksmith, Nolan, Susan, his sister-in-law, shop assistant, Mullins, Patrick, employee, blacksmith, Deegan, Bridget, employee, domestic servant, Kelly, James, employee, coachman, domestic servant

9 Nolan, Margaret, lodging house keeper, Wall, John, lodger, labourer, Wall, Robert, lodger, labourer

10 Duffy, John, tailor, Duffy, Ellen, his wife

11 Simpson, Patrick, harness maker, Simpson, Mary, his wife

12 Jones, Griffith, RIC pensioner, Jones, Alicia, his wife, Jones, James Geo., his son, shop assistant

13a Mill House, Morrin, Peter P., miller & farmer, Morrin, Esther, his wife, Thorpe, Eliza, employee, domestic servant, Dunbar, Esther, employee, nurse, domestic servant, Colgan, Mary, employee, governess, Dalton, Mark, employee, clerk

13b Morrin, corn mill, proprietor: Peter P. Morrin

West Side

(Dublin Road to Belan Street)

14 Lawlor, John, railway signalman, Lawlor, Johanna, his wife, housekeeper, Riordan, John, boarder, railway porter, Blunt, Thomas, boarder, railway porter

15 Prendergast, Bridget, shopkeeper, Prendergast, John, her son, cattle dealer, Prendergast, Mary, her daughter-in-law, shopkeeper, Nolan, Michael, servant, farm servant

16 McCann, glass, china & toy dealers, McCann, James, shopkeeper, McCann, Catherine, his wife, shopkeeper

17 Tyrrell, Edward, baker, Tyrrell, Mary, his sister, Tyrrell, Patrick, his brother, carpenter, Gorman, Patrick, boarder, car driver, Lynch, Anne, boarder

18 Baltinglass Post Office, sub-postmaster: Michael Cooke, Cooke, Michael, sub-postmaster, Cooke, Mary, his daughter, Cooke, Bridget, his daughter, post office assistant, Cooke, Sarah, his daughter, post office assistant, Cooke, Catherine, his daughter, post office assistant

19-20 O'Toole, shop, O'Toole, Catherine, shopkeeper, Dodd, H.W., boarder, bank clerk, National Bank

[here joins Station Road]

21 Wesleyan Methodist Chapel, no resident minister

22 Moynihan, Jeremiah[472], RIC. constable, Moynihan, Margaret, his wife

23 McCluskey, Patrick, Acting Sergeant, RIC, McCluskey, Mary H., his wife

24 Sullivan, John, RIC sergeant, Sullivan, Margaret, his wife

25 Royal Irish Constabulary Barracks, Sergeant: John Sullivan, Constables: Jeremiah Moynihan, James Peters & David Woods

26 Graham, grocers & hardware dealers[473], Graham, Jacob Whitfield, shopkeeper, Graham, Mary Jane, his wife, Bailey, James Wm., his son-in-law, shop assistant, Bailey, Miriam P., his daughter, Crowe, Bridget, employee, servant

[here joins Tan Lane]

27 Brennan, grocers & glass & china dealers, possibly not in business & unoccupied[474]

28 Leonard, drapers[475], Leonard, George, draper, Leonard, William G., his son, draper, Jones, Sarah, boarder, shop assistant, Carty, Catherine, employee, servant

29 Doyle, public house, Doyle, Michael, shopkeeper, Doyle, Bridget, his wife

Newtownsaunders townland (see Green Lane, Kiltegan Road & Redwells Road)

Oldtown townland (see also Hartstown Road)

1 Keogh, Anne, farmer, Keogh, Michael, her son, Keogh, Bridget, her daughter, Keogh, Kate, her daughter

5 Bolger, James, farmer, Bolger, Julia, his wife

6 Owens, Patrick, farmer, Owens, Julia, his wife, Dugan, Charles, employee, agricultural labourer

Pound Lane, Baltinglass West & Bawnoge townlands (see Edward Street)

Raheen Hill Road, Stratfordlodge, Raheen & Rampere townlands
West Side
(Dublin Road to the 'Five Crossroads')
[Stratfordlodge townland]

no houses here

[Raheen townland]

[here bridge over railway]

1 Scott, George[476], railway gauger, Scott, Dora, his wife

2 Heydon, Anne, Heydon, Patrick, her son, principal, Baltinglass NS, Heydon, Michael, her son, cooper, Heydon, John, her son, unemployed grocer's assistant

3 Hendy, Francis, farmer, Hendy, Francis, his son, Hendy, William, his son, Hendy, Elizabeth, his daughter, Hendy, Ellen, his daughter, Brennan, George A., employee, farm servant

4 unoccupied house (entrance to)

[Rampere townland]

5 Neill, William, farmer, Neill, Alice, his wife, Neill, Benjamin, his son, Leybourne, Elizabeth, his sister

East Side

('Five Crossroads' to Dublin Road)

[Rampere townland]

6 Fogarty, John, railway servant, Fogarty, Mary, his wife

[Raheen townland]

7 Whelan, James, farmer, Whelan, Patrick, his brother , shopkeeper, Whelan, Maria Anne, his sister, Coventry, Anne, employee, domestic servant, Donohoe, Thomas, employee, farm servant

8 Kelly, Esther, Kelly, Eliza, her daughter, unemployed lady's maid, Kelly, Patrick, her son, milesman GS&W railway, Kelly, Francis, her son, milesman GS&W railway

[here bridge over railway]

no houses here

[Stratfordlodge townland]

9 see No. 1 Dublin Road [Slaney Lodge – Anderson]

Raheen townland (see Colemans' Road, Dublin Road & Raheen Hill Road)

Rampere townland (see also Cabra Road, Colemans' Road, Hartstown Road & Raheen Hill Road)

1a Leigh, Thomas[477], farmer, Leigh, Margaret, his wife, Byrne, Bridget, employee, servant, Stynes, Gerard, employee, servant

1b Donohoe, James[478], Donohoe, Margaret, his wife

2 Fowler, Michael[479]

Rathbran Road, Tuckmill, Tuckmill Upper, Mattymount & Tuckmill Lower townlands

South Side

('Tuckmill Cross' to Goldenfort)

[Tuckmill Upper townland]

1 see No. 2 Dublin Road [Edward Ward]

[here Tuckmill Bridge; road crosses River Slaney]

[Mattymount townland]

2 Bulmer, Joseph, blacksmith, Bulmer, Laurence, his son, blacksmith, Bulmer, Winifred, Laurence's wife

[road continues into Goldenfort townland]

North Side
(Goldenfort to 'Tuckmill Cross')
[Mattymount townland]
no houses here
[here Tuckmill Bridge; road crosses River Slaney]
[Tuckmill Lower townland]
no houses here

Rathmoon Road, Baltinglass West & Rathmoon townlands
North Side
(Belan Street / Brook Lane to Carrigeen)
[Baltinglass West townland]
no houses here
[here joins Knockanreagh Road]
[Rathmoon townland]
1 Roe, Paul, general labourer, Roe, Ellen, his wife, Horan, John, lodger
2 Cashin, William, general labourer
[road continues into Carrigeen, Co. Kildare at this point]
South Side
(Carrigeen to Bawnoges Road)
[Rathmoon townland]
3 Brien, William, farmer, Brien, Mary Anne, his sister, Byrne, William, employee, servant
4 Byrne, Michael, labourer, Byrne, Kate, his wife, domestic servant
5 Rathmoon House, Burke, Anne, farmer, Burke, Joseph, her son, Burke, James, her son,
 Burke, Frances, her daughter, Burke, Martin, her son
[Baltinglass West townland]
no houses here

Rathmoon townland (see Knockanreagh Road & Rathmoon Road)

Rathvilly Road, Bawnoge, Clogh Upper, Holdenstown Lower, Cloghcastle & Clogh
 Lower townlands
West Side
('Clough Cross' to Rahill)
[Bawnoge townland]
1 Thorpe, Sarah, farmer
[Clogh Upper townland]
2 Thornton, Mary, farmer, Thornton, James, her son, Thornton, Jane, James' wife,
 Thornton, William, Mary's son
3 unoccupied house[480]
4 Farrell, Bridget, farmer, Farrell, James, her son, Farrell, Hannah, her daughter
5 McHugh, Winifred, farmer, Doolan, James, her son, agricultural labourer
6 Coogan, Hugh, farmer, Coogan, Kate, his sister, Coogan, Mary, his sister, Coogan,
 Bridget, his sister
7 Molloy, Patrick, farmer, Molloy, Mary, his wife, Molloy, Daniel, his son
[Holdenstown Lower]
no houses here
[road continues into Rahill, Co. Carlow at this point]

East Side

(Rahill to 'Clough Cross')

[Holdenstown Lower]

8 Rogers, Patrick, farmer, Rogers, Catherine, his daughter

[Cloghcastle townland]

9 (entrance to) Brien, John, farmer, Hughes, Thomas, his nephew, farm servant, Davis, Sarah, employee, cook/ domestic servant

10 Jones, William, farmer, Jones, John, his son, agricultural labourer

11 unoccupied house owned by the Guardians of Baltinglass Union

12 Abbey, Mary, farmer

13 Kelly, Ellen, farmer, Kelly, Patrick, her son, agricultural labourer, Kelly, Mary Anne, Patrick's wife

14 (entrance to) Kehoe, Andrew, farmer, Kehoe, James, his brother

[Clogh Lower townland]

15 Cunningham, Mary, farmer, Cunningham, Patrick, her son, farm servant, Cunningham, Michael her son, farm servant

[here site of Rellickeen]

16 Kehoe, Patrick, farmer, Kehoe, Anne, his wife, Kehoe, Andrew, his son, Kehoe, Margaret, Andrew's wife

[here shared entrance to No. 17 and No. 5a of Clogh Lower townland]

17 Dunne, Patrick, agricultural laboure, Dunne, Ellen, his wife

18 Abbott, Mary

[Bawnoge townland]

no houses here

The Redwells (see Kilmurry Lower, Kilmurry Upper & Redwells Road)

Redwells Road, Lathaleere, Slaney Park, Kilmurry Upper, Kilmurry Lower & Newtownsaunders townlands

West Side

(Kiltegan Road at 'Whitehall Cross' to Mountneill Bridge)

[Lathaleere townland]

1 Reilly, Julia[481]

2 Finn, John, builder & contractor, Finn, Maryanne, his wife, Finn, Annie, his daughter, dressmaker & milliner, Farrell, James, employee, domestic servant

[Newtownsaunders townland]

3 Gaffney, Michael, farmer, Gaffney, Mary, his wife, Gaffney, Margaret his daughter

[road intersects with Green Lane]

no houses here

[Slaney Park townland]

4 unoccupied old gate lodge

5 gate lodge, Roberts, William, general labourer, Roberts, Kate, his wife

6 Slaney Park (entrance to) Grogan, Elizabeth Mary [482], Falkner, Fanny, employee, kitchen maid, Gillgen, Jane, employee, cook, Johnston, Sarah, employee, domestic servant, Webb, Jane, employee, maid

7 Burrows, George, coachman, Burrows, Emily, his wife

8 unoccupied house[483]

[here 'Redwells Cross'; here joins road through Holdenstown]

[Kilmurry Upper townland]

9 Thorpe, Frederick, farmer

[here Mountneill Bridge; road continues into Mountneill, Co. Carlow at this point]

East Side

(Mountneill Bridge to Kiltegan Road at 'Whitehall Cross')

[Kilmurry Upper townland]

[here shared entrance to Nos. 10 & 11]

10 Byrne, James, farmer, Byrne, Anne, his sister, Byrne, Teresa, his sister, Byrne, Michael, employee, farm servant

11 Whelan, Thomas, farmer, Whelan, Elizabeth, wife

12 Jones, Edward, farmer

[here 'Redwells Cross'; here joins road through Kilmurry]

[Kilmurry Lower townland]

13 Coogan, Joseph, farmer, Coogan, Anne, his wife, Coogan, Laurence, his son, Coogan, Catherine, his daughter

[Slaney Park townland]

no houses here

[Newtownsaunders townland]

14 Newtownsaunders (entrance to), Jones, Thomas, farmer

[here road intersects with Green Lane]

15 Neill, Michael, farmer, Neill, Mary, his wife

[Lathaleere townland]

no houses here

Saundersgrove townland (see also Dublin Road)

1aa Saundersgrove, Saunders, Robert J.P.[484]

1ab Dunne, Edward, gardener[485]

1ac Crowe, John, keeper, woodranger, Crowe, Caroline, his wife

Saundersgrovehill townland (see also Dublin Road)

5 vacant (formerly Cullens)

Slaney Park townland (see also Redwells Road)

1d gate lodge, Oliver, Walter Frank, gardener, Oliver, Henrietta, his wife (on road to Holdenstown)

Sruhaun ['Shrughaun' or Dublin Old] Road, Baltinglass East, Sruhaun & Tuckmill Upper townlands

West Side

(Chapel Hill to Dublin Road)

[Baltinglass East townland]

1 unoccupied house[486]

[Sruhaun townland]

no houses here

[Tuckmill Upper townland]

no houses here

East Side

(Dublin Road to Chapel Hill)

[Tuckmill Upper townland]

2 Brien, Peter, farmer, Brien, Mary, his wife

[Sruhaun townland]

3 Brien, Charles, farmer, Brien, Mary, his wife, Loughlin, James, employee, agricultural labourer

[here lane to Nos. 14a & 14b of Sruhaun townland]

[Baltinglass East]

no houses here

Sruhaun ['Shrughaun'] townland (see also Sruhaun Road)

14a Birmingham, John, general labourer, Birmingham, Bridget, his wife

14b unoccupied house (formerly Bowes')

Station Road[487], Baltinglass West townland

North Side

(Mill Street to the Railway Station)

1 see No. 20 Mill Street [Catherine O'Toole]

2 Baltinglass Railway Station (entrance to)

South Side

(Railway Station to Mill Street)

3 see No. 21 Mill Street [Wesleyan Methodist Chapel]

Stratfordlodge townland (see also County Road, Dublin Road & Raheen Hill Road; includes Baltinglass Railway Station – entrance from Station Road, & Station House – entrance from County Road),

Murphy, John, general labourer, Murphy, Hannah, his wife, Murphy, Michael, his son, railway servant, Grady, Sarah, general labourer, Grady, Eliza, her daughter, labourer, Grady, Thomas, her son, labourer

Stratford Lodge (ruins of)

Graham, Andrew, general labourer,

Enright, James, general labourer, Enright, Margaret, his wife, Byrne, Thomas, herd, Byrne, Hannah, his wife, domestic servant, Byrne, James, his son, domestic servant

Tailor's Lane, Tuckmill, Tuckmill Lower & Tuckmill Upper townlands

East Side

(Kilranelagh Road to Coolinarrig)

[Tuckmill Lower townland]

1 Lee, Thomas, farmer, Lee, Bridget, his wife, Lee, Thomas, his son

2 Lee, Catherine, farmer, Lee, John, her son, Lee, Anne, John's wife

3 unoccupied house owned by John Byrne of Coolinarrig Lower

4 unoccupied house owned by McDonnell of Coolinarrig

[road continues into Coolinarrig Lower townland]

West Side

(Coolinarrig to Kilranelagh Road)

[here Tuckmill Hill townland – outside of area being covered]

[Tuckmill Upper townland]

no houses here

Tan Lane, Baltinglass West townland
North Side
(Mill Street to end)
1 McCormack, Catherine, charwoman, Butler, Alice, her daughter, Ryan, Laurence, boarder, railway servant, Keane, Peter, boarder, agricultural labourer
2 Farrell, Sarah, domestic servant, Farrell, Eliza, her sister, washerwoman
3 vacant
North Side
(Mill Street to end)
4 Fogarty, James, agricultural labourer, Fogarty, Anne, his wife, Fogarty, James, his son, postman
5 Leigh, John, agricultural labourer, Leigh, Katherine, his wife
6 Mooney, Jane, charwoman, Duffy, Michael, her son, postman, Halloran, Julia, her daughter

Tinoranhill North townland (see also Hartstown Road)
1a Farrell, Michael[488],herd, Farrell, Ellen, his wife

Tinoranhill South townland (see also Hartstown Road & Tinoran Road)
7a vacant[489]

Tinoran Road, Baltinglass West, Glennacanon & Knockanreagh townlands
North-East Side
(Ballytore Road / Brook Lane to 'Tinoran Cross')
[Baltinglass West townland]
1 Nolan, Richard, caretaker, Nolan, Mary A.,his wife
[Glennacanon townland]
2 Brophy, James, farmer, Brophy, Teresa, his wife, Brophy, Kate, his sister
3 Byrne, Joseph, herd, Byrne, Jane, his wife, Murphy, James, his brother-in-law, general labourer
4 Byrne, Eliza, farmer, Gleeson, John
[Tinoranhill South townland]
5 Neill, John, farmer, Neill, Kate, his wife, Neill, Annie, his daughter
6 Neill, John, farmer, Neill, Elizabeth, his wife, Neill, Deborah, his mother, Neill, Deborah, his sister
7 Byrne, Patrick, farmer, Byrne, Julia, his wife, Byrne, Patrick, his son, Byrne, Sarah, his daughter
[here 'Tinoran Cross'; here joins Hartstown Road; road continues into Oldtown Lackareagh & Monatore townlands]
South-West Side
('Tinoran Cross' to Brook Lane)
[here Monatore townland – outside of area being covered]
[Tinoranhill South townland]
no houses here
[Knockanreagh townland]
8 Halloran, John, general labourer, Halloran, Kate, his wife
[here joins Knockanreagh Road]
[Glennacanon townland]

no houses here
[Knockanreagh townland]
no houses here
[Baltinglass West townland]
no houses here

Tuckmill Lower townland (see Dublin Road, Kilranelagh Road, Rathbran Road & Tailor's Lane)

Tuckmill Upper townland (see also Dublin Road, Rathbran Road, Sruhaun Road & Tailor's Lane)
11 Murray, William, labourer, Murray, Mary, his wife

Tullow Old Road, Baltinglass West & Bawnoge townlands (see Bawnoges Road)

Weavers' Square, Baltinglass East townland
West Side
(Main Street to Kiltegan Road)
[here ground held by William Prendergast]
1 McGuinness, John, general labourer, McGuinness, Bridget, his wife, McGuinness, Michael, his son, general domestic servant
2 Pearson, Johanna, labourer's widow
3 McGuinness, James, farmer, McGuinness, Julia, his wife, McGuinness, James, his son, baker
4 Flynn, Joseph, boot maker, Flynn, Eliza, his wife, housekeeper
5 D.J. Kehoe, public house[490], Kehoe, Daniel J., shopkeeper, Kehoe, Mary, his wife, shopkeeper, Kealy, Mary, employee, servant
6 Prendergast, butchers, Prendergast, William, butcher, Prendergast, Mary, his wife
7 Hanrahan, bakery, Hanrahan, Nicholas, baker, Hanrahan, Mary, his wife, shopkeeper, Hanrahan, Mary, his daughter, dressmaker, Hanrahan, Denis, his son, baker
8 Timmins, public house[491], Brien, Michael, shopkeeper, Brien, Elizabeth, his wife, shopkeeper
9 Kelly, shop, Kelly, Anne, shopkeeper
10 Conway, John, general labourer, Conway, James, his half-brother, general labourer
11 Abbey, Patrick, general labourer, Abbey, Mary, his wife, housekeeper
12 Hughes, Esther, Hughes, James, her son, labourer, Hughes, Mary, James' wife
13 Hearns, Michael, butcher, Hearns, Kate, his wife
East Side
(Kiltegan Road to the Fair Green / Chapel Hill)
14 St. Joseph's Roman Catholic Church,
Parish Priest: V. Rev. Thomas O'Neill, Parochial House, Kiltegan Road,
Curates: Rev. John Breen & Rev. John Dunne, Parochial House, Kiltegan Road
15 Murphy, James, mason, Murphy, Anne, his wife
16 Hanley, shop, Hanley, Michael, R.I.C. constable (not stationed in Baltinglass), Hanley, Eliza, his wife, shopkeeper, Bracken, Kathleen, his wife's sister, Sheehan, John, boarder, journalist
17 Lennon, Anne, lodging house keeper, Gaffney, Monica, her niece, dressmaker
18 Ellis, John, farmer, Ellis, Honoria, his wife, housekeeper

19 Kavanagh, Michael, farmer, Kavanagh, Sarah, his wife

20 Kenny, John[492]

21 Lennon, Catherine[493], Lennon, Laurence, her son, general labourer, Lennon, Patrick, her son, general labourer, Fowler, Patrick, boarder, mason, Brennan, Anne, lodger, laundress

22 Humphrey, James, car proprietor[494]

[Nos. 23 & 24 behind No. 22]

23 Rooney, Michael, general labourer, Rooney, Ellen, his wife

24 Byrne, Edward, general labourer[495], Byrne, Bridget, his wife

25 Moore, Samuel, Moore, William J., his son, Petty Sessions clerk

26 Brereton, William, RIC pensioner, Brereton, Isabella, his wife, Brereton, George, his son, soldier 'Natal volunteer', Brereton, Isabel, his daughter, milliner

27 Byrne, Patrick, cattle dealer, Byrne, Peter, his son, Byrne, Elizabeth, his daughter

28 Kehoe, Patrick, farmer, Kehoe, Catherine, his wife, Kehoe, Mary, his daughter

29 Brien, Daniel, chimney cleaner, Brien, Esther, his wife

30 Byrne, Christopher[496], Byrne, Johanna, his wife

[No. 31 behind No. 29]

31 Murphy, Judith[497]

32 Coates, Margaret[498]

33 see No. 1 Chapel Hill [Joseph Brady]

Woodfield townland, (see also Kiltegan Road)

1 Byrne, John, farmer, Byrne, Mary, his wife, Murphy, Elizabeth, his mother-in-law

3 Reilly, Patrick, farmer, Reilly, Christopher, his brother, farmer, Reilly, Terence, his son, farmer, Reilly, Mary, Terence's wife, Whelan, Christopher, employee, farm servant

5 Neill, William, farmer, Neill, Mary, his wife

6 Cranny, Mary, farmer, Cranny, Joseph, her son

10aa unoccupied (owned by McDonnell)

11 Jones, Henry, farmer, Jones, Frances, his wife

12 Nicholson, Bridget　　　farmer, Nolan, Patrick, her brother, labourer

13 Burke, Michael, carpenter, Burke, Margaret, his daughter, Burke, William, his son, carpenter, Murray, William, boarder, labourer

13b Staunton, Patrick, general labourer, Staunton, Mary, his wife

15a Whelan, Mary[499]

FOUNDATION STONE OF MCALLISTER MONUMENT LAID
SUNDAY 15 JUNE 1902

The centenary of the 1798 Rebellion was used as an opportunity for awakening the passion of nationalists. Local centenary committees were formed in various parts of the country. In Baltinglass the focus of the local effort was the erection of a commemorative monument in the centre of the town. The obvious choice to personify the insurrection would have been Michael Dwyer, one of the main leaders of the rebels in Wicklow and a native of Camara in the Glen of Imaal. However, Baltinglass chose a relatively obscure character, Samuel McAllister,

in his place. Though it was to be the Dwyer and McAllister Memorial, it would be the less famous man whose image would symbolise 1798 to future generations in Baltinglass and the monument would become familiarly known simply as 'McAllister'.

Little is known of McAllister's background or of his life other than the few months prior to his death. Dwyer's biographer, Charles Dickson, states that McAllister was referred to by his companions as 'the man who always wore a green cravat'.[500] He was a Presbyterian from Ulster and he may have been from Antrim. McAllister was a member of the Antrim Militia, but he enlisted in Wicklow on 1 April 1798. Ruán O'Donnell, the leading authority on activity in Wicklow during the 1798 Rebellion, speculates that Sam McAllister may have been re-enlisting at that point or that he may have been one of a group of Antrim people who were living in County Wicklow before the rebellion. In any case, he was one of twenty-six Antrim Militia men who deserted from the garrison at Arklow in July 1798. O'Donnell suggests that McAllister and others may have enlisted in the militia in order to recruit for the United Irishmen and obtain weapons.[501] While the insurrection in the south Leinster area was almost exclusively one of Roman Catholics, the Presbyterians played the leading part in the rising in Ulster.

The selection of McAllister as the personification of the '98 Rebellion was justified by the circumstances of his death in an ambush at Derrynamuck in the Glen of Imaal. Twelve insurgents, led by Dwyer, were sheltering in three adjacent houses in Derrynamuck on the night of 15 February 1799. McAllister, Michael Dwyer, Patrick Costello (a tailor from Baltinglass) and John Savage, another Antrim deserter, were staying in the home of the Connell family. In the early hours of the following morning the houses were surrounded by a detachment of Glengarry Highlanders from Hacketstown. Those in the other two houses were captured but Dwyer elected to fight rather than surrender. Costello and Savage were killed and, with the thatched roof on fire and the situation almost impossible, McAllister was wounded in the arm. Unable to offer any effective resistance, he chose to sacrifice his life in an attempt to save Dwyer. He stood in the doorway, drawing the fire of the surrounding soldiers, and against all odds Michael Dwyer escaped.[502] The eight insurgents who had been in the other two houses were brought to Baltinglass and on 23 February they were sentenced to death by court-martial. Three of them, who were deserters, were shot, four were hanged and one saved his life by informing on other United Irishmen.[503]

Sam McAllister was buried in Leitrim graveyard but later his friends decided to transfer his remains to Kilranelagh. In the dead of night Dwyer's sisters Mary and Esther, along with some neighbours, carried the corpse to the other graveyard. Shortly afterwards McAllister's mother came to visit the grave and remained in Imaal for some days. It was said that she had been living in the Dolphin's Barn area of Dublin. In 1846-7 Anne Devlin stated that this woman had ended her days in a widows' almshouse in John's Lane, Dublin[504]. The fact that McAllister's mother was in Dublin at about the time of his death suggests that she and her son may well

have migrated from Ulster before the Rebellion. It is far more likely that she would have moved to the city from Wicklow than from Antrim. The only Antrim people identified by O'Donnell as living in County Wicklow before the rebellion are those in Stratford.[505] In 1798 Stratford was a model industrial town less than two decades old, and it was drawing in textile workers from outside Wicklow. It is said that the Orr family, who purchased Stratford in 1791, brought in workers from Paisley in Scotland.[506] A Presbyterian church had been established in Stratford by at least 1799 and there were Presbyterians living there as early as 1794.[507] A local informant advised Dublin Castle in May 1798 that there were people living in Stratford who 'were fugitives from the county Antrim' and who were 'intimately acquainted with many of the Antrim militia'.[508] It is quite conceivable that Sam McAllister and his mother lived for a time in Stratford, moving there from Ulster sometime in the 1790s. Of course, this is pure conjecture, there being no definite proof.

A century after Sam McAllister's fatal act of heroism it was decided to place his statue on the monument about to be erected in the town. McAllister was a more interesting choice, given that he was a Presbyterian from a different part of the country and that the organisers were exclusively Roman Catholic and from Wicklow. It was originally intended that the monument would represent Dwyer, but then it was suggested that a statue of McAllister would commemorate both men as a result of the Derrynamuck ambush.[509] However, it is unlikely that the Baltinglass committee was motivated by a spirit of social inclusion. There was a belief that McAllister was chosen over Dwyer because Dwyer was not particularly popular in Baltinglass and that this was as a result of the violent events of 8 December 1798 close to the town.[510]

It was the fair day in Baltinglass and Dwyer and a group of rebels were in the vicinity of the town. They had a chance meeting on the Sruhaun Road with someone who related details of the funeral of one of their comrades who had been killed in a recent skirmish. sOne of the rebels swore to avenge his death. Afterwards they entered the home of a weaver named Magennis, some 150 yards above the road, on the side of Baltinglass Hill. Magennis and his son served in the Saundersgrove Yeomanry. After a scuffle Dwyer's party killed the father.[511] Back on the Sruhaun Road they encountered a sergeant and then a bandsman, both of the 89th Regiment, and put them to death. Proceeding towards Tuckmill, just short of what is now the site of the old toll house they came on Thomas Young, a local farmer and yeoman, and shot him dead. Finally, passing Tuckmill Cross the rebels attacked and burned the house of John Wilson in Saundersgrove. Wilson, who was sergeant of the Saundersgrove Yeomanry, was not at home and this would have saved his life.[512] As the fair seems to have been what enticed Dwyer's group to the Baltinglass area, it is not unreasonable to speculate that they may have been indulging in the usual pastime at such events. If this series of random revenge killings was really a drunken murder spree, it may well account for the tarnishing of Dwyer's reputation in Baltinglass. Not only was he one of the group involved but he was their leader. However, this again is merely conjecture.

The driving force behind the commemorations started in 1898 was the executive of the '98 Centenary Committee in Dublin, which encouraged the formation of local groups throughout the country. In relation to county Wicklow, two organisations which were also based in Dublin, the Wicklowmen's '98 Association and the Wicklow '98 Monuments Committee, provided much of the impetus. In Baltinglass the initial move towards a local commemoration was the calling of an open air public meeting, which was held in Main Street on Sunday 27 March 1898 and attended by people from all the surrounding parishes. It was chaired by Patrick Byrne of Main Street, then a Poor Law Guardian. A resolution to establish a branch of the '98 Centenary Committee was passed unanimously. In moving the resolution, William Flinter of Main Street referred to the split in the nationalist movement over Parnell, and suggested that it could help heal the split for nationalists to work together on a commemoration of the legacy of 1798. A meeting of the new branch was then held. Patrick Byrne was elected chairman and Denis Kehoe (also of Main Street) became treasurer, while Flinter and a Mr. Doyle were appointed honorary secretaries, and a committee 'embracing all sides of national opinion' was formed.[513]

The local branch became known as the Dwyer and McAllister Memorial Committee. At least some of its meetings were held in the home of Patrick Byrne, in Main Street.[514] In the six years between the formation of the committee and the unveiling of the monument the office holders changed a number of times. Though the erection of the monument was largely the work of a local committee, it was guided and assisted by the Wicklowmen's '98 Association and the Wicklow '98 Monuments Committee, and most of the money appears to have been raised elsewhere in Ireland or abroad.

On Sunday 9 February 1902 a Gaelic football tournament was held in Baltinglass, with the gate receipts going to the memorial fund. The day was very cold and the ground was covered with a light fall of snow, but play was not prevented, though the first match was a disaster. It was to start at one o'clock, but both teams, Hacketstown and Ballyhackett, turned up after that time and then the Ballyhackett captain refused to allow his team play unless Hacketstown produced their affiliation papers. The *Nationalist* reported:

> Whether affiliated or not Hacketstown didn't produce the affiliation papers and a scene then ensued which was verily a disgrace to any team professing to be Irish. Hacketstown finding that their efforts to have the match were in vain gave an exhibition of their 'prowess' by beating and assaulting, not only some of the opposing team, but some of the most prominent members of the Tournament Committee.

After the field was cleared a match between Carlow and Castledermot was played which resulted in a draw. They were followed by Tullow and Athy, with Tullow winning by eight points to two. The final match of the day was between the Young McAllisters of Baltinglass and Athy's Geraldines No. 2. As darkness was

approaching it was decided to reduce it to fifteen minutes a side. Though Athy did not play to their usual form, the home side were very much the weaker team and they lost by five points to nil.[515]

Early in 1902 the manager of the Queen's Theatre in Dublin, J.W. Whitbread, agreed to stage a performance of *The Insurgent Chief* in aid of the Baltinglass monument.[516] Eventually the date for the laying of the foundation stone was set as Sunday 15 June 1902. Arrangements were made with the traffic manager at Kingsbridge for special trains to run to Baltinglass on the day with a third class return fare of two shillings.[517] William Hoey of Church Lane was appointed marshal for the procession, which was to begin in Main Street at one thirty p.m. The chosen route was up Chapel Hill, along the Sruhaun Road and back on the Dublin Road over Eldon Bridge and in by Mill Street, ending at a platform erected in Main Street ('Market Square').[518]

So the day arrived, and with it came uninviting weather. It rained at intervals throughout the morning and shortly after noon a continuous drizzle began, turning to a downpour by evening. Despite this there was an enormous crowd in the town for the event. Five special trains travelled from Dublin and people from places such as Arklow, Wicklow, Carlow, Tullow and Mountmellick came by alternative transport. The procession began at two o'clock. It was led by a car decorated with ribbons and evergreens on which the foundation stone, 'a huge block of granite', was drawn. It was followed by members of the Baltinglass committee, the Dublin-based Wicklowmen's '98 Association and the Wicklow '98 Monuments Committee, representatives of the GAA, the Irish National Foresters (dressed in Robert Emmet costume), various municipal, urban and rural district council representatives and numerous other groups and individuals.[519] The whole procession took about an hour and, as the *Nationalist* report stated:

> The march was enlivened by the stirring strains of the brass and fife and drum bands in attendance. The pageant presented a striking spectacle on entering the town, and the sight is not likely to be soon forgotten by the crowds who lined the footway and on every point of vantage. The town was gaily decorated for the occasion, banners waving from nearly every house, and the streets were here and there spanned with arches bearing suitable mottos, which became somewhat obliterated owing to the rain as the day wore on.

The honour of laying the foundation stone was given to E.P. O'Kelly, then Chairman of Wicklow County Council. He was presented with an inscribed silver trowel by Hugh McCarthy, Chairman of the Wicklowmen's '98 Association. In a cleft in the foundation stone a scroll was placed. It was signed by the officers of the committee and it read:

> To honour the memory of the brave who fought undaunted for the freedom of their native land, to point the way to liberty, this monument has been erected by public subscription, in the confident hope that the structure shall outlast the British Empire.[520]

The ceremony was 'performed amidst unbounded enthusiasm' and it was followed by a public meeting, chaired by P.J. Byrne of Baltinglass. Among those present were the poet, T.D. Sullivan, and Jennie Wyse Power, the Baltinglass born former Land League activist who was then a Poor Law Guardian in Dublin. E.P. O'Kelly spoke, and he was followed by John Mooney of Blackrock Urban District Council, who noted that letters of apology had been received from several people for non-attendance, including Rev. P.F. Kavanagh, OSF, a nationalist historian from Limerick. It had initially been intended that Father Kavanagh would perform the ceremony but for some reason this did not happen. His letter was read out. Even by the standard of hot blooded rhetoric of the day, he made some extraordinary assertions:

> ... England's cruel and unjust policy towards Ireland has not altered since that time of Michael Dwyer and his brave followers. She now tramples on an unarmed Ireland, but let her consider that Ireland may not be always unarmed. If one of those days a foreign Power should declare war against her, that Power will assuredly arm the men of Ireland and use them as an instrument for her destruction. That such an event may happen is far from being improbable. It is well nigh certain to happen. England's pride has been humbled and her weakness exposed by the Boer War. The nations have discovered that an ass has been wearing a lion's hide ...

The letter had its share of barbed comments about the 'sham' loyalty to England of Irish Orangemen and, perhaps significantly, it did not contain a single reference by name to Sam McAllister, the Presbyterian who was being honoured in Baltinglass that day.[521]

When T.D. Sullivan came to address the meeting he was greeted with loud cheers. He was the writer of the famous ballad about Dwyer's escape from Derrynamuck, and his speech concentrated primarily on Michael Dwyer. The final speaker was Joseph McCarroll of Wicklow, a member of the County Council. He said he came to honour the memory of his 'Northern Protestant fellow-countryman, Samuel McAllister' and his words in praise of McAllister were greeted with the usual cheers. Finally he singled out three men, Hugh McCarthy, John Mooney and Bernard Doyle, members of the Wicklowmen's '98 Association and the Wicklow '98 Monuments Committee, as mainly responsible for the idea of erecting the monument.[522]

UNVEILING OF MCALLISTER MONUMENT
SUNDAY 8 MAY 1904

Though the foundation stone of McAllister was laid in June 1902, it was almost two years before the monument was completed. The delay was evidently due to funding and little progress appears to have been made till late in 1903. Following the ceremony of the laying of the foundation stone the local committee continued to

have fortnightly meetings. At the meeting on 22 July 1902 a letter was read which it was intended to send for publication to the editor of the *Irish World*, a newspaper published in New York. The letter explained that the foundation stone had recently been laid and that the committee was 'already nearly £100 in debt, and this sum is sorely needed to complete the memorial'.[523]

At some point the sculptor George Smyth of Dublin was commissioned to execute the statue. Apparently it was complete or nearly so by December 1903 as a photograph of it was submitted to a meeting of the local committee that month. The statue was of Sicilian marble with a life-sized figure of McAllister. It was described as representing McAllister 'as standing with his right arm in a sling, and his rifle by his side, seemingly at bay, yet with the countenance of the unconquerable soldier'. The Ballyknockan granite stones, which were to form the base of the monument, had been delivered in stages from the quarries and were then being stored in T.B. Doyle's premises adjacent to the proposed site. The erection of the statue was planned for the following May.[524]

On Sunday 27 March 1904 the sculptor visited Baltinglass and met with the committee. He advised that a three foot foundation of concrete should be laid before the granite base of the monument was put in place. The committee agreed and appointed Myles Doody of 'The Steps', Main Street, as contractor. A sub-committee consisting of James Byrne, Thomas C. Cooke and Edward O'Neill was appointed to deal with this work and supervise the preparation for the monument. Two days later Myles Doody started work on the concrete foundation. This created some interest within the town as it was the first approach at construction since the foundation stone was laid in June 1902.[525] On Monday 11 April the erection of the base and pedestal of the monument was begun and the work was completed by the following evening.[526] By the last week of April the statue had not yet arrived from Dublin, but it was 'daily expected'. The funds were still a little off target and it was thought that a second collection would be made in the town. Between twelve and fifteen special trains were expected to travel from Dublin on the day of the unveiling.[527]

The final arrangements for the unveiling were made at a meeting on Sunday 1 May. Delegates from the Dublin based Wicklow '98 Monuments Committee and the Wicklowmen's '98 Association were present, as was the sculptor, George Smyth. It was decided that an arch should be placed at the entrance to the Railway Station and that the procession should begin there and take the same route as was followed at the foundation ceremony in 1902. The townspeople were to be asked to hang flags from their houses and a platform was to be erected on the street, with James Byrne, Thomas C. Cooke, E.P. O'Kelly and Edward O'Neill delegated to superintend its construction.[528]

The day arrived and the enthusiastic correspondent for the *Nationalist* estimated the crowd at over ten thousand, with several bands in attendance. In contrast to the conditions two years earlier, the day was fine, with bright sunshine. The uniforms worn by the members of the Robert Emmet Costume Association and

the banners carried by the various delegations gave a festive air to the day. Green flags were placed at the top of the hill and at places associated with the Rebellion. 'Banneretts' hung from many windows in the town.[529]

Father Kavanagh, the nationalist historian, had been invited to perform the unveiling in the presence of the Lord Mayor of Dublin They were greeted on arrival at the Railway Station and the procession began there, with William Hoey leading it on horseback. Behind him were two brakes (large, high, four-wheeled carriages). In the first, Father Kavanagh, the Lord Mayor, E.P. O'Kelly and D.J. Cogan, M.P., were seated, along with members of the Wicklow '98 Monuments Committee. In the second were the members of the Baltinglass committee. Both brakes were escorted by the Robert Emmet Costume Association members. They were followed by the Old Guard Union and numerous delegations including representatives of the Cumann na nGaedheal executive, South Dublin Board of Guardians, district councils, trade unions, workmen's clubs, GAA clubs, '98 memorial committees, branches of the United Irish League and branches of the Irish National Foresters. Among the bands in attendance were those from the Carlow Workmen's Club (brass), Carnew and Tinahely (fife & drum), Rathdangan Foresters Independents (fife & drum), Ballyknockan (brass), Belan (fife & drum) and Ballymore Eustace (brass).[530]

When the procession reached the platform in Main Street, the Lord Mayor of Dublin was invited to preside over the ceremonies. He addressed the gathering before Father Kavanagh unveiled the statue 'amidst loud cheering'. Father Kavanagh then gave a long speech in praise of both Dwyer and McAllister. It contained a certain amount of nationalist rhetoric but it was decidedly more restrained than the message he had written for the foundation ceremony two years before. Among the other speakers was TD Sullivan, who was again received with 'loud and continued cheering'. He said that it had been forty-nine years since the ballad he had written in praise of Dwyer and McAllister was published in the *Nation*, and that it touched his heart to hear it sung that day in Baltinglass. He was followed by Michael Cusack, founder of the GAA, who addressed the meeting in Irish and then in English. *The Nationalist* report on the event concludes as follows:

Before the meeting separated, 'Who fears to speak of '98?' was sung by Mr Goggin, P L G, and chorused in vigorous style by numbers in the crowd and on the platform.[531]

Over a period of some six years it is likely that there were changes in the make up of the Baltinglass Dwyer and McAllister Memorial Committee, so a complete list cannot be given. However, the following were the members at the time of the unveiling: Chairman – Denis Kehoe of Main Street; Vice-Chairman – Patrick Byrne of Main Street; Treasurer – Thomas C. Cooke of Main Street; Secretary – James Byrne (almost certainly of 'Dublin Byrnes', Main Street); and John T. Clarke of 'Geoghegan Clarkes', Main Street, Thomas Cooke junior (only seventeen years old in 1904), James Doyle of Tuckmill (correspondent for the *Leinster*

Leader), T.F. Doyle (almost certainly Thomas Doyle of 'Finnegan-Doyles', Main Street), Thomas Doyle of Deerpark, John Farrell, Joseph Flynn, Nicholas Hanrahan of Weavers' Square, William Hoey of Church Lane, Michael Lalor of Main Street (chemist), Patrick Moore of Deerpark, Andrew O'Brien of Clogh, Nicholas O'Brien junior, E.P. O'Kelly of St. Kevin's, Edward O'Neill of Main Street (publican) and M.J. O'Neill (correspondent for the *Nationalist*).[532] The following had been members in 1902: J.J. Sheehan (a journalist lodging with Hanleys in Weavers' Square), T. Doran (possibly Tom Doran of Kiltegan Road, Lathaleere, who was later noted as a local historian), Daniel J. Kehoe of Weavers' Square, Joe Kitson (then a shop assistant in Flinters', Main Street). Sheehan served as secretary, with James Byrne as assistant secretary.[533]

The local committee held a special meeting on 11 July 1904 to nominate a delegation to attend the laying of the foundation stone of the Father John Murphy Memorial in Tullow on Sunday 17 July.[534] On 16 August the next monthly meeting was held and it was reported that the second town collection had realised £7-19-6. Finances were being considered as the committee was looking at the question of erecting a railing around the monument. It was also decided to ask Baltinglass District Council to replace the street lamp which had been removed from the site of the monument.[535] By the time of the local committee's meeting at the end of October, the Dublin organisers had sufficient funds to pay the outstanding fees to the sculptor, the District Council had decided to erect two street lamps at the statue, and the one remaining matter for the Baltinglass committee was the provision of railings around the monument.[536]

The local committee continued in existence for at least a decade after the unveiling, though it was possibly dormant for much of that time. It had another unpleasant reason to become active in 1911. In the early hours of New Year's Day the monument was attacked in an act of vandalism. The face of the statue was completely covered with tar, along with the front of the body and the left hand. Tar was also thrown on the window of Bridget Finnegan's premises[537] close by. The pedestal appears to have been stained also. There was a public outcry and the local committee offered a reward of £10 for information leading to the conviction of the perpetrator. A number of names were mentioned in rumour but nothing definite was known. A public meeting was held on the street the following Sunday after eleven o'clock mass and messages of support were received from the Church of Ireland parishioners. The damage seemed irreparable and there was speculation that the monument would have to be demolished and replaced. A man was engaged to clear the statue and for many weeks it was out of view behind a platform, as he worked on it. Eventually he was dismissed when the committee realised that he had been unable to remove the stains and was merely in the process of painting over them.[538]

In February it was reported that the police had received information which might lead to a prosecution, but in April when E.P. O'Kelly raised a parliamentary question in Westminster, the reply stated that no incriminating evidence had been

found, that the attack appeared to have been meaningless and that it was 'probably done as a practical joke'. It appears that no formal charge was ever made.[539]

Apparently it took a long time to remove the marks and, indeed, it is possible that the statue never really recovered its original appearance. In 1914 the committee held a collection to fund renovation work. The statue was enamelled to resemble its original marble, the railings were painted, and some work was done to the base. The renovation was completed by John Snow.[540]

THE OPENING OF THE TECHNICAL SCHOOL
MONDAY 9 MAY 1904

In 1899 the Agriculture and Technical Instruction (Ireland) Act was passed, establishing the Department of Agriculture and Technical Instruction for Ireland and enabling councils to set up committees to further the implementation of technical and agricultural education. The system was to be financed partly by the Department and partly by the rates.[541] In 1900 Baltinglass District Council No. 1 received a circular from the Department asking what steps had been taken to form a committee. The Council replied that they were not in a position to co-operate on the matter at that time.[542] In 1901 Wicklow County Council agreed to levy a rate of one penny in the pound for the scheme and the first County Committee of Agriculture and Technical Instruction was apparently appointed in January 1902.[543]

Instructors in various subjects were appointed by the county council. By 1910 there were two permanent centres for instruction in the county, in Arklow and Wicklow, where courses were taught throughout most of the year. Elsewhere in the county there were centres which were visited by itinerant instructors.[544] The first reference found to courses being given in Baltinglass was to a series of four lectures given by the horticultural instructor in 1904. The lectures were given on Monday evenings in the Town Hall, beginning on 4 January.[545] In the second week of February 1904 the Town Hall was also used for a series of free cookery lessons. However, these were unrelated to the technical instruction authorities. They were given by a representative of an American company as an advertising promotion.[546] At the end of March the poultry instructor started a four week course of lectures in the area. The first was given in Baltinglass, with others given in Stratford, Dunlavin, Talbotstown and Rathdangan. In announcing the course, the Baltinglass correspondent commented in the *Nationalist*:

> It has been said that Baltinglass is very slow to avail of the advantages to be derived from the instructions, which the Department have arranged for their benefit, and, indeed, the lectures in other branches of agriculture and technical instruction were nearly always badly attended in Baltinglass.[547]

Arguably the proper commencement of technical classes in Baltinglass can be dated from when a building was made available for instruction by the then Parish

Priest, Father O'Neill. This coincided roughly with the start on 9 May 1904 of the first of two courses given in the summer of 1904. On 30 April 1904 the *Nationalist* reported:

> The Department of Technical Instruction have provided for a course of instruction in domestic economy extending over four weeks in Baltinglass to commence on the 9th prox, and at the conclusion of which the services of a manual instructor will be available for the same period. The Very Rev. Thomas O'Neill has had the old school renovated for an instruction room. So far Baltinglass has proved itself slow in availing of the opportunities held out, and it is to be hoped that in future it will realize the benefits that may be derived from such instruction.

Whether the domestic economy course, begun the day after the unveiling of McAllister, took place in the building provided by Father O'Neill is unclear. This building was on Chapel Hill and it is still there as the front portion of Fatima Hall. It had served as the Girls' School before the new Convent was opened in 1879. Subsequently it had been used for the boys before the adjacent Boys' National School was finished in the late 1890s. In the Convent Annals reference is made in an entry dated 22 September 1904 to the bishop granting 'permission to fit up as cookery school the old schools which were used by the Boys when the seniors moved into their new Convent'. This permission may have been retrospective, as the 30 April newspaper report implies that the school was already renovated. This building continued to be used for technical classes for several years. In the Parochial Accounts there is an entry under July 1906 which reads 'to Rev. Mother for Technical School £10-12-0'.

To encourage enrolments, at the end of the five week woodwork course given in 'the Technical School' in the summer of 1904 members of the local technical instruction committee presented prizes for neatness of work and good attendance in senior and junior categories. Those who gave the prizes were Father O'Neill, Dr. Cruise, E.P. O'Kelly, William Flinter and T.F. Doyle. In the senior (or adult) section the top four were Joseph Burke, William Clarke, B. Neale and John T. Clarke. In the junior section the top four were E.J. O'Kelly, Thomas Doyle, George Griffin and Patrick Carty. At the time it was stated that as a result of the interest shown in the classes Baltinglass was 'likely to become a central station'.[548] However, this did not happen and the town continued to benefit from visiting instructors only.

It must be remembered that these early courses simply consisted of one evening class per week and ran over four or five weeks. While they were really aimed at those who would not otherwise receive an education beyond primary level, it appears that for whatever reason they were not greatly attended by poorer people. In 1910 the Baltinglass correspondent for the *Leinster Leader* commented that 'facilities for technical training have up to the present been so much out of reach of the very class of people to whom such a training would be most useful'.[549] While general attendance

levels may have been high in the early years, the county authorities received much criticism for neglecting Baltinglass. The poultry, dairying and horticultural instructors did not visit the town in 1909, when only woodwork classes were given, and in 1910 there were no courses given in Baltinglass. The town was not even listed among the sixteen centres to which itinerant instructors would travel in 1911.[550]

Despite this low ebb, there was talk at the same time of purpose-built technical schools being erected in Baltinglass and Arklow. The cost of the construction was estimated at £2,800. A loan of about £2,500 was to be obtained and the county council agreed to contribute £125 a year towards repayments, provided that the Department would make a special grant of £300 in aid of the project. The Department refused to do so, but in January 1910 it was reported that a deputation from the Technical Instruction Committee for County Wicklow visited the Department and obtained a promise that it would co-operate in the project.[551] The county council then agreed to raise a loan for the building work.[552] However, more than a year later, though a site had been chosen for the Baltinglass school, there was no sign of construction commencing. The local correspondent for the *Nationalist* commented that the penny in the pound continued to be levied off the Baltinglass district despite the fact that there were no classes being given in the town.[553] Quoting the 1910-11 year book of the Technical Instruction Committee for County Wicklow, he also indicated that a local committee had been formed in Baltinglass in 1909 but had never met, and that the same members' names were still listed two years later even though some of them had since left the area.[554]

By 1914 the school in Arklow was built but the much smaller one planned for Baltinglass still had not been started. The Technical Instruction Committee approached the county council seeking additional funds to allow them proceed with the project. The architect's estimate in 1907 had been £475 but building costs had increased enormously since and only one tender had been received, which was about double the architect's estimate. A loan of £200 was sought from the council but this did not materialise. At that point, just weeks after the death of E.P. O'Kelly, who was one of their members and an advocate for a school in west Wicklow, the Technical Instruction Committee indicated that they intended the Baltinglass school to be named the E.P. O'Kelly School.[555]

Two years later the *Nationalist* correspondent was still lamenting the neglect of Baltinglass. He pointed out that the Technical Instruction Committee for the county met in Wicklow town and that members from west Wicklow had to 'motor directly to Wicklow or travel by train to Dublin, and remain a night in the city'. As a consequence of this difficulty, Baltinglass was not getting a proper hearing on the committee.[556] At that time the local representative on the committee, Rev. Arthur Murphy, C.C., had recently been transferred from Baltinglass to Maryborough and there was a vacancy on the committee. He was not replaced until November, when Edward O'Neill of Main Street was nominated in his place by the Baltinglass committee. At the same time the local committee passed the following resolution, proposed by Joseph Turtle and seconded by Percy Mogg:

As the building of technical schools in Arklow and Baltinglass was incorporated in the same scheme, and as the Arklow school was completed long ago while the prospect of the Baltinglass building being realised seems indefinitely remote, and as the erection of the latter structure has been delayed for years owing to the increased cost of building materials, etc., while an additional grant was recently given to Arklow schools on the very grounds on which it was denied to Baltinglass and West Wicklow is contributing equally to the general fund according to its rated value: we, for all those reasons, protest in the strongest possible manner against the unfair and unequitable treatment, and we call upon the County Committee to take immediate steps for the erection of Baltinglass Technical School.[557]

Despite this urgent plea, it would be another three years before a permanent technical school was opened in Baltinglass, and another two decades before a purpose-built school would be provided.

E.P. O'KELLY RETURNED UNOPPOSED AS MP FOR WEST WICKLOW
TUESDAY 29 MARCH 1910

The day of E.P. O'Kelly's election as MP in March 1910 must have been a particularly proud one for Baltinglass. Though O'Kelly had already sat in Parliament for a few months almost fifteen years earlier, he had then been representing a different constituency. This time he was chosen as member for West Wicklow and declaration of his election was made on home ground, in Baltinglass Courthouse. While his election in 1895 was the more historic, this victory must have held more sentimental significance for the town.

By March 1910 E.P. was sixty-three years of age and this victory came after almost three decades in political life. He was a nationalist of the generation that rolled back the landlords' political power. In the early 1880s he had been a Land Leaguer kicking against the establishment. In 1910 he was the establishment – MP for West Wicklow, Chairman of Wicklow County Council, magistrate, and elder statesman of Baltinglass Board of Guardians and District Council. Though the nationalists were a minority in Westminster, they controlled county and local administration in Wicklow, and E.P. O'Kelly was at the helm.

The by-election was occasioned by the death of the sitting MP for West Wicklow, James O'Connor. O'Connor had served as representative for the constituency since the 1892 general election, when he had won decisively standing as an anti-Parnellite. In 1900 the nationalists were reunited as the Irish Parliamentary Party under John Redmond and the division caused by the O'Shea divorce case was put to rest. Redmond had been leader of the Parnellites in the 1890s, while James O'Connor and E.P. O'Kelly had been of the opposite camp. O'Connor was last returned for West Wicklow in January 1910, in the general election. He was then in his mid-seventies and in poor health. Nevertheless, he was nominated by the Irish Party without a selection meeting. Being unable to travel to Baltinglass

for his nomination on 18 January, he was represented by a relative, Thomas O'Reilly, TC, of Dublin. He was returned unopposed, but little interest in the proceedings was shown locally.[558]

O'Connor died on 12 March 1910.[559] At a meeting of the recently resuscitated Baltinglass branch of the Town Tenants' League held shortly afterwards, a resolution was passed calling for the nomination of the General Secretary of the League, J. Coghlan Briscoe, to the vacancy. However, it appears that the meeting was unaware that E.P. O'Kelly would be willing to allow his name go forward. Later in the month John Redmond requested O'Kelly to stand for the Irish Party, again without a selection meeting, and he agreed. At the same time it was rumoured in the daily newspapers that the Conservatives were to contest the seat, with 'a well-known local man'.[560] Nominations for candidates were to be handed in at Baltinglass Courthouse on Tuesday 29 March between eleven a.m. and one p.m. That morning the Lord Mayor of Dublin, Michael Doyle, arrived in Baltinglass on the ten a.m. train, along with Denis Johnston of the United Irish League and Thomas O'Reilly, TC. At eleven thirty they and several 'representative residents of the town and district' accompanied E.P. O'Kelly to the courthouse. The High Sheriff for County Wicklow, Mervyn Tynte of Tynte Park, Dunlavin, was there to receive nominations, along with William Toomey, the Sub-Sheriff. Fourteen nominations were handed in, all of them for E.P. O'Kelly. The first of these was proposed by the Parish Priest of Baltinglass, V. Rev. Thomas O'Neill, seconded by Rev. John Donovan, C.C., Baltinglass, and the assenting electors were Nicholas Hanrahan, William Prendergast, Daniel J. Kehoe, Joseph Flynn, Patrick Byrne, Sen., Patrick Byrne, Jun., John T. Clarke, and Nicholas Cott, all of Baltinglass. However, the other nominations were from throughout West Wicklow, and two of them were proposed by Protestants.[561]

By one o'clock there were no nominations for any other candidates, so Col. Tynte formally declared O'Kelly elected. Addressing the new MP he said:

> I have great pleasure in congratulating you on becoming member for this division of the County Wicklow. We all know the good work you have done on the county council and I hope that you will do everything in your power for the county now that you have become a Member of Parliament.

After O'Kelly, the Lord Mayor and Thomas O'Reilly made brief speeches thanking Col. Tynte and Mr. Toomey for performing their duties with efficiency and impartiality, the business was concluded.

Immediately afterwards a public meeting was held over which Father Donovan presided. During his speech to this meeting, O'Kelly stated:

> ... Mr. Redmond has one of the most difficult moments of his life just as I am addressing you, for the House of Lords is in the smelting pot in the House of Commons, and if Mr. Asquith does what he should do and what he was returned to

do, and if he comes out triumphant over the House of Lords, in a short time we will have Home Rule.

The Liberal leader, Herbert Asquith, was then Prime Minister. He was attempting to remove the House of Lords' veto over bills passed by the House of Commons.

E.P. O'Kelly, MP, set off that week for Westminster. He travelled from Baltinglass to Dublin by train, and was greeted at Kingsbridge Station by several Wicklow residents of the city. After speeches he was driven in the Lord Mayor's carriage to Westland Row, and then travelled by train to catch the mail boat for Euston. By the end of the week he had taken his seat.[562] Another general election followed in December, but E.P. was again returned unopposed.

Eventually in August 1911 Asquith managed to curb the powers of the House of Lords with the passing of the Parliament Act. This removed the Lords' veto, and ultimately cleared the way for the passing of home rule for Ireland. In October 1911 John Redmond was in Baltinglass to address a nationalist meeting. He referred to the fact that the Parliament Act had removed the greatest obstacle to home rule, and stated that a Home Rule Bill was not only in preparation but was almost completed. He asked for the public's trust as the Irish Party continued confidential negotiations with the government. He said that in a matter of weeks the bill would be before the public.[563] A little over a year later the Home Rule Bill was passed by the Commons but defeated by the Lords. It had to have two further passages through parliament before it became law. Though it was subsequently delayed by the Great War, the granting of home rule after over 110 years of direct rule from London was a historic landmark, and E.P. O'Kelly was a member of the parliament that passed the legislation.

THE COUNTY JUNIOR FOOTBALL CHAMPIONS
SUNDAY 26 JANUARY 1913

Baltinglass had its first taste of county championship victory in Gaelic games with its footballers winning the 1912 Wicklow Junior title. Though it was a 1912 Wicklow championship, the final took place in Jones' Road (now Croke Park), Dublin, in January 1913. The reason for the Dublin venue was that their opponents were Newcastle. With the mountains dividing them and motor transport still a luxury confined to the wealthy, it was easier for both sides and their supporters to travel to the city.

The winning Baltinglass team was captained by Tom Kehoe of Weavers' Square[564], and the other members were Peter Conway, Christy Timmins, Tom Loakeman, Pat Harte, J. Harte, Jim Ryder, Garret Byrne, Peter Tynan, Jack Kenny, W. Whelan, J. Coogan, M. Nolan, Mick Ryder, J. Reilly, J O'Toole and Dan O'Neill.[565]

The weather that morning was unseasonably fine, with a cloudless sky and bright sunshine. A special excursion train was put on for the match. It was to leave

Baltinglass at ten thirty a.m. and by that time there was a crowd of about 250 waiting on the platform. On the way to Dublin the train picked up more passengers at Grangecon, Colbinstown, Dunlavin and Naas, so that there was standing room only. Not all of those travelling were necessarily going to cheer on Baltinglass, as Kildare were also playing that day. Arriving at Kingsbridge Station, the train was met by a large crowd of supporters from Dublin. The platform was so densely thronged that the only indication for the Baltinglass supporters of where to go was to follow 'Gorman's Hat'. This hat must have been fairly large, as it caused quite a stir as the crowd passed through the city and while they were in Jones' Road.[566]

Before the Wicklow final there was a challenge match between Antrim and Kildare, which was won by the northern team. As a result of the playing of this match and rain in recent days, the ground was slippery and soggy in places, so it was far from ideal. The first half was notable for the number of near misses in the Baltinglass attempt to score, with Loakeman, Reilly, Ryder and Tynan conspicuous in the play. Then, as the *Leinster Leader* reports, '... P. Harte, on the right, got possession and brought down, a lively piece of play near the Newcastle end-line resulting in a fifty being awarded to Baltinglass, and Reilly sending the ball well up, gave Loakman his chance to send over the bar, thus drawing first blood for Baltinglass.' Shortly afterwards, 'after a fast bit of play around the Newcastle posts Timmins succeeded in finding the net in clever fashion.' Reilly scored another point and at half time Baltinglass led by 1-2 to nil. In the second half 'the game practically resolved itself into one of attack and defence, Baltinglass being the aggressors, and Newcastle with outposts driven in, concentrating for defence and occasionally getting free to make an excursion into Baltinglass territory.' The *Leinster Leader* report continues:

> The Baltinglass forwards at length had their efforts rewarded, Timmins negotiating a goal during the last quarter, and shortly afterwards adding a point for his side, leaving the play as follows when the long whistle sounded:- Baltinglass, 2 goals 3 points; Newcastle, nil.[567]

The account given by M.J. O'Neill in the Baltinglass notes in the *Nationalist* was not particularly flattering to either team:

> Play in the opening stages of the Baltinglass v. Newcastle match was rather dull, but as it progressed it got livelier. During the first half, the ball was seldom out of Newcastle territory, but the shooting of Baltinglass forwards was weak missing many fine chances of scoring. The exhibition of football given by the teams was not considered by any means brilliant, but, with practice, both teams should give a good account in future.

The sports coverage in the same edition was a little more encouraging, stating that:

Both teams worked very hard right through the match, and, though the football was not up to the usual form in Junior finals, with more attention to the game both sides should do very well, for in appearance they certainly looked fit enough to meet any team in the country.[568]

The victorious team, accompanied by Father Arthur Murphy, travelled home by train and were met at Baltinglass station by Father James Mahon, the other curate of the parish, and a large gathering. On hearing the result the crowd cheered and tar barrels were lit on the streets to celebrate the victory.[569]

The *Nationalist* noted that the Baltinglass club was only about two years old but that it had only once been defeated in competition, adding that 'this season they have won three sets of medals'. In fact, it was only twenty-one months before that a meeting was held in the Town Hall for the purpose of reviving Gaelic football in Baltinglass. Joe Kitson appears to have been the instigator of the revival. He chaired that meeting in April 1911 and over fifty young men attended. The most important point was the finding of a suitable field. Kitson, Denis Hanrahan and M.J. O'Neill, the then local correspondent for the *Nationalist*, were appointed to make enquiries and they got permission to use the field in Newtownsaunders that had formerly been used for Gaelic football.

The following Sunday, 23 April, a meeting was held at the field and a committee was appointed. J.P. Keegan was appointed president of the new club, Denis Hanrahan, vice-president, Joe Kitson, treasurer, M.J. O'Neill, secretary, Garret Byrne, assistant secretary, and the committee members were P.J. Byrne, John Fitzpatrick, Robert Griffin, John Harnett[570], Tom Kehoe, John Murphy, John Noone and John O'Neill. Over forty subscriptions were handed in, and the first practice session was arranged for the following Sunday. Some of the members were seasoned footballers who had played for the former club. When the members gathered the following Sunday more than twenty others were there wishing to join. Father Mahon arrived in Baltinglass in 1911 and the following year he was elected president of the club. Father Murphy was supportive from the start, and he was made the club's patron about the same time.[571]

As a result of the victory in the 1912 Junior Championship, Baltinglass players began to appear on Wicklow teams. Tom Loakeman, J. Nolan, Jim Ryder, Christy Timmins and Peter Tynan featured on county teams in 1913 and 1914.[572] Tynan, who was from County Kildare and was a teenage shop assistant in E.P. O'Kelly's at the time, replaced Tom Kehoe as captain of the Baltinglass team, apparently in 1913. 1914 was a bad year for the club, as reported at the annual general meeting in the Town Hall in February 1915. It was to hold two tournaments but these had to be postponed. Then the Volunteer movement started in June 1914 and the members were drilling and had little time to play football. Despite this, Baltinglass had five players, E. Nolan, Dan O'Neill, Mike Prendergast, Jim Ryder and Peter Tynan, on a Wicklow team competing in the Leinster Championship in May 1915. Mike Prendergast, who was from Weavers' Square, was then a teenager. Two years

later, in April 1917, he died aged twenty. He was described as 'one of the finest Gaelic footballers that ever did duty for Wicklow' and it was noted that just a few months before his death he 'found net with lightening shot that gave victory against Carlow at Croke Park'. His neighbour Christy Timmins, another Wicklow player and the man who scored the second goal in the Baltinglass victory in 1913, died in the 'flu epidemic the following year.[573]

The Baltinglass club had ceased to exist by the end of the Great War, as a meeting was held in the Town Hall on 28 April 1919 to revive it. A provisional committee was appointed but a new field had to be found, as the old one was then under tillage. In July the team made their first appearance at the Aeridheacht at Tynock, accompanied by the Baltinglass Pipers' Band, and defeated Rathdangan. Despite 'The Troubles', Baltinglass continued to compete on a regular basis, and they reached the final of the county senior championship of 1919. This was played in March 1920 at Hacketstown. Jim Ryder captained Baltinglass against Tinahely but the latter won by 1-3 to 0-3. In May 1920 it was stated that the club's membership level had never been so high. However, the disturbed state of the country eventually took its toll. The club was yet again being re-organised in December 1921 after a year or more of inactivity. The idea was to find suitable grounds for football and athletics, and it was guaranteed financial support by 'a prominent Baltinglass gentleman'. This may have been Ned Doyle of Main Street, who was elected president at a preliminary meeting on 6 December. He was already president of the Baltinglass Sports committee, which ran an athletics and cycling day in September. The following year he presented a cup to the County Board.[574]

Even though the country was in the midst of the Civil War in 1922, the club continued to function and it had three representatives, W.E. Lynch, Jim Ryder and Michael Timmins on the Wicklow team against Meath at Croke Park in May 1923. At the Baltinglass GAA club annual general meeting on 15 June 1923 it was announced that a field had been secured for £9 for six months and a pitch was to be laid. The club was to hold an athletics and cycling sports day on 15 August. Ned Doyle was returned as president, Joe Kitson and Willie Turtle as vice-presidents, Dan Kehoe, junior, as treasurer, Ben Farrell and Michael Timmins as hon. secretaries, and on the committee were M. Byrne, Henry Gaskin, Denis Hanrahan, Dan O'Neill, C. Regan and Jim Ryder.[575]

Despite the enthusiasm, the football club again failed. Handball and hurling had their heyday in the late 1920s, and Tuckmill's football club took centre stage in the early 1930s, drawing many of its players from the town. It was not until 1934 that a Baltinglass Gaelic football club returned to the scene.

IRISH VOLUNTEER CORPS FORMED IN BALTINGLASS
SUNDAY 14 JUNE 1914

In 1913 the Home Rule Bill put forward by Asquith's government was passed by the Commons on 16 January and two weeks later defeated by the Lords. However,

as a result of the Parliament Act the Lords could only stall legislation, not veto it. Irish unionists were alarmed. The following day the Ulster Volunteer Force was established. Its aim was armed resistance to the establishment of a separate parliament for Ireland.

The Home Rule Bill was passed a second time in the lower house on 7 July and again defeated. The unionists responded in September by appointing a provisional government for Ulster in the event of home rule being granted. To avoid conflict Redmond was persuaded by Asquith to consider excluding Ulster from the area to be granted home rule. To counter the very effective posturing of the Ulster Volunteers, the nationalists formed the Irish Volunteers in November.

When, on Monday 25 May 1914, the Commons passed the Home Rule Bill a third time the Lords could do nothing to stop what seemed to be the inevitable. But international conflict, brewing for many years, was to do what the Lords could not. Though the bill received Royal Assent on 18 September 1914, things had already come to a head on the Continent. The assassination on 28 June in Sarajevo of Archduke Franz Ferdinand was the spark that triggered a war that was to touch the lives of millions. On 4 August the United Kingdom entered what was to become known at the time as the Great War. As a result of hostilities the Irish Party agreed to suspend the operation of the Home Rule Act until peace was restored. Of course, it was not anticipated that the war would last any more than a matter of months.

The night of the third passing of the Home Rule Bill saw fires ablaze in Baltinglass as the town celebrated. Tar barrels for the bonfires were supplied by Andy Doyle, Michael Harbourne, Thomas Jackson, Ned O'Kelly and Joseph Turtle. The following evening E.P. O'Kelly returned home and 'gratitude was expressed to him for his splendid record of attendance during the progress of the Home Rule measure'.[576] A week later plans were afoot to belatedly form a corps of the Irish Volunteers in Baltinglass.[577] It may well have been that trouble was anticipated after the passing of the bill. In any case, hundreds attended an open air meeting that was held on Sunday 14 June. It was chaired by Father Arthur Murphy, while M.A. Hargadon, a journalist based locally, acted as secretary. The Kiltegan and Tynock corps attended, as did many from the Castledermot corps. Hargadon read a letter from E.P. O'Kelly, who was then back in Westminster.

The O'Mahony, who lived in Grangecon House and was a former nationalist MP, then addressed the meeting, outlining the background to the bill, which would be delivered 'in a few weeks after it has received the assent of the king'. Hargadon stated that it was six months since the movement began and that Baltinglass was late to start recruiting but he spoke encouragingly. He proposed the following resolution:

> That this meeting welcomes the Irish Volunteer movement as a necessary reply to the threat to deprive Ireland by force of the Parliament now on the point of being won back for her under the leadership of Mr. Redmond and the Irish Party, and we pledge

our practical support to the Volunteers as the guardians of the liberties of Irishmen against any attack, and we request the Dublin Provisional Committee to reconsider their decision in order to meet the views of Mr. Redmond and the Irish Party.

It was seconded by Joe Kitson and carried unanimously.

A provisional committee was to be appointed and The O'Mahony agreed to be patron of the corps. In accepting the position, he said that he would be away in Bulgaria for some months and he suggested the following officers and provisional committee – President: Rev. Arthur Murphy; Vice-President: Rev. Martin Brophy; Treasurer: Edward O'Neill; Secretaries: Ned O'Kelly and M.A. Hargadon; Committee: E.P. O'Kelly, Joe Doyle (Tuckmill), John Connolly (Rathmoon), Jim Doyle (Mill Street), Marks Dalton, Joe Kitson, Patrick Byrne (Baltinglass), Dan Kehoe and Charles McCauley (Grangecon). The suggestion was unanimously carried. Enrolment took place after the meeting, and about three hundred Volunteers marched through the town.[578]

The Baltinglass corps was a fortnight in existence on the day of the Sarajevo assassination. By then the corps had 158 members. Each man was to pay a weekly fee of two pence and it was agreed to pay a small fee to Martin Butler of Ballyraggan to drill the corps. Jim Doyle of Mill Street, a Boer War veteran, was also a drill instructor. Drills were arranged for Sunday, Tuesday and Thursday evenings, and the largest assembly of Volunteers on any one night was about two hundred. Early in July preparations were being made for forming a pipers' band. There had been a band in the town before and there was money belonging to it in an old bank account, while it was thought that there was also money belonging to the race meeting committee of the 1880s languishing in an account. Joe Kitson had drums in his possession and these were sent for repair.[579]

By the end of September a fife and drum band had been established, as it led a march of Volunteers to eleven a.m. Mass on Sunday 27 September after haversacks and belts were distributed. The following Sunday twenty-five rifles were distributed among the corps.[580] A few weeks earlier the Home Rule Act had received Royal Assent but had been suspended because of the war. At a meeting in Woodenbridge John Redmond had appealed to the Irish Volunteers to not only defend their own country but to serve 'in defence of right, of freedom, and religion in this war'. This led to a split in the leadership of the Volunteers, with the more ardent nationalists rejecting Redmond. As with earlier nationalist movements, the Volunteers were infiltrated by the IRB. This element of the movement then began planning in earnest for a rebellion.

Possibly because of the split, the Volunteers began to dwindle in West Wicklow. Nonetheless, the majority of Volunteers in the area remained loyal to Redmond. He motored through Baltinglass a number of times about then and was cheered by his supporters. The Stratford corps came out in favour of him, while Baltinglass and Kiltegan initially took a neutral stance. Then, at a meeting on Sunday 6 December, the Baltinglass corps passed the following resolution:

That we, the Baltinglass Volunteers assembled, hereby testify our allegiance to
our worthy leader, Mr. John E. Redmond, and under his able commandership we
organize our National Volunteers to train, arm and equip the Volunteer force for the
defence of Ireland and the advancement of Irish rights and the maintenance of Irish
self-government.[581]

The Baltinglass corps held a fundraising concert in the Town Hall on St Patrick's
Night 1915. The artists were local, but they included the 'celebrated baritone'
William Cope, making one of his frequent appearances in his native town.Later a
Baltinglass deputation of twenty-four, all carrying rifles, was sent to take part in a
national parade of Irish Volunteers in Dublin on Easter Sunday.[582] The Volunteer
corps appear to have become inactive in Baltinglass over the next few months,
as there is little or no mention of it in the local newspapers. However, the local
nationalist movement remained loyal to Redmond and the Irish Party.

On Sunday 17 October 1915 the Baltinglass branch of the United Irish League
hosted a large public meeting at the Market Square primarily to rejuvenate the
nationalist movement in West Wicklow and to show support for 'a disciplined and
united pledge-bound Irish Party in Parliament until the Home Rule Bill has been
actually put in force'. Father Arthur Murphy was chairman of the branch, William
Kehoe of Main Street was vice-chairman, William Byrne of Kilmurry was secre-
tary, and Joe Burke of Rathmoon was treasurer. Others to the fore included John
T. Clarke of Main Street, James Doyle of Tuckmill and Joe Kitson. The meeting
was chaired by Father Murphy and the speakers included the local MP, John T.
Donovan, who had succeeded E.P. O'Kelly, J.M. Gallagher, who was Lord Mayor
of Dublin, and Joseph Devlin, MP. The resolutions were enthusiastically adopted.
Donovan was cheered when he praised the Irish soldiers then fighting on the con-
tinent as upholding Ireland's commitment to democracy. He said 'Did the people
of Ireland listen for a moment to the voice of the factionist, the critic, or the other
impossible person who dreamed of an Irish republic, then, indeed, would the
country commit national suicide.'[583]

Devlin was the next speaker. In calling on dissidents to support mainstream
nationalism he said: 'If local opinion is to be brought to bear upon public ques-
tions, there is no more effective way of doing this than by keeping the local branch
of the UIL and the local unit of the National Volunteers in good working order in
affiliation with the central offices in Dublin.' He added that the Volunteers would
'prove a great instrument in the welding together of all Irishmen of all creeds and
classes for the welfare of Ireland under Home Rule'.[584]

In November what seems to have been a meeting to regenerate the corps was
addressed by a Volunteer organiser. It resulted in the recruitment of about twen-
ty-five members, but again the Volunteers disappeared from the local press and may
well have ceased to train. In August 1917 the sound of knocking on the door of Joe
Kitson's house in Main Street at one a.m. revived the memory of the corps. Kitson was
custodian of its rifles and bayonets, and his surprise visitors were the Dunlavin and

Baltinglass police who were there to confiscate the weapons. By then the political climate in Ireland was changing. Mainstream nationalism was beginning to lose support to republicanism.[585]

THE DEATH OF E.P. O'KELLY
WEDNESDAY 22 JULY 1914

On 26 May 1914 E.P. O'Kelly returned from London to Baltinglass as the hero of the hour, one of the Irish Party Members of Parliament who had achieved Home Rule. He addressed a meeting of the Kiltegan corps of the Irish Volunteers, telling them that better days were on the way for Ireland. Before the Baltinglass corps was formed he returned to London and on 22 July, less than two months after the Home Rule triumph, he died at the age of sixty-eight.

News of O'Kelly's death must have stunned Baltinglass. For over thirty years he had been the most prominent nationalist activist in the town. He had evolved into a father figure and a politician respected by many who differed from him in ideology. The son of William Kelly from Englishtown and Anne Germaine from Lisnavagh, E.P. was born in July 1846 in Main Street,[586] where his father ran a grocery shop and public house. From the early 1880s he had been involved in practically every aspect of Baltinglass life. Having been a local leader in the Land League days, he became a member of the Board of Guardians, then its first nationalist chairman and briefly an MP for East Wicklow, then first chairman of Wicklow County Council, and finally MP for West Wicklow. He was one of those behind the town's cricket club, the race meetings, the 'Maurice Davins', the Town Hall and the Volunteer corps, as well as recording some interesting items of local history.

On Friday 24 July a mass was held at St James's Church, Spanish Place, London and among the congregation was the Irish Party leader, John Redmond. That night many of O'Kelly's fellow MPs gathered on the platform at Euston Station as his remains left London on the mail train. At Carlisle Pier in Kingstown the following morning many Baltinglass and Dublin friends were there to pay their respects. The long journey to Baltinglass continued by train and the remains arrived at ten o'clock that morning. A huge crowd had gathered at the railway station. Under the command of Jim Doyle, the newly formed Baltinglass Volunteer corps lined the platform. All shops were closed that Saturday morning as the hearse moved through the town. In the churchyard the Volunteers formed a guard of honour and eight of them carried the coffin into the church.[587]

At a special meeting of the Baltinglass Board of Guardians that day, the members passed a vote of sympathy and many made personal tributes. Among them was James Wynne (of Manger House, Stratford) who said 'Mr. O'Kelly has been to me more than a friend, as one who, perhaps, differed from him in political views and in religion I found him one of the truest and most sincere friends I ever met in my life'. The Clerk of the Union, Ralph Dagg, said that though he and O'Kelly

disagreed on certain matters they were firm friends. When he first met him over thirty-five years earlier he found that their opinions coincided on matters such as remedial legislation. While O'Kelly was chairman of the Board of Guardians they co-operated in making Baltinglass one of the most efficiently managed unions in the country. He added that if O'Kelly erred at all it was 'on the side of liberality'.[588]

Following eleven o'clock mass on Sunday the funeral proceeded to the graveyard. Nearly a thousand Volunteers from throughout West Wicklow and neighbouring areas lined the streets and saluted as the hearse passed.[589] At the time there was a determination to perpetuate the memory of E.P. . A committee, with Protestant and Catholic members and chaired by Denis Kenna, one of the two Baltinglass doctors, began collecting subscriptions for a suitable memorial. The two main suggestions were a market arcade or shelter and an ornamental fountain. Sufficient funds were collected for the memorial but the type of memorial was still being debated a year later. Eventually it was decided to build the shelter, assuming that there was no objection from the owners and occupiers of adjacent properties.[590] For whatever reason, no memorial was ever built. Shortly after O'Kelly's death the local Technical Instruction Committee were hoping to build a new school in Baltinglass and they stated their intention of calling it the E.P. O'Kelly School.[591] As the new building did not materialise for another two decades this never happened. So by the end of the twentieth century, the man once described by a disgruntled exile to America as 'boss' of Baltinglass[592] was only a disembodied name to older residence and entirely unknown to younger generations.

EASTER RISING
MONDAY 24 APRIL 1916

John Redmond's co-operation with the government in 1914 in relation to the war on the continent alienated the more radical nationalists, who set about planning a rebellion. When their relatively small uprising took place it surprised the general populous. As it was centred on Dublin on a holiday weekend, it caused confusion and great inconvenience, and it was hardly looked on as an important historical event. It was only afterwards that it became significant as a turning point in the nation's ideology and took on the mantel of an epic occurrence.

Most of Baltinglass's experience of the 1916 Easter Rising was confined to the anxiety and inconvenience it caused, but there were a few locals who could give first hand accounts of scenes in the city centre. The incident began on Easter Monday, and from then until the Wednesday afternoon Baltinglass had no news of what exactly was happening in Dublin. There was no railway or telegraph communication, and no newspapers arrived. The many visitors who had travelled by train to Baltinglass for the weekend were stranded in the town for the rest of the week. Each day they went to the railway station hoping that the trains would resume. Likewise, locals who had to spend Easter in the city or elsewhere found it impossible to get out of Dublin 'except by motor or the less modern hackney'.

At the time the journey from the suburbs of Dublin to Baltinglass took about two hours motoring, and motor cars were a luxury.[593]

H. Dillon, an assistant chemist in Gorry's Medical Hall, was one Baltinglass resident trapped in Dublin during that week. He wrote: 'We were shot at, burned out of Wynne's [Hotel in Lower Abbey Street] and imprisoned in the Custom House for several days where our daily allowance was one biscuit with some bully beef.' However, the experience of J.H. Nugent, manager of the National Bank, was even more immediate. He and his wife had gone to spend Easter with his brother-in-law, who was manager of the Great Britain Street [now Parnell Street] branch of the National Bank. Their enjoyment ended abruptly when the bank house was occupied by the military, who used the building as a point from which to shell the G.P.O. As Nugent became seriously ill, he had to remain there.[594]

A general feeling of relief descended 'when it became known on Wednesday evening that the military had the situation well in hand'. These words of the Baltinglass correspondent of the *Nationalist* were representative of public opinion at the time. Writing an account three weeks later of a visit to the devastated city, the same man concluded: 'The general impression I got of the prevailing feeling among the citizens was one of quiet relief that the horrible nightmare had passed away.'[595]

There was fluctuation in the prices of various items in the weekly market in Baltinglass on the Friday after Easter Monday, with eggs hardly selling at all. Otherwise the uprising had no other immediate impact on the town. A few weeks later the army began to stream into Coolmoney military camp in the Glen of Imaal, which had been almost disused since the beginning of the war almost two years before. Many insurgents were deported to English prisons. The Irish Party worked for their release. There were few among the prisoners from the West Wicklow constituency. However, John T. Donovan, the local MP, was successful in having Joseph Byrne of Cryhelp and Joseph Byrne of Baltinglass freed.[596]

During 1917 republican activity began to register in the Baltinglass area. On the last Saturday night of April a republican flag was suspended from a wire tied to trees on either side of the road somewhere near St Joseph's church. It was removed the next day by the police. In May a large flag was placed on top of one of the row of lime trees on the riverbank opposite the mill. After the Sinn Féin victory in the East Clare election in July, when Eamon de Valera took the seat, there was celebration in Baltinglass. Bonfires were lit and there was a parade through the streets, headed by the local Pipers' Band.[597]

The relationship between this band and Sinn Féin is unclear. It was not the fife and drum band set up by the Irish Volunteers in 1914, but it most likely included many of the same people. This Baltinglass (later also called O'Byrne) Piper's Band gave its first public performance on Christmas Eve 1916 in the Town Hall and ushered in 1917 with a parade on New Year's Eve. It was the band of the Workmen's Club, which had been set up with the support of local businessmen the previous August 'with the main object of providing amusement for the workers'. The club

organised various events in its initial months to raise funds for a band. It had a club room but in March 1917 it acquired larger premises. As no mention of the Workmen's Club was found after April 1917, it would appear that it continued under the name of Baltinglass Piper's Band. By December its instruments were being stored in the premises of the Sinn Féin club, which may mean that it some-how merged with Sinn Féin.[598]

At the end of August 1917 a 'very large contingent' from Baltinglass, accompanied by the Pipers' Band, attended a public meeting in Tullow organised by Sinn Féin. The party was evidently gaining support in the area. Despite the more conservative political attitudes of the leaders of the Volunteers, the organisation had IRB activists within its ranks. Under these circumstances it is perhaps not surprising that the Volunteers' rifles and bayonets were confiscated by the police earlier in August.[599]

Up to February 1918 the Baltinglass Sinn Féin club was content to serve its members, 'without any effort of a propagandist nature amongst the general public', but it then decided to expand its activities. At a meeting in the Town Hall on 16 February a provisional committee was appointed, with John T. Clarke chairing, while John Gallagher and Jim Ryder were joint secretaries. The others appointed were Edmund Byrne, D. Kehoe, James Lawlor, Edward O'Neill (of Main Street), James Phelan, Tommy Phelan, John Snow and John Wall. On 24 February and 3 March further meetings were held in the Town Hall, a permanent committee was selected and nearly a hundred membership fees were paid.[600]

As the end of the Great War approached the local Sinn Féin organisation was posing a serious threat to the Irish Party, whose position in Baltinglass at the beginning of the war had been solid.

BALTINGLASS AND THE GREAT WAR
MONDAY 11 NOVEMBER 1918

The First World War, or the Great War as it was known at the time, began on 28 July 1914. The United Kingdom entered it on 4 August. On 20 September John Redmond called on the Irish Volunteers to serve in the war. Conscription did not apply in Ireland, but even before Redmond's call there was a large and long established Irish element in the British Army. This was due in no small way to economics, as for many of the poorer class there were few alternative career options.

On Tuesday 20 July 1915, the Fair Day, the band of the 3rd Battalion of the Royal Dublin Fusiliers paraded through Baltinglass prior to a recruitment meeting, chaired by Father Arthur Murphy. One of the speakers was The O'Mahony. Referring back to the meeting at which the Volunteer corps was formed just over a year before, he said that he had spoken then about the need to defend Home Rule. He said that the opponents against whom they had formed the Volunteers were now united with them in fighting this war and that it was unthinkable that afterwards men who had fought side by side against the same enemy 'could ever

have feelings towards one another, but those of respect and brotherhood'. He said that now Home Rule had to be defended 'not in Ireland but on the battlefields of Belgium and France' and that every Irish soldier was 'fighting as truly and as really the battle for Irish liberty and freedom as if he were to shed his blood in the streets of Baltinglass in a vain endeavour to keep the Germans out if ever they were to land on the shores of Ireland'. William Redmond, son of the Irish Party leader, also spoke, reminding the people that Ireland had said 'Give us a free constitution and treat us as you have treated other portions of the British Empire and your trust shall not be betrayed'. As the Home Rule Act was on the statute books it was 'up to us now to prove that our word was our bond'. At the end of the meeting many recruits were enlisted.[601]

The Baltinglass correspondent for the *Nationalist* wrote on 21 August 1915:

> The names of several Baltinglass men have recently appeared in the roll of honour, and many have from time to time been invalided home. It is only when some familiar name appears in the casualty list those at home get some idea of the terrible slaughter which is taking place on the Continent. Last winter thousands of our fellow-countrymen suffered untold hardships while exposed to the rigours of a severe winter in the trenches in Flanders. There does not seem much prospect at present that the war will be over before next winter, so that everything possible should be done now to provide the necessary warm clothing for the men.

From the outset of the war there was energetic and practical support for the servicemen. As early as August 1914 young women were meeting twice a week in Baltinglass to make garments for wounded soldiers. Grace Macleod, wife of the manager of the National Bank, and Esther Morrin, wife of Peter Morrin, the miller, were the supervisors of the group. Originally they gathered in the Courthouse but they later moved to the Bank House. By October there was a Baltinglass committee in place to relieve distress among dependants of soldiers serving in the war. There was also a branch of the Red Cross in Baltinglass, and Grace Macleod was its president.[602]

At the end of 1914 there was a strong possibility that refugees from war torn Belgium would be brought to Baltinglass. The Local Government Board asked the Baltinglass Board of Guardians if they could accommodate the refugees at the Workhouse. They responded that they could take a total of 150, but they were later asked to accommodate only sixty. In the end it was not necessary to send any refugees to Baltinglass as they were allocated to other centres.[603]

From the early months of the conflict the local press was reporting injuries and casualties among Baltinglass soldiers. In December 1914 two brothers, Patrick and William Conway of Deerpark, were home with war wounds. Patrick had part of his thigh torn away by shrapnel at the battle of the Aisne, while William was shot through the foot at Ypres.[604] He eventually returned to the war and was killed in action two years later.

Several families had a number of members in the forces. When Patrick Doyle, a teenager from Belan Street, was killed on the Western Front his three uncles, Peter, Mike and Pat Byrne, were also fighting in the war, Pat Byrne having been a survivor of the first landing at Gallipoli.[605] The Brereton brothers from Weavers' Square, George, Harry and Ross, also served in the forces at the time. Harry had a lucky escape at the battle of Ginchy in 1916, when a bullet passed through his helmet and just cut away some hair. Six months later George, a veteran of the Boer War, was lost at sea when the ship taking his battalion to Egypt was torpedoed in the Mediterranean. James Kearney was on the platform staff at Kingsbridge railway station before volunteering at the beginning of the war. A while before he lost his life on the Western Front, his younger brother had his leg amputated as a result of a severe war wound. Joseph Doody was a married man when he was killed in action, but he was only twenty-three years old and the youngest of three brothers serving in the forces.[606]

Among the locals who volunteered were some young doctors. Frank Morrin (son of Peter and Esther Morrin), F.G. Morris of Saundersgrove, William O'Kelly (son of E.P.), and Frederick Walsh, who had been dispensary medical officer in Baltinglass Union for six years, all joined the Medical Corps.[607]

Many familiar faces disappeared forever from Baltinglass during the four years of conflict. Dick Jones of Mill Street, remembered as 'a bright, cheerful boy with a very winning disposition', died far from home in what is now Al Kut in Iraq.[608] Ambrose Shearman, cashier at the National Bank, 'so courteous and kindly that it was a pleasure to be attended by him', made light of the dangers as he left the town, saying that he was going on a pleasant tour of Europe, 'right up to Berlin'.[609] He died three years later at a casualty clearing station on the Western Front, aged twenty-six. Jimmy Doogan, the telegraph messenger for Baltinglass Post Office from his early teens, died at Ypres two months before his twentieth birthday but his family were only told three months later that he was wounded and missing.[610]

In August 1915 the *Leinster Leader* reported that two Baltinglass natives, John Abbey and James Hennessy of the Irish Guards, on duty in a dug-out in northern France, were reportedly killed by one shell, which also injured another local man, Sergeant A. Carroll of Graney.[611] Michael Harbourne went to Australia before the war began, barely aged seventeen. He joined the Australian Imperial Force, travelled back across the globe and 'saw some severe fighting in Gallipoli, Egypt and France in which he had some marvellous escapes'.[612] Two months before hostilities ended he was killed in an enemy air raid at the age of twenty-one.

While there was no conscription in Ireland, the possibility in 1918 that the government would introduce it, despite the protests of the Irish Party, worked very much in the favour of Sinn Féin. Mass demonstrations took place around the country. In Baltinglass the Parish Priest, Father O'Neill, presided at a large gathering on Sunday 21 April to express opposition to the proposed move. Yet again, The O'Mahony was on the platform, this time opposing the government. Over

three thousand people signed an anti-conscription pledge during the day.[613] The following Tuesday there was a national one-day anti-conscription strike.

By the end of four years over eight million people on either side had lost their lives in the Great War. Almost a million of these were soldiers, sailors or nurses from the British Empire, including the United Kingdom, and tens of thousands of them were Irish. At five o'clock on the morning of 11 November 1918 a truce was signed between the last of the Central Powers, Germany, and the Allies. At eleven o'clock that morning the war ended.

Those who had given everything short of their lives to the war effort returned home to the problems of readjusting to normal existence after experiencing a living hell. The political climate in Ireland had changed during the course of the war and instead of being lauded by all for their endeavours they faced hostility from republicans. In many cases they also returned to long-term unemployment. They were not entirely abandoned to their own devices. During the conflict a Baltinglass recruiting committee had operated. It had tried to get locals to enlist, for instance using a door to door canvass, with soldiers home on leave taking part. However, it had also done what it could to boost morale among the troops. It was still in existence early in 1919, when it organised a 'smoking concert' at the Town Hall to entertain wounded soldiers from the area. During the war the distress relief committee had cared for soldiers' families. Many of the individuals who had devoted their energies to distress relief and recruiting were still to the fore when, in May 1926, the Baltinglass branch of the British Legion began work. It administered funds to those ex-servicemen and their families who were in strained circumstances due to unemployment. The local committee also ran fundraising functions such as whist drives, which were well supported.[614]

On Remembrance Day, 11 November 1927, 'wearers of poppies were very numerous' in Baltinglass, and the public listened to the broadcast of commemoration ceremonies in Dublin and London, facilitated by local owners of loud speakers. In 1928, on the tenth anniversary of Armistice Day, a large group of Baltinglass ex-servicemen travelled to Dublin to remember their dead colleagues, and the local sale of poppies was much larger than the previous year. The British Legion continued its charitable work in the Baltinglass area for several years. In 1938 sales of poppies for the twentieth anniversary of Armistice Day raised £36-8-9 in the general area.[615]

Of the many men from Baltinglass who served in the Great War, the following have been identified as dying in or as a result of the conflict.[616] This is by no means a comprehensive list of all casualties from the area. Five members of Baltinglass Church of Ireland parish are commemorated on a plaque in St Mary's church, which was unveiled on Sunday 11 April 1920.[617] Apart from some of the men being mentioned on family gravestones, there is no other monument in Baltinglass to this lost generation.

FROM BALTINGLASS [THE AREA COVERED IN THIS BOOK]

Charles Ferris son of James Ferris of Lathaleere, Baltinglass (birth place stated as Wexford)
Lance-Corporal in the 1st Battalion, Irish Guards, enlisted in Dublin
killed in action Sunday 25 October 1914 on the Western Front on the Ypres Salient in
 Belgium; reported missing, and subsequently confirmed dead in February 1916.
Commemorated on the Menin Gate Memorial, Ieper (Ypres), West-Vlaanderen, Belgium;
 ref.: Panel 11

James Glynn of Sruhaun Road; born in Belan Street; son of George & Kate Glynn
Private in the 2nd Battalion, Royal Dublin Fusiliers, enlisted in Carlow
killed in action aged 24, Tuesday 15 December 1914 on the Western Front near Ypres in
 Belgium.
Commemorated in Prowse Point Military Cemetery, Comines-Warneton, Hainaut,
 Belgium; ref.: I.C.7

Patrick Joseph Kehoe of Weavers' Square; born in Baltinglass; son of Patrick & Catherine
 Kehoe.
Company Serjeant Major in the 2nd Battalion, East Yorkshire Regiment, enlisted in
 Dublin died of wounds aged 35, Thursday 13 May 1915 on the Western Front in or
 near Bailleul in Nord, France.
Commemorated in Bailleul Communal Cemetery Extension (Nord), Bailleul, Nord,
 France; ref.: I.A.112

Matthew Whyte of Glasgow; formerly living in Doyles' in Tuckmill Lower
Private in the 5th Battalion, Connaught Rangers, enlisted in Glasgow
died Sunday 18 July 1915 at Gallipoli in Turkey.
Commemorated on the Helles Memorial, Gallipoli, Turkey; ref.: Panel 181 to 183

John Abbey of Weavers' Square; son of Patrick & Mary Abbey
Lance Serjeant in the 1st Battalion, Irish Guards, enlisted in Carlow
killed in action aged 24, Sunday 8 August 1915 on the Western Front near Bethune in Pas
 de Calais, France.
Commemorated in Guards Cemetery, Windy Corner, Cuinchy, Pas de Calais, France;
 ref.: I.B.13

James Hennessy of Chapel Hill; son of William & Kate Hennessy
Private in the 1st Battalion, Irish Guards, enlisted in Tamworth, Staffordshire
died of wounds aged 24, Monday 9 August 1915[618] on the Western Front near Bethune in
 Pas de Calais, France.
Commemorated in Guards Cemetery, Windy Corner, Cuinchy, Pas de Calais, France;
 ref.: I.A.14

Laurence Sutton [enlisted as Groves] of Belan Street; son of Laurence & Catherine (née
 Groves) Sutton
Private in the 1st Battalion, Leinster Regiment attd. 181st Field Company, Royal
 Engineers
died aged 22, Thursday 25 November 1915 on the Western Front near Armentieres in
 Nord, France.
Commemorated in Estaires Communal Cemetery, Estaires, Nord, France; ref.: II.L.8

Richard Jones of Mill Street; son of Griffith & Alicia Jones
Corporal in 'S' Battery, Royal Horse Artillery, enlisted in Dublin
killed in action aged 29, Wednesday 8 March 1916 at Kut al-Amara, Mesopotamia (now Al
 Kut, Iraq).
Commemorated on family headstone in Baltinglass C. of I. graveyard, on plaque in St
 Mary's Church, Baltinglass, and on the Basra Memorial, Iraq; ref.: Panel 3 and 60.

Joseph Bayle formerly of Main Street; son of Thomas & Elizabeth Bayle; mother of 15
 Bath Avenue, Sandymount, Dublin
Serjeant in the 9th Battalion, Royal Inniskilling Fusiliers, enlisted in Dublin
died of wounds aged 27, Tuesday 21 March 1916 on the Western Front near Gezaincourt
 in Somme, France.
Commemorated in Gezaincourt Communal Cemetery, Somme, France; ref.: A.9

Patrick Doyle of Belan Street; son of James & Margaret (*née* Byrne) Doyle; birth place
 stated as Rathfarnham, County Dublin.
Private in the 8th Battalion, Royal Dublin Fusiliers, enlisted in Naas
killed in action aged 18, Saturday 29 April 1916 on the Western Front in or near Pas de
 Calais, France
commemorated on the Loos Memorial, Loos-en-Gohelle, Pas de Calais, France; ref.:
 Panel 127 to 129

Patrick Greene (birth place & residence stated as Baltinglass)
Private in the 2nd Battalion, Royal Dublin Fusiliers, enlisted in Carlow
killed in action Saturday 1 July 1916 on the Western Front in or near Somme, France
commemorated in Sucrerie Military Cemetery, Colincamps, Somme, France; ref.: Sp. Mem. 4

Patrick Kane of Holdenstown (birth place & residence stated as Baltinglass)
Private in the 2nd Battalion, Royal Dublin Fusiliers, enlisted in Naas
killed in action Saturday 1 July 1916 on the Western Front in or near Somme, France
commemorated in Sucrerie Military Cemetery, Colincamps, Somme, France; ref.: I.D. 93

William Lanegan formerly a shoemaker in Clarkes of the Bridge; birth place stated as
 Baltinglass; son of Elizabeth Lanegan of 150 James's Street, Dublin
Private in the 1st Battalion, Irish Guards, enlisted in Dublin
died of wounds aged 24, Monday 18 September 1916 on the Western Front in or near No.
 21 Casualty Clearing Station, La Neuville, Corbie in Somme, France
commemorated on plaque in St. Mary's Church, Baltinglass, and in La Neuville British
 Cemetery, Corbie, Somme, France; ref.: II.E.69

Thomas William Middleton formerly of Baltinglass; son of Thomas William & Elizabeth
 (née Cope) Middleton; father one time schoolmaster & Master of the Workhouse
Ordinary Seaman, H.M.S. "Marshall South", Royal Navy
killed in enemy air raid aged 28, Sunday 24 September 1916 in or near Dunkirk in Nord,
 France
commemorated in Dunkirk Town Cemetery, Nord, France; ref.: I.C.2

James Christopher Doogan of Main Street; born on the County Road; formerly tele-
 graph messenger for Baltinglass Post Office; son of Charles & Margaret Doogan

Private in the 6th Battalion, Royal Irish Regiment, enlisted in Clonmel, Co. Tipperary

killed in action aged 19, Wednesday 18 October 1916 on the Western Front on the Ypres
 Salient in Belgium

commemorated on the Menin Gate Memorial, Ieper (Ypres), West-Vlaanderen, Belgium;
 ref.: Panel 33

William Conway of Kiltegan Road, Deerpark; son of Peter & Anne Conway

Lance Corporal in the 6th Battalion, Connaught Rangers, enlisted in Naas

killed in action aged 26, Saturday 9 December 1916 on the Western Front near Ypres in
 Belgium

commemorated in Pond Farm Cemetery, Heuvelland, West-Vlaanderen, Belgium; ref.: G.15

James Kearney of the Green Lane, Newtownsaunders; birth place stated as Linlithgow;
 son of Patrick & Ellen Kearney

Private in the 1st Battalion, Irish Guards, enlisted in Dublin

killed in action Thursday 15 March 1917 on the Western Front

commemorated on family headstone in Baltinglass R.C. graveyard and in Sailly-Saillisel
 British Cemetery, Somme, France; ref.: IV. E. 5

George Somerset Brereton of Weavers' Square; son of William & Isabella Brereton

Lance Corporal in the 1st Garrison Battalion, Royal Irish Regiment, enlisted in Liverpool,
 formerly in the Royal Irish Fusiliers; served in the Boer War, and in the 1906 Natal
 Rebellion with the Durban Light Infantry

died aged 42, Sunday 15 April 1917 in the Mediterranean when the 'Arcadian' (carrying
 reinforcements for Egypt) was torpedoed and sunk north-east of the Greek island of
 Milos

commemorated on family headstone in Baltinglass Abbey, on plaque in St. Mary's
 Church, Baltinglass, and on the Mikra Memorial, Mikra British Cemetery, Kalamaria,
 near Thessaloniki, Greece; ref.: 21

Joseph Doody of Stratfordlodge; originally of Rathvilly Road, Clogh Upper; son of
 James & Bridget Doody; husband of Hannah Doody (née Donnelly)

Private in the 10th Battalion, Royal Dublin Fusiliers, enlisted in Bristol

killed in action aged 23, Monday 28 May 1917 on the Western Front near Arras in Pas de
 Calais, France

commemorated on the Arras Memorial, Faubourg-d'Amiens Cemetery, Arras, Pas de
 Calais, France; ref.: Bay 9

Henry Hawkins of Lower Rutland Street, Dublin; born in Newtownsaunders; son of
 Alexander & Ellen Hawkins; husband of Margaret Hawkins

Stoker 1st Class, HMS 'Vanguard', Royal Navy

killed by internal explosion of vessel aged 41, Monday 9 July 1917 at Scapa Flow, Orkney,
 Scotland

commemorated on the Chatham Naval Memorial, Chatham, Kent, England; ref.: 24

William Kelly (birth place stated as Kiltegan; residence stated as Baltinglass) former mem-
 ber of Baltinglass Town Hall Club

Private in the 1st Battalion, Irish Guards, enlisted in Naas
killed in action Friday 3 August 1917 on the Western Front on the Ypres Salient in
Belgium
commemorated on the Menin Gate Memorial, Ieper (Ypres), West-Vlaanderen, Belgium;
ref.: Panel 11

Thomas Malone of Main Street; born in Portarlington area; formerly a gardener in
various locations including Slaney Park; son of John & Margaret Malone; husband of
Bridget Malone (née Staunton)
Private in the 15th Battalion, Machine Gun Corps (Infantry), enlisted in Portarlington,
formerly in the Leinster Regiment
killed in action aged 39, Sunday 24 March 1918 on the Western Front near Arras in Pas de
Calais, France
commemorated on the Arras Memorial, Faubourg-d'Amiens Cemetery, Arras, Pas de
Calais, France; ref.: Bay 10

Ambrose Augustine Shearman of the National Bank, Main Street; originally from
Kilkenny City; son of Edward and Johanna Shearman
Lieutenant (Acting Captain) in 'C' Company, 2nd / 7th Battalion, London Regiment
died of wounds received in action aged 26, Saturday 20 April 1918 on the Western Front
at the Casualty Clearing Stations in Picquigny in Somme, France
commemorated in Picquigny British Cemetery, Somme, France; ref.: B.16

Hubert Lawrence Grogan of Slaney Park; son of John Hubert & Alice Grogan
Captain in the 4th Battalion, Worcestershire Regiment
killed in action aged 21, Sunday 5 May 1918 during the German offensive on the Western
Front near Hazebrouck in Nord, France
awarded the Military Cross posthumously
commemorated on plaque in St. Mary's Church, Baltinglass, and in Cinq Rues British
Cemetery, 259, 2, Hazebrouck, Nord, France; ref.: C.8

Michael James Harbourne of the Bridge Hotel, Main Street; son of Michael & Elizabeth
Harbourne
Private in the 39th Battalion, Australian Infantry, A.I.F., enlisted in Melbourne
27 September 1916
killed in enemy air raid aged 21, Tuesday 10 September 1918 on the Western Front near
Cerisy in Somme, France
commemorated on family headstone in Baltinglass and in Cerisy-Gailly French National
Cemetery, Somme, France; ref.: I.E.13

Henry Pollard (birth place & residence stated as Baltinglass) very likely the Henry Pollard
listed in the 1911 Census in Baltinglass Workhouse as aged 11 and having been born in
the Workhouse
Private in the 1st Battalion, Royal Dublin Fusiliers, enlisted in Carlow
died Monday 9 December 1918 in Germany
commemorated in Berlin South-Western Cemetery, Berlin, Germany; ref.: II.E.8

CONNECTED WITH BALTINGLASS BUT IDENTITY NOT ESTABLISHED

Patrick Sullivan (birth place & residence stated as Baltinglass)
Guardsman in the 2nd Battalion, Scots Guards, enlisted in Coatbridge, Lanark
killed in action Wednesday 28 October 1914 on the Western Front on the Ypres Salient in
 Belgium
commemorated on the Menin Gate Memorial, Ieper (Ypres), West-Vlaanderen, Belgium;
 ref.: Addenda Panel 58

Patrick Doyle (birth place stated as Baltinglass)
Private in the 2nd Battalion, Royal Dublin Fusiliers, enlisted in Dublin
died of wounds Thursday 12 November 1914 on the Western Front in or near Nord, France
commemorated in Cite Bonjean Military Cemetery, Armentieres, Nord France; ref.:
 IX.B.80

George Herbert Morris (birth place stated as Baltinglass; residence Linlithgow, Scotland;
 son of Joseph & Anna Maria Morris of 32 [Vicinage?] Park, Belfast)
Private in the 2nd Battalion, Gloucestershire Regiment, enlisted in Camberwell
killed in action aged 22, Sunday 7 February 1915 on the Western Front on the Ypres
 Salient in Belgium
commemorated on the Menin Gate Memorial, Ieper (Ypres), West-Vlaanderen, Belgium;
 ref.: Panel 22 and 34

James Dunne (birth place stated as Baltinglass; son of Henry Dunne of Fontstown, Athy)
Private in the 1st Battalion, Leinster Regiment, enlisted in Fermoy
killed in action aged 23, Sunday 14 February 1915 on the Western Front on the Ypres
 Salient in Belgium
commemorated on the Menin Gate Memorial, Ieper (Ypres), West-Vlaanderen, Belgium;
 ref.: Panel 44

Michael Brien (birth place stated as Baltinglass)
Corporal in the 1st Battalion, Irish Guards, enlisted in Athlone
died of wounds aged 23, Wednesday 5 May 1915 on the Western Front in or near Bethune
 in Pas de Calais, France
awarded the Distinguished Conduct Medal
commemorated in Bethune Town Cemetery, Bethune, Pas de Calais, France; ref.: IV.B.78

John Nolan (birth place stated as Baltinglass; residence Linlithgow, Scotland)
Private in the 5th Battalion, Connaught Rangers, enlisted in Linlithgow
died Monday 13 September 1915
commemorated in Alexandria (Chatby) Military and War Memorial Cemetery,
 Alexandria, Egypt; ref.: F.126

John Joseph Behan (birth place stated as Baltinglass; residence Dover)
Corporal in the 2nd Battalion, Royal Irish Rifles, enlisted in Dublin
killed in action aged 27, Sunday 23 April 1916 on the Western Front in or near Pas de
 Calais, France
commemorated in Ecoivres Military Cemetery, Mont St. Eloi, Pas de Calais, France; ref.:
 I.F.8

Henry O'Neill (birth place stated as Dublin; residence stated as Baltinglass; son of
 Elizabeth O'Neill of 35 Oxford Street, Daventry, England)
Private in the 1st Battalion, Queen's (Royal West Surrey Regiment), enlisted in Reigate,
 Surrey
killed in action aged 23, Saturday 6 May 1916 on the Western Front near Cambrin in Pas
 de Calais, France
commemorated in Cambrin Churchyard Extension, Cambrin, Pas de Calais, France; ref.:
 M.25

Edward Tutty formerly of Ballintaggart (birth place stated as Baltinglass); son of Matthew
 & Charlotte Tutty; mother of "Glen Brae", Shankill, Co. Dublin
Corporal in the 9th Battalion, Royal Inniskilling Fusiliers, enlisted in Dublin
killed in action aged 27, Saturday 1 July 1916 on the Western Front in the Battle of the
 Somme in France
commemorated on the Thiepval Memorial, Somme, France; ref.: Pier & Face 4 D and 5 B

William Byrne (a native of Baltinglass; stated as son of Robert Byrne)
Lance-Corporal in the 8th Battalion, Royal Dublin Fusiliers
killed in action aged 22, Wednesday 6 September 1916 on the Western Front in the Battle
 of the Somme in France
commemorated on the Thiepval Memorial, Somme, France; ref.: Pier & Face 16 C

Thomas Fitzgerald (birth place stated as Baltinglass; residence Bonnybridge, Stirling,
 Scotland)
Gunner in the 124th Battery, Royal Garrison Artillery, enlisted in Dunfermline, Scotland
killed in action Wednesday 1 November 1916 on the Western Front in the Battle of the
 Somme in France
commemorated on the Thiepval Memorial, Somme, France; ref.: Pier & Face 8 A

Michael O'Neill (birth place stated as Lusk, Co. Dublin; residence stated as Baltinglass)
Private in the 2nd Battalion, Royal Dublin Fusiliers, enlisted in Dunlavin
died Sunday 18 March 1917 on the Western Front
commemorated in Bailleul Communal Cemetery Extension (Nord), Nord, France; ref.:
 III. B. 12

Michael Kane (residence stated as Baltinglass)
Driver in the 65th Ammunition Col., Royal Field Artillery, enlisted in Dublin, formerly
 in the Royal Army Service Corps
killed in action Sunday 21 October 1917 on the Western Front in or near Ypres, Belgium
commemorated in Welsh Cemetery (Caesar's Nose), Ieper (Ypres), West-Vlaanderen,
 Belgium; ref.: I.C.10

Joseph Brean (residence stated as Baltinglass; son of Mrs. Anne Higgins of Collin,
 Moone)
Private in the 19th Remount Squadron, Army Service Corps, enlisted in Bristol
died Saturday 26 October 1918 on the Southern Front in or near Arquata, Italy
commemorated in Arquata Scrivia Communal Cemetery Extension, Italy; ref.: I.D.8

FROM ELSEWHERE IN BALTINGLASS, BALLYNURE OR RATHBRAN CIVIL PARISHES

Thomas Devine, son of Patrick Devine of Stratford; husband of Mary Devine of Donard
 (residence stated as Lucan, Co. Dublin)
Corporal in the 2nd Battalion, Royal Dublin Fusiliers, enlisted in Dublin
killed in action aged 45, Saturday 1 July 1916 on the Western Front in the Battle of the
 Somme in France
commemorated on the Thiepval Memorial, Somme, France; ref.: Pier & Face 16 C

Andrew Jones of Boleylug; son of William & Esther Jones
Private (Signaller) in the 1st Battalion, Royal Dublin Fusiliers, enlisted in Baltinglass
killed in action aged 35, Saturday 1 July 1916 on the Western Front in the Battle of the
 Somme in France
commemorated on the Thiepval Memorial, Somme, France; ref.: Pier & Face 16 C

Anthony Ovington of Woodfieldglen; son of Anthony Ovington
Corporal in the 10th Battalion, Royal Dublin Fusiliers, enlisted in Armagh
killed in action Monday 13 November 1916 on the Western Front in the capture of
 Beaumont-Hamel during the Battle of the Somme in France
commemorated on plaque in St. Mary's Church, Baltinglass, and on the Thiepval
 Memorial, Somme, France; ref.: Pier & Face 16 C

William James Mallen of Grangecon; son of John & Margaret Mallen
2nd Lieutenant in the 11th Battalion, Royal Dublin Fusiliers
killed in action aged 18½, Thursday 16 August 1917 on the Western Front on the Ypres
 Salient in Belgium
commemorated on family headstone in Baltinglass and on Tyne Cot Memorial,
 Zonnebeke, West-Vlaanderen, Belgium; ref.: Panel 144 to 145

James Moore of Ballyhook; son of Thomas & Kate Moore
Private in the 2nd Battalion, Royal Dublin Fusiliers, enlisted in Naas
died of wounds aged 24, Thursday 2 January 1919 in Germany
commemorated in Berlin South-Western Cemetery, Berlin, Germany; ref.: VI.G.9

FLU EPIDEMIC CLAIMS EIGHTEENTH LIFE IN BALTINGLASS
FRIDAY 29 NOVEMBER 1918

The final months of the Great War coincided with the start of an influenza epi-
demic that was to result in about twenty million deaths worldwide, much more
than the number of military and civilian fatalities during the four year conflict. It
was often referred to as the Spanish 'flu, because it first came to public attention in
the latter half of May 1918 in Spain, where hundreds of people died in the space
of a week. Within a month it was in Ireland, with outbreaks reported in places as
far apart as Athlone and Belfast. By early July there had been ninety-seven deaths
from the disease in Belfast, and it was spreading rapidly in Dublin.[619]

It is surprising that it did not spread to the general area of Baltinglass till
October 1918. Towards the end of the month a dozen people were reported as

dying in Naas in the space of a week.[620] The first death directly resulting from influenza in the immediate Baltinglass area of West Wicklow was that of a four and a half year old boy in Grangecon, on 7 October. The next death was not until 2 November. By then the disease was rampant in the district. Over forty cases were being treated in the fever hospital and infirmary of Baltinglass Workhouse in the first week of November.[621]

The patients crowding the Workhouse medical facilities were from through-out Baltinglass Poor Law Union, encompassing much of West Wicklow as well as parts of Carlow and Kildare. The first death within the institution occurred on 5 November. The victim was Margaret Flynn, a forty-two year old single woman from the town. During November eleven patients in the Workhouse died of the 'flu. John Lawlor (aged thirty-four) and Michael Keogh (aged forty) were also from the town, while the others were from places outside the area covered by this book. Seven people from Baltinglass died in their own homes between 10 and 23 November. They were Tommy Phelan (aged twenty-five, one of the founders of Baltinglass Pipers' Band), Sarah Kitson (aged thirty-six, wife of Joe Kitson), Paddy Doyle (aged thirty, manager of the Harp Hotel or 'The Hollow'), Christy Timmins (aged twenty-nine, a Wicklow county footballer), George Byrne (aged thirty-three, a shop assistant, apparently at The Hollow), James Jackson (aged twenty-nine) and Bridget Duffy (aged nine).[622] Phelan, Doyle, Jackson, Bridget Duffy and possibly Byrne lived within yards of one another in Mill Street.

In Baltinglass Registrar's entire district there were twenty-five deaths recorded in November 1918. Nineteen of these resulted directly from influenza. Between those in the town and those in the Workhouse, eighteen people died during November within the area covered by this book. The last of these was a twenty-three year old man from Rathdaniel, County Carlow, who died in the Workhouse on 29 November.[623]

During November the doctors and relieving officers (Maurice Byrne and Ben Farrell) in the area, the Jubilee nurse (Miss Comerford) and the nursing staff in the Workhouse fever hospital and infirmary were striving to cope with the tragedy. Denis Kenna was the medical officer or doctor in charge of the fever hospital and infirmary. Francis Cruise, the only other doctor in the town, was the Baltinglass dispensary medical officer. When he was taken ill the care of the whole population fell to Dr Kenna. A Dr Donohoe was engaged temporarily to do Dr. Cruise's duty. The Local Government Board sent Thomas Sheedy as acting dispensary doctor, and he had to employ Robert Dore, the manager of Gorrys' Medical Hall, as a temporary dispenser from 4 November to assist in his work. M.J. Doyle and Sons (later known as Tommy Doyles) of Main Street were engaged to provide motor transport for Dr. Sheedy. When their drivers fell ill, Elizabeth Grogan of Slaney Park volunteered the services of her chauffeur, a Mr. Donohoe, to drive Doyles' car. The O'Mahony also provided a car and a driver for Edward Lyons, the Dunlavin dispensary doctor.[624]

Tuesday 19 November was fair day in Baltinglass. Because of the epidemic many of the main shops in the town were closed. Though the situation was still

critical that week, a slight improvement in the situation was noticeable, and it was anticipated that another week would bring the situation under control and stop the deaths.[625]

The disease subsided in December, with only one death in the district, occurring in Ballycore on 9 December. There was a recurrence in 1919, but this was not as virulent and it did not hit Baltinglass, though there was a death in Knockarigg on 22 February. The outbreak in the Tullow area in March resulted in a family of seven from Ballybit, between Tullow and Rathvilly, being admitted to Baltinglass Workhouse in the last week of the month.[626] A two year old child from this family died on 27 March, the last person to die in Baltinglass in the Spanish 'flu epidemic.

The death toll in the Baltinglass area appears to have been considerably below the national average. Two years later, when it was announced that the Workhouse fever hospital and infirmary were to close, the *Nationalist* correspondent commented that these facilities had saved scores of lives during the epidemic, adding that in a neighbouring town where there was no such medical facility there was an appalling loss of life.[627]

ROBERT BARTON AT THE TOWN HALL
SUNDAY 5 JANUARY 1919

At the beginning of 1919 Sinn Féin dominated domestic politics in West Wicklow. The party had benefited from the gradual shift in public opinion after the execution of the 1916 leaders and the possibility of conscription in 1918. The Home Rule ideal was being discarded in favour of independence, and the Irish Party, founded by Parnell, had just been dissolved. West Wicklow's new MP, Robert Barton, made his first post-election appearance in Baltinglass at a hastily arranged meeting in the Town Hall on the first Sunday evening of 1919. The gathering was chaired by Edward (or Eamon) O'Neill of Main Street, and its object was to support the call for the release of republican prisoners. However, Barton used the opportunity to thank those most involved with his election victory – Thomas Fleming of Shillelagh and Edward O'Neill and Garret Byrne of Baltinglass.[628]

Six weeks before, just a fortnight after the end of the Great War, and while the 'flu epidemic was rampant in Baltinglass, two opposing political meetings had been held in the town. That was on Sunday 24 November 1918 and bad weather along with the epidemic restricted attendance at both. In the Town Hall supporters of the Irish Party gathered to discuss the selection of a candidate for the upcoming general election. Outside in Market Square (the area around the McAllister monument) Sinn Féin supporters were gathered to hear their candidate, Robert Barton of Glendalough, a former army officer.

The Irish Party meeting decided to leave the selection of the candidate to the new party leader, John Dillon, and the sitting MP, John T. Donovan, who was not seeking re-election as he was to contest South Donegal instead. In responding to a vote of thanks, Donovan said that the candidate representing 'the new cult of

revolution and Irish Bolshevism had been wooing the electorate of West Wicklow for some time'. He added that Sinn Féin had placards all over the constituency with the catchphrase 'West Wicklow for a Wicklow man', suggesting that they reject him as an outsider. He suggested that the Irish Party put forward a local man of prominence. He observed that if the people had stayed loyal to the late John Redmond 'legislative freedom' would have been achieved by then, but instead certain nationalists had betrayed Redmond.[629]

Meanwhile, out on the street Edward O'Neill presided over the Sinn Féin supporters, and Barton himself addressed them. Barton called for complete independence and said that since the Act of Union any political gains had been achieved by 'the agitation of the people' rather than by parliamentary means. He referred to his opponents as the 'Provincialist Party' and said that their record of 'lost chances and betrayals' was unique in the history of politics. Thomas Fleming made reference to the meeting then in progress in the Town Hall, saying that not a single man or organisation from the town was attending it, and he proposed a resolution mocking Donovan's move to the Donegal constituency.[630]

Eventually The O'Mahony was chosen as the Irish Party candidate. The general election took place in December, and Barton won the West Wicklow seat with an overwhelming majority. The Irish Party took only six seats, while Sinn Féin took seventy-three. The O'Byrne Pipers' Band led the Sinn Féin victory celebrations in Baltinglass, a bonfire was lit, 'patriotic songs sung and "slap bangs" exploded', before the crowd went to the Town Hall for an impromptu concert. The following Sunday was when Barton addressed the protest meeting. While they were demanding the release of all republican prisoners, Barton focused on three Baltinglass men then incarcerated. These were John Rogers, John Gallagher and John Snow. Rogers was aged thirty-eight, and a farmer from Holdenstown. Gallagher was originally from Enniscorthy and was a twenty-four year old hotel bookkeeper in Doyles' Commercial Hotel, Main Street. Snow, who was born in Dundalk, was a painter and contractor who had been living in Baltinglass a number of years. He was then in his mid thirties. He and Gallagher were lodgers in Hanleys' in Weavers' Square.[631]

The Sinn Féin Convention was held in Dublin over two days at the end of October 1918. Joe Wall, son of Willie Wall of Belan Street, then living in Dublin, acted as a steward on both days and he met Snow and Edward O'Neill. It would appear that Rogers and Gallagher were also at the convention and that they travelled home by train that evening, as they were at Baltinglass railway station when apprehended.[632] Rogers was searched and found to have a revolver in his hip pocket and five rounds of ammunition. The police followed Gallagher from the railway station and arrested him in Mill Street. He was carrying a document detailing plans for a military operation. It indicated that when orders were given Baltinglass would become a battalion headquarters. Volunteers based there would seize the police barracks, railway station and post office as well as the railway line and telegraph wires. Similar operations were to take place in neighbouring towns

and villages. Strict military law was to be imposed. Looters and those suspected of supplying information to 'the enemy' were to be arrested and 'dealt with'. Motor cycles and lorries were to be commandeered and all male residents would have to do whatever work was necessary. Lines of communication were to be held until orders were given to abandon them and destroy the railway line. Baltinglass were to dismantle the section from Grangecon to Mountneill bridge. All rolling stock and stores of flour or corn would be destroyed. Trenches were to be dug on the main road at half mile intervals, bridges were to be demolished, and Coolmoney Camp was to be burned.[633]

Snow was taken into custody the same night, and it was expected that Edward O'Neill would also be arrested but this did not happen. Rogers, Gallagher and Snow were all committed on remand to Mountjoy Prison on 31 October. On 19 November Rogers was charged at a court martial in Dublin. He admitted to carrying the revolver but said he did not recognise the court. Sergeant P.J. Kerins of Baltinglass stated that Rogers had always borne a good character. He was sentenced to two years, but fifteen months were remitted. Gallagher and Snow's court martial was on New Year's Day 1919. Gallagher was sentenced to five years. On 11 January he was transferred to Maryborough (now Portlaoise) Prison. Snow's offence was apparently minor. He was charged with being in possession of a document, 'the publication of which would be likely to cause disaffection', and was given a two week sentence. He was released on 14 January.[634]

On New Year's Night 1919 there was a minor attack on Baltinglass police barracks in Mill Street, when windows were broken and the door was damaged. The owner of the premises was awarded £10 compensation, to be levied off the ratepayers in Baltinglass No.1 Rural District, for the damage caused.[635]

The Sinn Féin candidates elected as MPs in December 1918 did not take their seats in Westminster. Instead, on 21 January 1919 they met as the first Dáil Éireann, and Robert Barton was among them. What became known as the War of Independence began on the same day. In February Barton was arrested for making seditious speeches. In July 1919 John Gallagher was released from Maryborough. Though he had been sentenced to five years he was released due to ill health. On his return to Baltinglass he was met at the outskirts of the town by the pipers' band and members of Cumann na mBan, and they marched through the town to 'the Sinn Féin Club rooms'. Gallagher addressed the crowd opposite the rooms and an all night dance was held in his honour. At two thirty a.m. two revolver shots were fired through an upstairs window of Baltinglass police barracks, where Sergeant Kerins, his wife and children were sleeping. On Tuesday 19 August John Rogers was accorded a similar welcome on returning after serving his nine months in Mountjoy.[636]

Cumann na mBan apparently had an active branch in Baltinglass at the time. Two young women who were involved in carrying dispatches for the republican movement were Mary Hanrahan of Weavers' Square and Kathleen Wall, daughter of Willie Wall of Belan Street.[637]

THE BEGINNING OF THE TECHNICAL SCHOOL
TUESDAY 11 NOVEMBER 1919

After many years of struggle with Wicklow County Council, the Baltinglass Technical Instruction Committee achieved a partial victory with the opening of a permanent centre for technical instruction at the end of 1919. It was not the purpose-built school they had hoped for, but it was a step towards their goal.

Ever since the first technical classes were held in Baltinglass in 1904, local representatives had been pressing the authorities to provide the town with a permanent technical instruction centre for the West Wicklow area. As early as 1910 there was the promise to build a technical school in Baltinglass but by the end of 1916 the local committee was still demanding of the County Wicklow Technical Instruction Committee that it erect a school in the town.

At some point, presumably as early as 1907 when an architect's estimate was obtained, it was decided to build the new school on part of the Town Hall premises and a lease was obtained from the Town Hall Company. During the summer of 1917 the Baltinglass Technical Committee decided that this site, possibly the ball alley, would be too confined 'within the precincts of the high walls' and that they should think of future expansion.[638] A year and a half later rent was still being paid to the Town Hall Company for the unused site and it emerged that the lease could not be surrendered. At that time the secretary of the County Technical Instruction Committee pointed out that due to the increased costs of building it was no longer feasible to construct a permanent school according to the original plans, and he suggested that a premise should be leased for the time being. Under these circumstances domestic economy and manual instructors could be sent to Baltinglass for the following winter session, each to teach about three days a week in the town and complete the week by travelling to other locations in West Wicklow.[639]

The directors of the Town Hall Company were prevailed on in the public interest to forego the lease for the proposed school site. A lease was then taken for a term of years on the former convent school premises on Chapel Hill, which had been used for technical classes as early as 1904.[640] The Technical School was to open on Monday 3 November 1919 with three teachers. Girls were to be taught cookery and needlework by Miss Clerkin, while boys were to be instructed in cabinet-making and woodwork. By the end of that week the woodwork equipment and a new cooker were still to arrive, so the classes did not commence till 11 November. At the request of the local Gaelic League branch, Irish classes for females were introduced the following month. During its first academic year, the school had eighty-four students enrolled and nine subjects were taught.[641]

Miss Clerkin was the first of three domestic economy instructors who taught during that first year, and it would appear that the manual instructor was available only for one night a week. Due to an increase in grants, a permanent manual instructor, C. Davidson, was appointed for the year commencing in October 1920. As classes were held in the evening, the Curfew Order, introduced on

24 September, interfered with the schedule, with classes that were to start at seven p.m. being deferred. During the summer of 1921 a course in motor engineering was run in the school and applications were so numerous that two classes had to be organised.[642] Danny O'Brien, who taught in that course, was killed the following year in the Civil War when an officer in the National Army.[643]

Attendance in Baltinglass during the 1921-1922 sessions was the highest in the county. In October 1922, in addition to domestic economy and manual instruction, Baltinglass 'Tech' introduced a commercial course. Irish classes were delayed until early in 1923, when a new teacher was appointed.[644] The commercial and Irish classes were not continued, as by the 1926-1927 sessions only the domestic economy and manual courses were on offer. These were taught by Miss A. Reeves and T. Walshe, respectively.[645]

In November 1929 commercial classes were re-introduced into the 'Tech', with Seamus Gleeson teaching the course. The following year Gleeson, who taught commerce and Irish, and the domestic economy instructress, Miss Rice, were joined by a new manual instructor, Hugh Armour. Armour had arts and crafts qualifications, so it was arranged that he and Gleeson would run a course for girls and boys to prepare them for training as technical teachers.[646] This was to lead the 'Tech' to another stage in its development into a full post-primary school.

THE WAR OF INDEPENDENCE: ATTACK ON BALTINGLASS POLICE BARRACKS
SATURDAY 24 JANUARY 1920

The last train from Dublin arrived at Baltinglass station sometime after seven p.m. on Saturday 24 January 1920. The passengers walked down Station Road and into Mill Street on their way home. About that time twenty-four year old Maggie Doogan collected the evening newspaper and, along with her teenage sister Essie, headed for the police barracks in Mill Street to deliver it, as she did regularly. She tapped on the window. Inside were Sergeant Kavanagh and three constables, Bellew, Malynn and Robinson. James Malynn went to open the door, expecting Maggie as usual. Before she had time to hand him the paper a group of men rushed at the door. A man shouted 'hands up' and Maggie was pushed into the hall where she fell. She heard shots and as she tried to crawl into the dayroom Malynn fell to the floor, saying 'Maggie, I'm shot'. She heard more shooting and then the door was shut.[647]

Before the raid the telegraph wires leading to Baltinglass were cut. Allegedly there were forty to fifty men involved, but most of them were posted at the approaches to the town. Three or four motor cars were also said to have been on the outskirts and to have disappeared shortly afterwards. The men who carried out the attack itself are said to have been from Wexford.[648]

The incident lasted no more than a few minutes. When the shooting started Constable Bellew fired a revolver out of the doorway, while Robinson started to

load a carbine. The sergeant was upstairs. Meanwhile, Francis McPartlan, an off-duty constable, had just bought a newspaper and was standing outside the door of his house next to the police station. Though it was dark, he saw about six or seven men rush at the barracks door when it opened. Immediately he heard shooting and he believed that at least three shots were aimed at him. He was injured in the left hand and right leg. The street was relatively busy due to the arrival of the train. Willie Wall of Belan Street had met it in his jaunting or hackney car and was taking some commercial travellers to the Bridge Hotel when he was grazed in the leg by a stray bullet. Essie Doogan must have been on the street all the while. The men told her 'keep back; keep back' and she said that shots were fired right over her head. She saw three men running away. It would appear that they made their getaway in motor cars.[649]

In November 1919 the authorities had issued an order prohibiting the possession of a motor vehicle without a permit. The Irish Automobile Drivers and Mechanics' Union directed its members not to apply for permits, with the result that commercial vehicles were off the roads almost immediately. This meant no fuel deliveries and virtually a total absence of motor vehicles for the eleven weeks the 'permit strike' lasted. On 7 January the Army, along with some local police, went to the two garages in Baltinglass, those of M.J. Doyle and Sons and Edward O'Neill, both in Main Street. They dismantled the vehicles and removed essential parts. The Baltinglass correspondent for the *Leinster Leader* indulged in a little sarcasm on 31 January: 'Judging by the number of motor cars reported to have taken part in the attack on the Baltinglass barracks, the object of the Motor Permit Order has not been realised.'[650]

On the night of the attack the two local doctors, Francis Cruise and Denis Kenna, were soon on the scene, and Father Martin Brophy also arrived to minister to Malynn and McPartlan. At two o'clock in the morning Sir William Wheeler, an eminent surgeon, arrived. He found James Malynn in a 'very collapsed and anaemic condition'. With the assistance of the two Baltinglass doctors he transfused him. Malynn's injuries were all caused by one bullet. It passed through the fleshy part of his arm, into his chest, through his right lung and lodged in his spine, severing it. On Sunday evening he was conveyed to Dublin in a special train and later admitted to Mercer's Hospital. That morning at Mass Father Brophy denounced the attack, saying that the misdeeds of those in authority were not a justification for the shedding of innocent blood and that the two injured men were not responsible for any trouble that had taken place in the district. He said he felt that the raiders were not from the area and he hoped that they had not been assisted by locals.[651]

At twelve o'clock on the Monday a special court was held in the police barracks. Seven men were charged with shooting at Malynn and McPartlan with intent to murder. They all refused to recognise the court. The Constabulary was confident that it would be able to connect the prisoners to the charges, and they were remanded in custody until 2 February. That afternoon, with a heavy escort

of soldiers and police, the handcuffed prisoners were taken away to Mountjoy Jail in a military motor lorry. A big crowd gathered and they cheered as the lorry drove away. The seven prisoners were Patrick Breen, Joe Byrne, John Harte, John Kehoe, Mickie Lalor, Joe Martin and John Snow. Breen was a twenty-seven year old motor mechanic, originally from Borris. Byrne was twenty-six, and living in Hartstown. Harte was thirty-two and a farmer in Hartstown. Kehoe was twenty-eight and a farmer from Blackbog (or Moneymore). Lalor was a twenty-one year old railway porter from Edward Street. Martin was also twenty-one, living in Hartstown. Snow, then thirty-seven, had already been in custody for the October 1918 incident.[652]

The seven prisoners were not returned to Baltinglass on 2 February. In mid-February John Snow was 'deported' from Mountjoy to Wormwood Scrubs in England. The other six were released a month later, and returned to Baltinglass to 'an enthusiastic welcome'. Snow joined other republican prisoners in Wormwood Scrubs on three separate hunger strikes. The last one was for fifteen days, after which he was moved to Marylebone Hospital in a weak condition. He returned to Baltinglass early in June.[653]

Meanwhile, James Malynn was still confined to bed, his lower body and legs paralysed. He went to live in Moate, County Westmeath, and never saw Baltinglass again. Sir William Wheeler's summary of his condition was succinct:

> The man is absolutely done for. The entire skin and muscle of the back are gone, and the bone is exposed in the back. He is suffering from bed sores, and he has lost all power over his normal functions. He will require the services of two nurses for the rest of his life.[654]

Malynn was born in Cork and stood almost six foot two in height. In February 1911 he joined the Hull Police in England, and after almost three and a half years' service he resigned to join the R.I.C., which he did on 1 July 1914. He served in counties Limerick and Westmeath. His wife Teresa, whom he married in October 1916, was from Westmeath and they had one child together. On 2 March 1920, some five weeks after being invalided, James Malynn turned thirty-one.[655]

Francis McPartlan, who was thirty-three at the time of the attack, remained in Baltinglass afterwards. He suffered persistent insomnia and was still unfit for duty in April. He lodged a compensation claim of £1,000, while Malynn claimed £8,000 for malicious injuries. If granted, these amounts would be charged against the local ratepayers. Their cases were heard at Baltinglass Courthouse on 8 April 1920. The claims were opposed by Baltinglass No. 1 District Council, Wicklow County Council and 'certain ratepayers in the district'. Malynn's projected career earnings were calculated, with and without promotion, were he to have completed his service. The one certainty was that his wife would not be entitled to a pension, as they had married before he had the requisite years of service to qualify for leave to marriage. Eventually, in June McPartland was awarded £600 and Malynn

£3,000, with a further £135 to cover medical care and the cost of the special train. The awards were charged on the county at large.[656]

In April Sir William Wheeler said of Malynn:

> Some people have lived in this miserable condition for years with the greatest care, but I would hardly say he will be alive in six months' time. I think he is in the most pitiable condition I have ever seen a human being in.

Malynn's suffering ended on 30 November 1920. He died at his home in Main Street, Moate.[657]

THE WAR OF INDEPENDENCE: BALTINGLASS COURTHOUSE DESTROYED BY FIRE
WEDNESDAY 14 APRIL 1920

On Thursday 8 April 1920 Judge Drumgoole heard the compensation claims for Constables Malynn and McPartlan at Baltinglass Courthouse. The following Wednesday night the courthouse was completely destroyed by fire. With it went the irreplaceable Petty Session records, detailing the administration of justice on the most local level. But for the efforts of the townspeople the adjoining Town Hall would also have gone up in flames.

In the absence of any absolute evidence, it must be assumed that the fire was started by the Volunteers (the republican element of the Volunteers, who became the Irish Republican Army August 1919). It seems very unlikely that an accidental fire in the empty building would have been so extensive. On the Thursday morning it spread to the Town Hall. Residents did all they could to stop the progress of the fire, and this included pulling down part of the Town Hall building, but extensive damage was done. Much of the glass roof of the handball alley, proudly put in place twenty years before, was shattered. William Moore, the Clerk of the Baltinglass Petty Sessions, asked the county surveyor that the weights and measures office be equipped with a table and chairs in order to continue holding the Petty Sessions Court there, and permission was granted. The next sitting of Baltinglass Quarter Sessions was held in Bray.[658]

As its insurance company refused responsibility, Wicklow County Council found itself in the bizarre situation of presenting itself with a malicious injury claim of £4,300 for the courthouse and its furniture. The Registrar of Petty Sessions claimed £50 for the records lost in the fire, while the Town Hall Company claimed £150. The latter were awarded £60, which was charged on the county at large.[659]

THE WAR OF INDEPENDENCE: SAUNDERSGROVE DESTROYED BY FIRE
SATURDAY 8 MAY 1920

On 17 April 1920 the local press commented that of the police stations in Baltinglass Union, which had recently been vacated, only one remained standing. Those in Ballytore, Donard, Hacketstown and Rathvilly were among those already destroyed. Evidently the last one standing was Stratford, as on the night of Saturday 8 May the vacant building was set on fire. On the same night, possibly after midnight, a short distance away Saundersgrove, a two hundred year old mansion, was also deliberately burned. As the *Leinster Leader* correspondent commented, it was one of the oldest houses in West Wicklow and 'possessed much historical interest'.[660] The Saunders family were regarded as decent landlords who were good to their tenants, so unpopularity was not an element in the destruction.[661]

Saundersgrove was one of the earliest Georgian houses in Ireland, built in the latter half of the 1710s. It had three storeys over a basement, and two fronts, each with nine window spaces per storey. The entrance front faced towards the river. The garden front faced what is now the Dublin Road, and had a roof parapet with ornamental eagles and urns. Descending the hill towards this front, from what is now the entrance to the estate, was an artificial cascade of water.[662]

Its original owner was Morley Saunders, who bought the lands in the early eighteenth century. His only daughter, Cordelia, married George Pendred, who assumed the surname of Saunders. Their eldest son, Morley Pendred Saunders, inherited Saundersgrove. His son Morley Saunders was Captain of the Saundersgrove Yeomanry at the time of the 1798 Rebellion. On 24 May 1798 at least seventeen members of his corps were among those executed on Dunlavin Green as suspected rebel sympathisers. Morley Saunders was one of the officers in charge at Dunlavin. The traditional ballad 'Dunlavin Green' repeatedly blames him for the mass execution, with lines such as 'Bad luck to you, Saunders, may bad luck never you shun!' In recent years the historian Ruán O'Donnell has suggested that the principal responsibility was that of another officer, and has referred to Saunders as a 'much-maligned moderate'.[663] Nonetheless, back in 1920 the power of the ballad made Morley Saunders a hate figure for republicans, and it is reasonable to speculate that this justified the burning of Saundersgrove in the eyes of those involved. However, the main reason was most likely that the vacant mansion might have been commandeered by the army.

The last of the Saunders family to live at Saundersgrove was Morley's grandson, Robert John Pratt Saunders. After his death the property passed to his cousins, the Tyntes of Tynte Park, Dunlavin. From 1918 Violet Tynte of Tynte Park and Hardress Waller, husband of her sister, Elise, were trustees of the estate. After the fire they lodged a claim of £26,425 for malicious injury of the house and contents. Some weeks later they made a further claim of £400 for damages arising out of

another burning at Saundersgrove. They were awarded £26,100 to be levied off the county, with an additional £220 for the destruction of out houses.[664]

The house was rebuilt a few years later, but in an entirely different style. The new building has two storeys, each with seven window spaces, below an attic in the high-pitched roof. The door-case from the entrance front of the original building is incorporated in the new house. Mrs. Waller's daughter, Madeline, and her husband John Lytton Bellamy lived there for a time, but in the mid-twentieth century Saundersgrove was sold and it went through a series of owners thereafter.

THE WAR OF INDEPENDENCE: MILITARY OCCUPY THE WORKHOUSE
WEDNESDAY 19 MAY 1920

With the burning of all the vacated police stations in the area, as well as the court-house and Saundersgrove, it was perhaps not altogether surprising that the army decided to take up a position in Baltinglass. Nevertheless it caused quite a stir when Colonel Chaplin and a party of the Cameronian Regiment arrived in motor wagons at Baltinglass Workhouse on the morning of 19 May 1920 to comman-deer part of the building as a military base. The colonel told the Master of the Workhouse, Pat Furlong, that accommodation for a hundred men was required. After inspecting the building he decided on the male wing and the front portion, which included the boardroom.[665]

Baltinglass had already seen some military activity in the weeks prior to this occupation. On the evening of Good Friday (2 April) the congregation leaving devotions in St Joseph's church found that the army was posted throughout the town. Those living outside Baltinglass had to stop at a rope barricade where their vehicles were searched. The soldiers left the following day. A military party again appeared the weekend before Col. Chaplin's arrival, and remained over night.[666]

However, the commandeering of a large part of the Workhouse was a more serious move. At the time there were 104 inmates in the institution. The Clerk of the Union, Ralph Dagg, telegraphed the Local Government Board and they sent their inspector the next day. On Saturday 22 May the Board of Guardians met to discuss the situa-tion. The meeting was at the Town Hall as their boardroom in the Workhouse was being used as the army officers' dormitory. Dr Kenna informed them that to vacate the male wing of the Workhouse some inmates had been moved to the observation sheds, but that they were comfortably accommodated there. The Guardians passed a resolution condemning the occupation of the Workhouse 'without any notice to the guardians or to the Local Government Board'.[667]

In June it was announced that the army would take over the entire Workhouse within a matter of weeks. The Guardians and staff had to make arrangements for the inmates. The sick were transferred to Shillelagh Workhouse. This accounted

for about half of the inmates. The rest became self-dependent, with the exception of two who were given outdoor relief. Afterwards patients for infirmary treatment were brought by ambulance to Naas Workhouse. Despite the occupation of the building, it was possible for Baltinglass No. 1 District Council to conduct its meeting on 11 June in the schoolroom of the Workhouse.[668]

During their time in the Workhouse the army made occasional raids on houses and sometimes patrolled the streets.[669] Though people went about their daily lives more or less as normal, this period was what history calls the War of Independence. Strangely, the Volunteers (or the IRA) appear to have operated a parallel administration under the noses of the army. They placed boycotts on local businesses that supplied provisions to the army. One trader had the embargo lifted in July after promising to obey the IRA's order in future. On 19 July 1920, the night before the fair day, the Volunteers ordered the local public houses to be closed 'at the regulation time'.[670]

During July and August 1920 Francis Cruise, Ralph Dagg, Denis Kenna and Peter Morrin all resigned their commissions as magistrates or Justices of the Peace. However, this was not an act of defiance on the part of the Baltinglass JPs. Dagg had been called on to do so in a resolution passed by Baltinglass No. 1 District Council, of which he was clerk. Morrin received a note dated 20 July stating:

You are hereby Ordered to hand in your resignation as J.P. by Friday 23rd Inst. and publish same in Freeman and Independent failing to obey this order you shall be severely dealt with By Order

I.R.A.

Another possible case of intimidation surfaced in 1919, when Ellen Whelan of Lathaleere made a malicious injury claim alleging that she had refused to sign a plebiscite for representatives of Sinn Féin and that a shed on her farm and the pigs it housed were burned, while farm machinery was dismantled.[671]

The events of the first week of August 1920 had the inhabitants of Baltinglass on edge. For about a month beforehand there had been regular nightly thefts, with cows being milked and vegetable plots raided. Eventually on the morning of Sunday 1 August the Volunteers caught two young men stealing and brought them to the Town Hall where they were held for some time. Later that morning Brian Coogan of Carrigeen was on his way to mass when he was attacked and badly injured in Belan Street allegedly by friends of the two prisoners.[672]

The identity of the prisoners or their friends was not revealed in the press report, but evidently the army was concerned about the Volunteers' actions. Early on the Monday morning the army arrested Ned Nolan and John Rogers for having arms and ammunition, and brought them to the Workhouse before transferring them to Mountjoy. Nolan was aged twenty-three and a railway worker from Weavers' Square. Later that day Paddy Donegan, Joe Hennessy and Paddy Rourke were arrested and brought to the Workhouse, charged with being concerned in illegal

arrests and having fire arms. Donegan (aged twenty-three) and Rourke (aged twenty-seven) were milesmen on the railway. Donegan had lived with Rourke's family in Main Street since childhood. Hennessey was a twenty-two year old labourer from Chapel Hill. That night a small group of soldiers came into the town. One was a sergeant whose 'revolver display for hours on the streets' caused great alarm. Two of them, one carrying a revolver, went into the billiard room of the Town Hall where a game was in progress, shouted 'Hands up all' and searched those present. Evidently the conduct of these soldiers was completely out of line and was not sanctioned by their officers, as they were reportedly removed from the Workhouse camp by the end of the week. It was noted that the behaviour of these soldiers was out of character with the army's general conduct since their arrival in Baltinglass.[673]

On the Tuesday morning a hackney car belonging to Willie Wall was doused in petrol and set on fire in a shed at the bottom of Belan Street. However, it was discovered before too much damage was done. That evening Hugh Coogan, a twenty-five year old farmer from Carrigeen, was brought into custody in the Workhouse, similarly charged with being involved in illegal arrests and having fire arms. He was then transferred along with Donegan, Hennessy and Rourke to Mountjoy. Later in the week, Thomas Loughlin was also sent to Mountjoy, bringing the number of Baltinglass men in custody to seven. He was charged with being involved in a raid for arms.[674]

Perhaps the most sinister occurrence of that week happened on the Friday evening when a stranger entered Edward O'Neill's shop in Main Street asking to speak to the owner. Being told that O'Neill was in the yard, he went out there, confronted him and took out a revolver. On O'Neill's admitting that he was in Sinn Féin, the stranger said 'I am going to shoot you'. Then Dora O'Neill threw herself between her husband and the stranger, grabbing his arms. The stranger left, but warned that he would be back. Edward O'Neill was a leading member of the local Sinn Féin club. He had been returned unopposed as County Councillor for the area in May, and then in June he had been elected chairman of both Baltinglass No. 1 District Council and Baltinglass Board of Guardians.[675]

The second week of August was calmer. The Army continued to patrol the area and to search houses, but there was no untoward conduct on the streets as on the previous Monday, and very few people ventured outside after nine o'clock at night.[676]

THE WAR OF INDEPENDENCE: HUTTONS' BURNED BY BLACK & TANS
WEDNESDAY 22 SEPTEMBER 1920

In the early hours of Wednesday morning 22 September the people of Baltinglass were awoken by the sounds of shooting and explosions, and found that three separate houses were on fire. By the time the noise had stopped two of the fires had died away. Feeling it was now relatively safe to venture from their homes, people went to the scene of the remaining fire, which was Bridget Hutton's public house

on the corner of Edward Street and the bridge. By that stage there seemed to be no hope of saving any part of the house. All the people could do was work to save the adjoining houses, which they succeeded in doing.[677]

The other buildings that had been set alight were The Hollow, the public house and grocery shop in Mill Street owned by M.J. Doyle and Sons of Main Street, and Charlie Nolan's house in The Flags, Weavers' Square. The shop assistants sleeping in The Hollow were awoken by the sound of breaking glass and an explosion downstairs. They fled across the river. Andy Doyle, one of the owners, arrived and along with his cousin Hugh C. 'Soup' Doyle, Willie Turtle and the shop assistants, controlled the fire with Minimax extinguishers. In the attack on Nolan's house, shots were fired through the kitchen window and the hall door and window were set alight. One of the sons, almost certainly Ned, who had been arrested back on 2 August and released from Mountjoy at the end of that month, came downstairs to quell the fire. Though further shots were fired into the house he managed to save it.[678]

The destruction of Mrs. Hutton's house was long remembered in Baltinglass, and it was attributed to a reprisal by the Black and Tans. The Black and Tans were a reserve force of the RIC recruited in England and they included a large number of demobbed soldiers, many of whom had been desensitised by the carnage of the First World War. They first appeared on the streets of Ireland in March 1920. Lacking the training and discipline of the regular police force, they soon gained a reputation for using aggressive and even illegal methods. Edward O'Neill's strange visitor on 6 August was almost certainly a Black and Tan. However, their first major impact in Baltinglass appears to have been in mid-August.

On the evening of Monday 16 August a large number of cattle dealers arrived in Baltinglass for the fair the following morning. At about eleven p.m. the town was roused by the sound of breaking glass. People were afraid to venture out and the noise continued at intervals for some time. Windows were broken in Johnny Kinsella's, Charlie Nolan's (both in The Flags), Huttons' and Miss J. Wall's, while attempts were made to start fires at the doors of Hourihanes', Tom Germaine's and Webbs' in Mill Street. Sarah Hourihane poured water out an upstairs window, while the door was doused with water on the inside, stopping the flames. Meanwhile, Bridget Hutton and her sister, Mary Quinn, had a more frightening experience. They saw five men come out of a house nearby and cross the bridge. They then lifted a half empty barrel outside and threw it against the window of Huttons', while an upstairs window was smashed with a stone. The two women crept out of the house, down the yard and across the river to safety in another house. Various reliable eyewitnesses said they knew the identity of those who ran amok that night and while the police denied being out of the barracks, it seems clear that the perpetrators were reserve policemen or Black and Tans.[679]

The following morning a large army contingent arrived from the Workhouse in motor lorries. An officer, along with about twenty soldiers and two policemen went to seven public houses, asking each owner if they would serve the military. Bridget Hutton, Dan Kehoe, Edward O'Neill and Mick Timmins each refused to

do so. Their premises were shut down and chalked 'Closed by Order' and a guard was placed outside each one. Soldiers patrolled the town till noon. Hundreds of people were about for the fair, but their usual business was constrained by the military presence and many left early. That night the army returned to search the houses of Lalors and Ryders in Edward Street as well as that of Henry Gaskin, secretary of the local branch of the Irish Transport and General Workers' Union, but the searches were conducted without unnecessary inconvenience.[680]

On Saturday 28 August six of the seven prisoners arrested in the first week of the month were acquitted and released. However, Thomas Loughlin (aged twenty-one, a timber feller from Belan Street) was given a two year sentence. On the night of the prisoners' homecoming four men, M. Byrne, Jack Cashen, Christy Lalor and Jack Leigh, were arrested and held at the Workhouse until the Thursday evening.[681]

On the night of Friday 10 September Mick Timmins's house in Weavers' Square and The Hollow were searched by the army and the police but nothing of a political nature was found. The following Tuesday night Marks Dalton was crossing the bridge in the dark on his way home to Mill Street from the Town Hall sometime after nine o'clock when he was ordered to halt. He did so, but immediately was felled by a blow that knocked him unconscious. He was then given a further kicking and beating. A few minutes later Tommy Doyle of Main Street was crossing the bridge when, without warning, he too was struck on the left temple and knocked unconscious. He was kicked repeatedly and left with a permanent neck injury. The attackers in both cases were in civilian clothes, but it was believed that they were Black and Tans.[682]

On the evening of Monday 20 September Jim Doyle of Mill Street was travelling home from Moone in a pony-drawn car, accompanied by Constable Richard Evered, when they were ambushed at Coolrake, Co. Kildare, by a group of armed men. Forty year old Doyle was the Boer War veteran who had trained the Volunteers back in 1914. Because he made his pub open to policemen and soldiers his business was boycotted by republicans from about July 1920. He was shot in the face, arm and back, while Evered was wounded in the shoulder and chest. Evered was a Black and Tan who was appointed to the force on 28 May 1920 and allocated to Baltinglass in July. He was an ex-soldier who was born in Birmingham, and he was thirty-four years old at the time. Having been attended by Drs. Cruise and Kenna, both men were transferred to hospital in Dublin, where more than thirty pellets were removed from Doyle's body. This attack on Doyle and Evered was just over twenty-four hours before the Black and Tans took revenge by burning Huttons'.[683]

Bridget Hutton later lodged a claim of £6,000 with Baltinglass No. 1 District Council for the burning of her property, while the executors of Alice Gardiner, the landlord, claimed £1,000. On Friday 24 September a curfew order came into force in Baltinglass. No one was to be out of doors after eight thirty p.m. The curfew was complied with to such an extent that 'almost perfect stillness has descended by 8.31'. The town was much quieter the following week as ordinary life continued.[684]

THE WAR OF INDEPENDENCE: WEBBS' OCCUPIED BY THE POLICE
WEDNESDAY 13 OCTOBER 1920

On the morning of Monday 11 October 1920 Joseph Turtle, the owner of Webbs' in Mill Street, was notified that his premises were to be commandeered in two days' time.[685] The building was one of the most substantial ones in the town, with three storeys over a basement, and overlooking the bridge, the main junction in Baltinglass. It had been built in the 1860s by the Chandlee family but had been bought in the mid-1870s by Herbert Webb. After Webb's death his brother-in-law, Joseph Turtle, took over the management of what remained Webbs', one of the most extensive businesses in the town.

Given two days to vacate the building, Turtle was lucky to be given the use of the Town Hall as business premises, while his furniture was transferred to the house of his son-in-law, Soup Doyle. During the following week the police moved from the barracks in Mill Street across the road to Webbs'.[686]

During October and much of November there was no escalation of disturbances. People grew accustomed to the curfew, there were house searches, motor vehicles were occasionally stopped and searched, and there were some minor incidents, but the situation was comparatively calm. However, on Monday night 22 November extensive house searches were conducted and Pat Harte of Hartstown, John Kehoe of Blackbog and John Rogers were arrested, Rogers for the third time. On the night of Saturday 11 December the calm was again disturbed when the windows of 'most houses' in Weavers' Square were broken.[687]

Trenches were dug across some of the roads in the area by republicans in March 1921. They were filled in but some were re-opened on Friday night 1 April, and on the following Monday many of those who went to Baltinglass Labour Exchange for unemployment benefit found themselves pressed into re-fill the trenches. The same solution was used in early May. At the end of March, Luke McDonnell of Coolinarrig was arrested and brought to the Workhouse camp. He was a local rate collector. He had been collecting rates but not passing them on to the authorities but instead channelling them to the independence movement. He was tried in May and sentenced to fifteen months with hard labour.[688]

Jim Doyle, who spent five weeks in Dr. Steevens' Hospital as a result of the injuries he received in the ambush in September 1920, lodged a claim of £3,000, while Richard Evered, the Black and Tan who was also wounded in the attack, claimed £250. Their claim came before Kildare Quarter Sessions on 29 April 1921. Doyle's business continued to be boycotted, with no civilians entering his premises after the ambush. He was awarded £500, with £16 expenses, to be levied off County Kildare at large. Evered had resigned from the police force since the incident and returned to England. He came back for the hearing, but appeared not to be sober when his case was called, and so it was adjourned.[689]

About three o'clock on the morning of Tuesday 10 May, Jim Doyle's premises at the corner of Mill Street and Belan Street were discovered to be in flames. By that time it was beyond saving, so the police and soldiers, with the help of civilians, fought to preserve Tom Germaine's property next door. Minimax extinguishers were used, and a human chain brought buckets of water from the river, while others moved most of Germaine's stock away from danger. It was a long struggle and for some time it seemed that the fire would win, but Germaine's house was saved. Despite the timing, it appears that the fire was not the result of a republican attack. Doyle had recently sold the premises to Evelyn Farrell, wife of Ben Farrell of Kiltegan. Mrs. Farrell applied for £7,000 compensation but malice was not proved and the application was dismissed.[690]

The War of Independence officially ended with the Truce on 11 July 1921. For Baltinglass the first impact of this was the lifting of the curfew which had been in operation since the previous September, and many sat out of doors long after ten p.m. (which had been curfew hour at the time) in appreciation.[691]

Republican (or parish) courts were established in County Wicklow in October 1921 and the first one in Baltinglass was held on Saturday 22 October, and one of the witnesses was an Irish Republic policeman. During the months it existed, William Byrne of Kilmurry presided at the Baltinglass parish court, with Mick Timmins and P. O'Dwyer as the other bench members, while Dan Kehoe junior, of Weavers' Square was registrar. It was a strange time in which two parallel systems operated. Baltinglass Petty Sessions continued dispensing justice as they had for decades, while the RIC continued to be the official police force.[692]

There was another shooting incident in Baltinglass on Sunday 30 October. That evening two motor lorries arrived in the town, bringing handball players home to Hacketstown from a match in Dunlavin. The lorries stopped in Weavers' Square for the handballers to go to a pub. As they were leaving again there were three RIC policemen walking along the footpath with three girls. According to one report the men in the lorries jeered at the constables and when they moved towards the lorries someone shot at them. Another account stated that the policemen had passed the lorries when a shot was fired from one of them. However, witnesses said that the lorries had travelled too far for the shot to have come from them and that the sound did not come from their direction. In any case, Constable McCarthy was seriously wounded in the groin. He was brought into a house nearby and there attended by Dr Kenna before being transferred to the Curragh hospital. The incident, if politically motivated, would have had implications for the truce, so the Divisional Commissioner of the RIC and the liaison officer of the IRA were expected to make a report on it. Later that night a group of three men visited three houses. One of them, who had his face masked, asked if a particular Volunteer was at home. In one of the houses, when told that the man in question was not there, he said that he would be 'shot at sight'.[693]

On Saturday 12 November John Rogers returned to Baltinglass on the evening train, having been released on parole after serving almost twelve months at

Ballykinlar. There were no celebrations as on his first release as, apparently, he wanted to avoid any such marking of the event under the circumstances. While he was in detention his father died and he was not allowed attend the funeral. His home had been closed up since the death and there had been no one to maintain the farm. The Anglo-Irish Treaty was signed in London on 6 December, and by the end of 1921 the only political prisoner from the area still in detention was Luke McDonnell, who was serving eighteen months in Wandsworth Prison in England. He was subsequently released and returned on the evening of Monday 16 January 1922 to Baltinglass, where he was given an enthusiastic reception at the railway station by members of Cumann na mBan and the Volunteers, as well as a large gathering of the general public.[694]

Back at the beginning of November the RIC stations in Dunlavin, Hollywood and Kiltegan had been evacuated and the police transferred to Baltinglass Workhouse camp, to occupy the hospital building. On Wednesday 2 November the police also vacated Webbs', almost thirteen months after they first occupied it, and likewise moved to the Workhouse. However, this did not mean that Joseph Turtle could reopen his business on the premises. The post-Treaty split in the republican movement led to the Civil War, and Webbs' was again occupied, this time by the forces of the pro-Treaty government. It appears that Turtle did not return in November 1921, and certainly the building was occupied from July / August 1922 by the National Army. When peaceful conditions returned Turtle was able to move home to Mill Street. Webbs' reopened as a leading business house early in June 1923, almost two years and eight months after Joseph Turtle was given two days to vacate the premises.[695]

BALTINGLASS GUARDIANS SUPPORT THE TREATY
SATURDAY 31 DECEMBER 1921

The Irish delegation signed the Anglo-Irish Treaty in London on 6 December 1921. Many republicans disapproved of the deal as it involved partition, with Northern Ireland, already a political entity under the Government of Ireland Act of 1920, forming a separate political unit. Eamon De Valera led the Anti-Treaty faction.

On Saturday 31 December 1921, the Baltinglass Board of Guardians had its final meeting. Its functions would henceforth be carried out by the respective County Councils of Wicklow, Carlow and Kildare. The meeting was chaired by Edward O'Neill and Mick Timmins proposed the following resolution:

'That we, the members of the Baltinglass Board of Guardians, voicing the opinions of the people in our area, while realising that the Treaty does not embody full Irish National aspirations, consider it is an acceptable agreement arising out of the basis of the conference, and see no other alternative to its acceptance but chaos.'

It was seconded by Dan Kehoe, but John Heydon of Tankardstown proposed an amendment that no resolution be forwarded from the meeting and that Dáil Éireann be trusted to make the right decision. However, on a show of hands, Timmins's resolution was adopted by twelve votes to two.[696]

On Saturday 7 January the Dáil approved the Treaty by sixty-four votes to fifty-seven. Robert Barton, the Kildare-Wicklow (formerly West Wicklow) representative, who was one of the delegates who signed the Treaty, voted for it but he subsequently sided with De Valera. According to the local correspondent for the *Nationalist*, the result of the vote was received in Baltinglass the following morning with 'general jubilation' and the decision had 'unqualified and unlimited approval' in the area, as the people saw it as a vote for peace instead of war.[697]

On Saturday 28 January, the Baltinglass Sinn Féin club met to appoint delegates to the West Wicklow Comhairle Ceantair at Tinahely the following day, and to the Ard Fheis in Dublin on 7 February. Edward O'Neill, who presided, suggested that the feeling of the meeting be taken as regards the Treaty and that delegates be appointed from those in the majority. John Rogers asserted that whoever was selected should put forward the opinions of the majority. On a show of hands the majority supported the Treaty, and O'Neill and Mick Timmins were unanimously selected as delegates. However, the following day the majority of delegates at the Comhairle Ceantair opposed the Treaty.[698]

In the last week of January, the British Army vacated the Workhouse camp and a tricolour was placed on the building. However, the RIC continued to occupy the adjacent hospital building until Saturday 4 March, after which all the Workhouse property was in the hands of the IRA.[699]

Later that month four members of a 'newly-appointed temporary force' of police began work in Baltinglass, with their headquarters at the old RIC barracks in Mill Street. It would appear that these were recruited from the local Volunteers (or IRA members). Lar Lennon of Deerpark was in charge. The other members of the temporary police were Peter Brennan of Tuckmill Hill, Mick Byrne of Coolinarrig and Paddy Fleming of Belan Street. At the same time some other local Volunteers went to serve as temporary police in other areas, while more had already passed preliminary examinations for the Civic Guards, a force which had been established the previous month. It had been intended that the Baltinglass temporary police would be funded by subscription, but as sufficient money was not forthcoming the force was disbanded on Saturday 1 April. Two days later the IRA moved out of the Workhouse camp and took up their quarters in the former RIC station vacated by the temporary police.[700]

Despite the presence of the temporary police, there appears to have been a state of lawlessness in Baltinglass in March 1922. Jack Cashen and Rose Lawlor of Belan Street (actually the Bawnoges Road) lodged complaints that their houses were attacked late at night by armed men and that considerable damage was done, while Michael Byrne claimed compensation for the malicious burning of his recently

vacated house in Belan Street. On the morning of 31 March the last two wagons of the goods train were seized at the railway station by armed men, stated in the *Nationalist* as members of the IRA. They contained grass seed valued at £135, the property of Scottish seed merchants, bound for Thomas Doyle's (or Finnegan Doyles) in Main Street. The bags of seed were removed on cars to the side of the river, slit open, and the contents dumped into the water. The following night the upstairs windows of Paddy O'Grady's house in Main Street were smashed.[701]

In April an election committee supporting pro-Treaty candidates was established in Baltinglass, as a general election was called for June. On Friday 14 April Edward O'Neill and Michael Timmins were selected as its delegates for the County Wicklow convention at which candidates would be chosen. Campaigning brought Harry Boland to Baltinglass as an anti-Treaty advocate the week before the election. Standing on a platform beside the McAllister monument, he recalled a previous visit to the town, when he came with a Gaelic football team from Dublin for a fundraiser to put railings around the statue. Also with the team were Sean McDermott and John MacBride, two men who were subsequently executed as leaders of the Easter Rising. Boland's speech struck a chord and gained ground for his cause.[702]

The election showed majority support for the Pro-Treaty faction. Twelve days later the country was officially in a civil war that had been coming to the boil for some months.

THE CIVIL WAR: IRREGULARS OCCUPY BALTINGLASS
SUNDAY 2 JULY 1922

The Civil War had an immediate impact on Baltinglass. From Wednesday 28 June 1922 the railway service was disrupted and news of what was happening elsewhere was limited. Consequently, the people's anxiety was extremely high by Saturday 1 July. That evening a number of lorries carrying National (or pro-Treaty) soldiers arrived in the town. They left after a short while, and half an hour later motor lorries, cars and a motor coach carrying fully armed Irregulars (or anti-Treaty troops) passed through Baltinglass, heading towards Dublin.[703]

The following afternoon, while most of the townspeople were in St Joseph's church for the monthly meeting of the Sacred Heart Sodality, a large force of Irregulars arrived in the Dublin Road with the aim of attacking the former police station in Mill Street, then occupied by the National troops. At the time there were only seven soldiers in the barracks. The Irregulars swiftly occupied a number of houses in Mill Street and took up positions on the high ground behind the barracks, above the railway cutting. Using rifles and bombs, they began a sustained attack, and the soldiers in the barracks returned fire. By the time the congregation was leaving the church, about three thirty p.m., the sounds of the siege had reached them. The women and children stayed around the church, while some of the men moved cautiously towards the danger zone but no one could cross the bridge. Just after four o'clock the men in the barracks

surrendered, having exhausted their ammunition. Thus began the Irregulars' occupation of Baltinglass.[704]

An anxious crowd poured over the bridge towards the former police barracks. They found the front of the building dented with bullets, the hall door and windows smashed and even the interior greatly damaged. Six of the seven National soldiers who had been in the building were lined up facing the barracks, on the opposite side of the street. Their guards were chatting with them. Despite wild rumours of fatalities, the Irregulars claimed that they had suffered no losses, though three of their troops and one of the National soldiers, P. Harte, were slightly injured.[705]

The following days were trying times for the people of Baltinglass as they worried about their future safety. The effects of the occupation were immediate. The train service was completely suspended, and so there was no post and the town was almost completely isolated. There was none of the usual passing traffic and little business was done. The Irregulars patrolled the streets in groups and the approaches to the town were heavily guarded. Food and equipment were commandeered from most shops and supplies dwindled, bringing fear of foodstuffs running out. Copes, Douglases, M.J. Doyles and Thomas Doyles in Main Street, and Catherine Byrne and Webbs in Mill Street later claimed for grocery, clothing and hardware items, as well as petrol, commandeered by the Irregulars. They also took a Ford motor lorry from Webbs, which was damaged.[706]

On the Tuesday evening, two days into the occupation, a rumour circulated that the National Army had reached Carrigower and were marching on Baltinglass. This seemed to be confirmed by immediate activity by the occupying Irregulars. The townspeople took swift precautions. Houses were shut up, and many families fled their homes. The streets were almost totally deserted. Despite a night of anticipation no attack came. On the Thursday and Friday some daily newspapers arrived, giving the people some idea of what was happening in the outside world, and on the Saturday the sound of an approaching train brought a semblance of normality. The first goods train in over a week arrived on Monday 10 July and a passenger train followed at its usual time. It was rumoured the next morning that the Irregulars were to leave the town. From about midday there were no more patrols on the streets, and the usual observation posts on the approaches to the town were abandoned. In the evening the barracks were vacated and conflicting rumours spread as to whether the Irregulars were withdrawing from Baltinglass temporarily or permanently. Then in the late evening an aeroplane circled above the town and disappeared heading south.[707]

Whatever was the cause of the assumed evacuation that Tuesday, the Irregulars remained in occupation throughout the weekend. It is possible that the events of Tuesday were related to the Irregulars occupying Tullow, which they did on that day. The Irregular force in Baltinglass increased towards the end of the week and this was attributed to their evacuation of some towns in Wexford as well as Tullow, which they vacated on the Saturday evening. The National Army reported that it

took possession of Newtownbarry (now Bunclody) and Tullow. On the Sunday the extra forces were billeted on many Baltinglass households.[708]

Early on the morning of Monday 17 July the sound of an aeroplane was heard as it circled the town a number of times before flying off. Before long a very strong force of the National Army had encircled the town. Led by Major-General Emmet Dalton and Commandant-General Tom Ennis, the army approached from the direction of Dublin. At Tuckmill it divided into two wings – one going to the left by Tuckmill Hill and Coolinarrig, the other going to the right by Goldenfort and Rampere to enter Baltinglass by Tinoran. The Irregulars found this pincer movement impossible to repel. The town was under fire from Baltinglass Hill, while a section of the Army entered from the Kiltegan Road. Armoured cars rolled through the streets. Irregular snipers allegedly positioned themselves in the Abbey and in the tower of St Joseph's church. The Convent Annals record: 'Shortly after breakfast we heard great firing. A Machine Gun from Cars' Rock sent volly after volly (sic) over Convent & Town & compelled the Republicans to resign'. The convent was struck by two bullets. Five soldiers came to the back door to make sure that there was not a sniper firing from the Convent's tower. According to an official National Army communiqué reported in *The Times*, five National aeroplanes 'hovered over the town' during the battle. It lasted some three hours, ending with the surrender of those Irregulars who did not manage to escape. The prisoners were placed under guard at the barracks. A bag of grenades was uncovered at a Red Cross station in the town, and a woman displaying a Red Cross badge was found to be concealing a dumdum bullet in her clothes, while another was in possession of papers belonging to an Irregular leader.[709]

During the engagement one civilian and a National Army officer were slightly injured. In the thick of the battle some strong-willed ladies found the opportunity to bring tea to some of the National soldiers. Afterwards the troops were readily billeted in the town. The occupation of Baltinglass by the Irregulars had lasted fifteen days. News of the retaking of the town got around quite quickly, as that evening some buyers arrived on the train in anticipation of the monthly fair going ahead as usual on Tuesday.[710]

The Workhouse, which had been vacant since April, again became a military base. The prisoners captured by the National Army were moved there. On the fair day William Kinsella of Marshalstown was arrested in Baltinglass and added to their number. Within a fortnight the National Army was also occupying Webbs'. Further arrests were made in the general area throughout August. From Baltinglass itself, Dan Phelan was among those detained. However, there were no major incidents in the area during August and September, and ordinary life resumed.[711]

THE CIVIL WAR: THE GRANEY AMBUSH
TUESDAY 24 OCTOBER 1922

The relative peace that had prevailed in the Baltinglass area since the retaking of the town by the National Army in July 1922 came to a shocking end, with an

ambush by the Irregulars on a National Army motor van at Graney, on the road from Castledermot to Baltinglass.

About noon on 24 October 1922 a National Army party of eight left Baltinglass in a Crossley tender van to go to Athy. In charge was Comdt. Hugh Kenny and the others were Lieut. Edward (Ned) Nolan, the driver James Hunt of Ballyconnell, and five Volunteers, including Patrick Allison of Brannockstown, sixteen year old Edward Byrne from the Clonmore area and James Murphy of Killalesh. Between Castledermot and Athy they ran out of petrol and had to send to Athy for fuel. On their return they stopped in Castledermot for a few minutes and then proceeded towards Baltinglass.[712]

Meanwhile, a large body of Irregulars, allegedly a flying column from outside the area along with a small number of locals, had arrived at Graney. From about three o'clock that afternoon people travelling through Graney were stopped and ordered into houses nearby. Men working on the roads were also forcibly detained. At about four o'clock the Crossley tender arrived. As it got to the junction and was going around the bend to the left to cross the bridge, two volleys were fired in quick succession from a cottage on the right hand side. The driver lost control and the van ran into the ditch opposite the cottage. The Irregulars then opened fire from all sides, using rifles, revolvers and bombs. As well as using the cottage, they had taken up positions in another house, in a walled area called 'the Pound' and in the ruins of the old Pilsworth house. Three of the Volunteers, Allison, Byrne and Murphy, were shot dead and fell out of the van on to the road. Hunt, the driver died in hospital some days later. The other men in the van were wounded, most of them badly. Having fallen from the vehicle some of them crawled along by the ditch to relative shelter.[713]

Ned Nolan was wounded in the back and the face. According to his own account at the inquests held in Carlow the following evening, he crawled some yards along the edge of the ditch before being discovered by three Irregulars. About twenty armed men came out of the cottage and from behind a ditch. He recognised three of them. They burned the lorry and marched off towards Knocknacree. The civilians detained during the ambush rushed to Baltinglass and Castledermot with the shocking news. Father O'Neill and Dr. Kenna from Baltinglass arrived on the scene shortly afterwards. When Brigadier-General McNeill in Carlow barracks was informed of the ambush he went to Graney and found the smouldering van. In a house nearby one wounded man was being cared for while there were two dead bodies on the floor. His troops found three more injured men up the road. From his assessment of the scene, he reckoned that it would have been impossible to escape the ambush and that the soldiers would have been justified in surrendering had they been given the chance to do so. He also said that the attackers were not justified in firing several volleys in succession as they gained no military advantage for them. From the wounds inflicted on one of the injured men he concluded that he was shot while he lay on the ground.[714]

The dead and wounded were conveyed to Carlow. On the Wednesday evening the bodies of young Edward Byrne and James Murphy, who was aged about forty,

were removed to Clonmore and Tynock churches, respectively. Murphy's cortege passed through Baltinglass, where it was joined by a large crowd. Most of the garrison at Baltinglass attended the funerals. Patrick Allison was interred at St Mary's cemetery in Carlow on the Thursday. The wounded were transferred to hospital at the Curragh. Over the weekend several arrests were made in the area, but most of those detained were subsequently released.[715]

The Graney Ambush was for a very long time too sensitive an issue to be treated as mere history. It represented the essential horror of the Civil War. The National soldiers ambushed were locals, as were a number of their attackers, some of whom were greatly disturbed by the experience. Certain stories maintained by tradition may be no more than versions of the conflicting rumours that circulated immediately afterwards. However, it is said that the original target of the ambush was an officer based in Baltinglass who had a reputation for cruelty towards prisoners detained at Webbs'. Allegedly he was supposed to be in charge of the party that travelled to Athy but Hugh Kenny took his place. It is also said that those lying on the ground were shot by one of the Irregulars at close range with a revolver. Ned Nolan's own statement the following day may have concealed some of the facts. It is maintained that an Irregular was about to shoot him as he lay wounded but that a Baltinglass man saved his life by pretending to have shot him already. Nolan, it is said, repaid this act of mercy by not naming the man as one of the attackers.[716]

THE CIVIL WAR: WORKHOUSE DESTROYED BY FIRE
TUESDAY 6 FEBRUARY 1923

The months following the Graney Ambush were relatively quiet in Baltinglass. The Republican courts were abolished in November 1922 and replaced shortly afterwards by a new system, Dan Kehoe junior, being appointed registrar for the Baltinglass and Hacketstown areas. On Monday 13 November John Rogers was arrested by the National Army, a year almost to the day after his last release by the British administration. Along with him on this occasion was Patrick Kehoe of Blackbog, Grangecon, a roads overseer. The following week the first members of the Civic Guard took up duty in Baltinglass. Sergeant Edward Grey and five policemen-Carney, Gailing, Lavelle, O'Halloran and Sullivan – were temporarily stationed in what was later called Mrs. Gavin's Ivy Restaurant in Weavers' Square. Apparently the force was still located there eighteen months later, when the restoration of the old police barracks in Mill Street was required for their permanent accommodation.[717]

One of the last major occurrences of the Civil War in Baltinglass took place in the early hours of 6 February 1923, when armed men broke into the Workhouse and set fires in various areas. It would appear that the National Army had again vacated its camp there before this, given that such an attack was possible and the damage was so extensive. Despite the arsonists' best efforts, the entire building was not destroyed. However, the office, the porter's apartments, and the nuns' old

apartments were reduced to rubble. The laundry escaped damage. At the time it was stated that it was possible to save the infirmary but that the boardroom was destroyed. This may not be correct, as the compensation claim lodged by Wicklow County Council made no reference to the boardroom, while specifically mentioning the office, porter's apartments, convent and ward. The 'ward' was damaged partly in an attempt to stop the spread of the fire. The detached fever hospital was sprinkled with petrol, but it was not set alight.[718]

Many people think of a workhouse as a place of Victorian oppression. Workhouses were established throughout Ireland in the early 1840s to assist those who fell on hard times. The Victorian ethos dictated that people only appreciated charity when they had to earn it, so those admitted to institutional charity were expected to work in return for their keep. The workhouse was not a place of luxury but it saved many people from a life of greater misery. During the Famine many more people in the Baltinglass area would have died were it not for the Workhouse. The Poor Law system made a community responsible for the welfare of those within that community who could not support themselves or their families. The Board of Guardians was made up of local people who administered the system on behalf of the community. By reading the newspaper accounts of the Baltinglass Guardians' meetings it can be seen that they were practical but also compassionate and they took the well-being of the inmates seriously. Baltinglass Workhouse's infirmary and fever hospital served the functions of retirement home, maternity and general hospital for the poor of the community, though without the comforts expected from the twenty-first century perspective. During the 'flu epidemic in 1918 many Baltinglass lives were saved by having these hospital facilities in the area.

The Baltinglass Workhouse opened its doors to the poor on 28 October 1841. It was partly occupied on 19 May 1920 by the British Army, who took complete possession the following month, when the remaining inmates were transferred to Shillelagh. For almost eighty years the institution was an essential part of the fabric of Baltinglass, so, when it was destroyed in February 1923 a major facility was removed from the town. Luckily the fever hospital was left undamaged by the arsonists, as it provided the community with a material argument for demanding its re-establishment of a permanent district hospital for West Wicklow. Despite the damage, it was possible for the National Army to occupy the Workhouse area again in March, and the Baltinglass No. 1 District Council had its quarterly meeting there in April, though this may have been held in the fever hospital.[719]

Tradition attributes the cause of the Graney Ambush to abuse of prisoners. Further abuse was alleged in two parliamentary questions raised in 1923. Michael Glynn of Baltinglass and Robert Keogh of Stratford were arrested on 4 March and were still in custody a month later. Keogh was stated to have been held for three days in a cattle wagon at Baltinglass railway station and later held at the Workhouse. They both claimed to have been assaulted by troops. The Minister responded that neither man had been ill-treated by troops but had been beaten by

an officer who was 'labouring under excitement' having recognised them as being involved in an ambush in which four men were killed and the officer and others wounded. It was explained in Keogh's case that he shared accommodation in a cattle truck with troops for a time and was eventually sent to Carlow barracks.[720]

The last major occurrence of the Civil War in Baltinglass was an attack on the National Army guard at Baltinglass railway station on the night of Monday 26 March 1923. It began at about eleven o'clock, when rifle fire was opened from various directions, and reportedly lasted some hours, the bullet holes on the walls of the station and shattered windows revealing the severity of the attack the next day. However, the Irregulars were unsuccessful as the station was held by the army.[721]

John Rogers was released in April 1923, having served four prison terms during the War of Independence and the Civil War. There was considerable military activity in the general area in mid-April and further arrests were made. However, by that time the Irregulars were all but defeated, and in May de Valera called a ceasefire. In early June Webbs' reopened for business in Mill Street and Baltinglass resumed normal life. Back in 1919 it had been a small Irish town in the United Kingdom. Having come through four years of conflict it emerged not much altered on the surface, but with deeply buried acrimony, as a small town in the Irish Free State.[722]

GUARD O'HALLORAN SHOT DEAD
MONDAY 28 JANUARY 1924

After the turbulent years of the War of Independence and the Civil War, life in rural Ireland more or less settled back to quiet normality for most people. Some of those active during the years of unrest found the transition to peace difficult, and the fledgling Free State was faced with a wave of crime. The last Monday of January 1924 started out like an ordinary Monday in Baltinglass and no one could have expected it to be remembered for decades to come. What changed it was the arrival in town of Peter Jordan and Felix McMullen.

Jordan, aged twenty-nine, and McMullen, aged twenty-six, were captains in the National Army until December 1923. They met up that morning at the Ormond Hotel in Dublin and decided to raid a bank. Their target may have been influenced by a recent visit to Baltinglass, as Tony Harbourne later gave evidence that he recognised them as men who had stayed at the Bridge Hotel about a month earlier. They telephoned the LSE Motor Company and ordered a taxi. When the driver arrived, in a large Talbot-Darracq touring car, he was told to drive to Baltinglass. There are conflicting reports of the exact details of Jordan and McMullen's movements in the town, but the following are the basic facts.[723]

The taxi driver said that they went to St Joseph's church and Jordan, the shorter of the two men, went in for a few minutes. They then drove to the post office in Mill Street where Jordan enquired whether there was a telephone. They arrived at the National Bank[724] in Main Street and made a similar enquiry. On being told

by the manager, Maurice Wolfe, that there was no telephone in the bank they left. The taxi driver was told to stop again at the post office and wait for the two men. It was a little after two o'clock when Jordan and McMullen re-entered the bank. On seeing McMullen carrying a revolver, Cyril Corcoran, the teller, hid the cash in a cupboard below his desk. Wolfe was then in the boardroom. Answering a knock on the door, he found the two men standing there, with the junior clerk, Cecil Shade. Jordan pointed a revolver at Wolfe and shouted 'Hands up'. Wolfe reached into his pocket and produced a .25 automatic revolver, which he aimed at McMullen. Unable to bring himself to shoot, he then aimed it at Jordan. Thinking that the raiders were about to shoot the manager, Cecil Shade jostled McMullen, whose gun seemingly went off in the confusion. Apparently Wolfe's gun also discharged before he fell to the ground wounded, but not seriously.[725]

Jordan took the manager's pistol and demanded the keys to the safe from him. Wolfe threw him a bunch of keys which did not include that for the safe. About then Mrs. Wolfe arrived down from upstairs. Shade told her that her husband was injured and asked her to go for a doctor. McMullen threatened to shoot her if she attempted to leave but, ignoring his threats, she rushed out the main door shouting for help. McMullen bolted the door. Jordan ordered Shade to open the safe, but the keys were useless. A policeman's whistle was blown outside the building and Shade threw the keys out the window. Jordan and McMullen ran out the back door of the bank.[726]

Outside, a number of people heard the shots and Mrs Wolfe calling for help. Joe Germaine, whose premises were close by on the opposite side of the street[727], went upstairs and got a fully loaded Colt automatic pistol and ran towards the bank. In the meantime Paddy O'Halloran, a twenty-seven year old Civic Guard who had been stationed in Baltinglass for fourteen months, had met Mrs Wolfe and had gone to the bank and started knocking on the door. He then blew his whistle. When Joe Germaine arrived he gave O'Halloran the revolver. Then the two raiders came out the gateway beside the bank and ran up the bridge. O'Halloran ran after them, calling for them to halt. They kept running. The guard pressed the trigger of the gun but it failed to work as the safety catch was not released. McMullen turned around and fired at O'Halloran, who fell to the ground. The people on the street continued to chase the raiders. Someone handed Tony Harbourne a gun and he shot at the raiders but they got away with the taxi driver at the wheel. Harbourne took the registration number and telephoned from the railway station to Dunlavin with a description of the men.[728]

Apparently the National Army was stationed at the time at the Workhouse, as the officer in charge of a military camp there was said to have pursued the raiders while word of the raid was wired to Dublin. Jordan and McMullen got out of the taxi at Kimmage Road, then on the outskirts of the city. Having failed to rob any money, they told the driver that the £5 fare would be paid in a few days.[729]

Back in Baltinglass, Guard O'Halloran was seriously wounded. The bullet had entered the lower abdomen, run along the pelvis and exited from the lower back.

He was carried from the bridge into a house, where Drs Cruise and Kenna tended him. That evening he was removed to the Curragh Military Hospital, reportedly with seven perforations in his intestines. The next day those Civic Guards on parade at the Depot in the Phoenix Park were asked for volunteers to give blood for O'Halloran. They all stepped forward. Nine were selected and two of them were sent to the Curragh but at three o'clock that afternoon, while they were on their way, Paddy O'Halloran died. At an inquest at the Curragh the following day the jury returned a verdict of wilful murder by persons unknown. Paddy O'Halloran was a native of Gort, Court Galway. He was born on 15 May 1896 and he worked as a railway signalman before joining the Civic Guard. He was the third member of the force to be killed in the line of duty. His body was returned to Gort for burial. At the graveside Eoin O'Duffy, then Chief Commissioner of the Civic Guard, announced that if necessary the force would be armed with revolvers 'for a time to cope with this robber menace'.[730]

A number of arrests were made within a fortnight but the suspects were released. Eventually, on Thursday 14 February detectives travelled from Dublin to Monaghan town, where they arrested Peter Jordan. The following day, apparently working on information given by Jordan, they went to Athlone in search of Felix McMullen and their enquiries led to the police in Liverpool being contacted. McMullen was arrested at 24 Rose Place, Scotland Road, in Liverpool and sent under escort to Dublin. The hearing began at the Dublin Police Court on 26 February. On 11 March Jordan and McMullen were returned for trial. Ultimately they were tried at the Central Criminal Court in July 1924.[731]

On Tuesday 8 July the jury retired. After half an hour they returned to ask the judge if they could bring in a verdict of manslaughter rather than murder. They were told that they could only give a verdict of guilty or not guilty. They retired again but came back to say that they could not agree on a verdict. Eventually they were dismissed and the judge fixed the re-trial for two days later. On Thursday, the new jury deliberated for forty minutes before returning a verdict of not guilty for Jordan and guilty for McMullen, but they strongly recommended him to mercy. However, McMullen was sentenced to death, with the execution set for 1 August, and the judge denied access to an appeal. Jordan was rearrested on the further charges of assaulting Maurice Wolfe and intending to steal money from the bank. He was convicted the next day and given ten years' penal servitude and twenty strokes of the lash. Despite further representations for clemency, Felix McMullen was hanged at eight o'clock on the morning of Friday 1 August at Mountjoy Prison.[732]

HURLING CLUB OFFICIALLY FORMED
MONDAY 30 MAY 1927

The bright flame of success in hurling that Baltinglass experienced in the late 1920s was brief, and it came about because a few talented players had come to live in the area. In their first season they won the Wicklow county championship but

within a few years the club that was formally launched on 30 May 1927 had ceased to exist.

During 1889 Martin Gleeson came to the Baltinglass area as a schoolteacher. Apparently he was a member of Baltinglass Davins in his initial years in the area, before he helped form a club in Stratford in October 1896. He was to spend the rest of his career teaching in Stratford. Coming from North Tipperary, he had a passion for hurling. He is credited with being the first person to try to introduce the sport into Wicklow. In or about 1890 he arranged a hurling match at Poulaphuca between a team from West Wicklow and the Brian Borus of Dublin. The home side had no hope against the Dubliners. Gleeson's efforts to popularise hurling were unsuccessful and it was not until 1902 that the sport reappeared in the county. At that point Baltinglass, Newbawn and Wicklow had formed an affiliation and Matt Byrne is credited with launching the sport in Baltinglass.[733]

At the end of December 1902 a meeting of the committee of a Baltinglass hurling and football club took place and it was decided to call the new hurling section Baltinglass Hurling Club. The hurlers had their first practice match on New Year's Day 1903 and the captain taught the members the rudiments of the game. During 1903 Baltinglass hosted the Naas hurlers, who beat them by a single point. They planned to organise a hurling and football tournament in November but this was postponed indefinitely. In January 1904 they had another encounter with Naas, this time at Dunlavin, and were again beaten. The final of the Wicklow County Championship of 1903 was played at Annacurra on Sunday 27 March 1904 between Baltinglass and Wicklow. Wicklow won by 1-6 to 0-2. There was bad feeling about the match in Baltinglass because it was postponed several times by the county committee, the appointed referee did not turn up, and the Wicklow team allegedly contained a number of outside players. Baltinglass played another match in July, against the Fontenoys of Dublin at Poulaphouca, and lost. In October the hurling club was holding a meeting 'on their grounds', but there was no further mention of them in the *Nationalist* up to the end of March 1905. The field used for matches at that time was supposedly on the land of Alice Gardiner (formerly Hargrove) in Lathaleere. It may have been the field formerly used for cricket. As hockey was being played in Baltinglass about the same time, the field may have been shared by the two clubs.[734]

It was not until 1927 that Baltinglass again had a hurling team. By May of that year two West Wicklow Gardai, Jim Conway of Baltinglass and Jim Grace of Hollywood (transferred to Baltinglass shortly afterwards), had found their way on to the county hurling team to play Dublin at Croke Park. In the same month Jack Martin, the accountant at the National Bank in Main Street, organised a hurling club in Baltinglass, which was affiliated in time for the county championship, and training three days a week began immediately. So many players turned out each time that it was possible to play a match with full teams. On Monday 30 May a general meeting was held and Matt Byrne was elected president, Martin secretary, Jim Conway captain, and one committee member was from as far away as

Donard. Arrangements were being made for friendly matches with teams within easy distance. Jack Jones of Newtownsaunders was thanked for allowing the use of a field.[735]

On Sunday 26 June an inter-county match was played at Baltinglass between Carlow and a Baltinglass selection representing Wicklow, both teams containing well known players from other parts of the country who were then living in the respective counties. This was the Baltinglass club's first competitive match. There was a return match at the end of July. The Wicklow County Championship that year was delayed by postponements, so that the semi-final between Avondale and Baltinglass did not take place until December. It was played at Carnew and Baltinglass won 3-3 to 3-1.[736]

The 1927 final did not take place until early in 1928. Baltinglass were the victors at Annacurra against Barndarrig. This was almost certainly on Sunday 12 February, though it has not been possible to find a definite account of it. The *Nationalist* merely stated that the club 'should be proud of the fine support they received on Sunday from the residents', adding that over eighty supporters travelled while rain prevented others from going. At the annual general meeting in May, Matt Byrne stated that a fine crowd had accompanied the team to Annacurra for the final.[737]

In April 1928 the Wicklow county team was selected and six Baltinglass players were included. These were Matt Byrne junior, Jim Conway, J. Fogarty, Jim Grace, Jimmy Lynch and Michael Quinlan, while J. O'Halloran and J. O'Neill were named as substitutes. Conway was appointed captain. In addition to Conway and Grace, Lynch, O'Halloran and Quinlan were Civic Guards. The Baltinglass club's annual general meeting was held on 12 May. Matt Byrne noted that a large number of those on the team were Civic Guards (some of them were stationed at Kiltegan) and he thanked Superintendent O'Reilly for facilitating them by allowing them to travel to matches. Byrne, Martin and Conway were returned as president, secretary and captain, respectively. Unfortunately, in September Martin was transferred out of Baltinglass.[738]

A number of matches in the 1928 season were cancelled for various reasons. Eventually in December Baltinglass were defeated by Wicklow at Aughrim. Beginning at three thirty p.m., Baltinglass were leading by two points at half time, but the match ended in darkness with a final score of Wicklow 5-1, Baltinglass 3-0. After winning their opening encounter of 1929 by a big margin, against Ballymoney at Aughrim, Baltinglass had to withdraw from the county championship because, as the only team in West Wicklow, they found it too difficult to travel to the other side of the county on each occasion.[739]

The club went out of existence, but in 1934 an attempt was made to revive hurling in Baltinglass. In March of that year a team was practising for an initial match against Tomacork. This venture was evidently under the auspices of the Tuckmill club as, at its first annual dance on Easter Sunday, Jim Conway spoke on behalf of 'Tuckmill Football and Hurling Clubs'. In July Tuckmill ran a football,

camogie and hurling tournament, but the effort to revive hurling apparently failed after that.[740]

There was a much later revival, with a minor team winning the 1954 county championship and a junior team representing Baltinglass in the late 1950s. In 1967 there was another highlight when a Baltinglass team had a surprise victory over St Patrick's by the narrowest of margins in the final of the county junior championship. The team was a combination of the then all-conquering senior footballers and a number of locally based players from traditional hurling counties. One of these was Con Hayes, a garda from Tipperary. After the 1967 success hurling faded from Baltinglass again.[741]

OPENING OF BALTINGLASS GOLF CLUB
WEDNESDAY 2 MAY 1928

When Major Mitchell officially opened St John's Golf Club's course on 2 May 1928 by driving a ball off the first tee, the newly formed club was beginning a journey into the unknown. There were only a few golfers among its first members, but members of neighbouring clubs such as Carlow, Naas and Tullow were there to support the new venture. The club proved to be a success. Despite enduring a very bleak period in the 1940s, during which it all but ceased to exist, Baltinglass Golf Club, as it is now known, survived to be the oldest sports organisation in the town by the beginning of the twenty-first century.[742]

From the time of the fire in 1858 that destroyed Stratford Lodge, the residence of the last Earl of Aldborough, the ruins stood gloomily over the town, slowly decaying. After the Earl's death the property passed to the representatives of the three children of an earlier Lord Aldborough. These were Catherine Dora St John, Baron Tollemache and John Stratford Best. For decades the land was let to local farmers for grazing. In 1917 it was anticipated that the Department of Agriculture would take over the property and divide it for tillage, but this did not happen. In 1924 Martin Gleeson and C.M. Byrne, TD, suggested that the Irish Land Commission should acquire the Lord's Wood, as it was known locally, apparently with the similar idea of having it divided into allotments for the townspeople. It was not until 1927 that the Land Commission actually purchased the land, consisting of just over two hundred acres, with the intention of placing it under the care of trustees for the people of Baltinglass. By then it had been decided that the land was not suitable for allotments and that it might be used for grazing.[743]

At or after a public meeting on 11 April 1927, a number of individuals were nominated to act as trustees but some of them declined when they thought of the personal financial burden if the project failed. The West Wicklow GAA board made an approach to the Land Commission in an attempt to have part of the land secured as a football pitch. However, nothing came of this. In May a list of those willing to serve as trustees was given to the Land Commission. These were Father Gerald Byrne, C.C., Meade Dennis of Fortgranite, Hugh C. (Soup) Doyle

of Main Street, Percy Mogg of Slaney Lodge, Dermot O'Mahony of Grangecon House (son of The O'Mahony), Pat Ronan then of Dunlavin (later of Main Street) and Violet Tynte of Tynte Park, Dunlavin. Miss Tynte had been an international golfer. The Lord's Wood was purchased by the Land Commission on 11 July 1927 and on the same day it was, with the exception of part which went to the Nolan family who were already living there as caretakers, granted to the seven trustees. Later that year O'Mahony declared his candidacy for the Dáil and decided to stand down as a trustee. He was replaced by Christopher Mitchell of Ballynure House, Grangecon, the man who eventually opened the course.[744]

For whatever reason, the trustees decided to use the land primarily for development as a golf course. By August they had contacted Lionel Hewson, a well-known golf writer, with a view to having him lay out the course. On his advice they decided to construct a nine hole course, which was apparently completed within a matter of weeks, and people were playing golf on it by December. The club was by then open for membership, with Percy Mogg acting as hon. secretary. However, it was not until May 1928 that the official opening took place. Father Byrne served as the club's first captain.[745]

The first clubhouse was merely a shed in the yard of the ruins of Stratford Lodge. Sadly, the club decided to demolish most of the ruins to construct a new building. This was completed in 1930. On Wednesday 26 November 1930 the new 'Golf Pavilion', with its large ballroom, was officially opened with a whist drive and dance. The Pavilion was to become a popular venue for dances throughout the next three decades, providing an alternative to the Town Hall. It was hired out to various organisations for functions, and the badminton club was for many years accommodated there.[746]

A badminton club was well established in Baltinglass as early as October 1928. In February 1930 the badminton and lawn tennis club held a whist drive and dance at Stratford Lodge School in Church Lane. The badminton club may have been based at Stratford Lodge School. Certainly tennis was being played about that time in the adjacent field attached to the Rectory. Many of the people who played badminton and tennis were also members of the golf club. Even if the badminton and tennis clubs were in some way associated, they had separate annual general meetings. In January 1931 there were plans to lay out a tennis court beside the Golf Pavilion but this appears not to have happened till May 1934, when two courts were opened and it was decided to run the tennis club in conjunction with the golf club. At that time it was reported that there had been a tennis club in the town 'up to lately' but that it was 'no longer available to the public' and the golf club had decided to fill the void. The unavailability of the tennis court at the Rectory may have had something to do with the retirement that year of Canon Dwyer, who had been Rector since 1907. Sometime after its annual general meeting in October 1935 the badminton club apparently went out of existence, but in October 1937 it was revived. In November it played a match against the 'Stratford Lodge' club, based in the Church Lane school. In January 1938 the trustees made alterations

in order to assist the badminton and tennis clubs. The annual general meeting in February 1939 was that of the combined membership of the golf, tennis and badminton clubs, and it was decided to amalgamate the three into Baltinglass Sports Club, which proved to be a short lived alliance.[747]

During the years of the Second World War there was a decline in the golf club's membership, while the tennis club ceased to exist. The trustees' finances were down, with the Pavilion not being used for dances and becoming quite neglected. To generate income they allowed grazing for cattle and felled hundreds of trees. By 1947 they and the golf club were in serious financial difficulty. The land was being grazed by cattle and sheep, and little golf was being played. The trustees came to the conclusion that the land would have to be returned to the Land Commission, but they held a public meeting in the Town Hall on 28 January 1948 to discuss the matter, inviting local organisations to attend. At the suggestion of Ger Dooley, then the teacher at Bigstone School, a committee representative of all sports was formed to take over financial responsibility. Baltinglass Sports Club elected Ben Farrell as chairman and Ger Dooley as secretary and treasurer. Neither of them played golf. Dermot Mogg, who had been Captain of the golf club the previous year, continued as Captain for 1948. Tennis was revived at the same time. Ger Dooley and Mary O'Kelly went from door to door in the town in an attempt to recruit members. Most of those who joined were more interested in tennis. Inter-club tennis competitions and dances were organised and new life was breathed into the club. By the end of the year the Sports Club was in a good financial position. By October 1949 there was again an active badminton club.[748]

In the early 1950s the trustees agreed with the Land Commission to return about a hundred acres of the original property in order to make their finances more easily managed. The badminton and tennis clubs continued for some time, but the 'Sports Club' was soon forgotten. Tennis died out in the mid-50s and was revived from 1959 for a while. From the 1960s the golf club's reputation was enhanced by the careers of three players who learned golf on its course – Sean Hunt, Hilda Gorry and Mary Gorry. Financially, it was given a new lease of life in the mid-60s by a large number of new members from Dublin who were prepared to make the journey down from the city. On 28 February 1999 an extraordinary general meeting of Baltinglass Golf Club was held at the Downshire Hotel in Blessington with a view to purchasing land to develop an eighteen hole course. Following on that, seventy-eight acres of land was purchased from Coillte Teoranta. Trees were removed from the new site in 2000 and earth moving work was completed in 2001, allowing for the fairways to be created and seeded. In the first year of the twenty-first century, after course construction and expenses that would have been bewildering to the club's founders, the new eighteen hole course was almost ready to be played. It was to open on 25 August 2002, seventy-five years after Lionel Hewson first mapped out the original nine.[749]

PETER NOLAN AND THE WINNING HANDBALL TEAM
AT TAILTEANN GAMES
WEDNESDAY 15 AUGUST 1928

Peter Nolan was long remembered in Baltinglass as a champion handballer. That reputation was gained during a few months in 1928 during which he excelled in the junior softball section. His highest achievements were in representing Leinster on the winning team in the Tailteann Games that August and in taking the individual Leinster title the following December.

It would appear that handball was played in Baltinglass as early as the late 1880s, with an exercise yard of the disued bridewell being used as a ball alley.[750] In 1900 the Town Hall was opened, with this ball alley, newly revamped and covered in, being part of the complex. From that time forward, handball had a permanent home in Baltinglass for a few decades, and its history was associated more with the Town Hall than with the GAA.

In the early years the famous handballer John Lawlor was claimed by Baltinglass. Lawlor was born in Pennsylvania in about 1860 of Wicklow parents, but as a baby he came to live in Ireland. Supposedly he went to school at Talbotstown, but at an early age he was brought to live in Dublin. He began playing handball as a teenager at St Patrick's Court in Dublin. Lawlor defeated David Browning of Limerick in 1885 at Doyle's Alley in Carlow and claimed the Irish professional title, which he retained until 1888. In 1887 he took on the American champion, another Irishman named Phil Casey, for a purse of £400 and the title of world champion of this essentially Irish sport. The first ten games were played at the Racquet Court, Grafton Street, Cork, on 4 August, after which Lawlor led by seven games to three. However, at the opening of the new Brooklyn Handball Club in New York at Thanksgiving, Casey won eight games in a row to claim the purse and the title. John Lawlor returned to Ireland but the following March he was back in New York. He had challenged Casey or any other player in America to another match. As the challenge, open for six months, was not accepted, Lawlor then claimed the world championship. He remained in the U.S.A. until 1895 and won a number of matches. Returning to Ireland, he was defeated by James Fitzgerald of Tralee, who then became Irish champion.[751]

On Sunday 28 August 1904 members of the Dublin Workingmen's Club, including John Lawlor, were guests of the Baltinglass handballers. They were brought on an excursion to Humewood Castle and then had dinner at the Doyles' Commercial Hotel in Main Street (now Horans'). Afterwards a number of matches were played by the visitors, with Lawlor playing in a doubles. The following month he travelled back to the U.S.A. to challenge Michael Egan for the world title. At the time the local correspondent for the *Nationalist* referred to him as a Baltinglass 'townsman', adding that he had 'on several occasions given exhibits in handball in Baltinglass alley before a large number of spectators'. Egan became ill, so Lawlor agreed to take on anyone put forward by Egan's backers.

They nominated Daniel J. Bruder, whom Lawlor defeated by four games to two. Lawlor became the first President of the Irish Amateur Handball Association in 1923. He died in 1929.[752]

In the 1910s Peter Butler and Henry Gaskin were among the leading Baltinglass handballers. In 1920, with the burning of the Courthouse, much of the glass roof of the ball court at the Town Hall was destroyed. In 1923 handball was being played, with a new committee in place to organise matters. Peter Butler, Matt Byrne junior and Henry Gaskin all competed in the first Tailteann Games in 1924. In the mid-1920s Butler, Byrne and Dan Kehoe junior were to the fore. They all represented County Wicklow, as did others, but the one who is best remembered is Peter Nolan.[753]

Nolan was born in August 1906 in Church Lane but his family moved to The Flags in Weavers' Square when he was a child. He was a younger brother of Ned Nolan, who featured prominently in the War of Independence and Civil War, and who was a noted footballer. Peter represented Baltinglass Handball Club in competition in the summer of 1927, and possibly earlier. In July 1928 the twenty-one year old was nominated by the Wicklow County Board for the Leinster junior softball team in the second Tailteann Games. He was to represent the province in singles competition, as was a Louth nominee, while Dublin was nominating the doubles pairing. Before the Tailteann competitions began, Nolan got the opportunity to shine in an encounter between Wicklow and Dublin in the Leinster junior softball championships. The first leg was played on Sunday 8 August at the Castle ball alley in Dublin and Nolan, as the singles representative, was somewhat lost in the unfamiliar court. The Wicklow doubles partnership was made up of two other Baltinglass men, W. Hughes and Mick Timmins. Nolan and Luke Sherry played for an hour and fifty minutes, after which Sherry led by three games to one, the scores being 21-12, 14-21, 21-11, 21-12. However, the *Irish Independent* correspondent was impressed and 'it was only the more experienced play of L. Sherry that gained him the lead of three games to one, but he was fully extended by the fast two-handed play' of Nolan. The following Sunday in Baltinglass Nolan's 'all-round play more than counter-balanced Sherry's superiority in alley craft' and he won all four games, 21-7, 21-7, 21-0, 21-12.[754]

More or less concurrent with this inter-county clash was Peter Nolan's involvement in the Tailteann Games. Peter Butler and Matt Byrne junior also competed in the 1928 Games, playing in the senior softball doubles. In the inter-provincial junior softball section Leinster played Munster in the semi-final. Nolan beat Matt Flannelly of Waterford in his match. On Wednesday 15 August the final was played between Leinster and Connaught. In this encounter Nolan beat M.J. Morgan of Leitrim.[755]

It was intended that the All-Ireland championships would be played at the same time as the Tailteann Games, but they were still in progress at the end of August. This was the first year that national junior championships were introduced. On 2 September in Dublin, Matt Flannelly beat Jack Reilly of Cavan

in the first semi-final of the national junior softball championship, but by the end of the year the second semi-final was yet to be played. This was between Peter Nolan and P. Murphy of Westport. It would appear that the delay was due at least in part to the Leinster section not being concluded until December. At the end of October in Dublin, Nolan had defeated his opponent from County Louth, winning three straight games, 21-16, 21-1, 21-5, in the best of five games. The Leinster final was contested at Naas on Sunday 9 December 1928. Peter Nolan beat J. O'Brien of Borris, County Carlow, 21-10, 21-15, 18-21, 21-11. According to the report in the weekly *Sport* newspaper, 'Nolan's play all through was masterly, and he showed more court craft. His returns were very good and he appeared to be in control throughout and played very strongly.' The *Nationalist* stated that Nolan's 'superb killing and accurate tossing' was the main feature of the encounter.[756]

As Leinster junior champion, Peter Nolan was now in the semi-final of the All-Ireland championship. He was informed that the match would be played the following Sunday at Westport, his opponent's home court. The venue was a three-walled alley and this too weighed against his chances, as 'a strong factor in his play is the liberal use of a back wall'. He and his supporters were unhappy about the arrangements. Whether the match took place is uncertain but in any event Murphy advanced to the 1928 national final which was played in two legs, in Waterford on 4 May and in Westport on 12 May 1929.[757]

Peter Nolan did not compete in 1929 because of a 'justifiable grievance against the Central Co., ruling the previous year over his game against the Connaught representative'. However, in July 1930 he was returning to competition, training for his partnership with Martin O'Neill of Bray for the All-Ireland senior doubles. It was said that Nolan was better then than he was in 1928, but for whatever reason he did not partner O'Neill in the championship. Instead, O'Neill played with Luke Sherry of Bray and they went on to become All-Ireland champions for 1930 and 1931.[758]

Peter Nolan played on the Wicklow junior football team in the early 1930s. He returned to the team in 1936 and played an important part in Wicklow's defeat of Dublin on their way to Leinster and ultimately All-Ireland victory. In 1937 Wicklow fielded its first senior team in two decades, and Peter Nolan was included. He continued at that level until 1941. In 1943 he captained the Baltinglass team that won the Wicklow junior championship. Sadly but fittingly, Peter Nolan passed away while playing handball in the new alley on Chapel Hill. That was in May 1959 when he was only fifty-three years old. Later a plaque was placed on the front wall of the alley in his honour.[759]

PROTEST MEETING ABOUT MEDICAL SERVICES
MONDAY 11 FEBRUARY 1929

In February 1929, having waited for eight years for a new hospital to replace the old Workhouse fever hospital, the people of the Baltinglass area were indignant

when they learned that County Wicklow Board of Health proposed to amalgam-
ate the positions of dispensary and hospital medical officers. A protest meeting
was held at the Town Hall on 11 February.

Up to 1920, when the Workhouse was commandeered by the British Army,
the institution's infirmary and fever hospital had served the medical needs of
Baltinglass Union, primarily those of the poorer inhabitants. During the 1918
'flu epidemic they contributed greatly to the saving of lives. After the occupa-
tion of the Workhouse the sick inmates were transferred to Shillelagh Workhouse
and afterwards those needing medical attention were sent to the Naas Workhouse
infirmary. The Baltinglass Board of Guardians then found themselves in the posi-
tion of paying the Shillelagh guardians to house the Baltinglass inmates and paying
their own officers' salaries while they had no duties to perform. They decided to
board-out the healthy inmates and impose compulsory retirement on the officials,
thus saving about £400 in the first year alone.[760]

In January 1921 the Baltinglass correspondent for the *Nationalist* commented
that the decision to board-out the inmates was a good idea, while noting that it
was generally understood that the Workhouse fever hospital would not be closed
permanently. However, he said that it was regrettable that it had been decided to
'dismantle' the hospital as it could have been easily equipped. He further ventured
to hope that Denis Kenna would be back in his old position when the hospital
re-opened. Dr Kenna, medical officer of the Workhouse infirmary and fever hos-
pital, was among the officials of Baltinglass Union who were compulsorily retired
by the guardians. The comment about 'dismantling' the hospital is confusing,
especially if it was believed that the authorities expected to re-open it eventually.
There had been an auction in December in which furniture, clothing and other
items from the Workhouse were sold. Perhaps this was the 'dismantling' to which
he referred.[761]

In October 1921 there was a conference to consider the amalgamation of poor
law unions in County Wicklow. It was felt that this conference would recommend
the establishment of a district hospital in West Wicklow. Later that month the
Baltinglass Guardians recommended to the conference that a district hospital for
West Wicklow was an absolute necessity, that it should be located at Baltinglass and
that the Workhouse fever hospital be used for the purpose. However, the confer-
ence decided that the Wicklow workhouses should be replaced by a county home
at Rathdrum, a county hospital at Wicklow and a fever hospital at Shillelagh. In
December 1921 Shillelagh Workhouse transferred all its Baltinglass Union inmates
to the respective county homes of Wicklow, Carlow and Kildare. On Saturday 31
December 1921 the Baltinglass Board of Guardians had their last meeting. Their
functions in terms of medical services were then taken on by the County Wicklow
Board of Health.[762]

At some point it was decided by the County Board of Health to establish a dis-
trict hospital for West Wicklow, as recommended to the 1921 conference, and the
use of the Baltinglass fever hospital as the core of such a building was evidently

agreed. When the Workhouse was destroyed by arsonists in February 1923, the fever hospital was doused with petrol but it was not set alight. The following month the Baltinglass correspondent for the *Nationalist* stated that there was 'every probability of Baltinglass Hospital being re-opened' soon. However, four years later the Board of Health was considering tenders for rebuilding Baltinglass Hospital. The lowest tender was £2,354, that of Eugene Hetherston. Six months after that the *Nationalist* correspondent was bewailing the 'injustice of depriving West Wicklow of the Baltinglass Hospital' since 'the existing arrangements came into operation', whereby patients were being transported across the mountains to facilities in the east.[763]

A full year later, in January 1929, it was reported that Baltinglass Hospital had come into the Board of Health's estimate for the first time. A tender for the building's renovation had been accepted but the work had not yet been completed, though it was intended that the hospital would be in operation during the coming financial year. Then, following the departure of Bannie Cooke, the former dispensary doctor, came the news that the positions of dispensary and hospital medical officers were to be amalgamated. Local frustration found expression in the protest meeting on 11 February.[764]

The Town Hall was crowded for the meeting, chaired by James Byrne, and Dermot O'Mahony, TD for Wicklow, was present. It was explained that the Baltinglass area had no representative on Wicklow's Board of Health, though Dan Kehoe of Weavers' Square and Major Mitchell of Ballynure were local County Councillors who would be eligible to serve on it. Ned Doyle of Main Street commented that the people of the area were paying a rate of three shillings in the pound and that the highest rate in the days when they had a satisfactory medical service (with two medical officers) was only 6½ pence. Despite the message sent forth from this meeting, the County Board of Health decided to go ahead with the amalgamation and they appointed Dr M.A. Clements of Tinahely with an annual salary of £175 as dispensary doctor and £125 as doctor to the hospital.[765]

In September 1929 the Baltinglass correspondent for the *Nationalist* was musing sarcastically on the possible whereabouts of the town's hospital as it was still not open. Evidently Dr Clements did not take up the joint posts assigned to him earlier in the year, as it was announced at the beginning of October that Dr. W.G. Lyons of Dunlavin had been appointed medical officer for Baltinglass. In November it was reported that the hospital was not properly built for its purposes and that Dr. Lyons was making a list of required equipment. In February 1930 'proposed alterations and an addition to' the hospital came before the Board of Health. During the summer of 1930 work was being conducted on the extension to the hospital. However, in January 1931 the *Nationalist*'s correspondent was complaining of the delay in opening the facility, commenting that it seemed 'ages since the work was undertaken'.[766]

The hospital opened during 1931, as in January 1932 the *Nationalist*'s correspondent praised the doctor, matron and nursing staff for making Christmas enjoyable

for the patients. There was accommodation for fifty beds, and in 1934 there was an average of thirty beds occupied. In December 1934 the hospital was fitted out for radio reception, with headphones for all patients and a loud speaker, the cost being covered by local subscription. Very early on Billy Lyons and the West Wicklow County Councillors recommended an extension to the building. Instead what was suggested by the authorities was a downgrading of the facility. Serious cases were to be sent to Dublin, fever cases were to be sent to Naas, and the accommodation was to be reduced to twenty-five beds, with six of these for maternity cases. These proposals prompted another protest gathering at the Town Hall on 29 June 1935. As a result the reduced status of Baltinglass hospital apparently was dropped, but no extension came until the 1950s. Early in 1952 construction of the hospital's extension was in progress and it continued through the summer.[767]

ELECTRIFICATION OF BALTINGLASS
MONDAY 21 OCTOBER 1929

When the electric current was switched on for the first time in Baltinglass on 21 October 1929, it must have brought about unbelievable change for the area. Almost everyone welcomed it and praised the results, but there were a few who had not been looking forward to the event, with the attitude of 'what did your forefathers do when they had only a rush?'[768]

The Shannon hydro-electric scheme for the electrification of rural Ireland was started under an Act passed in 1925. A power station was built by Siemens Schukert at Ardnacrusha, County Clare, to be fed with water diverted by a canal from the River Shannon. The official opening of the canal was in July 1929 and the turbo-generators of the power station were switched on in October.

Anticipation of the impending electrification began locally in the last week of June 1928, when the first consignment of electricity poles arrived. At that time it was expected that Baltinglass would have electricity by the following October. Erection of the poles was to commence immediately. By mid-August the insertion and wiring of the poles was almost complete. At the end of November 'preliminary work of wiring' had been done on all the houses in the town whose occupiers had applied for electricity, and an inspector was coming to give an estimate to each householder. Even then it was expected that people would have electric power before Christmas. In the first half of May 1929 a large number of Electricity Supply Board workers were busy installing in Baltinglass, and it was expected that Baltinglass and Tullow would have street lights by June. However not all premises in the town were immediately connected up on 21 October. The ESB workers were in Baltinglass into early November. St. Joseph's church and the convent were among the last buildings to be connected.[769]

The new street lighting proved its worth immediately. In November some very heavy rainfall brought 'numerous oases of mud surrounded with ponds and pools of varying sizes' to the streets and under former conditions pedestrians would

have had great difficulty at night. In December the County Wicklow Board of Health had complaints from Baltinglass residents about an alteration to the lighting of the town. The engineer pointed out that further work had to be done by the ESB. However, a board member objected to any increased public lighting for Baltinglass, stating that all of West Wicklow was paying for it. He had agreed to seven streetlights and the town now had fifteen. Of course, the public lighting of Baltinglass was useful to people in outlying areas when it came to the fair day, especially in winter. The old streetlights were always lit on the morning of the fair, and the new electric ones were lit for the December fair. The fat cattle section of the January 1930 fair opened in darkness and confusion, leading to more complaints about the new lighting.[770]

All in all the people of Baltinglass were happy with the service and quickly adapted to the improvement in their living conditions. In May 1930, the Board of Health agreed to an annual sum of £51,170 with the ESB for the town's public lighting.

THE BALTINGLASS CREAMERY
FRIDAY 6 DECEMBER 1929

For over two and a half years efforts were made to establish a creamery in Baltinglass. Discussions and public meetings were held, but enticing local farmers to sign up to a venture with no guarantee of success was difficult. Eventually, at a meeting in the Town Hall on 6 December 1929, agreements were reached that allowed the project to go ahead.

The idea was first mooted in about April 1927. The first public meeting about it, on Sunday 10 April, was chaired by Father Gerald Byrne. It was explained that a guarantee of supply from about eight hundred cows would be required before the Department of Agriculture would provide any assistance. Some of those present were appointed to canvass support in the locality and report back to a meeting the following week. By mid-May it was felt that the venture would go ahead. At a meeting on 13 May it was reported that they had guarantees of almost eight hundred cows. Each intended member had to sign a contract for at least three £1 shares for each cow they owned, and at application two shillings and six pence had to be paid in cash for each share, the balance to be paid in milk over a number of years. Regarding possible sites for the creamery, Joe Burke of Rathmoon, who chaired the meeting, suggested that if the Town Hall was not acquired for the project, the Lord's Wood could be a suitable site. This was, of course, shortly afterwards developed into a golf course.[771]

By June 1927 share applications were being received and the honorary treasurer, Tommy Doyle of Main Street, anticipated that the required number would be reached within a few weeks. However, almost an entire year went by before any further progress was made with the project. Father Patrick O'Haire chaired a public meeting at the Town Hall on Sunday 10 June 1928 to discuss a report by an

inspector from the IAO Society who had visited the general area of west Wicklow and East Carlow and interviewed interested parties. The report recommended that the location of a central creamery be agreed on at the outset; that six to seven hundred cows would have to be guaranteed in the area of the central creamery, with five to six hundred in each other district; that at least two auxiliary stations would have to be established; and that each applicant should sign a five hundred year agreement. Reggie McCann of Main Street stated that two hundred and fifty farmers had signed up in the Baltinglass area. A committee was appointed to canvass others to sign up, including those who had previously agreed to the initial project. The members were Hugh P. Doyle, Tommy Doyle, Ned Hanlon, Dan Kehoe, senior, Reggie McCann, Mylie McDonnell and Mick Timmins.[772]

After this the project stagnated again for over a year until November 1929, when another meeting was held. By that time Tullow had stolen the advantage and its creamery had an official opening in June 1930. Back in December 1929, the meeting that eventually led to the establishment of the Baltinglass creamery was chaired by Father Byrne. At that point they still did not have the necessary number of cattle but it was anticipated that a sufficient number of suppliers would soon be signed up. Agreement from farmers in one outlying area was particularly below expectations and it was pointed out that one of the reasons for their hesitation was to do with transport. This was overcome by Tommy Doyle, who said that for a reasonable fee, he could supply a lorry. Edward O'Neill of Main Street also said he would consider providing a lorry and there were other possible sources of transport. By 12 December the requisite number of cows had been promised.[773]

The preliminary steps for establishing what was then described as an auxiliary creamery at Baltinglass, were completed by mid-March 1930 and a suitable site was being discussed. Two months later the site had been agreed upon. It was on the north side of Main Street, facing onto The Green. There were three cottages on the site, one occupied, one vacant and the other in ruins. Charlie Shortt was given the contract for construction and work was to begin in the last week of June. The property was signed over on 23 July 1930 by Reggie McCann, presumably a trustee, to the Slaney Valley Co-operative Creameries Ltd., whose registered office was in Tullow. The building work progressed through the summer. At the same time the Pavilion at the golf club and the extension to the hospital were being constructed, providing an unusual supply of employment for local workers. The new creamery building was almost completed by early September.[774]

Baltinglass Creamery opened early in 1931. By May it was averaging eight hundred gallons of milk a day, which greatly exceeded expectations, and residents were buying separated milk at a very reasonable price. It operated on a seasonal basis. It re-opened in June 1932, with a satisfactory supply and it was anticipated that it would be operating to full capacity within a short time. Despite this initial success, the Baltinglass Creamery had a short lifespan. In April 1933 a meeting of the shareholders was held to decide whether to re-open the creamery for the coming season. It opened in June. By July over forty shareholders were being sued

by the Slaney Valley Co-operative Creameries for not supplying any milk to the Baltinglass Creamery.[775]

In the first week of June 1934, Baltinglass Creamery again opened for the season, with a larger supply than at the beginning of the previous summer, but by September it was operating a four day week due to a decline in milk supply. In November 1937 Slaney Valley Co-operative Creameries were again suing Baltinglass shareholders. In March 1938 one of the shareholders against whom the company had taken action was making a counter claim, protesting about the Baltinglass Creamery being closed and the machinery being removed. Within two months the premises had been acquired as a store for use in relation to the Poulaphuca hydro-electric scheme, and was employing locals. By then the new Technical School had been built beside it. Later the creamery building was bought by the VEC for additional classroom space and an extension was constructed, linking the two buildings. The creamery still exists as part of the Resource Centre, but as a business venture it lasted less than a decade.[776]

OPENING OF THE DAY TECHNICAL SCHOOL
MONDAY 3 NOVEMBER 1930

In its earlier days the 'Tech' catered mainly for adults wishing to acquire manual skills. As these students were employed during the day, the classes were held in the evening. In 1930 the Vocational Education Act provided for the introduction of a day school for those who had left primary school but had not yet joined the workforce. Whether by coincidence or design, Baltinglass Technical School gained a new teacher, Hugh Armour, in 1930 whose qualifications, combined with those of the existing commerce and Irish teacher, Seamus Gleeson, allowed for the opening of day classes.

Enrolment for the 'Day School of Business Training' began at eleven a.m. on Monday 3 November 1930. Twenty students registered the first week and this number filled the course. Holding day and evening classes in the Chapel Hill premises utilised the existing facilities to their full potential and it was evident that a more spacious building would soon be needed. By the end of the year the construction of a new school was anticipated, especially as legislation making school attendance compulsory under the age of fifteen was being introduced and this was likely to hugely increase demand for a day school.[777]

In October 1932 the local Technical Committee expressed approval of the purchase of a site for the new school. The site was at the eastern extremity of Main Street, between Chapel Hill and the creamery, and directly across The Green from the Town Hall. It was purchased on 8 July 1932 from Mary McDonald of Chapel Hill, a daughter of Nicholas O'Brien who had owned it in the late nineteenth century. In 1933 a new technical (or vocational) day school opened in Dunlavin but the new premises in Baltinglass was still only a dream of the future. In the meantime limited funds and a reduction in the staff had occasioned a scaling down

of the Baltinglass facilities. Nonetheless, there was a sixty six per cent pass rate in the Department of Education examinations at Baltinglass in 1933, which was above the national average. In the summer of 1934 it was expected that the new vocational school in Baltinglass would be opened during the next academic year. However, it does not appear to have been under construction at that time. A further year was to pass before the teachers and students would first occupy the new purpose-built school.[778]

TUCKMILL WIN COUNTY JUNIOR FOOTBALL CHAMPIONSHIP
SUNDAY 17 MAY 1931

Wicklow GAA county championships appear to have often run into the following year. Baltinglass won the junior football championship of 1912 in 1913, and the hurling championship of 1927 in 1928. In May 1931 Tuckmill followed suit in winning the junior football championship of 1930.

In the mid-1920s there was no Gaelic football club in Baltinglass. The enthusiasm of the 1910s had evaporated, and handball was the only Gaelic game pursued in the town till the hurling club was formed in 1927. Then, in 1929 two new football teams were formed in the vicinity, Tuckmill and Newtown. The Tuckmill team came into existence early in the year and had its first competitive outing against another new club, Kiltegan, in early May. The Tuckmill goalkeeper for this debut was the hurler Jim Conway. On Sunday 2 June Tuckmill took on the other new local team, Newtown from Newtownsaunders, who were playing their first competitive match, and Tuckmill received their second defeat. Both matches were played in Baltinglass.[779]

It was Jim Phillips of the Mill in Tuckmill who introduced the idea of a local team. He was in Newbridge College and played football there. He and Mylie McDonnell of Coolinarrig went to Dublin to buy jerseys for the Tuckmill club. The nucleus of the team came from the immediate area of Tuckmill but it incorporated members from the town, including some of the hurling Civic Guards, and from as far away as Dunlavin. At the beginning they trained and played in a nearly flat field in Mattymount owned by Shortts, just over the river from Tuckmill Cross, but they later moved to Wards' bog beside Baltinglass Hospital.[780]

Despite their inauspicious start, Tuckmill improved with experience and in their second season battled their way through to represent the western division in the semi-final of the county junior championship against Crossbridge, representing the south. A postponement and a draw brought this semi-final of the 1930 championship into the early weeks of 1931 for a replay. Eventually Tuckmill emerged as the team to contest the final against Brittas. The final was played at Annacurra and it resulted in a win by one point for Brittas, but after an objection was lodged the county board demanded a replay. This was scheduled for Woodenbridge on Sunday 17 May. It was a long journey for the Tuckmill team and some members failed to reach the venue due to motoring problems. Nonetheless, Tuckmill took the championship by

3-1 to 1-3. According to Jim Brophy, the members of the winning team on that day were Hugh Armour, Jim Byrne (of Weavers' Square), Pat Clarke, Jim Conway, Seamus Deering (from Dunlavin), Simon Doody, Tom Douglas, Paddy Doyle, Dan McDonnell, Mylie McDonnell, Mick O'Brien, Paddy O'Brien, Charlie O'Connell, Joe O'Neill (of Main Street; in goal) and Pat Sutton, while Mick Doody, Tommy Doyle and Mick Timmins played in earlier matches in the campaign.[781]

The club continued to prosper. By early 1933 they boasted a number of new players, such as Louis Dillon, who was from Kerry and was teaching in Grangecon, and Willie Sutton. They were able to field junior and intermediate teams that season, while Pat Sutton played on the Wicklow team. At the annual general meeting in January 1934, Luke McDonnell was elected chairman of the club, and Pat Clarke and Joe O'Neill were elected joint secretaries. It was decided to hold a fundraising dance on Easter Sunday night. This was advertised as their first annual dance and it was held at the Golf Pavilion. As Jim Conway spoke on behalf of 'Tuckmill Football and Hurling Clubs', Tuckmill had evidently expanded its activities by then. On 22 July the club held a one day football, hurling and camogie tournament. During the year it also spent considerable money enclosing the playing field.[782]

However, in the meantime a rival club was getting off the ground. In February 1934 a meeting was held in order to form a new Baltinglass GAA club and to enter a team for the county junior championship. Tom Kehoe was elected president, Denis Hanrahan vice-president, and Dan O'Neill secretary. In March Baltinglass applied to the West Wicklow district board for the transfer of twenty-three players from Tuckmill. The chairman of the board asked if this meant the dismantling of one club to form another, but Mick Timmins replied that Tuckmill was not objecting to the transfers. Nonetheless, the request was refused. Ultimately the new club was to displace Tuckmill and last throughout the rest of the century, but Tuckmill still had life left and its best year was to come in 1935.[783]

AN INCIDENT WITH THE BLUESHIRTS
WEDNESDAY 25 APRIL 1934

A dance was being held at the Town Hall on 25 April to honour Comdt. E.J. Cronin, with music by the Savannah Dance Band. It was to start at ten o'clock. Cronin and his wife were driving down from Dublin and about 150 members of the Young Ireland Association, or 'Blueshirts', waited to greet them outside the town. About half an hour before the dance was to begin the electricity supply was sabotaged and the town was blacked out. When the Cronins arrived the Baltinglass Pipers' Band led a procession through the streets. As the band crossed the Bridge, Jim Nolan of Carrigeen rushed out from the crowd and slashed the side of the big drum. Pursued by the Gardaí and the Blueshirts, he ran down the slipway by Clarkes' and across the river. It was an odd incident, but it was symptomatic of the political divide in Irish life at the time.[784]

Baltinglass supported the treaty in 1921 and the occupation of the town by the Irregulars in July 1922 was generally unpopular but, of course, there were strong pro and anti-Treaty sympathies within the area. The pro-Treaty side that prevailed in the Civil War evolved into Cumann na nGaedheal, which held political power until 1932. On Sunday 11 May 1930, Ernest Blythe, then Minister for Finance, paid a visit to the town in support of local efforts to establish a West Wicklow branch of Cumann na nGaedheal. It was the first time an Irish government minister had come to Baltinglass. At a meeting chaired by Martin Gleeson in the Town Hall, the local TD, Dermot O'Mahony, said that a local branch of the party would help him in his work. Thomas F. O'Higgins, TD for Dublin North, and brother of the late Kevin O'Higgins, was also present. Blythe spoke about national finances, predicting that Fianna Fáil policies would threaten the country's economic progress. A West Wicklow executive was then formed, with Gleeson as chairman, Soup Doyle as vice-chairman and John Hourihane as secretary. Among the executive members were Dickie Barron, Tommy Doyle (Main Street), Mick Timmins and Joseph Turtle of Baltinglass, and Anthony and Henry Kavanagh of Holdenstown.[785]

Civil War politics were very much alive when Eamon de Valera's Fianna Fáil party first came to power in the General Election of February 1932. Just before the election the Army Comrades' Association (ACA) was established, initially to support former members of the National Army. However, after Fianna Fáil's victory the IRA, the remnants of the Irregulars who had lost the Civil War, began disrupting meetings of Cumann na nGaedheal. Comdt. E.J. Cronin was credited with steering the ACA towards adopting the role of protectors of free speech. Early in 1933 the ACA began using a uniform of blue shirts and black berets so that members could recognise one another at meetings. It was because of this uniform that the movement gained the nickname 'Blueshirts'.[786]

Later that year General Eoin O'Duffy, who had been dismissed by de Valera as Commissioner of An Garda Síochána, became leader of the ACA and changed its name to the National Guard. On 22 August 1933, de Valera declared the National Guard an unlawful association. As the IRA was allowed to continue as a private army, many in the opposition saw the ban on the National Guard as a step towards a de Valera dictatorship. In September Cumann na nGaedheal, the National Centre Party and members of the National Guard came together to form the United Ireland party (later Fine Gael), with O'Duffy as president. The Young Ireland Association was formed as a youth wing of the new party, and they inherited the quasi-military role of the Blueshirts, later being called the League of Youth. Comdt. Cronin, who had been secretary to the National Guard, continued in that capacity with the Young Ireland Association.

On St. Patrick's Day 1934, Ernest Blythe, then a senator, paid another visit to Baltinglass, accompanied by the local TD, then styled The O'Mahony, having succeeded his father. They were met about a mile outside the town by some two hundred Blueshirts who marched into Baltinglass. At a meeting near the McAllister Monument, presided over by Mick Timmins, Blythe said 'We are here

today mainly for a parade to show that the Blueshirts cannot be put down'. He said that a Bill was before the Dáil to 'make it an offence to wear a blue shirt' but that even if it were passed it would not stop the Blueshirt movement. He continued by promoting the economic policies of the United Ireland party.[787]

At that time Ned Cronin was serving a three month prison sentence at Arbour Hill for refusing to sign a guarantee to keep the peace. The following month saw him visit Baltinglass and opponents of the Blueshirts attempted to disrupt the event. Speaking in the Town Hall, Cronin urged employers to engage Blueshirt employees and workers to support Blueshirt traders. Jim Nolan was later charged with damaging the drum that night. He continued to live in the area for decades. In his later years he was well known for his eccentric behaviour. With unkempt hair and wearing a long coat and rolled down Wellingtons, he would be seen directing traffic outside St Joseph's church before midnight mass at Christmas in the 1970s.[788]

In September 1934 O'Duffy resigned from Fine Gael and attempted to keep the Blueshirt movement going, but it disintegrated. The O'Duffy leadership's adoption of the Roman salute for the Blueshirts left a bad aftertaste, as it was the one in vogue with the various contemporary fascist and extreme nationalist movements in Europe. This, the uniform and some of O'Duffy's nationalist views drew unflattering comparisons between the Blueshirts and the Italian fascists and the Nazi party in Germany, leading to the generally held but unjustifiable belief that the Blueshirts were the Irish equivalent.

THE CLOSURE OF THE METHODIST CHURCH
TUESDAY 18 JUNE 1935

The beginning of the annual conference of the Methodist Church in Ireland on 18 June 1935 heralded the end for the Methodist chapel in Baltinglass. Among the properties sanctioned for sale at the Conference was the century old building in Mill Street.[789] The chapel, which was on the Carlow Circuit, never had a resident minister and its congregation was never large. By the 1930s the dwindling Methodist community could no longer sustain it.

Methodism was originally a movement of worshipping societies rather than a religious denomination, with most of its followers adhering to the Anglican Church. The English clergymen John and Charles Wesley founded the movement. On his tenth tour of Ireland John Wesley came to Baltinglass for the first time on 23 July 1765. According to his journal, he preached in the town on his way from Donard to Carlow. There was a downpour of rain so he and his hearers had to retreat into a building. In editing Wesley's journal almost a century and a half later, Rev. Nehemiah Curnock assumed that the building was one which had been acquired by the Methodists, which he referred to as an 'old Huguenot church, … [of which] only a portion now remains.' However, no other written record of a Huguenot place of worship in Baltinglass has been found. In any case, if the

Methodists had a meeting house as early as 1765 they must have had a substantial following in the area by then. Wesley did not stay overnight on that or any of his subsequent three visits to Baltinglass. These were on 16 July 1767, 14 July 1769 and 11 July 1771.[790]

In 1806 two missionaries came to Baltinglass and revived the Methodist movement in the area. The following year a preacher visited and he stayed with the Winnett family, who were converts. In the late 1810s Methodism in Ireland divided on the issue of adherence to the Church of Ireland. This was when the Wesleyan Methodist Connexion became a separate religious denomination, while the Primitive Wesleyan Methodist Connexion remained an Anglican society. The Baltinglass community apparently chose the former, but in 1828 a Primitive Wesleyan preacher gathered a small following in the town. The group became quite large and the preacher apparently applied for use of the Courthouse for meetings and permission was granted. How long these meetings continued is uncertain.[791]

The Wesleyan Methodist Connexion still had a community in Baltinglass in the 1830s and they set about building a chapel. They leased a plot on the west side of Mill Street from the then Lord Aldborough on 25 April 1833. It had a frontage of fifty-two feet and it was 279 feet in depth. It had formerly been held by William Johnson of Belan Street or his under-tenants. At that time there was another property to the north of this plot. Later the Ballytore Road (or Station Road as this portion became) was constructed adjoining the Methodists' plot. The lease was for ninety-nine years at an annual rent of £2 and it was granted to two of the Methodist members, John Jones of Newtownsaunders and Henry Winnett of Main Street. By the time Samuel Lewis's *Topographical Dictionary of Ireland* was published in 1837, the chapel was in use. By July 1848 Winnett was deceased, and Jones assigned the premises to Sheppard Jones of Newtownsaunders as well as five Wesleyan ministers and individuals from Athy, Carlow and Tullow as trustees for the Methodist congregation.[792]

The Baltinglass chapel was a rectangular structure, with the doorway in the gable wall facing the street, and it had seating space for between 80 and 100 people. It was almost halfway up the plot of ground, with a path leading from the door to the street. There was space of a few yards to the north and south sides of the building, allowing access to the lawn behind it. No marriages were ever performed in the chapel, as it was not listed in the Register of Separate Buildings compiled under the 1844 and 1863 Marriage Acts.[793]

Census statistics show that the Methodist congregation in Baltinglass was small. Within Baltinglass civil parish there were twenty-three Methodist in 1861 and in 1871. By 1881 there were twenty-one and by 1891 the number had dropped to fourteen. In 1901 there were only eight Methodists in the much larger area of Baltinglass No. 1 Rural District. Despite their small numbers, the Methodists were the most significant Non-Conformist denomination in Baltinglass in the mid-nineteenth century. In 1861 in Baltinglass civil parish there were eight Quakers, three Presbyterians and four others whose denomination was undefined

in the statistics. There were six Presbyterians in 1871, two in 1881 and just one in 1891. The statistics for 1871 do not list Quakers separately, but include them with the undefined 'others'. There was a remarkable increase in these smaller denominations between 1861 (when there were twelve Quakers and 'others') and 1871, when there were thirty-eight 'others'. They diminished in numbers after that, with twenty-four in 1881 and twelve in 1891.[794]

Baltinglass never had a Presbyterian meeting house. Presumably those living in the Baltinglass area were part of the Stratford congregation. The Baltinglass Quakers most likely attended the Ballytore meetings. Richard Chandlee and John Chandlee had businesses in Mill Street in the 1860s and early 1870s. Richard had the premises beside the bridge, while John ran the mill. Richard's successor in the business was Herbert Webb, who was later replaced by his brother-in-law, Joseph Turtle. The Chandlees, Webbs and Turtles were Quakers, as was Jacob Whitfield Graham, who also lived in Mill Street in the late nineteenth century.

The increase in 'others' between 1861 and 1871 may have been as a result of the Plymouth Brethren, sometimes called the White Mice, whom Robert Anderson supposedly introduced to Baltinglass. Anderson rented the mill from the Chandlee family in the 1850s, but he subsequently lived up to the mid-1870s on Main Street where the Bank of Ireland is now situated. According to Joseph Turtle, Anderson started a Brethren meeting house there. His neighbours, the Douglases, were members of that denomination. The meeting house was in a two storey outhouse which had granite steps running up to the first floor door on the east gable wall.[795] The steps were removed by the bank in recent years and the outhouse sold to Murrays next door. Where the Brethren worshipped between the 1870s and the early twentieth century is unclear. By 1911 they had a new meeting house in Church Lane. It was a one storey building attached to the east side of St. Kevin's. Its site is now part of the widened road. They worshipped there until the mid-1950s. Like the Methodists, their numbers dwindled to the point where they could no longer sustain a meeting house.

In 1921 discussion centred on the possibility of the Methodist chapel closing. The Freemasons offered to buy the property but this proposal was refused. On 7 September 1923, Meade J.C. Dennis of Fortgranite renewed the lease to the Methodist congregation for 150 years at a yearly rent of £10, but it was stipulated that an annual fee of 1-10-0 would be accepted in lieu of the rent so long as it was used for religious purposes. The lease was granted to a group of trustees including three Methodist ministers, John Cooke Jones senior and John Cooke Jones junior, both of Newtownsaunders, Samuel Cope of Castledermot, William H. Hadden of Carlow, William H. Shaw of Athy, and Richard Wright and James F. Wright, both of Prumplestown, Castledermot. In 1926 the Freemasons applied to rent the premises but they were again refused. However, a decade later the Methodists evidently decided that they could no longer keep the chapel open. Sunday services ceased and the 1935 Conference gave permission to sell the property, intending that Baltinglass members would attend services in Castledermot.[796]

In November 1936 the lease of the Mill Street property was sold for £150 to Charlie Shortt, the building contractor from Tuckmill. Ned O'Kelly was the auctioneer. On 3 June 1937 the surviving trustees made over the property to Shortt. He built a new house on the front lawn and the chapel itself became a store, with access through a door facing Station Road. In recent years the back lawn was sold to Quinns of Baltinglass and it now forms a car park for workers in Quinns' wool and grain stores.[797]

COUNCIL HOUSES IN SRUGHAUN OCCUPIED
FRIDAY 11 OCTOBER 1935

For those living in overcrowded and unsanitary conditions in areas of Baltinglass such as Church Lane and Tan Lane the provision of twelve new County Council houses in the townland of Sruhaun brought the prospect of a brighter future. Prior to this the local authority houses had been built mainly in ones and twos, scattered about the town and its environs. The largest concentrations of new dwellings had been the four houses on the Bawnoges Road adjacent to Belan Street, built in the 1890s, and the four houses that became known as The Flags, built in a garden in Weavers' Square in the 1900s. No local authority dwellings had been built in Baltinglass for decades before the Sruhaun houses became available.[798]

Back in June 1932 a meeting of Baltinglass residents was convened to discuss a government grants scheme that was to make loans for projects available, including public bodies, roads and housing. The meeting concentrated mainly on the provision of a sewerage system. A new water scheme had been installed a few years previously and this had cost about £6,000 while the government grant for it was less than £1,000 and the ratepayers had to provide the rest of the money. Ned Doyle of Main Street therefore questioned what percentage of the cost of a sewerage system a government grant might cover. When he suggested that the town had good sanitation it was pointed out that Belan Street, Chapel Hill and Weavers' Square had no sewerage at all. On the matter of housing, a resolution was passed supporting the application for the building of new houses under the government grants and urging the County Board of Health to implement the scheme as soon as possible.[799]

In the early part of 1933 the County Board of Health announced that the sewerage scheme would begin immediately. It started at the end of April, providing employment for local labourers. A 'housing inquiry' was held at the Courthouse in June. Here applications for houses from about forty men were considered. The applicants were from as far away as Castleruddery and Griffinstown, though most were from the immediate area of Baltinglass. One man said that he lived in a single room in Belan Street with four children. Another family with seven children had one room and a kitchen in Church Lane. Many of the owners of land on which the applicants wished to have houses built, lodged objections. Robert Jackson of Tallyho, Tinahely, the owner of Parkmore House, opposed the application for a number of sites on his land.

He stated that he had bought the property in 1925 for £2,500 and intended to live there but was still attempting to sell his old residence. The farm consisted of 46 acres. He had given a site containing one acre and twenty perches free of charge for a tank in connection with the sewerage works. This was beside the river, directly behind where Winders' shop is now located. It was formally handed over on 26 June 1935. An official stated that Jackson had been very co-operative in relation to the sewerage and stated that he could secure alternative sites and transfer the applications.[800]

It would appear that Jackson's Parkmore land was spared on this occasion and perhaps the Sruhaun site, owned by James Patrick O'Brien, was the substitute. The construction of the houses, by Charlie Shortt of Tuckmill, began in September 1934. After just over a year the work was completed and the twelve families moved into their new homes on 11 October 1935. Another two houses, those furthest from the town, were completed a few years afterwards. Each house came with a large plot of ground in which it was intended that the occupiers would grow their own vegetables. Other council houses were built in the general area that year. The Baltinglass correspondent for the *Nationalist*, Matt Byrne, often bemoaned the fact that there were unsightly derelict sites about the town and that the council did not purchase these for building sites, especially as a decision to do so had been made years before.[801]

As there were almost no buildings between the new Sruhaun houses and Chapel Hill, the new occupants must have felt very removed from Baltinglass, especially as most of them were used to living in the town. One serious problem they encountered was a lack of running water, and the nearest supply was the pump on Chapel Hill. The only alternative was to use water from the river below them. Another grievance voiced on their behalf in the *Nationalist* by Matt Byrne in January 1937, was the bad state of Sruhaun Road, which was covered in places by water and mud. As more than forty children would be using the road when the schools reopened after the Christmas break, he suggested that it should be repaired. He was still echoing the same complaint in December 1939. The houses were sometimes called Slaney View and were even humorously nicknamed Boston Terrace because 'Boston' Kinsella lived in one of them, but they were generally referred to simply as Shrughaun, or 'Struckaun' as many people pronounced it. The official spelling of the place name Sruhaun is almost never used locally. They remained isolated from the town for a further two decades before Ben Hooper's house was built between them and Chapel Hill. Slowly the Sruhaun Road became dotted with new houses until, by the end of the 1980s, the town grew to encompass Shrughaun.[802]

TUCKMILL WIN COUNTY INTERMEDIATE CHAMPIONSHIP
SUNDAY 17 NOVEMBER 1935

Tuckmill Football Club went one step further than in 1931, by winning the intermediate championship of 1935. Having fought their way through to the final, they prepared by playing Leighlinbridge on 27 October. Three weeks later they made the journey to Aughrim to take on Greystones for the title.[803]

The game was played in cold but ideal weather. Tuckmill showed their superiority from the outset, with Louis Dillon and Pat Sutton outclassing Greystones at mid-field. Jim Conway scored the first point about half way through the first half, following with another shortly afterwards. In the second half John Moran from Tuckmill Lower scored the only goal of the match, but the opposition fought back with three points. Conway gained a third point to keep Tuckmill ahead by a goal but then Greystones scored again, and one of their side was on the verge of producing a goal when the whistle sounded. The final score was Tuckmill 1-3 to Greystones 0-4. So the west retained the intermediate championship title, won by Donard the previous year.[804]

At the club's annual general meeting at the Town Hall on 10 March 1936 Matt Byrne was invited to present the championship medals. The recipients were Jim Byrne, Jim Conway, Louis Dillon (captain), Mick Doody, Paddy Doody, Simon Doody, Dan McDonnell, John Moran, Ned Nolan, Dan O'Brien, Willie O'Brien, Charlie O'Connell, John O'Hara, Joe O'Neill and Pat Sutton, as well as J. Moran, T. Moran, P. O'Hara. At that meeting Luke McDonnell, the out-going chairman, was re-elected, while Louis Dillon was re-appointed captain.[805]

At the same time Baltinglass Gaelic Football Club was providing opposition for Tuckmill by giving an outlet to players, but Tuckmill would appear to have been the stronger club in early 1936. It held its annual dance at the Golf Pavilion at Easter and followed up a few weeks later with a card tournament. At the annual general meeting on 1 March 1937 Luke McDonnell and Louis Dillon were re-appointed to their respective positions. However, sometime afterwards the club ceased to function and the Baltinglass club inherited its membership. By late 1939 there was also a Tinoran club. While this was not long-lived, it was still in existence in May 1940.[806]

TECHNICAL SCHOOL MOVES TO NEW BUILDING
MONDAY 25 NOVEMBER 1935

Almost thirty years after the building of a Technical School was first planned, Baltinglass got its wish. For sixteen years the 'Tech' operated in the old convent school on Chapel Hill. It met its requirements but there was no room for expansion, and from 1930 when the day school opened it was clear that a new building would have to be constructed. Five years later the new 'Tech' opened just down the hill in Main Street. Enrolment for both day and night schools began on 25 November 1935. An official opening was planned for January 1936 but this was postponed till March and it is not certain whether it ever took place.[807]

The new Baltinglass school was to have its own headmaster. In July 1935 it was announced that A.K. Killeen, formerly headmaster in Rathdrum, would fill the position. By October the new building was nearing completion. Matt Byrne described it thus in the *Nationalist*:

Viewed from the street its appearance is an imposing one, with its immense windows set out in bold relief, with its delightful shade of green on a white back ground of steel-finished cement. Entrance is from either side. From the left admission is had to the spacious woodwork room splendidly lighted by large windows occupying most of the space in the southern side, while an installation of electricity does duty at night. A lovely pitch pine stairs leads to the spacious Domestic Economy room, splendidly fitted up with a large electric cooker. A third room is set apart for the teaching of commerce. This also is equipped in keeping with every other part of the structure.[808]

At the time of opening the teaching staff consisted of A.K. Killeen, the headmaster, Kathleen Sheehan (domestic economy) and Seamus Gleeson, while J.J. Doyle came in January as manual instructor. In addition Mrs. Gaskin was attendant at domestic economy classes, as she had been in the old school, and J. Lalor was given the new position of caretaker but he was replaced by 1940 by Henry Gaskin. That first academic year in the new building ended sadly with the death in May 1936 of Seamus Gleeson, a young man whose association with the 'Tech' as teacher of commerce and Irish from 1929 and later also typing and shorthand, had helped develop it into a day school. The local Technical Committee was forceful in its protest when it learned that Gleeson was being replaced by two part-time teachers. However, the 1936-1937 session offered evening classes in commerce, woodwork and domestic economy, while the day school offered continuation and commerce courses. The continuation course consisted of Irish, English, history, geography, arithmetic, elementary book-keeping and woodwork (for boys) or domestic economy (for girls). The commerce course covered book-keeping, accounts, commercial correspondence, retail practice, business methods, commercial geography, commercial arithmetic and civic economics.[809]

In July 1936 Killeen was appointed chief executive officer of County Wexford VEC. He was replaced as headmaster by C. Kiersey in October. During the 1936-1937 session camogie was introduced into the school. A branch of County Wicklow Library was opened in the school in 1937 for the student's use. Kiersey left in 1940 and was replaced by Ben Hooper. In the headmaster's report to a meeting of the Baltinglass Vocational Education Committee in September 1943, it was stated that there were seventy passes in the Department certified examination that year, compared to forty-nine in 1942 and thirty-one in 1941. At the same meeting it was stated that there had been no developments regarding the proposed acquisition of the adjacent creamery building. Eventually the creamery was bought and it became part of the Technical School, the greater part of it accommodating the woodwork room. A single storey extension was constructed between the creamery building and the 1935 Technical School, connecting the two. This new section housed the metalwork room.[810]

In 1942 another secondary school opened in Baltinglass. Since 1873 the Presentation Sisters had been providing primary education for the girls of

the area. While the girls might stay in the school into their early teens as 'seniors' they were not prepared for state examinations. This changed when Mother Columba Russell decided to use the old convent school on Chapel Hill to start St Therese's Secondary School. This building had been home to the 'Tech' until 1935. Though the school was on Chapel Hill, its entrance was at the back, through the Convent grounds.[811]

Mother Columba had to contend with the opposition of Bishop Keogh, who wished the Presentation Sisters within his diocese to confine themselves to primary education. Many convents earned his disapproval by dealing directly with the Department of Education. So too did Mother Columba, and she used an influential intermediary to secure the department's permission.[812]

Sister Alphonsus Dolan, a young nun who came to Baltinglass from the noviciate in 1940 and then trained for two years at Carysfort College, was chosen to start the new secondary 'top' as it was called. While she was training Mother Columba got the approval for the school. St Therese's opened in September 1942 with one teacher and fourteen pupils. Later Sister Alphonsus was joined by Sister Therese Morrissey and Sister Immaculata McCormack. The first class produced four girls who sat the Intermediate Certificate and they had to travel to Kildare town for the examination. By the time they were doing the Leaving Certificate there were sufficient Intermediate Certificate students to allow for the examination to be conducted in Baltinglass.[813]

The Presentation Sisters' primary school was classed as a five teacher school which meant that the convent received the equivalent of five salaries regardless of how many of them taught. The secondary school was entirely the initiative of the nuns and it was financed by the money they received for running the primary school. It provided free education to teenage girls from a wide area around Baltinglass for a quarter of a century. Secondary education was very much taken for granted by the last decades of the twentieth century, but in the 1940s when times were difficult it involved a real commitment on the part of the student, especially if living a distance from school, and considerable sacrifice for poorer parents. St Therese's operated exclusively in the Chapel Hill premises up to 1955. After the nuns' new primary school opened, rooms in the old school attached to the convent were used for the junior classes of St Therese's.[814]

In 1954 CIE introduced a school bus service linking Baltinglass with Annalecky Cross, Dunlavin and Colbinstown. It continued till 1968 when it was absorbed into the new free school transport system. Ben Hooper is said to have been responsible for this initiative which benefited St Therese's as well as 'the Tech' in that student numbers increased. Hooper also introduced a course for the British General Certificate of Education (GCE) for older students for whom the Leaving Certificate was not an option.[815]

The story of the 'Tech' and St Therese's was to become intertwined later with their amalgamation.

THE FIRST PHASE OF THE PARKMORE COUNCIL ESTATE
MONDAY 14 DECEMBER 1936

In 1936 Wicklow County Council approved the raising of a sum of £222,000 for the building of more than seven hundred houses throughout the county. At a County Board of Health meeting on 14 December 1936, it was stated that the Department wrote asking to be given a report from the board's engineer in relation to the proposed acquisition of land adjoining Parkmore House for building purposes. The report was to cover the suitability of the site in relation to economical development, levels and danger of flooding, accessibility of water and sewerage, and the possibility of acquiring a more suitable site at a higher level.[816]

According to Matt Byrne in the *Nationalist*, two county councillors from West Wicklow made a strong case for their area. As a result of the efforts of P.P. O'Reilly of Ballyknockan, supported by Mick Timmins of Baltinglass, it was agreed that ten houses would be provided in Blessington, forty-three in Dunlavin and sixty-three in Baltinglass, on Robert Jackson's Parkmore House land. This was the initial step in the development of a whole new area of the town that was to become known as Parkmore.[817]

The housing estate took its name from Parkmore House on whose land it was built. Most of what is now called Parkmore is in the townland of Baltinglass East, while its southern extremity, including the Fourth Avenue, is in Lathaleere townland. Parkmore House and Whitehall House, directly south of it in Lathaleere townland, were at one time in the hands of the De Renzy family whose ancestor, Sir Mathew De Renzi, claimed descent from the fifteenth century Albanian warrior Skenderbeg. In the 1830s Parkmore was the residence of a Mr Jones who preferred to call it Jones's Lodge, while Benjamin Butler lived in Whitehall.[818] The last of the De Renzys connected with Baltinglass was Emily De Renzy whose residence was Parkmore in the 1850s. Whitehall was by then in ruins. Miss De Renzy's successor in Parkmore was Abraham Coates. Afterwards it was owned by Essie Anne Shaw of Main Street, but she was not living in it in 1901. She sold it to Francis Cruise and his widow, Kathleen, sold it in 1925 to Robert Jackson of Tallyho, Tinahely.

As already mentioned, in 1933 Jackson opposed the proposal to build a number of council houses on his Parkmore land, which consisted of forty-six acres, and it was proposed that alternative sites would be found and the applications transferred.[819] However, three years later the decision was taken to construct sixty-three houses on his land. The first ten houses to be built were at a distance from the town, just within the boundary of Lathaleere townland. Four of them were on the Kiltegan Road and the other six were on the north side of a new road running from the Kiltegan Road towards the river. This new road was to become the Fourth Avenue when the rest of Parkmore was built. These ten houses still retain their old numbers, though there are other numbers one to ten in the estate.

By October 1938 the first ten houses were nearing completion and it was antic-
ipated that they would be handed over to their tenants in time for them to prepare
their large gardens for sowing in the spring. However, by the end of January 1939
the building was not fully complete. By early May some of these new houses in
Lathaleere were occupied, while applications for the rest were to be dealt with at
the next Board of Health meeting. They were all occupied by November 1939,
by which time the Second World War had begun and Ireland had found itself
vulnerable to outside influences. The large gardens provided with council houses
throughout the country for the tenants to grow their own vegetables were now of
vital importance to Ireland's self-sufficiency. This was emphasised over and over
again in the local press. By the beginning of the summer of 1940, most of the
tenants of the first ten houses had their plots under potatoes and other vegetables,
producing much more than they needed for domestic consumption.[820]

The second, much larger, phase of building must have been under way by the
time the first houses had been handed out. They were apparently reaching com-
pletion by early 1941 when it was pointed out by Mick Timmins, then a county
councillor, at a parish council meeting that they were intended for people living
in condemned houses. At the end of February the Board of Health agreed to
hand over the plots to the incoming tenants to allow them prepare the gardens for
vegetable production, and it was stated that those failing to use their plots would
be penalised.[821]

This second phase consisted of fifty-four houses. Sixteen of them were along the
Kiltegan Road north of the original ten, and four were on the Kiltegan Road south
of them. A further eight were on the south side of the new road that become the
Fourth Avenue. The remainder were built along three new roads that became the
First, Second and Third Avenues. Parkmore was built by Charlie Shortt, though
much of the work was subcontracted to people such as Mick O'Neill of Tuckmill.[822]

It would be over thirty years before there was any further development in
Parkmore. In July 1974 the foundations were laid for twelve new houses at the
bottom of the Third (or Beech) Avenue and along its south side.[823] In the 1980s
Parkmore Extension was built, with twenty houses on a new road running
between the Second and Third Avenues, and another sixteen houses on a cul-de-
sac adjoining that new road. The next development by the Baltinglass County
Council was on the other side of the Kiltegan Road in Lathaleere townland,
opposite the Parkmore houses furthest from the town. In 1985 the first houses in
Lathaleere Estate were occupied, and further extensions to Lathaleere were built
so that it had forty-eight houses by the end of the century.

THE EMERGENCY: LOCAL SECURITY FORCE FORMED
SUNDAY 7 JULY 1940

War in Europe was looming for a long time before Germany invaded Poland on
1 September 1939. The following day Eamon De Valera announced that Ireland

would remain neutral in any conflict. A day later France and the United Kingdom declared war on Germany. Matt Byrne made the following observation in the Baltinglass notes in the *Nationalist* that week:

> The war is naturally the most absorbing topic of the moment, already numerous local activities bring home to us the terrible catastrophe which has fallen on the world. The 'black-out' of the public and private lighting, the return of multitudes of our people from Great Britain and the trend to ration supplies of all description are at the moment the most convincing reminders of our position.[824]

Éire remained neutral throughout the Second World War and saw little of the conflict. However, isolation, shortages, rationing and the real threat of invasion made 'the Emergency', as it was called, a time of hardship and anxiety for people throughout the country. By May 1940 the Germans were winning the war. Their rapid advance through the Low Countries resulted in the Allied evacuation from Dunkerque. At that point it was anticipated that Hitler would invade Great Britain and that this might well be done through Ireland. On 28 May the Local Security Force (LSF) was created for auxiliary policing and internal security. Within a few weeks almost 45,000 men had enrolled. On 22 June the LSF was divided into two sections, Group A becoming an auxiliary army and Group B continuing to augment An Garda.[825]

It was in late June or early July 1940 that the LSF was organised in West Wicklow. Because of a Mission taking place in St Joseph's church at the time, Baltinglass was left till last, as it would have been too late to assemble after evening devotions. An initial gathering of those enrolled for the LSF in Baltinglass was held on Sunday 7 July. Over seventy men turned out and they were addressed by Superintendent Reynolds. However, a full assembly was arranged for Tuesday 16 July.[826]

That second gathering took place at the courthouse. The main purpose of the meeting was to divide the membership into Groups A and B. The majority chose Group A. These were taken away for instructions while Garda Jim Conway took charge of Group B. On Sunday 28 July, Sergeant Quigley gave instructions at the Town Hall and then there was a parade of Group A under their instructors, including Ned Nolan, veteran of the War of Independence. That evening some forty LSF men, led by John Breen, Fintan Doyle and Ned Nolan, had occasion to display the results of their initial training when a major fire at Saundersgrove was reported. It was just twenty years after the original house was burned by republicans that the local population were striving to save the new house. Within a short time the local Garda and the LSF were at the scene and they managed to control the flames until Carlow Fire Brigade arrived. Two nights later about a hundred LSF members paraded in Baltinglass and the following appointments were made: Soup Doyle in charge of the communication section, Mick Timmins, transport section, Denis Byrne and Dan Phelan, defensive measures. By early August there

were eighty in Group A and ninety in Group B. The leaders were as follows: Ned Nolan, Group Leader; Peter Lalor and John Breen, Section Leaders; Patrick Glynn, Willie Sutton, Denis Byrne, Michael Lalor, James Nolan, Thomas Gavin, Edward Gethins, James Martin, Squad Leaders.[827]

Early in August a meeting was held with the object of setting up a local branch of the Irish Red Cross Society. In opening the meeting the Parish Priest, Father Doyle, pointed out that the government had urged the establishment of branches throughout the country. A committee was appointed, with Father Doyle as president, and Rev. William Parker, Rector of Baltinglass, and Father Gerald Byrne, C.C., as vice-presidents. Birdie Kenna and Matt Byrne acted as joint hon. secretaries, and Nellie Cooke was hon. treasurer. The committee members included Eva and Soup Doyle, Clare Lyons and Kitty O'Kelly. They had to arrange panels of stretcher bearers and drivers, while cars would be placed at their disposal. Dr Lyons, the medical officer of Baltinglass Hospital, agreed to give a series of classes in first aid. The convent gave permission to hold these in what was then the cookery school (later Fatima Hall) and they were held on Thursday nights, commencing on 22 August. It was predominantly women in attendance. This is not surprising as most men were busy with the LSF.[828]

In early October the LSF were granted the use of the Town Hall for general purposes, training, fundraising entertainments and lectures. This allowed them to run events, such as their weekly dances. Benefit nights were also given for the LSF and the Red Cross by Ted Bradley in his touring cinema, then located at the end of Edward Street. The LSF had regular parades after mass on Sundays as well as much larger ones occasionally, along with other units from the district.[829]

Though Group A had been an auxiliary army from June 1940, it continued under the command of An Garda. However, at the beginning of 1941 An Garda handed over responsibility to the army, and Group A became An Fórsa Cosanta Áitúil, or the Local Defence Force (LDF). Group B continued as an auxiliary police force under An Garda, and was known as the LSF. The LDF wore green uniforms, while the LSF wore blue. In January 1941 the following officials of Baltinglass LSF were appointed: Fintan Doyle, Group Leader; Luke McDonnell, Assistant Group Leader; Matt Byrne junior, Group Adjutant; Ned O'Keeffe, Group Quartermaster; Soup Doyle, District Staff Officer No. 4; Mick Timmins, District Staff Officer No. 5; Felix O'Neill, Transport Officer; Ronnie Quigley, Communications Officer; John A. Doyle, Air Raid Precautions and First Aid. Section Leaders were Michael Lalor, Joseph Doyle and M. Owens. Assistant Section Leaders were Cecil Gale, Thomas Doyle and Michael Murphy. Squad Leaders were Jim Brophy, Patrick Kinsella, Ben Case, T. Hanbidge, Thomas O'Hara and Patrick Gorman.[830]

In February 1941 the Wicklow Board of Health decided to allocate a fire engine and complete fire fighting equipment to Baltinglass. At an LDF and LSF gathering in Stratford in October 1942 the Baltinglass fire fighting squad, under Ned O'Keeffe, took part in a display, using a new fire engine and a trailer pump which were to be permanently installed in Baltinglass. One of the Baltinglass squad's

first real tests was on 10 December 1942 when Goldenfort, an old Saunders family residence, went on fire. Despite the prompt response from the Baltinglass and Stratford squads the building was completely destroyed.[831]

The LDF had a rifle competition between the various units within the district. The 1941 final took place in Baltinglass, though Baltinglass did not feature in it. The local forces had their first St Patrick's Day parade in 1941. Over 150 LDF and LSF members took part. Under the charge of Superintendent Reynolds and led by the O'Byrne Pipers' Band, they marched after mass from St Joseph's church. The 1943 St Patrick's Day parade was one of the largest and most impressive ever seen in the town. It included LDF units from Baltinglass, Hacketstown, Rathvilly and Kiltegan, and LSF and Red Cross members from Baltinglass and Kiltegan. At other times during the year big parades took place, such as that for the blessing of the colours on Sunday 16 May 1943.[832]

In February 1942 Baltinglass Red Cross began a second series of first aid classes, again given by Billy Lyons. Refresher courses were also run in 1943. All the emergency services continued their work during the war years. In October 1944 the Baltinglass units were among the LDF, LSF and Red Cross groups who gathered at Humewood for the blessing of the Kiltegan LDF colours. When the war ended in 1945, it brought to a close an unprecedented period of sustained work within the community for the common good. It was a time of hardship but also a time that those who experienced it looked back on with nostalgia.[833]

THE EMERGENCY: PARISH COUNCIL FORMED
SUNDAY 8 SEPTEMBER 1940

Two months after the formation of the local LSF, Baltinglass fell in line with the rest of the country in another aspect of the Emergency. As the war advanced, the real possibility of food and fuel shortages prompted the government to request communities to organise local committees to ensure that supplies were in place. Parish councils were formed throughout the country for this purpose. On Sunday 8 September the Baltinglass Parish Council was formed following a public meeting.[834]

Father Doyle presided at the meeting that evening at which a circular letter from the secretary of Wicklow County Council was read. A parish council, embracing the Baltinglass, Grangecon and Stratford areas, was then formed. Father Doyle was elected chairman, while Rev. Mr. Parker, Rector of Baltinglass, was elected vice-chairman. Dan Kehoe junior became hon. secretary. The resident county councillors, Patrick Doyle of Winetavern, Dan Kehoe senior and Mick Timmins, were appointed. Tommy Doyle, Luke McDonnell and Ned O'Kelly, all of Main Street, were elected from the business community. Henry Gaskin, M. Lalor and Ned Nolan represented the workers. Joe Burke of Rathmoon, J. Giblin of Glencannon and Matt Owens of Tinoran represented the farmers. The other members elected were J. Cranny of Stratford,

M. Harrington (teacher in Stratford), Billy Lyons (local doctor), J. Moore of Grangecon and The O'Mahony. Though not mentioned in the initial list of council members, Matt Byrne senior is named among those attending meetings from the outset.[835]

At their initial meeting on 15 September, the Baltinglass Parish Council discussed the supply of bread should transport become a problem. Other essentials were in danger of becoming scarce if the electricity supply went. It was decided to send a delegation to the local shopkeepers to determine the level of supplies of flour, bread soda, petrol, paraffin oil, candles, salt and coal. The council was still going strong in early 1941. Unemployment had been accentuated by the war and the county council appealed to parish councils to help in fundraising. The Baltinglass council decided to run a function on St Patrick's Night. Originally it was to be a whist drive but a dance was organised instead. It was held in the Town Hall. Gerry Roughan, who worked in Soup Doyle's, was MC, and the dance was stewarded by the LDF and the LSF.[836]

The council entered into serious discussion then about turf production. It was decided to acquire turf banks in the Donard area to supply the parish with fuel, and workers were employed for the cutting. Paddy Dunne and Lukie Hanrahan were enrolled to transport it to Baltinglass and it was stored in the galvanised shed next to The Steps. In May 1941 the council had exhausted its funds on the turf cutting scheme and individual members made substantial contributions for its subsistence.[837]

The Baltinglass Parish Council appears to have ceased to function by August 1942. Certainly by November of that year it was defunct. In April 1943 a meeting was to be held to revive the council but this did not happen. In October a whist drive was held in the 'Tech' in aid of a fuel fund for the needy residents, but the council did not function again. Though the parish council lasted less than two years, the LDF, LSF and Red Cross continued to do good work in Baltinglass throughout the Emergency.[838]

The war in Europe came to an end with the German surrender to the Allied Forces on 7 May 1945. The war in the Pacific continued, but after the U.S.A. dropped atomic bombs on the cities of Hiroshima and Nagasaki in August, annihilating more than 132,000 people, the Japanese government was forced into an unconditional surrender. The Second World War ended with the signing of an agreement on 2 September 1945. Unlike the Great War, in which so many young Irishmen died, the Second World War did not have as much Irish participation. Nevertheless, there were Baltinglass casualties. Of the men from the Baltinglass area who served in the Second World War, the following have been identified as dying in or as a result of the conflict.[839] This is by no means a comprehensive list of all casualties from the area.

FROM BALTINGLASS (THE AREA COVERED IN THIS BOOK)

Robert Terence Grogan formerly of Slaney Park; son of John Hubert & Alice Grogan of Lower Walmer, Kent; brother of Hubert Lawrence Grogan who died in the First World War; Commander, HMS Hood, Royal Navy; died at sea aged 40, Saturday 24 May 1941; commemorated on Portsmouth Naval Memorial, Portsmouth, Hampshire, England; ref.: Panel 45 Column 2

Patrick Michael Heydon formerly of Mill Street; son of Patrick Heydon (schoolmaster); American Air Force; killed aged 36, Monday 30 July 1945 on Okinawa Island, Japan; commemorated on family headstone in Baltinglass

CONNECTED WITH BALTINGLASS BUT IDENTITY NOT ESTABLISHED

Joseph Kehoe (stated as son of James & Elizabeth Kehoe of Baltinglass); husband of Margaret Kehoe; Sapper in 940 (I.W.T.) Company, Royal Engineers died aged 23, Wednesday 8 August 1945; commemorated in Munster Heath War Cemetery, Munster, Germany; ref.: 3.E.21

FROM SURROUNDING AREAS

David Carroll Mitchell of Ballynure; son of Christopher C. & Star Mitchell; Second Lieutenant in the 1st Battalion, Royal Fusiliers (City of London Regiment); killed in action aged 21, Sunday 16 March 1941 at the battle for Keren near Asmara in Eritrea; commemorated in Keren War Cemetery, Keren, Eritrea; ref.: 4.C.1

Richard Jones of Maplestown, Rathvilly; son of William J. & Jane A. Jones; nephew of Richard Jones of Mill Street who died in the First World War; Sergeant (Air Gunner) in the Royal Air Force Volunteer Reserve; killed in action aged 21, Sunday 25 June 1944; commemorated on family headstone in Baltinglass and in Abbeville Communal Cemetery Extension, Abbeville, Somme, France; ref.: Plot 6 Row C Grave 13

THE OPENING OF CARLTON CINEMA
SUNDAY 7 MARCH 1943

A benefit night for the LDF launched a venue that was to become a very important part of life in Baltinglass over the next four decades. In the years before television came to rural Ireland and for many years afterwards the local cinema was a special place. Bradleys' Carlton Cinema brightened up the childhood and teen years of generations of Baltinglass inhabitants.

Ted and Josephine Bradley were both from Ulster and they belonged to families of travelling show people. During the early years of their married life they operated a touring cinema, travelling all over Ireland bringing Hollywood to small towns and villages. Normally they chose a town for the winter months in case they got stranded by the weather in a place where the cinema attendance would be low. In 1938 they settled in Ferns for the winter. In 1939 they chose Baltinglass. The Bradley family, Ted, Josephine and their six children, arrived in Baltinglass on 1 November 1939, having been there already during the summer. The Second World War had started two months previously and Ted Bradley knew that the usual winter sojourn might be extended due to the shortages imposed by the

Emergency. The Bradleys' touring cinema was erected at the end of Edward Street in an open space in front of Phelans' house and opposite what was then Richard Marsh's garage. The original cinema was too small as a permanent base, so they built a larger makeshift structure. It had timber walls and a canvass roof. It ran lengthways along the street. Despite the confined space, it could seat in the region of 200 people. Admission price was four pence for children at the front, eight pence in the middle and a shilling for the back rows, which were a step higher than the others.[840]

The Bradleys were not the first to introduce the magic of the cinema to the town. As already mentioned, a cinematograph presentation was given in the Town Hall in 1900, and there were occasional showings thereafter. Apparently about the time of the Great War the Sylvesters, another touring show family, presented pictures in the shed beside The Steps. Almost three years before the Bradleys arrived in Baltinglass a new 'Picture House' was opened by Father Whitney in the Town Hall. This was on Christmas Night 1936 and it drew a full house. Just a few weeks before the Town Hall had undergone alterations and the results 'surprised and delighted' those who attended the opening night, though the work was not yet completed. The cinema operated again two nights later, and pictures were to be shown twice weekly, while the hall was to be available for different activities on other nights. In April 1937 a new dance hall was opened at the same venue, which was renamed St Patrick's Hall, though this name never gained currency. Apparently the showing of pictures was reduced to once a week, on a Sunday night, and Father Whitney decided not to show any films during the summer. The cinema returned in October with Wednesday night showings.[841]

Films continued to be shown once a week at St Patrick's Hall into early 1938 but at some point after that they were suspended. The hall was again refurbished in early 1939 and, under new management, the cinema reopened on Monday 8 May, when a packed house watched *Devil's Playground*, starring Richard Dix and Dolores Del Rio. Films were to be shown on Monday and Friday nights. However, just over seven months later there was another reopening, again under new management and after re-decorating. On Friday 15 December 1939 a double bill was shown – *It's in the Air*, with George Formby, and *The Pluck of the Irish* (or *Great Guy*), with James Cagney. 'Baltinglass Town Hall Cinema', as it was then called, advertised new electric heating and perfect sound, but apparently the acoustics were not really suitable and this was one of the venue's drawbacks.[842]

By this time the Bradleys had arrived and there were two rival cinemas, but the Town Hall would appear to have discontinued picture shows. Bradleys' touring cinema became a permanent fixture in Edward Street. Ted Bradley gave many benefit showings, paying for the films himself. The first was possibly in September 1940 for the newly formed Red Cross branch. This was followed a few weeks later by a benefit for the LSF. From October 1940 the LSF had the use of the Town Hall but a year later that venue was yet again in business as a cinema, again under

new management and again refurbished. The 'Grand Re-Opening' was on Sunday 14 September 1941 with Errol Flynn and Olivia De Havilland in *Dodge City* in Technicolour. This cinema continued in operation until at least April 1944.[843]

During the 1930s Richard Marsh ran a garage at the end of Edward Street. He also took part in car races during that time. However, he went bankrupt and his premises were auctioned by the Bankruptcy Court in Dublin on 13 November 1942. Ted Bradley went to the sale, expecting that there would be considerable interest in the property. To his surprise he was able to buy the garage for £250. Little structural work was needed to convert it into a cinema as the garage was spacious, and only the interior had to be renovated, while a concrete canopy was built at the entrance. There was no particular reason why Bradley chose to call the new cinema the Carlton. Indeed, apart from seeing it on the weekly poster that was distributed throughout the town, most people were probably unaware of its official name. It was called 'Bradleys'.[844]

This new cinema that was to be an integral part of the town's life for forty years opened with a variety show in aid of the LDF on 7 March 1943. It was the last Sunday before Lent and there was a dance afterwards in the Town Hall. The spacious new cinema was full. The evening opened with an item called 'Round the Camp Fire', with LDF members 'seated round a glowing fire in typical fashion, rendered several popular choruses'. That and the concluding item, 'The Roll of the Drum', were particularly praised. The MC for the night was Frank Glynn, who was a District Staff Officer in the LDF.[845]

In 1944 an unusual event was held in the cinema that supposedly drew an attendance of over five hundred. This was a 'Question Time Broadcast', presented by Joe Lenane of Radio Éireann, and broadcast on the wireless. Held over two nights, it attracted a huge audience. On the first night a Miss Cooke from Carlow won, while Mick Healy (the Bigstone teacher) was runner-up. The quiz was followed by a concert and after that was a presentation of the play *The Far-off Hills* in which the main part was played by Felix O'Neill. The other cast members were Nan Dowling, Fintan Doyle, Joe Fitzpatrick, Agnes Gaskin, Tom Murphy (teacher in the 'Tech'), Eileen Sinnott, Margaret Sinnott, Sheila Stafford and Tom White. The following night the 'Question Time Contest' continued, with the previous night's contestants facing a new group. Joe Jeffares of Mill Street came out on top, with Garda Tom Scott second. The entertainment continued with singers from Grangecon and it concluded with the playlet *Mrs. Mulligan's Millions* performed by the Grangecon Dramatic Troupe.[846]

Occasional other non-cinematic entertainments were held in the Carlton Cinema up to the 1970s. These included dances or, in the latter years, discos. Sometimes concerts or plays were performed there, such as when the cast of the television series *The Riordans* visited Baltinglass. In terms of cinema, the Carleton provided nightly entertainment, with Sunday matinees occupying legions of children on wet dreary afternoons. Two generations of the Bradley family were involved in the business. Ted and Josephine Bradley still took an active part in it in

their twilight years, with Mrs Bradley operating the ticket desk in the front hall. Their sons Willie, George and Davey each played a part in running the cinema over the years, but after Ted Bradley died in the early 1980s it was decided to close the business. Colour television and the emergence of video had already detracted from the magic of 'the pictures'. The last picture show was *The Warriors*, starring Michael Beck and James Remar.[847]

THE END OF RAILWAY PASSENGER SERVICE
MONDAY 27 JANUARY 1947

The end of the regular railway passenger service was remarkable by how quietly it happened. For over sixty years the railway had been a lifeline for the town, connecting it with Naas and Dublin as well as Tullow, Rathvilly, Grangecon and Dunlavin. The goods trains were perhaps of more importance to the town's economy than the passenger services, but both were valuable assets. Unfortunately, the passenger traffic appears to have never been high enough to make the Sallins to Tullow line economically viable for its owners.

There were times when it was so low that closure was threatened, and the advent of the motor car and the omnibus worsened the situation. Great Southern Railways, as the company was then called, changed and reduced the passenger service on the line at various times. In 1938 a rumour went around that the line was to be closed. Jimmy Nolan, who worked in Baltinglass station from 1919, remembered seeing trains carrying as few as four passengers. In 1944 the passenger service did come to a halt but this was a temporary Emergency measure and the service resumed the following year. Perhaps the final closure of the passenger service in January 1947 seemed inevitable to the population, as it passed without the expected upset and protests.[848]

Baltinglass was served by motor buses from at least the mid-1920s. A private company called Irwin Tours, owned by J.D. Furey and operating out of Ringsend, ran buses from Tullow and Newtownbarry (now Bunclody) to D'Olier Street, Dublin, and back daily. The Tullow bus went through Rathvilly and Baltinglass, while the Newtownbarry service passed through Carnew, Tinahely, Kiltegan and Baltinglass. The single fare from Baltinglass to Dublin on the Newtownbarry bus was three shillings and three pence. In August 1927 the Irish Omnibus Company informed Furey of their intention to open a service along the Tullow route. On 3 October 1927 the IOC daily service to Burgh Quay, Dublin, began. It departed Tullow at eight thirty a.m. and serviced Baltinglass, Blessington, Tallaght and Terenure, with the return bus leaving at six thirty p.m. The departures were an hour later on Sundays. The fare between Baltinglass and Dublin was four shillings and nine pence single and eight shillings and six pence return. The following month the IOC agreed to buy Furey's two buses and to take him on as traffic supervisor for the two routes.[849]

The same day that the IOC started its Tullow service the passenger rail service was reduced, with the midday train discontinued. Despite the additional bus

service the population felt aggrieved, and a petition from Baltinglass residents was sent to the railway company. In July 1928 the rail service was improved, with three trains daily in both direction and the return fare from Baltinglass to Dublin reduced to four shillings and six pence. Fares were further reduced a few months later. In December 1928 the fares on the Newtownbarry bus were reduced considerably. In 1929 Great Southern Railways took over the IOC and it was then possible to use a return ticket for Baltinglass on either train or bus. By the end of that year there was an IOC bus from Dublin to New Ross through Baltinglass, Tullow, Bunclody and Enniscorthy. The fares between Dublin and Baltinglass were two shillings and six pence single and five shillings return. From about the same time the other bus terminated in Carnew instead of running to Bunclody. In July 1930 second class tickets for the train were discontinued, leaving only first and third class, and fares were almost doubled. This increase was short lived, but it had an adverse effect on the service. When the fare was reduced two months later it made little impact on the passenger volume as people had grown accustomed to taking the bus instead.[850]

From 1932 a morning and evening bus operated each day in both directions on the New Ross route, while the Carnew route had a bus up in the morning and down in the evening. In February 1941 the Carnew bus was withdrawn. A month later one of the New Ross buses made a detour to serve Hacketstown and Kiltegan. Another result of the Emergency was the suspension of the passenger service on the railway from 24 April 1944, due to a shortage of coal. Reaction of the announced alteration was noticed at Baltinglass Fair the previous Monday, when there were fewer buyers than usual and trade was very slow. Commencing on that date, a substitute bus service was run by Great Southern Railways twice a week, on Mondays and Thursdays, following a route close to the railway line. It travelled from Tullow to Kingsbridge (now Heuston) Railway Station in Dublin in the morning and returned in the evening. On 10 July the service was expanded to operate every day from Monday to Saturday. Under the Transport Act of 1944, the Great Southern Railways Company was dissolved and its undertakings transferred to a new statutory company, Córas Iompair Éireann (CIE). The bus service was continued by CIE until 10 December 1945, when the passenger train service recommenced.[851]

When the regular passenger service was permanently withdrawn on Monday 27 January 1947, the substitute bus route, Service No.145, was again opened. It had the same Monday to Saturday schedule as before. It ran between Tullow and Kingsbridge Station through Rathvilly, Baltinglass, Carrigower Cross, Dunlavin, Brannockstown, Naas, Sallins, Clane, Celbridge and Lucan. In 1949 the section between Baltinglass and Dunlavin was altered to go through Grange Con and Colbinstown, and to mirror the railway route more closely. Though the journey was long and indirect, it allowed people working in Naas to commute and it operated for serveral decades before CIE deemed it unfeasible and discontinued it from 8 June 1982.[852]

A few weeks after the passenger service on the Sallins to Tullow railway finished, the regular goods service was also suspended. This was on 10 March 1947.

However, monthly livestock specials were operated until 1959. The only opportunity people had of travelling on the line after 1947 was on special passenger services, such as those laid on for pilgrimages.

The Carnew bus was reinstated at some point, though it was reduced to operating a few days a week. From 1982 until 2000 the only public transport out of Baltinglass provided by CIE (or Bus Éireann) consisted of mid-morning and evening buses to and from Dublin on the Carnew and Enniscorthy / New Ross / Waterford routes.

THE DEATH OF MATT BYRNE
SUNDAY 21 SEPTEMBER 1947

In the autumn of 1947 Baltinglass GAA Club lost both a father figure and a strong link with its past, and the town lost one of its most prominent and respected residents with the death of Matt Byrne.

Matt Byrne was born in February 1870 in Main Street, a son of Matt Byrne and Mary Connell. His father ran a shop in what was until recently the vacant house next to Kinsella Estates (demolished in 2006). He was the same Matt Byrne who was jailed during the Land League days. The son was a teenager when the town was introduced to cricket, rugby and Gaelic football. In December 1886, while still aged 16, he represented Baltinglass at the first Wicklow county convention of the GAA. This was the beginning of an association that was to continue for the rest of his life. While still in his teens he captained both Baltinglass cricket team and the Maurice Davins football team. Byrne is also credited with promoting hurling in Baltinglass in the early years of the twentieth century, though it did not take off then.

Matt Byrne was a National School teacher by profession, and taught in Baltinglass for most of his career, beginning as a monitor in 1888. He was also amongst those who over the years wrote on Baltinglass in the local newspapers, questioning those in authority, encouraging debate and needling the town's social conscience. As someone committed to the development of the town, he served on many committees, from the local Technical School committee to the Emergency period Red Cross. Matt Byrne was, amongst others, responsible for the mid-1930s excavation of the cairn at the Pinnacle. He was a long time member of the County Board of Wicklow GAA, serving as its registrar, and was a representative on the Leinster and Central Councils. In 1941 he was elected chairman of the Irish Amateur Handball Association. He was honoured by the Leinster Council of the GAA with the dedication of the O'Byrne Cup in his memory.[853]

THE BATTLE OF BALTINGLASS: THE POST OFFICE MEETING
MONDAY 27 NOVEMBER 1950

Towards the end of 1950 a dispute began over the position of sub-postmaster in Baltinglass. Two opposing factions, the supporters of Helen Cooke and Michael

Farrell, took to the streets in protest. Fuelled by politics, what might have been nothing more than a brief local controversy developed into a prolonged struggle that made national and even international news. References to it appeared in the most unlikely of places. In 2005 in Stockholm an Irish archivist came across a briefing from the Swedish embassy in Dublin mentioning the dispute.[854] It was for a time of some importance as it served to weaken the already unstable coalition government of John A. Costello. It became known as the Battle of Baltinglass.

The political landscape at that time was quite complex. The then government had come into power in February 1948. Headed by Fine Gael's John A. Costello, the inter-party administration also included Clann na Poblachta (a republican party founded by Sean MacBride), Labour, National Labour (which reunited with Labour in 1950), Clann na Talmhan (the farmers' party) and independents. It was an uneasy alliance, while Fianna Fáil, the largest party, constituted the opposition.

Wicklow was represented in Dáil Éireann by three TDs, Tom Brennan of Carnew (Fianna Fáil), Paddy Cogan of Tobinstown, County Carlow, (independent) and Jim Everett of Wicklow (Labour). As leader of the National Labour Party, Everett had become Minister for Posts and Telegraphs. On a more local level the two county councillors resident in Baltinglass for several years up to 1942, were Dan Kehoe (Fianna Fáil) and Mick Timmins (Fine Gael). In 1942 Dan Kehoe junior (Fianna Fáil) succeeded his father and Ben Farrell (Labour) replaced Timmins. Kehoe died in 1944 and Farrell was the town's lone councillor until the 1950 elections, when he lost out on the fourth seat by two votes having been in second place after the first count.[855] The new Baltinglass representatives in 1950 were Paul Kehoe, another son of Dan Kehoe, and twenty-three year old Godfrey Timmins, whose father Mick had died two years previously.

The family of Helen Cooke were well established and respected in the town. Sometime prior to November 1881 Michael Cooke of Main Street[856] became sub-postmaster for Baltinglass. He moved to Mill Street[857] in the late 1880s and the post office remained there throughout the first half of the twentieth century. His daughters Bridget, Sarah and Katie were assistants in the post office. After his death in 1912 Bridget was sub-postmistress until her death in 1936. She in turn was succeeded by Katie. Shortly before Bridget died her niece Helen Hardie Cooke came to care for her. Helen, or Nellie, was born on 25 November 1894 in Ardrishaig in Argyllshire, Scotland, where her father was an Inland Revenue officer. Her family moved to Ireland about 1910 and in her mid-twenties she entered the Poor Clare Sisters, leaving after four years, in February 1922, without taking final vows. She is said to have been a messenger for the anti-Treaty side during the Civil War. About a decade later, before coming to Baltinglass, she worked in the post office in Rathdrum, where her brother Jock was living. He was a Fianna Fáil member of Wicklow County Council from 1934 to 1937, when he resigned. During the Emergency Nellie Cooke was prominent in the Baltinglass branch of the Red Cross.[858]

Though Katie Cooke was officially sub-postmistress after Bridget's death, Nellie Cooke ran the post office on her behalf. By 1950 Miss Cooke was eighty-one

years old and in failing health. Assuming that her niece would obtain the position, she resigned as sub-postmistress on 14 April 1950. Of course, Nellie Cooke was engaged by her aunt and was not an employee of the Department of Posts and Telegraphs, but she was among the applicants. Despite the portrayal of Nellie Cooke in Lawrence Earl's book *The Battle of Baltinglass* as demure and efficient, she was remembered in the town as curt and officious, before and after the events of 1950-51. On Thursday 23 November she was informed that her application had not been successful and that the job had gone to Michael Farrell.[859]

Michael Farrell was then aged twenty-six and he lived at the other end of Mill Street, on the corner with Belan Street. His family ran a public house, grocery and drapery business there. It had been set up in the 1920s by his parents, Ben and Evelyn, on the site of Jim Doyle's premises which had been burned down in 1921. As a shopkeeper, Ben Farrell was unusual in that he was a supporter of the labour movement. He served as a Labour Party County Councillor from 1942 to 1950 and at the time was hon. secretary of the Baltinglass branch of the ITGWU. The Farrells were known for their generosity towards poorer families, allowing them credit on goods for which payment might never be expected. Mick Farrell had grown up in Baltinglass and had served in the LDF during the Emergency. He was a lieutenant in the FCA at the time. The fact that the Minister for Posts and Telegraphs was a Labour Party member and an associate of Michael Farrell's father left Farrell's appointment open to claims of political influence.[860]

On the day she received the disappointing news Nellie Cooke contacted Paddy Cogan, the independent TD, Bernard Sheridan and apparently Father James Moran. Sheridan had mentioned to her that he knew the Minister for Justice. In *The Battle of Baltinglass*, Lawrence Earl states that 'the Battle' might never have been fought were it not for Sheridan. This seems a reasonable assessment, as Bernie Sheridan was central to most of the action and the protest on behalf of Nellie Cooke was put in motion too rapidly to have been generated by popular opinion. Though much of the detail in Earl's book was evidently supplied by Sheridan, his role in the incident does not appear to have been exaggerated by vanity. His ability to draw people into the protest and to attract press attention suggests that he had particular skills in dealing with such a situation. Sheridan had come to Baltinglass some five years before. He lived in Mill Street for a time before moving to Main Street, where he ran a public house[861] in what was formerly Joe Kitson's. His political leanings are not defined in the book, but he was involved in IRA activities in the latter half of the 1950s.[862]

Things moved surprisingly fast. The night Nellie Cooke got the news Father Moran, a curate in Baltinglass since 1946, used a meeting of the Boy Scouts' committee to voice his opinion. As chairman, in the presence of Ben and Evelyn Farrell, who were fellow committee members, he disbanded the meeting in protest at the appointment. That same night Sheridan visited the two local County Councillors, Paul Kehoe (Fianna Fáil) and Godfrey Timmins (Fine Gael). In the spirit of leaving politics aside they agreed to go with him and Paddy O'Grady of Main Street to

Dublin the following day and seek meetings with politicians. O'Grady was a local Clann na Poblachta activist. Clann na Poblachta had been formed in 1946, attracting republicans disillusioned with Fianna Fáil. Its decision to join the inter-party government headed by Fine Gael was unpopular with its republican base.[863]

Sheridan's uncle was a friend of Sean MacEoin, the Minister for Justice, and this helped the four men get an interview with him. Before the meeting Sheridan went to the Irish Press offices to look for publicity. The same day Paddy Cogan, TD, discussed the matter with the Taoiseach. Also that day, Father Moran, originally from Ballinakill, County Laois, arranged a meeting with Oliver J. Flanagan, Fine Gael TD for Laois-Offaly. The priest asked Ben Hooper, headmaster of Baltinglass Technical School, to meet Flanagan in his place. However, the TD stated that he had supported the application of Mick Farrell because of a contact in the LDF.[864]

On Saturday 25 November, two days after the news broke, Sheridan and Felix O'Neill called a meeting which was held in O'Neill's ice cream parlour in Weavers' Square. O'Neill was secretary of the Fine Gael branch in West Wicklow. Among those at the meeting were John A. Doyle of Main Street, Ben Hooper and his brother-in-law Bill Judge, Luke McDonnell of Main Street, Paul Kehoe and Godfrey Timmins. They arranged to hold a public meeting in the Town Hall on the Monday night at eight o'clock to protest at Nellie Cooke not getting the position. After their initial Cooke Protest Committee meeting, Sheridan drove to Portlaoise, hired a loudspeaker and drove through Baltinglass announcing Monday night's public meeting. On Sunday morning he parked his car outside St Joseph's church and announced the meeting as the congregation left mass. Gathering again on Sunday, the protest committee decided to ask Jim Everett's opponents in the constituency, Tom Brennan and Paddy Cogan, to attend the public meeting, as well as The O'Mahony, chairman of Fine Gael in West Wicklow. Hooper indicated that Father Moran was unwilling to chair the group and it was suggested that Major-General Meade Dennis be asked to do so. Dennis was living in retirement at Fortgranite after a career in the British Army. He was a prominent figure, having commanded the Royal Artillery at the Battle of Alamein. Des Cullen of Main Street, a pharmaceutical chemist living in the town about four years, was deputised to approach him. Father Moran followed up with a personal visit and persuaded Dennis to accept with a spurious story about his grandfather being responsible for Helen Cooke's grandfather's appointment to the post office.[865]

It was claimed that seven hundred people attended the public meeting on the Monday night. As General Dennis opened it he was heckled by Paddy Greene, a supporter of Mick Farrell, but, according to Sheridan's account, the crowded hall was fully behind Miss Cooke. Tom Brennan and Paddy Cogan addressed the meeting and Cogan promised to raise the matter in the Dáil. On the proposition of Bernie Sheridan, seconded by Paul Kehoe, a resolution was passed condemning the fact that Nellie Cooke had not been appointed, and copies were to be sent to the Taoiseach, the Tánaiste, Jim Everett (Minister for Posts and Telegraphs) and the political party leaders.[866]

As promised, Cogan raised the matter in the Dáil on the Wednesday. Despite the rumour that a number of people applied for the position, including one of those who became prominent in the Cooke Protest Committee, Brendan Corish, then a Parliamentary Secretary, stated in reply that there were only two applicants. It was stated in the press that a number of applications were made but only two were persisted with. Both Cogan and Tom Brennan accused their fellow constituency representative, Jim Everett, of making a political appointment.[867]

In the afternoon of Thursday 30 November, a week after the news broke, an engineer and ten or twelve linesmen from Posts and Telegraphs arrived in Baltinglass and began digging a trench for the telephone cable, while also installing a fifty line switchboard at Farrells' to replace the thirty line one at Cookes'. The next morning the pro-Cooke group began a picket outside Cookes' to prevent the switch over of the telephone cable. Carrying placards, Nan Jackson of Mill Street, Paul Kehoe, Paddy O'Grady and Bernie Sheridan were the first to walk up and down in front of the premises. Sheridan telephoned the Irish Press office and in the afternoon a reporter and a photographer arrived.[868]

A few hours later two of the linesmen, who were still working on the cabling, came down the street. O'Grady stood on the concrete slab covering the cable junction. After some words were spoken the linesmen withdrew and Sheridan telephoned General Dennis. Shortly afterwards Dennis and his wife appeared and she took up duty on the concrete slab. A few hours later Madam O'Mahony, wife of The O'Mahony, replaced Mrs. Dennis and a chair was produced for her. The picket was withdrawn at eight o'clock but O'Grady remained on vigil inside the window of Morrins' office opposite the post office. That evening Sheridan, Dennis and Joe Morrin drove to Dublin to see the editor of the *Irish Times* and the following day a reporter and a photographer were sent to Baltinglass. On Saturday 2 December Baltinglass post office was on the front page of the *Irish Times* with three photographs. So the publicity grew.[869]

THE BATTLE OF BALTINGLASS: MEETING IN SUPPORT OF FARRELL
TUESDAY 5 DECEMBER 1950

During the first week of December reporters from various newspapers, including London's *Daily Mail*, appeared in Baltinglass. Among these reporters was a Canadian called Lawrence Earl who had been working out of London since the end of the Second World War and whose work was syndicated widely. That same week the newspaper men got another twist on the increasingly newsworthy story of the post office when Daphne Lalor volunteered for picket duty. She was the wife of a local farmer, Eddie Lalor, and was a cousin of Queen Elizabeth, wife of George VI. Sheridan brought this fact to the attention of the *Irish Press* reporter and 'the Queen's cousin' became part of the Baltinglass story.[870]

As the picketing continued outside Cookes' and work was under way in converting part of Farrells' shop for the new post office, the Labour Party held a

meeting in support of Mick Farrell on the night of Tuesday 5 December. It was preceded by a torchlight procession through the town. Cooke supporters 'blacked-out' their houses in protest. After the march the pro-Farrell faction gathered in the Town Hall, where the pro-Cooke assembly had been held eight days before. Seemingly at the meeting a Farrell Support Committee was formed. According to Lawrence Earl, Jimmy Doyle of Parkmore addressed the meeting and used Daphne Lalor's royal connection to disparage the pro-Cooke camp, causing Meade Dennis to tell the *Irish Times* that she had no connection with the Cooke Protest Committee. The *Irish Times* reported that about 150 people attended the meeting. Interviewed for the *Nationalist* that week, Mick Farrell stated that there were 500 present. He said 'I applied for the post office job in the ordinary way, and got several recommendations from every party in the Dáil.' He also claimed that the 'Football Club stood firm to two members.' Jimmy Doyle, who was an army man with twenty-six years' service, was on secondment to the FCA as a company quartermaster sergeant and he threatened to resign from the army if the campaign against Farrell was allowed to continue.[871]

On the Wednesday Cogan and Brennan were to continue their assault on Everett in the Dáil. Several car loads of pro-Cooke supporters went to witness the debate from the public gallery. There was a political brawl in the house, with deputies hurling insults at one another and at the Minister, preventing him from finishing his reply. Up in the public gallery, while the deputies were abusing one another below, Des Cullen rose to his feet and started shouting about Everett. He was ejected and detained for an hour before being released without charge. The session ended in disorder and was adjourned till the following morning. The next day Everett defended his decision to appoint Mick Farrell and pointed out that Farrell's application had been supported by four Fianna Fáil representatives, Deputies J. Davern and R. Ryan and Senators A. Fogarty and S. Hayes. At a later date he mentioned that Farrell had also been recommended by Deputies O.J. Flanagan, J. McQuillan and E. Rooney. He acknowledged that in May he had received a memorial in support of Miss Cooke signed by the Parish Priest, a curate and a number of Baltinglass residents. On 14 December Oliver J. Flanagan acknowledged that he had recommended Farrell and stated that he stood over the recommendation.[872]

At the time of the controversy the Parish Priest, Father Doyle, had been ill for some two years. On Thursday 7 December he allegedly dictated a letter to be sent to the Taoiseach in which he asserted that Everett had done 'a grave injustice in appointing Mr Farrell to the position which Miss Cooke so ably filled for so many years.' However, some believed that in his condition, Father Doyle, who died three months later, was unaware of what was happening in the outside world and that his curate, Father Moran, was the author.[873]

That Friday evening Sheridan suggested a change of tactics to the Cooke Protest Committee, to discontinue the picket and instead install a siren to warn in case Garda reinforcements came to assist in moving the cable. The next day Sheridan

set up two hooters outside his bedroom window, posing for a press photographer in the process.[874]

Since 1937 a branch of County Wicklow Library had operated in the Technical School. Apparently it was opened twice weekly, on Wednesdays and Sundays. On Sunday 10 December Ben Hooper was operating the library. After mass the Farrell supporters marched through the town. Later four men placed a picket on the 'Tech' in protest against the headmaster's activities in the increasingly political dispute. At this point both factions were confident in their opposing objectives.[875]

THE BATTLE OF BALTINGLASS: DAY OF BATTLE
MONDAY 11 DECEMBER 1950

Late on the night of Sunday 10 December, Bernie Sheridan got word from an unnamed source that the posts and telegraphs linesmen would be arriving at seven thirty in the morning with Garda backup. He alerted Ben Hooper, Paddy O'Grady and Jimmy McCann, all of whom lived close to him at the top of Main Street, as well as Felix O'Neill, and told them to call the other committee members to a meeting in his bar. He also claimed to have tried unsuccessfully to rouse Paul Kehoe. However, Kehoe's newborn child died on 3 December and he took no part in the controversy after that point.[876]

Sheridan sent O'Grady to the post office to man the switchboard so that Sheridan could phone various households. The others continued their meeting in the bar until three o'clock. At seven fifteen a.m. Sheridan switched on the siren and O'Grady ran through the streets ringing a hand bell. A large crowd gathered outside the post office and at eight o'clock lorries carrying about fifty Gardaí arrived. Shortly afterwards the linesmen appeared. The Cooke supporters stayed grouped outside the post office. Among them was Father William O'Mahony, the second curate, allegedly representing the invalid parish priest. The Gardaí and linesmen remained on the street. At about ten thirty a small number of the Cooke supporters, including Meade Dennis and Sheridan, walked up to Farrells' premises and the General spoke with Mrs Farrell and then with her son, trying unsuccessfully to persuade him to resign.[877]

About the same time, a picket of Farrell supporters were again placed on the 'Tech', protesting at the headmaster's involvement in the dispute. Less than ten people were outside the post office by midday. Seeing the Gardaí assemble around Farrells', Sheridan phoned his wife and told her to turn on the siren. In response to the alarm the Cooke supporters returned to the street. A Garda lorry was driven very slowly into the gathered crowd, driving them back until the Gardaí had possession of the concrete slab. This allowed the linesmen access to the junction and just before one o'clock the cable was cut. The TD Paddy Cogan arrived and, standing on a chair just down from the post office, he made an impromptu speech. He was followed by other speakers and this kept the protesters occupied for about an hour.[878]

About three o'clock the crowd dispersed and eight young women marched up the town carrying black flags, signifying mourning. Earl states that by then most shops had drawn their blinds, 'except for the few whose proprietors were close friends of the Farrells'. Later a counter-demonstration of Farrell supporters, some wearing LDF overcoats, marched through the streets. As a result of the picketing of the 'Tech', Cogan sent a telegram to the Minister of Education urging him to have the protesters moved. At three fifteen p.m. the new telephone cable was connected to Mick Farrell's post office. Undeterred, the Cooke Protest Committee met again in Felix O'Neill's and organised a picket of the General Post Office in Dublin for the Wednesday. Later that night four telephone poles were cut down beside the railway line between Grangecon and Colbinstown. The names of the culprits were never revealed.[879]

THE BATTLE OF BALTINGLASS: PICKETING THE GPO
WEDNESDAY 13 DECEMBER 1950

Immediately after the change over to Mick Farrell's premises, the Cooke supporters escalated their protest. They boycotted the new post office and organised for mail to be left at Felix O'Neill's shop, which was licensed to sell stamps. A list of drivers was drawn up, running into the month of February. The mail was to be collected at three p.m. and posted in Grangecon or Rathvilly.[880]

On Tuesday night 12 December a pro-Cooke meeting of 'telephone subscribers' was held in the Town Hall. It was chaired by J.R. Grogan of Slaney Park. Suggestions of over use of phones to upset the system and of a partial boycott were put forward. Those present agreed to not use the system at all each Thursday while Mick Farrell held the position. On Wednesday morning the pro-Farrell picket was resumed outside the 'Tech'. When the protesters reappeared on the Friday, Ben Hooper called the Gardaí and had them removed. This was the last day of protest against Hooper. Members of the Cooke Protest Committee apparently regarded this picketing as victimisation of the headmaster and of a different nature to their boycott of the new post office. On one of the occasions that the 'Tech' was being picketed one of their number drove his car at the picket, though no one was injured.[881]

The afternoon of Wednesday 13 December brought the pro-Cooke protest to Dublin. At two o'clock a group began marching up and down O'Connell Street, close to the GPO, and distributing leaflets. That afternoon Norman Ashe, an aerial photographer hired by the Cooke Protest Committee, flew his plane over the capital using a loudspeaker to publicise the pro-Cooke cause. On the same day the general secretary of Clann na Poblachta received a letter from Paddy O'Grady stating that the Baltinglass branch had been dissolved because of the party's continued participation in government.[882]

On the Thursday a new tactic was employed. Meade Dennis, as their landlord, visited Farrells and informed Evelyn Farrell that installing the post office would de-license part of the premises and, therefore, devalue his property. On

the Friday evening, Farrell supporters, estimated by Earl as numbering eighty, held a torchlight procession and a meeting afterwards in the Town Hall. It was rumoured that the Minister for Posts and Telegraphs, Jim Everett, was to attend, so the pro-Cooke faction organised that shops would shut and blinds would be pulled to show disapproval. A small number of people managed to remain neutral throughout the dispute, having no wish to damage either the Cooke or the Farrell family. However, those in business were placed in an invidious position by a pro-posal put forward by a Cooke Protest Committee member, namely that those who were not on the pro-Cooke side were anti-Cooke. This translated into a boycott of any business house that refused to close up and turn out the lights when told to do so. As a consequence of this Gorrys' Medical Hall and the Bridge Hotel, run by the Harbourne family, were boycotted by Cooke supporters.[883]

On the Thursday morning more telephone poles were cut and that evening a cable was cut near the railway station. The dispute was condemned in a letter from Father Doyle read at all masses on the Sunday. This apparently finished the acts of sabotage. The next week The O'Mahony, a former TD and the chairman of Fine Gael in West Wicklow, resigned his membership of the party. Then Felix O'Neill, secretary of the local branch, followed suit. During the same week the Cooke Protest Committee held what they called a 'referendum' of those on the electoral list for the area served by the post office. This was in the form of a peti-tion on behalf of Miss Cooke, which they claimed was signed by eighty seven per cent of voters. [884]

THE BATTLE OF BALTINGLASS: MICK FARRELL RESIGNS
WEDNESDAY 20 DECEMBER 1950

Because of the involvement of the two Baltinglass curates in the protest the Farrell family were by mid-December travelling outside the parish to attend mass. The claim by their landlord that their lease was violated by the partitioning of part of the premises for the post office placed further pressure on them. As well as the new post office, the family's business was subject to a prolonged boycott by the pro-Cooke faction. Despite the support of many of the working people of the town, Mick Farrell could no longer weather the storm. On 20 December, nine days after the official transfer of the telephone and postal services to his premises, he wrote a letter of resignation to the Minister for Posts and Telegraphs, Jim Everett. The resignation was accepted and it was announced on the ten o'clock news on Radio Éireann the following night.[885]

Miss Cooke and her supporters celebrated their victory that night, but Farrell's resignation did not guarantee that she would be given the job. At a Cooke Protest Committee meeting on the Friday it was suggested that they tour the country with loudspeakers attached to cars in order to keep up the momentum. This was agreed. In a press release afterwards they stated :'This committee once again wishes to stress that at no time has any question of party politics influenced them

in their actions, and deplores the harm that may have resulted to Michael Farrell and his family through the Minister's action.'[886]

The idea of sending cars out around the country to continue the protest was proceeded with, and four cars – owned by Soup Doyle, Cecil Gale, Ben Hooper and Luke McDonnell – were volunteered. The *Irish Times* reported that three cars left Baltinglass on Friday 29 December and headed to Galway, Cork and Drogheda. Earl states that Bernie Sheridan and others travelled to Connaught, Ben Hooper and his team to Munster, and Des Cullen to Wexford. Protest committees were reportedly formed in various locations. The position of sub-postmaster was advertised, with a closing date of 6 January 1951 for applications. The pro-Cooke faction continued boycotting the post office, sending mail through Felix O'Neill's premises to outside post offices. On Friday 26 January Nellie Cooke was informed that she was the new sub-postmistress. And so 'the Battle' ended.[887]

Eleven weeks later, as a result of the controversy surrounding his 'Mother and Child' scheme, the Minister for Health, Noel Browne, a Clann na Poblachta member, resigned. This was the final straw for the beleaguered inter-party government, leading to a general election in which Fianna Fáil regained power. Labour or National Labour had one and sometimes two county councillors representing the Baltinglass Electoral Area from 1925 to 1953, when P.P. O'Reilly resigned. In 1955, the first local government election after 'the Battle', Labour failed to take a seat in that area and did not regain one until 1991.[888]

The Farrell family left Baltinglass early in 1953 and settled in Rosslare. Despite the animosity they endured in 1950-1951, they were always hospitable to visitors from Baltinglass, even to some individuals who had taken part in the picket. Ben and Evelyn Farrell died in Rosslare in the early 1960s. Michael Farrell died on 17 August 1994 aged eighty. Bernie Sheridan left Baltinglass in the early 1960s. Katie Cooke died in May 1953. Helen Cooke continued to run the post office until 1963, when she retired to Dublin. The position of sub-postmaster was given to Felix O'Neill who operated from his Weavers' Square premises for a short period before he was succeeded by Peter Murphy who had bought Cookes' house in Mill Street. In 1965 Nellie Cooke went to Australia to live with her sisters in Melbourne. She died there on 20 March 1972.[889]

Nellie Cooke's unhappy situation in November 1950 certainly sparked genuine sympathy, and the early gesture of setting politics aside was most certainly sincere on the part of several who joined her cause, perhaps not thinking of its effect on the Farrell family. It was very likely that some of the Cooke Protest Committee members were unaware of any political undercurrent. However, it would be naïve to think that politics played no part in the Battle of Baltinglass. Fine Gael, Clann na Poblachta and Labour were in an uneasy government alliance, and each had branches in Baltinglass. Fianna Fáil was in opposition and it too had many members in the locality. While there were Fine Gael, Clann na Poblachta and even Labour party members among the Cooke supporters, the presence of at least three prominent Fianna Fáilers on the Cooke Protest Committee throughout the conflict,

is significant. In addition there was Bernie Sheridan, the most politically astute member of all, whose party allegiance at the time is unknown. Farrell's supporters accused the pro-Cooke faction of being a front for Fianna Fáil and suggested that the protest committees formed around the country following the tour of the Baltinglass cars were actually Fianna Fáil branches. It seems unlikely, despite the massive media attention, that people in small communities on the other side of the country would spontaneously form clubs in support of Miss Cooke. In his book, Lawrence Earl refers repeatedly to Sheridan's network of sympathisers who were able to supply him with confidential information. This suggests that he had the backing of some well connected organisation.

The *Irish Press*, controlled by De Valera, was the first national newspaper to send a reporter to cover the post office dispute and it gave the affair significantly more coverage than its competitors. While relatively balanced newspaper reports were published, the Battle of Baltinglass was by and large sold by an uncritical press as a simple case of innocence against corruption. Lawrence Earl's book was published within two years of the incident. He was unashamedly biased in favour of Miss Cooke's cause and evidently viewed the whole affair as comical, littering the book with stage-Irish dialogue of a type he would never have heard in Baltinglass. The general atmosphere was of an Irish version of an Ealing comedy along the lines of *Passport to Pimlico* or *Whisky Galore*. It was the second of Earl's nine books. The first was *Yangtse Incident*, published in 1950 and made into a feature film in 1957. In 1953 he won an award for *The Battle of Baltinglass*. This was a Canadian annual literary prize, the Stephen Leacock Memorial Medal for Humour. Unfortunately, his widely available book was what informed people for decades on what happened in Baltinglass in 1950-1951.[890]

In the aftermath Baltinglass was a damaged, divided community. Bitterness and a certain amount of shame remained for decades, making 'the Battle' a subject not to be talked of in public. In 1986 plans were being made for a television dramatisation of the event. By then over three decades had passed and some of the surviving protagonists were happy to speak of their participation but no one from the Farrell side was willing to put forward their case. Jimmy Doyle, one of Mick Farrell's most loyal supporters, was approached by this writer at that time but the memories were too upsetting and the subject too divisive for him to enter into the discussion. On 10 October 1996 a documentary on the Battle of Baltinglass in the *Telling Tales* series was screened on RTE television. It used the Lawrence Earl book as its main source and sacrificed balance to devote time to an aspect of Miss Cooke's private life that had no connection with or bearing on the story.

In November 2000 the West Wicklow Historical Society held a discussion to mark the fiftieth anniversary of 'the Battle'. The meeting was not a significant event in the history of the town, but it produced some interesting reflections on the episode. Present were some people who had been active Cooke protesters as well as a relative of the Farrells who remembered the incident. It was generally agreed that the enthusiasm and determination generated by the Cooke Protest

Committee was uncharacteristic of the town. Indeed over the past century and a half, with the exception of the Land League, the War of Independence and 'the Battle', Baltinglass has never been known for its perseverance with any protest. Without the careful selection of key people for the Cooke Protest Committee, astute political thinking and an uncommon ability to handle the media, in all likelihood the protest would have fizzled out after a few meetings. The consensus was that Bernard Sheridan was the main instigator, then a young publican only a few years resident in the town. Another outcome of the meeting was the recollection of the generosity of the Farrell family and their dignity in subsequent years. There was a sense of regret at the treatment they received during 'the Battle' when enthusiasm got the better of the normally neighbourly community.

This writer spoke recently to the widow of one of those who was for a time involved in the Cooke Protest Committee. Her first utterance on the subject was 'it should never have happened.'

BLESSING OF THE HOLY YEAR CROSS
SUNDAY 24 DECEMBER 1950

Towards the end of the Holy Year designated by Pope Pius XII, it was decided that a Holy Year Cross would be erected on Baltinglass Hill. A committee was formed, with Paddy Doody of Parkmore as chairman, Jim Brophy (who was working in T.P. Doyle's, Main Street), vice-chairman, Frank Hunt, secretary, and Felix O'Neill, treasurer. Funds were raised by collection and the Cross was made by Tom Burke of Weavers' Square, presumably in his family's workshop at The Steps. It was put in place on Sunday 10 December at the top of Carsrock. On the afternoon of Christmas Eve the Baltinglass Pipers' Band led a procession to the Cross, where Father Moran performed the blessing ceremony. The Cross was illuminated that night and again on Christmas night. The bulbs were lit by large batteries that had to be carried up the hill, so the illumination was only at certain times rather than daily.[891]

The committee continued to function in order to raise funds for the ongoing costs. In the early 1970s the Cross was damaged in a storm. The then committee, chaired by Billy Doody, son of the original chairman, found on examination that the timber was rotten, and a new Cross had to be made. The replacement was made in September 1974 and the new Cross was specially treated to withstand the weather. From that time it was lit by electricity. The committee, which is linked very much to the fire brigade, continues to function and ensure that the Holy Year Cross is kept in good repair. After over fifty years in place it has become part of the fabric of Baltinglass, a symbol of the town in the night sky.[892]

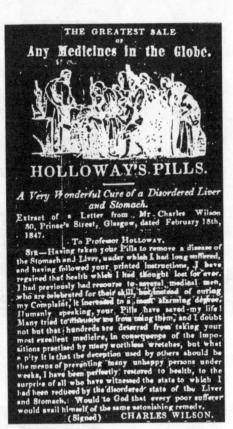

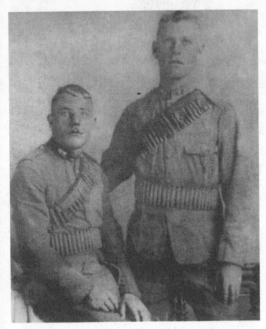

3 Two Baltinglass men, John Groves and John McCormack, who served in the Boer War.

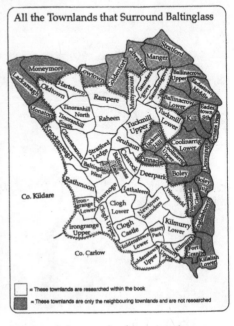

4 Map of the townlands surrounding Baltinglass.

5 Godfrey Timmins, TD.

6 Helen Cooke.

7 E.P. O'Kelly, MP.

8 Michael Farrell, briefly sub-postmaster during the Battle of Baltinglass, 1950.

10 Shauna Bradley, Special Olympics medallist, and her mother Liz. (Photo: Nigel Gillis).

9 Kevin O'Brien, All Stars footballer. (Photo: Nigel Gillis).

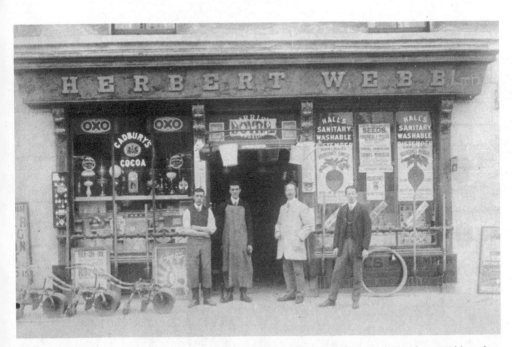

11 George Griffin, William Hendy, Joseph Turtle and Willie Turtle outside Herbert Webb Ltd., *c.*1910.

12 Farrell supporter being questioned by Gardai outside the 'Tech', December 1950.

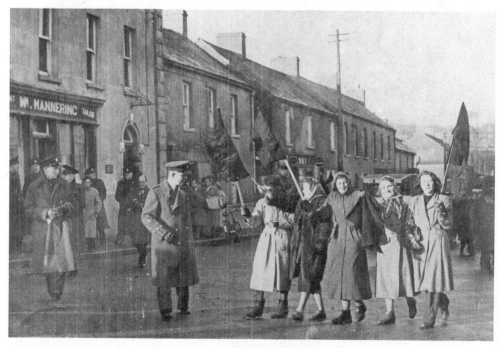

13 Black flag protestors on Mill Street, Monday 11 December 1950.

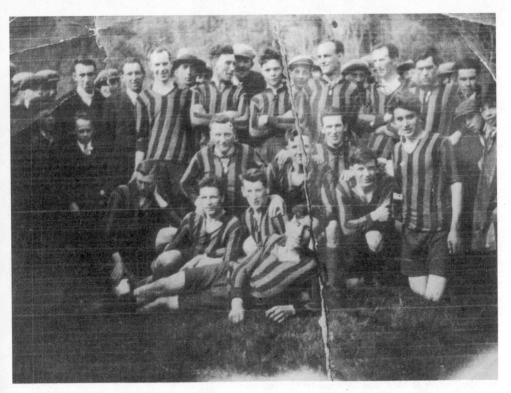

14 Tuckmill Gaelic Football Team, *c.*1931.

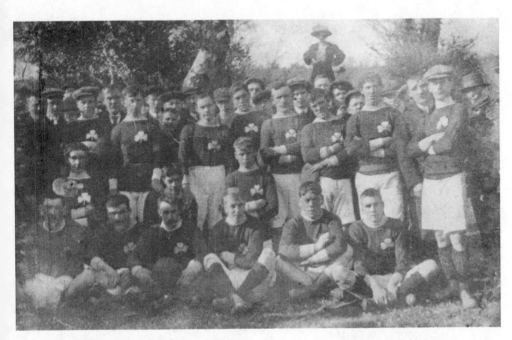

15 Baltinglass Gaelic Football Team, *c.*1913.

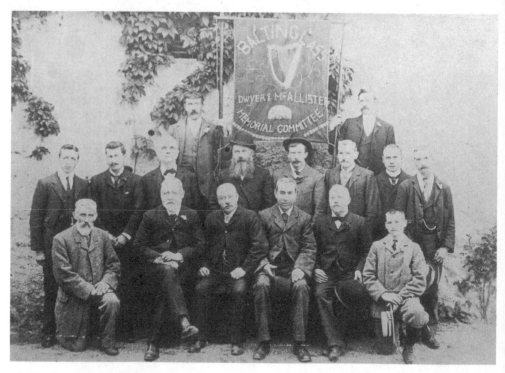

16 The Dwyer & McAllister Memorial Committee, *c.*1904.

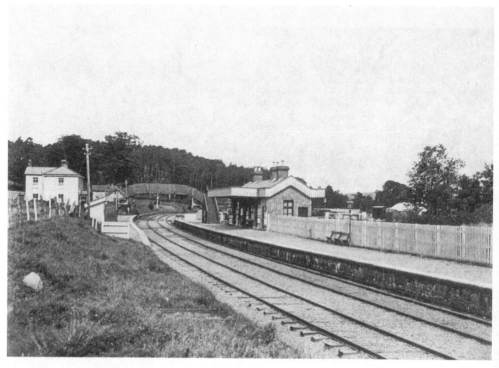

17 Baltinglass Railway Station in the early twentieth century.

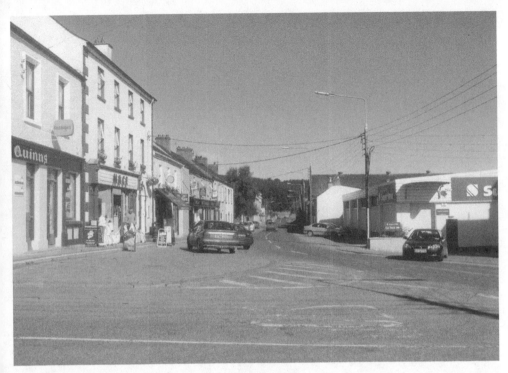

18 Mill Street, Baltinglass, in 2001. (Photo: Pat Gorry).

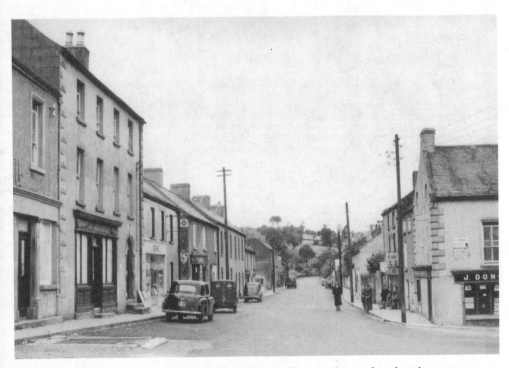

19 Mill Street, Baltinglass, c.1955, from the Cardall Collection. (Reproduced with permission from the Board of the National Library of Ireland).

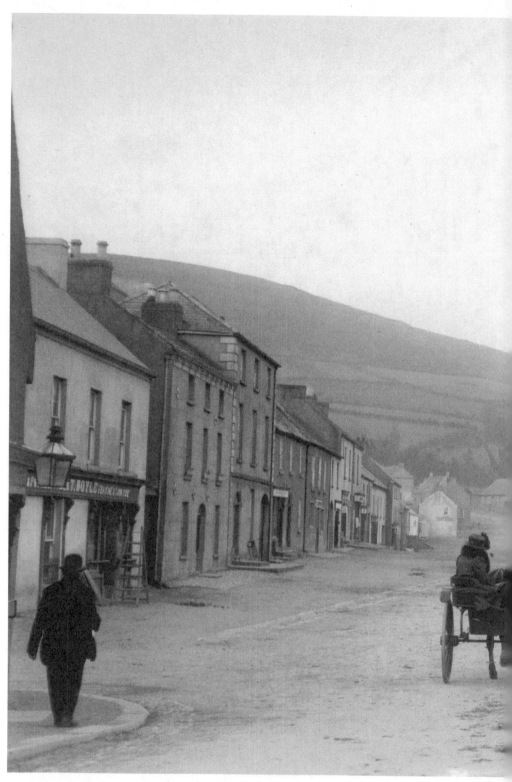

20 Main Street, Baltinglass, *c.*1910, from the Eason Collection. (Reproduced with the permission of the Board of the National Library of Ireland).

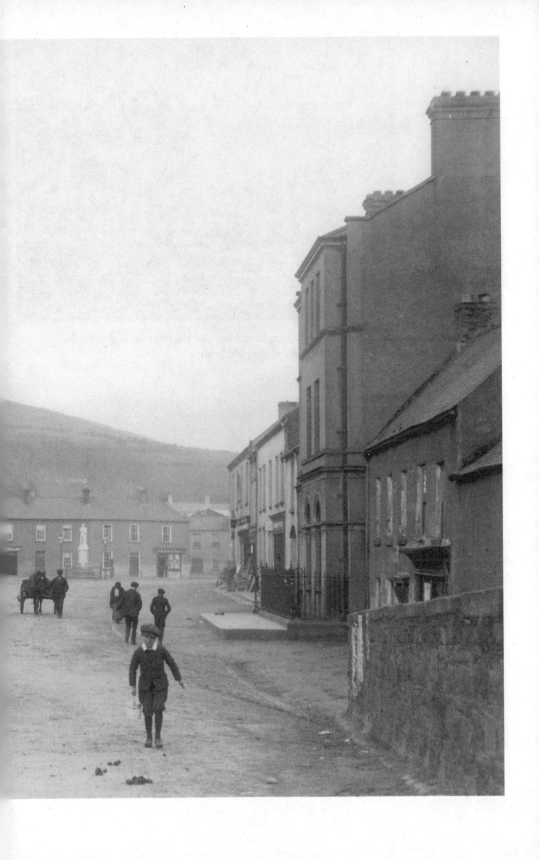

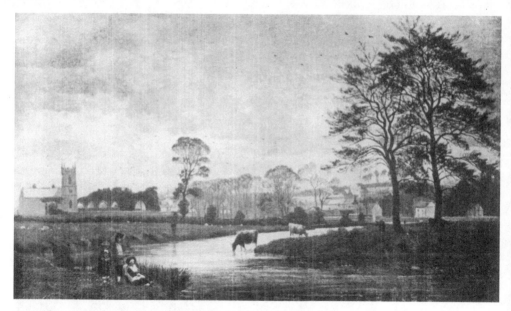

21 Mid-nineteenth century painting of Baltinglass Abbey and the river viewed from the north, from an oil painting by Bartholomew Colles Watkins.

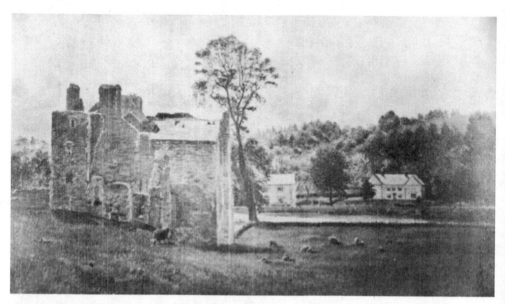

22 Mid-nineteenth century painting of Baltinglass Castle viewed from the east, with the original Stratford Lodge School in the background, from an oil painting by Bartholomew Colles Watkins.

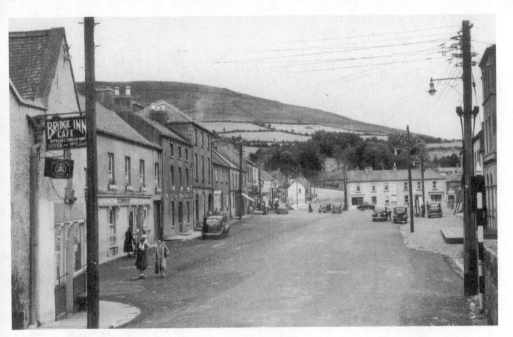

23 Main Street, Baltinglass, *c.*1955, from the Cardall Collection. (Reproduced with the permission of the Board of the National Library of Ireland).

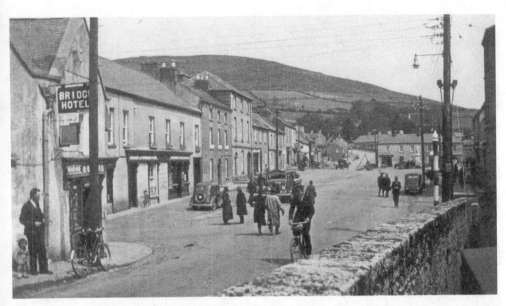

24 Main Street, Baltinglass, *c.*1950, from postcard.

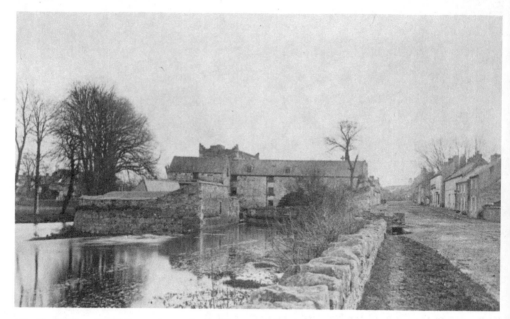

25 The Mill and Mill Street from the Dublin Road, *c*.1900.

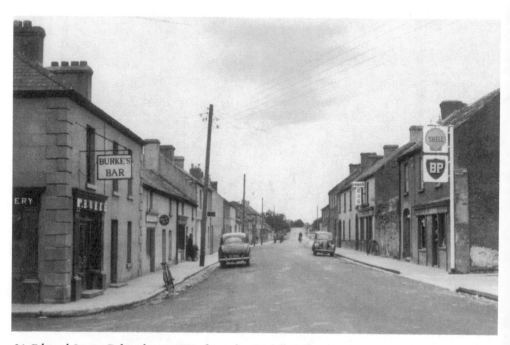

26 Edward Street, Baltinglass, *c*.1955, from the Cardall Collection.
(Reproduced with permission from the Board of the National Library of Ireland).

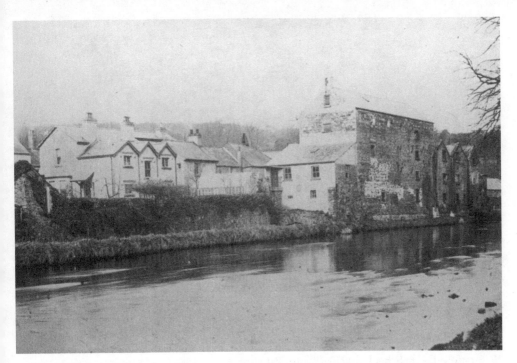

27 The Mill from St Kevin's, *c.*1900.

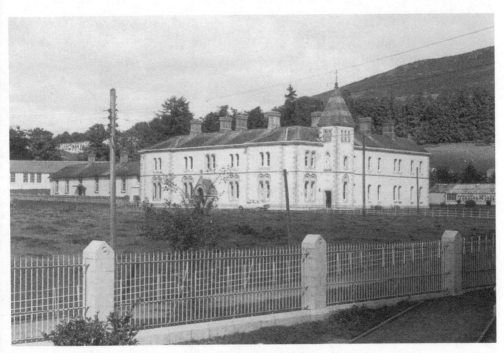

28 St Joseph's Convent in 1980. (Photo: Pat Gorry).

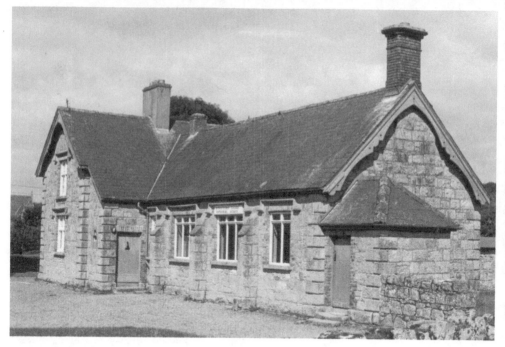

29 Stratford Lodge School in 1980. (Photo: Pat Gorry).

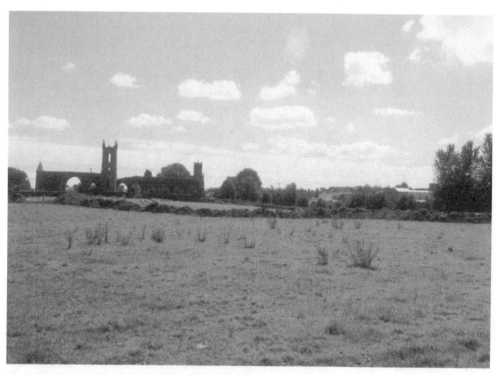

30 Baltinglass Abbey in 2001. (Photo: Pat Gorry).

31 Main Street, Baltinglass, in 2001. (Photo: Pat Gorry).

32 View to the south from Baltinglass Bridge, with Bridge House (formerly the Infirmary) in 2001. (Photo: Pat Gorry).

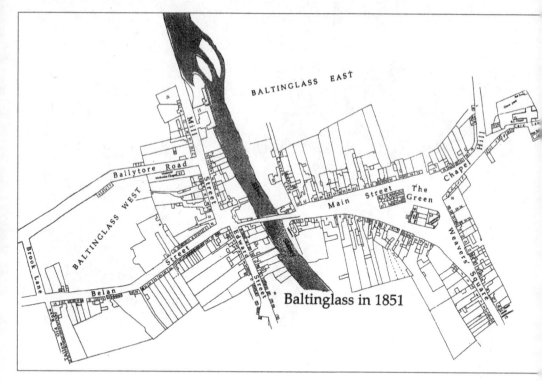

33 Map of Baltinglass in 1851.

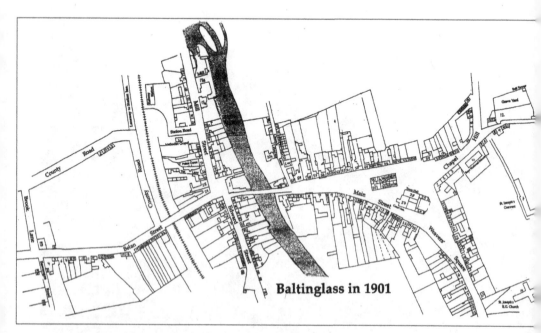

34 Map of Baltinglass in 1901.

BALTINGLASS IN 1951

Life in Ireland had been transformed over the half century between 1901 and 1951 by motor transport, electricity, radio and cinema. For the wealthy there was the availability of air transport. The monarchy had been replaced by a republic. Women had gained full voting rights. Two world wars had been fought. Despite all the changes worldwide, in many ways Baltinglass altered very little between 1901 and 1951. It retained the same small town atmosphere. Its physical structure remained static by and large, except for the addition of the large 'suburb' of Parkmore. Its landmarks were almost the same; the one noticeable difference was the addition of McAllister, but the statue was almost fifty years old by 1951.

Baltinglass probably felt bigger and more important at the beginning of 1951, as it was in the glare of media interest in the ongoing post office dispute. As a result of 'the Battle' Nellie Cooke found herself in the position of the town's most prominent citizen. The fifty-six year old assistant sub-postmistress had kept a relatively low profile existence up to just a few months earlier. Now her name was known throughout Ireland and beyond.

On 31 December 1921 Baltinglass Board of Guardians was abolished after eighty years of existence and its functions were taken over by the county council. A few years later Baltinglass Rural District Council met a similar fate. By 1951 the town was used to all local government matters being dealt with over the mountains in Wicklow town. With the abolition of Petty Sessions, in which minor legal cases had been heard by local magistrates, Baltinglass Courthouse was now only used for District Court sessions and the clerk of the court was a man living in Athy. Government and the justice system were decidedly less local than they had been in 1901.

Another change in Baltinglass between 1901 and 1951 was the disappearance of the Workhouse, burned in the 1920s and demolished in the 1930s. However, its fever hospital had been converted into the District Hospital, and it was just about to be extended. The courthouse, though also destroyed in the turbulent early 1920s, had almost immediately risen from the ashes. Beside it the Town Hall was still the focal point of life in the town, though by 1951 in private ownership. The other places of entertainment were Bradleys' Carlton Cinema in Edward Street and, for occasional dances, the Golf Pavilion. Indeed, the Pavilion took the place of the sad ruins of Stratford Lodge, overlooking the town from the side of Tinoran Hill. St Joseph's church still dominated the streetscape, with St Joseph's convent beside

it enhancing the town's overall appearance. St Mary's church still stood in contrast to the Abbey ruins. The Dublin Road approach to the town was decidedly less attractive than it had been in 1901, with the view of the millwheel and the mill's old grain stores obliterated by a functional warehouse. The Plymouth Brethren had their meeting house in Church Lane, but the Methodist chapel was by then a storehouse. As well as Stratford Lodge School, the boys' school on Chapel Hill and the girls' school at the convent, the town was by 1951, home to two secondary schools, Baltinglass Technical School and St Therese's.

By 1951 the town had lost its regular train service and public transport consisted of CIE buses. As in 1901, the market was held every Friday and the fair on the third Tuesday of every month, though about this time the cattle fair changed to a Monday. The National Bank was still the only bank. Morrins' mill was still the main source of employment, while among the shops Webbs' (then owned by R.N. Gillespie) had the largest staff. There was no industry as such.

As mentioned above, Parkmore was the main change to the structure of the town, concentrating much of the population to the south-east of the town centre, and adding four new roads. However, the fourteen council houses at Sruhaun and the smaller group on the Carlow Road at Bawnoges, were also a significant change to the shape and population spread of the town. All three provided decent housing and put an end to the overcrowding in Church Lane, while Tan Lane was all but finished as a place of habitation.

In May 1951 a meeting was held in Carrigeen and a resolution was passed calling for the Irish Land Commission to purchase and divide the large farm there, formerly owned by the Nolan family.[893] The Land Commission did eventually take over the property and, as a result, families from Mayo and Kerry came to Carrigeen and became part of the Baltinglass community.

BALTINGLASS 1951
ADMINISTRATION

County Councillors (resident within the Baltinglass area)
Paul Kehoe, Weavers' Square
Godfrey Timmins, Weavers' Square

Commissioners for Oaths (resident within the Baltinglass area)
Luke McDonnell, Main Street

Peace Commissioners (resident within the Baltinglass area)
Joseph Burke, Rathmoon House
Anthony Farrell, Knockanreagh
Patrick A. Gorry, Main Street
William G. Lyons, Parkmore House
Felix O'Neill, Weavers' Square

Clerk of District Court: Fiontain O'Braonain, Offaly Street, Athy
Registrar of Births, Deaths & Marriages: William G. Lyons, Parkmore House
Relieving Officer: James Byrne, Weavers' Square

Organisations

Baltinglass Boy Scouts
Baltinglass Dramatic Society
Baltinglass Gaelic Football Club. Officers (for 1951): Chairman- Patrick O'Brien; Hon.
 Sec. – Patrick Rohan; Hon. Treas. – William Mannering
Baltinglass Golf Club, Stratfordlodge : founded 1928. Officers (as of 1 Jan. 1951):
 Captain- Desmond B. Doyle; Hon. Sec. – J. Desmond Cullen; Hon. Treas. – Michael
 Healy; Lady Captain- Evelyn F. Doyle. Officers (for 1951): Captain- William G.
 Lyons; Hon. Sec. – J. Desmond Cullen; Hon. Treas. – Michael Healy; Lady Captain-
 Mabel Doyle
Baltinglass Golf Pavilion Badminton Club. Officers (for 1951): Captain- Dermot Mogg;
 Hon. Sec. – William Sherlock; Hon. Treas.- Mary O'Kelly
Baltinglass Hurling Club. Officers (for 1951): Chairman- Patrick O'Grady; Hon. Sec.-
 Frank Hunt; Hon. Treas.- Enda Kinsella
Baltinglass Old Age Pension Committee. Officers (for 1951): Chairman- Rev. J. Moran
Baltinglass Pipers' Band
Baltinglass Young Farmers Club. Officers (for 1951): Chairman- Charles Wynne
Holy Year Cross Committee, founded 1950. Officers (for 1951): Chairman- Patrick
 Doody; Hon. Sec. – Frank Hunt; Hon. Treas.- Felix O'Neill
Pioneer Total Abstinence Association. Officers (for 1951): Hon. Sec. – Mary O'Kelly
Tynte Lodge of the Freemasons of Ireland, Church Lane, founded 1909

PUBLIC TRANSPORT

TRAINS
CIE operating no regular passenger service; special excursion trains only

BUSES
CIE operating the following services through Baltinglass:

to Dublin (Aston Quay)

from New Ross	departing Mill Street 12.03pm	(Mon.-Sat.) [via Kiltegan]
from New Ross	departing Mill Street 6.45pm	(Mon.-Sat.)
from Tullow	departing Mill Street 7.33am	(Mon.-Sat.)
from Tullow	departing Mill Street 10.33am	(Sun.)

from Dublin (Aston Quay)

to New Ross	departing Mill Street 10.36am	(Mon.-Sat.)
to New Ross	departing Mill Street 7.09pm	(Mon.-Sat.) [via Kiltegan]
to Tullow	departing Mill Street 7.53pm	(Mon.-Sat.)
to Tullow	departing Mill Street 8.14pm	(Sun.)

STREET DIRECTORY

It has not been possible to positively identify the exact residence of the following individuals appearing in the electoral register about 1951:

Baltinglass East townland (including the eastern half of the town and most of Parkmore)

Alcock, Mary
Brennan, Josephine
Burke, Mary
Burke, Patrick
Butler, Annie
Butler, Patrick
Byrne, Anthony
Byrne, Brigid
Byrne, Catherine
Byrne, Ellen
Byrne, Mary
Byrne, Mary Ellen
Byrne, William
Carroll, Mary
Codd, Jane
Curran, John
Donegan, Patrick
Doyle, John
Duffy, William
Dunne, Mary E.
Farrell, Catherine
Foley, Mary
Fox, Nora
Fox, Thomas
Gethings, Elizabeth
Greene, Patrick
Hayden, Denis
Kelly, Frances
Lawlor, Kathleen
Lennon, Ellen
McGuinness, James
Molloy, Eileen
Roberts, Mary
Swayne, Annie
Swayne, Patrick

Baltinglass West townland (including most of the western half of the town)

Byrne, Elizabeth
Collins, Mary
Donohoe, Mary A.
Dunne, John
Gahan, Christopher
Hoctor, Vincent
Lalor, Mary Anne
Nolan, Michael

Deerpark townland
Jones, Henry

Newtownsaunders townland
Breen, Moira
Byrne, Jane
Finn, Michael

Raheen townland
Byrne, Anne
Byrne, Jane
Byrne, William

Ballytore Road, Baltinglass West townland (see County Road; Station Road)

Bawnoge ['Bawnoges'] townland (see Bawnoges Road, Carlow Road, Edward Street & Rathvilly Road)

Bawnoges Road, Baltinglass West & Bawnoge townlands
East Side
(Belan Street to 'Clough Cross')
[Baltinglass West townland]
no houses here
[Bawnoge townland]
no houses here
West Side
('Clough Cross' to Belan Street)
[Bawnoge townland]
1 farm buildings owned by Morrin
2 Humphries, Mary, Humphries, Thomas, mill worker, Black, Patrick, general worker, Black, Mary
[Baltinglass West townland]
3 ruins
4 Lawlor, James, cabinet maker, Lawlor, Julia
5 Rowe, John, farm worker, Burkes', Rathmoon, Rowe, Mary, Rowe, Paul, farm worker
6 Cashin, John, farmer
7 Lawlor, Peter, construction worker, Lawlor, Elizabeth

Belan Street ['Cuckoo Lane'], Baltinglass West townland
North Side
(Mill Street to Brook Lane)
1 see No. 29 Mill Street [Benjamin Farrell]
2 Farrell, butcher's stall, proprietor: Benjamin Farrell, Mill Street
[here bridge over railway]
[here joins County Road]
[here street bounded by a field]
3 out office owned by Jacksons of Deerpark
[here space with no houses]

South Side

(Bawnoges Road to Edward Street)

4 ruins

5 Greene, William, general worker, Greene, Mary, Greene, Christopher, general worker, Greene, Rose

6-7 ruins

8 Dowling, Brigid

9 house under construction

10 house under construction

11 house under construction

12 house under construction

13 Fleming, Patrick, farmer, Cahill, Anne, Cahill, Michael, postman

14-17 ruins

[here space with no houses]

18 ruins

19 Kenny, Christopher, retired

[here laneway to 'Gallows Hill']

20 Foster, Mary

21 house under construction

22 house under construction

23 Hunt, John, driver & mechanic, Thomas Doyle's, Main Street, Hunt, Bridget, Hunt, Teresa, retired

24 Dunne, Michael, blacksmith, Tan Lane, Dunne, Ellen

25 McInerney, Annie, retired teacher

[here bridge over railway]

26 house under construction

27 house under construction

28 Cummins, James, retired, Cummins, Mary

29 ruins

30 see No. 1 Edward Street [ruins]

The Bridge, Baltinglass East & Baltinglass West townlands
South Side

(Edward Street to Main Street)

[Baltinglass West townland]

1 see No. 29 Edward Street [William Burke]

2 Russell, Harry, Russell, Agnes

3 O'Connell, Daniel, barber[894]

[here River Slaney]

[Baltinglass East townland]

4 see No. 1 Main Street [Bridge House]

North Side

[Baltinglass East townland]

5 see No. 55 Main Street [Bridge Hotel]

6 see No. 56 Main Street [Joseph Farrell]

[here River Slaney]

[Baltinglass West townland]

7 see No. 1 Mill Street [Webbs']

Brook Lane, Baltinglass West townland
(between Belan Street/Rathmoon
Road & Ballytore Road/Tinoran Road)
East Side
1 Leigh, William, Leigh, Elizabeth
West Side
no houses here

Cabra Road, Rampere, Rampere townland
(between the 'Five Crossroads' & Goldenfort)
no houses here
[road continues into Goldenfort townland]

Carlow Road, Bawnoge, Irongrange Lower & Irongrange Upper townlands
West Side
(Edward Street to Carrigeen)
[Bawnoge townland]
no houses here
[here bridge over railway]
1 Nolan, Michael, carpenter, Nolan, Mary
2 Greene, William, general worker, Greene, Kathleen, Greene, Patrick, retired tinsmith
3 Byrne, Thomas, baker, Byrne, Ellen, Byrne, Christopher, retired baker, Byrne,
 Christopher, general worker
4 Curry, Gerald, farm worker, Curry, Elizabeth
5 Farrell, Margaret, Connell, Ellen, Bollard, Elizabeth, Farrell, Patrick
6 Fogarty, Richard, general worker, Fogarty, Teresa
[here 'Clough Cross'; Tullow Old Road & Rathvilly Road intersect]
no houses here
[Irongrange Lower townland]
7 O'Connor, Annie, O'Connor, Thomas, Murphy, James
8 Murphy, Mary, Murphy, Patrick, Murphy, Nancy, Murphy, Margaret
[Irongrange Upper townland]
no houses here
[road continues into Carrigeen, Co. Kildare at this point]
East Side
(Carrigeen to Edward Street)
[Irongrange Upper townland]
[here joins Irongrange Lane]
9 Sharpe, Mary L.
[Irongrange Lower townland]
[here entrance to No. 3 of Irongrange Lower]
[Bawnoge townland]
no houses here
[here 'Clough Cross'; Tullow Old Road & Rathvilly Road intersect]
10 out office owned by Timmins
11 Kearney, Patrick, Kearney, William, mill worker
[here bridge over railway]
no houses here

Cars' Lane, Baltinglass East townland, (see Chapel Hill)

Carsrock townland
2 Timmins, Josephine, farmer[895]
3 outhouse owned by William Kearney
[of Redwells Road, Lathaleere][896]

Chapel Hill, Baltinglass East townland
South Side
(Weavers' Square / the Fair Green to Sruhaun Road, including Timmins' [or Cars'] Lane)
1 O'Rafferty, Sean, O'Rafferty, Christina
2 Gaskin, Henry, Gaskin, Ita
3 St. Therese's Girls' Secondary School
(entrance through No. 7 further up the hill)
4 Boys' National School, principal: Richard L. Barron
other teachers: Margaret Doyle, Francis P. Hunt & Eileen Lynch
5 Clancy, Catherine, Harris, Mary Anne
(Timmins' Lane south side)
6 ruins
7 (entrance to) St. Joseph's Girls' National School
8-11 ruins
(Timmins' Lane north side)
[here side of Baltinglass Roman Catholic Graveyard]
(Timmins' Lane to Sruhaun Road)
12 Baltinglass Roman Catholic Graveyard
North Side
(Sruhaun Road to the Fair Green, Main Street)
[next five properties (13-17) a row of small houses running west off Chapel Hill]
13 Noon, Mary
14 Reidy, James
15 ruins
16-17 unoccupied (dilapidated)
18-19 ruins
20 house owned by John Lally [of Main Street]
21 Byrne, Ellen, Leydon, Gerald, lodger, engineer, Murphy, Thomas, lodger, veterinary
 surgeon, O'Donnell, John, lodger, ESB employee, Rohan, Patrick, lodger, N.S.
 teacher, Skelly, Anthony, lodger, agricultural drainage assessor
22 vacant lot
23 Hennessy, Agnes
24 ruins
25 unoccupied
26 Butler, John
27a Barron, Richard L, primary teacher
27b Labour Exchange, manager: Gerard Vincent Clarke

Church Lane, Baltinglass East townland
East Side
(Main Street to the Abbey)

1 see No. 54 Main Street [Patrick Gorry]
[here side entrance to No. 53 Main Street]
3-12 ruins
13 Stratford Lodge National School, schoolmistress: Freda Dukelow
13a Dukelow, Freda, schoolmistress
14 Tynte Masonic Lodge
15 The Rectory[897], Champ, Rev. Cyril B., Rector of Baltinglass, Champ, Sarah
16 St Mary's Church of Ireland parish church, Rector: Rev. Cyril B. Champ
17 Baltinglass Abbey (ruins of)
West Side
(Abbey to Main Street)
[here space with no buildings]
18 Connors, Mary Anne, O'Brien, May
19 ruins
20a Plymouth Brethren Meetinghouse
20B St. Kevin's, Baltinglass Civic Guard Barracks, Superintendent: Thomas Heaphy,
 Sergeant: Malachy Griffin, Guards: Kevin Browne, James Conway, John Duignan,
 Francis McPartland & Thomas Scott
20C Griffin, Malachy, Sergeant, Civic Guards, Griffin, Anne
22 see No. 55 Main Street [Bridge Hotel]

Cloghcastle ['Clough Castle'] townland (see also Rathvilly Road)
2 Fleming, Mary, Fleming, Catherine

Clogh ['Clough'] Lower townland (see also Rathvilly Road)
1a unoccupied house
5a Fennell, Patrick, farmer, Fennell, Brigid
7a unoccupied house owned by Fennell

Clogh ['Clough'] Upper townland (see Rathvilly Road)

Colemans' Road, Raheen & Rampere townlands
West Side
(Dublin Road to the 'Five Crossroads')
[Raheen townland]
no houses here
[here bridge over railway]
1 Molloy, Michael, railway man, Molloy, Patrick, Molloy, Kathleen, domestic in Convent
2 O'Brien, Terence, farm labourer, O'Brien, Elizabeth
3 Byrne, Joseph, Byrne, Christina
4 Nolan, Elizabeth
[Rampere townland]
5 O'Hara, Thomas, farm labourer, O'Hara, Bridget
East Side
('Five Crossroads' to Dublin Road)
[Rampere townland]
6 Kinsella, Terence, farm labourer, Kinsella, Elizabeth
[here joins Cabra Road]

7 out offices owned by Shortt
8 Byrne, Joseph, farm labourer, Byrne, Margaret, Byrne, Mary
9 derelict house owned by Shortt
[Raheen townland]
no houses here
[here bridge over railway]
no houses here

County Road, Baltinglass West townland
East Side
(Belan Street to Tinoran Road / Brook Lane)
[here road bounded by the railway cutting]
[here lane leading to No. 1, and to Baltinglass Golf Club in Stratfordlodge townland]
1 Station House (entrance to)[898]
[here County Road turns west]
North Side
no houses here
south side
(Brook Lane to Belan Street)
ruins here
[here County Road turns south]
West Side
no houses here

Cuckoo Lane, Baltinglass West townland, (see Belan Street)

Deerpark townland, (see also Kiltegan Road)
2 Moore, John, farmer, Moore, Mary, Moore, John, jnr., Moore, Thomas
3A ruins owned by Moore
6 Old workhouse graveyard

Dublin Old Road, Baltinglass East, Sruhaun & Tuckmill Upper townlands, (see Sruhaun Road)

Dublin Road, Stratfordlodge, Raheen & Tuckmill Upper townlands
West Side
(Mill Street to Ballinacrow Upper)
[Stratfordlodge townland]
[here livestock loading bank for Railway Station]
[here 'The Lord's Piers'; right-of-way to properties in Stratfordlodge townland]
no houses here
[here joins Raheen Hill Road]
1 Slaney Lodge, Mogg, Dermot, Mogg, Irene
[Raheen townland]
2 Byrne, Thomas, Byrne, Connie, Byrne, Mary Josephine
3 Hayden, Murtagh, cattle drover, Hayden, Bridget
[here joins Colemans' Road]
no houses here

[here Eldon Bridge; road crosses River Slaney]

[Tuckmill Upper townland]

4 Doyle, Philip, carpenter, Doyle, Mary, Doyle, Maureen, Doyle, Rita

5 O'Neill, Michael, farmer, O'Neill, Annie, O'Neill, James, farmer, O'Neill, John, farmer, O'Neill, Thomas, farmer

[here 'Tuckmill Cross'; here joins Rathbran Road]

[Tuckmill Lower townland]

no houses here

[Saundersgrove townland]

6 Edwards, Mary, Edwards, John, Edwards, Walter[899]

[here entrance to Saundersgrove estate – see under Saundersgrove townland]

[Saundersgrovehill townland]

[here the 'Hangman's Corner']

7 (entrance on road to Manger Bridge)

house owned by Esther Kehoe [of South Richmond Street, Dublin]

[here joins road by Manger Bridge to Stratford]

no houses here

[road continues into Ballinacrow Upper at this point]

East Side

(Ballinacrow Upper to Mill Street)

[Saundersgrovehill townland]

8 Moore, Patrick, County Council worker, Moore, Sarah

9 Loughlin, John, retired, Loughlin, Bridget, Loughlin, William

10 Foley, Richard, farm labourer, Foley, Mary

11 unoccupied house

[here the 'Hangman's Corner'

12 Murphy, John, farmer, Murphy, Anne Mary

13 Saundersville, Burke, Peter, farmer, Burke, Mary, Burke, Peter, jnr., farmer

[Tuckmill Lower townland]

14 Phillips, James, miller, Phillips, Maureen

15 Phillips' Mill, proprietor: James Phillips

16 ('Doyles of the Shop') Doyle, Mary Bridget, Doyle, Brigid, Doyle, Joseph

[here 'Tuckmill Cross'; here joins Kilranelagh Road]

[Tuckmill Upper townland]

17 Shortt, Martha

18 Hanlon, Edward, farmer, Hanlon, Mary, Hanlon, Patrick J., farmer, Hanlon, Sheila

19 Nolan, James, farm labourer, Nolan, Mary Josephine

20 ruins[900]

[here joins Sruhaun Road]

no houses here

[here Eldon Bridge; road crosses River Slaney]

[Raheen townland]

21 ruins (formerly Nolans)

22 ruins (formerly Byrnes)

23 ruins (formerly Fluskeys)

[Stratfordlodge townland]

no houses here

[here 'Horse Pond']

Edward Street ['Pound Lane'], Baltinglass West & Bawnoge townlands
West Side
(Belan Street to Carlow Road)
[Baltinglass West townland]
1-3 ruins
4a J. Rogers, grocery, proprietor: John Rogers, Rogers, John, farmer & grocer, Rogers, Catherine
4b Heydon, Anne Mary
5 ruins
6 P.J. McDonagh, public house, proprietor: Patrick J. McDonagh, McDonagh, Patrick J.McDonagh, Mary Josephine, Somers, Bridget, employee, domestic servant
7 Hughes, James, Hughes, Sarah, Hughes, Gertrude
8-9 Farrell, Joseph, saddler & upholsterer, The Bridge, Main Street, Farrell, Mary
10 Byrne, Patrick or Elizabeth
11 Dunne, Patrick, tailor, Dunne, Mary, Dunne, Mary (Molly)
12 Murphy, Julia, Murphy, Mary, Murphy, James, working in Webbs', Mill Street
13-15 ruins
16 Phelan, Daniel, undertaker, Phelan, Catherine, Phelan, Liam, Phelan, John
[Bawnoge townland]
17 unoccupied house
East Side
(Carlow Road to The Bridge)
[Bawnoge townland]
18 Donohoe, Thomas, farmer, Donohoe, Joseph, farmer, Donohoe, Patrick, Farrell, Michael, farmer, Farrell, Marie
19 Carlton Cinema, proprietor: Edward Bradley
20 Bradley, Edward, cinema proprietor, Bradley, Josephine, Bradley, William, Bradley, Edward, jnr., Bradley, George, Bradley, John
[Baltinglass West townland]
21 Lynch, Terence, gardener
22 Hendy, John, postman, Hendy, Julia M.
23 vacant ground
24 Norton, John, Norton, Elizabeth
25 Byrne, Bridget, Byrne, Anthony
26 Healy, Michael, primary teacher, Bigstone, Healy, Winifred
27 out office owned by Patrick Scott
28 Scott, Patrick, Scott, Brigid
29 Whelan, Margaret, dressmaker, Smith, Annie
30 S. Byrne, sweetshop, proprietor: Sarah Byrne, Byrne, Sarah
31 Wm. Burke, public house, proprietor: William Burke, Burke, William, publican, Burke, Margaret (Meta)

Fair Green, Baltinglass East townland (an alternative name for the area north of the 'south-east' block in Main Street; see Main Street)

The Flags, Baltinglass East townland, (on west side of Weavers' Square, Nos. 1-4)
1 Nolan, Peter, Nolan, Mary
2 Kinsella, John

3 Nolan, Edward, Nolan, Annie
4 Deegan, Michael, Byrne, Anastasia

Glennacanon ['Glencannon'] townland (see Tinoran Road)

The Green, (see Fair Green)

Green Lane, Newtownsaunders townland
North Side
(Kiltegan Road to River Slaney)
1 Hanley, James, Hanley, Alice, Hanley, Elizabeth, Hanley, Gerald
[here Redwells Road intersects]
2 Kelly, Edward, Kelly, James, Kelly, Elizabeth
[ends at Maidens Ford at River Slaney]
South Side
no houses here

Hartstown Road, Oldtown, Hartstown, Rampere, Tinoranhill North & Tinoranhill
 South townlands
North Side
('Tinoran Cross' to 'Five Crossroads')
[Oldtown townland]
1 Moran, Michael, farmer, Moran, Catherine
2 Gorman, Catherine, Gorman, Patrick, farmer, Gorman, John, Gorman, Thomas
3 Walsh, John, farmer, Walsh, Kathleen, Harte, John
[Hartstown townland]
4 outhouse owned by Patrick Kearney [of Tinoranhill North]
5 (entrance to) unoccupied house owned by Patrick Kearney [of Tinoranhill North]
6 Doody, John, farmer & builder, Doody, Claire
[Rampere townland]
no houses here
South Side
('Five Crossroads' to 'Tinoran Cross')
[Rampere townland]
7 Greenidge, Hilda
[here site of Rampere Church]
[Tinoranhill North townland]
8 Byrne, William
9 Kearney, Patrick, farmer, Kearney, Mary
10 Donohoe, Elizabeth
[Tinoranhill South townland]
no houses here

Hartstown townland, (see also Hartstown Road)
[shared entrance to Nos. 2a & 4 on the 'Bed Road'[901]]
2a Smyth
4 unoccupied house owned by Mary Murphy [of Lowtown]

Holdenstown Lower townland, (see also Rathvilly Road)

3 Carpenter, Abraham, farmer, Carpenter, Emily, Carpenter, Abraham, jnr., Carpenter, William

5 Whelan, Patrick, farmer, Kelly, Thomas, employee, farm labourer

9a Moore, Laurence, farm labourer

[ruins owned by Julia Farrell of Rahill]

12 Donegan, Patrick, Donegan, Mary, Donegan, Margaret[902]

HoldenstownUpper townland

1 Holdenstown Lodge, Kavanagh, M. Anthony, farmer, Kavanagh, Mary T., Kavanagh, Rosanna M., Kavanagh, Thomas, Kavanagh, Henry, Kavanagh, Agnes

4 Pollard, Robert, farmer, Pollard, Mary Jane, Pollard, Marie M.

5 Donohoe, James, Donohoe, Bridget, Donohoe, Mary

7 Balfe, Myles, farmer, Balfe, Mary Anne, Hanlon, Arthur, farm labourer

12 Jones, Alfred, farmer, Jones, Dora

14a unoccupied house owned by Carpenter

Irongrange Lane, Irongrange Upper townland
Left Side
(Carlow Road to end)

1 Kehoe, Thomas, farmer, Kehoe, Mary

2 out office owned by Kelly of Ballyraggen

3 Coogan, Patrick, farmer

End of Lane

4 Byrne, Patrick, farmer

Right Side
(end to Carlow Road)

5 Cahill, James, farmer, Cahill, Jane

6 Bookle, John, farmer, Bookle, Mary

7 Somers, Daniel, farmer, Somers, Margaret, Somers, Thomas

8 Doyle, Michael, farmer, Doyle, Catherine, Doyle, Catherine, jnr., Doyle, Seamus, Doyle, Thomas

9 Irongrange House, O'Brien, Matthew, farmer, O'Brien, Mary, O'Brien, Patrick

Irongrange Lower townland, (see also Carlow Road)

3 Kavanagh, Michael, farmer, Kavanagh, Annie

Irongrange Upper townland, (see Carlow Road & Irongrange Lane)

Kilmurry townland, (see also Kiltegan Road)

1 Lawler, Denis, Lawler, Margaret

2a gate lodge of Fortgranite estate, Doyle, John, gardener, Doyle, Nora, Doyle, Elizabeth

2b Jones, Richard, land steward, Jones, Sarah

4 Clinch, John, farmer, Clinch, Gerald, farmer, Clinch, Peter, farmer

Kilmurry Lower townland, (see also Kiltegan Road & Redwells Road)

6 Tutty, John, retired farmer

7 Farrar, John, farmer, Farrar, Mary, Jackson, Edith, Farrar, Annie

9 unoccupied house owned by Clinch

Kilmurry Upper townland, (see also Redwells Road)
1a unoccupied house owned by Farrell
1b Doyle, James, blacksmith house & forge

Kilranelagh Road, Tuckmill, **Tuckmill** Lower & Tuckmill Upper townlands
North Side
('Tuckmill Cross' to 'Kyle Bridge')
[Tuckmill Lower townland]
1 see No. 16 Dublin Road ['Doyles of the Shop']
2 ('Doyles of the Lough'), Doyle, Thomas, farmer, Doyle, Thomas, jnr., farmer, Doyle,
 Mary Bridget
3 Doyle, Patrick, farmer, Doyle, Bridget, Doyle, Thomas
4 Brien, Michael, farmer
[here lane leading to Haydens' in Ballinacrow Lower]
5 Nolan, Thomas, farm labourer, Nolan, Mary
6 Moran, Anne, Moran, Edward, farmer, Moran, Thomas
7 Moran, John, farmer, Moran, Sheela
8 Sands, William, farmer
[road continues into Kill ['Kyle'] townland]
South Side
('Kyle Bridge' to 'Tuckmill Cross')
[Tuckmill Lower townland]
9 Byrne, Michael, farmer, Byrne, Ellen
10 Dawson, John, engine driver, Dawson, Bridget
11 unoccupied house owned by Michael Byrne
[here joins Tailor's Lane]
[Tuckmill Upper townland]
12 see No. 17 Dublin Road [Martha Shortt]

Kiltegan Road, Baltinglass East, Lathaleere, Newtownsaunders, Woodfield & Deerpark
 townlands
West Side
(Weavers' Square to Fortgranite)
[Baltinglass East townland]
1 Parkmore House, Lyons, William G., physician & surgeon, registrar of births, deaths &
 marriages, medical officer to Baltinglass Dispensary, Lyons, Clare
[here joins Parkmore First Avenue]
2-9 see Nos. 9-16 Parkmore
[here joins Parkmore Second Avenue]
10-17 see Nos. 29-36 Parkmore
[here joins Parkmore Third (Beech) Avenue]
[Lathaleere townland]
18-21 see Nos. 1-4 Parkmore
[here joins Parkmore Fourth Avenue]
22-25 see Nos. 51-54 Parkmore
['Whitehall Cross'; Redwells Road continues south; Kiltegan Road turns east]
26 see No. 16 Redwells Road [Millett]
[here lands of Allen Dale, site of the former race course]
[here Kiltegan Road turns south]

27 Allen Dale, Hendy, Thomas, farmer, Hendy, Elizabeth, Twamley, Eva

28 Murphy, John, stonemason

[Newtownsaunders townland]

29 Kehoe, James, Kehoe, Elizabeth, Kehoe, Patrick

[here joins Green Lane]

no houses here

[Woodfield townland]

30 Furlong, Thomas, farm labourer, Furlong, Mary, Furlong, Anthony, Furlong, John

[Newtownsaunders townland]

[here entrance to Newtownsaunders – see under Redwells Road]

[Kilmurry Lower townland]

31 Lennon, William, farmer, Lennon, Rose, Lawler, Mary, Lennon, Patrick

32 out office owned by Donegan

33 Donegan, Thomas farmer, Donegan, Ellen, Donegan, Mary

[here joins road to Redwells]

[Kilmurry townland]

no houses here

[road continues into Fortgranite townland]

East Side

(Englishtown to Weavers' Square)

[Kilmurry Lower townland]

34 Freeman, William, farmer, Freeman, Jane

35 out office owned by Freeman

[Woodfield townland]

[here joins road to Talbotstown]

36 McDonnell, Patrick, farmer, McDonnell, Rose

37 Burke, John, farmer, Burke, Annie, Whelan, Martin

[here shared entrance to No. 38, and to Nos. 1, 5 & 6 of Woodfield townland]

38 Byrne, John, farmer, Byrne, Julia

[Newtownsaunders townland]

39 (entrance to, opposite Green Lane), Finn, John

40 Fox, John, Fox, Mary

41A Baltinglass District Hospital under Wicklow County Council, medical officer: P.J. Lord, Weavers' Square (temporary whole time), matron: Margaret Browne. Browne, Margaret, matron, Collins, Ellen, nurse, Dalton, Josephine, nurse, Lowe, Elizabeth, nurse

41b hospital gate lodge, McDonnell, Daniel, ambulance driver, McDonnell, Josephine

42 Byrne, Michael, Byrne, Jennie

43 Cullen, Esther

[Deerpark townland]

44 Lennon, Laurence, Lennon, Julia, Lennon, Robert

45 "The Spout" (entrance to), Jackson, Susan, Jackson, Peter, Jackson, John, Jackson, Charlotte, Jackson, Margaret E.

46 Finn, Patrick, Finn, Esther

47 Cullen, Patrick, Cullen, Annie

48 Jones, Margaret

49 Deerpark House (entrance to) Hendy, John, farmer, Hendy, Emily

50 Conway, Agnes

51 Nolan, sweet shop, ('Locky Nolans'), Nolan, Mary, Darcy, Thomas, lodger, overseer,
 Wicklow County Council, Power, Maureen, lodger, teacher, Technical School
[here lane leading to No. 52, and to Nos. 2 & 3A of Deerpark and No. 3 of Carsrock
 townlands]
[Lathaleere townland]
52 Doran, Thomas
[here Kiltegan Road turns west]
no houses here
['Whitehall Cross'; Kiltegan Road turns north]
no houses here
[Baltinglass East townland]
53 Kehoe, Peter, Kehoe, Elizabeth
54 Lennon, Brigid
55a Parochial House, Doyle, V. Rev. Patrick, Parish Priest, Farrell, Elizabeth,
 housekeeper
55b Parochial House [Curates' residence], Moran, Rev. James, Roman Catholic curate,
 O'Mahony, Rev. William, Roman Catholic curate, Cranny, Nancy, housekeeper

Knockanreagh Road, Baltinglass West, Glennacanon, Knockanreagh & Rathmoon
 townlands
West Side
(Tinoran Road to Rathmoon Road)
[Knockanreagh townland]
1 Pigott, Andrew, labourer
2 Farrell, Anthony, farmer, Farrell, Mary Ellen
[Rathmoon townland]
no houses here
East Side
(Rathmoon Road to Tinoran Road)
[Baltinglass West townland]
no houses here
[Knockanreagh townland]
3 Twyford, Michael, farmer, Twyford, Josephine
[Glennacanon townland]
no houses here

Knockanreagh townland, (see Knockanreagh Road & Tinoran Road)

Lathaleere townland, (see Kiltegan Road, Parkmore & Redwells Road)

Main Street, Baltinglass East townland
South Side
(The Bridge to Weavers' Square)
1 Bridge House, Clarke, Margaret, Clarke, Rebecca (Ruby), Clarke, Annie, Eager,
 Elizabeth, employee, shop assistant
2 ruins
3 Kearney, Patrick, Kearney, Margaret
4 McGeer, Mary

.5 Murray, James, Murray, Marcella

6 National Bank, manager: Thomas Liston, Liston, Thomas, bank manager, Liston, Natalie

7 Douglas, drapery, Davis, Arthur H., Davis, Margery, Morrison, Harriet, employee, shop manager

8 McDonnell, Luke, Commissioner for Oaths, McDonnell, Frances

9 Thomas P. Doyle, proprietor: Thomas P. Doyle, Doyle, Thomas P., Doyle, Mabel, Doyle, May, Brophy, James, employer, shop assistant, Brophy, Peter, employee, shop assistant

10 Doyle, John A., cattle dealer, Doyle, Margaret, teacher, Baltinglass Boys' N.S.

11 ('Dublin Byrnes') Byrne, Anna M. (Nan), Byrne, Margaret M. (Maggie), Byrne, Brigid M.

12 A.J. Flynn, drapers, proprietor: Albert J. Flynn, Flynn, Albert J., draper, Flynn, Eileen, Hendy, Phyllis, employee, shop assistant

13 Lally, John, Lally, Christina

14a T.C. Cooke, drapers, Cooke, Anne, draper, Cooke, Sarah, clerk, Robinsons'

14b Robinson, turf accountants, clerks: Sarah Cooke & Bernadette Hayes

15 ('Mackey Byrnes'), Byrne, Patrick J., farmer, Byrne, Margaret

16 Sheridan, public house, proprietor: Bernard Sheridan, Sheridan, Bernard, publican, Sheridan, Maureen

17 Dwan, John, Dwan, Johanna

18 ('Saxie Byrnes'), Byrne, Peter

19 Kehoe, tea rooms, proprietor: Mary Kehoe, Kehoe, Mary, Kehoe, Patrick

20 Gorman, Anne

21 Doran, William, Doran, Maureen

22 McCann, Reginald, bicycle dealer, McCann, Katherine, McCann, James, McCann, Thomas

23 O'Grady, Patrick, O'Grady, Bridget, O'Grady, Patrick, O'Grady, Thomas

24 Leybourne, Simon retired farmer, Stewart, Eliza

South-East Block

(south face)

25 Hooper, Benjamin, principal, Technical School, Hooper, Nina, Judge, William, engineer

[here side of No. 26]

(west face; facing into Market Square)

26 Courthouse, clerk: Fiontain O'Braonain, Offaly Street, Athy

27 Baltinglass Town Hall, proprietors: James & Mary J. Hughes, 30 Parkmore

(north face; facing into the Fair Green)

[here side of No. 27]

28 Murphy, Thomas, teacher, Technical School, Murphy, Josephine, Turner, Louise

(east face; facing into Weavers' Square)

[here sides of Nos. 25 & 28]

North-West Block

(east face; facing into the Fair Green)

no houses here

(south face; facing into Market Square)

29 Lalor, Thomas, porter, National Bank, Lalor, Mary, Lalor, Patrick, mill worker, Morrins'

30 Harte, John, tailor

31 Hearns, James, retired butcher

32 Rose, Joshua

(west face; facing into Market Square)

[McAllister Monument in front of Nos. 33 & 34, facing bridge]

33 Byrne, James J. & Son, drapers, proprietors: Byrnes, Kilcullen, Byrne, Catherine Mary, draper

34 McLoughlin, Julia, Mooney, Annie

(north face)

35 Byrne, John, Byrne, Josephine

36 Breen, Peter, Breen, Agnes

37 Lawlor, James

38 Coventry, William, painter

North Side

(Chapel Hill to The Bridge)

[No. 39 facing the Fair Green]

39 Baltinglass Technical School, principal: Benjamin Hooper, Main Street

other teachers: Thomas Murphy (woodwork); Maureen Power (domestic economy)

40 'The Steps', Burke, William, carpenter, residence: Weavers' Square

41 out office owned by Thomas P. Doyle

42 Heydon, Mary, sacristan, Foley, Christopher, steward, golf club

43 Malone, Thomas, shoemaker, residence: 11 Parkmore

44 O'Kelly, Edward J., O'Kelly, Katherine, O'Kelly, Mary

45 J.D. Cullen, chemist, proprietor: J. Desmond Cullen, Cullen, J. Desmond, pharmacist, Cullen, Angela

46 O'Neill, public house, filling station & hackney service, proprietor: M. Joseph O'Neill, O'Neill, Dora, O'Neill, M. Joseph, publican, O'Neill, Eileen

47 W. Quinn, proprietor: William Quinn, Quinn, William, Quinn, Mary T., Farrell, Rose, employee, clerk, Germaine, Joseph, employee, shop assistant, O'Toole, Sean, employee, shop assistant

48 Johnston, Mary B. (Connie), Johnston, Colette, Kearney, Elizabeth, employee, domestic servant

48a Richard Power, turf accountants, clerk: Aileen O'Mahony

49 Patterson, Michael, Patterson, Julia

50 McLoughlin, John, McLoughlin, Frances

51 Heaphy, Thomas, Superintendent of Civic Guards, Heaphy, Anne

52 Garryowen, as follows:

52a Roughan, Gerard, shop assistant, H. Doyle's, Roughan, Mary, nurse,

52b Doyle, Fintan S., Doyle, Angela

52c T.F. Millett, solicitors, proprietor: Thomas F. Millett, Redwells Road

53 H. Doyle, proprietor: Hugh C. Doyle, Doyle, Hugh C.[904], Doyle, Evelyn, Finnegan, John, employee, shop assistant, Olwell, John, employee, shop assistant

54 J. Gorry, chemist, proprietor: Joseph Gorry, Naas, Gorry, Patrick A., pharmacist, Gorry, Eileen

[here joins Church Lane]

55 Bridge Hotel, proprietor: J. Anthony Harbourne, Harbourne, J. Anthony, hotel proprietor, Harbourne, Nora, O'Mahony, Aileen, boarder, clerk, Walshe, Patrick, boarder, agricultural inspector

56 Farrell, saddler & upholsterer, proprietor: Joseph Farrell, Edward Street

Market Square, (an alternative name for the areas south and west of the 'north-west' block in Main Street – obsolete by 2001; see Main Street)

Mattymount townland, (see Rathbran Road)

Mill Street, Baltinglass West townland
East Side
(The Bridge to Dublin Road)
1 Webbs, proprietor: R.N. Gillespie, Carlow, manager: Frank W. Richmond, Richmond, Frank W., Richmond, Sarah
[Nos. 2 & 3 facing south]
2 stores owned by R.N. Gillespie
3 J. Donohoe, public house ('The Hollow'), Donohoe, James, Donohoe, Mary
4 unoccupied house owned by Michael Breen
5 Breen, sweetshop, proprietor: Michael Breen, Breen, Michael, Breen, Mary Teresa
6 out office owned by Michael Breen
7 unoccupied house
8 Jackson, public house, proprietor: Annie Jackson, Jackson, Annie (Nan), Gale, Cecil
9-10 Dunne, Mary, Dunne, Patrick garage owner, Tan Lane, Dunne, Josephine, Dunne, Eugene lorry driver, CIE
11 Simpson, Patrick, saddler
12 Pigott, John, Pigott, Alice
13a Mill House, Morrin, Esther, Morrin, Arthur, Morrin, Joseph, Dalton, Marks, employee
13b E. Morrin & Sons, mill
West Side
(Dublin Road to Belan Street)
14 Lalor, Michael, Lalor, Hannah Mary (May), O'Brien, John, lodger, shop assistant, Webbs'
15 Glynn, Frank, primary teacher, Stratford, Glynn, Anne, Fennell, Mary
16a Ward, John, Ward, Annie, dressmaker, Morrissey, Thomas, shop assistant, Webbs', Morrissey, Claire
16b unoccupied house owned by McCanns of Main Street
17 Abbey, Ellen Mary, primary teacher, Bigstone, Abbey, Robert A.
18 Cooke, Catherine, retired sub-postmistress, Cooke, Helen
19-20 O'Donohue, Mortimer, tailor, O'Donohue, Brigid, Ellis, Tom, tailor
[here Station Road intersects]
21 Jeffares, Joseph, Jeffares, Annie
22-23 unoccupied houses owned by Annie Collins
24 Duignan, John, Civic Guard, Duignan, Annie
25 Wilson, Ferdinand, Wilson, Hazel
26a Baltinglass Dispensary, medical officer: W.G. Lyons, Parkmore House
26b Cranny, newsagents, proprietor: Christina Cranny, Cranny, Richard, Cranny Christina, newsagent, Dooley, Thomas, lodger, construction worker
[here Tan Lane intersects]
27 Hutchinson, Kathleen
28 Wm. Mannering, proprietor: William Mannering, Mannering, William, tailor, Ryan, Bridie, employee, housekeeper
28a (first floor room) Revenue Commissioners

28b Conway, James, Civic Guard, Conway, Margaret E.
28c Morrin, Gerald, veterinary surgeon
29 Farrell, Benjamin, Farrell, Evelyn, Farrell, Michael, Murphy, Olive

Newtownsaunders townland, (see Green Lane, Kiltegan Road & Redwells Road)

Oldtown townland, (see also Hartstown Road)
1 representatives of Michael Keogh
6 Owens, Matthew, farmer, Owens, Mary

Parkmore Estate, Baltinglass East & Lathaleere townlands
First Avenue
[Baltinglass East townland]
North Side
no houses here
South Side
(end to Kiltegan Road)
1 Swayne, Thomas, Swayne, Bridget, McGuinness, Anne
2 Sutton, James, retired, Sutton, Ellen (Eileen)
3 Murphy, Barbara
4 Gallagher, Hugh, Swayne, Laurence, Swayne, Alice
5 Doran, John, Doran, Mary
6 Sutton, Catherine
7 Byrne, Michael, water rate collector, Finnerty, Patrick, lodger, construction worker,
 Finnerty, Bridget, lodger
8 O'Grady, Aidan, O'Grady, Mary

Parkmore, Kiltegan Road, [Baltinglass East townland]
West Side
9 Gethings, Mary, Gethings, John
10 Moran, John, hackney driver, O'Neills', Main Street, Moran, Elizabeth
11 Malone, Bridget, Malone, Thomas
12 O'Neill, Pierce, O'Neill, Annie
13 Scott, Thomas, Civic Guard, Scott, Catherine
14 McPartland, Francis, Civic Guard, McPartland, Florence
15 Ward, Margaret, Ward, Mary
16 Doody, Patrick, Doody, Josephine
Second Avenue, [Baltinglass East townland]
North Side
17 Brennan, John
18 Gethings, Patrick
19 Farrell, Peter, Farrell, Catherine
20 Gethings, James, Gethings, Nora
21 Murphy, Joseph
22 Doyle, Charles, Doyle, Mary
South Side
23 Abbott, Laurence, Abbott, Sarah, Abbott, George
24 McGeer, Elizabeth

25 Abbey, John, Abbey, Mary, Lynch, Eileen, lodger, teacher, Baltinglass Boys' N.S.,
 Begley, Bridget, lodger, teacher, Bigstone N.S.
26 McGuinn, Michael, McGuinn, Catherine
27 Doyle, James, Doyle, Ena
28 Doyle, Annie (Nan), Doyle, Mary (Molly), Doyle, Michael, postman, Doyle, Patrick,
 Doyle, Joseph, Doyle, John

Parkmore, Kiltegan Road, [Baltinglass East townland]
West Side
29
30 Hughes, James, Hughes, Mary Josephine
31 Loughlin, Jeremiah, Loughlin, Mary Ann
32 Hegarty, Thomas, farm worker, Timmins', Hegarty, Kathleen
33 Humphries, Mary Anne
34 Buchanan, Coman retired Civic Guard, Buchanan, Maureen
35 Duffy, Mary
36 McCrea, William, McCrea, Nora, McCrea, Barbara
Third (Beech) Avenue
[Baltinglass East townland]
North Side
37 McGrath, Elizabeth, Kavanagh, Charles, Kavanagh, Mary
38 Alcock, Thomas, Alcock, Bridget
39
40 Lennon, Patrick, Lennon, Sarah
41 Winders, William, Winders, Catherine
42 Shannon, Louisa,

Parkmore, Kiltegan Road, [Lathaleere townland]
1 O'Keeffe, Edward, O'Keeffe, Mary
2 Kehoe, John, Kehoe, Elizabeth
3 Nolan, Mary, Nolan, John
4 Chown, Henry, mechanic, O'Neills', Main Street, Chown, Bridget

Fourth Avenue, [Lathaleere townland]
North Side
5 Hughes, Philip, Hughes, Winifred
6 Byrne, Denis, Byrne, Kathleen, Whelan, Kate
7 Connors, John, Connors, Margaret, Doogan, Margaret, Doogan, Michael, O'Neill,
 Pierce, O'Neill, Anne
8 Wall, Bridget, McElhenny, Dina, Collins, Bernard
9 Molloy, Francis
10 Hendy, Francis, Hendy, Mary
South Side
43 O'Hara, Laurence, O'Hara, Margaret
44 Brady, Francis, Brady, Mary
45 Foley, Thomas, Foley, Catherine
46 Gethings, Edward, Gethings, Mary
47 O'Neill, Patrick, O'Neill, Mary, O'Neill, William

48 Groves, John, Groves, Anne
49 Ford, William H., retired engineer, Ford, Barbara Jane
50 Wall, William, Wall, Kathleen

Kiltegan Road, [Lathaleere townland]
West Side
51 Nolan, Daniel, Nolan, Ellen, Nolan, Julia, retired
52 Plant, John, Plant, Bridget
53 Rooney, Patrick, Rooney, Elizabeth, McCarthy, Madge, lodger, poultry instructress
54 Duffy, Thomas, Duffy, Patricia

Pound Lane, Baltinglass West & Bawnoge townlands (see Edward Street)

Raheen Hill Road, Stratfordlodge, Raheen & Rampere townlands
West Side
(Dublin Road to the 'Five Crossroads')
[Stratfordlodge townland]
no houses here
[Raheen townland]
[here bridge over railway]
1 Loakman, Thomas, retired railway man[905]
[Stratfordlodge townland]
2 Weir, Hugh, Weir, Esther
[Raheen townland]
3 unoccupied house owned by Richard O'Neill [of Oldcourt]
4 O'Hara, Peter, labourer, O'Hara, Elizabeth, Martin, James, Martin, Annie
5 unoccupied house owned by Daniel McDonnell [of Coolinarrig]
[Rampere townland]
6 Neill, Frederick G., farmer, Neill, Louisa
East Side
('Five Crossroads' to Dublin Road)
[Rampere townland]
no houses here
[Raheen townland]
7 Whelan, Patrick, farmer, Whelan, Breda
8 Cullen, Patrick, farmer, Cullen, Bridget
[here bridge over railway]
9 greenhouses owned by Mogg
[Stratfordlodge townland]
10 ruins (formerly Doodys)
11 ruins (formerly Walls)
12 see No. 1 Dublin Road [Slaney Lodge – Mogg]

Raheen townland, (see also Colemans' Road, Dublin Road & Raheen Hill Road)
9 outhouse owned by Cecil Gale [of Mill Street]

Rampere townland, (see also Cabra Road, Colemans' Road, Hartstown Road & Raheen Hill Road)

1a Leigh, Julia, farmer[906]
6a out offices owned by William Quinn [of Main Street]s

Rathbran Road, Tuckmill, Tuckmill Upper, Mattymount & Tuckmill Lower
 townlands
South Side
('Tuckmill Cross' to Goldenfort)
[Tuckmill Upper townland]
1 see No. 5 Dublin Road [Michael O'Neill]
[here Tuckmill Bridge; road crosses River Slaney]
[Mattymount townland]
2 Breen, James, barber, Breen, Dora
[road continues into Goldenfort townland]
North Side
(Goldenfort to 'Tuckmill Cross')
[Mattymount townland]
3 Crean, Michael, farmer, Crean, Mary
[here Tuckmill Bridge; road crosses River Slaney]
[Tuckmill Lower townland]
no houses here

Rathmoon Road, Baltinglass West & Rathmoon townlands
North Side
(Belan Street / Brook Lane to Carrigeen)
[Baltinglass West townland]
no houses here
[here joins Knockanreagh Road]
[Rathmoon townland]
1 Doyle, Denis, Doyle, Annie
2 Byrne, Edward, Byrne, Michael, Byrne, Annie
[here lane leading to O'Neills' house in Carrigeenhill]
[road continues into Carrigeen, Co. Kildare at this point]
South Side
(Carrigeen to Bawnoges Road)
[Rathmoon townland]
3 O'Brien, William, O'Brien, Joseph, O'Brien, Sean, O'Brien, Patrick
4 Phelan, George, Phelan, Mary
5 Rathmoon House, Burke, Joseph, Burke, Anna Mary
[Baltinglass West townland] no houses here

Rathmoon townland, (see Knockanreagh Road & Rathmoon Road)
Rathvilly Road, Bawnoge, Clogh Upper, Holdenstown Lower, Cloghcastle & Clogh
 Lower townlands
West Side
('Clough Cross' to Rahill)
[Bawnoge townland]
1 Thorpe, Deborah, Thorpe, John
[Clogh Upper townland]

2 Thornton, John William, farmer, Thornton, Elizabeth, Thornton, William, farmer

3 Doyle, Patrick, mill worker, Morrins', Lennon, Christina

4 Farrell, William, farmer, Farrell, Catherine

5 Doyle, James, Doyle, Brigid, Humphries, James

6 Molloy, Daniel, farmer, Molloy, Mary, Molloy, Bridget

[Holdenstown Lower]

no houses here

[road continues into Rahill, Co. Carlow at this point]

East Side

(Rahill to 'Clough Cross')

[Holdenstown Lower]

7 out office owned by Julia Farrell [of Rahill] (formerly owned by Rogers)

[Cloghcastle townland]

8 (entrance to) O'Brien, Catherine, farmer

9 Doody, Patrick, Doody, Margaret, Doody, Patrick, jnr. (Patsy)

10 Curry, William, Curry, Kathleen

11 Gorman, William, Gorman, John

12 Kelly, Bartholomew, farm labourer, Kelly, Esther, Kelly, James, Kelly, Michael, farm labourer, Kelly, Patrick, farm labourer

13 (entrance to), Kehoe, James, farmer, Kehoe, Bridget, Kehoe, Andrew

[Clogh Lower townland]

14 Cunningham, Margaret, Cunningham, Matthew

[here site of Rellickeen]

15 Kehoe, Andrew, farmer, Kehoe, Mary, Kehoe, John, farmer

[here shared entrance to No. 16 and No. 5a of Clogh Lower townland]

16 Kenny, John, blacksmith, Kenny, Marcella, Kenny, Michael, railway worker

[Bawnoge townland]

no houses here

The Redwells, (see Kilmurry Lower, Kilmurry Upper & Redwells Road)

Redwells Road, Lathaleere & Newtownsaunders townlands

West Side

(Kiltegan Road at 'Whitehall Cross' to Mountneill Bridge)

[Lathaleere townland]

1 Lawlor, Patrick, retired, Lawlor, Margaret

2 Kearney, John, Kearney, Joseph, Kearney, Mary, Kearney, Michael, Kearney, William

3 O'Reilly, John, O'Reilly, Mary

[Newtownsaunders townland]

4 Byrne, Thomas, Byrne, Patrick, Gaffney, Monica

[road intersects with Green Lane]

no houses here

[Slaney Park townland]

5 gate lodge, Nolan, Matthew, steward

6 Slaney Park (entrance to), Grogan, John R., Grogan, Phyllis

7 unoccupied house owned by Grogan

8 Hanley, John, stonemason

[here 'Redwells Cross'; here joins road through Holdenstown]

[Kilmurry Upper townland]

9 ruins owned by Kearney

[here Mountneill Bridge; road continues into Mountneill, Co. Carlow at this point]

East Side

(Mountneill Bridge to Kiltegan Road at 'Whitehall Cross')

[Kilmurry Upper townland]

10 Whelan, Thomas, farmer, Whelan, Mary

11 Jones, Christopher

[here 'Redwells Cross'; here joins road through Kilmurry]

[Kilmurry Lower townland]

12 Coogan, Julia, farmer, Coogan, Joseph, Coogan, John, Coogan, Laurence, Coogan, Patrick, Coogan, Peter

[Slaney Park townland]

no houses here

[Newtownsaunders townland]

13 Newtownsaunders (entrance to), Jones, John C., farmer, Jones, Anna M., Jones, Hannah

[here road intersects with Green Lane]

14 O'Neill, John, farmer, O'Neill, Bridget, O'Neill, Sean

[Lathaleere townland]

15 Clynch, Michael, Clynch, Jane

16 Millett, Thomas F., solicitor, Millett, Brigid, Bennett, Patrick, employee, gardener

Saundersgrove townland, (see also Dublin Road)

1aa Saundersgrove, proprietor: Violet Tynte, Tynte Park, Dunlavin, Bellamy, John Lytton, retired army officer, Bellamy, Madeline

1ab Byrne, Nicholas, herd, Byrne, Mary[907]

1ac Wiseman, Lucy

Saundersgrovehill townland, (see Dublin Road)

Slaney Park townland, (see also Redwells Road)

1d gate lodge under Grogan's name, (on road to Holdenstown)

Slaney View, Sruhaun townland, (see Sruhaun)

Sruhaun ['Shrughaun'], Sruhaun townland

(on west side of Sruhaun Road, Nos. 1-14)

1 Connors, Mary

2 O'Hara, Joseph, O'Hara, Kate, Sutton, William, Sutton, Margaret

3 Browne, James, Browne, Elizabeth

4 Doyle, James, Doyle, Anne, Doyle, Michael, yard man, Timmins', Doyle, Bridget

5 Cogan, John, Cogan, Sarah, Butler, Mary

6 Byrne, John, Byrne, Mary, Barrett, Margaret

7 Leigh, Ellen

8 Kinsella, Joseph, Kinsella, Bridget, Doyle, Bridget, Pearson, Nathaniel, Pearson, Elizabeth

9 Flanagan, Elizabeth

10 Barrett, Henry (Harry), Barrett, Elizabeth
11 Doyle, Elizabeth
12 Byrne, Denis, Byrne, Kate, Byrne, Margaret (Peg)
13 Dunne, Henry, Dunne, Mary, Dunne, Henry, Dunne, Margaret
14 Fleming, Patrick, Fleming, Olive

Sruhaun ['Shrughaun'] Road, Baltinglass East, Sruhaun & Tuckmill Upper townlands
West Side
(Chapel Hill to Dublin Road)
[Baltinglass East townland]
no houses here
[Sruhaun townland]
1-14 see Nos. 1-14 Sruhaun
[Tuckmill Upper townland] no houses here
East Side
(Dublin Road to Chapel Hill)
[Tuckmill Upper townland]
15 Brien, Michael, farmer, Brien, Ellen
[Sruhaun townland]
16 Humphries, Patrick, Humphries, Anne, Birmingham, William
17 Mulhall, Matthew, Mulhall, Elizabeth
[here lane to No. 14a of Sruhaun townland]
[Baltinglass East]
18 Glynn, Patrick, Glynn, Mary

Sruhaun ['Shrughaun'] townland, (see also Sruhaun & Sruhaun Road)
14a Doyle, Michael W., Doyle, Lucy

Station Road, Baltinglass West townland
North Side
(Mill Street to the Railway Station)
1 see No. 20 Mill Street [Mortimer O'Donohue]
2 Baltinglass Railway Station (entrance to)
South Side
(Railway Station to Mill Street)
3 Shortt, Martha, (store)[908]
4 see No. 21 Mill Street [Joseph Jeffares]

Stratfordlodge townland, (see also County Road, Dublin Road & Raheen Hill Road; includes Baltinglass Railway Station – entrance from Station Road, & Station House – entrance from County Road)
1 Nolan, James, Nolan, Elizabeth
4 Baltinglass Golf Club, steward: Christopher Foley

Tailor's Lane, Tuckmill, Tuckmill Lower & Tuckmill Upper townlands
East Side
(Kilranelagh Road to Coolinarrig)
[Tuckmill Lower townland]

1 unoccupied house owned by Edward Byrne
2 unoccupied house owned by Edward Byrne
3 Byrne, Edward, farmer, Byrne, Mary
[road continues into Coolinarrig Lower townland]
West Side
(Coolinarrig to Kilranelagh Road)
[here Tuckmill Hill townland – outside of area being covered]
[Tuckmill Upper townland]
no houses here

Tan Lane, Baltinglass West townland
North Side
(Mill Street to end)
1 Dunne, garage, proprietor: Patrick Dunne, Mill Street
2 vacant
3 vacant
4 Dunne, forge, proprietor: Michael Dunne, Belan Street
North Side
(Mill Street to end)
5 Fagan, Joseph, Fagan, Bridget
6 Nolan, Michael
7 ruins

Timmins' Lane, Baltinglass East townland, (see Chapel Hill)

Tinoranhill North townland, (see also Hartstown Road)
1a ruins

Tinoranhill South townland, (see Hartstown Road & Tinoran Road)

Tinoran Road, Baltinglass West, Glennacanon & Knockanreagh townlands
North-East Side
(Ballytore Road / Brook Lane to 'Tinoran Cross')
[Baltinglass West townland]
1 out office owned by O'Neill
2 O'Neill, Daniel, farmer, O'Neill, Bridget
[Glennacanon townland]
3 Giblin, Mary
4 Carton, William, Carton, Sheila
5 outhouses owned by Daniel O'Neill
6 Byrne, Catherine, farmer, Byrne, Denis, farmer, Byrne, Maurice, farmer, Byrne, James, farmer, Byrne, Kathleen
7 Pigott, Elizabeth, Pigott, Andrew, Pigott, John, Pigott, James, Pigott, Murtagh
[Tinoranhill South townland]
8 Neill, Joseph, farmer, Neill, Annie
9 Neill, John B., farmer, Neill, Eileen, Neill, William Victor
10 Byrne, Matthew, farmer, Byrne, Julia, Byrne, Maurice
[here 'Tinoran Cross'; here joins Hartstown Road; road continues into Oldtown, Lackareagh & Monatore townlands]

South-West Side
('Tinoran Cross' to Brook Lane)
[here Monatore townland – outside of area being covered]
[Tinoranhill South townland]
no houses here
[Knockanreagh townland]
11 Doyle, Peter, labourer
12 Halloran, John, labourer
13 outhouse owned by Richard O'Neill
[here joins Knockanreagh Road]
[Glennacanon townland]
no houses here
[Knockanreagh townland]
14 Wicklow County Council
Reservoir & Filter Beds
[Baltinglass West townland]
no houses here

Tuckmill Lower townland, (see Dublin Road, Kilranelagh Road, Rathbran Road & Tailor's Lane)

Tuckmill Upper townland, (see also Dublin Road, Rathbran Road, Sruhaun Road & Tailor's Lane)
11 McDonald, Catherine

Tullow Old Road, Baltinglass West & Bawnoge townlands, (see Bawnoges Road)

Weavers' Square, Baltinglass East townland
West Side
(Main Street to Kiltegan Road)
1-4 see Nos. 1-4 The Flags
5 Flynn, Patrick, shoemaker
6-7 ruins[909]
8 public house, Kehoe, Paul, publican & public representative, Kehoe, Bridget, Hutton, Ellen, retired
9 Timmins, butchers, proprietor: Kate Timmins, Brangan, Matthew employee, butcher, Lynham, Gerry, employee, shop assistant
10 Hanrahan, Denis, Hanrahan, Anne, Hanrahan, James, Hanrahan, Luke, Hanrahan, Kathleen
11 public house[910], Timmins, Kate, publican & grocer, Timmins, Godfrey, public representative, Hunt, Francis P., lodger, teacher, Baltinglass Boys' N.S.
12 O'Neill, Mary, shop, O'Neill, Felix
13 O'Neills', ice cream parlour, proprietor: Felix O'Neill
14 Lennon, Richard, Lennon, Ellen
15 Heyden, [Sarah?]
16 Walker, Alice, retired
East Side
(Kiltegan Road to the Fair Green / Chapel Hill)
17 St. Joseph's Roman Catholic Church,

Parish Priest: V. Rev. Patrick Doyle, Parochial House, Kiltegan Road, Curates: Rev. James Moran & Rev. William O'Mahony, Parochial House, Kiltegan Road

18 St. Joseph's Presentation Convent (entrance to), Russell, Mother Columba, Superior of community, Casey, Mother Evangelist, Curry, Sister Brigid, Dolan, Sister Alphonsus, Doyle, Sister Albeus, Duffy, Sister Gerard, Dunne, Sister Martha, Flynn, Mother Gabriel, Healy, Sister Dympna, McCormack, Sister Immaculata, Morrissey, Sister Therese, Murray, Sister Joseph, Naughton, Sister Vianney, O'Donnell, Sister Josepha O'Dwyer, Sister Magdalen, Ryan, Sister Angelus, Scurry, Mother Clare, Whelan, Sister Anthony

19 Kehoe Brothers, general grocers, proprietors: Joseph & Patrick Kehoe, Dublin, Burke, Martin, employee

20a J. Kenny, blacksmith, proprietor: John Kenny, Rathvilly Road, Clogh Lower

20b Byrne, Felix, carpenter, Byrne, Margaret

21 Byrne, Garret

22 Browne, Kevin, Civic Guard, Browne, Mary T.

23 Kinsella, Patrick, Kinsella, Catherine, Kinsella, Enda, Kinsella, Patrick, jnr. (Park), Kinsella, Kathleen

24 Bourne, Elizabeth, retired nurse

25 Byrne, Maurice, retired relieving officer, Byrne, James, relieving officer, Byrne, Bridget

26 Ivy Restaurant, restaurant & lodging house, proprietor: Mary Gavin, Gavin, Mary (Molly), Clarke, Gerard Vincent, lodger, manager, Labour Exchange, Lord, Patrick J, lodger, medical doctor

27 Dowling, John, cattle dealer, Dowling, Julia, Dowling, Rosanna

28 Burke, William, carpenter, Burke, Thomas, carpenter, Burke, Catherine

29 Kenna, Bridget M.

30 see No. 1 Chapel Hill [Sean O'Rafferty]

Woodfield townland, (see also Kiltegan Road)
1 out office owned by James Neill [of Carrigeen]
3 Reilly, Patrick, farmer, Reilly, Annie
5a out office owned by John Byrne
6 derelict house (formerly Crannys)
11 Jones, Frances
12 Jackson, Robert
13a Burke, Patrick
17 Moore, Daniel, labourer, Moore, Winifred

INAUGURAL MEETING OF BALTINGLASS HANDBALL COMMITTEE
TUESDAY 7 OCTOBER 1952

From 1900 the all-purpose Town Hall provided an excellent venue for handball, but after the Town Hall's functions changed it was no longer available for that purpose. Baltinglass had already produced a handball champion in Peter Nolan as early as 1928 and Matt Byrne had served as chairman of the Irish Amateur Handball Association, but by the 1950s there was nowhere in the town to play the sport. So in 1952 an attempt was made to build a handball alley.

On 7 October 1952 a meeting took place in O'Gradys' on Main Street to consider the possibility of building an alley. Those present were Jim Byrne of Weavers' Square presiding, Frank Hunt, Paul Kehoe, Johnny Kenny, Enda Kinsella, Park Kinsella, Paddy O'Grady and Godfrey Timmins. Baltinglass Handball Club was formed and a committee was appointed. Father Gahan, the Parish Priest, was elected president of the club. Subsequently he provided a site on the north side of Chapel Hill, part of the Lalor Trust property, for the alley. In January 1953 he agreed to sell the site to the club with the provison that the alley would not be turned into a dance hall at a future date. Over the space of a few months, through fundraising and voluntary construction work, it was possible to clear the site and begin digging the foundations, under the supervision of Gerry Leydon. Grants were received from GAA central funds. At a committee meeting on 16 December 1952 it was agreed that, when completed, it should be called the Matt Byrne Memorial Alley, as stipulated by the Leinster Council of the GAA.[911]

Early in 1953 the foundations were to be laid. However, by the time of the club's annual general meeting in February 1957, the alley was still unfinished and members were calling for proper playing facilities. The Gaelic football club agreed to assist in completing the project. In February 1958 the handball club had a fundraising concert in the Carlton Cinema and in March a card drive in the Golf Pavilion, hoping that the alley would be soon finished. Apparently it was completed later that year. Throughout the 1960s it got good use, but handball in Baltinglass became even more popular with the arrival in 1971 of a new Garda, John McMahon. On his initiative and with financial backing from the Fatima Hall committee, the previously open air handball alley was enclosed. As well as the roofing, a glass wall, a 250-seat gallery and changing rooms were added. The refurbished building was officially opened on 6 April 1974 with a senior doubles tournament in which many of the country's leading players competed. The winners received the Inis Fáil Perpetual Trophy, presented by Joe Germaine. Members of Baltinglass Handball Club competed successfully throughout the 1970s and 1980s, most notably when Tommy Foley won the All-Ireland Under 15 Tailteann title in 1979. John McMahon played on the Wicklow team that won the 1973 National League. In 1982 three Baltinglass players, Mel McLoughlin and John McMahon's sons Damien and Kieran, represented the county on the team that won the Leinster Juvenile League, and in 1982 and 1983 the club won the County Juvenile League.[912]

Unfortunately, after this period of renewed activity, interest in handball waned and the sport eventually died, with the handball alley becoming derelict.

NEW GARDA STATION OCCUPIED
FRIDAY 25 MARCH 1955

From the arrival of the first Civic Guards in Baltinglass in November 1922, the force was based at a number of locations before a permanent station was

constructed. The first temporary base was in Weavers' Square, where Milletts now live, while the old RIC barracks in Mill Street was being renovated. It had been damaged during 'the Troubles'. In about 1929 St Kevin's in Church Lane was rented on a long term basis. These premises were ideal for a police force but a rented house was not suitable for a permanent station.

It was not until the 1950s that a purpose built station was provided. The site obtained was on the Carlow Road, close to the end of Edward Street. The two storey station was built at a cost of £16,845 and it had accommodation for the sergeant's family to the side as well as living quarters upstairs for Gardaí. As most Gardaí lived off the premises and the force consisted of about six men, what is now Baltinglass Garda Station was a very spacious building when it was first occupied on 25 March 1955.[913]

Sergeant Malachy Griffin was in charge of the station at that time and his family moved into the attached house. Kevin Browne was the Superintendent's clerk and he was permanently based at the station. The rest of the force consisted of about four men. A few years later Kiltegan Garda Station was closed and the staff transferred to Baltinglass.[914]

NEW GIRLS' SCHOOL
SUNDAY 21 AUGUST 1955

After six decades St Joseph's Girls' School was too small for the population so a new school had to be built. The site chosen by the Presentation Sisters for the new structure was to the north of the old school, close to the convent entrance on to Chapel Hill.

Basil Boyd-Barrett of the Office of Public Works was the architect. Carberys were the contractors. Work was completed in the summer of 1955 and the official opening took place on Sunday 21 August. That day Dr Thomas Keogh, Bishop of Kildare and Leighlin, presided at a mass celebrated by Father Dermot McDermott in St. Joseph's church. Afterwards there was a procession to the new St Joseph's Girls' School, where Dr Keogh performed the blessing. The following month classes started in the new building. At the time it was a five teacher school, but the teaching staff were to an extent shared with St Therese's secondary 'top' and two extra permanent staff members were required for this. Sister Therese Morrissey was then principal and taught fifth and sixth classes, while Sisters Albeus Doyle, Immaculata McCormack, Josepha O'Donnell and Mary Magdalen O'Dwyer taught the other classes. Sisters Alphonsus Dolan and Angelus Ryan confined their teaching to the secondary school. In addition, Sister Vianney Naughton took charge of the school when it opened in the morning, supervised the lunch break, during which she gave the children cocoa and spoke Irish to them, as well as taking the cookery and laundry classes. Three retired teachers worked part-time. Mothers Brigid Curry and Columba Russell took sewing classes, while Sister Joseph Murray taught writing and music.[915]

Part of the old school, attached to the convent, was thereafter used for the junior classes of St Therese's Secondary School. As the new primary school had no facilities for cookery and laundry classes, they were held in the old school, as were Sister Joseph's music classes. In 1956 Sister Columbanus Kyne came to Baltinglass and she took over as principal. She continued until 1977 when Sister Brid Burke succeeded her. Sister Brid's successor was Sister Joan Bland in 1981. The first lay teacher in the school was Mary O'Brien, who joined the staff in 1969. A second lay teacher was engaged in 1980, and a third in 1981. There were then only two nuns in the school, along with three lay teachers. In 1990 the Presentation Sisters left Baltinglass after 117 years in the town. At that point Sister Joan was succeeded as principal by Betty Quinn, who continued in the role till 1996. In that year St Joseph's Girls' School amalgamated with St Pius X Boys' School to become Scoil Naomh Iósaf. From then the children up to second class were taught in what had been the girls' school and third to sixth classes were taught in the former boys' school.[916]

FOURTH WIN IN A ROW FOR BALTINGLASS MINORS
SUNDAY 11 DECEMBER 1955

Baltinglass GAA Club came to maturity in the 1950s, developing a senior football team that was to win the county championship in 1958. From then on it was constantly replenished with new players that kept Baltinglass to the fore in Wicklow football for the rest of the twentieth century. The seeds of that prosperity were sown at minor level in the early 1950s.

The minor county championship of 1940 and the junior championship of 1943 had been won by Baltinglass but by 1949 the club's standard of football was so low as to draw unfavourable comment from the then hon. secretary, Jim Brophy. There was improvement, as the club reached the final of the intermediate championship in 1951 and 1953, being beaten by Roundwood and Annacurra, respectively. However, it was at minor level that the club was making steady progress. In 1952 the minors brought the county championship to Baltinglass for the second time ever, beating Glenealy. The team members then were Pat Abbott, Ken Browne, Peter Doyle, Bill Farrell, Sean Farrell, Paddy Fogarty, Kieran Gavin, Charlie Nolan, Edmond Nolan, Jim O'Keefe, Kevin O'Neill, Jimmy O'Reilly, Tom O'Reilly, Michael Patterson and Peter Timmins.[917]

They retained the cup in 1953 and 1954, beating Newtown both times, and progressed to the 1955 final where they again met Newtown in Aughrim on 11 December. Conditions were bad, with the pitch badly cut up after the preceding game, but the pace was fast from the beginning and the standard of play was high. There was little between the teams until the last quarter, when Baltinglass took the lead for the first time and they won by 2-5 to 0-3. The Baltinglass scorers on that occasion were Noel Scott and Micheál, Healy with a goal and a point each and Harry Fay with three points.[918]

Four minor county championships in a row set a record. Two players had featured on all four winning teams. They were Ken Browne and Edmond Nolan. In fact, they won five minor medals during those four years, as they were also on the winning Baltinglass minor hurling team in 1954. Two other players, Bill Nolan and Michael Patterson, featured on three of the winning football teams. Many of the players who brought the minor championships home to Baltinglass were to mature into the nucleus of the senior team later in the decade.[919]

FIRST WIN IN COUNTY CHAMPIONSHIP
SUNDAY 26 OCTOBER 1958

It was a night of great celebration in Baltinglass. Never before had the local club won a senior county title. The town 'rejoiced as never before' but it was only the beginning of a very long list of senior wins.

Following the Baltinglass minors' run of success, it was inevitable, assuming that the momentum was maintained, that the club would have an adult team to contend with in a few years. The club had unsuccessfully contested two intermediate county championships in the early 1950s but then in 1954 the grade was abolished and Baltinglass was promoted to senior level. With that premature promotion the club might have been expected to sink without trace, but instead they rose to the challenge. In 1955 they reached the senior county semi-final, being narrowly beaten by the eventual winners, St Patrick's of Wicklow. In 1956 they played against St Patrick's in a final and drew, but lost the replay. The Baltinglass team on that occasion was Peter Brophy, Ken Browne, Bill Burke, Bill Curry, Paddy Doyle, Tom Doyle, Francis Hendy, Hugh Kelly, Johnny Kenny, Bill Nolan, Charlie Nolan, Edmond Nolan, Sean O'Toole, John Rogers and Peter Timmins.[920]

In 1957 Baltinglass lost in the early stages to Donard, who went on to win the title. However, the minors won again, giving Baltinglass five championships in six years. At the club's annual general meeting in February 1958, the hon. secretary, Peter Brophy, stated that the purchase of a playing field of their own was a major event in the history of the club and he appealed to members to give their time and labour to develop the pitch. The idea of buying a field had arisen in 1953 and fundraising brought in more than the amount needed to secure a site in 1957. Prior to that the club had rented a field beside the river near Parkmore from the Kehoe family of Weavers' Square. The new site, which was purchased from Jimmy Hanley, was in Newtownsaunders, adjacent to the Kiltegan Road and it became the permanent home of Baltinglass GAA Club. In September 1959 the field was being levelled and the first match played in it was an O'Byrne Cup encounter between Wicklow and Longford in 1963.[921]

In 1958 the senior championship came to Baltinglass at last. The final was against St Patrick's and reportedly over 3,000 spectators poured into Aughrim. It was preceded by the final of the Dublin Wicklowmen's Cup, an Under 16's event in which a Baltinglass team captained by Bobby Nolan beat Newtown 1-7 to 1-2.

After the first half of the senior final, Baltinglass were trailing by four points and their trainer, Danny Douglas gave the team a stern talking to at the break. Then in the thirteenth minute of the second half George Deering scored a goal. In the next five minutes another goal and two points were added to the Baltinglass tally and a historic first victory was secured. The team fielded was Parkie Bookle, Ken Browne, Bill Burke, Bill Curry, George Deering, Harry Fay, Hugh Kelly, Johnny Kenny, Paddy Laverty, Tommy Leigh, Charlie Maguire, Charlie Nolan, Edmond Nolan, John O'Connell and John Rogers (in goal), while Peter Timmins came on in the second half in place of Burke.[922]

The two winning teams were met at Whitehall Cross at eight p.m. by a crowd of supporters led by a pipe band. The two captains, Johnny Kenny for the seniors and Bobby Nolan for the Under 16s, led their teams, carrying the cups aloft. In the town the speeches were begun by the club chairman, Godfrey Timmins. The hon. secretary, Peter Brophy, and the trainer, Danny Douglas, were given special thanks for the role they played in the preparation for the victory. The town celebrated with the customary bonfire and after-hours drinking in the pubs. This was the first of many senior celebrations, but the first is always more memorabe than any others.[923]

CLOSURE OF THE RAILWAY LINE
MONDAY 1 JUNE 1959

Though the regular passenger service had finished twelve years earlier, Baltinglass still maintained its railway up to 1959. Monthly livestock trains were run for the fair and there was the occasional special passenger service for excursions. However, the Sallins to Tullow line had long been unprofitable for CIE and when it was finally closed on 1 June 1959 it was no great surprise.[924]

During the last decade of the line's existence, Mr. Owens was the stationmaster in Baltinglass. He moved to Dublin when the line was closed. The Station House was sold at public auction in July 1959 and went for £550. The tracks and sleepers were pulled up, with the sleepers being sold locally. Baltinglass Golf Club purchased a quantity of sleepers for £6. CIE even disposed of the land on which the line was laid. Many years later the railway cutting on both sides of Belan Street was filled in. The ticket office and the surrounding land were acquired by Willie Quinn of Main Street and grain stores were built to the north of the ticket office. In 1967 the cattle mart was developed on the site of the railway line between Mill Street and the Lord's Piers. Later Quinns built large grain bins on the tracks behind the ticket office and the stretch of Station Road between the ticket office and the old Methodist meeting house was absorbed into a big yard that now stretches to the car park in front of Quinns' Super Store.[925]

In 1963 the course of the Carlow Road was altered and widened from just south of the Garda Station, removing the bottleneck created by the old railway bridge there.[926] The bridge later became an entrance to two private houses. The filling in of

the railway cutting left the bridge in Belan Street unrecognisable as a bridge. Houses were built on the site of the cutting on the County Road. By the end of the century the only visible signs that there was ever a railway passing through the area, were the bridges at Colemans' Road, Raheen Hill Road, Holdenstown and off the Carlow Road at Bawnoges, as well as the Ticket office (now housing Quinns' office) and the redbrick Station House.

OPENING OF ST PIUS X NATIONAL SCHOOL
MONDAY 24 AUGUST 1959

Just as the girls' school built in the 1890s was replaced six decades later, the Boys' National School on Chapel Hill, with its four classrooms was seen to be outdated by the 1950s and it too was replaced. The site chosen for the new school was on the Kiltegan Road, opposite Parkmore. It was on the most southerly part of the lands acquired for the Catholic parish by Father Lalor in the mid-nineteenth century.

By the time the new building was constructed in the summer of 1959, Dick Barron, who had been principal of the school since 1923, had retired. He finished his teaching career on Chapel Hill and the new school had a new principal, appointed a few weeks before the opening. This was Frank Glynn of Mill Street. Though he had lived in the town since the early 1940s, he taught at Bigstone and Stratford before taking charge in Baltinglass.[927]

Again like the girls' school, the new boys' school was designed by Basil Boyd-Barrett, architect with the Office of Public Works. It was constructed by Hannon Brothers of Fairview in Dublin, with four classrooms accommodating 180 pupils. The school was dedicated to St. Pius X, the early twentieth century Pope who had been canonised in 1954. On Sunday 23 August 1959 the building was blessed and the following day it was formally opened with mass celebrated there.[928]

Frank Glynn taught fifth and sixth classes. The other three teachers he joined had worked in the old school before the transfer. These were Peg Doyle, who taught the infants, Eileen Lynch, first and second classes, and John McGrath, third and fourth classes. Many years later when class sizes expanded a prefabricated classroom was added at the back of the building beside the playground. In the 1980s that was replaced by a permanent structure with several new rooms. Frank Glynn retired in September 1977 and he was succeeded by Tom Hannafin. In September 1996 the school amalgamated with St Joseph's Girls' School to become Scoil Naomh Iósaf. From then the children up to second class were taught in what had been the girls' school and third to sixth classes were taught in the former boys' school. After 2001, which is the last date covered in this book, a large extension to the original St Pius X school was opened in September 2002 and the former girls' school was closed within two months.[929]

SEAN HUNT IMPRESSES IN GOLF
THURSDAY 27 AUGUST 1959

Sean Hunt of Belan Street was the first Baltinglass native to make an impact in the world of championship golf. During the 1959 season he reached the finals of three of the four provincial championships in boys' golf. He did not compete in the Ulster championship and at the time there was no Irish Boys' title, nor was there an international series at that level. Undoubtedly Hunt would have been an automatic choice for the Irish boys' team, had there been one in 1959.

Sean started playing golf at the age of eight in 1951, and in his early teens he took lessons from Ernie Jones, the professional in Carlow. In 1957 he first entered a championship competition, the Leinster Boys'. He was then aged fourteen. The following year he played well in club competitions and reached the quarter-finals of the Leinster championship. Then in July 1959 he got to the final of the Connaught Boys' at Athlone. He and his opponent stood all square on the eighteenth tee, but he lost the hole and the championship. The next week he competed in the Munster Boys' at Thurles. He again fought his way into the final, going down by 2/1 against a local player. The Leinster Boys' was at Edmondstown the following month and Hunt reached a third championship final. Many travelled from Baltinglass to watch the sixteen year old perform on 27 August but he suffered his third defeat. After that he played for Leinster in an interprovincial match against Connaught and won both his games.[930]

Though he would have been eligible to play in boys' competitions again in 1960, Hunt made the decision to become an assistant professional, and in March 1960 went to England as assistant to Alec Booth in Nottingham. He was the leading money winner in the Notts Amateur and Professional Golfers' Alliance in 1961-62 and 1962-63, and he was given the opportunity to play the professional circuit in 1964. In the Carrolls International Tournament at Woodbrook he returned a second round of sixty-four to equal the best score of the day. That year he captured his first title, the Nottinghamshire Open. In 1965 he won the Midland Professional championship and was in a play-off with David Butler and Tony Jacklin for the British Assistants' championship that August. Jacklin, a future winner of The Open and the U.S. Open, won the Assistants' title, but Hunt regarded this event as the highlight of his career.[931]

In December 1965 Sean travelled to Africa for a sponsored tour, returning there in the winter of each of the following few years. He won Lord Derby's Assistants' Tournament at Formby in 1966. At Hoylake in 1967, playing in The Open for the first time, Hunt drew attention with a hole-in-one at the thirteenth. Later in the season he won the Midland Assistants' championship and the Wills Variety Club Tournament. For the latter he received the largest prize of his career, £275, and beat a field that included Jacklin and Peter Thomson. His highest position in the PGA Order of Merit was thirty-third, which he reached in 1968. The following season he won the Irish Assistants' title at Dundalk, and later that year he became

professional at Saltburn in Yorkshire. Though he played the circuit regularly for a few more years, his duties at Saltburn reduced his opportunities to compete. He later left professional golf altogether for a time, before returning as professional at Thurles.[932]

MICHAEL MCGUINN KILLED IN THE CONGO MASSACRE
TUESDAY 8 NOVEMBER 1960

The massacre of eight United Nations peacekeepers near the village of Niemba in the Congo in November 1960, made news headlines throughout the world. The story held more immediacy and sorrow for Ireland as the soldiers were Irish. Baltinglass was particularly touched by the tragedy because one of them, Michael McGuinn, had grown up in the town.

Ireland joined the United Nations in 1955 and in 1958 fifty Irish officers were sent as observers to Lebanon. On 30 June 1960 Belgium granted independence to Belgian Congo but within a week the country was in political turmoil. At the request of the Congolese government, the UN sent in peacekeeping troops in July. On 27 July Ireland's first overseas peacekeepers left for duty in the central African country. The political instability grew, and by November there were four competing governments in the Congo. The Irish had their headquarters at Albertville (now Kalemie) near Lake Tanganyika.

On 8 November, Lieut. Kevin Gleeson and ten members of A Company, 33rd Battalion, were on patrol near the village of Niemba when they were attacked by a very large force of Baluba tribesmen. There are conflicting reports of what exactly happened, but nine of the eleven men, including Private Michael McGuinn from Baltinglass, were brutally murdered.[933]

Michael McGuinn was born in Baltinglass in about 1939. He was the eldest of five children of Michael McGuinn, a soldier, and Kitty Bollard, a Baltinglass native, of Belan Street. The family moved to 26 Parkmore, in the Second Avenue, and later to Dublin. Michael joined the army as a teenager and he married Betty Keating of Staplestown Road in Carlow in June 1959. He was based at Clancy Barracks in Dublin before volunteering for service in the Congo. It was his first time to leave Ireland. At the time of the Niemba Ambush his wife was expecting their first child. She heard on the radio that a group of Irish soldiers were missing and presumed dead. Later two officers came to tell her that her husband had been one of the victims.[934]

The bodies of the nine Irish soldiers killed in the attack were flown back to Baldonnell Aerodrome and there was a state funeral on Tuesday 22 November, a fortnight after the ambush. Hundreds of thousands are said to have lined the streets as the procession passed through Dublin. Lieut. Gleeson's coffin was borne on a gun carriage, followed by the coffins of his men, carried in pairs on lorries. The nine were buried in a special plot in Glasnevin Cemetery. The people of Baltinglass had a novena of masses offered for Michael McGuinn. On 3 February 1961 his son Michael was born.[935]

THE FLOOD
WEDNESDAY 17 NOVEMBER 1965

A heavy snowfall and a rapid thaw were said to be responsible for what was for decades after simply referred to as 'The Flood'. On the evening of 17 November 1965 the waters of the Slaney started to spill into the streets of Baltinglass. By the next morning most houses in Main Street and many in Weavers' Square and Parkmore, as well as some in Mill Street, were flooded. So powerful was the surging river that the Building Bridge at Stratford and Tuckmill Bridge gave way, and there was real fear that Baltinglass Bridge would not sustain the force. At its height the water reached the ceiling of Murrays' shop in Main Street and it was up to four feet in many other premises.[936]

The flooding was not confined to the Baltinglass area or to the Slaney. Various towns were effected on this occasion. However, County Wicklow felt it more than other areas and Baltinglass was one of the worst areas in the county. Certainly it was regarded in the town as the most devastating in memory. The 1883 flood appears not to have been nearly as severe. There were several floodings between then and 1965, but none were comparable to this event. As the levels rose, water came up Church Lane and also around the back of the Abbey and along the low fields towards the Technical School. From there it streamed across the Green, into the houses on the south side of Main Street, and flowed down the street towards the bridge. The water reached the top of the counter in Peter O'Kelly's bar (now Germaines'), while Reggie McCann had to be rescued through an upstairs window by the fire brigade. Surprisingly, some premises on Main Street were left unscathed. What is now Brian and Carol Matthrews' house, then occupied by Lords, had no ground floor flooding. There was a legend in the town that the Cistercian monks had altered the course of the river in order to build the mill and weir, and that the river was taking its old course. Certainly the Abbey was built on higher ground than the land on both sides. There is physical evidence that the river did at some point flow to the east of the Abbey. However, it is possible that the Slaney's course altered naturally over several hundreds of years and that this had happened before the Cistercians arrived in the twelfth century.[937]

Among the premises damaged on Main Street were Clarkes' Bridge House, Murrays', the National Bank, Flynns', Cookes', Billy Lee's (now Kinsella Estates), Dorans', Reggie McCann's, Brendan McDermott's (now the Credit Union), O'Kellys', Des Cullen's, Fintan Doyle's, Gorrys' and the Bridge Inn (owned by Tony Harbourne). In Church Lane St Kevin's was flooded. In Mill Street Gillespies', Jacksons', Morrins' mill, Mickie Lalor's and Glynns' were damaged. Dogs, pigs and poultry were drowned. Parkmore was 'like a lagoon' with water four feet deep, and many people had to be evacuated through upper windows by the fire brigade. Sewage was discharged from pipes around Parkmore and floors were covered with unsanitary scum. There was damage to the foundations of the National Bank, with a crack appearing on the gable wall. The manager, Peter

Prendergast, and his wife had to vacate the house and a cement company was called in to repair the damage.[938]

The council workers, under the supervision of Jack Keogh, the Gardaí and the fire brigade were busy throughout the time, warning people, evacuating elderly residents and afterwards pumping out houses and generally clearing up the damage. The members of Baltinglass fire brigade, Paddy Doody and his son Billy, Frank Brady, Tom Duffy, Tony Duffy, Paddy Fleming and Paddy Lennon, were given special praise. The fire brigade had come a long way from the days of the Emergency, when in 1941 the County Board of Health provided the town with its first fire engine and trailer pump. At the time of the flood the fire engine was kept in the yard behind the Courthouse. In 1969 a new fire station was built on the Green, beside the loading bank.[939]

After the flood had almost completely subsided there was a deep pool, at the slipway beside the bridge, which had been dug by the water. Two separate accidents happened at the spot when people, thinking the water level was only a few inches, walked into the pool and very nearly drowned.[940] The 1965 flood was possibly the biggest flood in Baltinglass in the past two hundred years. It was thirty-five years before there was a flooding remotely approaching its devastation, but even then it was tame in comparison.

OPENING OF THE BALTINGLASS CATTLE MART
MONDAY 29 MAY 1967

The closure of the railway in 1959 brought an end to livestock trains for Baltinglass fair, which in turn eventually led to the demise of the fair. From then on local farmers had to transport their animals to Blessington or Tullow for sale. There was an opening for an alternative in Baltinglass and so the Cattle Mart came into operation in May 1967.

Traditionally the fair in Baltinglass was held on the third Tuesday of the month. Though one would expect it to have been held at the Fair Green, it was so large in its heyday that it spread throughout the town. Farmers would drive their livestock to town in the very early hours of the morning so as to ensure a good place. By the 1950s things had altered so that the monthly cattle fair was on the Monday, with a pig market every Tuesday. The market was still on a Friday. It was confined mainly to some farmers selling produce around McAllister and there were not many stands selling other items. In January 1953 the concrete loading bank at the edge of the Green (between the present Fire Station and Luigi's) was completed and it was used on the fair day in February. The cost of its construction was borne mainly by Macra na Feirme, but the county council took responsibility for it thereafter.[941]

In Ireland in the 1950s the traditional fair came under threat from the new phenomenon of livestock sales or marts. Instead of several dealers haggling with the individual farmers throughout the fair, most likely in a pub, the animals were

auctioned at a sales ring. By and large it made no real difference to the farmer, as neither system was guaranteed to give him a good deal. However, the dealers were naturally opposed to the mart system as it constricted their practices. The first attempt at introducing a livestock sale into Baltinglass was in late 1955. Joe O'Neill of Main Street transformed the paddock at the back of his premises (now part of Quinns') into a cattle mart. It appears that he was already hosting a pig market in his yard on Tuesdays. Pens were constructed and a covered sales area was to be built with seating for four hundred people. The first cattle sale in Joe O'Neill's yard was on Friday 16 December 1955 with a temporary covered ring. There was an official opening and a blessing before business started at eleven a.m. The sales were conducted by Clarke Delahunt & Co. of Wicklow. On this first occasion over seventy-five per cent of the cattle on offer were sold at good prices.[942]

O'Neill's attempt at a cattle mart lasted a little over a year. There were monthly sales up to at least December 1956, but they had ceased soon afterwards while the Baltinglass cattle fair continued. The fair was still in operation in early 1963 but wound up sometime thereafter. Late in 1965 there was a meeting to discuss how to replace the defunct fair. It was decided to invite in an established mart company to operate in Baltinglass but when arrangements did not work out it was decided to start a local livestock sales company. An appeal was made for subscribers and reportedly within three weeks £3,000 had been collected. Bobby Lennon was chairman of the subscribers' association and Donald Waldron, then manager of the National Bank, was secretary and treasurer. The four acre location for the new mart was obtained from Willie Quinn and it was on the site of the railway adjacent to the Dublin Road, where the original Stratford Lodge School had stood. Levelling and reclamation work by Fagan & Co. of Tullow began in the summer of 1966 and then Johnny Shortt of Tuckmill constructed the building, which contained a sales ring, offices and a bar. Pens for four hundred cattle and four thousand sheep were then to be installed by South of Ireland Equipment Co.[943]

Management of the enterprise lay in the hands of six directors. These were Leonard Craig of Athy, auctioneer, Charles Duncan of Athy, farmer, James Jordan of Bagenalstown, livestock exporter and farmer, P.J. McDonagh of Edward Street, auctioneer, Desmond Moore of Tinryland, livestock exporter and farmer, and John Neill of Tinoran, farmer. Craig was chairman and Pat McDonagh was secretary. The new cattle mart opened on Monday 29 May 1967 with a blessing by Father Gahan and the Rector of Kiltegan. Sales began at eleven a.m. In conjunction with the mart Willie Quinn built a bar adjacent to the sales ring.[944]

Eventually Baltinglass Livestock Mart, Ltd., was put up for auction on 11 September 1974 and purchased for £20,800 by Kinsella Estates, then of Carnew. It continued to be operated by Kinsellas throughout the rest of the century.[945]

HILDA GORRY – INTERNATIONAL GOLFER
MONDAY 21 AUGUST 1967

Following in Sean Hunt's footsteps, Hilda and Mary Gorry were the next prospects produced by Baltinglass Golf Club. In 1967 Hilda became an Irish international at junior level.

Hilda and Mary played in, and won, the ladies' competitions in Baltinglass from the age of twelve. Hilda first competed in championship golf in the summer of 1966. At the time, the Irish Girls' was the only tournament at that level in the country. On her second attempt at the title, in 1967 at Portrush, she reached the quarter-finals, losing at the 21st to the holder and eventual winner. Her performance earned the sixteen year old selection to play for Ireland in a girls' match against Wales on 21 August. However, her international debut was disappointing, as she played only foursomes in which Ireland lost decisively.[946]

In 1968 she was selected again to play against Wales and this time she won her singles by 5/3. Immediately afterwards she competed in the British Girls' but was beaten in the second round. The following year she reached the quarter-finals of the Irish Girls' for the third time and was named on the first Irish team to contest the Girls' Home Internationals, in which she won all three singles matches. In the second round of the British Girls' she lost a close match against Carol Le Feuvre, one of the main contestants. Afterwards she was named as one of the two Irish players on the Ladies' Golf Union's Girls' team against the Carris Boys, the elite of English junior golfers, at Moorpark in April 1970.[947]

Being no longer eligible for junior golf, Hilda competed at ordinary level in 1970 and was named a reserve for the Leinster team in the Ladies' Interprovincials, eventually being called up. However, due to university studies she had to decline. Though she competed again in 1971 and was again nominated as a reserve for the Leinster team, her time for golf was severely restricted by commitments as a student thereafter, and she gave up championship golf.

AMALGAMATION OF CONVENT AND VOCATIONAL SCHOOLS
MONDAY 4 SEPTEMBER 1967

When resuming after the summer holidays in 1967, the former pupils of St Therese's Girls' Secondary School and Baltinglass Technical (or more correctly Vocational) School found themselves in a new amalgamated institution to be known officially as Baltinglass Vocational School, though locally it continued to be called 'the Tech'.

This was a very important step forward for education in Baltinglass. For twenty-five years before this the Presentation Sisters had been teaching the girls of the area up to Leaving Certificate level, but they had a small staff. The Technical School had been teaching a larger number of students, boys and girls, but only up to Group

Certificate level. With the amalgamation full secondary education became available to a greater number within the area, which at the time stretched as far as Hollywood and Rathdangan.

The amalgamation came about through the initiative of the principals of the respective schools, Mother Alphonsus Dolan (who was also Superior of the Convent at the time) and Ben Hooper. Due to the opposition of Father Gahan, the Parish Priest, to the move, negotiations were done quietly with the Department of Education in 1966. Despite Father Gahan's disapproval the move went ahead.[948]

Four Presentation nuns, Mothers Alphonsus Dolan and Immaculata McCormack, and Sisters Josepha O'Donnell and Declan Power became members of the staff of the new institution. Sister Katherine Ryan joined them the following year. Ben Hooper, principal of the former 'Tech' continued in that capacity under the new arrangements. The lay staff members at the time were Miriam Bannon, Brian Dempsey, Con Doyle, Dave Hallahan, Nora Timmins, John Tyndal and Pat Murphy, who came as a new teacher to the Vocational School. There were also three priests from St Patrick's Missionary College in Kiltegan, Fathers John Carroll, Leonard Forrestal and Denis O'Rourke, who had all been teaching in the Technical School.[949]

The amalgamation brought classroom congestion. The Technical School had 140 pupils and the new institution had 235. As well as the main school building, rooms in the old school attached to the convent, which had been accommodating St Therese's, were used. The former boys' school on Chapel Hill also provided space. At the time Fatima Hall was under construction, so it is unlikely that any part of the original St Therese's school was available for classes. It was expected that fourteen new rooms would be provided relatively soon. In fact, four prefabricated rooms were given shortly afterwards and these were located at the back of the main school building. The rooms attached to the convent were not used after that point. In 1972 the school was utilising the main building, the prefabs, the two lower rooms of the former boys' school and occasionally the upstairs room in Fatima Hall. A further two prefabs were added in about 1973.[950]

Ben Hooper, who had been principal since 1940, was not to see a new premises built during his career. He retired in 1978 and Dave Hallahan became principal. In about 1970, when the present writer was in primary school, the field behind St Pius X School was being surveyed as a possible site of a new 'Tech'. He finished studying at Baltinglass Vocational School in 1978 and there was still no sign of a new school being built. It was the 1980s before construction got under way, not behind St Pius X School but beside it. When the new Scoil Chonglais Post-Primary School opened late in 1982 'the Tech' finally had the home it had been looking for since the early years of the century.

THIRD SENIOR COUNTY CHAMPIONSHIP IN A ROW
SUNDAY 17 SEPTEMBER 1967

By 1967 the novelty of winning senior county championships had worn off but Baltinglass was by no means unimpressed when the footballers brought the Miley Cup home for a third time in succession and the fifth time overall.

After the initial win in 1958 there was a four year gap before a second county title came in 1963. On that occasion, having disposed of the holders, Kilbride, along the way, they met Arklow Geraldines in the final. Arklow were ahead until Tony Norton's goal in the closing minutes gave Baltinglass victory by 2-7 to 2-5. Baltinglass appeared in their fourth final in 1964 but surprisingly lost to Newtown, 3-4 to 3-3. Then in 1965 came the first of the string of victories. The final was against St Patrick's and it ended in a draw, 1-6 each. In the replay on 10 October, which reportedly drew a record crowd of 4,000, Baltinglass emerged winners by 2-4 to 0-4, the goals coming in the second half from Tony Norton and Andrew Buchanan. This was Johnny Kenny's last year as captain. The 1966 final, on 11 September, was also against St Patrick's and Baltinglass led 3-3 to 0-4 at half time, the goals being provided by the captain, Tony Norton, his brother Larry and Bobby Nolan. In the end the margin was 3-7 to 1-5.[951]

The final on 17 September 1967 was against Newtown. It rained that morning and the game got under way almost an hour late. The pitch in Aughrim was sodden and there were pools of water. The earlier matches left the field churned up and the rain continued through much of the match. Despite the drawbacks Baltinglass rose to the occasion. At half time they led by five points to one. The final score was 0-10 to 0-2. Johnny Kenny scored five points, while young Padraig Byrne of Rathcoyle, son of Hugh Byrne, the then chairman of the County Board, accounted for three points. Byrne had been recruited to the half forward line in the previous round to replace the injured Billy Wall. A great crowd gathered at Whitehall Cross to greet the victors, and a pipe band led the way into town, where Godfrey Timmins spoke from a platform and a bonfire blazed in Weavers' Square.[952]

Those who appeared in all three finals, 1965-1967, were Ken Browne, Andrew Buchanan, Johnny Kenny, Bobby Nolan, Larry Norton, Tony Norton, Charlie O'Connell, John O'Connell, John Rogers, Pat Rogers, Noel Scott and Tom Scott. All of these except Andrew Buchanan, Larry Norton and Pat Rogers also featured in the 1963 final. Four men were on the first winning team in 1958 as well as the 1963, 1965, 1966 and 1967 victorious sides. These were Ken Browne, Johnny Kenny, John O'Connell and the goalkeeper John Rogers.[953]

Baltinglass reached their sixth final in a row in 1968 but on this occasion Kilbride deprived them of glory by a point, 1-4 to 1-3. However, they were back at the top with two further victories in 1971 and 1972. In 1971 they beat Carnew 2-8 to 0-10 and in 1972 Dunlavin were their victims by 1-9 to 0-6. Ken Browne and John O'Connell received their sixth senior medals in 1971 and Browne won a seventh in 1972, the only man to appear on all the winning teams between

1958 and 1972. At his height he was regarded as one of the best defenders ever to play for Wicklow. Other long time campaigners who appeared on the 1971 team were Andrew Buchanan and the brothers Larry and Tony Norton, and Noel and Tom Scott. That year nineteen year old Peter Burke made his first appearance on a winning senior team and the following year he was on the senior county team. Burke was to become one of the all time greats of Baltinglass football, rated as possibly the most gifted player ever in Dave Hallahan's 1984 assessment.[954]

A further two county championships came later in the 1970s. In 1976 Baltinglass beat Hollywood by five points to four, with all five scored by Peter Burke. The team had seasoned campaigners in Larry and Tony Norton, and Tom Scott. There was a lot of young blood including John Byrne, John Dooley, John Farrell, Tommy Murphy, Matt Owens and Billy Timmins, all of whom were also on the Baltinglass Under 21 team that year that won the first of four consecutive county championships. The 1979 senior final was a memorable affair in that play had to be abandoned some twelve minutes before time because of violence. Baltinglass were leading 1-8 to 0-4 against Rathnew when the booking of a Rathnew player transformed mounting anger among supporters into actual violence and the pitch was invaded. The championship was later awarded to Baltinglass.[955]

The cup was retained in 1980, when Baltinglass beat Blessington by 1-10 to 0-5, and the eleventh win came in 1982 against Tinahely, 1-9 to 0-7. 1980 was Tony Norton's last championship win. The veteran of the team claimed his ninth senior medal on that occasion. Other stalwarts by the early 1980s were John Byrne, Brendan and John Dooley, Tommy Murphy and, of course, Peter Burke. In 1984, with much of his football career still ahead of him, Murphy was another player singled out by Hallahan as among the most gifted to have played for Baltinglass. Those new to the medals in 1979 included Brian Fitzpatrick, Bryan Kilcoyne and Con Murphy. Robert McHugh joined the victors in 1980, while the 1982 winners included the sixteen year old Kevin O'Brien, whose star was destined to eclipse those of all the other great footballers Baltinglass had ever produced.[956]

GODFREY TIMMINS ELECTED TO DÁIL ÉIREANN
SATURDAY 16 MARCH 1968

Baltinglass celebrated in traditional fashion when a parliamentary seat was again won by one of its own. Almost fifty-four years after the death of E.P. O'Kelly, the town had another resident and native in parliament. However, it was also a first, as Godfrey Timmins became the town's first member of Dáil Éireann.

Michael Godfrey Timmins was born in September 1927 into a family deeply involved in Gaelic games. His father, Michael Timmins, a publican and shopkeeper, was also involved in politics, supporting Cumann na nGaedheal (later Fine Gael). Mick Timmins served as a member of Wicklow County Council from 1934 to 1942. He died in 1948, aged fifty-three, and when the local elections came about in 1950 Godfrey was put forward as a candidate by Fine Gael. He was elected then

as a twenty-three year old and retained his seat for an unprecedented forty-nine years, only retiring in 1999. However, he was but two months on the council when he found himself embroiled in the Battle of Baltinglass. If he allowed himself to be manipulated at that time by anti-government activists, he may have learned caution by the experience. As he matured he developed the political savvy that kept him in politics until he chose to retire as a septuagenarian.

In 1961 he was chosen to contest the general election in the Wicklow constituency. As one of six candidates for three seats, he gained 3,368 first preference votes to lie in fourth position, just behind his running mate, Michael J. O'Higgins. O'Higgins took the third seat. In the 1965 general election Mark Deering of Dunlavin, a former TD, was chosen as O'Higgins's running mate, but failed to take a seat. During the Christmas recess of 1967-1968 Jim Everett, the man at the centre of the Battle of Baltinglass controversy, died having served as a TD since 1922. Direction for the issuing of a writ for a by-election in Wicklow was made on 21 February 1968 and the election took place on Thursday 14 March. Counting of votes began the next day in Wicklow town and at two o'clock on the morning of Saturday 16 March forty year old Godfrey Timmins was declared elected. That night the Narraghmore pipe band led a torchlight procession to a platform in Weavers' Square where tributes to Timmins were paid by fellow TDs Des Governey and Michael J. O'Higgins, and Mary Walshe of Tinahely, MCC.[957]

Timmins's first action within the Dáil was to ask the Minister for Education when he would sanction the construction of a new vocational school in Baltinglass. Brian Lenihan's response was that Wicklow VEC's proposal was 'under active consideration'. At the general election the following year Timmins retained his seat. In 1973 he took 23.58% share of the vote and was the first to be declared elected in the constituency. He successfully contested the next four general elections. In 1987, Wicklow was a four seat constituency. Back in 1981 Timmins had been joined on the Fine Gael ticket by Gemma Hussey. Hussey failed to be elected then, but she took a seat in the February 1982 election and retained it in November 1982. For the first time in history, Fine Gael now had two TDs in the constituency. Hussey's support base was in the more populous Bray area and she had a higher national profile. When it came to the 1987 election Timmins was to suffer. There were twelve candidates in all. Godfrey Timmins received 5,710 first preference votes, which placed him in fifth position and he failed to retain his seat. However, in the 1989 general election he regained his position.[958]

Godfrey Timmins bowed out of national politics in 1997, when his seat was successfully contested by his son Billy. In the local elections on 10 June 1999 Billy Timmins also won the seat his father had occupied since September 1950. From the twenty-three year old beginner to the forty year old new TD, to the seventy-two year old senior statesman, Godfrey Timmins had an extraordinarily long career as a public representative. Along the way he was Fine Gael chief whip in 1972-1973, chairman of the Public Accounts Committee in 1981, and chairman of Wicklow County Council on four occasions, 1975-1976, 1978-1979, 1981-1982

and 1996-1997.[959] Despite his long time in public life, he was a remarkably unassuming man who seemed more comfortable chatting on the street than speaking from a political platform. Perhaps that was the secret of his success.

OPENING OF FATIMA HALL
SUNDAY 3 NOVEMBER 1968

Since the closure of the Town Hall in the 1950s Baltinglass was without a regular function hall until late in 1968 when a new centre was opened. Fatima Hall was to become the main focus of social activity in the town over the next few decades.

Back in the early 1940s the Presentation Sisters opened their new secondary school on Chapel Hill in what had been their school when they first came to the town. It consisted of what might today be called a split-level building, with two rooms. Sister Alphonsus Dolan had a flair for drama and music, and she decided to include these subjects in her girls' education. In December 1944 the school gave its first concert, with the pupils performing on a stage in the upper room. As the space available was too cramped for performances and the school could benefit from an assembly hall, the nuns decided to build one attached to the upper room at the back. In 1951 they applied for planning permission for such a building and were granted it. Through sales of work and donations they managed to start construction. In the foundations was placed a statue of Our Lady of Fatima. When the three walls were roof-high Bishop Keogh, who had been against the nuns opening the secondary school, forbade them from holding further sales of work.[960]

The shell of the building remained there for over a decade. Father P.J. McDonnell arrived as a curate in Baltinglass in January 1967. The Presentation Sisters were still interested in having the building completed and Ben Hooper expressed interest in it as well. Through Father McDonnell's initiative a committee was formed to complete the construction to provide the parish with a function hall. He was able to get Father Gahan's approval of the project. A meeting was held and out of it a committee was appointed. Father McDonnell was remarkably fast in getting things under way, though he would deny his central role in the project. Just two months after his arrival the Convent's Annals recorded 'Work is resumed on Fatima Hall – it being the 50th anniversary of the Apparitions', referring to the events of 1917 at Fatima in Portugal.[961]

Father McDonnell was elected chairman of the hall committee, with Fintan Doyle as vice-chairman, Joe Doherty and Len O'Connell, joint secretaries, and Sean O'Toole, treasurer. The committee members were Tom Burke, Peadar Farrell, Ben Hooper, Kevin Kennedy, Peter McCabe, Kevin Moore, Tom Morrissey, Tom Murphy (V.S.), and the lone woman, Frances McDonnell. A collection brought in a remarkable £6,000, and then a twenty week draw raised over £1,000. Bill Judge, a former resident of Baltinglass and Ben Hooper's brother-in-law, was engaged as the architect. The contractor chosen was Johnny Shortt. He began work in March 1968. It was expected that work would be completed by

October at a cost of about £9,000. All the work – electrical, plumbing and paint-
ing, as well as construction – was given to local tradesmen. Because the outer walls
were already constructed, the shape of the building was predetermined, whereas
Father McDonnell would have preferred to widen the function room. Because the
bare walls had been standing exposed for so long, it was necessary to replace the
top level of blocks. The nuns had intended calling their building Fatima Hall, so
this was the name chosen by the new committee.[962]

Fundraising continued while the building was in progress, and at the time of
the official opening there was still a debt of about £6,000. The committee's plans
were not confined to the hall. They intended at the time to build a gallery at the
handball alley on the opposite side of Chapel Hill, to convert the 'old boys' school'
beside the hall into a social centre and to build a swimming pool adjacent to it.
Fatima Hall was officially opened and blessed by Dr. Keogh's successor, Bishop
Lennon, on 3 November 1968. It had been agreed that the Presentation Sisters
would have free access to the hall. As a token of this agreement a key was presented
to them by Fintan Doyle on behalf of the Fatima Hall committee. The first dance
was held in the new hall that night, and a free dance was held the following Sunday
night in appreciation of the support received from the community.[963]

In the new building the former upper room was divided into an entrance hall
and toilets, with a new committee room overhead. The lower room became a min-
eral bar with a corridor behind leading into the large function room at the rear of
the upper room. The function room had seating capacity for 550 or could take
over 700 dancers, and it had a maple floor. At the end of the room was a spacious
stage and beside it were two dressing rooms. Sister Alphonsus Dolan realised her
dream when the pupils of the vocational school performed Gilbert and Sullivan
operas in Fatima Hall under Brian Dempsey's and her joint supervision. Through
the years the hall provided a focal point for social activities in Baltinglass. Many
clubs used the committee room, while the function room hosted badminton, keep
fit classes, concerts, plays, discos, live-music dances (including one with the then
famous British group Mud), jumble sales, elections and some protest meetings,
such as those about the 'Superdump' in 2000. In its early days Fatima Hall doubled
as part of the vocational school, with the committee room used for classes and the
function room serving as assembly hall and physical education area. More than
anything the activity most associated with Fatima Hall was bingo. For decades,
while bingo was a craze, it maintained Fatima Hall and provided surplus funds.[964]

The Fatima Hall committee never realised their aims of converting the former
boys' school or installing a swimming pool. However, the handball alley was not
only refurbished but also enclosed. Sadly, it fell into disuse, while Fatima Hall
continued into the twenty-first century as a centre for social activity, though not
as vital as it had been in its first two decades.

OPENING OF THE INDUSTRIAL ESTATE
MONDAY 28 DECEMBER 1970

What is now Lathaleere Industrial Estate was a green field site slightly outside the town in the late 1960s. Industry was not a word associated with Baltinglass at the time. The West Wicklow Development Association came into being in 1966, with branches throughout the district. It tried to promote the social, cultural and economic life of the area and urged the Industrial Development Authority (IDA) to encourage manufacturers into the region. In 1970 Baltinglass saw the first step that was to lead to the gradual expansion of an industrial area in the town.

In the late 1960s Gillespies, Morrins and Quinns were the largest employers in Baltinglass, while the smaller businesses provided jobs for a much smaller number of people. The only manufacturing industry was in Joe Farrell's mattress factory in Belan Street and Tommy McCormack's tailoring business in Edward Street, but these did not employ any more than about four to eight people at any given time. Many Baltinglass people had to travel out of town to find work. In April 1969 a second clothing manufacturer began work. Martin Doogue from Carlow started what was to become Kaideen Knitwear. His first factory was in the upper two rooms of the former boys' school on Chapel Hill.[965]

In 1970 another new business came to town. Michael Gleeson of Thurles began building a factory on the Kiltegan Road at Lathaleere, in an area designated for industry. His new company, Suspended Ceilings Ireland, availed of an IDA grant for the venture. In March of that year his brother-in-law, Fran Quaid, who had worked in the industry in England, arrived to join the company. The factory, which was quite innovative in design, was constructed by a company from Bray. Suspended Ceilings had an inauspicious start. Everything was in place and ready by Christmas Eve 1970. However, three days after Christmas, when the workers turned up for their first day, there was more than a foot of snow outside and the heating system was out of order. An electrician and a plumber had to be called in, while a fire in a barrel served as a makeshift heater.[967]

Suspended Ceilings began with Michael Gleeson, Fran Quaid and a workforce of five. At its height it employed fifteen. Unfortunately, while the concept of its product was then well established in the United Kingdom, the timing was not right for Ireland and the company was not ultimately successful. In about 1974 or 1975 the Suspended Ceilings factory was sold to Martin Doogue and he relocated his business to Lathaleere. At about the same time a factory was built by the IDA beside the original factory. In 1974 Wampfler took over this building, making it an industrial area of two manufacturers.[950]

When the course of the Kiltegan Road was altered to remove the corners at Whitehall Cross and 'Locky Nolans', the new road cut across the lands of Allen Dale. The 'old' stretch of the Kiltegan Road on which the Kaideen and Wampfler factories were located then had less through traffic. In the 1990s Wicklow County Council developed a cul-de-sac off the Kiltegan Old Road as a second phase

of the industrial estate. The council built three small units and sold other sites to businesses. By the end of the century Kaideen and Wampfler had been joined by Baltinglass Meats, Healystone and Leslie Codd Mushrooms, while Morrins opened an organic grain store there.[968]

MARY GORRY – IRISH INTERNATIONAL GOLFER
WEDNESDAY 30 JUNE 1971

During her years in girls' golf, Mary Gorry lived in the shadow of her slightly older sister, Hilda. However, in 1971 she surpassed her by achieving interprovincial and international status at senior level, representing Ireland on two teams.

Both girls had played from the age of twelve in the Baltinglass ladies' competitions. Mary's first experience of championship golf was in the Irish Girls' at Portrush in 1967, the year her sister was first selected to play for Ireland. Though Mary competed for the national girls' title in four consecutive years, she never progressed beyond the early match play rounds. Nevertheless, in 1970, her last year at junior level, she was named for the Irish team in the Girls' Home Internationals and competed in the British Girls' championship. In 1971 at Baltray she played for the first time in the Irish Ladies' championship and her career blossomed. She advanced to the quarter-finals, defeating an international on the way, before losing 4/2 to Mary McKenna, then Ireland's leading lady golfer. At the conclusion of the event, the five-member Irish team to compete in the European Ladies' Team Championship was announced, and Mary Gorry was a surprise inclusion.[969]

On 30 June 1971 at the age of nineteen, Mary Gorry made her debut for Ireland at senior level, playing in the stroke play qualifying round of the European championship. Disappointingly, Ireland missed the top flight by four strokes. After further competition within Ireland that season she was selected to represent Leinster for the first time in the Interprovincials, and was picked for the Irish team in the Ladies' Home Internationals. She went on to retain her place on the Irish team in the biennial Europeans and the annual Home Internationals for ten years without a break, adding two wins in the Irish championship and gaining other victories along the way.[970]

Having completed four years as an international, Mary Gorry went to Tramore for the 1975 Irish Ladies' Championship as a seasoned golfer. She progressed to the quarter-finals for the first time since 1971, where she again met Mary McKenna who had stopped her advance four years earlier. On this occasion it was Gorry who won the encounter, by a margin of 6/5, causing something of a sensation as McKenna was the holder and practically unbeatable on the national front at the time. That afternoon Mary Gorry beat another fellow international, Claire Nesbitt, by 5/4 to claim a place in the final against Elaine Bradshaw, a three time winner of the event. The following morning, 24 May, there was a very close match between Bradshaw and Gorry, which ended with Mary sinking a seven foot putt on the eighteenth for victory.[971]

In its forty-seven year history, Baltinglass Golf Club had never before won a national championship. In recognition of Mary Gorry's achievement the club gave her an honorary life membership. Later in the season she played in top position on the Irish team in the Home Internationals and won all her three singles matches. Two years later she came to another milestone in her career when she reached the semi-finals of the British Ladies' Open Amateur championship and, as a result, was selected for the Great Britain & Ireland team to play continental Europe in the Vagliano Trophy matches in Sweden. Gorry finished 1977 by being named Lady Golfer of the Year in the Irish Golf Writers' Awards. As a member of the panel from which the Great Britain & Ireland team was to be picked for the Curtis Cup matches against the U.S.A. in 1978, she won the Irish championship a second time. Despite advancing to the last sixteen of the British championship, she was surprisingly only named second reserve for the Curtis Cup. However, she was given the Irish Golf Writers' award for the second year in succession.[972]

During Mary Gorry's years representing Ireland, the Irish team made slow but steady progress to a level where they were serious contenders for championship victories. In 1979 the Europeans were held at Hermitage in Dublin and Ireland advanced to the final, where they beat Germany. This was the first victory for an Irish ladies' team since 1907 and contributing to that win was the very pinnacle of Mary's career. In 1980, which was to be her last year playing for Ireland, Gorry was on the team that won the Home Internationals after a seventy-three year gap. Though she lost her place on the international team in 1981, she continued to play for Leinster for a number of years. In 1983-1984 she was non-playing Captain of the Irish junior ladies' team and in 1988-1989 held that same position with the Irish ladies' team. In her career, as well as the two Irish championships, Mary Gorry won sixteen scratch cups, two Leinster and two Midland titles, as well as the Ulster and Connaught championships once each, and the Irish Foursomes title twice.

BALTINGLASS CREDIT UNION LAUNCHED
TUESDAY 4 JUNE 1974

The West Wicklow Development Association, formed in 1966, may have been a relatively short lived organisation but its work had some long lasting results. As well as being the spur to the IDA's initial development of what is now Lathaleere Industrial Estate, the WWDA was responsible for inspiring the establishment of Baltinglass Credit Union, an institution that contributed greatly to the area over the last quarter of the twentieth century.

At a meeting of the Baltinglass branch of the WWDA early in 1974 it was suggested that the idea of forming a credit union be explored. Before a credit union could be established those interested had to form a study group in order to acquaint themselves with regulations and procedure. A study group was begun in Baltinglass on 21 February 1974, with twenty people attending a meeting in Fatima Hall. Mick Healy of Edward Street, a teacher for many years in Bigstone

School, chaired this initial meeting at which Father Brophy, just a few weeks in the town, was elected chairman, while Jack Kelly of the Dales became vice-chairman, Margaret Cronin of Grangecon became secretary and Pat Murphy (teacher in the Vocational School) became treasurer. Other people involved in these study group meetings included P.J. Kavanagh of Bawnoges, Bill Lawlor of Bawnoges Road, Nancy McGrath of Carrigeen and Tommy O'Connor of Irongrange. Some of the meetings were attended by a field officer of the Irish League of Credit Unions and representatives of credit unions in neighbouring towns.[973]

Baltinglass Credit Union Ltd. was registered as a credit union on 22 May 1974. The group applied to the VEC for facilities in Baltinglass Vocational School for transacting business. Permission was given and it was agreed that the credit union would open at the school on the evening of Friday 7 June. The previous Tuesday 4 June, the organisation was officially launched at a general meeting in Fatima Hall. Jack Kelly was appointed the first chairman of the credit union, with Margaret Cronin as secretary and Pat Murphy as treasurer. Nine directors were elected – Father Brophy, Margaret Cronin, Tim Cronin, Teresa Healy, P.J. Kavanagh, Jack Kelly, Bill Lawlor, Nancy McGrath and Pat Murphy. The three supervisors appointed were Mick Healy, Joe McHugh and Donal McDonnell.[974]

The weekly transactions continued on Friday nights in 'the Tech' until October 1981, when the credit union moved to the opposite side of the Green, to a house on the corner with Weavers' Square formerly occupied by the Jolly brothers, which was purchased in 1980. Some preliminary renovations had been made but the building was still in disrepair when business opened there, with gaping holes in the roof. Following reconstruction an official opening took place on 20 June 1984. Up to this point the credit union was open for business from six p.m. until nine thirty p.m. on Fridays, being run by volunteers. From October 1984 it also opened an additional two hours on Fridays, two p.m. to four p.m., and Nancy McGrath became the first part-time employee. In May 1985 Helena Byrne became the first full-time employee and from 4 July the credit union opened on Thursdays, Fridays and Saturdays. In 1988 the opening hours were further extended.[975]

Jack Kelly continued as chairman until his death in 1991. P.J. Kavanagh became chairman at the following annual general meeting and remained in that position until 2002. Margaret Cronin was succeeded as secretary by Owen Cooney, Brid Connolly and another Margaret Cronin (from Stratford), while Pat Murphy was treasurer from the foundation up to 2005. The premises adjoining the credit union's then office but facing out to the other side of the block at the top of Main Street was purchased in 1993. The house, most recently occupied by the Quaid family, was demolished and a new, larger office was built in its place. The architect was John Delaney of Newbridge and the builders were O'Reillys of Dunlavin. Work was completed in May 1997. The premises were officially opened on Saturday 13 June 1998 by P.J. Kavanagh and Pat Murphy, founder members.[976]

WAMPFLER COMES TO BALTINGLASS
WEDNESDAY 28 AUGUST 1974

When Wampfler came to Baltinglass there was much more attention given to the search for escaped prisoners than to this new source of local employment. The search for the escapees is long forgotten, but Wampfler is still a very important part of the town's life.

The discovery at Ballinroan near Baltinglass of a car, thought to have been used by some of the nineteen prisoners who had escaped from Portlaoise Prison on 18 August, made the town the hub of a massive Garda and army operation in the last week of August 1974. Fatima Hall was used as a base by the soldiers and the town was abuzz as the presence of hundreds of personnel provided a topic of conversation. Into this atmosphere Manfred Wampfler's company, new to Baltinglass, made a quite start, though it must be admitted that it was not until the following month that the news would have had any impact on the town. It was not long after Ireland joined what was then the European Economic Community, and German investment in Irish industry was something of a novelty.[977]

Manfred Wampfler was born in the late 1920s in Reinsberg, a small town in what became East Germany after the Second World War. He qualified as an engineer and in 1955 moved to West Germany to work in the industrial Ruhr area. In 1959 he started his own business, making rubber buffers for the end stops on cranes, entirely on his own. From that small beginning grew a business that became one of the world's leading companies in its industrial field. Fifteen years later Wampfler was encouraged by the IDA to consider setting up a production plant in Ireland. Accompanied by a young Irish engineer called Nick Carty, Manfred Wampfler went about looking at potential sites for the enterprise. The story goes that they passed through Baltinglass and Wampfler was so taken with its similarity to his native Reinsberg that he decided to locate his Irish plant in the town. There being an IDA 'advance factory' available at Lathaleere, the matter was decided.[978]

Wampfler Manufacturing GmbH Ireland was incorporated on 28 August 1974. In September Nick Carty was appointed general manager of the Irish concerns. He engaged two local workers, Chris Keogh and Michael O'Neill. This was another small beginning in the story of Wampfler worldwide. By 1979 the Irish venture had shown such success that it was decided to build a larger factory. This was opened by Godfrey Timmins in 1980. Up to 1990 all output from the Baltinglass base was for export, though unsolicited orders had been received from Irish engineers. In October 1990 there was a 'technical launch' of Wampfler on the Irish market, with engineers from the south-east being introduced to the range of products manufactured in Baltinglass. In 1992 the factory achieved the ISO 9002 quality award. By the time the company was celebrating its quarter century in Baltinglass it was employing over thirty-five people and its production area was more than three times the size of the original factory, which had become a storage area.[979]

Under Nick Carty's management, the factory offered training in various areas, including German and computers. Carty also ventured to help the development of Baltinglass in general. On his initiative a Junior Chamber of Commerce was started in the 1980s, out of which grew an annual Baltinglass Festival. Unfortunately, neither was long lived. Through him Wampfler provided a caravan as a tourist information office, staffed by FÁS workers. They also financed a footpath to the factory to facilitate a visibly impaired employee. Carty's drive was responsible for a restoration fund for St Joseph's church and the development of the public park beside the weir. In the 1990s he was involved in the local committee concerned with developing a heritage centre following Baltinglass being designated a 'heritage town'. Sadly, just months after happily celebrating the success of Wampfler's first twenty-five years in Baltinglass, Nick Carty died while undergoing heart treatment in January 2000.[980]

SCOIL CHONGLAIS OPENS
TUESDAY 9 NOVEMBER 1982

Some thirteen years after Godfrey Timmins placed his first parliamentary question, asking the Minister for Education when a new building would be provided for Baltinglass Vocational School, the building finally opened. In the first decade of the twentieth century the 'Tech' began life in a few rooms on Chapel Hill. E.P. O'Kelly was working for a permanent building for the school, but a purpose built school did not materialise until twenty-one years after his death in 1935. Thirty-two years later it merged with St Therese's and the need for a larger and better equipped building became a pressing issue. However, it was another fifteen years before Baltinglass Vocational School was given a home that had sufficient room for future expansion. At its new site it became Scoil Chonglais Post-Primary School.

Staff and pupils of the 'Tech' had become used to, and perhaps almost fond of, the chaotic 'campus' of the old school, which involved Fatima Hall, the 'old boys' school' and six prefabs as well as the main building. However, it was not ideal in terms of education. The Parents' Association, and in particular Jack Kelly of the Dales and Mary Murray of Broadstown, put up a long fight for new facilities. They were supported by Ben Hooper, principal until 1978, and his successor, Dave Hallahan, along with Godfrey Timmins. When agreement was eventually reached, a number of sites were considered and the preferred option was for a long time one at the top of Belan Street at the junction with the Back Road. Coincidentally, it was about there that Stratford Lodge School was to be built in the 1890s. Eventually a site was purchased by the VEC from Father Gahan, on Lalor Trust land beside St Pius X Boys' School. However, Father Gahan retired in 1974 and plans were delayed by the Department of Education. The VEC engaged Padraig Smith & Partners of Wicklow as architects and eventually in May 1980 the building began.[981]

The new building was all but ready by the summer of 1982 but the school could not open there in September for a number of reasons, principally because the

furniture had not been delivered and the metalwork and woodwork rooms were not equipped. That was why the school did not open until 9 November. Father Brophy, Godfrey Timmins and Dave Hallahan welcomed the staff and over 320 students in the assembly hall. Part of the heritage of this new school was the secondary 'top' called St. Therese's started by the young Sister Alphonsus Dolan on Chapel Hill in 1942. Sister Alphonsus was still on the teaching staff forty years later as they moved into Scoil Chonglais, along with two other members of the Presentation Order, Sister Teresa Baugh and Sister Rose Gargan. At the time it was stated that the official opening would possibly be later in the year. In fact, it did not take place until some seven or so years later, when the then Minister for Education, Mary O'Rourke, performed the ceremony in 1989.[982]

After the move part of the grounds of the old premises, along with one of the prefabs, was used for a decade as the base for the special training centre, before it moved to the Lalor Centre. The old school building was renovated and the VEC converted it into the Educational Resource Centre, later called the Outdoor Education Centre, providing a base from which groups of school children could pursue outdoor sports. The new school was built without any real sports facilities, so Dave Hallahan and the Parents' Association had another fight on their hands to have a sports hall added. Almost twenty years after Scoil Chonglais opened, in the summer of 2001, construction of the extension began.

WEST WICKLOW DAY CARE CENTRE OFFICIALLY OPENED
THURSDAY 15 SEPTEMBER 1983

The development of the West Wicklow Day Care Centre was a great community effort. Many organisations came together to co-operate on the project and in the short space of two and a half years the dream became a reality.

The ladies who may claim credit for the initial work towards the facility are the members of the now defunct Baltinglass branch of the ICA. They had already, in 1978, established a permanent Baltinglass Senior Citizens Committee in order to qualify for a grant to run meals-on-wheels, Christmas parties and summer excursions for the many older members of the community. The meals-on-wheels rosters were maintained by Kathleen Hanlon and Kathy McGrath. A great many volunteer drivers took part in the scheme and they were primarily but not exclusively women.[983]

Despite this activity, the local ICA branch was already losing its momentum. Seeking a stimulus, its officers asked the staff of Baltinglass District Hospital how the branch might be able to render assistance to the hospital. This is how the idea of a day care facility came about. At the branch meeting in November 1980 the proposal was put forward, along with the background information gathered by Anne Aspill and Anne Lee. It was agreed to call a public meeting and invite representatives from all voluntary organisations in West Wicklow. The gathering was held in the Acot Centre (now Teagasc) on the evening of 10 March 1981. Anne Aspill

chaired the meeting and thirty-two others were present, including representatives
of some twenty organisations. Kathleen Phelan, matron of the hospital, spoke
of how a day care centre would provide social contact for senior citizens as well
as weekly monitoring of their health. It was agreed to proceed with the project
and Father Pat Hennessey was elected chairman, with Therese Leigh as honorary
secretary, Nuala Rogers as honorary treasurer and Anne Aspill as public relations
officer. It was agreed that the organisation would be called the West Wicklow Day
Care Centre Committee. The first contribution towards its fundraising was £15
presented by on behalf of the ladies' branch of Baltinglass Golf Club.[984]

The day care centre was to be built as an annex to the hospital. Various events
– bazaars, concerts, discos, fashion shows – were organised in order to raise suffi-
cient capital to get the project started. The building costs amounted to more than
£100,000, of which £30,000 had to be raised locally. The architect, engaged by the
Eastern Health Board, was R. McConnell. While construction by the Baltinglass
builder Brian Moore progressed in 1982 the committee aimed at raising their tar-
get figure by the end of the year. However, fundraising continued into 1983. At
last the building was completed. The centre admitted its first visitors during 1983,
with twenty people attending daily. Half of the visitors were transported by vol-
unteer drivers on a roster, while the others were brought by ambulance and the
local Red Cross unit. On 15 September 1983 the centre was officially opened by
Liam Kavanagh, Minister for Labour, though it was already operational for some
months at that stage.[985]

Of course, the work of the WWDCC committee did not stop with the offi-
cial opening. Ongoing costs, extra facilities and building extensions have kept the
organisation working into the twenty-first century. Among the more significant
financial contributions made by the committee, through continued fundraising,
are £20,000 in 1986 towards the building of St Joseph's Unit, £40,000 in 1990
towards the building of a new day room for the hospital, £25,000 in 1991 for a day
care centre ambulance, £45,000 in 1994 towards an extension to the centre, almost
£37,000 in 1998 towards the building of the Alzheimer's Unit, and £70,600 in
1999-2000 towards the building of the Palliative Care Unit.[986] The Senior Citizens
Committee ran in tandem with the WWDCC committee through the years but it
disbanded on 31 December 2005. The WWDCC committee continues. Its energy,
success and longevity are extraordinary. It is possibly true that the community
effort of raising capital to start and support a day care unit for West Wicklow saved
Baltinglass District Hospital from extinction under the centralisation trends of
recent decades. The hospital and its various adjuncts are perhaps taken for granted
now, but a town the size of Baltinglass should never underestimate such facilities
on its doorstep.

ALL IRELAND CHAMPIONS
SATURDAY 17 MARCH 1990

It was the most memorable St Patrick's Day in the history of Baltinglass. Nothing could compare with it. Back in 1958 when the Baltinglass footballers won the senior county championship for the first time the celebrations were wild. When they won the All Ireland club championship in 1990 the town experienced limitless joy.

Having won their fifteenth county championship in September 1989, Baltinglass fought their way to the final of the Leinster championship for the second time, beating Ferbane on the way. Their final opponents were Thomas Davis of Tallaght. Their first encounter ended in a draw but in the replay at Newbridge the provincial championship was secured. The All Ireland semi-final was against the Cork team Castlehaven, and Baltinglass were severely handicapped by the absence of Robert McHugh, who was fighting a bout of pneumonia. His 'almost telepathic understanding' of the full-forward Kevin O'Brien was greatly missed. Nonetheless, Baltinglass came through for their Croke Park encounter with the Roscommon side Clann na nGael on St Patrick's Day 1990, with McHugh back in place.[987]

The greater part of the population of Baltinglass was in Croke Park on the day. After twenty minutes of play Clann na nGael were leading by three points to two. Then, fed by a pass from McHugh, Con Murphy scored a first goal. Before half time Murphy had provided a second goal and Baltinglass took a 2-2 to 0-5 lead into the second half. After resumption, with the wind behind them, Baltinglass added a further five points. The final score was 2-7 to 0-7. In the *Nationalist,* Paul Donaghy cited the contribution of the full-backs, Thomas Donohue, Hugh Kenny and Sean O'Brien, as 'memorable', while saying that Bryan Kilcoyne had 'probably the trickiest assignment' of the half-backs marking Eoin McManus. In relation to the forwards he called Con Murphy 'the shining knight, with high-class contributory work contributed by brother Tommy, McHugh and O'Brien'.[988]

The line-up that day was as follows: Dan Leigh, Sean O'Brien, Hugh Kenny, Thomas Donohue, Bryan Kilcoyne, Pat Murphy, Brian Fitzpatrick (captain), Raymond Danne, Billy Kenny, Liam Horgan, Robert McHugh (scoring three points), Paul Kenny, Con Murphy (two goals, three points), Kevin O'Brien (one point) and Tommy Murphy. Billy Timmins came on for Paul Kenny. There were three sets of brothers in the Kennys, O'Briens and Murphys. The three Kennys were sons of Johnny Kenny, captain of the first Baltinglass senior county victors in 1958, and grandsons of Jack Kenny, who featured in the first Baltinglass junior county winning team of 1912.[989] As well as playing, Tommy Murphy was the team's trainer, while Tony Norton was manager.

The victory was the biggest day in the history of the GAA in County Wicklow. It was a day for the whole county to enjoy. When the population returned to Baltinglass the town set about celebrating in traditional style. The team arrived just before nine p.m. to ecstatic applause. Godfrey Timmins was there again

to welcome the champions, just as he had been in 1958, but this time as president of the club. There was just one break with tradition: as the club chairman Seamus Kelly pointed out, the streets were so thronged that there was no space for the usual bonfire.[990] It was a long night of celebration that stretched far into Sunday morning.

THE PRESENTATION SISTERS LEAVE BALTINGLASS
FRIDAY 26 OCTOBER 1990

There was more than a tinge of sadness about the events to mark the departure of the Presentation Sisters from Baltinglass in October 1990. The community were saying thank you for the contribution of the Order to the town, and celebrating the contribution of generations of nuns. At the same time they were witnessing the end of 117 years of association with the town.

The declining number of vocations in the two decades leading up to the closure of St Joseph's Convent foretold a change. When St Therese's School amalgamated with the Technical School in 1967 four Presentation Sisters became part of the staff of the new institution, and they were joined by a fifth the following year. At the same time five Presentation Sisters were running the girls' primary school. By 1982 there were three nuns in Scoil Chonglais, one of whom retired shortly after the new building opened, and three in the girls' school. By September 1984 Sister Rose Gargan was the only member of the Presentation community on the staff of Scoil Chonglais. A discussion was held in November 1985 between the Presentation provincialate and Father Brophy, Parish Priest of Baltinglass, regarding the future of St Joseph's Convent, it being parish property for the use of the Presentation Order rather than the property of the nuns themselves. The Baltinglass nuns were then consulted on the use of the buildings as a positive contribution to the town, as well as on the future of retired Sisters.[991]

In 1986 Sister Rose was asked to inform Father Brophy of the imminent closure of the convent, while Bishop Lennon was informed by the provincialate. The Bishop offered to supply a house for the remaining community if they were left in the town. A bungalow on the Kiltegan Road at Deerpark was purchased and extended to accommodate six nuns. In June 1987 Sisters Joan Bland, Martha Dunne, Gabriel Flynn, Rose Gargan and Gabriel Thornton moved from St Joseph's Convent to their new home. Two months later they were joined by a new member of the community, Sister Agnes O'Sullivan. In stark contrast with the sheltered conditions under which the founders of the Baltinglass community arrived 113 years earlier, Sister Agnes came to the town on her motor bicycle.[992]

The old convent was sold by Father Brophy to a family called Madden who converted it into a private nursing home called Cill Cora, while the land was set. Cill Cora later changed hands a number of times and under the name Rathcoran House was used as the reception centre for the Kosovar refugees in 1999. The provincialate apparently decided to withdraw the Sisters from Baltinglass in 1990.

When the girls' school reopened that September, for the first time since 1873 there were no Presentation Sisters on the staff. On 5 October 1990 the Sisters living in the town were assigned to other convents.[993]

A committee of past pupils and colleagues from the girls' school and Scoil Chonglais organised a farewell gathering on 26 October. All surviving Sisters who had served in Baltinglass were invited back for the occasion. Mass was celebrated in St Joseph's church at seven thirty p.m. and a party was held afterwards at Inis Fáil.[994] Carmel Honan, NT, who was in the first class in St Therese's Secondary School spoke eloquently of the enormous debt Baltinglass owed to the Presentation Sisters for all they had done for the area over their 117 years of service to education. Providing free secondary education to the girls of the district for a quarter of a century was one of the Sisters' most generous acts. Starting Fatima Hall and providing facilities for the pilot scheme that grew into the Lalor Centre are other contributions for which the town is indebted to them. Over the course of 117 years their influence on Baltinglass was far greater than can be calculated.

The year the Presentation Sisters departed a small new group of Mercy Sisters began work within the parish with the arrival of Sister Brigid Morgan. A house close to the Parochial House was provided and in 1991 two other Sisters joined her. Sister Carmel Duggan and Sister Brigid continued to serve with community work into the new century.

KEVIN O'BRIEN – ALL-STAR
THURSDAY 6 DECEMBER 1990

Back in 1984 when writing the history of the GAA in Baltinglass, Dave Hallahan reflected on the most gifted players through the years. Having mentioned Johnny Kenny, Ken Browne, Tom Scott, the Norton brothers, Peter Burke and Tommy Murphy, he mused on the future, posing the question 'where, for instance, will the name of Kevin O'Brien rank by the turn of the present century?'[995] At the time O'Brien was only aged eighteen, but already he was marked for greatness. Expectations were confirmed in December 1990, when the twenty-four year old was named full-forward in the Bank of Ireland All-Star football team.[996]

Kevin O'Brien, born in 1966, was displaying a natural talent in the early 1980s. In 1981 he featured on the Baltinglass team that won the minor county championship for the ninth time, and made his first appearance on the county minor team. Aged sixteen, in 1982 he was on the winning Baltinglass team in the senior county championship. That year he also captained Baltinglass 'Tech' to its first Vocational Schools senior county victory. Then in 1983 O'Brien captained County Wicklow to victory against Clare at Croke Park in the Vocational Schools All Ireland final.[997] No wonder he was seen as a star in the making by 1984.

After Baltinglass won the 1985 Wicklow championship Kevin was selected for trials for Leinster. He made the provincial team, while Robert McHugh was a

substitute. On St Patrick's Day 1986 at Croke Park O'Brien collected the first of three Railway Cup medals playing for his province. Oddly, his selection for provincial honours came before his first appearance on a Wicklow senior team, which was later that year. He was to remain on that team for a decade and a half, winning three O'Byrne Cup medals along the way. In September 1989 Kevin O'Brien as a seasoned footballer was claiming his fourth Wicklow club championship medal with Baltinglass. A few months later he added a Leinster club championship medal and was short-listed for the All-Stars. He did not make the final selection, but was called up as the replacement full-forward when the team travelled to San Francisco and New York to play Cork in 1990.[998]

1990 was a busy and successful year for O'Brien. On St Patrick's Day came the All Ireland club championship victory with Baltinglass. His indispensable contribution to the progress of the club brought him into consideration for the Irish team that was to tour Australia for an International Rules test series. This was to be the first series since 1987. Over several months Kevin attended training sessions and practice games, at the end of which the final Irish team was chosen, and he was among the number. Late in October 1990 the Irish team flew to Australia. There were three tests, in Melbourne on 2 November, in Canberra on 10 November and in Perth on 17 November. Ireland won the first two tests and the series. O'Brien played in all three tests, contributing significantly to Ireland's performance, particularly in Canberra. A few weeks later he was named as one of forty-four footballers short-listed for the All-Stars. Robert McHugh was the other Wicklow player to make the first round of selection. A panel of Gaelic games journalists then voted on those selected and on 6 December the 1990 All-Stars were named. Kevin O'Brien became the first Wicklow player to be honoured with inclusion. In 1991 he travelled with the All-Stars to Toronto, where they took on Cork at the Skydome.[999]

A further landmark in his career came in 1992 when he captained Wicklow to victory in the All Ireland senior "B" championship. This was the occasion when he was famously photographed looking jubilant but dismayed, holding the cup and its separated handle. The International Rules tests were discontinued after 1990 but resumed in 1998, when two tests were played at Croke Park. O'Brien was again included in the training panel for the series. Despite recurring knee problems he progressed through the sessions and found himself among the final selection. He was on standby but was brought on briefly during the first test. He was the only survivor of the 1990 team to feature again in 1998.[1000]

Back in 1984 Dave Hallahan wrote about the gifted players Baltinglass produced and wondered about the future. A whole team of gifted players emerged in the decade that followed, but as for Hallahan's question about where the name of Kevin O'Brien would rank by the turn of the century, history has provided the answer.

PUBLIC TRANSPORT OPTIONS INCREASE
MONDAY 12 AUGUST 1991

Public transport for Baltinglass residents throughout most of the twentieth century was concentrated on the Dublin route, whether by train or bus. On 12 August 1991 J.J. Kavanagh & Sons of Urlingford began a weekday service between Hacketstown and Carlow, via Baltinglass and Tullow. This gave the town its first public transport link to Carlow in at least a hundred years. This service was to continue into the twenty-first century. Kavanaghs also made a brief attempt at linking Tullow to Naas, via Baltinglass and Ballymore Eustace. It ran only on 8-18 July 1997.[1001]

Just over two years later the town received another new service. Over the years Baltinglass used individual taxis or, more correctly, hackneys, but there was never what could be called a full hackney service, nor was there sufficient demand to make one viable until the 1990s. By that time the stricter surveillance of drink driving caused more caution among frequenters of pubs all over the country and in Baltinglass the need for transport for drinkers in the run up to Christmas 1993 presented an opportunity for the entrepreneur. That opportunity was grasped by Johan van de Kerkhof with the establishment of the Dutchman's Hackney Service. It began on Friday 3 December 1993.[1002]

Johan Van de Kerkhof, a native of the Netherlands, had come to the town a few years before and transformed the pub on the corner of Edward Street and the bridge into the centre of social life for Baltinglass twenty-somethings as well as a lot of older people. The hackney, operated by Dermot Allen, complemented the nightlife in the Dutchman's Inn and from that the service developed. The following year Van de Kerkhof transferred his interest in the service to Allen who continued it under the name Dermot Allen's Hackney Service. Operating out of Stratford, but covering the general Baltinglass area, the service developed, with a number of cars and mini buses on the roads. On 11 November 1998 the business name changed to Baltinglass Cabs Ltd. and for a few months in 1999 an office was maintained in Edward Street. Since then it was again based in Stratford.[1003]

For Baltinglass people working or studying in Tallaght or Dublin, Monday 3 April 2000 was a very welcome day. At six forty-five a.m. Bus Éireann's improved service frequency came into effect when the new early morning bus departed from Tullow. It left Baltinglass at seven fifteen a.m. and, due to Dublin's chronic traffic congestion, reached Bus Áras after nine o'clock. The same bus travelled back down from Dublin at twelve thirty p.m., left Tullow again at two thirty p.m., and returned from Dublin at five p.m. Other than the early morning bus being brought forward by a quarter hour from 8 May, this weekday service continued unaltered through the year and into 2001, alongside the already familiar mid-morning and evening buses.

It might seem strange to future generations that such a basic service for a town less than forty miles from the capital should be so significant. However, Baltinglass had

long been neglected by the transport authorities and those commuting to work were doing so by car or travelling to Castledermot to take the coaches privately operated by J.J. Kavanagh & Sons of Urlingford. Within weeks of the early morning Bus Éireann service being introduced, the passenger numbers had gone from a handful to tens. By the end of twelve months it was necessary on occasions to put on an auxiliary bus from Baltinglass.

THE DICEMAN'S FUNERAL
THURSDAY 23 FEBRUARY 1995

Thom McGinty, Ireland's most famous mime and street artist, known to all as the Diceman, asked that his ashes be brought to Baltinglass. This choice was not based on a mere whim. Baltinglass was part of his heritage and, allegedly, he believed that he was conceived there. Thousands thronged Dublin's Grafton Street on 23 February 1995 to pay their respects and a sad farewell to a man of unique talent.

Thom McGinty was born in Scotland in the 1950s but his mother, Mary O'Hara, was from Baltinglass and her parents and sisters lived in the town when Thom was growing up. He moved to Dublin in the 1970s and first became noticed as a 'colourful pseudo-beggar' in the Dandelion Market. He acquired his 'stage' name by advertising a game shop called the Diceman, standing motionless in Grafton Street for hours. He soon became a familiar spectacle in the city centre and earned a living through advertising. The Diceman was in much demand for festivals throughout Ireland and he travelled abroad to events in Berlin, Moscow, Paris and Seville.[1004] He was already a household name and presumably capable of commanding a substantial fee when he performed at the Baltinglass Festival in the mid-1980s. It can hardly have been his most lucrative engagement, but it was in the town where he was conceived. He walked, at a snail's pace and barefoot, through the streets, occasionally and suddenly animating his motionless face to wink at a startled child. He also paid occasional personal visits to the town and might be seen 'out of character' having a drink in Terry O'Doherty's pub (now the Dutchman's).

In November 1994 Thom McGinty appeared on RTE's *Late Late Show* to disclose that he was suffering with AIDS and to speak frankly about the disease. The television appearance brought a wave of goodwill. He died just three months later on 20 February, aged forty-two. His funeral took place the following Thursday. His remains were removed from Massey Bros. Funeral Home in New Cabra Road that morning and brought to Grafton Street, his most famous 'stage', arriving at ten thirty a.m. The coffin was carried shoulder-high by relays of pallbearers, preceded by his sisters and two friends bearing a board on which a white facemask was surrounded by flowers. An estimated 2,000 people filed down Grafton Street in silence. When the procession reached Bewleys' Cafe the gathering 'burst into sustained applause'. A hearse was waiting at the bottom of the street to take the Diceman's remains to Glasnevin for the cremation.[1005]

Afterwards Thom McGinty's ashes were taken to Baltinglass. He is commemorated on the headstone of the O'Hara family, along with his grandparents, Joe and Kitty.

OPENING OF THE LALOR CENTRE
SUNDAY 28 APRIL 1996

When President Robinson visited Baltinglass to officially open the Lalor Centre on 28 April 1996, fourteen years of dedicated work was rewarded in having a purpose-built modern learning facility established in the town.

What was to be known for a decade as Baltinglass Special Training Centre came into being in September 1982, funded by Sunbeam House Industrial Centre in Bray. At the time there were two such Sunbeam House facilities in County Wicklow, located in Arklow and Bray, and they wanted to get an opening in Baltinglass. They were put in touch with Mags and Stephen Byrne of Tuckmill Lower. Mags had been on the committee that started St Laserian's Special School in Carlow, a facility for special needs children up to the age of eighteen. The training centre was to be for more mature special needs people. Through the Byrnes, Sunbeam House approached the Presentation Sisters to ask for premises in the grounds of St Joseph's Convent in which to run a pilot scheme. The Sisters gave a room in the old school attached to the convent, part of the greenhouse and a plot in the orchard to be used until June 1983. Edie Kennedy was appointed to run the scheme and she began in September, preparing the premises. On 2 November two trainees started, and two more started on 4 November. As it turned out, the convent facilities were used for about a year and nine months.[1006]

In 1984 the training centre moved to one of the prefabs at the back of the former vocational school, with eight trainees attending. In 1986 an association of parents and friends was formed in order to fundraise and supplement the amount received from Sunbeam House. In 1989 Father Garry Doyle became Parish Priest of Baltinglass and he became heavily involved with the training centre. Through his influence a site between St Joseph's church and the Parochial House was donated in 1990 as a permanent premise for the training centre. The centre was still being run under the auspices of Sunbeam House in Bray but it was then felt that it would be more practical to associate with an organisation closer to Baltinglass. In November 1990 a meeting was held with members of the Board of KARE (the County Kildare Association of Parents and Friends of Handicapped People). In January 1991 the Baltinglass association of parents and friends joined KARE under whose management, with a local committee, the training centre was to operate. The benefit of joining KARE was that trainees could avail of the wider range of services, including sports activities, provided by the larger organisation. At that time the Baltinglass Special Training Centre had fifteen trainees and two staff members.[1007]

The main fundraising revolved around annual auctions and fashion shows in Inis Fáil, as well as the work of a sheep committee. There were fifty ewes on the

parochial farm and Father Doyle donated them to the centre. The sheep committee were responsible for them. Work on the new site began by 1991, with an acre of trees planted. In 1992 the horticultural unit was almost complete, and planning permission for the new building was received that September. At the end of October the building project had commenced, and two years later the trainees and staff moved into the new premises.[1008] Like other portions of parish property which had been granted or sold for educational purposes, this site was part of the lands acquired in the 1850s through the efforts of Rev. Daniel Lalor, the then Parish Priest, and left in the care of trustees. For this reason the new facility was called the Lalor Centre.

The Lalor Centre was already a year and a half in use when the formal opening ceremony was performed by President Robinson. This was almost certainly the first time a President of Ireland made an official visit to Baltinglass. Mrs. Robinson attended eleven o'clock mass in St Joseph's church and then walked up the driveway to the Lalor Centre. Having performed the opening ceremony, she was presented by David Goggins of Kiltegan, one of the trainees, with a 'willow' (a cushion that opens out into a blanket) made in the centre. Bishop Ryan of Kildare and Leighlin and Rev. Mervyn McCullagh, Rector of Baltinglass, performed a joint blessing. Afterwards there was a reception in Inis Fáil.[1002]

The total cost of the Lalor Centre was approximately £320,000, of which £167,000 was raised through local efforts, £125,000 was granted by the Department of Health, and there were two donations of £10,000 from the 'People in Need' telethon. The centre was equipped with industrial sewing and crafts, horticultural and equestrian sections, as well as incorporating a parish office and a meeting room. In 2001 a purpose built indoor riding arena was opened. At the time of the opening there were ten trainees employed locally under the 'Connect' programme.[1010] From the pilot scheme in the convent grounds in 1982 to a magnificent facility at the heart of the community, opened by the President, the story of the Lalor Centre was remarkable. It was fitting that the chairperson of the Lalor Centre committee at the time of the opening was Mags Byrne who gave so much of her time to the project from its very inception.

BILLY TIMMINS ELECTED TO THE DÁIL
FRIDAY 6 JUNE 1997

The general election in 1997 was held on 6 June. It marked a change in Baltinglass, as Godfrey Timmins who had represented Wicklow in the Dáil for all but a few years since 1968 had retired and had passed the gauntlet to his son Billy. Godfrey's popularity throughout Wicklow was a great asset to the son, but that alone would not be enough to guarantee a seat. Nonetheless, William Godfrey Timmins, an officer in the army since 1979, took the risk of resigning his commission in order to contest the election.

Having been in the Army since joining as a cadet twenty years earlier, Timmins had lived outside of Wicklow for two decades. However, many constituents

would have heard of him and seen him in action as one of the Baltinglass team who dominated Wicklow senior football for so many years. Between 1976 and 1991 he was on the winning side in eight county championship finals, as well as being a member of the unforgettable All Ireland club championship team. In his professional career he was stationed in Galway, Donegal and Kilkenny, as well as serving overseas with the United Nations in Lebanon and Cyprus.[1011]

Counting of the votes began in Wicklow town the morning after the election. In what was now a five seat constituency, Billy Timmins lay in sixth position after the first count, with 5,171 first preference votes against a quota of 8,717. The process went on all day and into the night. It was not until the eighth count that the first two candidates were deemed elected. The ninth count finished in the early hours of Sunday morning. Its result was that three candidates, including Timmins, were deemed elected without reaching the quota.[1012]

Baltinglass was used to having a Dáil representative in the town by then, so there was none of the speech making and fanfare that had attended Godfrey's first election back in 1968 and, of course, bonfires were no longer politically correct in a more environmentally conscious era. Even if the celebrations were less visible, the election of a Baltinglass person to parliament for the second time since the foundation of the State, and the third person to enter parliament in a span of almost two hundred years, was a significant event in the history of the town.

CONSTRUCTION OF ALLEN DALE
TUESDAY 27 APRIL 1999

The effect of the much vaunted 'Celtic Tiger' economy on Dublin property prices was one of the main reasons for Baltinglass getting its first commercially built housing estate at the end of the twentieth century. Construction began on 27 April 1999 on land in Lathaleere townland adjoining the Kiltegan Road. The site was a corner of what was the race course in the eighteenth and early nineteenth centuries. It was also part of the farm attached to Allen Dale House, once the home of a family named Allen. Similar schemes being built about the same time in other areas were often given attractive names with no relation to the locality and no history. In this case the estate was appropriately called Allen Dale.

Over forty houses were built by the developers, Miley Construction, under the supervision of the foreman, Chris Foster. They were sold through Kinsella Estates and they were first advertised in September 1999 in the *Tallaght Echo*. The first house was sold in January 2000 but the estate really only went on the market two months later. By January 2001 twenty-two of the houses in Allen Dale were occupied, almost all of them by people new to the area. The influx of new families brought the promise of more business to the town and more members for local organisations as Baltinglass entered the twenty-first century.

ARRIVAL OF THE KOSOVAR REFUGEES
THURSDAY 13 MAY 1999

As people gathered at the gates of Rathcoran House on 13 May 1999 they were well aware of the trauma suffered by the refugees they were about to greet. The unimaginable horrors of the war in Kosova had become familiar through television news reports. Now Ireland was accepting 1,000 of the estimated million Kosovars who had fled as Serb forces advanced through their homeland, killing and destroying property. Because Rathcoran House (formerly the Presentation Convent) was vacant and deemed suitable for accommodation, Baltinglass had been one of the few communities chosen to host these guests.

The conflict in Kosova had a long and vexed history. Throughout the twentieth century the Balkans experienced prolonged disputes between the many ethnic groups which had migrated in earlier generations within the former Austrian and Ottoman Empires. Differences of language and culture contributed to resentment and discrimination. Within the federal state of Yugoslavia such disputes were generally contained during the benign dictatorship of Tito. Throughout the Tito years (1945-1980) Yugoslavia was made up of six republics and two autonomous provinces, one of which was Kosova. In 1987 the erosion of Kosova's autonomy was begun by Slobodan Milosevic, then leader of the League of Communists of Serbia, who became President of Serbia (the neighbouring republic) in 1989 and of Yugoslavia in 1997. By the late 1980s an estimated ninety-two per cent of Kosova's population were of Albanian extraction and spoke Albanian as their first language. The majority of them were Muslim. Linguistically and religiously they differed from Serbians who were mainly Orthodox Christians. In 1989 the Kosovar Albanian leadership initiated a policy of non-violent protest against the loss of autonomy.

Open conflict in Yugoslavia began in 1991 when Slovenia, Croatia and Macedonia, three of the six republics of the federation, declared their independence. In an effort to maintain the federation, Serbia waged war against Croatia and later supported ethnic Serbs in a brutal civil war in Bosnia. Within Serbia, Milosevic's authoritarian regime kept a tight rein on the media and dissident groups, while in Kosova Serbian security forces maintained control. In 1996, the Kosova Liberation Army emerged and by 1998 the armed resistance was such that the Serbian government reacted with indiscriminate force. Stories of appalling brutality began to appear in news reports and refugees streamed out of Kosova, but the international community was slow to react. The UN re-imposed economic sanctions on Yugoslavia and NATO warned of air strikes, but nothing happened till early in 1999 when the Yugoslav Army was concentrated on the province and systematic 'ethnic cleansing' was reportedly in operation. Peace negotiations were held but it became apparent that Milosevic would accept no compromise. NATO began bombing Yugoslav targets on 24 March. The Serbian response was to escalate the systematic violence against Albanians in Kosova, aided in many cases by

local Serb paramilitaries. Over 11,000 Kosovars were reportedly murdered and hundreds of thousands fled over the borders into neighbouring countries, bringing only what they could carry. In many cases the possessions they left behind were pillaged and their houses destroyed. On 2 April an estimated 45,000 people crossed the border into Macedonia, the largest exodus on any one day during the conflict.

Refugee camps were set up in Albania, Macedonia and Montenegro but they quickly became dangerously overcrowded and evacuation to other countries became an urgent necessity. Over 90,000 people were airlifted from Macedonia to twenty-nine countries, including Ireland. The first group to come to Ireland arrived in Kerry on 10 May. Three days later the second group, who had been in Stankovic 2 refugee camp, landed in Dublin Airport. Forty-eight of them were brought by coach to Baltinglass, where Rathcoran House had been prepared for their arrival by the Health Board and local volunteers.

Many of the group were related to one another, with almost half of them from the extended Ferizi family. They were predominantly Muslim, their native language was Albanian and few of them knew any English words, so Baltinglass appeared a strange environment to them. Despite this, integration into the community was surprisingly swift. Within a few weeks the people of Baltinglass became used to meeting their new neighbours on the street and the language barrier was no obstacle to making the Kosovars feel welcome. The younger adults soon had enough English to gain employment in the area and the children started to attend the local schools in September. In November the group was joined by a man who was reunited with his wife and children, having been in Germany. By April 2000 their number had increased to fifty-one with the birth of two children.

Meanwhile, the situation in Kosova was changing. On 27 May 1999 Milosevic was indicted in absentia by the UN International Criminal Tribunal for crimes against humanity, including murder in Kosova. In June 1999 the Serbian government accepted a peace proposal and withdrew its troops from Kosova. An international peace keeping force took charge, but the devastation to property during the war left the population in destitution and open hostility remained between the Albanian and Serbian communities within Kosova. Within three weeks of the peace deal over 600,000 refugees returned home and approximately 180,000 Serbs and Roma fled to Serbia. The UNHCR estimated that at least 67,000 homes had been damaged or totally destroyed during the conflict. Rebuilding normal life was a slow process.

After a year the Irish government offered to provide substantial financial assistance to those refugees who wished to return home. Most accepted the offer. The first of the Baltinglass Kosovars left Shannon Airport on Tuesday 18 July 2000. The last group from Baltinglass to return home left Shannon on Thursday 14 September 2000. In the sixteen months during which Baltinglass played host to these people their faces became familiar about the town. They were regarded as hard working, friendly and unassuming, and their behaviour won great respect for

their homeland. It was gratifying that sixteen of the 51 chose to remain in Ireland, all but one staying in Baltinglass. In March 2001 the sixteen were granted leave to remain in Ireland indefinitely.

THE KOSOVARS WHO LIVED IN BALTINGLASS FROM 13 MAY 1999 WERE AS FOLLOWS:

Ragip, Fatime, Adem, Aida, Agron (Agi) and Agnesa Bernica
Bujar, Luljeta, Argjenda, Blinera and Ardita Dauti[1013]
Basri, Emine, Fortesa, Doruntina and Liridona Ferizi
Hyzri,[1014] Sadie, Kushtrim, Fitore, Jehona, Krenare and Betim Ferizi
Shaip, Sadie, Burim, Uran and Arbresha Ferizi
Shyqa, Fikrie Ferizi, Merita and Veprim Ferizi
Besim (Bes) Koliqi
Besnik (Nicky) Mustafa
Feriz, Fatime, Violeta and Jeton (Tony) Nazifi
Edmond (Eddie), Hasa, Lirida, Syzana, Lindita, Nazmije, Anita and Granit Shala
Burhan, Nazlie, Elmedina, Fuad and Ardit Shehu[1015]

SHAUNA BRADLEY – SPECIAL OLYMPICS MEDALIST
SUNDAY 4 JULY 1999

When the 1999 Special Olympics World Summer Games closed in Raleigh, North Carolina, on America's Independence Day, twenty year old Baltinglass woman Shauna Bradley was in possession of two medals. These were for bowling, but this was just one of the very many sports Shauna excelled in through the years.

Shauna, a granddaughter of Ted and Josephine Bradley who opened the Carlton Cinema back in 1943, began her association with sports as an eight year old in St Laserian's Special School in Carlow. Over the years she took part in gymnastics, table tennis, basketball, swimming, pentathlon, shot putt, track and field, and bowling. Moving to the Lalor Centre, she also took up equestrian sports. Shauna Bradley partook in Special Olympics events at area, regional and national level, amassing an array of medals in various sports. It was for bowling that she was chosen to represent Ireland in the 1999 World Summer Games.[1016]

The 1999 Special Olympics opened on Saturday 26 June with a ceremony hosted by the Hollywood star Billy Crystal. The Irish team of seventy-seven was led out by Jim McDaid, the Minister for Sport. Throughout the event it was extremely warm, with high humidity. Ireland competed in nine sports and won twenty-nine gold, thirty-five silver and twenty-two bronze medals.[1017] Shauna Bradley's contributions to that tally were a silver and a bronze. A photograph of Shauna standing on the podium with her coach Maureen Brannock, waving to supporters, was later used in the Bank of Ireland's 2001 calendar as the picture for the month of July.

Back home in Baltinglass, Shauna was given a homecoming parade and was driven through the town on a float. This was followed by a party in McDonaghs'. Afterwards she and other winning athletes associated with KARE were given a celebratory reception at Lumville House on the Curragh.[1018]

Ireland was chosen as venue for the next World Summer Games in 2003, the first time they had ever taken place outside America. Though the 2003 Games were held after the period covered in this book, it would be remiss not to mention three facts about them. Firstly, Baltinglass played host to the team from the Seychelles, with enormous work put into the preparation by those associated with the Lalor Centre. Secondly, four commemorative postage stamps were issued by An Post in May 2003 and one of them featured the photograph of Shauna and Maureen Brannock from the Bank of Ireland 2001 calendar. Thirdly, at the opening ceremony of the Games in Croke Park the athletes' oath was read before 80,000 people by Shauna Bradley of Baltinglass.

LIBRARY OPENS IN NEW BUILDING
MONDAY 6 MARCH 2000

Those who remembered Dave Hallahan dispensing library books from a press in the corner of the big room in the 'Old Boys' School', some three decades earlier, must have been astounded when they entered the new Baltinglass Library in March 2000. Those who never saw the press in the corner would never appreciate the contrast.

The origins of what is today a splendid recreational, research and communications facility go back to 1937 when a branch of the county library was opened for students in what was then the new Baltinglass Technical School on the green. During the Battle of Baltinglass the 'Tech' was picketed one Sunday while the principal, Ben Hooper, was performing his extra duties, supervising public access to this meagre branch library. By the late 1960s another teacher, and Hooper's future successor as principal, Dave Hallahan, was in charge of the library. The present writer can double as an eyewitness to the spectacle of the press that contained 'Baltinglass Library'. It had been transferred to the former boys' school on Chapel Hill. However, it was still opened for just a few hours a week.

At the time remuneration for the task of supervising access to the press was as meagre as the book collection itself. At the beginning of the 1970s Hallahan gave up the task and the facility was transferred to a small room in the Courthouse, fitted out with bookshelves. The transfer was also a transformation, as there was space for possibly ten times as many books, as well as a small reference section containing material on local history, perched on the mantelpiece of the disused fireplace. Opening hours were also extended, so that it could at last be regarded as a real library. It was run in the Courthouse by Michael O'Keeffe for about a year. When he left Breeda O'Neill replaced him. For many years there were rumours that a bigger facility would be provided and that it would be in a new building. In the mid to late 1990s the Courthouse was to be refurbished and the library was to be closed temporarily. Instead, Mrs. O'Neill made available her own premises, the former 'T.F. O'Neill's' shop in Weavers' Square. The library remained there for a short time after Mrs. O'Neill retired.[1019]

In May 1999 Catherine Walshe took over duty as branch librarian, while still based in T.F. O'Neill's. In the meantime a large amount of money had been spent in purchasing, renovating and fitting out the former Town Hall as a 'heritage centre'. An agreement was made between Wicklow County Library and the promoters for the upper floor of this new building to be used as a branch library. On 6 March 2000 Baltinglass Library transferred from Weavers' Square back to the Green, directly opposite where it had such an inauspicious beginning back in 1937. On the same day its staff doubled, as Teresa Kenny began work in charge of the separate children's section. The transfer was again a transformation, with two large rooms filled with new stock. Computers, with internet access were added, making it an outlet more than adequate to the needs of a growing small town.[1020]

Baltinglass thus gained a valuable asset in the last few months of the twentieth century. By a strange coincidence it was on the very site of the Town Hall, the valuable asset Baltinglass had gained in the last few months of the nineteenth century. As an epilogue it is worth noting that late in 2005 the library expanded to encompass the whole building, while the 'heritage centre' information boards continued to share space on the ground floor. After only a matter of months the benefits to the public of this change were apparent, with the building revitalised.

LAST FLOOD OF THE TWENTIETH CENTURY
SUNDAY 5 NOVEMBER 2000

Memories of November 1965 literally came flooding back to Baltinglass on the night of 5 November 2000. After thirty-five years of relative quiet, the Slaney burst its banks with startling speed. In a matter of hours Church Lane, Main Street, Weavers' Square and the first two avenues of Parkmore were under water, with most premises in those areas having ground floor damage. The western half of the town was unaffected, with the exception of the low lying SuperValu site. The flood began to creep up Church Lane and the slipway beside Bridge House, but within two hours it had also come up the fields behind Main Street and emerged through the Resource Centre grounds on to the Green.

While the dutiful went about trying to stem the tide, the undaunted customers in Harbournes' bar remained on their stools at the counter with the water lapping at their feet. At midnight there were people canoeing around the upper part of Main Street and into Weavers' Square. Meanwhile, the water rushed down Main Street and flowed freely down the Bridge House slipway. The fire brigade worked into the early hours, barricading doorways with sandbags, and the following morning, after the flood had subsided slightly, they and the county council workers were on hand to pump water out of the worst affected premises and dispose of damaged fittings. While the 2000 flood was several feet lower than the 1965 disaster, it was rapid and widespread enough to cause thousands of pounds worth of damage and to remind Baltinglass of the Slaney's potency. Some residents of Parkmore needed no such reminder, as they had been visited by its waters on more than one occasion during the 1990s.

BALTINGLASS IN 2001

The Baltinglass of 2001 is a very different place from the Baltinglass of 1951. Leaving aside the worldwide advances in technology achieved over the latter half of the twentieth century, and the creature comforts which came with them, life in Baltinglass altered markedly over the fifty years in many other ways. The most striking changes occurred in the last decade of the century and many of the recent developments in the town stem from Ireland's much talked of 'Celtic Tiger' economy. Until the early 1990s the town was still a little 'sleepy'. As a business centre it had not developed over the years and new residents were still few and far between. Public transport was minimal and remained fundamentally unchanged since the 1960s.

Looking back in time it was fairly easy to select the last Earl of Aldborough, E.P. O'Kelly and Nellie Cooke as the most prominent Baltinglass residents in 1851, 1901 and 1951, respectively. What is meant by this is that they were at the time the individuals whose names were most associated with Baltinglass in the minds of people outside, as well as being known to everyone within the community. In making a similar choice for 2001 a number of names might spring to mind. The businessmen Joe Germaine and Liam Quinn could arguably be considered the most prominent, as could the footballer Kevin O'Brien. The sitting TD, Billy Timmins, could also be a contender. However, in the end the choice would have to be the TD's father, Godfrey Timmins.

Though he had recently retired from national and local politics, Godfrey had served half a century as a county councillor and half that time as a Dáil Deputy. By 2001 he was an institution known to all by the single name 'Godfrey'. The sudden death of the remarkably youthful looking seventy-three year old was, therefore, a great blow to Baltinglass. As President of Baltinglass GAA Club, with which he had a lifelong association, he was also an active supporter of its young footballers. He was watching an underage football match on Wednesday 11 April in Dunlavin, where the Baltinglass team included one of his grandsons. Minutes after it finished he collapsed and died. His funeral had a huge attendance of people from all walks of life and all age groups, with a guard of honour from Wicklow County Council and Baltinglass GAA Club. He was aptly described in the *Wicklow People* as 'a man who was renowned throughout his career as somebody who favoured consensus over controversy, hard work over sensational speeches, and quiet anonymity over media notoriety'. But he was still the town's most prominent resident.

By 2001 Baltinglass was a busy, if small, shopping town with many new retail outlets. Along with the increased trade came traffic congestion, particularly at the approaches to the bridge and especially on Friday afternoons. The eighteenth century bridge was not built for twenty-first century vehicles, but it was still the only crossing over the Slaney within the town. Many blamed the county council's recent paving of the areas of Main Street in front of the courthouse, around the McAllister Monument and on what used to be called The Green, for this congestion. The paving, as well as the placing of bollards across the opening from The Green to the courthouse, very likely added to the poor traffic flow, but there is no denying that Baltinglass was a busier place then than it was just a few years before.

Another noticeable change was the gradual move towards the Dublin commuter belt. At the beginning of the 1980s it was unusual for Baltinglass people to commute to work in Dublin. Slowly the numbers increased and in 2001 there were dozens of workers and students travelling to the city every weekday. Celtic Tiger property prices in Dublin in the late 1990s forced many people to move beyond the metropolitan area and this increased the recent trickle of new families into Baltinglass. This in turn added to the commuter traffic. In 2000 Bus Éireann finally acknowledged the growing need for public transport when they introduced an early morning commuter coach and added a mid-afternoon bus to Dublin. However, private enterprise had already provided Baltinglass with a hackney service and two daily buses to Carlow via Tullow.

Beyond all other changes, cultural diversity was by far the most significant by-product of the Celtic Tiger. The arrival in 1999 of the Kosovar refugees was the town's first major exposure to multicultural society. The Kosovars' smooth integration into Baltinglass life could hardly have been foreseen at the beginning of that year, let alone back in 1951 when Albanian-speaking Muslims would have been unimaginably exotic. By 1999 Baltinglass was home to Argentinean, ethnic Chinese, Dutch and Italian residents. After the Kosovars, migrant workers from Latvia and Poland came to the town. In the latter half of 2000 the nationally controversial issue of asylum seekers became a local reality when Inis Fáil became a reception centre. By the beginning of 2001 just over twenty asylum seekers from various African and east European countries were living in Baltinglass, hoping to be given a chance to share in Ireland's prosperity. During 2001 the numbers of migrant workers and asylum seekers resident in Baltinglass increased significantly, and it was interesting to see how these new cultural elements blended into and enhanced Baltinglass society in the subsequent years.

Baltinglass had travelled light years from 1951. After the notoriety of the Battle of Baltinglass, heightened by the publication in 1952 of Lawrence Earl's uneven account, the town settled back into relative obscurity. But well into the 1980s that event was still remembered by people from other parts of the country. In Baltinglass itself 'the Battle' was a bad memory, something that had a divisive effect on the community that lasted, albeit quietly, for decades. Younger generations would be excused for thinking it was something that happened in 1798

or in Cromwell's time as it was rarely mentioned in Baltinglass. When the West Wicklow Historical Society included press photographs of 'the Battle' in an exhibition in the 1980s the organisers were apprehensive about how they would be received by surviving participants. However, by then it could be looked on as something that happened to other people. Later a television production company planned to make a drama based on the event and engaged Dermot Bolger to write the script, but the project never came to fruition. In the late 1990s a short documentary on 'the Battle' was broadcast by RTE, but this concentrated more on aspects of Helen Cooke's private life than on the event itself.

The end of the town's railway life in 1959 was a significant retrograde step. Even though its passenger and freight services had already been discontinued, the final closure sealed the fate for future generations. With the huge increase in commuter traffic to Dublin towards the end of the century many lamented the short-sightedness of the authorities in selling off the land, making it virtually impossible to reopen the line. About a decade after the closure, the railway cutting between the station and Belan Street was filled in. Afterwards houses were erected on its site and an entrance to Tan Lane was built crossing it. The station itself was sold to Quinns and eventually its site became part of a large yard, though the ticket office and the station master's house still remain. The stretch of railway just north of the station became the site of the cattle mart in the mid-1960s. The Carlow Road was slightly altered in the 1960s and the former railway bridge there now forms a private entrance off the new road.

Clogh Cross was altered about that time so that the section of the Carlow Road heading out of town merged with the Rathvilly Road, instead of continuing directly towards Irongrange. The other significant road change in the years since 1951 was on the Kiltegan Road at Lathaleere, with Whitehall Cross being bypassed by a new stretch running across the lands of Allen Dale. On the old stretch of road the industrial estate began with 'advance factories'.

Shortly after 1951 Tan Lane lost its last residents to Parkmore. However, it was not until the 1970s and afterwards that any significant new changes to the housing situation occurred, with ribbon development becoming noticeable through the years along the Bawnoges, Carlow, Kiltegan, Rathmoon, Redwells and Sruhaun roads. New housing provided by the county council was confined to one area of the town, with eleven extra houses in Beech Avenue, Parkmore, thirty-six houses in another extension to Parkmore, and forty-eight in a new estate in Lathaleere. At the end of the 1990s a new trend in Baltinglass housing began with the first privately developed estate at Allen Dale. Rumours of other such schemes were rife at the time but it was not till the summer of 2001 that a second private housing estate was begun.

In 1951 Morrins were the only firm employing more than a handful of workers. Over the second half of the twentieth century the business begun by Willie Quinn in 1936 and continued by his son Liam grew from a shop in Main Street to become the largest source of employment in the town, with drapery, grain, grocery and

hardware outlets, two pubs and a restaurant operating in three separate locations. The development of the Industrial Estate from the 1970s also provided new sources of employment. Of these the most significant was Wampfler which, after twenty-five years in operation, had over thirty-five employees at the turn of the century.

In 1951 the Town Hall was the focus of social activity in the town. It closed shortly afterwards and it was not till the mid-1960s that Fatima Hall was built and began to fill some of the same functions. In additional there was Inis Fáil, built in the 1970s by Joe Germaine. Other additions to Baltinglass between 1951 and 2001 included such institutions as the Library, the Fire Station, the Credit Union, the Lalor Centre, the Day Care Centre and the VEC Education Resource Centre (now the Outdoor Education Centre). The 1969 fire that destroyed the Bridge Inn left an ugly derelict site at the centre of the town. It later became a car sales area before Slaney Mall, with six shop units and a car park, took its place, with part of the garden of St Kevin's also taken into the new feature.

RECENT EVENTS IN BALTINGLASS

During the summer of 2000 the major controversy in the area was the issue of the 'Superdump', centring on the county council's proposal to extend the acreage of its Waste Disposal Site at Rampere, rather than terminate its use as previously planned. Two public protest meetings were held in Fatima Hall but by the end of the year the issue was unresolved. In January 2001 the beginning of the new millennium was greeted in Baltinglass, as elsewhere in the world, as the start of just another year, since millions had been spent on premature celebrations twelve months earlier. In spring the national effort to stop Foot and Mouth Disease spreading from the United Kingdom brought all types of activity to a standstill. Most meetings and social gatherings were cancelled, businesses placed disinfectant mats at their doorways and the entrances to farms showed notices warning against unnecessary visits.

In the summer of 2001 Baltinglass saw a large amount of construction work begin. This included the commencement of an estate of twenty-eight bungalows adjacent to Belan Street and Bawnoges Road. About the same time work started on the long awaited sports hall at Scoil Chonglais. While these were in progress, construction of a new reservoir began on the side of Baltinglass Hill at Carsrock, with pipes being laid between it and the old reservoir on the Tinoran Road. In October the extension to Scoil Naomh Iósaf on the Kiltegan Road also commenced. In autumn, Rathcoran House, once home to the Presentation Sisters and later the Kosovars, was briefly in the limelight again. This time it was masquerading as an orphanage for part of the filming of Bruce Beresford's film *Evelyn*. Of more importance to celebrity spotters was the presence of the film's star, Pierce Brosnan. This was the third film made or partly made in Baltinglass. *Ireland, A Nation*, made in 1914 and concerning Robert Emmet's rebellion, is said to have been shot in the Baltinglass area. In 1970 the town's residents, the present writer included, were entertained for several evenings watching

the filming of Brian Friel's play *Philadelphia Here I Come*. All the exterior scenes were shot in Baltinglass, mainly on Main Street, with Cookes' being Gar's father's shop and Reggie McCann's (which had just been bought by Joe Kinsella) doubling as a pub.

Baltinglass experienced an unusually high number of unexpected deaths in 2001, so in many ways it was a sad year for the town. There were several very large funerals, among them those of Godfrey Timmins in April and Father Garry Doyle in November. Father Doyle's sudden death was another shock to the town as it geared up for its role as a host town for the Special Olympics in 2003, a project to which he was very much committed. As the year drew to a close the people of Baltinglass, like their fellow citizens in twelve of the fifteen countries in the EU, were talking with apprehension and interest about the conversion to the new Euro currency, and speculating about how smooth or how difficult the transition would be on New Year's Day.

BALTINGLASS 2001
ADMINISTRATION

Dáil Representative (resident within the Baltinglass area)
Billy Timmins, Sruhaun Road
County Councillors (resident within the Baltinglass area)
Thomas Cullen, Kiltegan Road, Deerpark
Billy Timmins, Sruhaun Road
Commissioners for Oaths (resident within the Baltinglass area)
Thomas O'Doyle, Sruhaun Road
Mary O'Keeffe, Rathmoon Road
Peace Commissioners (resident within the Baltinglass area)
Patsy Burke, Belan Street
Margaret Mary Cullen, 9 Parkmore
Billy Doody, 16 Parkmore
Len O'Connell, Sruhaun Road
Breeda O'Neill, Weavers' Square
Clerk of District Court:
Billy Dunphy, Carlow
Registrar of Births, Deaths & Marriages:
Miriam Lord, Fawn Lodge, Rathmoon Road
Relieving Officer
Maurice Byrne, Health Centre, Belan Street
Wicklow County Council Overseer:
Seamus Halloran, Kiltegan Old Road, Deerpark

Organisations
Adult Education Service, Baltinglass Adult Learning Centre, Main Street. Organiser:
 Annette Mangan
Baltinglass Amateur Dramatics, founded March 2001. Officers (for 2001): Chairperson-
 Janet Gorman; Hon. Sec.- Monica Gorman; Hon. Treas.- Eamon Horan;
 PRO- Rosario Murphy

Baltinglass Badminton Club, Church Lane. Officers (for 2001): Chairman- Joey Fagan; Acting Hon. Sec.- Genevieve Doyle; Hon. Treas.- Billy Doody

Baltinglass Boys' Brigade (St. Mary's Company), (affiliated to the Church of Ireland) officers (for 2001): Chaplain in Charge- Canon McCullagh; Captain- Jane Hanbidge

Baltinglass Bridge Club, founded 1968. Officers (for 2001): President- Rev. Derek Byrne; Hon. Sec.- Pamela Nolan; Hon. Treas.- Irene Mogg

Baltinglass Community Shop Committee, (disbanded August 2001). Officers (for 2001): Chairman- Mai Farrell; Hon. Sec.- Hilary McCullagh; Hon. Treas.- Kitty Patterson

Baltinglass Foróige Club. Officers (for 2001): Leaders- Martin Donegan, Winifred Keogh & Patrick Lennon; Chairperson- Ann-Jean Fitzsimons; Hon. Sec.- Elizabeth Donegan; Hon. Treas.- Fabian Dunne

Baltinglass GAA Club, Pairc Naomh Sheosaimh, Kiltegan Road. Officers (for 2001): Patrons- Liam Quinn, V. Rev. Gerald Doyle, Rev. Thomas Dooley, Rev. Pádraig Shelley & Rev. Canon McCullagh; President- Godfrey Timmins; Chairman- Eamonn O'Keeffe; Hon. Sec.- Martin Coleman; Hon. Treas.- Anne Whelan; PRO- Hugh Kenny

Baltinglass Girls' Friendly Society. Officers (for 2001): Patron- Canon McCullagh; Hon. Sec.- Pauline Lawrence; Hon. Treas.- Hazel Thompson; Leader- Muriel Pearson

Baltinglass Golf Club, Stratfordlodge , founded 1928. Officers (for 2001): President- Maurice Byrne; Captain- Dave Prendergast; Hon. Sec.- Owen Cooney; Hon. Treas.- Tom Hannafin; Lady President- Mary Gorry; Lady Captain- Maureen Dennis; Ladies' Hon. Sec.- Mai Quaid; Ladies' Hon. Treas.- Una McKeever

Baltinglass Lions Club. Officers (as of 1 Jan. 2001): President- David Hallahan; Hon. Sec.- Berni McGrath; Hon. Treas.- Nuala Allen; PRO- Sheila Grace. Officers (for 2001): President- Tom Hannafin; Hon. Sec.- Nuala Allen; Hon. Treas.- Maureen Plant; PRO- Assumpta O'Neill

Baltinglass/Rathvilly Macra Na Feirme. Officers (as of 1 Jan. 2001): Chairman- John Neill; Hon. Sec.- Malcolm Thornton; Hon. Treas.- Declan Leigh; PRO- Catherine Whelan

Baltinglass Senior Citizens Committee, founded 1978. Officers (for 2001): Chairperson- Anne Lee; Hon. Sec.- Attracta Cooney; Hon. Treas.- Una McKeever; PRO- Kathleen Hanlon

Baltinglass Table Tennis Club. Officers (for 2001): Patron- Canon McCullagh; Chairman- Edward Lawrence; Hon. Sec. & Treas.- Pauline Lawrence

Baltinglass Tidy Towns Committee. Officers (as of 1 Jan. 2001): Chairperson- Simon Murphy; Hon. Sec.- Janet Gorman; Hon. Treas.- Eamon Horan; PRO- Richard O'Beirne, officers (for 2001): Chairperson- Michael Browne; Hon. Sec.- Janet Gorman; Hon. Treas.- Eamon Horan; PRO- Noel Doody

Baltinglass Town Soccer Club. Officers (for 2001): Hon. Sec.- Damian Patterson; Hon. Treasurers: Ian Doyle & Michael O'Keeffe

Baltinglass Women's Group. Officers (as of 1 Jan. 2001): Chairperson- Áine Daly; Hon. Sec.- Mary Poll; Hon. Treas.- Maree Horan. Officers (for 2001): Chairperson- Teresa Kenny; Hon. Sec.- Maureen Murphy; Hon. Treas.- Mary Doran

Bough Youth Group (for Baltinglass Church of Ireland Union of Parishes). Leaders (for 2001): Elizabeth Edwards, Ruth Edwards, Jane Tutty, Trevor Tutty & Valerie Tutty

Christmas Appeal Fund. Co-ordinators: Mary Byrne, Brian Matthews & Carol Matthews

Civil Defence. Officers (for 2001): District Wardens- John Browne & Paddy Rooney; Welfare Officer- Sheila O'Neill

Fatima Hall Committee. Officers (for 2001): Chairman- Len O'Connell; Hon. Sec.-
David Hallahan; Hon. Treas.- Seán O'Toole

Gabhair Laighean Teoranta (Baltinglass Heritage Centre Committee). Officers (as of 1 Jan.
2001): Chairman- Michael Cogan

Imaal Walkers' Club. Officers (as of 1 Jan. 2001): Chairman- Frank McNulty; Hon. Sec./
Treas.- Anne Carpenter; Membership Sec.- Phyllis Flanagan

Irish Red Cross (Baltinglass Branch). Officers (as of 1 Jan. 2001): Chairman- Ann Halpin;
Hon. Sec.- Eoin Cuddy; Hon. Treas.- Theresa McDermott

Jolly Tots Parents' & Toddlers' Group. No officers; run by parents on a rota

Lalor Centre Committee. Officers (as of 1 Jan. 2001): President- V. Rev. Gerald Doyle;
Chairman- Seamus Leigh; Hon. Sec.- Sister Brigid Morgan; Hon. Treas.- Con
Hayes; PRO- Anna May Byrne. Officers (for 2001): President- V. Rev. Gerald Doyle;
Chairman- Seamus Leigh; Hon. Sec.- Sister Brigid Morgan; Hon. Treas.- Con Hayes;
PRO- Margaret Byrne

Legion of Mary – Our Lady of the Sacred Heart Senior Praesidium. Officers (for 2001):
President- Kathleen Hanlon; Hon. Sec.- Kay Halstead; Hon. Treas.- Frank Doyle

Pioneer Total Abstinence Association. Officers (as of 1 Jan. 2001): President- Frank Hunt;
Chairman- Michael Kehoe; Hon. Sec.- Ann Whittle; Hon. Treas.- Nuala Rogers

Quinns' Golf Society. Officers (as of 1 Jan. 2001): President- Joe McHugh; Captain- Billy
Bradley; Hon. Sec.- Joe Cullen; Hon. Treas.- Pat Byrne. Officers (for 2001): President-
Joe McHugh; Captain- Eamon Sweeney; Hon. Sec.- Joe Cullen; Hon. Treas.- Pat
Byrne

Rainbows. Co-ordinator: Marita Kavanagh; facilitators: Catherine Doody, Sister Carmel
Duggan, Noeline Finnegan & Teresa O'Reilly

St. Joseph's Parish Choir. Co-ordinator: Sister Brigid Morgan

St. Joseph's Parish Folk Group. No officers or elected committee; duties shared by members

Tynte Lodge of the Freemasons of Ireland, Belan Street, founded 1909

West Wicklow Day Care Centre Committee. Officers (as of 1 Jan. 2001): Chairman-
Valerie Hamilton; Hon. Sec.- Anne Aspill; Hon. Treas.- Nuala Rogers;
PRO- Kathleen Hanlon. Officers (for 2001): Chairman- Billy Lee; Hon. Sec.- Anne
Aspill; Joint Hon. Treas.- Nuala Rogers & Phyllis Flanagan; PRO- Margaret Byrne

West Wicklow Historical Society, founded 1980. Officers (as of 1 Jan. 2001): Chairman-
Donal McDonnell; Hon. Sec.- Brenda Kenny; Hon. Treas.- Peadar Cullen. Officers
(for 2001): Chairman- Peadar Cullen; Hon. Sec.- Donal McDonnell; Hon. Treas.-
Phyllis Flanagan

PUBLIC TRANSPORT
BUS SERVICES

Bus Éireann operating the following services through Baltinglass:
to Dublin (Bus Áras)

from Tullow	departing Mill Street 7.00am	(Mon.-Fri.)
from Enniscorthy	departing Mill Street 10.10am	(Mon.-Sat.)
from Carnew	departing Mill Street 10.30am	(Thurs. only)
from Tullow	departing Mill Street 3.00pm	(Mon.-Fri.)
from Waterford	departing Mill Street 6.30pm	(Mon.-Sat.)
from Carnew	departing Mill Street 1.10pm	(Sun.)

from Waterford departing Mill Street 3.15pm (Sun.)
from Waterford departing Mill Street 7.10pm (Sun.)

from Dublin (Bus Áras) [all times approximate]

to Waterford departing Mill Street 10.15am (Mon.-Sat.)
to Tullow departing Mill Street 1.50pm (Mon.-Fri.)
to Tullow departing Mill Street 6.30pm (Mon.-Fri.)
to Enniscorthy departing Mill Street 7.00pm (Mon.-Sat.)
to Carnew departing Mill Street 7.00pm (Thurs. only)
to Carnew departing Mill Street 7.20pm (Fri. only)
to Waterford departing Mill Street 12.15pm (Sun.)
to Waterford departing Mill Street 6.55pm (Sun.)

Rapid Express operating the following services through Baltinglass:
to Carlow (via Rathvilly & Tullow)

from Hacketstown departing Main Street 7.50am (Mon.Sat.)
from Hacketstown departing Main Street 2.15pm (Mon.Sat.)

from Carlow (via Tullow & Rathvilly)

to Hacketstown. departing Main Street 12.55pm (Mon Sat.)
to Hacketstown. departing Main Street 6.05pm (Mon Sat.)

HACKNEY SERVICES

Baltinglass Cabs Ltd. (based in Stratford), proprietor: Dermot Allen
Hackney Service, Dublin Road, Tuckmill Upper, proprietor: James Fitzmaurice

STREET DIRECTORY

As of 1 Jan. 2001, including permanent residents aged 18 or over; houses on all streets numbered for clarity; numbers given under townland addresses [with the exception of Saundersgrove & Stratfordlodge] equate to current Valuation Office lot numbers.

Allen Dale Avenue, Lathaleere townland
(there are no nos. 10, 12 & 14)
East Side
(Kiltegan Road to Allen Dale Lawn)
1 Leigh, Anthony, retired, Leigh, Patricia, retired
3 unoccupied
5 Wall, John, Wall, Jacqueline, housewife
[here joins Allen Dale Court]
7 Fay-Cooper, Richard, general management, Fay-Cooper, Patricia, housewife
9 unoccupied
11 unoccupied
13 O'Reilly, Mark, working in Xtravision, Tallaght, Arnold, Kim, working in Xtravision, Tallaght
15 Vase, Eddie, Vase, Pauline

West Side

(Allen Dale Lawn to Kiltegan Road)

[here space with no buildings]

8 Garrod, Daisy Louise, retired

6 Murray, Christopher computer programmer, Dublin, Murray, Helen, full-time
 mother; former civil servant

4 Malone, Mark, working in Blessington, Malone, Lynn

2 Kerslake, George, working in Dublin, Kerslake, Marie

Allen Dale Court, Lathaleere townland

North Side

(Allen Dale Avenue to end)

1 Reilly, David, tower crane driver, Dublin, Reilly, Anna, managing director, Dublin

2 Power, Alan, chef, Dublin, Power, Martina , catering manager, Dublin

3 Occupier declined to be named

South Side

(end to Allen Dale Avenue)

5 Murphy, Kenneth, soldier, Cathal Brugha Barracks, Murphy, Adrienne, contracts man-
 ager, City West Business Park

4 Cosgrove, June, interior designer

Allen Dale Drive, Lathaleere townland

(there are no nos. 9, 11 & 13)

East Side

(Allen Dale Lawn to end)

1 Lingwood, Siobhan risk management, Tallaght Hospital

3 Kiernan, Brendan, finance manager, Toyota Garage, Dublin, Kilfeather, Helen, nurse,
 Dublin

5 Evans, David, officer, Irish Ferries, Evans, Catherine, housewife

7 unoccupied (owned by Reid)

[here space with no buildings]

West Side

(end to Allen Dale Lawn)

14 Aisling, KARE house, McClintock, Carol, O'Malley, Eoin, O'Neill, John

12 Mooney, Paul, sales representative, Dublin, Mooney, Karen, receptionist, Dublin

10 unoccupied (owned by McMahon)

8 unoccupied (owned by Kearns)

6 unoccupied (owned by Wilson)

4 unoccupied (owned by Hannon)

2 unoccupied (owned by Brazil)

Allen Dale Lawn, Lathaleere townland

(there are no nos. 9, 11 & 13)

North Side

(Allen Dale Avenue to end)

1 unoccupied

3 unoccupied (owned by Tyrrell)

5 unoccupied

7 Cawley, David Martin, carpenter, Pearse, Cawley, Carol Ann, teacher

South Side
(end to Allen Dale Park)
14 unoccupied (owned by Barry)
12 Staines, Liam, internal auditor, Tallaght Hospital, Staines, Jean, housewife
[here Allen Dale Drive]
10 unoccupied (owned by Dunne)
8 unoccupied (owned by Rogers)
6 Kelly, Derek, technician, Guinness, Dublin, Kelly, Fiona, accounts technician, Meteor, Dublin
4 unoccupied (owned by Reid)
2 unoccupied (owned by Hutchinson)

Allen Dale Park, Lathaleere townland
(there are no odd numbers)
East Side
(Allen Dale Lawn to end)
2 under construction
4 under construction
6 under construction
8 under construction
10 under construction
12 under construction
14 under construction
West Side
(end to Allen Dale Lawn)
no houses here

Ballytore Road, Baltinglass West townland, (see County Road; Station Road)

Bawnoge ['Bawnoges'] townland, (see Bawnoges Road, Carlow Road, Edward Street & Rathvilly Road)

Bawnoges Road, Baltinglass West & Bawnoge townlands
East Side
(Belan Street to 'Clough Cross') [Baltinglass West townland]
1 Leigh, Anthony, landscape gardener, Leigh, Patricia, housewife
2 Kilcoyne, Bryan, engineer, Eircom, Kilcoyne, Bernadette, Kilcoyne, Eilish
3 McKelvie, Seán, contracts director, McKelvie, Teresa, cashier
4 McEntee, Jim, head of development, Carlow Institute of Technology, McEntee, Nina, nurse, Baltinglass Hospital
5 Occupier declined to be named
6 O'Neill, Michael, machine operator, Wampfler, O'Neill, Clare, teacher, Scoil Naomh Iósaf
7 Jackson, Mary, housewife
8 Allen, Margaret, retired teacher, Allen, John, analyst (IT), Clondalkin
[Bawnoge townland]
9 McLoughlin, Mel, architectural technician, McLoughlin, Lynda, supermarket, supervisor

10 house under construction (owners Fergus & Fiona Brennan)

11 McMahon, John, retired Garda, McMahon, Betty, housewife, McMahon, Damien, bank clerk, Newbridge, McMahon, Eoin, bank clerk, Carlow

12 Owens, Andy, plasterer, Owens, Mary, part-time secretary, Tullow

13 Sweeney, Eamon, nursing officer, S.W.A.H.B., Kildare, Sweeney, Miriam, registered nurse, Naas

14 New Dawn, Dawson, Rick, sales manager, FBD, Dawson, Nuala, insurance inputter

15 unoccupied

16a unoccupied new house

16b (temporary structure) Barrett, Richard

17a Curry Beds, bed manufacturers, proprietor: Nicholas Curry,

17b Hill View, Curry, Nicholas, bed manufacturer, Curry, Mary, housewife

18 Fergus Kenny Autos Ltd., car sales, etc., proprietors: Fergus & Teresa Kenny, Kenny, Fergus, mechanic, Kenny, Teresa, assistant librarian

West Side

('Clough Cross' to Belan Street)

[Bawnoge townland]

19 out offices owned by Morrin

20 West Winds, Curry, Kathleen

21 Fogarty, Gerard, P.D.F., Fogarty, Ann, working in Quinns

22 Fogarty, Jack, Fogarty, Mary, working in Eastern Health Board, Fogarty, Oliver, Rooney, Mick, Rooney, Geraldine

[Baltinglass West townland]

23a Murphy, Bridget, housewife

23b Thomas A. Murphy, M.R.C.V.S., veterinary surgery, senior staff: Thomas A. Murphy

24 Lawlor, William, retired, Lawlor, Anne, Lawlor, Mary, instructor, Blessington

25 Rowe, Paul, retired

26 St. Anne's, Lynch, Eileen, retired teacher

27 unoccupied – under refurbishment

Belan Street ['Cuckoo Lane'], Baltinglass West townland

North Side

(Mill Street to Brook Lane)

1 see No. 22 Mill Street [Quinns Hardware]

2 The Corner Bar ('Quinns o' the Corner'), public house, proprietor: Liam Quinn,, Slaney Lodge

3a Fiona Kavanagh, optician, Proprietor: Fiona Kavanagh

3b Karen's Beauty Clinic beauty salon, proprietor: Karen Guing

4 out office owned by Quinn

5 Louie Fagan & Sons garage, proprietor: Louie Fagan, Kelshamore, Donard

[here bridge formerly over railway – now infilled]

[here joins County Road]

[here street bounded by a field]

5 Patterson, Breda, housewife

6 abattoir owned by Pattersons Butchers Ltd.

South Side

(Bawnoges Road to Edward Street)

7 see No. 1 Bawnoges Road [Anthony Leigh]

8 Kehoe, John, tradesman, Wicklow County Council, Kehoe, Katherine, supervisor, Shaws, Athy, Kehoe, Caroline, student, Dublin, Kehoe, Patrice, student, Dublin

9 Mogg, Irene, retired

10 Sutton, William, retired, Sutton, Margaret, retired

11 Dunne, Paschal, Dunne, Marie

12 Doyle, Hugh, heavy goods vehicle driver, Doyle, Genevieve, housewife & student

13 unoccupied (formerly Cahills)

14 Doyle, Fintan, printer, Doyle, Margo

15 Kenny, Jim, ex-soldier, Kenny, Kathleen, housewife

16 Rosbeg (entrance to)[1021], O'Beirne, Richard, civil servant, Department of Agriculture, Weavers' Square, O'Beirne, Mary

17a Tynte Masonic Lodge

17b Dervla's Hair Studio, hair salon, proprietor: Dervla Bolger, Rathvilly

17c Baltinglass Community Shop, retailing used clothes, toys, etc. operated by voluntary committee

18 Kavanagh, Orla

19 Foley, Margaret, retired

20 Burke, Kieran, secondary teacher, St. Kevin's, Dunlavin, Burke, Deirdre, housewife

21 vacant

22 Burke, Patsy, Burke, Marian

[here bridge formerly over railway – now infilled]

23 Dunne, Eugene, retired

24 Bernica, Ragip, Bernica, Fatime, kitchen staff, Quinns', Main Street, Bernica, Adem, barman, Quinns', Main Street, Bernica, Aida, shop assistant, SuperValu & student

25 vacant lot

26 South Western Area Health Board, Health Centre

[here side entrance to No. 2 Edward Street]

27 see No. 1 Edward Street [Baltinglass Service Station]

Bramble Court, Baltinglass East townland
South Side
(Chapel Hill to end)
1 Miley, Mary, retired
2 O'Modhráin, Lughaidh, factory employee, Wampfler
3 O'Neill, Carmel, teacher, Carlow
North Side
(end to Sruhaun Road)
4 Sinnott, Olivia
5 O'Reilly, Patrick Michael, retired, O'Reilly, Marian, retired
6 Doody, Eilis, secretary, St. Patrick's, Kiltegan

The Bridge, Baltinglass East & Baltinglass West townlands
South Side
(Edward Street to Main Street)
[Baltinglass West townland]
1 see No. 23 Edward Street [The Dutchman's]
[here River Slaney]

[Baltinglass East townland]
2 see No. 1 Main Street [Bridge House]
North Side
[Baltinglass East townland]
[here Slaney Mall]
[here River Slaney]
[Baltinglass West townland]
3 see No. 1 Mill Street [Gillespies']

Brook Lane, Baltinglass West townland, (between Belan Street / Rathmoon Road &
 Ballytore Road / Tinoran Road)
East Side
1 Vernon, John Bailey retired, Vernon, Mary, retired
West Side
no houses here

Cabra Road, **Rampere**, Rampere townland, (between the 'Five Crossroads' &
 Goldenfort)
no houses here
[road continues into Goldenfort townland]

Carlow Road, Bawnoge, Irongrange Lower & Irongrange Upper townlands
West Side
(Edward Street to Carrigeen)
[Bawnoge townland]
1 Baltinglass Garda Station
 Superintendent: Michael Hurley, Inspector: Patrick McDonald, Sergeants: Kevin
 O'Neill, James Owens & Daniel Stapleton, Gardaí: Karen Byrne, Kevin Byrne,
 Michael Curtin, Kevin Fahy, James Flannery, Brendan Gaynor, Bernard Graham,
 Sylvester Hipwell, Paul Hogan, Liam Horgan, James Kelly, James Lawlor, Maurice
 Mahon, Desmond Murphy, Seamus Murphy, Finbar O'Donovan, Charles Prendergast,
 Damien Prendergast & Padraig Teahan
1a Browne, Michael, Garda sergeant, Carlow, Browne, Noeline, deli/bakery manager,
 SuperValu
2 O'Kane, John, retired Garda sergeant, O'Kane, Bridget, retired nurse, O'Kane,
 Thomas, engineer, O'Kane, Declan, software engineer, Dublin, O'Kane, John, elec-
 tronic engineer, Dublin
3 Eircom plc, telephone exchange, staff: John Kennedy & Bryan Kilcoyne
4 Hugh Fleming & Son, electrical contractors, proprietor: Hugh Fleming, *Convent View*,
 Fleming, Hugh, electrician, Fleming, Marie, housewife, Fleming, Neil, computer pro-
 grammer, Kill, Fleming, Hugh, technician, Lex, Fleming, Paul, apprentice electrician
5 Browne, Ken, teacher, Scoil Chonglais, Browne, Hilda, housewife
[here site of bridge over railway]
6 Lee, William A., retired, Lee, Anne M., retired
7 new house not yet occupied (owners: Gary & Áine Daly)
8 Pat Lee Electrical & Pumps, electrical contracting & pumps, proprietors: Patrick &
 Frances Lee, Lee, Patrick, electrical contractor, Lee, Frances, housewife
9 *Cranagh*, Flood, Agnes, retired

10 Coyle, Magdalen B., medical doctor, Coyle, Charlotte, student, UCD

11 Crimin, John, butcher, Blessington, Crimin, Olga, book keeper, Millett & Matthews

12 Fitzgerald, William, courier, Fitzgerald, Kathleen, housewife, Fitzgerald, Liam, general operative, Naas, Fitzgerald, John, computer technician, Kilkenny, Fitzgerald, Brendan, cabinet maker

13 Nolan, Michael, carpenter, Nolan, Margaret, housewife, Nolan, Michael, jnr., carpenter, Nolan, David, welder, Dublin, Nolan, Ray, builder's labourer, Dublin, Barrett, Anne, retired

14 Nolan, Thomas, builder, Nolan, Elizabeth, housewife, Nolan, Brian, roofing apprentice

15 Curry, Kathleen, housewife

15a (temporary structure) unoccupied

16 Barrett, Ann, home help, Barrett, Kevin, apprentice bricklayer, Dublin, Barrett, Gerard, apprentice electrician, Dublin

17 Occupier declined to be named

18 Loughlin, Jeremiah, setter, Mediplast, Carlow, Loughlin, Therese, housewife

19 Fogarty, Paddy, Fogarty, Joan, Fogarty, Joan, jnr., Fogarty, John

[here 'Clough Cross'; Bawnoges Road & Rathvilly Road intersect]

no houses here

[Irongrange Lower townland]

20 O'Connor, Tommy retired, O'Connor, Cecelia, retired

21 Irongrange Lodge, Doyle, Richard, retired, Doyle, Mary Frances, retired

22 Kelly, Seamus, Garda, Baltinglass, Kelly, Maire, housewife, Kelly, Caroline, civil servant, Dublin, Kelly, Deirdre, Montessori teacher, Baltinglass

23 Doyle, Seamus, farmer, Doyle, Ita, housewife

24 Doyle, Seamus, prison officer, Curragh, Lambe, Frances, nurse, Carlow

25 Gethings, Vincent, production manager, Kaideen, Lynch-Gethings, Colette, primary teacher, Scoil Naomh Iósaf

26 unoccupied house (owned by Burke)

27 farm buildings owned by Burke

[Irongrange Upper townland]

28 derelict farm building owned by Christopher Kehoe

[road continues into Carrigeen, Co. Kildare at this point]

East Side

(Carrigeen to Edward Street)

[Irongrange Upper townland]

[here joins Irongrange Lane]

29 Duffy, Declan, manager, Healystone, Connell, Marian, social worker, South Western Health Board

30 farmyard owned by Rogers

[Irongrange Lower townland]

31 Byrne, Garrett, post office clerk, Carlow, Byrne, Elaine

32 Kelly, Michael, labourer, Kelly, Eileen, housewife, Kelly, Paul, ESB, Dublin, Kelly, Peter, student

[Bawnoge townland]

33 unoccupied new house

34 unoccupied new house

35 unoccupied new house

36 unoccupied new house

37 Barrett, Thomas, builder, Barrett, Miriam, housewife

38 Woodfields, Barrett, Seamus, builder, Barrett, Orla, civil engineer, Carlow

39 Kavanagh, Dan, machine operator, Kavanagh, Sheila, housewife, Kavanagh, Michelle, student

40 Clynch, Seamus, architectural technician, Naas, Clynch, Mona, shop assistant & housewife, Clynch, Sandra, legal secretary, Blessington, Clynch, James, student, Carlow Institute of Technology

41 unoccupied new house

42 unoccupied new house

43 McCormack, Tom, retired, McCormack, Florrie, retired

44 unoccupied new house

45 unoccupied new house

46 unoccupied new house

[here 'Clough Cross', Bawnoges Road & Rathvilly Road intersect]

45 out office owned by Timmins

46 Kavanagh, P.J., sales executive, Kavanagh, Marita, counsellor, Kavanagh, Gerard, student

47 Sliabh na mBan, Hayes, Con, retired Garda, Hayes, Mary, nurse, Baltinglass Hospital, Hayes, Claire, student, Lalor Centre, Ryan, Nora

48 unoccupied house (owned by Farrar)

49 McNamara, Desmond, McNamara, Ann

50 O'Brien, Matt, ESB employee, Turlough Hill, O'Brien, Theresa, housewife, O'Brien, Claire, tourist office employee, Dublin

51 Farrell, Michael, farmer & employee of Morrins', Farrell, Catherine, nursing sister, Tallaght Hospital

Cars' Lane, Baltinglass East townland, (see Timmins' Lane under Chapel Hill)

Carsrock townland
2 ruins (formerly Timmins')[1022]
3 unoccupied house[1023]

Chapel Hill, Baltinglass East townland
South Side
(Weavers' Square / The Green to Sruhaun Road, including Timmins' [or Cars'] Lane)
1 (see also No. 28 Weavers' Square – flats & Farm Development Office)
1a Sens, Elmars, forestry worker, Emerald Group, Grangecon, Puris, Egils, forestry worker, Emerald Group, Grangecon
1b Heeney, Louise
2 Flanagan, Phyllis, retired
3 Fatima Hall, Roman Catholic parish hall
4 'Old Boys' School'
4a The Den, Roman Catholic parish activities centre, manager: V. Rev. Gerald Doyle
4b Naíonra Bealach Chonglais, pre-school through Irish, proprietors & operators: Patricia Norton & Maisie Farrell
(Timmins' Lane south side)
5 Scoil Naomh Iósaf (Junior), primary school, principal: Tom Hannafin

[here space with no buildings]
(Timmins' Lane north side)
[here side entrance to Baltinglass Roman Catholic Graveyard]
(Timmins' Lane to Sruhaun Road)
6 Baltinglass Roman Catholic Graveyard
North Side
(Bramble Court to The Green, Main Street)
7 ruins[1024]
8 vacant lot
9 ruins
10 Byrne, Mary B, retired public health nurse, Baltinglass area
11 Lawlor, James, Garda, Lawlor, Teresa, housewife, Lawlor, Mark, toolmaker, Bray
12 unoccupied
13 Kennedy, Mary, housewife, Kennedy, Paul, carpenter, Kennedy, Noel, FAS worker
14 Handball Alley (disused)
15 Dooley, Thomas, Dooley, Bridget, Dooley, John, Dooley, Josie, Dooley, Claire,
 Dooley, Shawna
16 Shortt, Charles, retired farmer, Shortt, Elizabeth, housewife, Shortt, Cora, secretary

Church Lane, Baltinglass East townland
East Side
(Main Street to the Abbey)
1(also No. 53b Main Street) Gorry Research, genealogical researchers, proprietor: Paul
 Gorry
2 Baltinglass Badminton Club
3 Martin, Thomas, retired PVC contractor, Martin, Christina, childminder, Tinahely
4 Fintan Doyle Printing Services, general printing, proprietor: Fintan Doyle, Belan
 Street,
Home to Home auctioneers, proprietor: Fintan Doyle, Belan Street
5 B & A Autoparts, motor factors & lubricants sales, proprietor: Declan McGuckian,
 Tinakilly, Aughrim, staff: Declan McGuckian & Brian Harmon
6 The Cutting Room, hairdressers & beauticians, proprietors: Liam Lee & Jean
 Tompkin
7 Dee's Laundrette, laundrette, proprietor: Deirdre Lee Caplice
8 ruins
[here side entrance to No. 47 Main Street]
9 Stratford Lodge National School (Old), Church of Ireland parish hall, manager: Rev.
 Canon McCullagh
10 Stratford Lodge National School, primary school, teachers: June Snell (principal) &
 Ruth Moody
11 The Baltinglass Montessori School, proprietor: Yvonne Thomas, Donard, teachers:
 Yvonne Thomas, Mary Rose Doyle & Catherine Flynn (student)
12 The Rectory[1025], McCullagh, Rev. Mervyn Alexander, Rector of Baltinglass Group
 McCullagh, Hilary Joan, student, U.C.D.
13 St Mary's Church of Ireland parish church, Rector: Rev. Canon McCullagh, Glebe
 Wardens: John Farrar & Stanley Jackson, Church Wardens: Harry Edwards & Linda
 Valentine
14 Baltinglass Abbey (ruins of)

West Side
(Abbey to Main Street)
15a unoccupied chalet
15b (chalet) Gorecki, Wojciech, landscape worker, Murray Landscaping, Nemeczek,
 Stanislaw, landscape worker, Murray Landscaping
15c disused pool room
15D St. Kevin's, bed & breakfast accommodation, proprietors: Ciaran & Sharon
 Germaine, Germaine, Ciaran, Germaine, Sharon
16 Tommy Doyle Power Tools, hardware, proprietor: Thomas Doyle
[here Slaney Mall]

Cloghcastle ['Clough Castle'] townland, (see Rathvilly Road)

Clogh ['Clough'] Lower townland, (see also Rathvilly Road)
[houses on north side of lane between No. 20 Rathvilly Road and Fennells']
1 new house not yet occupied (owner: Niall Doogue)
2 house under construction
3 Cluain Ceoil Farrell, John Patrick, bank official, College Green, Dublin, Farrell, Mary
 Colette, teacher, Scoil Naomh Iósaf
4 Fennell, Brigid, housewife

Clogh ['Clough'] Upper townland, (see Rathvilly Road)

Colemans' Road, Raheen & Rampere townlands
West Side
(Dublin Road to the 'Five Crossroads')
[Raheen townland]
no houses here
[here bridge formerly over railway]
1 Molloy, John, retired, Molloy, Margaret, retired
2 Molloy, John, lorry driver, Barrett, Linda, shop assistant
3 unoccupied – under refurbishment (owned by O'Brien)
4 *Slaney*, O'Brien, Billy, shop assistant, Athy
5 Hayden Faulkner, Anne sales assistant, ESB
6 Faulkner, Joseph, Faulkner, Mary
7 unoccupied house (owned by Fleming)
[Rampere townland]
8 Ashton, David, aircraft maintenance, Ashton, Martha, chef
9 Shortt, Karl, farmer, Shortt, Marie, Montessori teacher, Kloyda Montessori School,
 Carlow
10 O'Hara, Michael, retired, O'Hara, Thomas, retired
11 Keogh, Noel, prison officer, Keogh, Fiona, nurse

East Side
('Five Crossroads' to Dublin Road)
[Rampere townland]
12 Kinsella, Elizabeth, housewife
13 Kinsella, David, secondary teacher, Ballyfermot, Dublin, Kinsella, Joan, housewife

[here joins Cabra Road]
14 Rampere Waste Disposal Site, Wicklow County Council
15 Byrne, Edward, retired
16 farmyard owned by Shortt
[Raheen townland]
no houses here
[here bridge formerly over railway]
no houses here

County Road, Baltinglass West townland
East Side
(Belan Street to Tinoran Road / Brook Lane)
[here side of No. 5 Belan Street]
1 Howard, Michael, mechanic, Howard, Angela, housewife, Howard, Alan, student
[here entrance to Tan Lane]
2 Sliabh gCua, Hallahan, David, school principal, Hallahan, Joan, housewife, Hallahan, Enda, crane driver
3 Hillbrook, Maher, Catherine
4 house owned by Donahoe
5 vacant lot
[here shared entrance to Nos. 6 & 7]
6 Station House (right-of-way to)[1026], Coleman, Martin, grain store manager, Quinns', Coleman, Patricia, housewife, Coleman, Paul William, cabinet maker, Langrells'
7 see Nos. 2a & 2b Station Road [Quinns of Baltinglass Ltd.]
[here County Road turns west]
North Side
8 Freddie McDaid & Sons, timber contractors, proprietors: Frederick & Donn McDaid, McDaid, Frederick, timber contractor, McDaid, Anne, assistant pharmacist, Gorrys, McDaid, Donn, timber contractor
South Side
(Brook Lane to Belan Street)
9 Occupier declined to be named
[here County Road turns south]
West Side
no houses here

Cuckoo Lane, Baltinglass West townland, (see Belan Street)

Deerpark townland, (see also Kiltegan Road & Kiltegan Old Road)
2 Moore, John, retired, Moore, Mary, housewife, Moore, Cecil, building labourer, Dublin
4C house owned by Carty
6 Old workhouse graveyard

Dublin Old Road, Baltinglass East, Sruhaun & Tuckmill Upper townlands, (see Sruhaun Road)

Dublin Road, Stratfordlodge, Raheen, Tuckmill Upper, Tuckmill Lower, Saundersgrove & Saundersgrovehill townlands

West Side

(Mill Street to Ballinacrow Upper)

[Stratfordlodge townland]

[here side of Quinns' grain stores – entrance on Station Road]

1 Kinsella Estates, livestock mart & auctioneers, proprietors: Joseph & Michael Kinsella

[here 'The Lord's Piers'; entrance to Baltinglass Golf Club & other properties – see under Stratfordlodge townland]

[here entrance to forestry]

[here joins Raheen Hill Road]

2 Slaney Lodge[1027], (entrance on Raheen Hill Road), Quinn, Liam, company director, Quinns', Quinn, Kathleen, company director, Quinns'

[Raheen townland]

3a (temporary structure), Burke, Stephen John, labourer, Naas, Byrne, Sandra Marie, dispenser, Boots, Tallaght

3b (temporary structure), Kenny, William, Byrne, Diane

3c Byrne, Thomas, Byrne, Kathleen

4 Hayden, Patrick

5 Byrne, John, Wicklow County Council worker, Flynn, Margaret, assistant house parent, Lacken, Flynn, Aisling, student, Carlow

[here joins Colemans' Road]

no houses here

[here Eldon Bridge; road crosses River Slaney]

[Tuckmill Upper townland]

6 Hackney Service, proprietor: James Fitzmaurice, Fitzmaurice, James, hackney operator, Fitzmaurice, Sheila, registered general nurse, Athy

7 O'Neill, Ambrose, farmer, O'Neill, Joan, housewife, O'Neill, Catherine, O'Neill, Barry

[here 'Tuckmill Cross'; here joins Rathbran Road]

[Tuckmill Lower townland]

no houses here

[Saundersgrove townland]

8 McCarthy, Damien, sub contractor, McCarthy, Lorraine, PT teacher, Scoil Chonglais[1028]

[here entrance to Saundersgrove estate – see under Saundersgrove townland]

[Saundersgrovehill townland]

[here the 'Hangman's Corner']

no houses here

[here joins road by Manger Bridge to Stratford]

no houses here

[road continues into Ballinacrow Upper at this point]

East Side

(Ballinacrow Upper to Mill Street)

[Saundersgrovehill townland]

9 unoccupied house (formerly Moores)

10 Staunton, John, builder, Staunton, Chris, housewife

11 house owned by Kavanagh

12 outhouse

[here the 'Hangman's Corner']

13 occupier declined to be named

14 Burke, Peter, farmer, Burke, Marion, housewife, Burke, Aine, student

[Tuckmill Lower townland]

15A Thomas Murphy Landscaping, landscaping & gardening, proprietor: Thomas Murphy

15B disused mill owned by Murphy

15C outhouse owned by Murphy

16 ('Doyles of the Shop'), Nolan, Paddy, stonemason, Dublin, Nolan, Mary, hairdresser, Dublin

[here 'Tuckmill Cross'; here joins Kilranelagh Road]

[Tuckmill Upper townland]

17 unoccupied house & farm buildings (owned by Shortt)

18 Shortt, James, retired farmer

19 farm buildings including former dwelling (owned by Hanlon)

20 Hillview, Hanlon, Patrick J., retired farmer, Hanlon, Kathleen M., housewife, Hanlon, Colette T., social care worker, Rathdrum

21 Nolan, Thomas

22 ruins [1029]

[here joins Sruhaun Road]

no houses here

[here Eldon Bridge; road crosses River Slaney]

[Raheen townland]

23 ruins

24 ruins

[Stratfordlodge townland]

25 Slaneyside, Morrin, Mona Teresa, company director

Edward Street ['Pound Lane'], Baltinglass West & Bawnoge townlands
West Side

(Belan Street to Carlow Road)

[Baltinglass West townland]

1 Baltinglass Service Station (not trading)

2a Moneysworth, discount store, proprietor: Gerry O'Driscoll, Kiltegan, senior staff: Margaret O'Driscoll

2b Rogers, John, farmer, Irongrange

3 Rogers, Pat, shop assistant, Rogers, Nuala, housewife, Rogers, Gerry, computer technician, Leixlip, Rogers, Carmel, bank official, Dublin

4a P.J. McDonagh & Son, auctioneers & valuers, proprietors: Anthony & Mary McDonagh, Mill Street, staff: Aileen Moody

4b McDonaghs, public house, proprietor: Pamela Treacy, Treacy, Richard, accountant, Treacy, Pamela, publican

5 unoccupied

6 Bradley, Christina, housewife, Bradley, Billy, telephone technician, Naas

7 Elliott Travel Ltd., travel agency, proprietors: Martina & Mervyn Block, senior staff: Martina Block & Aisling Farrell

8 Shoe Clinic, shoe repairers, Lock & Key Locksmiths, key cutters & locksmiths, proprietors: Sonnie & Enda Nolan

9a Howes Garage, DOE test centre & garage

9b Howes Service Station, service station & shop, proprietors: Declan & Mary Howe, Kiltegan

10 Murphy, Simon, auctioneer, Mill Street, Murphy, Rosario, post office manager, Slaney Mall

[Bawnoge townland]

11 Whelan, Paddy, retired farmer

East Side

(Carlow Road to Bridge Street)

[Bawnoge townland]

12 farmyard owned by Michael Farrell

13a Foster, Claire, cleaner, Scoil Chonglais

13b unoccupied shop unit

13c store owned by John Kelly

14 Bradley, David

[Baltinglass West townland]

15 McLoughlin, Elizabeth, housewife

16 Doran, Jack, retired

17 Norton, Elizabeth, housewife, Norton, Billie, carpenter

18a Little Feet Creche & Pre-School, proprietor & manager: Jacqueline Furlong-Kenny

18b Occupier declined to be named

18c Bean Café, proprietors: Pauline Hayes & Tony Saunders

19a Duffy, Debbie

19b Jones, Sean, Jones, Bernadette

19c Coleman, Alan, Kennedy, Tammy

20a Oppong, Seth, from Ghana, Oppong, Cynthia, from Ghana

20b V & M Entertainment, video shop, proprietors: Patrick & Valerie Fox

21 ruins

22 O'Brien, Mary Jane, retired

23 The Dutchman's Inn, public house, proprietor: Tom McKenna, manager: Paul Garrigan, Garrigan, Paul, bar manager

Fair Green, Baltinglass East townland, (see The Green)

The Flags, Baltinglass East townland
(on west side of Weavers' Square, Nos. 1-4)

1 Nolan, Mary, retired

2 Geraghty, Andrea, carer, Blessington

3 unoccupied (owned by Hunt)

4 Brennan, Fergus, printer, Tullow, Brennan, Fiona, nurse, Naas

Glennacanon ['Glencannon'] townland, (see Tinoran Road)

The Green, Baltinglass East townland, (formerly Fair Green; an alternative name – almost obsolete – for the area north of the 'south-east' block in Main Street; see Main Street)

Green Lane, Newtownsaunders townland
North Side
(Kiltegan Road to River Slaney)

1 farmbuildings owned by Kehoe

[here Redwells Road intersects]

2 McCarthy, Jarlath, County Council, Rampere Waste Disposal Site, McCarthy,
 Veronica, housewife

[ends at Maidens Ford at River Slaney]

South Side

no houses here

Hartstown Road, Oldtown, Hartstown, Rampere, Tinoranhill North & Tinoranhill
 South townlands

North Side

('Tinoran Cross' to 'Five Crossroads')

[Oldtown townland]

1 Moran, Peter, farmer, Moran, Elizabeth, nurse, Moran, Kenneth, plumber

2 unoccupied house (owned by Moran)

3 St. Joseph's, Lacey, John, machine operator, Lacey, Belinda, housewife

4 house under construction

5 Whelan, Patrick, fitter, Army, Coolmoney, Whelan, Tresa, homemaker

6 Whelan, Christy, Whelan, Imelda

7 Long, George, bricklayer, Lalor Centre, Long, Angela, housewife

8 Walsh, Katherine, retired, Bollard, Thomas, farmer, Bollard, Helen, housewife, Bollard,
 Declan, farm manager

[Hartstown townland]

9 EnviroClean, carpet & upholstery cleaners, proprietor: George Fisher, Fisher, George,
 contract cleaner, Fisher, Lisa, general operative, Donnelly Mirrors, Naas

10 Hennessy, John, construction worker, Hennessy, Orla, hairdresser

11 Doody, Michael, KARE worker, Doody, Catherine, KARE worker

[Rampere townland]

12 farmyard owned by Leigh[1030]

South Side

('Five Crossroads' to 'Tinoran Cross')

[Rampere townland]

13 Kirwan, James Brendan fitter, Newbridge, Kirwan, Mary, housewife

14 Carty, Culm, designer, Dublin, Carty, Catherine, clerical officer, Baltinglass

15 Leigh, Dan, farmer, Leigh, Anne, job coach / facilitator, KARE, Blessington

16 Leigh, Seamus, retired farmer, Leigh, Mary, housewife, Leigh, David, office worker,
 Glanbia, Ballytore

[here site of Rampere Church]

[Tinoranhill North townland]

17 house owned by Stewart

18 Mountain View, O'Connor, Brian, engineer, Cuisine de France, Tallaght, O'Connor,
 Philomena, nurse, Baltinglass Hospital

19 David McDermott Electrical, electrical contractors, proprietor: David McDermott,
 McDermott, David, electrician, McDermott, Eileen, secretary

20 McGowan, Paul Hugh, analyst, McGowan, Karen Anne housewife

21 Kearney, Kevin, farmer, Kearney, Bridie, housewife, Kearney, Ailís, student, Carlow
 IT

22 Donohoe, Seamus, retired, Donohoe, John, retired

[Tinoranhill South townland]
no houses here

Hartstown townland, (see also Hartstown Road)
1a (entrance on the 'Bed Road'[1031]), Woods, Owen, farmer, Woods, Martin, farmer

Holdenstown Lower townland, (see also Rathvilly Road)
3 Carpenter, Abraham, retired, Carpenter, Ellen, retired
3a Carpenter, Reggie, digger driver, Carpenter, Fiona, secretary
5a Whelan, Patrick, farmer, Whelan, Paula, clerical worker, Dublin
5 Whelan, Joseph, retired farmer, Whelan, Cecilia, retired farmer
7 Balfe, John, retired, Balfe, Mary, housewife
9 ruins
12 Donegan, Pat, plumber, Donegan, Bernie, housewife, Donegan, Philip, mechanic,
 Donegan, Kenneth, blocklayer[1032]

Holdenstown Upper townland
1 Holdenstown Lodge, Gorman, John, farmer, Gorman, Agnes, farmer
1a Gorman, Peter, bank official, AIB International, Dublin, Gorman, Janet, teacher,
 NTDI, Arklow
3a house under construction
4B Holdenstown House, Carpenter, Abraham, bank executive, Dublin, Carpenter,
 Elizabeth, school principal, Timolin & neuro-development therapist
5a Donohoe, Noel, blocklayer, Rathvilly
5 Donohoe, Mary, retired, Donohoe, John, retired
7 unoccupied house owned by Balfe
12 Gorman, Monica, post-graduate student, UCD
14a unoccupied house owned by Carpenter

Irongrange Lane, Irongrange Upper townland
Left Side
(Carlow Road to end)
1 Kehoe, Christopher, retired, Kehoe, Mary J., Kehoe, Thomas
2 Coogan, Hugh, farmer, Coogan, Theresa, Coogan, Patrick, student
3 farm building owned by Germaine
[end of lane]
4 Brennan, Martin, farmer / driver, Teagasc, Oakpark, Carlow, Brennan, Margaret,
 housewife
Right Side
(end to Carlow Road)
5 Fitzpatrick, John, self-employed electrician, Harper, Gillian, product manager, Knorr
 Bestfoods
6 Bookle, Mary, retired, Bookle, Sean, farmer, Bookle, Patricia, housewife
7 unoccupied (formerly Somers)
8 O'Brien, Sean, machine driver, Ballyboden Stone Quarry, Brittas
9 Irongrange House, O'Brien, Michael, farmer, O'Brien, Stephen, machine driver,
 Carniges, Blessington

Irongrange Lower townland, (see also Carlow Road)
3 ruins (formerly Kavanagh)

Irongrange Upper townland, (see Carlow Road & Irongrange Lane)

Kilmurry townland, (see also Kiltegan Road)
1 ruins (formerly Lawlors)
(2a & 2b part of Fortgranite estate)
2a gate lodge rented as holiday home
2b Steward's House, Russell, Michael Anthony, writer

Kilmurry Lower townland, (see also Kiltegan Road & Redwells Road)
6 ruins (formerly Tuttys)
6a Landon, Bernard, farmer, Landon, Kathleen, farmer, Landon, Brian, digger driver,
 Dublin, Landon, Philip, farm apprentice
7 house owned by Farrar
9 Jackson, Eric, farmer, Jackson, Anita, farmer

Kilmurry Upper townland, (see also Redwells Road)
1a unoccupied house owned by Farrell
1b unoccupied house & former forge owned by Coleburn
2b occupier declined to be named

Kilranelagh Road, Tuckmill, Tuckmill Lower & Tuckmill Upper townlands
North Side
('Tuckmill Cross' to Kyle Bridge)
[Tuckmill Lower townland]
1 see No. 16 Dublin Road ['Doyles of the Shop']
2 ('Doyles of the Lough') unoccupied house
3 unoccupied house (owned by Bollard)
4 ruins (owned by O'Neill)
[here lane leading to Brownes' in Ballinacrow]
5 Dawson, Bridget, Dawson, Donal, FAS worker
6 Moran, Edward, retired farmer
7 Radharc Ceadaoín, Just, Terry, building operative, Just, Anita, supervisor, SuperValu
8 Kelly, John, farmer in Eadestown, Kelly, Therese, homemaker
9 Dowling, Matthew, builder, Dowling, Breda, housewife, Dowling, Noel, articulated
 lorry driver
[road continues into Kill ['Kyle'] townland]
South Side
(Kyle Bridge to 'Tuckmill Cross')
[Tuckmill Lower townland]
10 Byrne, Joe, farmer, Byrne, Lena, editorial assistant, Farmer's Journal, Dublin
11 Byrne, John, retired farmer, Byrne, Josephine, housewife
12 Moore, Patrick, Moore, Gretta, Moore, Wayne
13 unoccupied house owned by Roisin Byrne
[here joins Tailor's Lane]
[Tuckmill Upper townland]
14 see No. 17 Dublin Road [owned by Shortt]

Kiltegan Road, Baltinglass East, Lathaleere, Newtownsaunders, Kilmurry Lower,
 Kilmurry, Woodfield & Deerpark townlands
West Side
(Weavers' Square to Fortgranite)
[Baltinglass East townland]
1 Parkmore House, Kinsella, Joseph, auctioneer, Kinsella, Maria, housewife
2 Winders', general grocers, video store & filling station, proprietor: William Winders,
 Winders, William, shop owner
[here joins Parkmore First Avenue]
3-10 see Nos. 9-16 Parkmore
[here joins Parkmore Second Avenue]
11-18 see Nos. 29-36 Parkmore
[here joins Parkmore Third (Beech) Avenue]
[Lathaleere townland]
19-23 see Nos. 1-4 Parkmore
[here joins Parkmore Fourth Avenue]
24-27 see Nos. 51-54 Parkmore
[here joins Redwells Road]
no houses here
[here joins Allen Dale Avenue]
28 *Allen Dale*, Hendy, Cedric, farmer, Hendy, William, carpet planner
29 Dalton, Thomas, Dalton, Mary, Dalton, Richard, Dalton, Thomas
[Newtownsaunders townland]
30 Owens, Matt, lorry driver, Wicklow County Council, Owens, Bridget, nurse,
 Baltinglass Hospital
31 Hillview, Cullen, Joe, barman, Quinns', Cullen, Paulette, waitress, Quinns', Cullen
 Siobhán, recruitment officer, Grafton in Dublin, Ennis, Bernard, sound technician,
 Dublin
32 Pairc Naomh Sheosaimh, Baltinglass GAA Club
33 Con Doyle Irish Woodcraft, woodturning, proprietors: Con & Máiréad Doyle, Doyle,
 Con, manager of woodturning firm & retired teacher, Doyle, Máiréad, retired teacher
34 McLoughlin, Sean, FAS supervisor, Wicklow County Council, McLoughlin, Alice, fac-
 tory worker, Wampfler
[here joins Green Lane]
35 Kenny, Hugh, county coach, GAA, Arklow, Furlong-Kenny, Jacqui, creche owner,
 Edward Street
[Woodfield townland]
36 Furlong, Noel, haulier, Furlong, Kathleen, housewife, Furlong, Thomas, haulier
[Newtownsaunders townland]
[here entrance to *Newtownsaunders* – see under Redwells Road]
[Kilmurry Lower townland]
37 Finnegan, Peter, shop fitter, Finnegan, Noeline, shop assistant, Winders', Finnegan,
 Paul, carpenter, Finnegan, Rosemary, telesales, Cuisine de France
38 partly constructed building
[here shared entrance to Nos. 39 & 40]
39 holiday home owned by Lennon
40 Lennon, John, haulage contractor, Lennon, Ina, accounting technician, Lennon,
 Dermott, barman
41 Donegan, Martin, farmer, Donegan, Bernadette, teacher, Scoil Naomh Iósaf

[here joins road to Redwells]

[Kilmurry townland]

no houses here

[road continues into Fortgranite townland]

East Side

(Englishtown to Weavers' Square)

[Kilmurry Lower townland]

42 out office (formerly part of Freemans' house)

43 *Maryland*, Marah, Brendan, supervisor, Schering Plough, Marah, Paula, housewife, Marah, Brendan T., student

44 out office (formerly part of Freemans' house)

[Woodfield townland]

[here joins road to Talbotstown]

45 McDonnell, Donal, farmer

46 Burke, William, soldier, Coolmoney Camp, Burke, Patricia, shop assistant, Quinns'

47 Jones Contractors, agricultural contractors, proprietor: John Jones, Jones, John, contractor, Jones, Declan, farm assistant

48 Wesara Lodge (entrance to), Jones, Philip, farmer, Jones, Heather, account secretary, Athy

[Newtownsaunders townland]

49 O'Hanlon, Trevor, packer, Baltinglass Meats, O'Hanlon, Jackie, field sales, City West

50 Kevin O'Neill Heating & Plumbing, plumbers, proprietor: Kevin O'Neill, *Hill View*, O'Neill, Kevin, plumber, O'Neill, Loraine, factory worker, Kaideen

51 Brady, Patrick, retired

52 Doody, Patrick, aircraft technician in Baldonnel, Whelan, Sinead, nurse, Mater Hospital

53 Doody, Noel, waste water inspector, Wicklow County Council, Doody, Jackie, part-time shop assistant

54 Jones, Nigel, electrical engineer, Jones, Josephine, administrator, Baltinglass Hospital

[here shared entrance to Nos. 55A & 55B]

55A Baltinglass District Hospital, under South Western Area Health Board of the Eastern Regional Health Authority, hospital manager: Liam Scully, administrator: Josephine Jones, clerical officers: Sandra Byrne & Stephanie Stephenson, receptionist: Ann Hunt, visiting general practitioners: Pat Carolan, Cáit Clerkin & Magdalen B. Coyle, director of nursing: Evelyn Barry, assistant director of nursing: Brigid Farrell, clinical nurse managers grade 2:, Imelda Burke & Carol Gannon, clinical nurse managers grade 1: Patricia Boland & Margaret Shortt, cook: Mary Rose Dunne, long term residential patients[1033]: Elizabeth Bollard, Elizabeth Byrne, Mary A. Byrne, Sarah Byrne, Daisy Connors, Elizabeth Coogan, Kathleen Cullen, Kathleen Dillon, Nancy Dowling, Andrew Doyle, Anna Egan, Brigid Farrell, Kathleen Fleming, Andrew Flood, Margaret Flood, James Graham, Kathleen Jones, Julia Kavanagh, James Kearney, John Keogh, Cora Lawlor, James Lennon, Chris Loughlin, Ann McGuinness, Edward Moore, Winifred Moore, Anne Nolan, Peter O'Brien, Brigid O'Halloran, Brigid O'Neill, William O'Neill, Martin O'Reilly, Mary O'Reilly, Mary Power, James Redmond, Josie Salmon, Elizabeth Shortall, Mary Tompkins, Charles Ward, Laurence Whelan & John Whitty,

55b West Wicklow Day Care Centre, clinical nurse managers grade 2: Pearl Cleary

55c sheltered home

55d Baltinglass Ambulance Base under South Western Area Health Board of the Eastern
 Regional Health Authority, emergency medical technicians: Paul Butcher, Ray
 Carney, Brian Delaney, Michael Gaffney & Seamus Hunt

56 Lennon, Don, farmer, Lennon, Mary, farmer

57 Cullen, William, bank porter, Bank of Ireland, Main Street, Cullen, Peggy, housewife
 [Deerpark townland]

58 Lennon, Michael, postman, Baltinglass area, Lennon, Mairead, clerical officer, Carlow

59 Lennon, Lorcan, driver, Lennon, Karen, housewife

60 Lennon, Bobby, retired, Lennon, Peg, housewife

[here shared entrance to Nos. 61 & 62]

61 'The Spout', Jackson, Mary Frances, housewife

62 Jackson, David, farmer, Jackson, Sylvia, classroom assistant

63 Kirby, Seamus, veterinary surgeon

64 Mount Carmel, Ryder, Christopher, retired, Ryder, Mary, retired, Ryder, Angela,
 administrator, East Coast Radio, Weavers' Square, Ryder, Hugh, on sabbatical, Ryder,
 Bronagh, student

65 William Wall & Son, painting contractors, proprietor: William Wall, Wall, William,
 painting decorator, Wall, Renee, substitute teacher, Wall, Declan, painter

66 Cullen, Thomas, public representative, Wicklow County Council

67 Coyle, Finbarr, civil servant, Baltinglass Meats

68 Jones, John, retired

[here joins Kiltegan Old Road]

[Lathaleere townland]

no houses here

[here joins Kiltegan Old Road]

no houses here

[here entrance to Lathaleere Estate]

69 Cogan, Michael, retired, Cogan, Vera, secretary, Murphy Auctioneers, Cogan, Kieran,
 engineer, Waterford Crystal, Cogan, Desmond, purchasing officer, J.D. Hackett, Dublin

[Baltinglass East townland]

70 Moore, Henry, farmer, Moore, Eithne, housewife

71 ruins and out office

72 Scoil Naomh Iósaf (Senior)[1035], primary school, principal: Tom Hannafin

73 Scoil Chonglais, secondary school under Co. Wicklow V.E.C., principal: David
 Hallahan, vice-principal: Patrick Murphy

74 Teagasc, farm advisory service, chief agricultural officer: Larry O'Loughlin

75 Duggan, Sister Carmel, parish sister, Morgan, Sister Brigid, parish sister

[here shared entrance to Nos. 76 & 77]

76 Parochial House, Doyle, V. Rev. Gerald, Parish Priest, Shelley, Rev. Pádraig, Roman
 Catholic curate

77a Lalor Centre, services for people with disability, proprietors: KARE, Newbridge,
 senior staff: Mary Keogh

77b Parish Office, (for Baltinglass Roman Catholic parish), staff: Anne Owens &
 Catherine O'Toole

Kiltegan Old Road, Lathaleere & Deerpark townlands
South Side
(Kiltegan Road to Kiltegan Road)

[Lathaleere townland]

1 Baltinglass Meats Ltd.meat processors, proprietor: Seamus Farrell, manager: Alan Gray

[here Kiltegan Old Road turns south]

West Side

2 football field owned by Wampfler

East Side

(Kiltegan Road to Kiltegan Road)

[Deerpark townland]

3 (entrance to), Breen, James, farmer, Breen, Margaret, housewife, Breen, John, farmer, Breen, Irene, office worker, Kildare County Council, Breen, Noel, farmer[1036]

4 Sun View, Walsh, Michael, retired, Walsh, Elizabeth, retired

5 Halloran, Seamus, overseer, Wicklow County Council, Halloran, Rose, housewife

6 Kirwan, John, Kirwan, Patrick, cook, Dublin

7 Cedarhouse, Doran, Sam, builder, Dublin & Wicklow, Moran, Tracey, accounts clerk, Baltinglass

8 unoccupied house

[here lane leading to Nos. 9, 10 & 11, and to Nos. 2 & 4C of Deerpark and No. 3 of Carsrock townlands]

9 MacNamara, Raymond, building contractor, MacNamara, Kathleen, housewife, MacNamara, Raymond, Jnr. carpenter, Dublin, MacNamara, Katherina, computer programmer, Dublin, MacNamara, Tommy, butcher, Hacketstown

10 *Tara*, Byrne, Frank, retired, Byrne, Dinah, cashier, SuperValu

[Lathaleere townland]

11 unoccupied house (formerly Dorans)

[here entrance to Lathaleere Industrial Estate]

[here Kiltegan Old Road turns west]

North Side

12 ESB Sub-Station

13 Doyle Vehicle Maintenance, garage, proprietors: Tommy Doyle & Jackie Nevins Doyle, 10 Lathaleere

14 Department of Social, Community and Family Affairs Employment Office, manager: Patrick Gahan, Rathmoon Road

15 Kaideen & Co. Ltd., knitwear manufacturers, proprietors: the Doogue family, Hillcrest, Rathvilly Road, manager: Martin Doogue

16 Wampfler Ltd., engineering, proprietor: Manfred Wampfler, senior staff: Brian Bible, Liz Gibbons & David Lord

Knockanreagh Road, Baltinglass West, Glennacanon, Knockanreagh & Rathmoon townlands

West Side

(Tinoran Road to Rathmoon Road)

[Knockanreagh townland]

1 Rooney, Patrick, forestry manager for Graf Westerholt, Rooney, Elizabeth, housewife, Rooney, Ultan, forestry worker for Graf Westerholt, Rooney, Brendan, trainee electrician with M. O'Brien, Rooney, Colm, factory worker, Baltinglass Meats

[here lane leading to Swaynes' in Hughestown]

2 Hill View, Farrell, Mary, housewife

[Rathmoon townland]

3 Donohue, Tom, retired forester, Donohue, Rosie, housewife

East Side

(Rathmoon Road to Tinoran Road)

[Baltinglass West townland]

4 Foley, Thomas, moulding manager, Wampfler, Foley, Linda, factory worker, Wampfler

[Knockanreagh townland]

5 O'Toole, Ray, fitter, Irish Times, O'Toole, Cathy, housewife

6a farm buildings – including formerly dwelling (owned by Twyford)

6b Twyford, Martin, farmer

[Glennacanon townland]

no houses here

Knockanreagh townland, (see Knockanreagh Road & Tinoran Road)

Lathaleere Estate, Lathaleere townland
First Avenue
West Side

1 O'Toole, Jimmy, Wicklow County Council worker, O'Toole, Rosie, working in Braun, Carlow

2 Groves, Ann, attendant, Baltinglass Hospital

3 Dunne, Patrick, builder, Dunne, Catherine, Dunne, Sylvia, Dunne, Nicola

4 Coughlan, William, aerospace technician, PWAI, Rathcoole, Williams, Mary, golf manager, Tulfarris Golf Club

5 Keogh, Sharon, quality control senior operative, Keogh, Anthony, security guard, Byrne, Lindzey, nanny

6 Kavanagh, Brendan, forklift operator, Coca Cola, Kavanagh, Pauline, factory worker, Wampfler

7 Dowling, Thomas, attendant, Baltinglass Hospital, Dowling, Eileen, housewife

8 Kinsella, Augustine

9 Flood, Betty, housewife

10 Doyle, Tommy, mechanic, Nevins, Jacqueline, office administrator

11 Lucas, Christine, assistant manager

12 Donegan, Martin, groundsman, Donegan, Mary, housewife

South Side

13 (above 14) occupier declined to be named

14 Fox, Michael, Fox, Tanya

15 Connolly, Martin, building worker, Dublin, Connolly, Bernadette, fitness instructor, Connolly, Leona, student

16 Andy Doran Signwriting, proprietor: Andy Doran, Doran, Andy, signwriter, Doran, Sally, quality controller, Baltinglass Meats

17 McDermott, Thomas, FAS worker, Tidy Towns, McEnerney, Colette, FAS worker, Tidy Towns

18 (above 17)Fox, Yvonne, mother

East Side

19 (above 20), Byrne, Nora

20 O'Neill, Julia, retired

21 Hayden, Rose

22 (above 21), Moore, Sylvia, mother

23 Byrne, Teresa, mother

24 Dunne, Liam, FAS worker, Dunne, Mary, housewife

25 Faulkner, Catherine, personal assistant, Barlo, Newbridge

26 English, Joe, soldier, English, Colette, factory worker, English, Amanda, secretary, meat factory

27 Nolan, Liam, tiler, Nolan, Mona, housewife, Nolan, Leeona, student

28 O'Neill, Michael, O'Neill, Theresa, manager, O'Neill, Brendan, machine driver

29 Farrell, Patrick, painting & decorating, Farrell, Pauline

30 Sionnach Decor, painting & decorating, proprietor: Patrick Fox, Fox, Patrick, painter & decorator, Fox, Valerie, secretary

Second Avenue
West Side

29A Byrne, Liz, housewife

30A Keane, Michelle, lone parent

31 Owens, James, Owens, Catherine, housewife

32 Costello, Tom, builder, Costello, Joy, I.T. teacher

33 Donegan, Justin, Access floor layer, Dublin, Donegan, Sinead, housewife

34 Lawler, John, factory worker, Irish Sugar, Carlow, Lawler, Anne, checkout operator, SuperValu

35 Cardiff, James, Cardiff, Colette

36 Curry, Adrian, boner, Baltinglass Meats, Curry, Carmel, housewife

37 Keogh, Adrian, Keogh, Geraldine

38 Taylor, Kevin, Nolan, Margaret

39 Pellegrini, Fulvio, chef, Golden Grill, Carlow, Pellegrini, Catherine, barmaid, Horans'

40 Corcoran, Bernie, housewife

East Side
no houses here

Third Avenue
North Side

41 Doyle, Kathleen, working for Wampfler, Doyle, Danny, trainee, Lalor Centre

42 Owens, Kathleen

43 Leonard, Joseph, Leonard, Bernadette

44 Furlong, Geraldine, purchasing manager, Purple Suppliers

45 Butler, Terence, packing operative, Wyeth Medica, Butler, Michelle, housewife

46 Nolan, Patrick, farm labourer, Rathvilly, Nolan, Caroline, housewife

47 Dempsey, Nigel, tyre fitter, Dempsey, Mary, housewife

48 Barry, Helen, mother, Barry, John, labourer, Dublin

South Side
no houses here

Lathaleere Industrial Estate, Lathaleere townland, (see also Kiltegan Old Road)
Left Side

(Kiltegan Old Road to end)

1 vacant factory unit[1037]

2 E. Morrin & Son Ltd., organic grains store

[end of cul-de-sac]

3 Leslie Codd Mushrooms, mushroom growing, proprietor: Leslie Codd, Killamaster, Carlow, senior staff: Leslie Codd & Remi Le Mahieu

Right Side
(end to Kiltegan Old Road)
4 Healystone Ltd. , reconstituted stone, proprietors: Peter Healy & Tess Healy, senior
 staff: Peter Healy, Tess Healy & Declan Duffy

Lathaleere townland, (see Kiltegan Road, Kiltegan Old Road, Lathaleere Estate,
 Lathaleere Industrial Estate, Parkmore & Redwells Road)

Main Street, Baltinglass East townland
South Side
(The Bridge to Weavers' Square)
1 Bridge House
1-a Connors, Noel, groundsman, Scoil Naomh Iósaf, Connors, Helen, housewife,
 Connors, John, bar worker, Horans'
1-b Byrne, Catherine, shop assistant, Doyle, James, labourer
1c Clarkes, drapery, proprietor: Gerry O'Driscoll, Kiltegan, staff: Gerry & Margaret
 O'Driscoll
2 Murray, Eileen, shopkeeper, Murray, James, shopkeeper
3-4 Murrays, grocery, proprietors: James & Eileen Murray
5 Bank of Ireland, banking & financial services, manager: Dave Prendergast, assistant
 manager: Terry Hogan
6 Douglas House, Doyle, Brendan, farmer
7 Burkes Newsagents, newsagents & Lotto station, proprietor: James Martin Burke,
 Rathmoon
8 Horans, public house & filling station, proprietors: Eamon & Maree Horan, Horan,
 Eamon, publican, Horan, Maree
9 Millett & Matthews, solicitors, proprietors: Brian & Carol Matthews, Main Street
10 unoccupied house (formerly 'Dublin Byrnes')
11a unoccupied shop unit (formerly Flynns)
11b Ferizi, Merita, clerical worker, Quinns', Ferizi, Uran, storeman, Quinns'
11c Kearney, Síofra, student
11d Fleming, Raymond, labourer, Tony Duffy Engineering, Faulkner, Louise, shop assis-
 tant, Quinns'
12a Turf Accountant, proprietor: John Wall, Newtownsaunders
12b unoccupied flat
13a Colgans Butchers, retail butchers, proprietor: John Colgan
13b The Kitchen Coffee Shop, coffee shop, proprietor: Stephen Mainwaring,
 Castlegrace, Tullow, manager Valerie Lacey
13c (Flat 1), Fox, Roy, Staunton, Jackie
13d (Flat 2), Curry, Sandra
13e Carmel's Hairdressers, proprietor: Carmel Whelan, Crookstown, Ballytore
14a Thomas P. Quinn, solicitor's office, proprietor: Thomas P. Quinn
14 Byrne, Kathleen P.
15 Harbournes, public house, proprietor: Ann (Harbourne) Farrar, Farrar, John, farmer,
 Farrar, Ann (Harbourne) publican
16 Kinsella Estates, auctioneers, proprietor: Joseph Kinsella
17-19 unoccupied houses (owned by Doran)
20 AIB Bank sub-office, banking & financial services

21 building under construction (owned by Gorrys Pharmacy Ltd.)

22a Surgery, medical surgery, doctor: Magdalen B. Coyle, secretary: Vicki Doyle

22b Koliqi, Besim, mechanic, Tony Duffy Engineering, Shala, Edmond, mechanic, Tony Duffy Engineering, Shehu, Burhan, labourer, Quinns' Superstore

23 Orchard Meadows, Bowes, Gerard, fabricator, Newbridge, Bowes, Bernadette, housewife

South-East Block

(south face)

24 Baltinglass Credit Union, financial co-operative, senior staff: Owen Cooney, Valerie Lawrence & Catherine Carty

[here side of No. 25]

(west face)

25 Courthouse, clerk: Billy Dunphy, Carlow

26a Baltinglass Heritage Centre

(north face; facing into The Green)

26b Wicklow County Libraries, Baltinglass Branch Library, (above Heritage Centre), branch librarians: Catherine Walshe & Teresa Kenny

27 Coillte Teoranta, Irish Forestry Board, manager: Oliver Cuddy

(east face; facing into Weavers' Square)

28 Treasa's Beauty Salon, beauticians, proprietor: Treasa Kearney, Carrigeen

[here side of No. 24]

North-East Block

(on The Green)

29 Baltinglass Fire Station, manager: Billy Doody

North-West Block

(east face)

no houses here

(south face)

30 Keogh, Joseph, truck driver, K.C.P., Lawlor, Valerie, hairdresser, Majella's

31 unoccupied house

32 Lawal, Kehinde, from Nigeria, Lawal, Bidemi, from Nigeria

33a Chai, Rachel, receptionist, Second Heaven, Slaney Mall, Chai, Stanley, kitchen staff, Second Heaven, Pang, Linda, kitchen staff, Second Heaven

33b Joey's Barber Shop, gents' hairdresser, proprietor: Joe Fagan, 39 Parkmore

(west face)

[McAllister Monument in front of Nos. 34 & 35, facing bridge]

34a Frank Murphy Photography, wedding & portrait photographers, proprietor: Frank Murphy

34b Danne, Stephanie, bank official, Naas

35 Germaine, Joseph, Sen., Germaine, Philomena

(north face)

36 Byrne, Jack

37 unoccupied house

38 O'Toole, Clement

39 Luigi's, fish & chip shop, proprietor: George Galbally, Newtownallen, Carlow

North Side

(Chapel Hill to The Bridge)

[No. 40 facing The Green]

40 Outdoor Education Centre, under Co. Wicklow V.E.C., manager: Paul Scott
 Baltinglass Adult Learning Centre, organiser: Annette Mangan

41a Dunnes' Funeral Parlour, undertakers, proprietor: Pascal Dunne

41b 'The Steps', workshop for Dunnes' Funeral Parlour

42 out office owned by Quinns of Baltinglass Ltd.

43 Inis Fáil, accommodation & function room, proprietors: Joseph & Deirdre Germaine,;
 Residents: Adigun, Omowunmi, from Nigeria, Golaj, Arben, from Kosova, Golaj,
 Aurora, from Kosova, Jurgelaitis, Ramùnas, from Lithuania, Kamara, Nancy, from
 Sierra Leone, Lukas, Bozeqa, from Slovakia, Lukas, Ladislav, from Slovakia, Ndlovu,
 Sana, from South Africa, Nzau-Sedi, Cele, from Congo, Pribán, Dušan, from Czech
 Republic, Pribánova, Sárka, from Czech Republic, Rozada, Jules, from Angola, Sejko,
 Afërdita, from Kosova, Sejko, Gentian, from Kosova, Sokas, Olga, from Lithuania,
 Tamutunga-Manunga, Thomas, from Congo, Tucker, Felix, from Sierra Leone,
 Zikhali, Beatrice, from South Africa

44 Germaines, public house, proprietors: Joseph & Deirdre Germaine

45a Baltinglass Towing & Recovery Service, motorcycle & car breakdown & repairs, AA/
 Europassistance, proprietor: Michael Germaine, Germaine, Michael Gerard, motor
 mechanic

45b K. Carey's Chemist, pharmacy, proprietor & pharmacist: Kevin C. Carey

46a Quinns' Bar & Lounge public house, proprietor: Liam Quinn, Slaney Lodge, man-
 ager: Joe Cullen

46b McAllister Restaurant at Quinns', proprietor: Liam Quinn, Slaney Lodge, manager:
 Paula Cullen

47a Quinns' Spar Supermarket, supermarket & off licence, proprietor: Liam Quinn,
 Slaney Lodge, manager: Ronan Malone

47b Quinns' Drapery, drapery, household goods & gifts, proprietor: Liam Quinn, Slaney
 Lodge, manager: Rosaleen McGrath

47c Quinn, Mary T., retired, O'Toole, Billy, hardware manager, Quinns', Mill Street

47d Quinns of Baltinglass Ltd., general merchants, head office & yard, proprietor: Liam
 Quinn, Slaney Lodge

48 Pattersons Butchers Ltd., retail meat, proprietor: Michael Patterson, Patterson,
 Damian, butcher, Patterson, Derek, butcher

49 ruins

50 Matthews, Brian D., solicitor, Matthews, Carol A., solicitor

51 Garryowen, unoccupied house

52a Graces Furniture & Craft Shop, furniture & Irish crafts, proprietors: Michael & Mary
 Grace, Whitestown, manager: Miriam Grace

52b O'Connell Insurances, insurance brokerage, proprietors: Len & John O'Connell,
 manager: John O'Connell

52c Baltinglass Computer Training Centre, computer training & secretarial services, pro-
 prietor: Patricia Whelan, Carrigeen

52d Eastlink Recruitment, recruitment & placement agency, proprietor: Martin O
 Donnell, senior staff: Martin O Donnell & Marina Balfe

53a Gorrys Pharmacy Ltd., pharmacy, proprietor: Eileen Gorry, pharmacist: Máiréad
 O'Modhráin, manager & assistant pharmacist: Anne McDaid, staff: Alice Doyle

53b (also No. 1 Church Lane), Gorry, Mary, Gorry, Paul, genealogist

[here joins Church Lane]

[here Slaney Mall]

Mattymount townland, (see Rathbran Road)

Mill Street, Baltinglass West townland
East Side
(The Bridge to Dublin Road)
1 store owned by Gillespies
[No. 2 facing south]
2 SuperValu, supermarket & off licence, proprietor: Arthur Gillespie, manager: Colin Jackson
3 Joe Kinsella's, public house, proprietor: Joseph Kinsella, Kinsella, Joseph, publican, Kinsella, Margaret, publican, Kinsella, Joseph, Jnr., barman, Kinsella, Therese, chef in St Patrick's College, Kiltegan, Kinsella, John, bus driver, Bus Eireann, Kinsella, Margaret, factory operative, Naas Mirrors
4 grain store owned by E. Morrin & Son
5 grain store owned by E. Morrin & Son
6 Mill House, unoccupied
7 E. Morrin & Son Ltd., animal feed manufacturers, proprietors: Peter P. Morrin & M.T. Morrin, senior staff: Noel Lyons & Michael Farrell
West Side
(Dublin Road to Belan Street)
8 Nazifi, Feriz, working in Quinns', Nazifi, Fatime, housewife, Nazifi, Violeta, working in SuperValu, Nazifi, Jeton
9 Glynn, Frank, retired primary teacher (St Pius X N.S.), Glynn, Anne, housewife, Glynn, Nora, guest
10a E. Morrin & Son Ltd., offices
10b Veterinary Centre, proprietor: Peter Griffin, MVB, MRCVS, Bough Lodge, Rathvilly, manager: Bernie Molloy
11 Walsh, Patrick, retired ESB employee, Walsh, Mary, retired, Walsh, Ann, mature student
12 Murphy Auctioneers, estate agents, proprietors: Simon & Rosario Murphy, staff: Simon Murphy, Vera Cogan, Irene Doyle & Mona Murphy
13-14 Harte, Thomas, retired, Harte, Rose
[here Station Road intersects]
15 Shortt, John, builder, Shortt, Margaret, nurse in Baltinglass Hospital, Shortt, Louise, nurse in Naas, Shortt, Eoin, engineer, Dublin, Shortt, Mark, engineer, Waterford
16 Brennan, Cora, housewife
17 unoccupied house
18 Des Dorans Menswear, mens' outfitters, Doran, Des, draper, Doran, Maureen, retired
19 McDonaghs, newsagents, proprietors: Anthony & Mary McDonagh, staff: Linda Barrett & Laura Pierce, McDonagh, Anthony, newsagent & auctioneer, McDonagh, Mary, newsagent
[here entrance to Tan Lane]
20a Turf Accountant, proprietor: John Wall, Newtownsaunders
20b All Occasions Florists/McGraths Fruit & Veg, florists & vegetable shop, proprietors: James & Rita McGrath, senior staff: James McGrath, Rita McGrath & Máiréad Foley
21 Mace Foodstore, grocery, proprietors: John & Mary Fleming, Fleming, John, shop-keeper, Fleming, Mary, teacher, Scoil Chonglais
22 Quinns of Baltinglass Ltd., hardware shop, proprietor: Liam Quinn, Slaney Lodge, manager: Billy O'Toole

Newtownsaunders townland, (see Green Lane, Kiltegan Road & Redwells Road)

Oldtown townland, (see also Hartstown Road)
1a O'Neill, Richard, farmer, O'Neill, Emma, homemaker
1b O'Neill, Declan, farmer, O'Neill, Assumpta, homemaker
6 Kearney, Pat, farmer

Parkmore Estate, Baltinglass East & Lathaleere townlands
(see also Parkmore Estate Extension)
First Avenue
[Baltinglass East townland]
North Side
no houses here
South Side
(end to Kiltegan Road)
1 Sinnott, Patrick, receiving invalidity benefit, Sinnott, Bernadette, housewife, Sinnott, Henry, student
2 Fogarty, Mary, Fogarty, Jody
3 Fogarty, Patrick, construction worker with Finchpalm, Fogarty, Theresa, factory worker, Kerry Foods
4 unoccupied house (owned by Swaine)
5 O'Neill, Paschal, storeman, Winder's, O'Neill, Ellen, housewife
6 McHugh, Joseph, retired, McHugh, Jenny, retired
7 Hunt, Seamus, ambulance driver, Baltinglass Ambulance Base, Hunt, Ann, receptionist, Baltinglass Hospital, Hunt, Jean, quality control officer, Kerry Foods, Shillelagh
8 Cullen, Esther, retired
8A house under construction (owners: Ely & Hunt)
9A Park-View House, Gethings, Thomas, postman, Naas, Gethings, Geraldine, bar person, Baltinglass, Gethings, Barbara, trainee VAT consultant, Dublin

Parkmore, Kiltegan Road
[Baltinglass East townland]
West Side
9 Gethings, John, Gethings, Annie Ryan, Gethings, John, Jnr.
10a Jones, William, supervisor, Jones, Helen Louise, housewife
10b Jones, Sarah
10c (temporary structure), Fagan, Stephen, sales representative, Kerry Foods, Fagan, Melanie, bank assistant, Bank of Ireland
11 Malone, Thomas, prison officer, Shelton Abbey, Arklow, Malone, Margaret, caterer, Baltinglass Golf Club, Malone, Mary, retired
12 O'Neill, Michael, O'Neill, Sheila, O'Neill, Michael, junior, O'Neill, Deirdre, O'Neill, Julia, O'Neill, Patricia
13 Scott, John Noel, teacher, Scoil Chonglais, Scott, Aileen
14 Lennon, Michael, retired, Lennon, Nellie, secretary, Teagasc, Kiltegan Road
15 occupier declined to be named
16 Doody, Billy, revenue collector, West Wicklow area, & fire officer, Doody, Patricia, secretaty, Scoil Naoimh Iósaf, Doody, Sinead, student

Second Avenue
[Baltinglass East townland]
North Side

17 Bradley, George, painter, Bradley, Liz, housewife, Bradley, Shauna, student, Lalor Centre

18 Curry, Esther, housewife, Curry, David, barman & self-employed courier, Curry, Pauline, hairdresser at Hairdressing by Frances, Curry, Declan, mill worker, Morrins', Curry, Elaine, secretary, O'Connell Insurance

19 Byrne, Patrick, soldier, Curragh, Byrne, Winnie, factory worker, Wampfler, Byrne, Derek, factory worker, Wampfler, Byrne, Olivia, factory worker, Wampfler, Byrne, Louise, equestrian worker, Harringtons, Moone

20 Gethings, Nora, retired, Gethings, Geraldine, knitwear finisher, Gethings, John (Seán), postman, Gethings, Teresa, secretary

21A PC All Firm, I.T. multi-media production, proprietor: Terry Crampton

21 Crampton, Terry, electrical engineer, Celestica Ireland, Swords

22 McLoughlin, Nancy, housewife, Farrell, Padraig, Garda, Farrell, Geraldine, housewife

South Side

23 Abbott, Patrick, retired, Abbott, Mary

24 house owned by McGeer

25 Barrett, Pat, builder, Doyle, Liz, housewife

26 Doyle, Desmond, landscape gardener, Murray Landscaping, Doyle, Marian, attendant, Baltinglass Hospital, Doyle, Raymond, student & landscape gardener, Murray Landscaping

27 Doyle, Brendan, plumber, Wicklow County Council, Doyle, Kathleen, working at Wampfler

28 Sweeney, Tony, retired, Sweeney, Evelyn, housewife, Sweeney, Jonathan, general labourer

[here joins Parkmore Extension (through road)]

Kiltegan Road,
[Baltinglass East townland]
West Side

29 Connors, Michael, retired, Connors, Alice, housewife

30 O'Neill, Brendan factory worker, Wampfler, O'Neill, Elizabeth, shop assistant, SuperValu

31 occupier declined to be named

32 Hegarty, Thomas, Hegarty, Gary, Hegarty, Michael

33 Owens, David

34 Duffy, Martin, lorry driver for Tony Duffy Engineering, Clarke, Martina, childminder, Hollywood

35 Tony Duffy Eng. Ltd., road surfacing contractors, proprietors: Tony & Elizabeth Duffy, Duffy, Tony, company director, Duffy, Elizabeth, company director

36 O'Keeffe, Jim, retired road overseer, Donard area, O'Keeffe, Teresa, retired teacher, (Talbotstown N.S.), O'Keeffe, Eamonn, accountant, Dublin, O'Keeffe, Mary, teacher, Stratford N.S., O'Keeffe, Bridget, clerical assistant, St. Patrick's College, Kiltegan

Third (Beech) Avenue
[Baltinglass East townland]

North Side

[here joins Parkmore Extension (through road)]

37 Pat Sleator Haulage, hauliers, proprietor: Pat Sleator, Sleator, Pat, haulier, Sleator, Ann, health care worker, E.H.R.A., Sleator, Geraldine, care assistant, special school, Curragh, Sleator, Brian, mechanic, Irish Commercial, Naas

38 Alcock, Christopher, retired, Alcock, Tríona, SRN, SCM, Baltinglass Hospital, Alcock, Kieran, RTC administration, Alcock, Bernadette, student, Maynooth

39 Fagan, Joseph, barber, Fagan, Sheila, housewife, Fagan, Sharon, secretary

40 Lennon, Sarah, housewife, Lennon, Patrick, clerk, Baltinglass Post Office, Lennon, Teresa, housewife, Lennon, Damian

41 Winder, Veronica, housewife, Winder, John, meter reader, Winder, Tracy, mother

42 Groves, Michael, labourer, McCloskeys', Dublin, Groves, Caitríona, assistant, Careys' Pharmacy

42A Harper, Joseph, retired, Harper, Catherine, retired

[Lathaleere townland]

West Side

1 Quirke, Joe, retired, Quirke, Betty, housewife, Quirke, Avril, shop assistant, Dunnes Stores, Quirke, Kenneth, lorry driver, Quinns', Quirke, Derek, fitter, Airmotive, Rathcoole

2 Hughes, Patrick, retired, Hughes, Nancy, receptionist, Parochial House, Hughes, Ann, factory worker, Wampfler

3 Farrell, Patrick, retired, Farrell, Kathleen, retired

4 Fleming, Martin, mill worker, E. Morrin & Son, Fleming, Elizabeth, wardsmaid, Baltinglass Hospital, Fleming, Elizabeth, machine operator, Kaideen Knitwear

5 Barry, Anne, retired

South Side

6 Pender, Keith, barber, Joey's Barber Shop, Fagan, Barbara, supermarket attendant, SuperValu

7 Moore, Fiona, waitress, Carlow

8 Fleming, Patrick, grain manager, Quinns' & part time fireman, Fleming, Jane, housewife & cleaner, Wicklow V.E.C.

9 Corcoran, Thomas, FAS worker, Corcoran, Helen, housewife, Corcoran, Stuart, builder, Corcoran, Thomas, builder's labourer

10 McDermott, William, bus driver, Duffys', McDermott, Patricia, housewife, McDermott, Theresa, shop assistant, Winders', McDermott, Patrick, JCB driver for Hugh O'Keeffe, Stratford, McDermott, Anthony, apprentice motor mechanic, Sheehy Motors, Carlow, McDermott, Mary, student, Dublin

11 Caira, Anne, counsellor, Secureways

[here space with no buildings]

12 (chalet), Connors, Thomas (Mossy), yardman, Quinns'

[here back entrance to 5A Fourth Avenue]

Parkmore, Kiltegan Road,

[Lathaleere townland]

West Side

1 O'Keeffe Mini Bus Hire, O'Keeffe, Michael, bus operator, O'Keeffe, Patrick, bus operator

2 Keogh, Anthony, Keogh, Winifred, housewife

3A Moorehouse, Joseph, retired, Moorehouse, Ellen, retired
3 Hayden, Brian, Hayden, Anne
4 Horan, John, contractor, Horan, Teresa, KARE worker

Fourth Avenue
[Lathaleere townland]
North Side
4A Ryan, Joseph, painter, St. James' Hospital, Ryan, Sandra, housewife
4B Wedgbury, Ronald, retired, Wedgbury, Kathleen, retired, Madden, Andrew, FAS
 worker
5A Hughes, John
5 Hughes, Philip, labourer, Thomas Logan & Sons, Hughes, Margaret, kitchen staff,
 Quinns'
6 Fleming, Kevin, electrician, Fleming, Carol, housewife
7 Campion, Daniel, tradesman, Wicklow County Council, Campion, Mary, housewife,
 Campion, Michael, toolmaker, Wampfler
8 Keogh, John, lorry driver, Dublin, Keogh, Mark, lorry driver, for Tony Duffy
 Engineering, Keogh, Margaret, shop assistant, SuperValu
9 Cullen, Margaret-Mary, retired, Cullen, Brendan
10 Cullen, John, Cullen, Mary
South Side
43 unoccupied house– under refurbishment (owned by W. Cullen)
44 unoccupied house (owned by T. Cullen)
44A *Whitehall*, Cullen, William, Wicklow County, Council worker, Cullen, Noreen,
 assembly worker, Braun
45 Nolan, William, Nolan, Agnes
46 O'Neill, Pierce, factory supervisor, Wampfler, O'Neill, Bridie, assembly worker,
 Wampfler
47 Fitzgerald, Patrick, retired, Fitzgerald, Kathleen, retired, Fitzgerald, Catherine, work-
 ing at Lalor Centre
48 Groves, Michael, retired from Wicklow County Council, Groves, Mary, housewife
49 O'Neill, Pierce, retired, O'Neill, Catherine, factory worker, Shillelagh, O'Neill,
 Henry, petrol pump attendant, Horans', O'Neill, Paul, builder's labourer
50 Wall, Kathleen, retired, Wall, Paschal, painter

Kiltegan Road
[Lathaleere townland]
West Side
51a Saunders, Tony, restaurant manager, Hayes, Pauline, restaurant manager
51b Nolan, Margaret, assembly worker, Braun, Carlow
52 Maureen's, hairdressers, proprietor: Maureen Plant,
 Parkmore Car Sales, garage, proprietor: Joe Plant, Plant, Joe, mechanic, Plant,
 Maureen, hair stylist
53 unoccupied house
54 G & J Duffy, coach hire, proprietors: Gerald & Josie Duffy, Duffy, Gerald, coach oper-
 ator, Duffy, Josie, Jackman, Louise, Jackman, Olivia

Parkmore Estate Extension, Baltinglass East townland, **Through Road**
East Side
(Second Avenue to Third Avenue)
1 Foster, Pat, truck driver, Ballytore, Foster, Rose, housewife, Foster, Karen, factory
 worker, Newbridge, Foster, Paddy, milkman, Foster, Anthony, working at railway
 upgrading, Dublin
2 Foley, Catherine, housewife
3 occupier declined to be named
4 Corcoran, Barry, machine operator, Corcoran, Tracy, chef
5 Cullen, Patrick Joseph, factory worker, Braun, Carlow, Cullen, Alice, cleaner at Garda
 Barracks, Cullen, Patrick Christopher, toolmaker, Braun, Carlow
6 Alcock, James, chef, V.E.C. Outdoor Education Centre, Alcock, Elsie, Alcock, Claire
7 Curry, John, factory operator, Baltinglass Meats, Curry, Catherine, facilitator/instruc-
 tor, Lalor Centre
8 Pearson, Patrick, lorry driver, Quinns', Pearson, Anne, housewife, Pearson, Dermot,
 draughtsman, Dublin
9 Donohoe, Noel, Donohoe, Bridie, factory worker, Wampfler, Donohoe, Brian, farm
 worker, Jacksons', Kiltegan
10 Fox, P.J., Fox, May, housewife, Fox, John
11 Barrett, Kevin, mechanic, Barrett, Ellen (Nellie), housewife
12 Fleming, Patrick, FAS worker, Fleming, Kathleen, housewife, Fleming, Jacinta, secre-
 tary, Fleming, Patrick, sen., lorry driver
13 Stynes, Mary, housewife, Stynes, Clifford, labourer, Cronans, Grangecon
14 occupier declined
15 Furlong, Michael, FAS worker, Furlong, Kathleen, housewife, Furlong, James,
 butcher, Hacketstown, Furlong, Amanda, office worker, Dublin
16 O'Keeffe, Angela, seamstress
17 Owens, James, Wicklow County Council worker, Owens, Anne
18 Larkin, Mark, Larkin, Rachel
19 Crampton, William, retired, Crampton, Margaret, retired
20 Humphries, Tom, bus driver for Dunnes, Humphries, Lily, housewife, Humphries,
 Kieran, builder's labourer, Dublin, Humphries, Louise, shop assistant, SuperValu
West Side
[here joins Cul de Sac]
no houses here

Cul de Sac
South Side
(Through Road to end)
21 Ryan, Mary, housewife
22 Avotina, Solvita, mushroom picker, Codds', Burkite, Anda, mushroom picker, Codds',
 Degle, Sandra, mushroom picker, Codds', Maralina, Elena, mushroom picker, Codds',
 Mikelsone, Aiga, mushroom picker, Codds', Plinta, Inta, mushroom picker, Codds',
 Plinta, Kristine, mushroom picker, Codds', Pule, Sandra, mushroom picker, Codds'
23 Redmond, Christopher, self-employed, Redmond, Sarah, general operative, R&H,
 Blessington, Redmond, Christopher, Jnr. ,charge hand, Dunlavin, Redmond, Janet,
 general operative, Naas, Redmond, Kevin, general operative, Dublin

24 Doyle, Ian, groundsman, Baltinglass Hospital, Doyle, Dolores, factory worker, Doyle, Vincent, Doyle, Celina, administrator

25 Donegan, Patrick, block layer, Donegan, Elizabeth, machinist, Kaideen Knitwear

26 Kehoe's Helping Hand, landscaping & gardening, proprietor: Sean Kehoe, Kehoe, Sean, landscape gardener, Kehoe, Martina, housewife

27 Fogarty, Thomas, general operative, Fogarty, Collette

28 Doyle, Charles, attendant, Baltinglass Hospital, Doyle, Georgina, housewife, Doyle, Robert, painter, Doyle, Victoria, secretary, Baltinglass

North Side

(end to Through Road)

29 Germaine, James, retired, Germaine, Rita, housewife, Germaine, Annmaire, nurse, Dublin, Germaine, Mary Jo, student, Carlow

30 Donegan, Liam, barman, Quinns', Donegan, Deirdre, factory operative, Kildare Chilling

31 Carton, Colette

32 Carton, David, lorry driver, Quinns', Carton, Brigid, housewife, Carton, Thomas, quarry worker, Carton, William, factory worker

33 Brady, Deirdre, secretary, doctors' surgery

34 Doran, Peter Anthony, building construction worker

35 *Peacehaven*, McMahon, Kathleen Patricia, clerical assistant

36 Nolan, Elizabeth, retired

Pound Lane, Baltinglass West & Bawnoge townlands, (see Edward Street)

Raheen Hill Road, Stratfordlodge, Raheen & Rampere townlands
West Side
(Dublin Road to the 'Five Crossroads')
[Stratfordlodge townland]
no houses here
[Raheen townland]
1 Valcomino, Matassa, Bruno, Matassa, Colette
[here bridge formerly over railway]
2 Farrell, Peter, retired[1038]
[Stratfordlodge townland]
3 house owned by Eamon Lalor
[Raheen townland]
4 Ryan, Declan, store manager, Carlow, Agar, Hazel, shipping, Dublin
5 The Lodge, MacMahon, Eugene, MacMahon, Ellen
6 O'Neill, Kevin, Garda sergeant, Baltinglass, O'Neill, Dolores, housewife
7 Mountain View, house owned by Beton
8 O'Hara, Elizabeth, retired
9 McDonnell, Winifred, retired
[Rampere townland]
10 Finlay, Benjamin, farmer, Finlay, Vera, housewife, Finlay, Dermot, farmer, Finlay, Ann, teacher, Finlay, Grace, administrator, Neill, Wilfred
East Side
('Five Crossroads' to Dublin Road)
[Rampere townland]

no houses here

[Raheen townland]

11 Whelan, Jimmy, farmer, Whelan, Brigid, housewife

11a (temporary structure), Whelan, Bryan, farmer, Whelan, Catherine, secretary, Dublin

12 Barrett, Henry, builder's labourer, Barrett, Mary, housewife, Barrett, Mark, apprentice electrician in Pat Lee's, Barrett, Damien, student

[here bridge formerly over railway]

no houses here

[Stratfordlodge townland]13 see No. 2 Dublin Road [Slaney Lodge – Quinn]

Raheen townland, (see Colemans' Road, Dublin Road & Raheen Hill Road)

Rampere townland, (see also Cabra Road, Colemans' Road, Hartstown Road & Raheen Hill Road)

6a out offices owned by Quinns of Baltinglass, Ltd.

Rathbran Road, Tuckmill, Tuckmill Upper, Mattymount & Tuckmill Lower townlands

South Side

('Tuckmill Cross' to Goldenfort)

[Tuckmill Upper townland]

1 see No. 7 Dublin Road [Ambrose O'Neill]

[here Tuckmill Bridge; road crosses River Slaney]

[Mattymount townland]

2 O'Neill, John, retired, O'Neill, Sheila, retired, O'Neill, Kevin, agricultural contractor, O'Neill, Patrick, haulier, O'Neill, Martin, hedge cutting contractor, O'Neill, James, plant hire

3 house under construction

[road continues into Goldenfort townland]

North Side

(Goldenfort to 'Tuckmill Cross')

[Mattymount townland]

4A Kearney, Anthony, retired, Kearney, Margaret, housewife

4Aa (temporary structure), Ovington, Anthony, Kearney, Sandra

4B house under construction (owners: Ovington & Kearney)

[here Tuckmill Bridge; road crosses River Slaney]

[Tuckmill Lower townland]

no houses here

Rathmoon Road, Baltinglass West & Rathmoon townlands

North Side

(Belan Street / Brook Lane to Carrigeen)

[Baltinglass West townland]

1 Danne, Raymond, sales representative, Daly, Joanne, human resource manager

2 Balding, Alec, retired, Balding, Belle, housewife

3 Patterson, Michael, Patterson, Mary

[here joins Knockanreagh Road]

[Rathmoon townland]

4 Doyle, Thomas, retired, Doyle, Elizabeth, retired

5 house owned by Joseph & Geraldine Gavin

6 Gahan, Patrick, manager, Dept. of Social, Community & Family Affairs, Kiltegan Old Road, Gahan, Kay, homemaker & clerical worker

7 Avalon, McLoughlin, Jim, kitchen fitter, McLoughlin, Teresa Kenny, teacher

8 O'Connell, John, insurance broker, O'Connell, Marie, bank official, Bank of Ireland, Dublin

9 O'Keeffe, Edward, mechanical work, Dublin, O'Keeffe, Mary, clerical work, Carlow, & Commissioner for Oaths

10 occupier declined to be named

11 Doran, John, carpenter, Dept. of Defence, Coolmoney, Doran, Mary, bank official, Bank of Ireland, Main Street

12 Hannafin, Tom, primary teacher, Scoil Naomh Iósaf, Hennessy, Máiread, primary teacher, Scoil Naomh Iósaf

13 Rattigan, Joe, teacher, Carlow Vocational School, Rattigan, Catherine, teacher, Scoil Chonglais, Rattigan, Aoife, student, St. Leo's, Carlow

[here lane leading to house of Jim & Myra Kearney in Carrigeenhill]

[road continues into Carrigeen, Co. Kildare at this point]

South Side

(Carrigeen to Bawnoges Road)

[Rathmoon townland]

14a M. Carwood, welding repairs, proprietor: Michael Carwood

14b An Teálta, Carwood, Michael, welder, Carwood, Patricia, housewife

15 Carolan, Pat, medical doctor, Carolan, Cáit, medical doctor (Dr. Cáit Clerkin)

16 Humphries, James, driver, Humphries, Brieda, housewife

17 Reilly, Thomas, retired Garda, Reilly, Agnes, teacher, Rathvilly

18 Radharc, Browne, John, haulier, Browne, Noreen, legal secretary

19 house owned by Hyland

20 Glenvine, Burke, James, shopkeeper, Main Street, Burke, Paula, housewife

[here shared entrance to Nos. 21 & 22]

21 Moon Lodge, Burke, Alice, household duties

22 Rathmoon House, Burke, John, farmer, Burke, Catherine, teacher, Dunlavin

[Baltinglass West townland]

23 Timmins, John, computer programmer, Dublin, Timmins, Anne, housewife

24 *Cashel,* Sheerin, Jim, veterinary surgeon, Sheerin, Joan, housewife

25 Murphy, Con, financial advisor & broker, Weavers' Square, Doyle Murphy, Leonora solicitor, Weavers' Square

26 Fawn Lodge, Lord, Miriam, housewife ®istrar of births, deaths & marriages

27 Norton, Tony, building contractor, Norton, Patricia, naíonra supervisor, Chapel Hill, Norton, Deirdre, bank official, Naas

28 house under construction

29 house under construction

Rathmoon townland, (see Knockanreagh Road & Rathmoon Road)

Rathvilly Road, Bawnoge, Clogh Upper, Holdenstown Lower, Cloghcastle & Clogh Lower townlands

West Side

('Clough Cross' to Rahill)

[Bawnoge townland]

no houses here

[Clogh Upper townland]

1 Thornton, James, farmer, Thornton, Ivy, Thornton, Malcolm, farmer, Thornton, William

2 house owned by Byrne & Prestage

3 Byrne, Thomas, factory worker, Woodfab, Byrne, Valerie, attendant, Baltinglass Hospital

4 Farrell, James, farmer, Farrell, Maisie, housewife & naíonra supervisor, Farrell, Brian, student

5 Doyle, James, retired, Doyle, Brigid, retired, Doyle, James Joseph, lorry driver, SuperValu, Doyle, John Paul, wood turner, Con Doyle's

6 farm buildings (owned by Farrell of Englishtown)

7 unoccupied house (owned by Farrell)

[Holdenstown Lower]

no houses here

[road continues into Rahill, Co. Carlow at this point]

East Side

(Rahill to 'Clough Cross')

[Holdenstown Lower]

8 ruins (formerly Rogers)

[Cloghcastle townland]

9 (entrance to), farmyard owned by O'Reilly of Castledermot

10 Doody, Patsy, retired, Doody, Nancy, housewife, Doody, Anne, insurance adjuster, VHI, Kilkenny, Doody, Theresa, Doody, Nuala, factory worker, Tullow, Doody, Claire, accounts, Dublin

11 Fisher, Neville, retired, Fisher, Rita, housewife

12 Gorman, Billy, welder, Carlow, Gorman, Katherine, housewife

13 Gorman, Betty, housewife

14 Kelly, Mark, Keogh, Sandra

15 McGrath, James, greengrocer, Mill Street, McGrath, Rita, florist, Mill Street

16 McGrath, John, farmer, McGrath, Theresa, hairdresser

17 (entrance to), McGrath, John, retired farmer, McGrath, Kathy, housewife

[Clogh Lower townland]

18 An Teachín, house owned by Byrne

[here site of Rellickeen]

19 Kehoe, Andrew, farmer

[here shared entrance to Nos. 20 & 21 and lane leading to houses listed under Clogh Lower townland]

20a Kenny, John, retired, Kenny, Margaret, housewife, Kenny, Sean, Kenny, Billy, panel beater

20b Billy Kenny, panel beating, proprietor: Billy Kenny

21 O'Brien, Kevin, Wicklow County Council official, O'Brien, Catherine, secretary

22 O'Farrell, Nuala, O'Farrell, Ron, working in McGraths'

23 Rosemount, Thornton, Elizabeth, housewife

[here shared entrance to Nos. 24, 25 & 26]

24 Grace, Sheila, shop proprietor, Hourigan, Grace, secretary, Hourigan, Nuala, secretary

25 unoccupied house (owner: Fergal Doogue)

26 Easgaidh, Doogue, Brendan, Doogue, Teresa
27 Hillcrest, Doogue, Martin, Doogue, Bernadette, housewife, Doogue, Niall, Doogue,
 Fergal, clerical officer
[Bawnoge townland]
no houses here

The Redwells, (see Kilmurry Lower, Kilmurry Upper & Redwells Road)

Redwells Road, Lathaleere, Newtownsaunders, Slaney Park, Kilmurry Upper &
 Kilmurry Lower townlands
West Side
(Kiltegan Road to Mountneill Bridge)
[Lathaleere townland]
1 Wicklow County Council, Waste Water Treatment Plant
2 Lawlor, Margaret, retired
3 O'Connell, Eamonn, shift manager, ESB, Turlough Hill, O'Connell, Dolores, house-
 wife, O'Connell, David forestry officer, Woodfab, Aughrim
4 Wilson, Mary, musician
5 Cuddy, Oliver, forester, Irish Forestry Board, Cuddy, Hannah, clerical worker, Tony
 Duffy Engineering, Cuddy, Kevin, administrator, Eagle Star Insurance Company,
 Cuddy, Eoin, underwriter, Marsh Financial Services
6 house owned by McHugh
7 Cooney, Owen, office manager, Baltinglass Credit Union, Cooney, Attracta, part-time
 worker, West Wicklow Day Care Centre, Cooney, Colm J., logistics manager, Dun
 Laoghaire
8 McKeever, Una, retired, McKeever, Ingrid, nurse, E.R.H.B.
9 O'Toole, Kieran, computer manager, Dublin, O'Toole, Pamela, bank official, Naas
10 ruins
11 Balfe, carpentry contractors, Balfe, Francis Martin, carpenter, Balfe, Yvonne Ann,
 housewife
12 Connolly, Timothy, retired, Connolly, Jean, retired
[Newtownsaunders townland]
13 Moore, Martin, soldier, Coolmoney Camp, Moore, Mary, housewife, Moore, Darren
 Joseph, mill manager, Quinns, Moore, Adele Patricia, machinist, Kaideen Knitwear
14 Gaffney, Michael, ambulance driver, Baltinglass Ambulance Base, Gaffney, Kathleen
15 Dunne, Patrick, coach operator, Weavers' Square, Dunne, Julie, housewife
16 Byrne, John, Byrne, Teresa
17 Wall, John, turf accountant, Wall, Breeda
[road intersects with Green Lane]
no houses here
[Slaney Park townland]
18A Slaney Park (entrance to) Grogan, William John, sales manager, Goulding Garden
 Care, & farmer, Grogan, Sarah Elizabeth, office manager, Magenta Direct
18B unoccupied gatelodge
19 ruins
[here 'Redwells Cross'; here joins road through Holdenstown]
[Kilmurry Upper townland]
20 ruins
[here Mountneill Bridge; road continues into Mountneill, Co. Carlow at this point]

East Side
(Mountneill Bridge to Kiltegan Road)
[Kilmurry Upper townland]
21 unoccupied owned by Byrne
22 derelict house (formerly Jones)
[here 'Redwells Cross'; here joins road through Kilmurry]
[Kilmurry Lower townland]
23 Coogan, Patrick, farmer
[Slaney Park townland]
24 house in short term tenancy
[Newtownsaunders townland]
[here shared entrance to Nos. 26 & 27]
25 Newtownsaunders[1039], Jones, Robert, farmer, Jones, Freda
26 The Bungalow, Newtownsaunders, Jones, Clive, farmer, Jones, Karen, secretary, Dublin
[here road intersects with Green Lane]
27 Colgan, John, butcher, Main Street, Colgan, Patricia, hairdresser
28 house owned by Andrew & Caroline Doyle
29 Kehoe, John, retired farmer, Kehoe, Jane, housewife
30 Ned Kehoe Heating & Plumbing, plumbers, proprietor: Ned Kehoe, Kehoe, Ned, heating & plumbing contractor, Kehoe, Myra, KARE worker, Kehoe, Eamon, apprentice plumber
31 O'Neill, Kevin, farmer, O'Neill, Julia, housewife
32 farmyard owned by O'Neill
[Lathaleere townland]
33 Fogarty, Michelle, HR executive, the Molloy Group
[here service entrance to Allen Dale construction site]
34 Hendy, Mervyn, Hendy, Hilda
35 Millett, Thomas F., retired solicitor, Millett, Brigid, housewife

Saundersgrove townland, (see also Dublin Road)
1 Saundersgrove, Kelly, Eamon, farmer, Kelly, Peggy, housewife, Kelly, Bernard, retired farmer, Kelly, Brian, software engineer, Kilkenny, Kelly, John, student, Kelly, George, student
2 The Steward's House, Daly, Gary, consultant, Wicklow, Daly, Áine, nurse, Kildare
3 The Herd's House[1040], Nolan Monaghan, Helen housewife, Murphy, Thomas, self-employed builder
4 Saundersgrove Lodge[1041], Delaney, Paddy, veterinary surgeon, Delaney, Patricia, veterinary surgeon

Saundersgrovehill townland (see Dublin Road)

Slaney Mall, Baltinglass East townland
(The Bridge to Church Lane)
A Hairdressing by Frances, hair salon, proprietor: Frances Walsh, Rathsallagh, Dunlavin, staff: Frances Walsh & Pauline Curry
B The Wicklow Way, outdoor clothing & equipment, proprietors: James McCabe & Deirdre Kearns
C Baltinglass Post Office, proprietors: Simon & Rosario Murphy, Mill Street, staff: Rosario Murphy (manager) & Patrick Lennon

D Communicate Now, mobile phone shop, proprietor: Tom McDermott Walshe, Tullow, manager: Jacqui Brennan

E Slaney Decor, decor centre, proprietor: Sheila Grace

F Second Heaven, Chinese takeaway restaurant, proprietor: Mark Seah

Slaney Park townland (see Redwells Road)

Slaney View, Sruhaun townland, (see Sruhaun)

Sruhaun ['Shrughaun'], Sruhaun townland
(on west side of Sruhaun Road, between Nos. 17 & 32)

1 Doyle, Michael, Doyle, Bernie

2 O'Neill, Helen, housewife

3 Kelly, Paddy, digger driver, Darcys', Tuckmill Hill, Kelly, Betty, housewife, Kelly, Brendan, construction worker, Barretts', Kelly, Margaret

4 Doyle, Michael, retired

5 Wilson, Joseph, Wilson, Maritza

6 Kenny, Frances, housewife, Kenny, John P., student, Carlow

7 Leigh, Michael, retired

8 Barrett, Margaret, housewife, Barrett, Martin, driver, Tony Duffy Engineering

9 Travers, Owen, bank official, Dublin, Travers, Cécilia, teacher, Dublin

10 Barrett, Harry, retired, Barrett, Elizabeth, retired, Barrett, Johnny, Barrett, Robert, Barrett, Declan

11 Slane Properties, property developers, proprietor: James McMahon, McMahon, James, builder, McMahon, Marie, waitress

12 Sinnott, Michael, construction worker, Sinnott, Marian, general operative, Wampfler

13 occupier declined to be named

14 Fleming, Olive Joyce, retired

Sruhaun ['Shrughaun'] Road, Baltinglass East, Sruhaun & Tuckmill Upper townlands
West Side
(Bramble Court to Dublin Road)
[Baltinglass East townland]

1 The Buttercups, Balak, Grzegorz, liaison manager, Eastlink, Szczech, Marta, cashier, Quinns' Superstore

2 McDermott, Patrick, McDermott, Elizabeth, housewife

3 Abbey View, Hamill, David, Hamill, Patricia

4 Majella's Hairdresser, hairdressers, proprietor: Majella Fisher, Fisher, Michael, shift manager, Kerry Group, Tallaght, Fisher, Majella, hairdresser

5 house owned by Westlake

6 Kennedy, John, Eircom employee, Kennedy, Linda, shop assistant, Quinns'

7 Doyle, Thomas, company director, Tommy Doyle Power Tools & Commissioner for Oaths, Doyle, Mary, housewife

8 Moorville, Murphy, Thomas A., veterinary surgeon, Bawnoges Road, Murphy, Catherine, housewife

9 Chapel Hill Lodge, Scanlon, Michael, farmer

10 *Maryknoll*, Caplice, Pat, hackney driver, Baltinglass Cabs, Stratford, Caplice, Deirdre Lee, laundrette proprietor, Church Lane

11 Cleary, John, post primary teacher, Community School, Tullow, Cleary, Pearl, nursing sister, Baltinglass Hospital, Cleary, Barry, civil engineer, Dublin, Cleary, Dónal, student, Dublin

12 *Tiglin*, Byrne, Willie, crane driver, Byrne, Isabel, nurse, Byrne, Russell, apprentice carpenter

13 Beton, Douglas, retired, Beton, Esther, retired

14 *Derreen*, Dalton, Denis, Dalton, Ann, Dalton, Richard, auditor, Ulster Bank, Dalton, Clare, administrator

15 Bourke, Helen, retired

16 Phelan, Oliver, Phelan, Una, Phelan, Brian, Phelan, Niall

17 occupier declined to be named

[Sruhaun townland]

18-31 see Nos. 1-14 Sruhaun

32 occupier declined to be named

33 Burke, Michael, Burke, Imelda

34 Kennedy, Richard, technician, Eircom, Dublin, Kennedy, Martina, Garda, Dublin

35 Lennon, John, plumber & horse trainer, Lennon, Mary, executive officer, Civil Service, Carlow

[Tuckmill Upper townland]

36 Byrne, James, purchasing manager, John Sisk & Son, Dublin, Byrne, Margaret, part-time secretary, Outdoor Education Centre, Byrne, Kiera, student

East Side

(Dublin Road to Chapel Hill)

[Tuckmill Upper townland]

37 McGrath, Patrick Joseph, retired

38 Doyle Healy, Tess, office manager, Healystone

39 Healy, Patrick, farmer, Healy, Ann, civil servant, Dublin

40 farmyard owned by Patrick Healy

41 Byrne, Erin, office worker, John Sisk & Son, Dublin

42 house under construction (owners Dallan Stephenson & Camilla Sweeney)

[Sruhaun townland]

43 Joyce, Fiona, musician

44 house owned by Kavanagh

45 McHugh, Robert, McHugh, Paula

46 Rosin's Gate, Hillan, Edward, administrator, Dublin, Hillan, Katherine, housewife

47a out offices owned by V. Doyle

47b Doyle, Vera, horse breeder, Khaleq, Sam, apprentice carpenter

[here lane to No. 14 of Sruhaun townland]

48 Timmins, Billy, public representative, Dáil Éireann, Hyland, Madeleine, homemaker

[Baltinglass East]

49 Murphy, Patrick, teacher, Scoil Chonglais, Murphy, Roisin, housewife

50 *Cedron*, Hunt, Francis P., retired teacher

51 Connors, Mary, housewife

52 Murphy, Michael, site foreman, P. Elliott & Co. Ltd., Murphy, Majella, housewife

53 O'Connell, Len, insurance broker, O'Connell, Nuala, retired primary teacher

54 Phelan, Colm, working for V.E.C., Phelan, Dora, home keeper, Phelan, Clare, student

Sruhaun ['Shrughaun'] townland, (see also Sruhaun & Sruhaun Road)
14 ruins (formerly Doyles' house)

Station Road, Baltinglass West townland
North Side
(Mill Street to site of Railway Station)
1 see No. 14 Mill Street [Thomas Harte]
[end of road]
[here shared entrance to Nos. 2a & 2b]
2a Quinns of Baltinglass Ltd., grain intake, wool & grain stores, & office[1042], proprietor: Liam Quinn, Slaney Lodge, manager: Martin Coleman
2b Quinns' Super Store, (also No. 7 County Road), hardware, proprietor: Liam Quinn, Slaney Lodge, senior staff: Kieran Hosey & Tom Kane
South Side
(site of Railway Station to Mill Street)
3 store owned by Shortt[1043]
4 see No. 15 Mill Street [John Shortt]

Stratfordlodge townland, (see also County Road, Dublin Road & Raheen Hill Road; includes part of Quinns of Baltinglass Ltd. wool & grain stores – entrance from Station Road; & Station House – entrance from County Road)
1 Baltinglass Golf Club, bar staff: Peg Malone (manager) & Geraldine Gethings, grounds staff: Martin Donegan (head greenkeeper), Dan Kearney & Eamon Doherty
2 O'Reilly, John, machine operator, Avonmore, Ballytore, O'Reilly, Martha, hardware employee, Quinns' Superstore
3 Nolan, Thomas, retired, Nolan, Pamela, secretary, APD, Carlow, Nolan, Dermot, clerical officer, Dublin Port
4 Stratford House, bed & breakfast, proprietors: Johan & Thea van de Kerkhof, van de Kerkhof, Johan, van de Kerkhof, Thea, van de Kerkhof, John
5 Apartments
Apt. 1 Murphy, Cathriona student
Apt. 2 Gibbons, Poraig, carpenter, Dillon, Catherine, bartender
Apt. 3 Cooper, Ron, carpenter, Country Kitchens, Ballymore Eustace, Cooper, Emer, staff nurse, Coombe Women's Hospital
Apt. 4 Daly, Clodagh
Apt. 5 McCarthy, Jacqui government official, Dublin

Tailor's Lane, Tuckmill, Tuckmill Lower & Tuckmill Upper townlands
East Side
(Kilranelagh Road to Coolinarrig)
[Tuckmill Lower townland]
1a Byrne, Margaret, housewife, Byrne, Bernie, shop assistant, SuperValu
1b Quinn, Turlough, farmer, Quinn, Stephanie, housewife
2 farm buildings – formerly dwelling (owned by Byrne)
[road continues into Coolinarrig Lower townland]
West Side
(Coolinarrig to Kilranelagh Road)
[here Tuckmill Hill townland – outside of area being covered]

[Tuckmill Upper townland]
3 house owned by Lynch

Tan Lane, Baltinglass West townland, (off west side of Mill Street)
no houses here

Timmins' Lane, Baltinglass East townland, (see Chapel Hill)

Tinoranhill North townland, (see Hartstown Road)

Tinoranhill South townland, (see Hartstown Road & Tinoran Road)

Tinoran Road, Baltinglass West, Glennacanon, Tinoranhill South & Knockanreagh
 townlands
North-East Side
(Ballytore Road / Brook Lane to 'Tinoran Cross')
[Baltinglass West townland]
1 Fairways, Lord, David, financial manager, Wampfler, Lord, Catherine, bank official
2 Clarke, John, news vendor, Tallaght, Clarke, Annette, news vendor, Tallaght, Bailie,
 Matt, air conditioning sales, Tallaght, Clarke, Suzanne, architect, Rathmines
3 The Beeches, Byrne, Maurice, civil servant, Byrne, Loretto, bank official, Byrne,
 Thomas, electrician
4 Beech Drive, O'Rorke, Dermot Micheal, fire fighter, Dublin Corporation, O'Rorke,
 Maria Bridget, kitchen staff, Quinns'
5 out office owned by O'Rorke
6 unoccupied house – under refurbishment (owned by B. O'Neill)
[Glennacanon townland]
7 Giblin, Richard, farmer, Giblin, Margaret Teresa housewife, Giblin, Stephanie Mary,
 farmer
8 O'Neill, Michael, farmer, O'Neill, Bridget, housewife, O'Neill, Breda, trainee
 accountant
9 Byrne, Maurice, farmer, Byrne, James, farmer, Nolan, Kathleen, retired
10 Norton, Henry, farm labourer, Norton, Theresa, housewife
[Tinoranhill South townland]
11 unoccupied house (owned by Barrett)
12 O'Neill, Katherine home duties
13 Tinoran House, Neill, John, farmer, Neill, Eileen, housewife
14 *Dorvic*, Neill, Victor, farmer, Neill, Dorothy, teacher, Dunlavin, Neill, John Samuel,
 farmer
15 Byrne, Maurice, inspector, DSPCA, Dublin, Byrne, Mary, student nurse,
 Monasterevin
[here 'Tinoran Cross'; here joins Hartstown Road; road continues into Oldtown,
 Lackareagh & Monatore townlands]
South-West Side
('Tinoran Cross' to Brook Lane)
[here Monatore townland – outside of area being covered]
[Tinoranhill South townland]
no houses here

[Knockanreagh townland]
16 Lee, Liam, electrician, Tompkin, Jean, hairdresser, The Cutting Room, Church Lane
17 Halloran, John, Halloran, Mary, Fitzgerald, Thomas
18 (temporary structure), Halloran, Gay, lorry driver, Greene, Sandra, secretary
19 Halloran, Jim, retired, Halloran, Ann, housewife
[here joins Knockanreagh Road]
[Glennacanon townland]
no houses here
[Knockanreagh townland]
20 Wicklow County Council, Reservoir & Filter Beds
[Baltinglass West townland]
no houses here

Tuckmill Lower townland, (see Dublin Road, Kilranelagh Road, Rathbran Road & Tailor's Lane)

Tuckmill Upper townland, (see also Dublin Road, Kilranelagh Road, Rathbran Road, Sruhaun Road & Tailor's Lane)
11 house owned by McLoughlin

Tullow Old Road, Baltinglass West & Bawnoge townlands, (see Bawnoges Road)

Twyfords' Lane, Baltinglass West, Knockanreagh & Rathmoon townlands, (see Knockanreagh Road)

Weavers' Square, Baltinglass East townland
West Side
(Main Street to Kiltegan Road)
1-4 see Nos. 1-4 The Flags
5 Breen, Winifred, retired
6 Dunne's Coach Hire, proprietor: Patrick Dunne
7 D.J. Kehoe, public house, Kehoe, Bridget, Kehoe, Daniel J., publican
8a Billy Timmins, TD, Fine Gael, constituency office, proprietor: Billy Timmins, secretary: Una Timmins
8b Farrell, Alice
9 Denis Hanrahan, small grocery shop, proprietor: Kathleen Gahan
10 Timmins', licensed premises, Timmins, Godfrey, retired public representative, Timmins, Nora, retired teacher, Timmins, Una, secretary, constituency office
11 unoccupied house
12 O'Neill, Breeda, housewife
13 ruins
14 ruins
East Side
(Kiltegan Road to The Green / Chapel Hill)
15 St. Joseph's Roman Catholic Church, Parish Priest: V. Rev. Gerald Doyle, Parochial House, Kiltegan Road, Curate: Rev. Pádraig Shelley, Parochial House, Kiltegan Road
16 Rathcoran House (entrance to), unoccupied

17a O'Toole, Seán, retired shopkeeper, O'Toole, Brighid, retired primary teacher

17b East Coast Radio, radio station office, proprietors: East Coast Radio, Prince of Wales Terrace, Bray, operations manager: Peter Moran

18 Byrne, Felix, retired

19 Kehoe, Claire, housewife

20 unoccupied house

21a Doyle Murphy & Company, solicitors, proprietor: Leonora Doyle

21b West Wicklow Financial Services Ltd., financial advisors & brokers, proprietor: Con Murphy

22 Dunne, Patrick, retired, Dunne, Josephine, housewife

23 O'Shea, Marie, housewife, Murphy, Donncha, farmer, Murphy, Ann Marie, claims assessor, VHI Kilkenny

24 Millett, Michael, law clerk, Millett, Teresa, housewife

25 Darcy, Maureen, housewife

26 Weavers' Square Surgery, medical surgery, doctors: Pat Carolan & Cáit Clerkin

27 unoccupied house (owned by Quinns)

28 (see also No. 1 Chapel Hill – flats)

28a Andrews, Mary

28b English, Lisa, working in Baltinglass Meats

28c Department of Agriculture, Farm Development Office (part of No. 1 Chapel Hill), senior staff: Richard O'Beirne

Woodfield townland, (see also Kiltegan Road)

3 unoccupied house owned by O'Reilly

3a O'Reilly, Seamus, retired farmer, O'Reilly, Teresa, housewife

16 Woodfield Construction Ltd., general builders, proprietors: Alan & Susan Jackson, Jackson, Alan, general builder, Jackson, Susan, housewife

17 Moore, Laurence, farm worker, Farrars', Kilmurry

PUBLIC REPRESENTATIVES

Chairmen of Baltinglass Board of Guardians, 1851-1921

Robert F. Saunders, Saundersgrove	1851-1870
William J. Westby, High Park, Kiltegan	1870-1882
Edward A. Dennis, Eadstown Lodge, Stratford	1882-1895
Edward P. O'Kelly, St Kevin's, Church Lane	1895-1914
Philip Bollard, Coan, Knockanarrigan	1914-1917
Martin M. Gleeson, Stratford	1917-1920
Edward (Eamon) O'Neill, Main Street	1920-1921

Chairmen of Baltinglass No. 1 Rural District Council, 1899-1925

James H. Coleman, Griffinstown, Dunlavin	1899-1908
William Byrne, Kilmurry	1908-1920
Edward (Eamon) O'Neill, Main Street	1920-1925

Members of Parliament from Baltinglass, 1851-1922

Edward P. O'Kelly, for East Wicklow	1895
Edward P. O'Kelly for West Wicklow	1910-1914

Dáil Deputies from Baltinglass, 1919–2001

M. Godfrey Timmins, for Wicklow		1968–1987
M. Godfrey Timmins, for Wicklow		1989–1997
William G. Timmins, for Wicklow		1997 to date

Members of Seanad Éireann from Baltinglass, 1922–2001

Jennie Wyse Power	1922–1936

Wicklow Co. Councillors from Baltinglass, 1899–2001

Edward P. O'Kelly	Main Street & St Kevin's	1899–1914
William Byrne	Kilmurry	1908–1920
Edward J. O'Kelly	Main Street	1914–1920
Edward (Eamon) O'Neill	Main Street	1920–1925
Joseph Burke	Rathmoon	1925–1928
Daniel J. Kehoe	Weavers' Square	1925–1942
Michael Timmins	Weavers' Square	1934–1942
Benjamin Farrell	Mill Street	1942–1950
Daniel J. Kehoe, Jnr.	Weavers' Square	1942–1944
Paul Kehoe	Weavers' Square	1950–1960
M. Godfrey Timmins	Weavers' Square	1950–1999
M. Joseph O'Neill	Main Street	1960–1974
Thomas Cullen	Deerpark	1991 to date
William G. Timmins	Sruhaun	1999–[2004]

Chairmen of Wicklow County Council from Baltinglass, 1899–2001

Edward P. O'Kelly	1899–1914
M. Godfrey Timmins	1975–1976
M. Godfrey Timmins	1978–1979
M. Godfrey Timmins	1981–1982
Thomas Cullen	1995–1996
M. Godfrey Timmins	1996–1997

CLERGY & RELIGIOUS

Roman Catholic Parish Priests of Baltinglass, 1851–2001

[1831]–1871, Daniel Lalor (born 1790; from Ballyfin; ordained 1815; died 24 Jan. 1871)

1871–1883, Denis Kane, (born 1822; from Ardnehue, Killerrig; ordained 1848; Professor of Natural Philosophy, Carlow College from 1851; Adm. Tullow 1860–1866; D.D. 1866; P.P. Philipstown [Daingean] 1866–1871; died 2 July 1883)

1883–1893, Arnold Wall, (from Arles; Adm. Carlow 1878–1883; died 28 August 1893)

1893–1930, Thomas O'Neill, (from Clonegal; ordained 1872; Adm. Tullow 1883–1893; died 1 April 1930)

1930–1939, Thomas Monahan, (from Donadea, Clane; ordained 1873; P.P. Hacketstown 1891–1930; died 11 August 1939)

1939–1951, Patrick Doyle, (from Ardoyne, Tullow; ordained 1907; died 5 March 1951)

1951–1974, Thomas Gahan, (from Old Grange, Graignamanagh; ordained 1925; Adm. Tullow 1947–1951; retired 1 Feb. 1974; died 21 Dec. 1976)

1974–1987, Thomas F. Brophy, (from Rathrush, Ballon; ordained 1942; Spiritual Director, Carlow College 1946–1968; Adm. Carlow 1968–1974; retired 1987; Pastor Emeritus; died in Spain 14 Sept. 1989)

1987–1989, John Fingleton, (ordained 1956; C.C. Baltinglass 1956–1963; Adm. Carlow 1978–1987; P.P. Graiguecullen & Killeshin from 1989)

1989–2001, Gerald Doyle, (born 1930; from Ballymurphy, Borris; ordained 1956; P.P. Bennekerry 1976–1989; died 12 Nov. 2001)

Church of Ireland Rectors of Baltinglass, 1851–2001

[1807]–1854, William Grogan, (born 1778; died 2 Nov. 1854)

1855–1876, William Norton, (born 1814; resigned 1876; later Rector of Pelham Parva, Herefordshire; died London, 4 July 1881)

1876–1907, John Usher, (born 1837; ordained 1873; Curate in Castledermot 1875–1876; died 2 Feb. 1907)

1907–1934, James Lefrod Dwyer, (ordained 1886; lived in Gloucestershire after retirement; died August 1949)

1934–1939, Alexander Victor Smyth, (born 1894; ordained 1917; Rector of Monasterevan 1939–1944; died 4 Dec. 1944)

1939–1947, William Samuel Parker, (ordained 1934; Rector of Gorey from 1947)

1947–1953, Cyril Bruce Champ, (born 1921; ordained 1944; Rector of Aughrim, Co. Galway, 1953–1965; Dean of Clonfert and Kilmacduagh 1965–1986; died 28 Oct. 1986)

1953–1957, Dermot Nichols Bowers, (born 1913; ordained 1941; Rector of Enniscorthy 1957–1966; later ministered in Thailand, Isle of Man & England)

1957–1967, Claude Lionel Chavasse, (born 1897; ordained 1928; retired 1967; author of *The Story of Baltinglass*; died Dublin, 29 May 1983)

1967–1977, John Robert Patrick Flinn, (born 1930; ordained 1965; Rector of Castlepollard 1977–1984; later Chancellor of Ossory & Leighlin Cathedrals)

1977–1987, Richard Rennison Wilson, (born 1938; ordained 1965; Rector of Dundalk 1987–1992; died Dundalk, 11 Nov. 1992)

1988 to date, Mervyn Alexander McCullagh, (ordained 1979)

Roman Catholic Curates in Baltinglass, 1851–2001

John Nolan, [1835]–1859, later P.P. Killeigh; Kildare; died 1880

Edward Foley, 1851–1854, died 1865

John Boland, 1851–1852, Workhouse chaplain; later P.P. Clonmore; died 1886

John Hennessy, 1852–1855, Workhouse chaplain

John Walsh, 1854–1856, later P.P. Clonbullogue; retired 1863

Stephen Conlan, 1855–1856, Workhouse chaplain; died 1866

[?] O'Beirne, 1856–1857

Patrick McDonnell, 1857–1878, later P.P. Hacketstown; Graiguenamanagh; died 1901

John Clancy, 1858, Workhouse chaplain

Thomas Morrin, 1859–1861, later P.P. Naas; died 1907

James Mahon, *c*.1860–*c*.1861, later P.P. Tinryland

[Fintan?] Phelan, 1861

John D. Clancy, 1861–1866

Francis Davie, 1862, later P.P. Stradbally; died 1882

Daniel Gilligan, 1862–1863, later P.P. Doonane; Raheen; died 1912

Laurence Dempsey, 1866–1867, later P.P. Tinryland; died 1882

Hugh McConaghty, 1867-1871, later P.P. Ballyfin; died 1890

Daniel Maher, 1871-1880, later P.P. Clonegal; died 1888

T Monahan, 1877

Joseph O'Neill, 1878-1885, died 1895

Joseph Delaney, 1880-1882, later P.P. Stradbally; died 1922

James Mulcahy, 1882-1886

Patrick Keenan, 1885-1888, died 1916

Patrick J. Loughlin, 1886-1889, later P.P. Raheen; died 1920

Peter Campion, 1888-1891, later P.P. Kildare; died 1926

James Parkinson, 1889-1897, later P.P. Ballyadams; died 1920

Henry Dunne, 1891-1898

Thomas Monaghan, 1897-1898, later P.P. Doonane; Clonmore; died 1926

John Dunne, 1898-1909, later P.P. Borris; died 1931

John Breen, 1898-1901, later P.P. Abbeyleix; died 1949

Michael Hayes, 1901-1903, died 1942

James Wall, 1903-1904, transferred to Co. Limerick prior to embarking on foreign
 missions

Michael Rice, 1904-1906, later P.P. Kilcock; died 1938

John Donovan, 1906-1911, later P.P. Kill; died 1929

Arthur F. Murphy, 1909-1916

James Mahon, 1911-1914, later P.P. Stradbally; died 1946

Martin Brophy, 1914-1923, later P.P. Suncroft; died 1949

Patrick O'Haire, 1916-1936, later P.P. Graiguecullen; died 1950

Albert Gerald Byrne, 1923-1942, later P.P. Arles; died 1963

Edward Kinsella, 1936-1942, later P.P. Tolerton; Daingean; died 1979

Patrick Anthony Maher, 1942-1946, later P.P. Emo; died 1982

James McDonnell, 1942-1947, later P.P. Clonbullogue; died 1975

James Moran, 1946-1952, later P.P. Ballyfin; died 1981

William O'Mahony, 1947-1956, died 1975

Austin Gogarty, 1952-1953, of St. Patrick's, Kiltegan; died 1993

Dermot McDermott, 1953-1968

John Fingleton, 1956-1963, later P.P. Baltinglass; Graiguecullen & Killeshin

Patrick B. McDonald, 1963-1967, transferred to Clane

Patrick J. McDonnell, 1967-1977, later P.P. Hacketstown

Thomas Walsh, 1968-1974, transferred to Mountmellick

Patrick B. Hennessy, 1977-1982, transferred to Clane

Patrick Hyland, 1978-1987

James Purcell, 1982-1985, (acting curate) former P.P. in England; transferred to Modeligo,
 Co. Waterford

Paul McNamee, 1985-1987

James Kelly, 1987-1990, later P.P. Raheen

Thomas F. Brophy, 1987-1989, Pastor Emeritus

Con Moloney, 1990-1994

Laurence Malone, 1994-2000, later P.P. Paulstown

Pádraig Shelley, 2000 to date

Church of Ireland Curates in Baltinglass, 1851-2001

Henry Scott, [1829]-1853, later Prebendary of Killamery; Staplestown; died 1877

George Samuel Gerrard, 1854, ordained 1849; later Curate in Callan

Charles Lomax Thomas, 1861-1864

Thomas Henry Royse, 1869-1873, ordained 1861; later Rector of Newbliss, Co. Monaghan; Forkhill, Co. Armagh; died 1896

Superioresses of the Presentation Convent in Baltinglass, 1873-1990

Mother Magdalen Claver Hussey	1873-1891
Mother Agnes Barrett	1891-1897
Mother Joseph Comerford	1897-1903
Mother Evangelist Casey	1903-1906
Mother Agnes Barrett	1906-1912
Mother Evangelist Casey	1912-1918
Mother Ignatius Carolan	1918-1923
Mother Evangelist Casey	1923-1929
Mother Columba Russell	1929-1935
Mother Evangelist Casey	1935-1938
Mother Columba Russell	1938-1944
Mother Gabriel Flynn	1944-1950
Mother Columba Russell	1950-1956
Mother Gabriel Flynn	1956-1962
Mother Alphonsus Dolan	1962-1969
Sister Gabriel Flynn	1969-1972
Sister Immaculata McCormack	1972-1978
Sister Teresa Baugh	1978-1984
Sister Rose Gargan	1984-1990

Presentation Sisters in Baltinglass, 1873-1990

Mother Magdalen Claver Hussey (*née* Mabel Hussey), 1873-1897

Mother Augustine Hussey (née Isabella Hussey), 1873-1909

Mother Agnes Barrett (née Anastatia Barrett), 1873-1929

Sister Catherine Heydon (née Catherine Heydon), 1873-1909

Mother de Sales Byrne (née Julia Byrne), 1873-1912

Mother Joseph Comerford (née Harriet Comerford), 1874-1912

Mother Evangelist Casey (née Anne Ellen Casey), 1885-1956

Sister Teresa McEniry (née Mary McEniry), 1887-1936

Sister Aloysius O'Reilly (née Josephine O'Reilly), 1891-1903 [left the Congregation to enter the Poor Clares, Notting Hill, London, as Sister Humilis died after a short time]

Mother Ignatius Carolan (née Marcella Carolan), 1892-1923

Sister Bernard Ennis (née Margaret Ennis), 1892-1907

Sister Francis Whelan (née Mary Whelan), 1894-1902

Mother Clare Scurry (née Catherine Scurry), 1894-1957

A Miss Eagar from Cork entered on 6 December 1900 but left after a brief sray

Sister Bridget O'Neill (née Mary Anne O'Neill), 1902-1903 [left owing to ill health]

Sister Patrick Keegan (née Jane Keegan), 1903-1948

Mother Columba Russell (née Johanna Russell), 1904-1968

Sister Dympna Healy (née Margaret Healy), 1905-1961

Sister Ita Bourke (née Mary Anne Bourke), 1905-1933

Mother Brigid Curry (née Margaret Curry), 1905-1968

Sister Mary Magdalen O'Dwyer (née Julia O'Dwyer), 1909-1962
Sister Alphonsus McDonnell (née Mary McDonnell), 1910-1916
Sister Albeus Doyle (née Mary Doyle), 1912-1974
Sister Gerard Duffy (née Mary Duffy), 1916-1960
Sister Anthony Whelan (née Mary Bridget Whelan), 1917-1960
Sister Joseph Murray (née Teresa Murray), 1919-1966
Mother Gabriel Flynn (née Margaret Flynn), 1925-1990, died 1992
Sister Therese Morrissey (née Mary Teresa Morrissey), 1932-1987
Mother Alphonsus Dolan (née Addie Dolan), 1940-1984
Sister Immaculata McCormack, 1942-1978
Sister Anna O'Sullivan, 1946-1948
Sister Martha Dunne, 1946-1990
Sister Josepha O'Donnell, 1948-1981
Sister Vianney Naughton, 1948-1973, died 1983
Sister Angelus [later Mairín] Ryan, 1950-1963
Sister Columbanus Kyne, 1956-1977
Sister Maria Goretti Cusack (née Mary Cusack), 1957
Sister Patrick Coady, 1957
Sister Colette Dunne, 1957-1963
Sister Gemma Hughes , 1957-[?]
Sister Pierre [later Nora] Cunneen, 1960-1977
Sister Carthage [later Katherine] Ryan, 1963-1974, died 2002
Sister Declan Power, 1965-1978
Sister Damien [later Anne] Farrell, 1966-1975
Sister Gabriel Thornton, 1969-1981, 1987-1990
Sister Celsus [later Mary] Grennan, 1974-1977
Sister Julia Miller, 1975-1980
Sister Brid Burke, 1977-1981
Sister Rose Gargan, 1977-1990
Sister Madeleine Houlihan, 1977-1980
Sister Teresa Baugh, 1978-1984
Sister Chanel Canney, 1979-1981
Sister Therese English, 1979-1980
Sister Dolorosa Doohan, 1980-1987
Sister Joan Bland, 1981-1990
Sister Agnes O'Sullivan, 1987-1990
Sister Carmel Danaher, 1989-1990

St John of God Sisters in Baltinglass, 1900-1919 (incomplete)
Sister Alphonsus Cahill (née Ellen Cahill), 1900-[?], died 29 Nov. 1924
Sister Josepha Corboy (née Ellie Corboy), 1900-[?], died 25 Feb. 1905
Sister Celestine McDonald, 1900-[?]
Sister Agatha Manning, 1900-[?]
Sister Francis Burke, 1901-[?], may not have been in Baltinglass
Sister Joseph Lacey, 1901-[?]
Sister Baptist Ryan, [?]-1919
Sister Mechtildus, [?]-1914
Sister Eugenius, [?]-1914

Sister Borgia Gunning *(née* Josephine Gunning), [?]-1919, in Baltinglass by 1911
Sister Finbar, 1914-[?]
Sister De Lellis Garty, [?]-1919
Sister Regis Nicholas, [?]-1919, died Sept. 1919

Mercy Sisters in Baltinglass, 1990–2001
Sister Brigid Morgan, 1990 to date
Sister Carmel Duggan, 1991 to date
Sister Mechtilde Stack, 1991-1996

ENDNOTES

1 Anon., 'Recollections of Visits to Belan House, Co. Kildare, in the Early Victorian Period', *Journal of the Co. Kildare Arch. Soc.*, Vol. 5 (1908), pp. 299-300.

2 Edward O'Toole, *Whist for your life, that's treason: Recollections of a Long Life*, (Dublin, 2003) pp. 8, 18.

3 National Archives of Ireland, CSORP 1850 O.49.

4 *Lewis' Topographical Dictionary of Ireland* (1837).

5 CSORP 1850 O.49.

6 Registry of Deeds, 1849/7/295.

7 William Nolan 'Land and Landscape in Co. Wicklow c1840', *Wicklow History and Society*. (Dublin, 1994) p.670

8 CSORP 1851 32/38.

9 *Kildare Observer*, 11 December 1880, p 3.

10 CSORP 1851 32/93, 95.

11 *Parliamentary Gazetteer of Ireland* (1846).

12 All figures taken from the statistical summaries of the 1841 and 1851 censuses.

13 NAI, OS 140.

14 Baltinglass Parish Vestry Minute Book, 1808-1888.

15 It was part of a sum of £60 which had been granted to the vestry by the government during a cholera epidemic in the early 1830s. Apparently little of this money was spent on cholera relief, as some time later the vestry was asked to return it. All but the £4-5-12 was returned, and it was placed in the savings bank.

16 Maeve Baker, 'The Famine in Wicklow 1846-47', *Journal of the West Wicklow Hist. Soc.*, No. 3 (1989), pp. 17-29.

17 *Census of Ireland, 1851*, Part V, Table of Deaths, Vol. II.

18 In the *Complete Catholic Directory*, 1848, p.343, he is reported as dying at Baltinglass, but he is not listed as curate in Baltinglass in or before 1847. A list of curates in the front of one of the baptismal registers, taken from a book of Father Lalor's indicates that he served as curate between 23 September and 9 October 1847.

19 Johnson's memorial inscription in Baltinglass Abbey indicates that he died of malignant fever.

20 Tommy Bourne, *A Guide to Stratford on Slaney – History and Folklore 1780-1974*, (1974, Stratford), pp. 6-8.

21 'Ullewood'.

22 Trevor McClaughlin, *Barefoot and Pregnant?- Irish Famine Orphans in Australia* (Melbourne, 1991), pp. 49-60.

23 CSORP 1850 O.2471, 13,527/50.

24 *The Times*, 8 Dec. 1826.

25 IBID.

26 *The Complete Peerage.*

27 Ibid.

28 This road, connecting Mill Street to the Tinoran (or Ballytore) Road at the end of the Brook Lane, was constructed in the 1840s. At the Grand Jury Special Session held in Baltinglass on 18 Nov. 1842 Edward Jones was given the contract to construct '75 perches of new line of road, between Mill-st. in Baltinglass and a stream of water at Cuckoo lane'.

29 The site of Nos. 2 & 3 was later part of the railway.

30 Re Nos. 2-11: 'pay no rent and are nearly ruins' according to the Town House Book, Aug.-Sept. 1853 (NAI, OL.5.3562).

31 Nos. 9-12 & 37-42 were later demolished to make way for the railway cutting; the western portion of No. 12 formed the site of the new stretch of road linking Belan Street to the western section of the Ballytore (or County) Road.

32 Re Nos. 24-27: 'wretched mud wall cabins' according to the Town House Book, Aug.-Sept. 1853 (OL.5.3562).

33 'was a dwelling – now used as a store' according to the Town House Book, Aug.-Sept. 1853 (OL.5.3562).

34 1851 Census statistics; houses 2; population 11.

35 Entrance by Cars' Lane.

36 Entrance by Kiltegan Road through Deerpark.

37 'this is to be given up to lessor [Ellen Lawler] & to be set along with new houses that are to be built next year' according to the Town House Book, Aug.-Sept. 1853 (OL.5.3562).

38 'occupier is labourer of Lessor [Richard Rawson]' according to the Town House Book, Aug.-Sept. 1853 (OL.5.3562).

39 'All greatly improved but not yet occd. nor Ho. not yet finished' according to the Town House Book, Aug.-Sept. 1853 (OL.5.3562).

40 'A Thatched House used as an office' according to the Town House Book, Aug.-Sept. 1853 (OL.5.3562).

41 'These concerns are part of an old castle which was put into habitable order about 40 or 50 years back but are now unoccupied the addition forming the 2d item [the second of three parts itemized in the House Book] was the main body but was converted into an office for cattle sometime since after all the lofts had been taken away excepting one which is used as a hay loft ...' according to the Parish House Book, Dec. 1843 (OL.5.2347).

42 House later known as St. Kevin's.

43 The location of this house is uncertain as it was not defined on the original Valuation Office map. It could have been on the opposite side of the road or closer to Raheen Hill Road.

44 Though this house was gone by 1901, the name 'Hunt's Garden' was still remembered at the beginning of the twenty-first century. Tall trees and the outline of walls close to the riverbank are still clearly visible from Eldon Bridge. Despite intensive farming over the years, daffodils bloomed in the garden in the Spring of 2001.

45 Site of former bleach green & bleach mill owned by Parke family.

46 Formerly the site of the Poor Shop. The Infant School was originally run in the gate lodge further down the Dublin Road.

47 Grothier may not have been the teacher in 1851. He was there in Sept. 1847 but was in Wexford by June 1852. His immediate successor was a Mr Murphy.

48 There was almost definitely a gate lodge on the Dublin Road at this time, as there was one in 1867. It may or may not have been the small house (No. 2b of Stratfordlodge townland) listed in Griffith's *Valuation* as occupied by Isaac Haliday. The original Valuation Office map has too many alterations to allow definite identification.

49 Formerly a hotel.

50 The original Valuation Office map is unclear, but Mannering's house (on Samuel Condell's land) in Raheen appears to have been located on the Dublin Road.

51 According to Tommy Doyle of the Lough this man roofed St. Joseph's church.

52 Formerly a police station.

53 'a new house not finished inside' according to the Town House Book, Aug.-Sept. 1853 (OL.5.3562).

54 It is unclear whether this and the next property were located here or between Nos. 23 and 24.

55 'In Nicholas Ryder's house formerly lived Peter Kane who sold milk, before him James Roach ...' according to the Turtle Ms.

56 'going out of repair the Tan yard not used for the last 7 years' according to the Town House Book, Aug.-Sept. 1853 (OL.5.3562).

57 'The Pound is worth very little or nothing ...' according to the Town House Book, Aug.-Sept. 1853 (OL.5.3562). It was this enclosure that gave the street its alternative name of Pound Lane.

58 Possibly also a public house.

59 The location of this house is uncertain as it was not defined on the original Valuation Office map. It could have been on the road from 'Tinoran Cross' to Ballytore.

60 The 'Bed Road', running between Rathtoole Bridge and Lowtown, is so called because a large stone referred to as St. Laurence's Bed once lay by the roadside.

61 The location of this house is uncertain as it was not defined on the original Valuation Office map. It could have been on the opposite side of the road or even on Tailor's Lane.

62 Only one of the houses marked as 7 here appeared in Griffith's *Valuation*. One of them may have been on the opposite side of the road.

63 Then in poor condition.

64 The exact location of No. 17 is uncertain as it was not defined on the original Valuation Office map.

65 The exact location of Nos. 21 & 22 is uncertain as they were not defined on the original Valuation Office map.

66 This was shown as Deerpark House on the original Ordnance Survey map, while No. 14 was given that name in the 1907-08 revision. The latter was certainly called Deerpark House, but the early application of the name to this house does not appear to be erroneous.

67 Uncertain whether the entrance was from here or through the lane at the next corner of the Kiltegan Road.

68 The remains of a Cromlech were in the field here.

69 It is not quite certain that No. 5 was located on this road, as the earliest Valuation Office map is unclear.

70 'The late Mr. Heath held No. 6 from Capt. King at £46.6.8 yearly and gave this ground for the Infirmary to be built on ...' according to the Town House Book, Aug.-Sept. 1853 (OL.5.3562); this building faced the river.

71 'Governors of Infirmary No. 1 pay the rent of this concern and give it free to Surgeon Wm. Heath as part of his yearly salary. Surgeon Heath does not occupy it but gives

it free to his brother & sister. It is in very bad repair' according to the Town House Book, Aug.-Sept. 1853 (OL.5.3562).

72 'Calico Murphy'.

73 'Lyons holds possession but does not live in it. there is some dispute about his right to it' according to the Town House Book, Aug.-Sept. 1853 (OL.5.3562).

74 'out office inside Ruin of Ho. only' according to the Town House Book, Aug.-Sept. 1853 (OL.5.3562).

75 This property was next to No. 26, adjoining Weavers' Square; its site is now part of the garden of the first house on *The Flags*.

76 The house later known as '*The Steps*'.

77 'old & house now mostly used as Storage' according to the Town House Book, Aug.-Sept. 1853 (OL.5.3562).

78 1851 Census statistics: houses 1; population 9.

79 Formerly the western approach to a ford over the river.

80 Formerly watchman for the bleach green (see No. 1 Dublin Road) according to the Turtle Ms.

81 'an extensive bakery also carried on' according to the Town House Book, Aug.-Sept. 1853 (OL.5.3562).

82 'It is now let to the subinspector of Police at £10-0. He is not to take possession of it unless it be [set?] in better repair' according to the Town House Book, Aug.-Sept. 1853 (OL.5.3562).

83 Later the police barracks.

84 In Griffith's *Valuation* Lot No. 2c of Stratfordlodge townland was an unoccupied small house. Though the original Valuation Office map has too many alterations to allow definite identification, it would appear that it was located here.

85 This is the only household in the area for which a full transcript of the 1851 Census return survives [NAI, Cen/S/32/133]; the other adults living with Francis Hendy were his wife Dora, mother Ellen, brother William, sister Martha, and a servant named James Coleman.

86 The location of this house is uncertain as it was not defined on the original Valuation Office map. It could have been on the Dublin Road.

87 Entrance possibly by lane through Tinoranhill North off road from Rampere to Tinoran.

88 Entrance on the road from the 'Five Crossroads' to Grangecon. St. Bernard's Well situated on this property.

89 1851 Census statistics for Mattymount townland: houses 1; population 9.

90 The exact location of Nos. 7-8, 13-21, 23 & 25 is uncertain as they are not defined on the original Valuation Office map.

91 Formerly a parochial school, according to the Parish House Book, Dec. 1843 (OL.5.2347).

92 Not separately entered in Griffith's *Valuation*.

93 Nos. 13 and 14a-f were grouped together high on the hill above the Sruhaun Road, on the boundary with Tuckmill Upper. Collectively they were referred to as Cunninghamstown. The houses had disappeared by 1901.

94 This house gone before publication of Griffith's *Valuation*.

95 This house included in 2a in Griffith's *Valuation*.

96 See Dublin Road.

97 'intended & once used as Workmens Cottages' according to the Parish House Book, Nov. 1852 (OL.5.2347).

98 Entrance possibly by lane through Tinoranhill North off road from Rampere to Tinoran.

99 Close to 'Cunninghamstown', see Sruhaun.

100 Alterations to the earliest Valuation Office Town Plan make it impossible to accurately place all houses, but it appears that Nos. 29-32 were behind Nos. 27, 28 & 33, while it is likely that Nos. 35, 36 & 38 were behind Nos. 34 & 37. Nos. 27-33 were the property of George Dunckley and Nos. 34-38 were the property of Mary Anne Sinnott.

101 It is not at all certain that Warburton lived here. However, he was living in Baltinglass in 1851 and this is the only gentleman's residence which appears to have changed hands in the period. In 1843 it was occupied by Captain Hugh Hawkshaw [Town House Book, June 1843 (OL.5.3563)] and in 1853 it was occupied by John Jones [Town House Book, Aug.-Sept. 1853 (OL.5.3562)], but Jones was still living in Newtownsaunders in 1851. Hawkshaw was Sub-Inspector of Police in Baltinglass up to 1843 or 1844. Warburton was Resident Magistrate in Baltinglass from about that time to 1852 or 1853. However, no evidence has been found to confirm that he lived in this house.

102 *The Times*, 17 June, 4, 9 & 10 July & 30 Aug. 1851.

103 NAI, LEC Rental Vol. 9 No. 6.

104 NAI, LEC Rental Vol. 32 No. 54.

105 *The Times*, 4 July 1851.

106 Geoffrey Marescaux de Saubruit, 'Aldborough – An Extinct Irish Earldom', *Journal of the Co. Kildare Arch. Soc.*, Vol. 16 (1977-8), pp. 22-23.

107 Edward P. O'Kelly, 'The Eccentric Earls of Aldborough', *Journal of the Co. Kildare Arch. Soc.*, Vol. 4, (1904), pp. 274-275.

108 The House Books for Baltinglass civil parish do not give very clear information on Lord Aldborough's house and out offices. However, it would appear that there was no balloon house in Dec. 1843 and that the mention of 'offices detached' in Nov. 1852 is a reference to it.

109 O'Kelly, op. cit., p. 274.

110 Registry of Deeds, 419/486/274815, 424/42/275546, 482/408/312265, 657/437/453021; summary of O'Brien's career prepared by Fergal Morrin who translated Benjamin Vicuna Mackenna's *El general O'Brien* (Santiago, 1902) and Pedro Pablo Figueroa's *Vida del General Don Juan O'Brien* (Santiago, 1904) on behalf of the West Wicklow Historical Society for a forthcoming publication.

111 Summary of O'Brien's career by Fergal Morrin; Mario Belgrano, *Repatriacion de los restos del general Juan O'Brien, Guerrero de la Independencia Sud Americana* (Buenos Aires, 1938).

112 Baltinglass R.C. Parish baptismal register, April 1872.

113 Registry of Deeds, 1845/1/232.

114 Ibid., 522/450/342850.

115 Ibid., 569/32/379754.

116 Sister Therese Morrissey, 'God's Acre – Burial-Ground, Chapel Hill, Baltinglass', *Journal of the West Wicklow Hist. Soc.*, No. 1 (1983-84), p. 46.

117 NAI, OL.5.3560 (Valuation Office House Book, Baltinglass Town).

118 OL.5.3562 (Valuation Office House Book, Baltinglass Town).

119 Registry of Deeds, 1845/1/232; 2 acres, 3 roods, 25 perches Irish plantation measure.

120 Ibid., 1846/15/148.

121 Jeremy Williams, *A Companion Guide to Architecture in Ireland 1837-1921* (Blackrock, Co. Dublin, 1994).

122 Kinsella Ms.

123 Brian M. Walker, *Parliamentary Election Results in Ireland, 1801-1922* (Dublin, 1978); Hume first contested a seat in the General Election in 1852 as a Conservative. He was elected then and held his seat until 1880. He changed his surname to Dick in 1864.

124 Oral tradition related by the late Tommy Doyle of the Lough.

125 National Library of Ireland, Ms. 19,452.

126 Williams, op. cit.

127 Sister Therese Morrissey, 'V. Rev. Dr. Denis Kane, P.P. V.G. (1822-1883)', *Journal of the West Wicklow Hist. Soc.*, No. 1 (1983-84), pp. 51-52.

128 Kinsella Ms.

129 Presentation Convent, George's Hill, Dublin, C56/1 (Baltinglass Convent Annals).

130 Morrissey, 'God's Acre ...', p. 46.

131 *Carlow Post*, 29 March 1873.

132 Presentation Convent, George's Hill, C56/1.

133 Information from Sister Mary O'Riordan, Brigidine Convent, Dartmouth Road, Dublin.

134 Registry of Deeds, 1851/16/41; 1852/18/105.

135 The purchase appears to have included all the east side of Weavers' Square except the properties designated Nos. 16-24 & 27-33 in the 1851 Street Directory in this book.

136 Nos. 23-26 of Chapel Hill in the 1851 Street Directory in this book; it appears that some of these were included in the purchase.

137 Nos. 27-33 of Weavers' Square in the 1851 Street Directory in this book.

138 Registry of Deeds, 1853/11/224; 1857/36/20.

139 Ibit., 1863/2/114.

140 Geoffrey Marescaux de Saubruit, 'Aldborough – An Extinct Irish Earldom', *Journal of the Co. Kildare Arch. Soc.*, Vol. 16 (1977-8), p. 24.

141 Edward P. O'Kelly, 'The Eccentric Earls of Aldborough', *Journal of the Co. Kildare Arch. Soc.*, Vol. 4, (1904), pp. 275-276.

142 Marescaux de Saubruit, op. cit., p. 25.

143 Baltinglass Parish Vestry Minute Book, 1808-1888.

144 Marescaux de Saubruit, op. cit., p. 22.

145 O'Kelly, op. cit., pp. 275-276.

146 George's Hill, C56/1.

147 *Kildare Observer*, 30 October 1880, pp. 2-3.

148 *Kildare Observer*, 23 October 1880, p. 2; 30 October 1880, pp. 2-3 (George O'Toole is erroneously referred to as Mr. J. O'Toole).

149 *Kildare Observer*, 30 October 1880, pp. 2-3.

150 Ibid.

151 Ibid.

152 Ibid.

153 O'Toole, *Whist for your life, that's treason: Recollections of a Long Life*, p. 37.

154 In the twentieth century, and probably back then, this property was known locally as 'The Hollow House'; its site is now (2006) partly absorbed into the SuperValu building and partly occupied by the widened street approach to the SuperValu car park.

155 O'Toole, op. cit., pp. 28-9, 34-6 (Doyle's Imperial Hotel was in Mill Street; the building is now (2006) Flemings'); *Nationalist and Leinster Times*, 10 August 1935, p. 2.

156 *Kildare Observer*, 30 October 1880, pp. 2-3.

157 *Kildare Observer*, 12 February 1881, p. 3; 26 February 1881, p. 3.

158 *Kildare Observer*, 19 February 1881, p. 3; *Carlow Independent*, 19 February 1881.

159 Ibid.

160 *Carlow Independent*, 26 March 1881, 23 April 1881, 30 April 1881, 8 October 1881; *Kildare Observer*, 15 October 1881, p 6.

161 *The Times*, 7 May 1881; 11 May 1881, p. 8; NAI, CSORP, 1881/13314, 13683, 14634, 14791, 15035, 15479, 15480, 15829 (Cope's house was in Main Street; the building was occupied in recent years by Flynns); *Kildare Observer*, 21 May 1881, p. 5.

162 *Carlow Independent*, 23 April 1881.

163 *Kildare Observer*, 27 August 1881, p. 5.

164 The area of Main Street in front of the Courthouse and around where the McAllister Monument is now situated.

165 *Kildare Observer*, 27 August 1881, p. 5.

166 *Burke's Landed Gentry of Ireland* (1958), pp 650-2, 'Herbert-Stepney (formerly Rawson) of Durrow Abbey and Abingdon Park'.

167 *The Times*, 8 September 1881, p. 6.

168 *Kildare Observer*, 27 August 1881, p. 5.

169 The double property then directly north of the junction with the Ballytore Road (now Station Road) recently occupied by Hartes. Rev. John Usher lived next door in the house now occupied by Murphys.

170 *Kildare Observer*, 3 September 1881, p. 5 *Kildare Observer*, 3 September 1881, p. 5; NAI, CSORP 1881/30718; *The Times*, 2 September 1881, p. 8.

171 NAI, CSORP 1881/29733.

172 NAI, CSORP 1881/30234 & 30718.

173 *Kildare Observer*, 8 October 1881, p. 7 (There were slight variations on the wording of the notice given in different sources).

174 *The Times*, 13 September 1881, p. 4; *Leinster Leader*, 17 September 1881.

175 NAI, CSORP 1881/42354.

176 *Kildare Observer*, 8 October 1881, p. 7; *The Times*, 1 October 1881, p. 10 (One report states that twelve were charged but only names eleven of them, while the other states that there were eleven charged).

177 Rickerby had two premises in Main Street at the time; one is now (2006) J. Burke's and the other is now Gorrys' All Things Natural. In the Valuation Office records by 1885 the former was in the name of Rickerby's John Geoghegan, who may have been managing the business there in 1881.

178 *The Times*, 28 September 1881, p. 7.

179 His shop was on the south side of Main Street; the premises was the vacant house next to Kinsella Estates, demolished in 2006.

180 *Kildare Observer*, 8 October 1881, p. 7.

181 Ibid.

182 His house in Main Street is still (2006) occupied by his great-granddaughter Kathleen Byrne.

183 His premises in Main Street was next door to Matt Byrne's, on the left hand side.

184 His house in Main Street is now (2006) occupied by Carmel's Hairdressers.

185 This is almost certainly Michael Byrne of Main Street, whose house is now (2006) Pattersons'.

186 Maher's house was in Main Street; the building was occupied in recent years by Dannes and now (2006) houses Frank Murphy's shop.

187 Lennon was most likely John or Michael Lennon. They lived next door to one another on the east side of Weavers' Square. There was no property in the town

occupied by anyone called Hunter at that time. Flinter was almost certainly one of the sons of Mary Flinter, the then owner of the family business in Main Street. Their premises is now (2006) absorbed into Quinns', being the part directly next to Kevin Carey's.

188 The site of her house in Mill Street is now (2006) occupied by Brennans.

189 *Kildare Observer*, 8 October 1881, p. 7.

190 *Carlow Independent*, 29 October 1881.

191 Information from his granddaughter, Mary Wade (née O'Kelly).

192 *Kildare Observer*, 15 October 1881, p. 6.

193 NAI, CSORP 1881/32485, 32882, 32983, 33733, 35434.

194 *The Times*, 24 January 1889, p. 6 (published in a report on the Parnell-Times Commission).

195 *The Times*, 8 October 1881, p. 7.

196 *The Times*, 3 October 1881, p. 6.

197 CSORP 1881/34071.

198 Presumably this was St. Kevin's in Church Lane, which Anderson owned at the time.

199 CSORP 1881/34909, 37882.

200 *The Times*, 13 October 1881, p. 6; 24 October 1881, p. 10; 28 October 1881, p. 4.

201 Beside the bridge; the building housed Gillespies' shop until recent years.

202 She was almost certainly from Belan Street, where there were two Doherty households.

203 *Kildare Observer*, 19 November 1881, p. 2; CSORP 1881/37383, 38882, 38970, 40157.

204 *Kildare Observer*, 28 January 1882, p. 2.

205 CSORP 1881/43676, 44828, 45722.

206 *Kildare Observer*, 5 November 1881, p. 5.

207 *Carlow Independent*, 19 November 1881; NAI, General Prison Board Prisons Index Register 1881/16919, 17018, 17143, 17144, 17432, 17454; CSORP, 1881/40396; *The Times*, 17 March 1882, p. 6.

208 *Kildare Observer*, 17 December 1881, p. 6; CSORP 1881/43676, 44828, 45722.

209 O'Toole: *Whist for your life, that's treason: Recollections of a Long Life*, p. 47.

210 *Freeman's Journal*, 7 December 1881; *The Times*, 7 December 1881; CSORP 1881/43676, 43867, 44828, 45722. The two sergeants (or constables) were Thomas McCabe and Samuel Moore.

211 A report in the *Leinster Leader*, 11 March 1882, of a branch meeting held on 5 March related that it was then 'more than twelve months since the formation of the branch'.

212 *Leinster Leader*, 16 July 1881, p. 7; CSORP 1881/33696.

213 The house in which she was born was on the site of the building which recently housed the offices of Millett & Matthews but is now (2006) owned by Horans. A plaque commemorating her was placed there in the early 1990s.

214 Marie O'Neill, *From Parnell to de Valera: A Biography of Jennie Wyse Power 1858-1941*. (Tallaght, 1991); *Leinster Leader*, 26 November 1881; *Kildare Observer*, 28 January 1882, p. 2.

215 O'Neill, op. cit.; *Oxford Dictionary of National Biography* (2004 edition).

216 *Leinster Leader*, 11 March 1882.

217 *Irish Times*, 29 May 1882; *Carlow Sentinel*, 3 June 1882; *Leinster Leader*, 3 June 1882.

218 Ibid.

219 *Irish Times*, 29 May 1882; *Leinster Leader*, 3 June 1882.

220 Ibid.

221 *Leinster Leader*, 11 March 1882; *Kildare Observer*, 11 March 1882, p. 4.

222 *Leinster Leader*, 13 May 1882.

223 Unless this is a misprint it was Friday 5 May, the night before Davitt's release.

224 O'Toole, *Whist for your life, that's treason: Recollections of a Long Life*, p. 52.

225 *Kildare Observer*, 13 May 1882, pp. 2, 5.

226 *Kildare Observer*, 29 July 1882, p. 4; 14 October 1882, p. 7.

227 Information from his granddaughter, Mary Wade (née O'Kelly).

228 Now (2006) part of Gillespies' yard.

229 *Kildare Observer*, 23 October 1880, p. 5.

230 *Daily Express*, 25 August 1882, p. 5; NAI, CSORP 1882/7142.

231 *Daily Express*, 25 August 1882, p. 5; *Kildare Observer*, 30 September 1882, p. 5.

232 *Daily Express*, 25 August 1882, p. 5.

233 Ibid.

234 Ibid.

235 Now (2006) the Dutchman's.

236 The entrance to the lane is now (2006) between McLoughlins' and Bradleys', the former cinema, and leads to an apartment block under construction.

237 *Kildare Observer*, 9 September 1882, p. 2.

238 Ibid.

239 Ibid.

240 Ibid.

241 Ibid.; *Leinster Leader*, 24 March 1883, p. 7.

242 *Kildare Observer*, 16 September 1882, p. 5; 23 September 1882, p. 2.

243 *Kildare Observer*, 24 September 1881, p. 3; 18 November 1882, p. 2; *Leinster Leader*, 24 March 1883, p. 7; NAI, CSORP 1883/14319, 14754.

244 NAI, CSORP 1883/3097; *Kildare Observer*, 18 November 1882, p. 2; 3 March 1883, p. 5; *Leinster Leader*, 24 March 1883; 14 April 1883; NAI, General Prison Board Correspondence Register 1883/2818, 2885.

245 *Kildare Observer*, 25 November 1882, p. 2; 27 October 1883, p. 2; *Leinster Leader*, 10 October 1885; 8 January 1887; 10 December 1887.

246 Tradition related by Donal McDonnell of Coolinarrig.

247 *Kildare Observer*, 24 February 1883, p. 5.

248 Now (2006) Gillespies'.

249 Now (2006) Bridge House.

250 Site now (2006) occupied by Slaney Mall.

251 *Parliamentary Papers, 1839, Vol. 7 (Appendix to the 17th Report [1838] of Inspectors-General of the Gaols of Ireland)*.

252 Kinsella Ms.; NAI, CSORP 1883/12527, 13450, 13767.

253 NAI, CSORP 1883/12527, 13450, 13767.

254 Information from Cedric Hendy.

255 Browner was the principal of Baltinglass Boys' National School.

256 Hanrahan lived in Weavers' Square.

257 *Leinster Leader*, 12 July 1884, p. 8.

258 *Leinster Leader*, 23 August 1884, stating that the match was on 17 August; *Nationalist and Leinster Times*, 23 August 1884, stating that the match was on 18 August.

259 *Kildare Observer*, 1 May 1886, p. 5.

260 *Leinster Leader*, 12 September 1885.

261 Burton was manager of the Munster Bank, Main Street.

262 Morrin was the owner of the mill.

263 Shanahan was a policeman in Baltinglass.

264 *Kildare Observer*, 19 September 1885, p.5.

265 *Kildare Observer*, 1 May 1886, p.5; 26 June 1886, p. 6.

266 *Kildare Observer*, 11 June 1887, p. 5; 18 June 1887, p. 5; *Leinster Leader*, 25 June 1887, p. 6; 9 July 1887, p. 3; 23 July 1887, p. 7; 6 August 1887, p. 7; 20 August 1887, p. 7.

267 *Leinster Leader*, 21 July 1888, p. 7; 28 July 1888, p. 7; 4 August 1888, p. 7; 18 August 1888, p. 7; *Nationalist and Leinster Times*, 6 July 1895.

268 Recorded in a list of E.I. Gray's personal performances, 1887-1903, in his scrapbook of *Kildare Observer* sports reports, in the author's possession; *Kildare Observer*, 22 July 1899.

269 E.I. Gray's *Kildare Observer* scrapbook; *Nationalist and Leinster Times*, 10 September 1904.

270 E.I. Gray's *Kildare Observer* scrapbook.

271 Kenna was a doctor, Matt Byrne was the well-known GAA figure, Ned O'Kelly was E.P. O'Kelly's son, Kennedy and Corcoran were on the staff of the National Bank, and Andy Doyle was from the 'Commercial Hotel' family.

272 *Nationalist and Leinster Times*, 29 April 1911.

273 *Nationalist and Leinster Times*, 9 June 1923, p. 5; 7 July 1923, p. 3.

274 Claude Chavasse, *The Story of Baltinglass* (Kilkenny, 1970), p. 30.

275 A list of pew owners in 1813 in the Baltinglass Parish Vestry Minute Book refers to 20 pews on the ground floor and 14 in the gallery, with no mention of transepts; the door was on the north side.

276 Baltinglass Parish Vestry Minute Book, 1808-1888.

277 Vestry Minute Book.

278 National Archives, OL.5.2347 (Valuation Office House Book, Baltinglass Parish).

279 Representative Church Body Library, Bishop's Visitation Book, Leighlin diocese, 1851.

280 Vestry Minute Book.

281 Once the Abbot's residence, but then a farm building; the present day Rectory was later built on its site.

282 Vestry Minute Book.

283 Vestry Minute Book; Registry of Deeds, 1882/14/26; 1882/17/50; 1883/53/127.

284 *Irish Builder*, 13 June 1883; Vestry Minute Book.

285 Lord Walter FitzGerald, 'Baltinglass Abbey, Its Possessions, and Their Post-Reformation Proprietors', *Journal of the Co. Kildare Arch. Soc.*, Vol. 5, (1908), p. 407; National Archives, OL. 5.2347.

286 FitzGerald, op. cit., p. 407. At the time (1908) the cannon ball and the seal were in the possession of Ralph Dagg of Holdenstown Lodge.

287 *Irish Builder*, 1 November 1883.

288 Turtle Ms.

289 *Carlow Sentinel*, 23 August 1884.

290 Chavasse, op. cit., p. 43.

291 Vestry Minute Book.

292 *Kildare Observer*, 6 December 1884, p. 3.

293 Thomas J. O'Brien (ed.), *County Carlow Football Club – Rugby History 1873-1977*, p. 29.

294 *Kildare Observer*, 22 November 1884, p. 5.

295 *Kildare Observer*, 6 December 1884, p. 3; 17 January 1885, p. 5.

296 *Leinster Leader*, 14 February 1885; *Kildare Observer*, 21 February 1885, p. 6; 21 November 1885, p. 4.

297 *Kildare Observer*, 1 May 1886, p. 5, 15 May 1886, p. 5.

298 *Kildare Observer*, 23 January 1886, p. 6.

299 T.F. O'Sullivan: *The Story of the G.A.A.*, p 35.

300 *Nationalist and Leinster Times*, 10 Jan. 1925.

301 *Nationalist and Leinster Times*, 9 April 1927; 16 April 1927; 23 April 1927; 30 April 1927; 14 May 1927; 4 January 1941.

302 Tony & Annie Sweeney, *The Sweeney Guide to the Irish Turf from 1501 to 2001* (Dublin, 2002).

303 O'Kelly, 'The Eccentric Earls of Aldborough', *Journal of the Co. Kildare Arch. Soc.*, Vol. 4.

304 Turtle Ms.

305 299 This field is now (2006) occupied by a small estate of houses called Deerpark View.

306 Information from Cedric Hendy.

307 Information from Cedric Hendy.

308 *Carlow Nationalist and Leinster Times*, 21 March 1885; *The Irish Sportsman*, 21 March 1885.

309 *Kildare Observer*, 21 February 1885.

310 *Nationalist and Leinster Times*, 21 March 1885; *The Irish Sportsman*, 21 March 1885.

311 *The Irish Sportsman*, 21 March 1885; *The Racing Calendar*, 1885.

312 *The Irish Sportsman*, 14 February, 14 March & 21 March 1885; *Nationalist and Leinster Times*, 21 March 1885; *Carlow Sentinel*, 21 March 1885; *The Racing Calendar*, 1885.

313 *Kildare Observer*, 2 Oct. 1886, p5.

314 *Kildare Observer*, 2 Oct. 1886, p5; *The Irish Sportsman*, 16 October 1886.

315 *Kildare Observer*, 5 September 1885.

316 *The Times*, 29 April 1871.

317 *Irish Builder*, 15 June 1885; Cora Crampton, 'The Tullow Line', *Journal of the West Wicklow Hist. Soc.*, No. 1, p. 8; Stephen Johnson: *Johnson's Atlas & Gazetteer of the Railways of Ireland*.

318 O'Kelly, 'Historical Notes on Baltinglass in Modern Times', *Journal of the Co. Kildare Arch. Soc.*, Vol. 5, p. 336.

319 In the results section of the report referred to as F.J. Meade and F.J. Reade.

320 Almost certainly Thomas C. Cooke of Main Street.

321 *Kildare Observer*, 12 September 1885; *Leinster Leader*, 12 September 1885.

322 Edward O'Toole: *Whist for your life, that's treason: Recollections of a Long Life*, p 90.

323 C.M. Byrne & P.J. Noonan, *50 Years of the G.A.A. in Co. Wicklow* (Wicklow, 1935), p. 38; *Nationalist and Leinster Times*, 1 January 1938, p. 2; T.F. O'Sullivan, *The Story of the G.A.A.* (Dublin, 1916), p. 29; Jim Brophy: *The Leathers Echo*, p 8.

324 Byrne & Noonan, op. cit., p. 38; Brophy, op. cit., p 16; *Leinster Leader*, 10 December 1887, p. 5.

325 *Leinster Leader*, 21 January 1888, p. 5.

326 *Leinster Leader*, 4 February 1988, p. 5; 11 February 1888, p. 7.

327 *Leinster Leader*, 18 February 1888, p. 4.

328 *Leinster Leader*, 17 March 1888, p. 7; 24 March 1888, p. 7.

329 *Nationalist and Leinster Times*, 26 February 1938, p. 6.

330 *Leinster Leader*, 21 April 1888, p. 7; 12 May 1888, p. 7.

331 *Leinster Leader*, 26 May 1888, p. 6; 2 June 1888, p. 6; 16 June 1888, p. 7; 28 July 1888, p. 7; *Nationalist and Leinster Times*, 28 July 1888, p. 2.

332 Byrne & Noonan, op. cit., p. 39; Brophy, op. cit., pp. 20, 93, 266; *Nationalist and Leinster Times*, 24 March 1934; 21 December 1940, p. 7.

333 *Leinster Leader*, 25 January 1890, p.6.

334 *Sport*, 12 July 1890, p. 7.

335 Brophy, op. cit., pp. 20, 93.

336 Ibid., pp. 24, 93; Byrne & Noonan, op. cit., p. 39.

337 *Nationalist and Leinster Times*, 11 January 1902; 15 January 1902; January-December 1904.

338 Martin Brenan, *Schools of Kildare and Leighlin, 1775-1835* (Dublin 1935), pp. 410-415.

339 Ibid.

340 Mihail Dafydd Evans, 'Byways', *Irish Roots*, 1993, No. 1.

341 NAI, ED 2/168, Baltinglass Male and Female Schools; ED 9/8433, *Report of Educational Endowments (Ireland) Commission, Scheme No. 190 Stratford Lodge School, Baltinglass*, public sitting 20 Oct. 1893, reply by Peter Douglas.

342 ED 9/8433, in evidence given in 1889 ... 'One witness, a Roman Catholic ...'

343 ED 9/8433.

344 ED 9/8433, evidence of Peter Douglas and George Leonard.

345 NAI, T.2934 & T.6488, transcripts of Lady Elizabeth Stratford's will.

346 NAI, Calendar of Wills and Admons., 1877; ED 9/8433.

347 ED 9/8433.

348 ED 9/6187; ED 9/8433.

349 ED 9/6187; ED 9/8433.

350 ED9/8433, letter dated 26 June 1894 from Capt. Meade J.C. Dennis to the Board of National Education stating that 'the original plans by Mr. Smith O'Brien (sic) had already been approved ...'

351 ED 9/6187.

352 ED 9/8433.

353 Ibid.

354 Ibid.

355 Ibid.

356 ED 9/8433; ED 9/10612.

357 ED2/168, No. 11888, Vol. 3, p. 26A; information from June Snell.

358 *Leinster Leader*, 15 January 1898, p. 5; *Kildare Observer*, 28 January 1899, p. 5; information from June Snell.

359 *Nationalist and Leinster Times*, 6 April 1895.

360 Walker, *Parliamentary Election Results in Ireland, 1801-1922*.

361 *The Times*, 17 April 1895, p. 7.

362 *The Times*, 11 April 1895.

363 *Nationalist and Leinster Times*, 4 May 1895.

364 Ibid.

365 Ibid.

366 George's Hill, C56/1.

367 NAI, OL.5.3560.

368 NAI, ED2/168/971, 972.

369 ED2/168/971.

370 Its site is now occupied by Fatima Hall.

371 ED2/168/972.

372 ED2/168/971.

373 *Leinster Leader*, 17 December 1898.

374 George's Hill, C56/2; information from Phyllis Flanagan.

375 ED2/168/11180.

376 *Leinster Leader*, 8 April 1899.

377 Brian Donnelly, *For the Betterment of the People – A History of Wicklow County Council* (Wicklow, 1999).

378 Ibid.

379 *Kildare Observer*, 4 March 1899; *Nationalist and Leinster Times*, 4 March 1899.

380 *Leinster Leader*, 8 April 1899.

381 *Leinster Leader*, 8 April 1899.

382 *Leinster Leader*, 22 April 1899.

383 *Kildare Observer*, 22 April 1899.

384 *Leinster Leader*, 22 April 1899.

385 *Kildare Observer*, 10 June 1899.

386 *Kildare Observer*, 10 June 1899.

387 *Nationalist and Leinster Times*, 10 May 1902.

388 *Kildare Observer*, 5 Jan. 1901.

389 *Nationalist and Leinster Times*, 7 June 1902.

390 Donnelly, op. cit.

391 *Kildare Observer*, 11 March 1899.

392 *Leinster Leader*, 5 May 1900, p. 8.

393 *Nationalist and Leinster Times*, 28 April 1900.

394 *Leinster Leader*, 5 May 1900, p. 8.

395 *Leinster Leader*, 5 May 1900, p. 8.

396 *Kildare Observer*, 18 May 1901.

397 *Leinster Leader*, 5 May 1900.

398 This would have been Friday 4 November, rather than Friday 11 November.

399 O'Kelly, 'Historical Notes on Baltinglass in Modern Times', *Journal of the Co. Kildare Arch. Soc.*, Vol. 5, p. 336.

400 NAI, ED 9/6187.

401 *Leinster Leader*, 29 April 1899, p. 4; 3 June 1899, p. 5; *Kildare Observer*, 20 May 1899, p. 4.

402 *Leinster Leader*, 10 March 1900, p. 5; 17 March 1900, p. 5; 26 May 1900, p. 5.

403 *Leinster Leader*, 26 May 1900, p. 5.

404 *Leinster Leader*, 27 October 1900, p. 5.

405 *Nationalist and Leinster Times*, 26 February 1916; 27 April 1929; various other editions 1903-1916; *Leinster Leader*, 18 January 1919, p. 2.

406 *Nationalist and Leinster Times*, 26 November 1904; 10 December 1904; 10 January 1914; 21 February 1914; 8 July 1916; 13 January 1917; *Leinster Leader*, 16 December 1916, p. 5.

407 *Leinster Leader*, 10 November 1917, p. 2; 16 November 1918, p. 3; 8 November 1919, p. 2; 22 November 1919, p. 3.

408 *Nationalist and Leinster Times*, 17 April 1920, p. 2; 16 October 1920, p. 5; 23 October 1920, p. 4; 9 June 1923, p. 5; 28 July 1923, p. 8; 27 May 1933, p. 10; *Leinster Leader*, 24 April 1920, p. 2; Registry of Deeds, 1926/3/86.

409 *Nationalist and Leinster Times*, 4 January 1936, p. 3; various editions 1937-1942.

410 *Leinster Leader*, 9 September 1899, p. 5; *Leinster Leader*, 16 September 1899, p. 7.

411 *Leinster Leader*, 10 February 1900, p. 6.

412 *Leinster Leader*, 24 February 1900, p. 8; *Leinster Leader*, 17 March 1900.

413 *Leinster Leader*, 8 September 1900; *Nationalist and Leinster Times*, 17 November 1900; *Leinster Leader*, 24 November 1900, p. 7; George's Hill, C56/1.

414 *Leinster Leader*, 1 December 1900, p. 2; *Kildare Observer*, 11 May 1901.

415 *Leinster Leader*, 23 February 1901; Sister Francis was mentioned in the newspaper as sent from Wexford but she did not appear in the 1901 Census, while Sister Joseph did.

416 *Leinster Leader*, 16 November 1918, p. 2.

417 *Leinster Leader*, 13 September 1919, p. 3; *Kildare Observer*, 13 September 1919, p. 4.

418 C56/1; *Leinster Leader*, 22 May 1920, p. 2; 31 July 1920, p. 5.

419 *Leinster Leader*, 20 January 1900, p. 5.

420 Lindsay's service record provided by his grandson Christy Alcock.

421 *Leinster Leader*, 19 January 1901, p. 3.

422 *Nationalist and Leinster Times*, 26 January 1901, p.3.

423 *Leinster Leader*, 2 February 1901, pp. 3, 6.

424 William McLoughlin died in March 1901 and Pierce O'Mahony of Grangecon House was co-opted in his place.

425 'Bess Lusk who lived in Cuckoo Lane was a maid in Aldborough Castle (sic) in her youth' according to the Turtle Ms.

426 This appears to be where Peter Crowe lived, though the Valuation Office revisions list the occupier as Mary Brennan from 1901, and the house appears to have been demolished by the 1902 revision.

427 Known as 'Tippy Toes Clancy' on account of his agility as an Irish step dancer according to the Turtle Ms.

428 Entrance by Cars' Lane.

429 This house was not returned in the 1901 Census. The Valuation Office revisions list the occupier as Michael Butler till 1901, and Elizabeth Byrne thereafter.

430 This house was not returned in the 1901 Census. The Valuation Office revisions list it as the Convent School up to 1903 (though it had ceased to be used as such in the 1890s) and then simply as a house. From 1910 it is again listed as a school house, but at that point it was in use as the Technical School.

431 Not present for 1901 Census.

432 While Daniel Brennan was listed here in the Valuation Office revisions, he may have been living in No. 32 Weavers' Square in 1901, as his 1901 Census form was listed between those of Johanna Byrne and Patrick Kehoe.

433 Not present for 1901 Census.
 Uncertain whether No. 3 was before or after No. 4.

434 Eliza's husband, Joseph Lindsay, was not present for the 1901 Census as he was a soldier fighting in the Boer War.

435 Site of Baltinglass Castle.

436 It is not certain that the meetinghouse was in this location as early as 1901 but it was here by 1911; this building may have housed the Dispensary in 1901.

437 The Dispensary was in some part of the buildings of St. Kevin's by at least 1907 and was most likely there in 1901; its exact location has not been determined and it may have shared low building which was certainly used as the meetinghouse by 1911.

438 The upper half of this road was the western portion of Ballytore Road in 1851; the two portions of that road were separated when the railway was built. The lower half of

this road was constructed at that time to link the truncated old Ballytore (or 'County') Road to Belan Street. It was sometimes referred to as the New Road or the Link Road.

439 House in Stratfordlodge townland.

440 Margaret's husband, Charles Doogan, was a soldier and, as he was not present for the 1901 Census, he may have been fighting in the Boer War.

441 Formerly a police station.

442 Old toll house.

443 Same premises as Robert Long's in 1851.

444 Same premises as Ellen Nolan's in 1851.

445 Not present for 1901 Census.

446 Not listed here in 1901 Census; may not have been living in this house then, as he was only listed for it in the Valuation Office from 1900 to 1901.

447 Not present for 1901 Census.

448 Same premises as George Dunckley's in 1851.

449 The location of this house is uncertain. It could have been further up Tinoran Hill.

450 The 'Bed Road', running between Rathtoole Bridge and Lowtown, is so called because a large stone referred to as St. Laurence's Bed once lay by the roadside.

451 Railway cottage.

452 Not present for 1901 Census.

453 Not listed here in 1901 Census; the house may not have been occupied at the time, as Anna & John were shown in the Valuation Office revisions as replacing Matthew Davis here in 1901.

454 Same premises as James Murphy's in 1851.

455 Same premises as William Murphy's in 1851.

456 Same premises as Edward Toole's in 1851.

457 Same premises as Thomas Nolan's in 1851.

458 Same premises as Rose Lawler's in 1851.

459 Same premises as James Fegan's in 1851.

460 In the Valuation Office revisions this house was stated as occupied in 1901 by lodgers. Bridget Lyttleton almost certainly lived here at the time of the 1901 Census. Her grandchildren, the Griffins, were living in this house at the time of the 1911 Census.

461 John W. Maher was listed here in the Valuation Office revisions for this period, but evidently this is where the Bayles lived at the time of the 1901 Census.

462 Same premises as Michael Walsh's in 1851.

463 Died in March 1901.

464 Erroneously entered as John Percival in 1901 Census.

465 As indicated on Aldborough estate sale documents dated June 1901.

466 The Cartys may have been living elsewhere in the eastern half of the town at the time of the 1901 Census. In the Valuation Office revisions Patrick Hayden was replaced here as occupier in 1901 by John Carty.

467 Same premises as James Rawson's in 1851.

468 Same premises as Daniel Mackey's in 1851.

469 Same premises as Michael Ennis's in 1851.

470 Same premises as Edward Kitson's in 1851.

471 Same premises as Michael Hayden's in 1851.

472 It is not certain that Moynihans were living here, but they were somewhere in Baltinglass West and most likely in Mill Street. The property was listed in the Valuation Office for Thomas Daly at the time, and as vacant from the 1902 revision.

473 Same premises as Robert Parke's in 1851.

474 The property was listed in the Valuation Office for John Brennan at the time, and for John Hourihane from 1902. As there was no return for the house in the 1901 Census, the business may not have been in operation at the time.

475 Same premises as Thomas Neill's in 1851.

476 Railway cottage.

477 Entrance on the road from the 'Five Crossroads' to Grangecon. St. Bernard's Well situated on this property.

478 Entrance may have been on the road from the 'Five Crossroads' to Grangecon or on the Hartstown Road.

479 This household not recorded in 1901 Census.

480 This house had been occupied by James Doody, who was in Edward Street in 1901. By 1903 he was occupying a house built close to it by the Baltinglass Poor Law Guardians.

481 Not listed here in 1901 Census; Julia Reilly was in the Valuation Office records as occupier up to 1906.

482 Not present for 1901 Census.

483 This building may have been in use at the time as a laundry. It was certainly used as such in later years. It was the building noted in 1851 as formerly a school.

484 Not present for 1901 Census.

485 Not separately entered in Valuation Office records.

486 The Valuation Office revisions list the occupier as Michael Byrne till 1902, after which the house is listed as vacant till 1903, when George Glynn was occupier.

487 This was the eastern portion of Ballytore Road in 1851; the two portions of the road were separated when the railway was built.

488 This property was listed in the Valuation Office records as an out office owned by Joseph Dunne. It is uncertain whether Farrells lived here but they were recorded for Tinoranhill North in the 1901 Census.

489 Entrance possibly by lane through Tinoranhill North off Hartstown Road.

490 Same premises as Anthony Wilson's in 1851.

491 Same premises as Laurence Farrell's in 1851. Elizabeth Brien was formerly Mrs. Timmins.

492 The Valuation Office revisions list the occupier as John Kenny till 1903, after which the house is listed as demolished. The house was not returned in the 1901 Census.

493 This appears to be where Catherine Lennon lived, though she herself was not present for the 1901 Census. The Valuation Office revisions list the occupier as Michael Cleary till 1902, after which the house is listed as vacant.

494 James Humphrey was the last driver of the LaTouche coach from Dublin to Baltinglass, according to the Turtle Ms.

495 This appears to be where Edward Byrne lived. The Valuation Office revisions list the occupier as John Byrne.

496 Not present for 1901 Census.

497 Not listed here in 1901 Census; Judith Murphy was in the Valuation Office records as occupier up to 1906.

498 This house was not returned in the 1901 Census. The Valuation Office revisions list the occupier as Margaret Coates till 1902, after which the house is listed as vacant.

499 Not listed here in 1901 Census; Mary Whelan was in the Valuation Office records as occupier up to 1908.

500 Charles Dickson, *The Life of Michael Dwyer* (Dublin, 1944), p. 305.

501 Ruán O'Donnell, *The Rebellion in Wicklow 1798* (Dublin, 1998), p. 288.

502 Ruán O'Donnell, *Aftermath post-Rebellion insurgency in Wicklow, 1799-1803* (Dublin, 2000), pp. 36-7; Dickson, op. cit.

503 O'Donnell, *Aftermath*, p. 37; Dickson, op. cit.

504 Dickson, op. cit., p. 305.

505 O'Donnell, *Rebellion*.

506 Bourne, *A Guide to Stratford on Slaney – History and Folklore 1780-1974*.

507 *A History of Congregations in the Presbyterian Church in Ireland 1610-1982*; Abbey Presbyterian (Mary's Abbey) church register.

508 O'Donnell, *Rebellion*, p 66.

509 *Nationalist and Leinster Times*, 14 January 1911.

510 Information from Donal McDonnell of Coolinarrig and the late Frank Glynn, National Teacher. Mr. Glynn's information may have come from the late Tom Doran, local historian, who in 1939 showed Dickson the sites of some of the incidents of 8 December 1798. Mr. Glynn's recollection of the cause of Dwyer's unpopularity is that he killed a lad he suspected of spying and that the incident took place on the side of Baltinglass Hill.

511 O'Donnell states that they killed father and son, while Dickson only refers to the killing of the father.

512 O'Donnell, *Aftermath*, p. 24; Dickson, op. cit., pp 96-98.

513 *Leinster Leader*, 2 April 1898, p. 5.

514 *Nationalist and Leinster Times*, 24 May 1902; this was the house later known as Mackey Byrne's.

515 *Nationalist and Leinster Times*, 11 January 1902; 15 February 1902.

516 *Nationalist and Leinster Times*, 17 May 1902.

517 *Nationalist and Leinster Times*, 24 May 1902.

518 *Nationalist and Leinster Times*, 24 May 1902.

519 *Nationalist and Leinster Times*, 21 June 1902.

520 *Nationalist and Leinster Times*, 21 June 1902.

521 *Nationalist and Leinster Times*, 17 May 1902; 21 June 1902.

522 *Nationalist and Leinster Times*, 21 June 1902.

523 *Nationalist and Leinster Times*, 26 July 1902.

524 *Nationalist and Leinster Times*, 26 December 1903; 14 May 1904.

525 *Nationalist and Leinster Times*, 2 April 1904.

526 *Nationalist and Leinster Times*, 16 April 1904.

527 *Nationalist and Leinster Times*, 30 April 1904.

528 *Nationalist and Leinster Times*, 7 May 1904.

529 *Nationalist and Leinster Times*, 14 May 1904.

530 Ibid.

531 Ibid.

532 *Nationalist and Leinster Times*, 14 May 1904; additional information added by author on identifiable members.

533 *Nationalist and Leinster Times*, 24 May 1902; additional information added by author on identifiable members.

534 *Nationalist and Leinster Times*, 16 July 1904.

535 *Nationalist and Leinster Times*, 20 August 1904.

536 *Nationalist and Leinster Times*, 5 November 1904.

537 The 'Leinster House', formerly owned by T.B. Doyle and now (2006) partly occupied by Kevin Carey's pharmacy.

538 *Nationalist and Leinster Times*, 7 & 14 January & 4 March 1911.

539 *Nationalist and Leinster Times*, 25 February & 15 April 1911.

540 *Nationalist and Leinster Times*, 11 July 1914.

541 Donnelly, *For the Betterment of the People – A History of Wicklow County Council*, pp 26-27.

542 *Leinster Leader*, 8 September 1900.

543 Donnelly, op. cit., p 27.

544 *Nationalist and Leinster Times*, 13 May 1911.

545 *Nationalist and Leinster Times*, 9 January 1904; 16 January 1904.

546 *Nationalist and Leinster Times*, 13 February 1904.

547 *Nationalist and Leinster Times*, 26 March 1904.

548 *Leinster Leader*, 23 July 1904, p. 5; *Nationalist and Leinster Times*, 23 July 1904.

549 *Leinster Leader*, 22 January 1910, p. 5.

550 *Nationalist and Leinster Times*, 29 April & 13 May 1911.

551 *Leinster Leader*, 22 January 1910, p. 5.

552 *Nationalist and Leinster Times*, 26 February 1910.

553 *Nationalist and Leinster Times*, 29 April 1911.

554 *Nationalist and Leinster Times*, 13 May 1911.

555 *Nationalist and Leinster Times*, 5 September 1914.

556 *Nationalist and Leinster Times*, 23 September 1916.

557 *Nationalist and Leinster Times*, 2 December 1916.

558 *Leinster Leader*, 22 January & 19 March 1910.

559 *Leinster Leader*, 19 March 1910.

560 *Nationalist and Leinster Times*, 26 March 1910.

561 *Nationalist and Leinster Times*, 2 April 1910; *Wicklow People*, 2 April 1910.

562 *Wicklow People*, 2 April 1910.

563 *The Times*, 23 October 1911, p. 7.

564 Not of the Dan Kehoe family; he lived on the east side of the Square.

565 The *Leinster Leader* and *Nationalist and Leinster Times* accounts concur on the team's membership.

566 *Leinster Leader*, 1 February 1913, p. 8.

567 Ibid.

568 *Nationalist and Leinster Times*, 1 February 1913.

569 *Leinster Leader*, 1 February 1913, p. 8; *Nationalist and Leinster Times*, 1 February 1913.

570 Newly arrived chemist in Gorrys' Medical Hall.

571 *Nationalist and Leinster Times*, 29 April 1911; 6 May 1911; 7 February 1914.

572 Byrne & Noonan, *50 Years of the G.A.A. in Co. Wicklow*, p. 61; Brophy: *The Leathers Echo*, p 32; Loakeman was born in Co. Kildare and was a railway worker then in his early twenties.

573 *Nationalist and Leinster Times*, 7 February 1914; 20 February 1915; 15 May 1915; *Leinster Leader*, 5 May 1917, p. 2; 23 November 1918, p. 3.

574 *Leinster Leader*, 3 May 1919, p. 2; 26 July 1919, p. 2; 22 May 1920, p. 2; *Nationalist and Leinster Times*, 3 December 1921, p. 5; 1 October 1921, p. 7; 10 December 1921, p. 5; Brophy, op. cit., p. 94; Byrne & Noonan, op. cit., p. 68.

575 *Nationalist and Leinster Times*, 17 June 1922, p. 5; 23 September 1922, p. 4; 12 May 1923, p. 4; 23 June 1923, p. 3.

576 *Nationalist and Leinster Times*, 30 May 1914.

577 *Nationalist and Leinster Times*, 6 June 1914.

578 *Nationalist and Leinster Times*, 20 June 1914.

579 *Nationalist and Leinster Times*, 4 July 1914; 11 July 1914; 18 July 1914; 8 August 1914; *Leinster Leader*, 1 August 1914, p. 5.

580 *Nationalist and Leinster Times*, 3 October 1914; 10 October 1914.

581 *Nationalist and Leinster Times*, 17 October 1914; 14 November 1914; 5 December 1914; 12 December 1914.

582 *Nationalist and Leinster Times*, 13 March 1915; 27 March 1915; 3 April 1915.

583 *Nationalist and Leinster Times*, 31 July 1915; 16 October 1915; 23 October 1915.

584 *Nationalist and Leinster Times*, 23 October 1915.

585 *Leinster Leader*, 20 November 1915, p. 5; 18 August 1917, p. 2.

586 The premises now (2006) occupied by Kevin Carey.

587 *Nationalist and Leinster Times*, 1 August 1914, p. 7.

588 Ibid.

589 Ibid.

590 *Nationalist and Leinster Times*, 3 October 1914; 17 October 1914; 7 November 1914; 10 July 1915; 25 September 1915.

591 *Nationalist and Leinster Times*, 5 September 1914.

592 *Nationalist and Leinster Times*, 24 December 1904, p. 6.

593 *Nationalist and Leinster Times*, 29 April 1916; 20 May 1916; *Leinster Leader*, 6 May 1916, p. 4.

594 *Leinster Leader*, 13 May 1916, p. 5.

595 *Nationalist and Leinster Times*, 29 April 1916; 20 May 1916.

596 *Leinster Leader*, 6 May 1916, p. 4; 20 May 1916, p. 5; 17 June 1916, p. 5; *Nationalist and Leinster Times*, 27 May 1916.

597 *Leinster Leader*, 5 May 1917, p. 2; 12 May 1917, p. 2; 14 July 1917, p. 2.

598 *Nationalist and Leinster Times*, 12 August 1916; 2 September 1916; 16 September 1916; 7 October 1916; 4 November 1916; *Leinster Leader*, 6 January 1917, p. 5; 31 March 1917, p. 5; 21 April 1917, p. 5; 29 December 1917, pp. 2 & 3.

599 *Leinster Leader*, 18 August 1917, p. 2; 1 September 1917, p. 2.

600 *Leinster Leader*, 23 February 1918, p. 2; 2 March 1918, p. 2; 9 March 1918, p. 2.

601 *Nationalist and Leinster Times*, 24 July 1915.

602 *Nationalist and Leinster Times*, 29 August 1914; 3 October 1914; 17 October 1914; 14 November 1914; 19 December 1914.

603 *Nationalist and Leinster Times*, 31 October 1914; 7 November 1914; 14 November 1914; 5 December 1914.

604 *Leinster Leader*, 12 December 1914, p. 5.

605 *Leinster Leader*, 17 June 1916, p. 5.

606 *Leinster Leader*, 7 October 1916, p. 5; 24 March 1917, p. 5; 12 May 1917, p. 2; 30 June 1917, p. 2.

607 *Nationalist and Leinster Times*, 29 August 1914; 27 March 1915; *Leinster Leader*, 20 March 1915, p. 5; 20 November 1915, p. 5; 4 December 1915, p. 5; 8 April 1916, p. 5.

608 *Leinster Leader*, 8 April 1916, p. 5.

609 *Nationalist and Leinster Times*, 10 April 1915.

610 *Leinster Leader*, 27 January 1917, p. 5.

611 *Leinster Leader*, 21 August 1915, p. 5.

612 *Leinster Leader*, 28 September 1918, p. 2.

613 *Wicklow People*, 27 April 1918.

614 *Nationalist and Leinster Times*, 1 January 1916; 12 February 1916; 2 April 1927; 5 November 1927; 3 November 1928; *Leinster Leader*, 22 February 1919, p. 5.

615 *Nationalist and Leinster Times*, 19 November 1927; 17 November 1928; 4 January 1930; 10 January, 1931; 14 Jan. 1939, p. 9.

616 Main sources of information are the Commonwealth War Graves Commission database and the *Soldiers Died in the Great War* CD-ROM by the Naval & Military Press Ltd.; other information from *Ireland's Memorial Records 1914-1918*, published by the Irish National War Memorial, memorial inscriptions in the Baltinglass area, 1901 and 1911 Census returns and parish registers; additional information supplied by Canon McCullagh, Tommy Malone, Dorothy Stephenson and Willie Sutton.

617 *Leinster Leader*, 17 April 1920, p. 3.

618 8 August according to the *Soldiers Died in the Great War* CD-ROM.

619 *The Times*, 3 June 1918, p. 5; 24 June 1918, p.8; 9 July 1918, p. 3.

620 *Leinster Leader*, 26 October 1918, p. 2.

621 *Leinster Leader*, 9 November 1918, p. 2.

622 *Leinster Leader*, 16 November 1918, p. 2; 23 November 1918, p. 3; 30 November 1918, p. 3.

623 Superintendent Registrar's Office, Wicklow, Register of Deaths, Baltinglass Registrar's District, 1918-1919.

624 *Kildare Observer*, 2 November 1918, p. 3; *Leinster Leader*, 16 November 1918, pp. 2 & 3; 23 November 1918, p. 3; 30 November 1918, p. suppl.; 4 January 1919, p. 2; *Nationalist and Leinster Times*, 16 February 1929.

625 *Leinster Leader*, 23 November 1918, p. 2.

626 Superintendent Registrar's Office, Wicklow, Register of Deaths, Baltinglass Registrar's District, 1918-1919; *Leinster Leader*, 1 March 1919, p. 2; 15 March 1919, p. 2; 29 March 1919, p. 2; 5 April 1919, p. 2.

627 *Nationalist and Leinster Times*, 8 January 1921, p. 5.

628 *Leinster Leader*, 11 January 1919, p. 3.

629 *Leinster Leader*, 30 November 1918, p. 2.

630 *Leinster Leader*, 30 November 1918, p. 3.

631 *Leinster Leader*, 4 January 1919, p. 2; NAI, Pris1/43/12, 1918/904 & 1919/16 & 17; Pris1/55/30 p. 69; information from Kathleen Wall.

632 Letter dated 31 October 1918 from Joe Wall to his sister, in the possession of Kathleen Wall.

633 *Leinster Leader*, 23 November 1918, p. 2; 4 January 1919, p. 3; *The Times*, 2 January 1919, p. 2; *Kildare Observer*, 4 January 1919, p. 3.

634 Joe Wall's letter; *Leinster Leader*, 23 November 1918, p. 2; 4 January 1919, p. 3; *The Times*, 2 January 1919, p. 2; *Kildare Observer*, 4 January 1919, p. 3; NAI, Pris1/43/12, 1918/904 & 1919/16 & 17.

635 *Leinster Leader*, 11 January 1919, p. 3; 25 January 1919, p. 5; *Kildare Observer*, 25 January 1919, p. 3.

636 *Kildare Observer*, 18 January 1919, p. 4; 2 August 1919, p. 5; *Leinster Leader*, 8 March 1919, p. 2; 2 August 1919, p. 2; 23 August 1919, p. 2.

637 Information from Kathleen Wall, sister-in-law of the Kathleen Wall referred to.

638 *Leinster Leader*, 28 July 1917, p. 2; *Leinster Leader*, 4 August 1917, pp. 2 & 3.

639 *Leinster Leader*, 22 February 1919, p. 5.

640 *Leinster Leader*, 11 October 1919, p. 2.

641 *Leinster Leader*, 25 October 1919, p. 2; *Leinster Leader*, 8 November 1919, p. 2; *Leinster Leader*, 15 November 1919, p. 2; *Leinster Leader*, 22 November 1919, p. 2; *Nationalist and Leinster Times*, 26 March 1921, p7.

642 *Leinster Leader*, 17 January 1920, p. 2; *Leinster Leader*, 31 January 1920, p. 2; *Nationalist and Leinster Times*, 29 May 1920, p. 5; *Nationalist and Leinster Times*, 11 September 1920, p. 5; *Nationalist and Leinster Times*, 2 October 1920, p. 5; *Nationalist and Leinster Times*, 12 March 1921, p. 5; *Nationalist and Leinster Times*, 11 June 1921, p. 5.

643 *Nationalist and Leinster Times*, 23 September 1922, p. 4.

644 *Nationalist and Leinster Times*, 14 October 1922, p. 4; *Nationalist and Leinster Times*, 25 November 1922, p. 4; *Nationalist and Leinster Times*, 10 March 1923, p. 5.

645 *Nationalist and Leinster Times*, 16 April 1927; *Nationalist and Leinster Times*, 30 April 1927; *Nationalist and Leinster Times*, 10 September 1927.

646 *Nationalist and Leinster Times*, 2 November 1929; *Nationalist and Leinster Times*, 27 September 1930; *Nationalist and Leinster Times*, 11 October 1930.

647 *Nationalist and Leinster Times*, 31 January 1920, p. 2.

648 *Irish Independent*, 27 January 1920, p. 5; *Leinster Leader*, 14 February 1920, p. 3; information from Kathleen Wall.

649 *Irish Independent*, 27 January 1920, p. 5; *Nationalist and Leinster Times*, 31 January 1920, p. 2; *Leinster Leader*, 31 January 1920, p. 2; 17 April 1920, p. 3; information from Kathleen Wall.

650 *Irish Times*, 30 April 2003; *Leinster Leader*, 10 January 1920, p. 2; 31 January 1920, p. 2.

651 *Irish Independent*, 26 January 1920, p. 5; *Nationalist and Leinster Times*, 31 January 1920, p. 2; *Leinster Leader*, 17 April 1920, p. 3.

652 *Nationalist and Leinster Times*, 31 January 1920, p. 2; 21 February 1920; NAI, Pris1/45/03, 1920/93-99; information from Kathleen Wall.

653 *Leinster Leader*, 7 February 1920, p. 2; 27 March 1920, p. 2; 15 May 1920, p. 2; *Nationalist and Leinster Times*, 21 February 1920; 5 June 1920, p. 5.

654 *Leinster Leader*, 17 April 1920, p. 3.

655 NAI, MFA 24/12, service no. 67903.

656 NAI, MFA 24/12, service no. 62265; *Leinster Leader*, 10 April 1920, p. 2; 17 April 1920, p. 3; 12 June 1920, p. 3.

657 *Leinster Leader*, 17 April 1920, p. 3; NAI, Calendar of Wills and Administrations re Malynn's administration.

658 *The Times*, 16 April 1920, p. 14; *Nationalist and Leinster Times*, 17 April 1920, p. 2; 29 May 1920, p. 5; *Wicklow People*, 17 April 1920, p. 4; 24 April 1920, p. 5; *Leinster Leader*, 12 June 1920, p. 3.

659 *Nationalist and Leinster Times*, 29 May 1920, p. 5; *Wicklow People*, 22 May 1920, p. 4; *Leinster Leader*, 22 May 1920, p. 3; 12 June 1920, p. 3.

660 *Leinster Leader*, 17 April 1920, p. 2; 15 May 1920, p. 2.

661 Information from Tommy Doyle of the Lough in January 1992 interview.

662 T.U. Sadleir, 'The Family of Saunders of Saunders' Grove, County Wicklow', *Journal of the Co. Kildare Arch. Soc.*, Vol. 9, pp. 125-133; Mark Bence-Jones, *Burke's Guide to Country Houses*, Vol. 1, p. 255; Sadleir gives a building date of 1718, while Bence-Jones gives 1716.

663 Sadleir, op. cit.; *Burke's Landed Gentry of Ireland*, 1912 edition; O'Donnell, *The Rebellion in Wicklow 1798*, p. 176; O'Donnell, *Aftermath post–Rebellion insurgency in Wicklow, 1799–1803*, p. 105.

664 *Leinster Leader*, 22 May 1920, p. 3; 19 June 1920, p. 5; *Wicklow People*, 22 May 1920, p. 4; *Nationalist and Leinster Times*, 16 October 1920, p. 5.

665 *The Times*, 21 May 1920, p. 16; *Leinster Leader*, 22 May 1920, p. 2; *Nationalist and Leinster Times*, 29 May 1920, p. 5.

666 *Leinster Leader*, 10 April 1920, p. 2; 22 May 1920, p. 2; *Nationalist and Leinster Times*, 10 April 1920.

667 *Leinster Leader*, 22 May 1920, p. 3; *Nationalist and Leinster Times*, 29 May 1920, p. 7.

668 *Nationalist and Leinster Times*, 5 June 1920, p. 5; 25 December 1920, p.2; *Leinster Leader*, 12 June 1920, p. 2; 19 June 1920, p. 5; 31 July 1920, p. 2.

669 *Leinster Leader*, 17 July 1920, p. 2; 31 July 1920, p. 2.

670 *Leinster Leader*, 24 July 1920, p. 2.

671 *Leinster Leader*, 8 November 1919, p. 3; 17 July 1920, p. 2; 24 July 1920, p. 2; 31 July 1920, p. 2; 14 August 1920, p. 2; NAI, Business Records, Wick 30, Morrin, miscellaneous documentation.

672 *Leinster Leader*, 7 August 1920, p. 2; *Nationalist and Leinster Times*, 7 August 1920, p. 4.

673 *Leinster Leader*, 7 August 1920, p. 2; *Nationalist and Leinster Times*, 7 August 1920, p. 4; NAI Pris1/45/03, 1920/845-846, 852-854.

674 *Leinster Leader*, 7 August 1920, p. 2; 14 August 1920, p. 2; *Nationalist and Leinster Times*, 7 August 1920, p. 4; NAI Pris1/45/03, 1920/851.

675 *Leinster Leader*, 8 May 1920, p. 2; 19 June 1920, p. 5; 14 August 1920, p. 2.

676 *Leinster Leader*, 14 August 1920, p. 2.

677 *Nationalist and Leinster Times*, 25 September 1920, p. 3.

678 *Nationalist and Leinster Times*, 25 September 1920, p. 3.

679 *Nationalist and Leinster Times*, 21 August 1920, p. 3; 6 July 1940, p 6; the site of Hourihanes' shop is now (2006) occupied by McGraths' and Walls' businesses.

680 *Nationalist and Leinster Times*, 21 August 1920, pp. 3 & 5.

681 NAI Pris1/45/03, 1920/845-846, 851-854 & 879; *Nationalist and Leinster Times*, 4 September 1920, p. 5; 11 September 1920, p. 5.

682 *Nationalist and Leinster Times*, 18 September 1920, p. 5; The newspaper report of the attacks on Dalton and Doyle did not mention the Black and Tans, but Jimmy Nolan of the Wood related this incident to the author in the 1970s, stating that they were the assailants.

683 *Nationalist and Leinster Times*, 25 September 1920, p. 5; 7 May 1921, p. 7; NAI, MFA 24/13, service no. 71486; 1891 Census of England, RG12/2465, ED 2, fol. 26.

684 *Nationalist and Leinster Times*, 2 October 1920, p. 5; 8 January 1921, p. 3.

685 *Nationalist and Leinster Times*, 16 October 1920, p. 5.

686 *Nationalist and Leinster Times*, 16 October 1920, p. 5; 23 October 1920, p. 4.

687 *Nationalist and Leinster Times*, 23 October 1920, p. 4; 6 November 1920, p. 5; 13 November 1920, p. 5, 27 November 1920, p. 4; 18 December 1920, p. 2; 25 December 1920, p. 2; *Leinster Leader*, 20 November 1920, p. 2.

688 *Nationalist and Leinster Times*, 12 March 1921, p. 5; 2 April 1921, p. 5; 9 April 1921, p. 5; 7 May 1921, p. 5; 28 May 1921, p. 5.

689 *Nationalist and Leinster Times*, 8 January 1921, p. 3; 7 May 1921, p. 7.

690 *Nationalist and Leinster Times*, 14 May 1921, p. 5; 11 June 1921, p. 2.

691 *Nationalist and Leinster Times*, 21 May 1921; 16 July 1921, p. 5.

692 *Nationalist and Leinster Times*, 8 October 1921, p. 5; 29 October 1921, pp. 5 & 7; 5 November 1921, p. 7; 4 February 1922, p. 5.

693 *The Times*, 1 November 1921, p. 10; *Nationalist and Leinster Times*, 5 November 1921, p. 5.

694 *Nationalist and Leinster Times*, 19 November 1921, p. 8; 31 December 1921, p. 4; 21 January 1922, p. 5.

695 *Nationalist and Leinster Times*, 5 November 1921, p. 5; 28 January 1922, p. 5; 5 August 1922, p. 5; 9 June 1923, p. 5.

696 *Nationalist and Leinster Times*, 7 January 1922, p. 7.

697 *Nationalist and Leinster Times*, 14 January 1922, p. 5.

698 *Nationalist and Leinster Times*, 4 February 1922, p. 5.

699 *Nationalist and Leinster Times*, 28 January 1922, p. 5; 4 February 1922, p. 5; 11 March 1922, p. 8.

700 *Nationalist and Leinster Times*, 25 March 1922, p. 5; 8 April 1922, p. 5; NAI, Financial Compensation File 405/64 (2).

701 *Nationalist and Leinster Times*, 8 April 1922, pp. 5 & 8; NAI, Financial Compensation 405/64.

702 *Nationalist and Leinster Times*, 22 April 1922, p. 5; 24 June 1922, p. 5.

703 *Nationalist and Leinster Times*, 8 July 1922, p. 4.

704 *Nationalist and Leinster Times*, 8 July 1922, p. 3.

705 *Nationalist and Leinster Times*, 8 July 1922, p. 3.

706 *Nationalist and Leinster Times*, 15 July 1922, p. 5; 9 May 1936, p. 3; NAI, Financial Compensation 405/61, 87, 120, 125 & 342.

707 *Nationalist and Leinster Times*, 15 July 1922, p. 5.

708 *The Times*, 19 July 1922, p. 10; *Nationalist and Leinster Times*, 22 July 1922, p. 2.

709 *The Times*, 19 July 1922, p. 10; *Nationalist and Leinster Times*, 22 July 1922, p. 2; George's Hill, C56/1; information from Freddie McDaid about the military manoeuvres.

710 *Nationalist and Leinster Times*, 22 July 1922, p. 2.

711 *Nationalist and Leinster Times*, 22 July 1922, p. 4; 5 August 1922, p. 5; 12 August 1922, p. 4; 19 August 1922, p. 4; 26 August 1922, p. 5.

712 *Nationalist and Leinster Times*, 28 October 1922, pp. 4 & 5; *Oireachtas Debates*, Dáil Éireann, Vol. 7, 8 May 1924; Vol. 8, 4 July 1924.

713 *Nationalist and Leinster Times*, 28 October 1922, p. 5; Information from Freddie McDaid; tradition has it that the Crossley van approached Graney by the Knocknacree road but the evidence given at the inquests in Carlow, as reported in the newspaper, clearly states that it came from Castledermot.

714 *Nationalist and Leinster Times*, 28 October 1922, pp. 4 & 5.

715 *Nationalist and Leinster Times*, 28 October 1922, p. 5; 4 November 1922, p. 4; 11 November 1922, p. 5; 18 November 1922, p. 4.

716 Information from Freddie McDaid.

717 *Nationalist and Leinster Times*, 18 November 1922, p. 4; 25 November 1922, p. 4; 24 March 1923, p. 5; Information from Tommy Doyle of the Lough in 1992 interview; NAI, Financial Compensation File 405/163.

718 *Nationalist and Leinster Times*, 10 February 1923, p. 8; NAI, Financial Compensation, 405/215, 252, 270, 294 & 301.

719 *Nationalist and Leinster Times*, 17 March 1923, p. 5; 7 April 1923, p. 8.

720 *Oireachtas Debates*, Dáil Éireann, Vol. 3, (written answers) 12 April & 9 May 1923.

721 *Nationalist and Leinster Times*, 31 March 1923, p. 5.

722 *Nationalist and Leinster Times*, 21 April 1923, p. 5; 28 April 1923, p. 5; 9 June 1923, p. 5.

723 *Irish Times*, 31 January 1924, p. 7; 27 February 1924, p. 3; 12 March 1924, p. 8; 8 July 1924, p. 6; *Wicklow People*, 2 February 1924, p. 4.

724 Now (2006) the Bank of Ireland.

725 *Irish Times*, 27 February 1924, p. 3.

726 *Irish Times*, 27 February 1924, p. 3.

727 Now (2006) the part of Quinns' supermarket next to Quinns' lounge.

728 *Irish Times*, 31 January 1924, p. 7; 27 February 1924, p. 3; 8 July 1924, p. 6; www. esatclear.ie/~garda/honour.html; *Wicklow People*, 18 July 1925.

729 *Wicklow People*, 2 February 1924, p. 4; *Irish Times*, 27 February 1924, p. 3.

730 *Wicklow People*, 2 February 1924, p. 4; *Irish Times*, 29 January 1924, p. 5; 30 January 1924, p. 7; 31 January 1924, p. 7; 2 February 1924, p. 5; www.esatclear.ie/~garda/honour.html.

731 *The Times*, 30 January 1924, p. 7; 16 February 1924, p. 9; 18 February 1924, p. 14; *Irish Times*, 18 February 1924, p. 5; 27 February 1924, p. 3; 12 March 1924, p. 8; 8 July 1924, p. 6.

732 *Irish Times*, 9 July 1924, p. 7; 12 July 1924, p. 8; 2 August 1924, p. 8; *Irish Independent* 11 July 1924, p. 7; *Oireachtas Debates*, Dáil Éireann, Vol. 8, 1 August 1924.

733 Brophy, *The Leathers Echo*, pp. 20, 23-4; Byrne & Noonan, *50 Years of the G.A.A. in Co. Wicklow*, pp. 44 & 113.

734 Brophy, op. cit., p. 94; *Wicklow People*, 3 January 1903, p. 4; *Nationalist and Leinster Times*, 7 November 1903; 30 January 1904; 26 March 1904; 2 April 1904; 16 July 1904; 15 October 1904; Hallahan, *The Path to the Pinnacle*, p. 54.

735 *Nationalist and Leinster Times*, 7 May 1927; 14 May 1927; 4 June 1927; 25 June 1927; *Wicklow People*, 8 September 1928, p. 8; Hallahan, op. cit., p. 50.

736 *Nationalist and Leinster Times*, 25 June 1927; 2 July 1927; 30 July 1927; 17 December 1927.

737 *Nationalist and Leinster Times*, 18 February 1928; 19 May 1928; Byrne & Noonan, op. cit., p. 77.

738 *Wicklow People*, 7 April 1928, p. 6; 8 September 1928, p. 8; *Nationalist and Leinster Times*, 14 April 1928; 19 May 1928.

739 *Nationalist and Leinster Times*, 2 June 1928; 4 August 1928; 17 Nov. 1928; 15 December 1928; 12 October 1929; 28 December 1929.

740 *Nationalist and Leinster Times*, 31 March 1934, p.4; 7 April 1934, p. 4; 28 July 1934, p. 9.

741 Hallahan, op. cit., p. 50.

742 Paul Gorry, *Baltinglass Golf Club 1928-2003*, p. 17.

743 Gorry, op. cit., pp. 7-8; *Leinster Leader*, 5 May 1917, p. 2; 28 July 1917, p. 2.

744 Gorry, op. cit., pp. 8-9 & 13.

745 Ibid., pp. 9, 14-5 & 17.

746 Ibid., pp. 17 & 23-4.

747 *Nationalist and Leinster Times*, 27 October 1928; 15 February 1930; 31 January 1931; 30 May 1931; 7 January 1933, p. 6; 9 June 1934, p. 4; 26 October 1935, p. 4; 16 October 1937, p. 2; 20 November 1937, p. 2; 5 February 1938, p. 3; Gorry, op. cit., pp. 26-7 & 35.

748 Gorry, op. cit., pp. 40, 42-6 & 48-50.

749 Ibid., pp. 51-2, 73-4, 118-9 & 121-2.

750 See under 'Opening of Baltinglass Town Hall'

751 John Gleeson, *Fyffes Dictionary of Irish Sporting Greats* (Dublin, 1993), pp. 60 & 257; Brophy, *The Leathers Echo*, p. 576; *Outing*, Vol. XII, no. 2 (May 1888), p. 187; O'Sullivan, *The Story of the G.A.A.*, pp. 60-2; *Nationalist and Leinster Times*, 6 July 1929.

752 *Nationalist and Leinster Times*, 3 September 1904, p. 4; 1 October 1904; 6 July 1929; O'Sullivan, op. cit., 166; Gleeson, op. cit., p. 257.

753 *Nationalist and Leinster Times*, 24 April 1920; 14 July 1923, p. 5; *Irish Times*, 5 August 1924, p. 4; 6 August 1924, p. 11; 7 August 1924, p. 10; 14 August 1924, p. 3; 16 August 1924, p. 5.

754 *Nationalist and Leinster Times*, 30 April 1927; 4 June 1927; 23 June 1928; 11 August 1928; *Sport*, 28 July 1928, p. 14; 11 August 1928, p. 3; *Irish Independent*, 6 August 1928, p. 13; 13 August 1928, p. 11.

755 *Irish Independent*, 16 August 1928, p. 8; 20 August 1928, p. 14; *Nationalist and Leinster Times*, 18 August 1928; *Sport*, 18 August 1928, pp. 12, 14.

756 *Sport*, 1 September 1928; 15 December 1928, p. 14; 29 December 1928, p. 11; *Wicklow People*, 3 November 1928, p. 5; *Irish Independent*, 8 December 1928, p. 13; *Nationalist and Leinster Times*, 15 December 1928.

757 *Nationalist and Leinster Times*, 15 December 1928; *Sport*, 27 April 1929, p 13; 11 May 1929, p. 3.

758 *Nationalist and Leinster Times*, 28 December 1929; 12 July 1930.

759 Brophy, op. cit., pp. 95, 374, 376, 595-6, 609; *Nationalist and Leinster Times*, 9 May 1936, p. 4; Hallahan, *The Path to the Pinnacle*, p. 87.

760 *Nationalist and Leinster Times*, 30 October 1920, p. 7; 27 November 1920, p. 4; 25 December 1920, p. 2.

761 *Nationalist and Leinster Times*, 11 December 1920, p. 2; 8 January 1921, p. 5.

762 *Nationalist and Leinster Times*, 15 October 1921, p. 3; 29 October 1921, p. 3; 5 November 1921, p. 5; 24 December 1921, p. 7; 7 January 1922, p. 7.

763 *Nationalist and Leinster Times*, 10 February 1923, p. 8; 24 March 1923, p. 5; 9 July 1927; 7 January 1928.

764 *Wicklow People*, 19 January 1929, p. 5; 9 February 1929.

765 *Nationalist and Leinster Times*, 9 February 1929; *Wicklow People*, 30 March 1929, p. 2.

766 *Nationalist and Leinster Times*, 14 September 1929; 5 October 1929; 8 February 1930; 2 August 1930; 3 January 1931; *Wicklow People*, 30 November 1929, p. 2.

767 *Nationalist and Leinster Times*, 2 January 1932; 10 March 1934, p. 4; 1 December 1934, p. 4; 8 December 1934, p. 4; 29 June 1935, pp. 2 & 10; 6 July 1935, p. 6; 27 July 1935, p. 2; 4 January 1936, p. 3; Gorry, *Baltinglass Golf Club 1928-2003*, p. 54; *Nationalist and Leinster Times*, 28 June 1952.

768 *Nationalist and Leinster Times*, 26 October 1929.

769 *Wicklow People*, 30 June 1928, p. 5; 11 August 1928, p. 6; *Nationalist and Leinster Times*, 1 December 1928; 4 May 1929; 11 May 1929; 9 November 1929; George's Hill, C56/2.

770 *Nationalist and Leinster Times*, 16 November 1929; 8 February 1930; 31 May 1930; *Wicklow People*, 21 December 1929, p. 11.

771 *Nationalist and Leinster Times*, 9 April 1927; 16 April 1927; 21 May 1927.

772 *Nationalist and Leinster Times*, 25 June 1927; 28 January 1928; 9 June 1928; 16 June 1928.

773 *Nationalist and Leinster Times*, 27 October 1928; 30 November 1929; 14 December 1929; 21 December 1929; 21 June 1930; 5 July 1930, p. 7.

774 *Nationalist and Leinster Times*, 15 March 1930; 10 May 1930; 21 June 1930; 2 August 1930; 6 September 1930; Registry of Deeds, 1930/28/262.

775 *Nationalist and Leinster Times*, 30 May 1931; 6 May 1933, p. 4; 3 June 1933, p. 5; *Wicklow People*, 11 June 1932; *Leinster Leader*, 29 July 1933, p. 2; 5 August 1933, p. 9.

776 *Nationalist and Leinster Times*, 26 May 1934, p. 6; 9 June 1934, p. 4; 15 September 1934, p. 4; 27 November 1937, p. 5; 5 March 1938, p. 8; 7 May 1938, p. 5.

777 *Nationalist and Leinster Times*, 1 November 1930; 15 November 1930; 3 January 1931; *Vocational Education Act, 1930*, 59 (1).

778 *Wicklow People*, 22 October 1932; *Nationalist and Leinster Times*, 16 September 1933, p. 7; *Nationalist and Leinster Times*, 28 July 1934, p. 4; *Nationalist and Leinster Times*, 22 September 1934, p. 4; Registry of Deeds, 1932/32/203.

779 *Nationalist and Leinster Times*, 11 May 1929; 8 June 1929.

780 Information from P.J. Hanlon; Jim Brophy, *The Leathers Echo*, pp. 263-4.

781 *Nationalist and Leinster Times*, 25 October 1930; 22 November 1930; 17 January 1931; 23 May 1931; Brophy, op. cit., pp. 263-4; information from P.J. Hanlon.

782 *Nationalist and Leinster Times*, 25 February 1933, p. 4; 27 May 1933, p. 4; 2 September 1933, p. 4; 27 January 1934; 31 March 1934, p. 4; 7 April 1934, p.4; 14 July 1934, p. 4; 28 July 1934; *Kildare Observer*, 16 February 1935, p. 2.

783 *Nationalist and Leinster Times*, 3 March 1934; 10 March 1934, p. 9.

784 *Nationalist and Leinster Times*, 28 April 1934; 9 June 1934, p. 4.

785 *Nationalist and Leinster Times*, 10 May 1930; 17 May 1930.

786 *Oireachtas Debates*, Dáil Éireann, Vol. 50, 1 March 1934.

787 *Nationalist and Leinster Times*, 24 March 1934.

788 *Oireachtas Debates*, Seanad Éireann, Vol. 18, 20 March 1934; *Nationalist and Leinster Times*, 28 April 1934,
9 June 1934, p. 4.

789 *Minutes of the Conference of the Methodist Church in Ireland, 1935*, p. 64.

790 Steven C. ffeary-Smyrl, *Irish Methodists – Where do I start?*, p. 1; Nehemiah Curnock (ed.): *The Journal of Rev. John Wesley, A.M.*, Vol. V, pp. 137, 216, 329, 423.

791 Dudley Levistone Cooney, *Asses' Colts and Loving People: The story of the people called Methodists on the Carlow Circuit*, p. 31; ffeary-Smyrl, p. 2.

792 Registry of Deeds, 1849/7/295.

793 Cooney, p. 31.

794 Census of Ireland statistics, 1861, 1871, 1881, 1891, 1901.

795 'Extracts from the Turtle Manuscripts 1940', *Journal of the West Wicklow Hist. Soc.*, No. 1, p. 87.

796 Cooney, p. 33; Registry of Deeds, 1923/39/10.

797 *Nationalist and Leinster Times*, 14 November 1936, p. 9; Registry of Deeds, 1937/30/220.

798 Valuation Office revision books; *Nationalist and Leinster Times*, 19 January 1935, p. 5.

799 *Nationalist and Leinster Times*, 25 June 1932.

800 *Nationalist and Leinster Times*, 8 April 1933, p. 4; 6 May 1933, p. 4; 13 May 1933, p. 5; 3 June 1933, p. 5; 10 June 1933, p. 2; Registry of Deeds, 1935/25/128.

801 Information from P.J. Hanlon; *Nationalist and Leinster Times*, 15 September 1934, p. 4; 19 January 1935, p. 5; 19 October 1935, p. 5; 4 January 1936, p. 3; 10 October 1936.

802 *Nationalist and Leinster Times*, 9 May 1936, p. 4; 9 January 1937, p. 2; 16 December 1939, p. 7.

803 *Nationalist and Leinster Times*, 26 October 1935, p. 4; 23 November 1935, p. 9.

804 *Nationalist and Leinster Times*, 23 November 1935, p. 9.

805 *Nationalist and Leinster Times*, 16 February 1935, p. 11; 23 November 1935, p. 9; 14 March 1936, p. 9; Brophy, op. cit., p. 264.

806 *Nationalist and Leinster Times*, 22 February 1936, p. 9; 11 April 1936, p. 4; 18 April 1936, p. 6; 2 May 1936, p. 9; 6 March 1937, p. 3; 7 Oct. 1939, p. 3; 11 May 1940, p. 6.

807 *Nationalist and Leinster Times*, 16 November 1935, p. 8; 30 November 1935, p. 6; 25 January 1936, p. 3.

808 *Nationalist and Leinster Times*, 13 July 1935, p. 3; 19 October 1935, p. 5; 26 October 1935, p. 4.

809 *Nationalist and Leinster Times*, 19 October 1935, p. 5; 16 November 1935, p. 8; 18 January 1936, p. 4; 16 May 1936, p. 2; 11 July 1936, p. 5; 5 September 1936, p. 2; 6 January 1940, p. 6.

810 *Wicklow People*, 18 July 1936; *Nationalist and Leinster Times*, 10 October 1936, p. 7; 31 October 1936, p. 5; 4 December 1937, p. 9; 6 January 1940, p. 6; 5 October 1940, p. 2; 2 October 1943, p. 5.

811 George's Hill, C56/2; information from Phyllis Flanagan, who was in the first class in St. Therese's.

812 Information from Sister Josepha O'Donnell.

813 C56/2; information from Phyllis Flanagan and Sister Josepha O'Donnell.

814 Information from Sister Josepha O'Donnell.

815 Information from Cyril McIntyre and Sister Josepha O'Donnell; David Hallahan: 'Life in Education', *The Baltinglass Review 2005*, p. 12.

816 *Wicklow People*, 19 December 1936, p. 15.

817 *Nationalist and Leinster Times*, 26 December 1936, p. 4.

818 National Library of Ireland, Ordnance Survey Name Book, Baltinglass parish.

819 *Nationalist and Leinster Times*, 10 June 1933, p. 2.

820 *Nationalist and Leinster Times*, 8 October 1938, p. 2; 28 January 1939, p. 6; 4 February 1939, p. 2; 4 May 1940, p. 4; *Wicklow People*, 6 May 1939; information from Kathleen Wall.

821 *Nationalist and Leinster Times*, 15 February 1941; 22 February 1941; 1 March 1941.

822 Information from P.J. Hanlon and Kathleen Wall.

823 *Nationalist and Leinster Times*, 28 June 1974; 5 July 1974.

824 *Nationalist and Leinster Times*, 9 September 1939, p. 6.

825 http://www.military.ie/reserves/fca_history.htm (viewed on 29 January 2006).

826 *Nationalist and Leinster Times*, 13 July 1940, p. 3; 20 July 1940, pp. 3, 6.

827 *Nationalist and Leinster Times*, 20 July 1940, p. 6; 3 August 1940, pp. 3, 8; 10 August 1940, p. 2.

828 *Nationalist and Leinster Times*, 17 August 1940, p. 2; 24 August 1940, p. 2; 31 August 1940, p. 8; 2 December 1950.

829 *Nationalist and Leinster Times*, 7 September 1940, p. 3; 14 September 1940, p. 3; 21 September 1940, p. 3; 5 October 1940, p. 2; 2 November 1940, p. 2; 9 November 1940, p. 3; 1 February 1941.

830 http://www.military.ie/reserves/fca_history.htm (viewed on 29 January 2006); *Nationalist and Leinster Times*, 25 January 1941; information from Paddy Dunne of Weavers' Square, who was in the LDF.

831 *Nationalist and Leinster Times*, 1 March 1941; 31 October 1942, p. 3; 12 December 1942, p. 2; 19 December 1942, p. 3.

832 *Nationalist and Leinster Times*, 15 March 1941; 22 March 1941; 29 March 1941; 5 April 1941; 27 March 1943, p. 5; 22 May 1943, p. 5.

833 *Nationalist and Leinster Times*, 28 February 1942; 1 May 1943, p. 4; 16 October 1943, p. 5; 4 November 1944, p. 3.

834 *Nationalist and Leinster Times*, 17 August 1940, p. 5; 7 September 1940, p. 3.

835 *Nationalist and Leinster Times*, 14 September 1940, p. 3; 21 September 1940, p. 5; 15 February 1941; 26 April 1941.

836 *Nationalist and Leinster Times*, 21 September 1940, p. 5; 15 February 1941; 8 March 1941; 15 March 1941; 22 March 1941; 5 April 1941.

837 *Nationalist and Leinster Times*, 5 April 1941; 26 April 1941; 31 May 1941; information from Paddy Dunne of Weavers' Square.

838 *Nationalist and Leinster Times*, 5 September 1942, p. 4; 5 December 1942, p. 2; 10 April 1943, p. 2; 15 May 1943, p. 2; 16 October 1943, p. 5; 23 October 1943, p. 5.

839 Main sources of information are the Commonwealth War Graves Commission database and memorial inscriptions in the Baltinglass area.

840 Information from Josephine Dunne, daughter of Ted and Josephine Bradley, and her husband Paddy Dunne.

841 *Nationalist and Leinster Times*, 4 January 1936, p. 3; 2 January 1937, p. 6; 3 April 1937, p. 2; 15 May 1937, p. 5; 5 June 1937, p. 3; 16 October 1937, p. 2; information from Paddy Dunne.

842 *Nationalist and Leinster Times*, 5 February 1938, p. 3; 13 May 1939, p. 3; 16 December 1939, p. 4; 30 December 1939, p. 4; information from Josephine Dunne.

843 Information from Josephine Dunne; *Nationalist and Leinster Times*, 7 September 1940, p. 3; 21 September 1940, p. 3; 5 October 1940, p. 2; 26 April 1941; 31 January 1942, p. 6; 12 December 1942, p. 2; 22 April 1944, p. 2; *Wicklow People*, 6 September 1941; 13 September 1941, p. 1; 20 September 1941.

844 Information from Josephine Dunne; *Nationalist and Leinster Times*, 2 January 1943, p. 3.

845 Information from Paddy and Josephine Dunne; *Nationalist and Leinster Times*, 6 March 1943, p. 2; 13 March 1943, p. 5.

846 *Nationalist and Leinster Times*, 15 April 1944, p. 3; 22 April 1944, p. 2; 16 December 1944, p. 2; information from Paddy and Josephine Dunne.

847 Author's personal memories; information from the late Davey Bradley.

848 *Nationalist and Leinster Times*, 1 October 1927; 25 June 1932; 20 August 1938, p. 6; 22 April 1944, p. 5; 29 April 1944, p. 6; Stephen Johnson, *Johnson's Atlas and Gazetteer of the Railways of Ireland*; Cora Crampton, 'The Tullow Line', *Journal of the West Wicklow Hist. Soc.*, No. 1, pp. 9-10.

849 Information from Cyril McIntyre.

850 Information from Cyril McIntyre; *Nationalist and Leinster Times*, 1 October 1927; 8 October 1927; 7 July 1928; 1 December 1928; 7 September 1929; 26 October 1929; 28 June 1930; 12 July 1930; 13 September 1930.

851 Information from Cyril McIntyre; *Nationalist and Leinster Times*, 15 February 1941; 15 March 1941; 22 April 1944, p. 2; Johnson, op. cit.

852 Information from Cyril McIntyre.

853 Profile by his nephew Matthew Byrne in *The Path to the Pinnacle*, edited by David Hallahan, pp. 76-77; *Wicklow People*, 27 September 1947, p. 5; Edward O'Toole: *Whist for your life, that's treason: Recollections of a Long Life*, p. 78.

854 Riksarkivet, Stockholm: Utrikesdepartementet, 1920 ars dossiersystem HP vol. 266.

855 *Wicklow People*, 23 September 1950, p. 5.

856 *Slater's Directory of Ireland*, 1881, lists W. Brereton as sub-postmaster; Dr. Coyle's surgery now occupies the premises in which Cooke lived.

857 The premises now occupied by Simon and Rosario Murphy.

858 NAI, CSORP 1881/38310; *Nationalist and Leinster Times*, 31 October 1936, p. 5; Lawrence Earl, *The Battle of Baltinglass*, p. 16; Maureen Cooke, *Mother in the Shadows*, pp. 26-29, 52, 136; Brian Donnelly, *For the Betterment of the People – A History of Wicklow County Council*.

859 Earl, op. cit., pp. 17-18, 20; *Oireachtas Debates*, Dáil Éireann, Vol. 123, 29 November 1950.

860 *Nationalist and Leinster Times*, 11 February 1950, 9 December 1950, p. 1; *Oireachtas Debates*, Dáil Éireann, Vol. 123, 7 December 1950; information from P.J. Hanlon.

861 The premises now run by Ann Harbourne.

862 Earl, op. cit., pp. 19, 22-24, 36-37.

863 Information from the late Pat Gorry; Earl, op. cit., pp. 21-22, 26-29, 131.

864 Earl, op. cit., pp. 29-33, 35-40.

865 Ibid., pp. 40-42, 44-47.

866 Ibid., pp. 49-50; *Nationalist and Leinster Times*, 2 December 1950.

867 Information from the late Pat Gorry; *Oireachtas Debates*, Dáil Éireann, Vol. 123, 29 November 1950; *Irish Times*, 2 December 1950, p. 1.

868 Earl, op. cit., pp. 52-53, 55; *Nationalist and Leinster Times*, 9 December 1950, p. 1.

869 Earl, op. cit., pp. 56-60; *Irish Times*, 2 December 1950, p. 1.

870 *Nationalist and Leinster Times*, 9 December 1950, pp. 1, 9; Earl, op. cit., pp. 61-62, 73-74.

871 *Irish Times*, 6 December 1950, p. 1; 7 December 1950, p. 1; 8 December 1950, p. 1; *Nationalist and Leinster Times*, 9 December 1950, pp. 1, 9; Earl, op. cit., pp. 74-75 (Earl appears to be in error in dating Mrs. Lalor's appearance as the Thursday).

872 Earl, op. cit., pp. 67-72; *Oireachtas Debates*, Dáil Éireann, Vol. 123, 6 December 1950, 7 December 1950, 13 December 1950, 14 December 1950; *Irish Times*, 7 December 1950, p. 1.

873 *Irish Times*, 8 December 1950, p. 1; *Nationalist and Leinster Times*, 10 March 1951, p. 4; Earl, op. cit., pp. 72-73, 151; information from the late Pat Gorry.

874 Earl, op. cit., pp. 14, 88-89, 91; *Irish Times*, 9 December 1950, p. 1.

875 Earl, op. cit., p. 92; *Irish Times*, 11 December 1950, p. 1.

876 Earl, op. cit., pp. 93-94; information from Dan Kehoe, son of Paul Kehoe.

877 Earl, op. cit., pp. 94-104; *Irish Times*, 12 December 1950, p. 1.

878 Earl, op. cit., pp. 104-107, 110, 113; *Irish Times*, 12 December 1950, p. 1.

879 Earl, op. cit., pp. 110-111, 113, 115-117; *Irish Times*, 12 December 1950, p. 1; 13 December 1950, p. 1; *Nationalist and Leinster Times*, 16 December 1950, p. 9.

880 Earl, op. cit., pp. 119; copies of the lists of drivers for January and February in author's possession.

881 Earl, op. cit., pp. 114, 120-121, 135; information from the late Pat Gorry; *Irish Times*, 13 December 1950, p. 1.

882 Earl, op. cit., pp. 128-131; *Irish Times*, 14 December 1950, p. 1.

883 Earl, op. cit., pp. 141-143, 147; information from the late Pat Gorry, the late Nora Harbourne and Pat McGrath (née Harbourne).

884 Earl, op. cit., pp. 149, 154-157; *Irish Times*, 16 December 1950, p. 1; 19 December 1950, p. 1; 20 December 1950, p. 1; 21 December 1950, p. 1.

885 Earl, op. cit., pp. 159, 163-164, 171.

886 Earl, op. cit., pp. 162, 167, 171; *Irish Times*, 23 December 1950, p. 1.

887 Earl, op. cit., pp. 177-178, 180, 184-185; *Irish Times*, 30 December 1950, p. 1; *Nationalist and Leinster Times*, 20 January 1951, p. 7.

888 Donnelly, *For the Betterment of the People – A History of Wicklow County Council*, pp. 112, 173-175.

889 Information from P.J. Hanlon; *Nationalist and Leinster Times*, 8 February 1963; Cooke, op. cit., pp. 102, 108, 111.

890 www.famouscanadians.net/books/e/earllawrence/ (viewed 12 February 2006); www.unb.ca/news/archives/releases/C118honorary.html (viewed 12 February 2006).

891 *Nationalist and Leinster Times*, 11 November 1950; 18 November 1950; 16 December 1950, p. 9; 23 December 1950, p. 4; 30 December 1950, p. 1; 6 January 1951, p. 4; information from P.J. Hanlon.

892 *Nationalist and Leinster Times*, 28 June 1974; 20 September 1974; information from Billy Doody.

893 *Nationalist and Leinster Times*, 12 May 1951.

894 'Danny the Barber'.

895 Entrance by Timmin's Lane.

896 Entrance by Kiltegan Road through Deerpark.

897 Site of Baltinglass Castle.

898 House in Stratfordlodge townland.

899 Formerly a police staion.

900 Old Toll House.

901 The 'Bed Road', running between Rathcoole Bridge and Lowtown, is so called because a large stone referrred to as St Laurence's Bed once lay by the roadside.

902 Railway Cottage.

903 'Jack the Tailor'.

904 'Soup Doyle'.

905 Railway Cottage.

906 Entrance on the road from the 'Five Crossroads' to Grangecon. St Bernard's Well situated on this property.

907 Not separately entered in Valuation Office records; house in Farmyard.

908 Former Wesleyan Methodist Chapel.

909 Same premises as Anthony Wilson's in 1851.

910 Same premises as Laurence Farrell's.

911 Baltinglass Handball Club minute book; *Nationalist and Leinster Times*, 3 January 1953, p. 5.

912 *Nationalist and Leinster Times*, 10 January 1953, p. 9; 23 February 1957; 15 February 1958; 8 March 1958; David Hallanan: *The Path to the Pinnacle*, pp. 87-88.

913 Garda Museum, Housing File No. A37/38/26.

914 Information from Freddie McDaid.

915 *Nationalist and Leinster Times*, 27 August 1955, p. 1; George's Hill, C56/4; information from Sister Josepha O'Donnell.

916 C56/4; information from Sister Josepha O'Donnell and Tom Hannafin.

917 Hallahan, *The Path to the Pinnacle*, p. 18; Brophy, *The Leathers Echo*, pp. 95-96.

918 Brophy, op. cit., pp. 95-96; *Nationalist and Leinster Times*, 17 December 1955, p. 11; *Wicklow People*, 17 December 1955, p. 6.

919 Brophy, op. cit., p. 96.

920 Hallahan, *The Path to the Pinnacle*, p. 22; *Nationalist and Leinster Times*, 1 December 1956, p. 6;

921 Hallahan, op. cit., pp. 22-23, 54-55; *Nationalist and Leinster Times*, 15 February 1958; 5 September 1959.*Wicklow People*, 25 October 1958, p. 14; 1 November 1958, p. 3; Johnny Kenny, 'Our glorious first', in Hallahan, op. cit., p. 78; Brophy, *The Leathers Echo*, pp. 96-97.

923 *Wicklow People*, 1 November 1958, p. 5; Kenny, op. cit.

924 *Nationalist and Leinster Times*, 6 June 1959.

925 Cora Crampton, 'The Tullow Line', *Journal of the West Wicklow Hist. Soc.*, No. 1, p. 10; *Nationalist and Leinster Times*, 25 July 1959; Gorry, *Baltinglass Golf Club 1928-2003*, p. 67.

926 *Nationalist and Leinster Times*, 17 May 1963.

927 *Nationalist and Leinster Times*, 1 August 1959; 8 August 1959; information from Nuala O'Connell (née Barron) and the late Frank Glynn.

928 *Nationalist and Leinster Times*, 8 August 1959; 22 August 1959; 29 August 1959, p. 1.

929 Information from John McGrath and Tom Hannafin; author's personal memories.

930 Gorry, *Baltinglass Golf Club 1928-2003*, pp. 66, 138; *Nationalist and Leinster Times*, 18 July 1959; 25 July 1959; 5 September 1959.

931 Gorry, op. cit., pp. 138-9; Sean Hunt's scrapbook.

932 Ibid.

933 *Oireachtas Debates*, Dáil Éireann, Vol. 184, 9 November 1960; *Irish Times*, 31 January 2006, p. 7.

934 Information from Madge Crampton; *Nationalist and Leinster Times*, 12 November 1960, p. 1; 12 January 2001.

935 *Nationalist and Leinster Times*, 19 November 1960, p. 1; 26 November 1960, p. 1; 12 January 2001.

936 *Nationalist and Leinster Times*, 26 November 1965.

937 *Nationalist and Leinster Times*, 26 November 1965; *Leinster Leader*, 27 November 1965, p. 1; author's personal memories; analysis by Basil Jach of Fergal Doogue's aerial photograph on the cover of the *Baltinglass Review 2005*.

938 *Nationalist and Leinster Times*, 26 November 1965; 3 December 1965; *Leinster Leader*, 27 November 1965, p. 1.

939 *Leinster Leader*, 27 November 1965, p. 1; *Nationalist and Leinster Times*, 28 February 1969, p. 4.

940 *Nationalist and Leinster Times*, 3 December 1965; author's personal memories.

941 *Nationalist and Leinster Times*, 24 January 1953, p. 9; information from P.J. Hanlon.

942 Information from P.J. Hanlon; *Nationalist and Leinster Times*, 3 December 1955, p. 7 10 December 1955, p. 11; 17 December 1955, p. 11, 24 December 1955, p. 6.

943 *Nationalist and Leinster Times*, 7 January 1956, p. 9; 24 November 1956, p. 5; 22 December 1956, p. 6; 29 March 1963; 6 July 1966; 26 May 1967, pp. 6, 17.

944 *Nationalist and Leinster Times*, 26 May 1967, pp. 16-17.

945 *Nationalist and Leinster Times*, 20 September 1974.

946 Gorry, *Baltinglass Golf Club 1928-2003*, p. 142; *Irish Times*, 22 August 1967, p. 4.

947 Gorry, op. cit.

948 Information from Sister Josepha O'Donnell.

949 *Wicklow People*, 16 September 1967, p. 20; George's Hill, C56/4; information from Dave Hallahan.

950 Information from Dave Hallahan; author's personal memories.

951 Hallahan: *The Path to the Pinnacle*, pp. 25, 29-30; Brophy: *The Leathers Echo*, p. 97.

952 *Wicklow People*, 16 September 1967, p. 16; 23 September 1967, pp. 13, 16; Hallahan, op. cit., p. 31.

953 Hallahan, op. cit., pp. 25, 29-31; Brophy, op. cit., p. 97.

954 Hallahan, op. cit., pp. 32-33, 73-74; Brophy, op. cit., pp. 97, 98, 605; *Wicklow People*, 16 September 1967, p. 16.

955 Hallahan, op. cit., pp. 33-35; Brophy, op. cit., p. 99.

956 Hallahan, op. cit., pp. 36-39, 74; Brophy, op. cit., pp. 99-100.

957 ElectionsIreland.org (viewed 4 March 2006); *Oireachtas Debates*, Dáil Éireann, Vol. 232, 31 January 1968; 21 February 1968; information from Billy Timmins; *Nationalist and Leinster Times*, 22 March 1968, p. 1.

958 *Oireachtas Debates*, Dáil Éireann, Vol. 233, 27 March 1968; ElectionsIreland.org (viewed 4 March 2006).

959 *Nealon's Guide to the 27th Dáil and Seanad* (Dublin, 1993); Donnelly, *For the Betterment of the People – A History of Wicklow County Council*.

960 George's Hill, C56/2; C56/21; information from Sister Josepha O'Donnell and Father P.J. McDonnell; *Nationalist and Leinster Times*, 16 December 1944, p. 2

961 C56/4; information from Sister Josepha O'Donnell and Father P.J. McDonnell.

962 Information from Sister Josepha O'Donnell and Father P.J. McDonnell; *Nationalist and Leinster Times*, 1 March 1968, p. 4; 8 November 1968, pp. 17-18.

963 C56/4, *Nationalist and Leinster Times*, 8 November 1968, pp. 4, 18.

964 *Nationalist and Leinster Times*, 8 November 1968, p. 18; author's personal memories.

965 Information from Maria McCormack and Martin Doogue.

966 Information from Fran Quaid.

967 Information from Fran Quaid and Martin Doogue.

968 Information from Tess Healy.

969 Gorry, *Baltinglass Golf Club 1928-2003*, pp. 143-4.

970 Gorry, op. cit., pp. 144.

971 Gorry, *Baltinglass Golf Club 1928-2003*, pp. 144.

972 Gorry, op. cit., pp. 144-5.

973 Pamphlet prepared for the 20th anniversary celebration of Baltinglass Credit Union in 1994, supplied by Owen Cooney.

974 Ibid.

975 Ibid.; information from P.J. Kavanagh.

976 20th anniversary pamphlet; *Nationalist and Leinster Times*, 11 June 1998, p. 22.

977 *Nationalist and Leinster Times*, 30 August 1974, p. 6.

978 Text prepared for the 25th anniversary celebration of Wampfler in Baltinglass in August 1999, supplied by Culm Carty.

979 25th anniversary text; *Nationalist and Leinster Times*, 2 November 1990, p. 9.

980 25th anniversary text; *Nationalist and Leinster Times*, 28 January 2000; information from Anne Aspill.

981 Information from Dave Hallahan; George's Hill, C56/34.

982 Ibid.; *Nationalist and Leinster Times*, 12 November 1982, p. 9.

983 Information from Anne Aspill.

984 Pamphlet prepared for the 21st anniversary celebration of the WWDCC committee in 2002, supplied by Nuala Rogers.

985 21st anniversary booklet; *Nationalist and Leinster Times*, 10 December 1982, p. 8; 17 December 1982, p. 8; 31 December 1982, p. 5; 7 January 1983, p. 7; 14 January 1983, p. 6; 23 September 1983, pp. 4, 5.

986 21st anniversary booklet.

987 *Nationalist and Leinster Times*, 16 March 1990, p. 9, supplement p. 1.

988 *Nationalist and Leinster Times*, 23 March 1990, p. 1, 11.

989 Information from Johnny Kenny.

990 *Nationalist and Leinster Times*, 23 March 1990, p. 11.

991 George's Hill, C56/34.

992 Ibid.

993 Ibid.

994 *Nationalist and Leinster Times*, 5 October 1990, p. 4; 12 October 1990, p. 4; 26 October 1990, p. 4.

995 Hallahan, *The Path to the Pinnacle*, pp. 73-74.

996 *Irish Times*, 7 December 1990, p. 21.

997 Hallahan, op. cit., pp. 65, 75; Brophy, *The Leathers Echo*, pp. 607-608.

998 Information from Kevin O'Brien.

999 Information from Kevin O'Brien; *Nationalist and Leinster Times*, 5 October 1990, p. 4; *Irish Times*, 3 November 1990, p. 15; 12 November 1990, p. 4; 19 November 1990, p. 19; 5 December 1990, p. 18; 7 December 1990, p. 21.

1000 Information from Kevin O'Brien.

1001 Information from Paul Kavanagh of J.J. Kavanaghs.

1002 Information from Dermot Allen.

1003 Ibid.

1004 *Irish Times*, 21 February 1995, pp. 1, 3.

1005 *Irish Times*, 21 February 1995, pp. 1, 3; 24 February 1995, p. 4.

1006 Information from Mags Byrne; Presentation Convent, George's Hill, C56/34.

1007 *St Joseph's Parish – Parish Magazine 1991*; *Nationalist and Leinster Times*, 28 September 1990, p. 6; 9 November 1990, p. 6; 4 October 1991, p. 11.

1008 Information from Mags Byrne; *St. Joseph's Parish – Parish Magazine 1991*; *Nationalist and Leinster Times*, 11 September 1992, p. 4; 3 May 1996, pp. 1, 11.

1009 *Nationalist and Leinster Times*, 3 May 1996, pp. 1, 11; 13 July 2001, p. 8.

1010 Ibid.

1011 *Irish Times*, 9 June 1997, election supplement, p. 2.

1012 *Irish Times*, 13 June 1997, p. 10.

1013 Ardita Dauti was born in Ireland in April 2000.

1014 Hyzri Ferizi arrived from Germany in November 1999 to be reunited with his family.

1015 Ardit Shehu was born in Ireland in April 2000.

1016 Information from Shauna and Liz Bradley.

1017 *Irish Times*, 28 June 1999, p. 7; 5 July 1999, p. 10.

1018 *Nationalist and Leinster Times*, 23 July 1999, pp. 3, 6; information from Shauna and Liz Bradley.

1019 Information from Dave Hallahan, Michael O'Keeffe and Breeda O'Neill.

1020 Information from Catherine Walshe and Teresa Kenny.

1021 Formerly laneway to 'Gallows Hill'.

1022 Entrance formerly by Timmins' Lane.

1023 Entrance by Kiltegan Road through Deerpark.

1024 Opposite main graveyard entrance; formerly a row of small houses running west off Chapel Hill.

1025 Site of Baltinglass Castle.

1026 House in Stratfordlodge townland.

1027 On site of origina; Slaney Lodge House.

1028 Formerly a police station.

1029 Ruins of the Toll House.

1030 St Bernard's Well situated on this property.

1031 The 'Bed Road', running between Rathcoole Bridge and Lowtown, is so called because a large stone referred to as St Laurence's Bed once lay by the roadside.

1032 Old Railway Cottage.

1033 Names taken from the *Draft Register of Electors* published on 1 November 2000.

1034 Formerly Gate Lodge.

1035 Formerly St Pius X National School.

1036 Site of Deerpark House.

1037 Formerly occupied by Wicklow Waffles.

1038 Old Railway Cottage.

1039 Site of original *Newtownsaunders* house.

1040 House in farmyard.

1041 Corresponds to no. 1 a c in 1951.

1042 Offices in former railway ticket office.

1043 Former Wesleyan Methodist Chapel.